High School
English I

능률(김성곤 외)

내신
100신

내신신

기출 예상 문제집

내신 100신 기출 예상 문제집
High School English I 능률(김성곤 외)

지은이 김성곤, 윤진호, 구은영, 전형주, 서정환, 이후고, 김윤자, 김지연, 백수자
선임연구원 신유승
연구원 윤인아, 이다연
영문교열 August Niederhaus, Nathaniel Galletta
맥편집 김미진
디자인 박정진, 안훈정, 오솔길

✛ 교재 네이밍에 도움을 주신 분
 원혜민 님 가재울 고등학교

Let's grow together

NE능률이
미래를
창조합니다.

건강한 배움의 고객가치를 제공하겠다는 꿈을 실현하기 위해
40년이 넘는 시간 동안 열심히 달려왔습니다.

앞으로도 끊임없는 연구와 노력을 통해
당연한 것을 멈추지 않고

고객, 기업, 직원 모두가 함께 성장하는 NE능률이 되겠습니다.

Preface

Learning is not attained by chance, it must be sought for with ardor and diligence.

Abigail Adams

배움은 우연히 얻어지는 것이 아니라 열성을 다해 갈구하고 부지런히 집중해야 얻을 수 있는 것입니다.

Structure & Features

- 교과서 Reading 본문에 제시된 **주요 단어 및 숙어**가 정리되어 있습니다.

- **Vocabulary Check-Up**을 통해 학습한 어휘를 바로 확인할 수 있습니다.

문법 Point / 확인 문제

- 교과서 단원별로 꼭 알아두어야 할 **대표 문법**과 **내신출제 Point**가 수록되어 있습니다.

- **Point Check-Up**을 통해 학습한 내용을 확인할 수 있습니다.

- **확인 문제**를 통해 해당 문법을 제대로 이해했는지 다시 한 번 점검할 수 있습니다.

분석 노트 / 빈칸 채우기

- **분석 노트**에서는 교과서 Reading 본문의 모든 문장에 대한 해설과 해석을 학습할 수 있습니다.

- **빈칸 채우기**를 통해 교과서 Reading 본문의 주요 내용을 써 보며 복습할 수 있습니다.

옳은 어법·어휘 고르기 / 틀린 문장 고치기

- **옳은 어법·어휘 고르기**를 통해
 Reading 본문의 주요 문장에서 혼동할 수 있는
 어법이나 어휘를 점검할 수 있습니다.

- **틀린 문장 고치기**를 통해 Reading 본문의
 모든 문장을 정확하게 숙지하고 있는지
 확인할 수 있습니다.

내신 기출 문제 / 실전 적중 문제

- 실제 학교 내신 기출 문제에서 엄선한 **내신 기출 문제**,
 내신 시험에 나올 확률이 높은 문제들로만 구성한
 실전 적중 문제를 통해 풍부한 실전 경험을 쌓을 수
 있습니다.

서술형으로 내신 만점

- **서술형으로 내신 만점**을 통해 까다로운 서술형 문항을
 철저히 대비할 수 있습니다.

중간고사 / 기말고사

- **중간고사**와 **기말고사**를 통해
 학교 내신 시험에 완벽하게
 대비할 수 있습니다.

Contents

Lesson

01

A Spark in You

Words

- injured 형 부상을 입은, 다친
 - injure 동 상처 입히다, 다치게 하다
- feed 동 먹이를 주다
- dormitory 명 기숙사
- struggle 동 투쟁[고투]하다, 허우적거리다
- suit 동 ~에게 맞다
- athletic 형 (몸이) 탄탄한
- except 전 ~을 제외하고는
 - exception 명 예외, 제외
- limited 형 제한된 (↔ unlimited)
- avoid 동 피하다 (= escape)
- company 명 함께 있음
- sweep 동 (빗자루로) 청소하다
- feather 명 깃털
- damaged 형 다친
 - damage 명 손해[손상] 동 손해[손상]를 입히다
- encouragement 명 격려
 - encourage 동 용기를 북돋우다
- opportunity 명 기회 (= chance)
- awkward 형 서투른
- stroke 명 (수영 등에서 팔을) 젓기
- swiftly 부 신속히, 빨리
- fireworks display 불꽃놀이

- astonished 형 크게 놀란
- hesitate 동 망설이다
- rescue 동 구하다, 구조하다
- magnificently 부 훌륭하게
- duet 명 이중주(곡), 이중창(곡)
- occasionally 부 때때로 (= from time to time)
- speechless 형 말문이 막힌
- normal 형 평범한 (↔ abnormal)
- brilliantly 부 뛰어나게, 훌륭하게
- extraordinary 형 기이한, 놀라운 (= unusual, incredible) (↔ ordinary)
- emerge 동 모습을 드러내다
- duckling 명 오리 새끼
- definitely 부 분명히 (= certainly)
- confidence 명 자신감
 - confident 형 확신하고 있는, 자신이 있는
- competition 명 경기 (= match)
 - compete 동 경쟁하다, 겨루다
- acknowledgement 명 인정
 - acknowledge 동 인정하다
- genuine 형 진짜의, 진실한 (= sincere)
- earn 동 얻다
- improve 동 개선[향상]되다

Phrases

- in particular 특히
- be frightened of ~을 무서워하다
- involve ~ in … ~을 …에 참여시키다
- make fun of ~을 놀리다[비웃다]
- have trouble v-ing ~하는 데 어려움을 겪다
- fit in 어울리다[맞다]
- look after ~을 돌보다 (= take care of)
- as soon as ~하자마자
- stare at ~을 응시하다
- knock into ~에 부딪히다

- on the opposite side 반대편에
- be familiar with ~에 익숙[친숙]하다
- in awe 놀라서
- chase after ~을 쫓다
- take the lead 선두에 서다
- become used to ~에 익숙해지다
- in silence 조용히
- make a correction 잘못을 바로잡다
- all the way 내내
- participate in ~에 참여[참가]하다 (= take part in, join)

Vocabulary Check-Up

다음 영어는 우리말로, 우리말은 영어로 쓰시오.

01 injured	형 _____		23 명 인정	_____
02 suit	동 _____		24 잘못을 바로잡다	_____
03 athletic	형 _____		25 형 진짜의, 진실한	_____
04 be frightened of	_____		26 동 개선[향상]되다	_____
05 damaged	형 _____		27 ~에 참여[참가]하다	_____
06 involve ~ in ...	_____		28 동 투쟁[고투]하다, 허우적거리다	_____
07 stare at	_____		29 반대편에	_____
08 awkward	형 _____		30 ~에 익숙해지다	_____
09 swiftly	부 _____		31 조용히	_____
10 have trouble v-ing	_____		32 내내	_____
11 astonished	형 _____		33 ~에 부딪히다	_____
12 magnificently	부 _____		34 동 (빗자루로) 청소하다	_____
13 fit in	_____		35 명 격려	_____
14 be familiar with	_____		36 형 제한된	_____
15 occasionally	부 _____		37 ~을 놀리다[비웃다]	_____
16 speechless	형 _____		38 동 망설이다	_____
17 in awe	_____		39 동 구하다, 구조하다	_____
18 in particular	_____		40 ~을 돌보다	_____
19 extraordinary	형 _____		41 ~하자마자	_____
20 take the lead	_____		42 동 모습을 드러내다	_____
21 fireworks display	_____		43 동 피하다	_____
22 stroke	명 _____		44 ~을 쫓다	_____

예제 ▶ They **had waited** for their friends all day long.
그들은 하루 종일 그들의 친구들을 기다렸다.

교과서 ▶ 과거완료 부정형
Diego's early education **had not prepared** him well for life at his new school.
Diego의 어릴 적 교육은 그의 새 학교에서의 생활에 그를 제대로 준비시켜 주지 못했다.

▶ 과거완료는 「had v-ed」로 나타내며, 과거의 특정 시점 이전의 일이 그 과거 시점까지 영향을 미친 것을 표현할 때 쓴다. 특정 과거 시점보다 이전에 일어난 일을 나타낼 때도 쓰며, 이때는 '대과거'라고도 한다.

▶ 과거완료 부정형은 had와 v-ed 사이에 not 또는 never를 써서 「had not[never] v-ed」의 형태로 쓴다. 과거완료 진행형은 「had been v-ing」로, 과거의 특정 시점 이전에 시작된 일이 그 과거 시점에도 진행 중임을 나타낸다.

내신출제 Point

 대과거 「had v-ed」

과거에 일어난 두 가지 일의 순서를 나타낼 때, 먼저 일어난 일을 대과거로 표현한다.

My aunt **sent** me a camera that she **had bought** in Tokyo.
고모가 도쿄에서 구입한 카메라를 나에게 보내주었다.
▶ 카메라를 보낸 시점 보다 카메라를 구입한 것이 더 먼저 일어남

We **had promised** to meet at the bank at 3 p.m., but it **was** already half past.
우리는 오후 3시에 은행에서 만나기로 약속했지만, 이미 삼십 분이 지났다.
▶ 이미 삼십 분이 지난 시점보다 은행에서 오후 3시에 만나기로 약속한 일이 더 먼저 일어남

 과거완료 부정형 「had not[never] v-ed」

Fortunately, the plane **had not sunk** into the ocean. 다행히도, 비행기는 바다에 가라앉지 않았다.

I **had never shopped** online before you showed me this website.
나는 네가 이 웹사이트를 보여주기 전에는 온라인으로 쇼핑한 적이 없었다.

Point Check-Up
정답 및 해설 p.1

1 다음 네모 안에서 어법상 알맞은 것을 고르시오.

(1) She [is doing / had been doing] exercises every week before she had surgery.

(2) Emma forgot to return the book that she [has borrowed / had borrowed] last week.

(3) He didn't know the place well because he [had never been / had been never] there before.

예제	The road (**which[that]**) we were driving on yesterday was dangerous.

우리가 어제 운전하던 도로는 위험했다.

교과서	Suddenly Diego was not the sad little boy (**whom[that]**) we had become used to.

갑자기 Diego는 우리가 익숙해 있었던 그 슬픈 꼬마 소년이 아니었다.

▶ 목적격 관계대명사 who(m), that, which는 관계대명사절 안에서 동사나 전치사의 목적어 역할을 하며 생략할 수 있다.

▶ 전치사의 목적어 역할을 하는 관계대명사를 생략할 때, 전치사는 관계대명사절 끝에 쓴다. 또한 「전치사 + 관계대명사」의 형태로 쓸 때는 관계대명사 that이나 who를 쓰지 않는다.

내신출제 Point

 관계대명사가 전치사의 목적어일 때 전치사의 위치

전치사의 목적어로 관계대명사가 쓰일 때 전치사는 관계대명사 바로 앞에 쓰거나 관계대명사절 끝에 쓴다.
「전치사+관계대명사」의 형태일 때는 관계대명사를 생략할 수 없다.

This is the apartment **in which** the group of professors lives.
↳ 「전치사+관계대명사」

▶ 「전치사+관계대명사」의 형태이므로 관계대명사를 생략할 수 없음

This is the apartment (**which[that]**) the group of professors lives **in**.
↳ 관계대명사 ↳ 전치사

▶ 관계대명사를 생략할 경우, 전치사 in을 관계대명사절 끝으로 옮겨야 함

이것은 교수들 집단이 사는 아파트이다.

 목적격 관계대명사가 생략된 문장 구조

목적격 관계대명사가 생략된 경우, 관계대명사절과 관계대명사절이 수식하는 선행사를 찾아 문장 구조를 파악한다.

I read the comic book (**which[that]**) my brother bought. 나는 내 남동생이 산 만화책을 읽었다.
↳ 선행사 ↳ 관계대명사절

▶ 선행사 the comic book을 목적격 관계대명사절이 수식하는 경우

One day a young man appeared (**who(m)**) everyone had given up for dead.
↳ 선행사 ↳ 관계대명사절

어느 날 모두들 죽은 것으로 여겨 포기했던 젊은 남자가 나타났다.

▶ 선행사 a young man을 목적격 관계대명사절이 수식하는 경우이며, 선행사와 관계대명사절은 떨어져 있을 수도 있음

Point Check-Up

정답 및 해설 p.1

2 다음 문장에서 생략 가능한 부분에 밑줄 치시오.

(1) Have you seen the house that they recently built?

(2) The cell phone which they were looking for was mine.

(3) The lady whom you met in the cafeteria is a well-known musician.

01 다음 괄호 안에서 어법상 알맞은 것을 고르시오.

(1) I (have never seen / had never seen) a panda before I visited China.

(2) She (had been waiting / has been waiting) for an hour when they arrived at the station.

(3) Harry (had been working / has been working) on our team, but later he went to another company.

02 다음 문장에서 생략 가능한 부분에 밑줄 치시오. 생략할 부분이 없다면 X를 쓰시오.

(1) He is the reporter whom we've been talking about.

(2) Most of the students failed the test that they took yesterday.

(3) Alice will apply to a college from which she can get a scholarship.

03 다음 중 어법상 틀린 것을 고르시오.

① Jenny didn't like the movie we had seen last week.

② The house had been empty before she moved in.

③ Mary had had few friends until she joined the club.

④ My grandmother loves the old town in she was born.

⑤ When I entered the room, the meeting had already begun.

04 다음 괄호 안의 단어를 바르게 배열하여 문장을 완성하시오.

(1) Tony bought a book (been / he / looking / that / for / had).

→ _____

(2) Laura (chatting online / been / for / had / an hour) when her father came back.

→ _____

(3) I was very nervous because I (given / never / in public / had / a speech) before.

→ _____

(4) Is there (I / do / you / that / for / anything / can) while you wait?

→ _____

05 다음 괄호 안의 단어를 빈칸에 알맞은 형태로 고쳐 쓰시오. 교과서 p.25

I (1) _____ always _____ (dream) of going to Jordan, in the Middle East, and last year I finally got the chance to go. I (2) _____ _____ (want) to go there to see Petra, a city carved out of rock. When I saw it, I (3) _____ (feel) a connection with its distant past. The ancient people of Jordan, the Nabataeans, built Petra long ago, but it is still well known today. Seeing the city in real life was a terrific experience.

06 다음 밑줄 친 ⓐ~ⓔ 중, 생략할 수 있는 것을 모두 고르시오. 교과서 p.25

For all those times you stood by me
For all the truth that you made me see
For all the joy ⓐ that you brought to my life
For all the wrong that you made right
For every dream ⓑ that you made come true
For all the love ⓒ which I found in you
I'll be forever thankful baby
You're the one ⓓ who held me up
Never let me fall
You're the one ⓔ who saw me through, through it all

07 다음 중 어법상 틀린 것으로 바르게 짝지어진 것은?

ⓐ Anna is the employee my colleague strongly recommended.
ⓑ The hostel at that we stayed was conveniently located near the airport.
ⓒ There are lots of homeless children that we need to help in this city.
ⓓ Before Mike got that prize, he had won never any kind of award.
ⓔ As she had been walking for an hour, her feet started to hurt.

① ⓐ, ⓔ ② ⓑ, ⓒ ③ ⓑ, ⓓ ④ ⓒ, ⓓ ⑤ ⓓ, ⓔ

Can I Swim?

01 Tom Michell is a British teacher. In the 1970s, he worked at an English language boarding
기숙 학교

school in Argentina. One day he visited a beach and found a penguin [that was injured and
주어 동사1 동사2 ↑ 주격 관계대명사절

alone].

Tom Michell은 영국인 교사이다. 1970년대에 그는 아르헨티나에 있는 영어 기숙 학교에서 일했다. 어느 날 그는 해변에 갔다가 상처 입고 홀로 있는 펭귄 한 마리를 발견했다.

02 Michell decided to help the bird. He cleaned it, fed it, and even gave it a name—Juan Salvado.
 명사적 용법 (decided의 목적어) 주어 동사1 동사2 동사3
From that day on, Juan Salvado lived on the terrace of his room in the school dormitory.
 = Michell

Michell은 그 새를 도와주기로 결심했다. 그는 그것을 닦고 먹이고 Juan Salvado라는 이름까지 지어 주었다. 그날 이후로, Juan Salvado는 학교 기숙사에 있는 그의 방 테라스에서 살았다.

03 The following is part of the story, written by Tom Michell, [about the penguin and a boy at the
 과거분사구 전치사구

school].

다음은 Tom Michell이 그 펭귄과 그 학교의 한 소년에 대해 쓴 이야기의 일부이다.

04 From the first day [that I brought a penguin to live at the school], one student in particular
 ↑_____ 관계부사절 특히
wanted to help with his care.
 명사적 용법 (wanted의 목적어)

내가 펭귄을 데려와 학교에서 살게 한 첫날부터, 한 학생이 특히 펭귄을 돌봐 주는 일을 도와주고 싶어 했다.

05 His name was Diego Gonzales. Diego was a shy boy [who seemed to be frightened of his own
 seem to-v: ~인 것처럼 보이다
 ↑_____ 주격 관계대명사절
shadow].

그의 이름은 Diego Gonzales였다. Diego는 자기 자신의 그림자에도 몹시 겁을 내는 듯한 수줍음 타는 아이였다.

06 He struggled with his classes, and none of the after-school activities seemed to suit him.
 아무것도 ~않다
He was neither strong nor athletic.
 neither A nor B: A와 B 둘 다 아닌

그는 수업을 힘겨워했고, 방과 후 활동 중 그 어느 것도 그에게 적합해 보이지 않았다. 그는 강하지도 않았고 체격이 좋지도 않았다.

07 On the rugby field, nobody passed the ball to him or involved him in the game, except to make
주어 　　　동사1　　　　　　　　　　　　　동사2　　　　　　　　　　　~을 제외하고는
fun of him.
~을 놀리다[비웃다]

럭비 경기장에서, 그를 놀릴 때를 제외하고는 아무도 그에게 공을 패스하거나 경기에 그를 끼워주지 않았다.

08 Diego's early education had not prepared him well for life at his new school. [His knowledge of
　　　　　　　　　　　　　　과거완료 부정형　　　　　　　　　　　　　　　　　　　　　　　　　　　　　주어
English] was limited, so he avoided conversation.
　　　　동사

Diego의 어릴 적 교육은 그의 새 학교에서의 생활에 (그가 잘 적응하도록) 그를 제대로 준비시켜 주지 못했다. 그의 영어 지식은 부족했고, 그래서 그는 대화를 피했다.

09 However, Diego enjoyed the company of Juan Salvado. Indeed, on the terrace, Diego could
　　　　　　　　　　　　　　　　함께 있음
relax. He had some friends [who also had trouble fitting in].
　　　　　　　　some friends　　주격 관계대명사절　　have trouble v-ing: ~하는 데 어려움을 겪다

하지만 Diego는 Juan Salvado와 함께 있는 것을 즐겼다. 확실히, 테라스에서 Diego는 긴장을 풀 수 있었다. Diego에게는 그처럼 (학교 생활에) 적응하는 데 어려움을 겪는 몇몇 친구들이 있었다.

10 Looking after Juan Salvado was good for those boys.
　　주어 (동명사구)　　　　　　　　동사

Juan Salvado를 돌보는 것은 이 소년들에게 좋은 일이었다.

11 They fed him fish, swept the terrace, and spent time with him.
주어 동사1　　　　　　동사2　　　　　　　　동사3　　　　　　= Juan Salvado

그들은 펭귄에게 생선을 먹였고, 테라스를 청소했으며, 펭귄과 함께 시간을 보냈다.

12 One day, I took Juan Salvado to the school swimming pool with the boys.
　　　　　take A to B: A를 B로 데리고 가다

어느 날, 나는 그 소년들과 함께 Juan Salvado를 학교 수영장으로 데리고 갔다.

13 As soon as the other swimmers left, we brought Juan Salvado to the water to see [if he would
~하자마자　　　　　　　　　　　　　　bring A to B: A를 B로 데리고 가다　　　　부사적 용법〈목적〉　명사절 (see의 목적어) ~인지 아닌지
swim].

수영하고 있던 다른 사람들이 나가자마자, 우리는 Juan Salvado가 수영을 하려고 하는지를 보기 위해 그를 물로 데리고 갔다.

14 Juan Salvado had been living at the school for several months by then.
　　　　　　　　과거완료 진행형　　　　　　　　　　　　　　　　　~까지

그때까지 Juan Salvado는 여러 달 동안 학교에서 생활해 오고 있었다.

15 However, in all that time, he <u>had never been</u> able to swim because his feathers <u>had been</u>
 과거완료 부정형 과거완료 수동태
<u>damaged.</u>

그런데, 그 기간 내내 그는 깃털에 상처를 입은 상태여서 수영을 전혀 할 수가 없었다.

16 "Go on!" I said. The penguin stared at me and then at the pool, <u>like</u> he was asking, "Ah! Is this
 ~처럼 (접속사)
where the fish come from?"

"어서!" 내가 말했다. 펭귄은 나를 쳐다본 다음 수영장을 바라봤는데, 마치 그는 "아! 이곳이 물고기가 사는 곳인가요?"라고 묻는 것 같았다.

17 <u>Without</u> further encouragement, he jumped in.
 ~ 없이

더 격려하지 않아도, 펭귄은 (물속으로) 뛰어들었다.

18 With a single movement of his wings, <u>he flew like</u> an arrow across the water and <u>knocked</u> into
 주어 동사1 ~처럼 (전치사) 동사2
the wall on the opposite side. <u>Luckily</u>, he was not hurt!
 다행히도

날갯짓 한 번에 그는 물을 가로질러 화살처럼 날아 반대쪽 벽에 부딪혔다. 다행히도, 그는 다치지 않았다!

19 I <u>had never had</u> the opportunity [to study a penguin in the water] before.
 과거완료 부정형 ↑_____ 형용사적 용법

나는 이전에는 물속에 있는 펭귄을 살펴볼 기회가 전혀 없었다.

20 I was familiar with <u>the awkward way</u> [that Juan Salvado walked on land], but now I watched
 ↑____ 관계부사절
<u>in awe.</u>
놀라서

나는 Juan Salvado가 육지에서 걸어 다니던 어설픈 방식에만 익숙해 있었는데, 이제 나는 감탄하며 바라보았다.

21 <u>Using only a stroke or two</u>, he flew at great speed from one end of the pool to the other, <u>turning</u>
 분사구문 〈동시동작〉 end of the pool
<u>swiftly before touching the sides.</u>
분사구문 〈연속동작〉

겨우 한두 번의 날갯짓으로, 그는 수영장의 한쪽 끝에서 다른 쪽까지 엄청난 속도로 날아갔고, 끝에 닿기 전에 재빨리 몸을 돌렸다.

22 It was amazing! Everyone could see [how much he was enjoying himself].
 간접의문문 (「의문사+주어+동사」의 어순)

그 모습은 놀라웠다! 모든 사람들이 그가 얼마나 즐거워하고 있는지 알 수 있었다.

23 "Ooh! Aah!" The boys shouted, as though they were watching a fireworks display. After a while,

가정법 과거 「as though+주어+동사의 과거형」: 마치 ~인 것처럼

Diego came over and asked quietly, "Can I swim, too?"

주어　동사1　　　　동사2

"우! 아!" 소년들이 마치 불꽃놀이를 보고 있는 듯이 소리쳤다. 잠시 후에, Diego가 와서 조용히 물었다. "저도 수영해도 되나요?"

24 I was astonished. He had never gone near the pool before. I was not even sure [if he could

과거완료 부정형　　　　　　　　　　　　　　　　　　　　~인지 아닌지

swim].

나는 깜짝 놀랐다. 그는 전에 그 수영장 근처에 가 본 적이 전혀 없었다. 나는 그가 수영할 수 있는지조차 확신할 수 없었다.

25 "The water is cold, and it's getting late. Are you sure you want to go in?" I asked.

접속사 that

"Please!" "All right then," I said, "but be quick!"

"물이 차갑고, 시간이 늦어지고 있단다. 정말 들어가고 싶은 거니?" 내가 물었다. "제발요!" "그럼 좋아," 내가 말했다. "하지만 빨리 하렴!"

26 I had never seen him so excited before. His eyes were shining with joy, and he seemed to be

과거완료 부정형　　　　지각동사(see)의 목적격보어　　　과거진행형　　　　　　seem to-v: ~인 것처럼 보이다

truly alive for the first time.

처음으로

나는 그가 그렇게 신나 하는 것을 이전에 본 적이 없었다. 그의 눈은 기쁨으로 빛나고 있었고, 그는 처음으로 진정 살아 있는 것처럼 보였다.

27 Without hesitating, he dived into the cold water. I was ready to jump in and rescue him [if he

동명사 (전치사 Without의 목적어)　　　　　　　　　　　　　　　　　　　　　　　　　만약 ~라면

could not swim].

망설임 없이, 그는 찬물 속으로 뛰어들었다. 나는 그가 수영할 수 없을 경우 뛰어들어가서 그를 구할 준비가 되어 있었다.

28 However, I soon realized [that I did not have anything [to worry about]].

명사절 (realized의 목적어)　　　　　　　형용사적 용법

그러나 나는 곧 걱정할 필요가 전혀 없다는 것을 깨달았다.

29 부정어가 문장 앞에 와서 주어와 조동사 도치

Not only could Diego swim, but he swam magnificently!

not only A but (also) B: A뿐만 아니라 B도

Diego는 수영을 할 수 있었을 뿐만 아니라 훌륭하게 수영을 해냈다!

30 He chased after Juan Salvado, and they swam in perfect harmony. It was like a duet [written for

chase after: ~을 쫓다　　　　　　　　　　　　　　　　　　　　　　　　　　　　과거분사구

violin and piano].

그는 Juan Salvado를 쫓아갔고, 그들은 완벽하게 조화를 이루며 수영했다. 그것은 바이올린과 피아노를 위해 쓰인 이중주곡 같았다.

31 Sometimes Juan Salvado took the lead and Diego followed after him. At other times Diego went
take the lead: 선두에 서다
ahead and the penguin swam around the boy.
앞에 주위에

때로는 Juan Salvado가 앞장섰고 Diego가 그를 뒤쫓았다. 다른 때에는 Diego가 앞서갔고 펭귄이 그 소년 주변에서 수영했다.

32 Occasionally they swam so close that they almost touched.
so ~ that ...: 너무 ~해서 ...하다

때때로 그들은 너무 가까이 수영을 해서 거의 닿을 뻔했다.

33 I was almost speechless. Suddenly Diego was not the sad little boy [we had become used to].
과거완료
목적격 관계대명사 whom[that]
He was a very normal boy with a very special talent.

나는 말문이 막힐 지경이었다. 갑자기 Diego는 우리가 익숙해 있었던 그 슬픈 꼬마 소년이 아니었다. 그는 매우 특별한 재능을 가진 아주 평범한 소년이었다.

34 "Diego! You can swim!" "Yes, I can swim."
= be able to-v

"Diego! 너 수영할 수 있구나!" "네, 수영할 수 있어요."

35 "I mean [you are able to swim really well]. Brilliantly, in fact!" "Do you think so?"
접속사 that
명사절 (mean의 목적어) 훌륭하게

"네가 수영을 정말 잘한다는 뜻이야. 실은, 아주 훌륭해!" "그렇게 생각하세요?"

36 He asked without [looking directly at me], but I saw a smile on his face.
동명사구 (전치사 without의 목적어)

그는 나를 똑바로 바라보지 않은 채 물었지만, 나는 그의 얼굴에서 미소를 보았다.

37 As we returned to the dormitory, Diego told me [that his father had taught him how to swim in
명사절 (told의 직접목적어)
~할 때 (접속사) 과거완료 how to-v: ~하는 방법
the river by their home].
~ 옆에

우리가 기숙사로 돌아올 때, Diego는 아버지가 집 근처에 있는 강에서 그에게 수영하는 법을 가르쳐 주셨다고 나에게 말했다.

38 It was the first time [he had talked about his life].
관계부사 that 과거완료

그가 자신의 삶에 대해 얘기한 것은 처음이었다.

39 I listened in silence, without [making any corrections to his English], as he talked nonstop all
동명사구 (전치사 without의 목적어)　　　　　　　　~할 때 (접속사)
the way back to the dormitory.

기숙사로 돌아오는 내내 그가 끊임없이 말할 때, 나는 그의 영어에 어떤 지적도 하지 않으면서 조용히 듣기만 했다.

40 The events of that day were extraordinary.
　　　주어　　　　　　동사

그날 있었던 일들은 놀라웠다.

41 A child had gone down to the water [to swim with a penguin], and shortly afterward, a young
　　　과거완료　　　　　　　　　　　부사적 용법 〈목적〉
man had emerged. The ugly duckling had become a swan.
　　　과거완료　　　　　　　　　과거완료

한 아이가 펭귄과 수영하러 물속으로 들어갔고, 잠시 뒤에 젊은 청년이 (되어 밖으로) 나왔다. 미운 오리 새끼가 백조가 된 것이다.

42 It was definitely a turning point. Diego's confidence grew quickly after that day. When the
　　　　분명히
school had a swimming competition, he won every race [he participated in].
　　　　　　　　　　　　　　　　　　every+단수명사 ┃목적격 관계대명사 that

그것은 분명히 전환점이었다. 그날 이후에 Diego의 자신감은 빠르게 커졌다. 학교에서 수영 대회가 있을 때, 그는 참가한 경기마다 우승을 했다.

43 The encouragement and acknowledgement [given by the other boys] was genuine.
　　　　　　　　　　　　　　　　　　　　　　　과거분사구

다른 친구들이 해 주는 격려와 인정은 진심에서 우러나오는 것이었다.

44 He had earned the respect of his classmates. Over the next few weeks, his grades improved
　　　과거완료　　　　　　　　　　　　　　　　　　few+셀 수 있는 명사의 복수형
and he became more popular.

그는 학급 친구들의 존경을 받았다. 다음 몇 주에 걸쳐서, 그의 성적은 향상되었고 그는 인기가 더 많아졌다.

45 Thanks to a swim with a penguin, a lonely boy's life was changed forever.
　~덕분에

펭귄과의 수영 덕분에, 한 외로운 소년의 삶이 영원히 바뀌게 되었다.

다음 빈칸을 채우시오.

Tom Michell is (1) _____ _____ _____. In the 1970s, he worked at an English language boarding school in Argentina.

Tom Michell은 영국인 교사이다. 1970년대에 그는 아르헨티나에 있는 영어 기숙 학교에서 일했다.

One day he visited a beach and found a penguin that (2) _____ _____ _____ _____.

어느 날 그는 해변에 갔다가 상처 입고 홀로 있는 펭귄 한 마리를 발견했다.

Michell (3) _____ _____ _____ the bird. He cleaned it, fed it, and even gave it a name—Juan Salvado.

Michell은 그 새를 도와주기로 결심했다. 그는 그것을 닦고 먹이고 Juan Salvado라는 이름까지 지어 주었다.

From that day on, Juan Salvado lived on the terrace of his room (4) _____ _____ _____ _____.

그날 이후로, Juan Salvado는 학교 기숙사에 있는 그의 방 테라스에서 살았다.

The following is part of the story, (5) _____ _____ Tom Michell, about the penguin and a boy at the school.

다음은 Tom Michell에 의해 쓰여진 그 펭귄과 그 학교의 한 소년에 대한 이야기의 일부이다.

(6) _____ _____ _____ _____ that I brought a penguin to live at the school, one student in particular wanted to help with his care.

내가 펭귄을 데려와 학교에서 살게 한 첫날부터, 한 학생이 특히 펭귄을 돌봐 주는 일을 도와주고 싶어 했다.

His name was Diego Gonzales. Diego was a shy boy who (7) _____ _____ _____ frightened of his own shadow.

그의 이름은 Diego Gonzales였다. Diego는 자기 자신의 그림자에도 몹시 겁을 내는 듯한 수줍음 타는 아이였다.

He (8) _____ _____ his classes, and none of the after-school activities seemed to suit him. He was (9) _____ _____ _____ _____.

그는 수업을 힘겨워했고, 방과 후 활동 중 그 어느 것도 그에게 적합해 보이지 않았다. 그는 강하지도 않았고 체격이 좋지도 않았다.

On the rugby field, nobody passed the ball to him or (10) _____ _____ _____ _____ _____, except to make fun of him.

럭비 경기장에서, 그를 놀릴 때를 제외하고는 아무도 그에게 공을 패스하거나 경기에 그를 끼워주지 않았다.

Diego's early education (11) _____ _____ _____ _____ well for life at his new school.

Diego의 어릴 적 교육은 그의 새 학교에서의 생활에 (그가 잘 적응하도록) 그를 제대로 준비시켜 주지 못했다.

His knowledge of English was limited, so he (12) _____ _____. However, Diego enjoyed the company of Juan Salvado.

그의 영어 지식은 부족했고, 그래서 그는 대화를 피했다. 하지만 Diego는 Juan Salvado와 함께 있는 것을 즐겼다.

Indeed, on the terrace, Diego could relax. He had some friends who also (13) _____ _____ _____ _____.

확실히, 테라스에서 Diego는 긴장을 풀 수 있었다. Diego에게는 그처럼 적응하는 데 어려움을 겪는 몇몇 친구들이 있었다.

(14) _____ _____ Juan Salvado was good for those boys. They fed him fish, swept the terrace, and spent time with him.

Juan Salvado를 돌보는 것은 이 소년들에게 좋은 일이었다. 그들은 펭귄에게 생선을 먹였고, 테라스를 청소했으며, 펭귄과 함께 시간을 보냈다.

One day, I took Juan Salvado (15) _____ _____ _____ _____ _____ with the boys.

어느 날, 나는 그 소년들과 함께 Juan Salvado를 학교 수영장으로 데리고 갔다.

(16) _____ _____ _____ the other swimmers left, we brought Juan Salvado to the water to see if he would swim.

수영하고 있던 다른 사람들이 나가자마자, 우리는 Juan Salvado가 수영을 하려고 하는지를 보기 위해 그를 물로 데리고 갔다.

Juan Salvado (17) _____ _____ _____ at the school for several months by then.

그때까지 Juan Salvado는 여러 달 동안 학교에서 생활해 오고 있었다.

However, in all that time, he had never been able to swim because his feathers (18) _____ _____ _____.

그런데, 그 기간 내내 그는 깃털에 상처를 입은 상태여서 수영을 전혀 할 수가 없었다.

"Go on!" I said. The penguin stared at me and then at the pool, like he was asking, "Ah! Is this (19) _____ _____ _____ _____ _____?" (20) _____ _____ _____, he jumped in.

"어서!" 내가 말했다. 펭귄은 나를 쳐다본 다음 수영장을 바라봤는데, 마치 그는 "아! 이곳이 물고기가 사는 곳인가요?"라고 묻는 것 같았다. 더 격려하지 않아도, 펭귄은 (물속으로) 뛰어들었다.

With a single movement of his wings, he flew like an arrow across the water and (21) _____ _____ _____ _____ on the opposite side. Luckily, he was not hurt!

날갯짓 한 번에 그는 물을 가로질러 화살처럼 날아 반대쪽 벽에 부딪혔다. 다행히도, 그는 다치지 않았다!

I had never had (22) _____ _____ _____ _____ a penguin in the water before.

나는 이전에는 물속에 있는 펭귄을 연구할 기회가 전혀 없었다.

I was familiar with (23) _____ _____ _____ _____ Juan Salvado walked on land, but now I watched in awe.

나는 Juan Salvado가 육지에서 걸어 다니던 어설픈 방식에만 익숙해 있었는데, 이제 나는 감탄하며 바라보았다.

Using only a stroke or two, he flew at great speed from one end of the pool to the other, (24) _____ _____ before touching the sides.

겨우 한두 번의 날갯짓으로, 그는 수영장의 한쪽 끝에서 다른 쪽까지 엄청난 속도로 날아갔고, 끝에 닿기 전에 재빨리 몸을 돌렸다.

It was amazing! Everyone could see (25) _____ _____ _____ _____ _____ himself.

그 모습은 놀라웠다! 모든 사람들이 그가 얼마나 즐거워하고 있는지 알 수 있었다.

"Ooh! Aah!" The boys shouted, as though (26) _____ _____ _____ a fireworks display. After a while, Diego came over and asked quietly, "Can I swim, too?"

"우! 아!" 소년들은 마치 그들이 불꽃놀이를 보고 있는 듯이 소리쳤다. 잠시 후에, Diego가 와서 조용히 물었다. "저도 수영해도 되나요?"

I (27) _____ _____. He had never gone near the pool before. I was not even sure (28) _____ _____ _____ _____.

나는 깜짝 놀랐다. 그는 전에 그 수영장 근처에 가 본 적이 전혀 없었다. 나는 그가 수영할 수 있는지조차 확신할 수 없었다.

"The water is cold, and it's getting late. (29) _____ _____ _____ you want to go in?" I asked. "Please!"

"물이 차갑고, 시간이 늦어지고 있단다. 너는 정말 들어가고 싶은 거니?" 내가 물었다. "제발요!"

"All right then," I said, "but be quick!" I had never seen (30) _____ _____ _____ before.

"그럼 좋아." 내가 말했다. "하지만 빨리 하렴!" 나는 그가 그렇게 신나 하는 것을 이전에 본 적이 없었다.

His eyes (31) _____ _____ _____ _____, and he seemed to be truly alive for the first time.

그의 눈은 기쁨으로 빛나고 있었고, 그는 처음으로 진정 살아 있는 것처럼 보였다.

(32) _____ _____, he dived into the cold water. I (33) _____ _____ _____ jump in and rescue him if he could not swim.

망설임 없이, 그는 찬물 속으로 뛰어들었다. 나는 그가 수영할 수 없을 경우 뛰어들어가서 그를 구할 준비가 되어 있었다.

However, I soon realized that I did not have anything to worry about. (34) _____ _____ _____ Diego swim, but he swam magnificently!

그러나 나는 곧 걱정할 필요가 전혀 없다는 것을 깨달았다. Diego는 수영을 할 수 있었을 뿐만 아니라 훌륭하게 수영을 해냈다!

He chased after Juan Salvado, and they swam in perfect harmony. It was like a duet (35) _____ _____ violin and piano.

그는 Juan Salvado를 쫓아갔고, 그들은 완벽하게 조화를 이루며 수영했다. 그것은 바이올린과 피아노를 위해 쓰인 이중주곡 같았다.

Sometimes Juan Salvado (36) _____ _____ _____ and Diego followed after him. At other times Diego went ahead and the penguin swam around the boy.

때로는 Juan Salvado가 앞장섰고 Diego가 그를 뒤쫓았다. 다른 때에는 Diego가 앞서갔고 펭귄이 그 소년 주변에서 수영했다.

Occasionally they swam (37) _____ _____ _____ they almost touched.

때때로 그들은 너무 가까이 수영을 해서 거의 닿을 뻔했다.

I was almost speechless. Suddenly Diego was not the sad little boy (38) _____ _____ _____ _____ _____. He was a very normal boy with a very special talent.

나는 말문이 막힐 지경이었다. 갑자기 Diego는 우리가 익숙해 있었던 그 슬픈 꼬마 소년이 아니었다. 그는 매우 특별한 재능을 가진 아주 평범한 소년이었다.

"Diego! You can swim!" "Yes, I can swim." "I mean you (39) _____ _____ _____ swim really well. Brilliantly, in fact!"

"Diego! 너 수영할 수 있구나!" "네, 수영할 수 있어요." "네가 수영을 정말 잘할 수 있다는 뜻이야. 실은, 아주 훌륭해!"

"Do you think so?" He asked (40) _____ _____ _____ _____ _____, but I saw a smile on his face.

"그렇게 생각하세요?" 그는 나를 똑바로 바라보지 않은 채 물었지만, 나는 그의 얼굴에서 미소를 보았다.

As we returned to the dormitory, Diego told me that his father had taught him (41) _____ _____ _____ in the river by their home. It was (42) _____ _____ _____ he had talked about his life.

우리가 기숙사로 돌아올 때, Diego는 아버지가 집 근처에 있는 강에서 그에게 수영하는 법을 가르쳐 주셨다고 나에게 말했다. 그가 자신의 삶에 대해 얘기한 것은 처음이었다.

I listened in silence, (43) _____ _____ _____ _____ to his English, as he talked nonstop all the way back to the dormitory.

기숙사로 돌아오는 내내 그가 끊임없이 말할 때, 나는 그의 영어에 어떤 지적도 하지 않으면서 조용히 듣기만 했다.

The events of that day (44) _____ _____. A child had gone down to the water (45) _____ _____ _____ _____ _____, and shortly afterward, a young man had emerged. The ugly duckling had become a swan.

그날 있었던 일들은 놀라웠다. 한 아이가 펭귄과 수영하러 물속으로 들어갔고, 잠시 뒤에 젊은 청년이 (되어 밖으로) 나왔다. 미운 오리 새끼가 백조가 된 것이다.

It was definitely (46) _____ _____ _____. Diego's confidence (47) _____ _____ after that day. When the school had a swimming competition, he won every race (48) _____ _____ _____.

그것은 분명히 전환점이었다. 그날 이후에 Diego의 자신감은 빠르게 커졌다. 학교에서 수영 대회가 있을 때, 그는 그가 참가한 경기마다 우승을 했다.

(49) _____ _____ _____ _____ _____ _____ the other boys was genuine. He had earned the respect of his classmates.

다른 친구들에게 받은 격려와 인정은 진심에서 우러나오는 것이었다. 그는 학급 친구들의 존경을 받았다.

Over the next few weeks, his grades improved and he (50) _____ _____ _____.

다음 몇 주에 걸쳐서, 그의 성적은 향상되었고 그는 인기가 더 많아졌다.

(51) _____ _____ a swim with a penguin, a lonely boy's life was changed forever.

펭귄과의 수영 덕분에, 한 외로운 소년의 삶이 영원히 바뀌게 되었다.

다음 네모 안에서 옳은 것을 고르시오.

01 One day he visited a beach and found a penguin who / that was injured and alone.

02 Diego was a shy / brave boy who seemed to be frightened of his own shadow.

03 He was neither strong or / nor athletic.

04 His knowledge of English was limited / enough, so he avoided conversation.

05 Looking / Looked after Juan Salvado was good for those boys.

06 Juan Salvado had been lived / living at the school for several months by then.

07 However, in all that time, he had never been able to swim because / because of his feathers had been damaged.

08 The penguin stared at me and then at the pool, like he was asking, "Ah! Is this when / where the fish come from?"

09 I had never have / had the opportunity to study a penguin in the water before.

10 I was familiar / similar with the awkward way that Juan Salvado walked on land, but now I watched in awe.

11 [Using / Used] only a stroke or two, he flew at great speed from one end of the pool to the other, turning swiftly before touching the sides.

12 "Ooh! Aah!" The boys shouted, [if / as though] they were watching a fireworks display.

13 However, I soon realized that I did not have anything [worry / to worry] about.

14 Not only [Diego could / could Diego] swim, but he swam magnificently!

15 Occasionally they swam so [close / far] that they almost touched.

16 I listened in silence, without [making / to make] any corrections to his English, as he talked nonstop all the way back to the dormitory.

17 The events of that day [was / were] extraordinary.

18 A child [has / had] gone down to the water to swim with a penguin, and shortly afterward, a young man had emerged.

19 When the school had a swimming competition, he won every [race / races] he participated in.

20 The [discouragement / encouragement] and acknowledgement given by the other boys was genuine. He had earned the respect of his classmates.

다음 문장이 옳으면 O, 틀리면 X 표시하고 바르게 고치시오.

01 Tom Michell is a British teacher. In the 1970s, he worked at an English language boarding school in Argentina.

02 One day he visited a beach and found a penguin that were injured and alone.

03 Michell decided helping the bird.

04 He cleaned it, fed it, and even give it a name —Juan Salvado.

05 From that day on, Juan Salvado lived on the terrace of his room in the school dormitory.

06 The following is part of the story, written by Tom Michell, about the penguin and a boy at the school.

07 From the first day that I brought a penguin to live at the school, one student in particular wanted to help with his care.

08 His name was Diego Gonzales. Diego was a shy boy who seemed to be frightening of his own shadow.

09 He struggled with his classes, and none of the after-school activities seemed to suit him. He was neither strongly nor athletic.

10 On the rugby field, nobody passed the ball to him or involved him in the game, except to make fun of him.

11 Diego's early education had not prepare him well for life at his new school. His knowledge of English was limited, so he avoided conversation.

12 However, Diego enjoyed the company of Juan Salvado. Indeed, on the terrace, Diego could relax.

13 He had some friends whom also had trouble fitting in.

14 Looking after Juan Salvado were good for those boys.

15 They fed him fish, swept the terrace, and spent time with him. One day, I took Juan Salvado to the school swimming pool with the boys.

16 As soon as the other swimmers left, we brought Juan Salvado to the water see if he would swim. Juan Salvado had been living at the school for several months by then.

17 However, in all that time, he had never been able to swim because his feathers had been damaging.

18 "Go on!" I said. The penguin stared at me and then at the pool, like he was asking, "Ah! Is this where the fish come from?" Without further encouragement, he jumped in.

19 With a single movement of his wings, he flew like an arrow across the water and knock into the wall on the opposite side. Luckily, he was not hurt!

20 I had never had the opportunity study a penguin in the water before.

21 I was familiar with the awkward way that Juan Salvado walked on land, but now I watched in awe.

22 Using only a stroke or two, he flew at great speed from one end of the pool to the other, turning swiftly before touching the sides.

23 It was amazing! Everyone could see how much was he enjoying himself. "Ooh! Aah!" The boys shouted, as though they were watching a fireworks display.

24 After a while, Diego came over and asked quietly, "Can I swim, too?" I was astonishing. He had never gone near the pool before.

25 I was not even sure if he could swim. "The water is cold, and it's getting lately. Are you sure you want to go in?" I asked.

26 "Please!" "All right then," I said, "but be quick!"

27 I had never seen he so excited before. His eyes were shining with joy, and he seemed to be truly alive for the first time.

28 Without hesitating, he dived into the cold water. I was ready to jump in and rescue him if he could not swim.

29 However, I soon realized what I did not have anything to worry about.

30 Not only could Diego swim, but he swam magnificent!

31 He chased after Juan Salvado, and they swam in perfect harmony. It was like a duet wrote for violin and piano.

32 Sometimes Juan Salvado took the lead and Diego followed after him. At other times Diego went ahead and the penguin swam around the boy.

33 Occasionally they swam such close that they almost touched.

34 I was almost speechless. Suddenly Diego was not the sad little boy we had became used to.

35 He was a very normal boy with a very special talent. "Diego! You can swim!" "Yes, I can swim."

36 "I mean you are able to swim really well. Brilliantly, in fact!"

37 "Do you think so?" He asked without look directly at me, but I saw a smile on his face.

38 As we returned to the dormitory, Diego told me that his father had taught him how to swimming in the river by their home.

39 It was the first time he had talked about his life.

40 I listened in silence, without make any corrections to his English, as he talked nonstop all the way back to the dormitory.

41 The events of that day were extraordinary.

42 A child went down to the water to swim with a penguin, and shortly afterward, a young man had emerged.

43 The ugly duckling had become a swan.

44 It was definitely a turning point. Diego's confidence grew quickly after that day.

45 When the school had a swimming competition, he won every race he participate in.

46 The encouragement and acknowledgement giving by the other boys was genuine. He had earned the respect of his classmates.

47 Over the next few week, his grades improved and he became more popular.

48 Thanks to a swim with a penguin, a lonely boy's life was changed forever.

1 다음 대화의 빈칸에 들어갈 말로 가장 적절한 것은?

> G: Let's go watch a movie.
> B: Sorry. I'm not really in the mood. I failed my piano audition again. This was the third time.
> G: Don't be discouraged. There's always next time.
> B: Yes, but I don't think I have any talent for music.
> G: Don't think that way. You have potential! As long as you keep trying, _____.
> B: Do you really think so?
> G: Sure. Just believe in yourself!
> B: Thanks. I feel much better now.

① you asked for it
② that's very kind of you
③ you'll eventually succeed
④ you'd better give it a try
⑤ you should think twice before you do it

2 다음 글의 밑줄 친 ⓐ~ⓔ 중, 가리키는 대상이 나머지 넷과 다른 것은?

> Tom Michell is a British teacher. In the 1970s, he worked at an English language boarding school in Argentina. One day he visited a beach and found ⓐ a penguin that was injured and alone. Michell decided to help ⓑ the bird. He cleaned it, fed it, and even gave ⓒ it a name—Juan Salvado. From that day on, ⓓ Juan Salvado lived on the terrace of ⓔ his room in the school dormitory. The following is part of the story, written by Tom Michell, about the penguin and a boy at the school.

① ⓐ ② ⓑ ③ ⓒ ④ ⓓ ⑤ ⓔ

3 Diego Gonzales에 관한 다음 글의 내용과 일치하지 않는 것은?

> From the first day that I brought a penguin to live at the school, one student in particular wanted to help with his care. His name was Diego Gonzales. Diego was a shy boy who seemed to be frightened of his own shadow. He struggled with his classes, and none of the after-school activities seemed to suit him. He was neither strong nor athletic. On the rugby field, nobody passed the ball to him or involved him in the game, except to make fun of him.

① 펭귄을 돌보는 일을 돕고 싶어했다.
② 수줍음 타는 아이였다.
③ 수업보다 방과 후 활동에 더 잘 적응했다.
④ 체격이 좋지 않았다.
⑤ 친구들은 놀릴 때만 그를 경기에 끼워주었다.

4 다음 글의 흐름으로 보아, 주어진 문장이 들어가기에 가장 적절한 곳은?

> However, Diego enjoyed the company of Juan Salvado.

> Diego's early education had not prepared him well for life at his new school. (①) His knowledge of English was limited, so he avoided conversation. (②) Indeed, on the terrace, Diego could relax. (③) He had some friends who also had trouble fitting in. (④) Looking after Juan Salvado was good for those boys. (⑤) They fed him fish, swept the terrace, and spent time with him.

① ② ③ ④ ⑤

5 다음 글의 밑줄 친 ⓐ~ⓒ를 시간 순서대로 배열하시오.

One day, ⓐ I took Juan Salvado to the school swimming pool with the boys. As soon as the other swimmers left, ⓑ we brought Juan Salvado to the water to see if he would swim. Juan Salvado had been living at the school for several months by then. However, in all that time, he had never been able to swim because ⓒ his feathers had been damaged.

_____ → _____ → _____

[6~7] 다음 글을 읽고, 물음에 답하시오.

"Go on!" I said. Juan Salvado stared at me and then at the pool, like he was asking, "Ah! Is this where the fish come from?" Without further encouragement, he jumped in. With a single movement of his wings, he flew like an arrow across the water and knocked into the wall on the opposite side. Luckily, he was not hurt!

I ① had never had the opportunity to study a penguin in the water before. I was familiar with the awkward way ② how Juan Salvado walked on land, but now I watched in awe. Using only a stroke or two, he flew at great speed from one end of the pool to the other, ③ turning swiftly before touching the sides. It was amazing! Everyone could see ④ how much he was enjoying himself.

"Ooh! Aah!" The boys shouted, as though they ⑤ were watching a fireworks display. After a while, Diego came over and asked quietly, "Can I swim, too?"

6 Juan Salvado에 관한 윗글의 내용과 일치하지 <u>않는</u> 것은?

① 물에 들어가기 전에 화자를 바라보았다.
② 수영장 벽에 부딪혀 부상을 입었다.
③ 육지에서 어설프게 걸어 다녔다.
④ 물 속에서 엄청난 속도로 날았다.
⑤ 소년들은 그를 지켜보며 소리쳤다.

7 윗글의 밑줄 친 ①~⑤ 중, 어법상 <u>틀린</u> 것은?

①　　　②　　　③　　　④　　　⑤

[8~10] 다음 글을 읽고, 물음에 답하시오.

I was astonished. Diego had never gone near the pool before. I was not even sure if he could swim.

"The water is cold, and it's getting late. Are you sure you want to go in?"

I asked.

"Please!"

"All right then," I said, "but be quick!"

I had never seen him so excited before. His eyes were shining with joy, and he seemed to be truly alive for the first time. Without hesitating, he dived into the cold water. I was ready to jump in and rescue him if he could not swim.

However, I soon realized that ____(A)____ . Not only could Diego swim, but he swam magnificently! He (B) _____ _____ Juan Salvado, and they swam in perfect harmony. It was like a duet written for violin and piano. Sometimes Juan Salvado took the lead and Diego followed after him. At other times Diego went ahead and the penguin swam around the boy. 때때로 그들은 너무 가까이 수영을 해서 거의 닿을 뻔했다.

8 윗글의 빈칸 (A)에 들어갈 말로 가장 적절한 것은?

① he wasn't prepared well
② swimming was hard to learn
③ Juan Salvado liked swimming alone
④ I did not have anything to worry about
⑤ Diego could play some musical instruments

9 윗글의 빈칸 (B)에 들어갈 말을 영영 뜻풀이를 참고하여 주어진 글자로 시작하는 단어로 쓰시오. (단, 과거형으로 쓸 것)

to follow quickly in order to catch

c_____　　a_____

10 윗글의 밑줄 친 우리말과 일치하도록 〈보기〉에 주어진 단어를 배열하여 문장을 완성하시오.

> 〈보기〉 that / almost / they / so / touched / swam / close / they

Occasionally _____
_____ .

[11~12] 다음 글을 읽고, 물음에 답하시오.

> I was almost ① speechless. Suddenly Diego was not the sad little boy we had become used to. He was a very normal boy with a very special ② talent.
> "Diego! You can swim!"
> "Yes, I can swim."
> "I mean you are able to swim really well. Brilliantly, in fact!"
> "Do you think so?" He asked without looking directly at me, but I saw a ③ smile on his face.
> As we returned to the dormitory, Diego told me that his father had taught him how to swim in the river (A) by their home. It was the first time he had talked about his ④ life. I listened in silence, ⑤ with making any corrections to his English, as he talked nonstop all the way back to the dormitory.

11 윗글의 밑줄 친 ①~⑤ 중, 문맥상 낱말의 쓰임이 적절하지 않은 것은?

① ② ③ ④ ⑤

12 윗글의 밑줄 친 (A) by와 쓰임이 같은 것은?

① We are all alarmed by the rise in violent crime.
② You can reserve the tickets by phone.
③ She earns her living by selling insurance.
④ The documents need to be ready by next Friday.
⑤ She started reading a magazine by the bookshelf.

[13~14] 다음 글을 읽고, 물음에 답하시오.

> The events of that day were extraordinary. A child had gone down to the water to swim with a penguin, and shortly afterward, a young man had ① been emerged. The ugly duckling ② had become a swan.
> It was definitely a turning point. Diego's confidence grew ③ quickly after that day. When the school had a swimming competition, he won every race ④ that he participated in. The encouragement and acknowledgement ⑤ given by the other boys was genuine. He had earned the (A) respect / neglect of his classmates. Over the next few weeks, his grades improved and he became more (B) popular / silent . Thanks to a swim with a penguin, a lonely boy's life was changed forever.

13 윗글의 밑줄 친 ①~⑤ 중, 어법상 틀린 것은?

① ② ③ ④ ⑤

14 (A), (B)의 각 네모 안에서 문맥에 맞는 낱말을 골라 쓰시오.

(A) _____ (B) _____

15 다음 글의 빈칸 (A), (B)에 들어갈 말로 가장 적절한 것은?

> In high school, I achieved my goal of becoming a skilled soccer player. When I was a first-year student, I joined my school's soccer team. At first, I wasn't a fast runner or a good kicker. ___(A)___ , I didn't let my limitations hold me back. I practiced every day, and I was always the last student to leave the field. It was hard work, but I kept believing that I would reach my goal. ___(B)___ , I got better and better. By the end of my junior year, I was the team's top scorer. This experience helped me believe in my own potential. Now I believe I can achieve my goals if I try my hardest.

	(A)		(B)
①	Moreover	⋯	Thus
②	For example	⋯	Nonetheless
③	For example	⋯	As a result
④	However	⋯	As a result
⑤	However	⋯	Nonetheless

1 다음 대화의 밑줄 친 ①~⑤ 중, 문맥상 낱말의 쓰임이 적절하지 <u>않은</u> 것은?

> G: What are you reading?
> B: I'm reading *Don Quixote*, a novel by Miguel de Cervantes. Have you read it?
> G: Yes. I've read it twice. Do you know how old Cervantes was when *Don Quixote* was published?
> B: I haven't got a ① <u>clue</u>.
> G: He was 57. He earned his reputation as a writer ② <u>early</u> in life.
> B: Aha. He was a late bloomer.
> G: Yes. He wrote some other novels before *Don Quixote*, but they didn't get much attention. He suffered from constant financial and physical ③ <u>hardships</u> in his thirties and forties.
> B: But he endured those hard times and wrote this ④ <u>masterpiece</u>.
> G: You're right. I think that shows it's never too late to reach our ⑤ <u>potential</u>.

① ② ③ ④ ⑤

2 다음 글의 흐름으로 보아, 주어진 문장이 들어가기에 가장 적절한 곳은?

> He cleaned it, fed it, and even gave it a name—Juan Salvado.

> Tom Michell is a British teacher. (①) In the 1970s, he worked at an English language boarding school in Argentina. (②) One day he visited a beach and found a penguin that was injured and alone. (③) Michell decided to help the bird. (④) From that day on, Juan Salvado lived on the terrace of his room in the school dormitory. (⑤) The following is part

of the story, written by Tom Michell, about the penguin and a boy at the school.

① ② ③ ④ ⑤

3 다음 글의 밑줄 친 ①~⑤ 중, 어법상 틀린 것은?

> From the first day ① <u>that</u> I brought a penguin to live at the school, one student in particular wanted to help with his care. His name was Diego Gonzales. Diego was a shy boy who seemed to be ② <u>frightened</u> of his own shadow. He struggled with his classes, and ③ <u>none</u> of the after-school activities seemed to suit him. He was neither strong ④ <u>or</u> athletic. On the rugby field, nobody passed the ball to him or ⑤ <u>involved</u> him in the game, except to make fun of him.

① ② ③ ④ ⑤

4 다음 글의 빈칸에 들어갈 단어를 영영 뜻풀이를 참고하여 쓰시오. (단, 주어진 글자로 시작할 것)

> Diego's early education had not prepared him well for life at his new school. His knowledge of English was limited, so he avoided conversation. However, Diego enjoyed the _____ of Juan Salvado. Indeed, on the terrace, Diego could relax. He had some friends who also had trouble fitting in. Looking after Juan Salvado was good for those boys. They fed him fish, swept the terrace, and spent time with him.

> • the state of having someone with you
> • the person or people who are with you

c _____

"Go on!" I said. The penguin stared at me and then at the pool, like he was asking, "Ah! Is this where the fish come from?" Without further ① encouragement, he jumped in. With a single movement of his wings, he flew like an arrow across the water and knocked into the wall on the opposite side. ② Luckily, he was not hurt!

I had never had the opportunity to study a penguin in the water before. I was familiar with the awkward way that Juan Salvado walked on land, but now I watched in ③ sorrow. Using only a stroke or two, he flew at great speed from one end of the pool to the other, turning swiftly before touching the sides. It was amazing! Everyone could see how much he was ④ enjoying himself.

"Ooh! Aah!" The boys ⑤ shouted, as though they were watching a fireworks display. After a while, Diego came over and asked quietly, "Can I swim, too?"

5 윗글의 분위기로 가장 적절한 것은?

① calm and cozy
② tense and urgent
③ lively and cheerful
④ noisy and terrifying
⑤ fantastic and mysterious

6 윗글의 밑줄 친 ①~⑤ 중, 문맥상 낱말의 쓰임이 적절하지 않은 것은?

① ② ③ ④ ⑤

I was astonished. Diego had never gone near the pool before. I was not even sure if he could swim.

"The water is cold, and it's getting late. Are you sure you want to go in?" I asked.

"Please!"

"All right then," I said, "but be quick!"

I had never seen him so excited before. His eyes were shining with joy, and he seemed to be truly alive for the first time. Without hesitating, he dived into the cold water. I was ready to jump in and rescue him if he could not swim.

However, I soon realized that I did not have anything to worry about. (A) (could / Diego / swim / only / not), but he swam magnificently! He chased after Juan Salvado, and they swam in perfect harmony. ① It was like a duet written for violin and piano. ② Ballet and the piano are beautifully and inseparably linked. ③ Sometimes Juan Salvado took the lead and Diego followed after him. ④ At other times Diego went ahead and the penguin swam around the boy. ⑤ Occasionally they swam so close that they almost touched.

7 윗글의 내용과 일치하지 않는 것은?

① 화자는 Diego가 수영할 수 있는지 몰랐다.
② 수영하기 직전에 Diego는 매우 신나 있었다.
③ 수영장 물은 차가웠다.
④ 화자는 Diego를 위해 물에 뛰어들었다.
⑤ Diego와 Juan Salvado는 조화롭게 수영했다.

8 윗글의 (A)에 주어진 단어를 알맞게 배열하시오. (단, not으로 시작할 것)

9 윗글의 ①~⑤ 중, 전체 흐름과 관계 없는 문장은?

① ② ③ ④ ⑤

I was almost speechless. Suddenly Diego was not the sad little boy we had become used to. He was a very normal boy with a very special talent.

"Diego! You can swim!"

"Yes, I can swim."

"I mean you are able to swim really well. Brilliantly, in fact!"

"Do you think so?" He asked without looking directly at me, but I saw a smile on his face.

As we returned to the dormitory, Diego told me (A) that his father had taught him how to swim in the river by their home. It was the first time he had talked about his life. I listened in silence, 그의 영어에 어떤 지적도 하지 않으면서, as he talked nonstop all the way back to the dormitory.

10 윗글의 밑줄 친 (A) that과 쓰임이 같은 것은?

① I found a store that sold candles.
② I brought that from the supermarket.
③ It was John that got an A on the math test.
④ Many people think that friends are important.
⑤ I've seen that woman wearing a hat and long dress.

11 윗글의 밑줄 친 우리말과 일치하도록 〈보기〉에 주어진 단어를 배열하여 문장을 완성하시오. (필요 시 형태를 변형할 것)

〈보기〉 any / corrections / English / his / make / to / without

[12~13] 다음 글을 읽고, 물음에 답하시오.

The events of that day were extraordinary. A child ⓐ go down to the water to swim with a penguin, and shortly afterward, a young man had emerged. _____ (A)

It was definitely a turning point. Diego's confidence grew quickly after that day. When the school had a swimming competition, he won every race he participated in. The encouragement and acknowledgement ⓑ give by the other boys was genuine. He had earned the respect of his classmates. Over the next few weeks, his grades improved and he became more popular. Thanks to a swim with a penguin, a lonely boy's life was changed forever.

12 윗글의 빈칸 (A)에 들어갈 말로 가장 적절한 것은?

① The penguin had made him feel depressed.
② The ugly duckling had become a swan.
③ A lonely boy had lost everything he had.
④ Diego had stopped taking swimming lessons.
⑤ A young man had regretted his past behavior.

13 윗글의 밑줄 친 ⓐ, ⓑ를 어법에 맞게 고쳐 쓰시오.

ⓐ go → _____

ⓑ give → _____

14 다음 글의 내용과 일치하지 않는 것은?

I had always dreamed of going to Jordan, in the Middle East, and last year I finally got the chance to go. I had wanted to go there to see Petra, a city carved out of rock. When I saw it, I felt a connection with its distant past. The ancient people of Jordan, the Nabataeans, built Petra long ago, but it is still well known today. Seeing the city in real life was a terrific experience.

① 화자는 Jordan에 가는 것을 꿈꿔왔다.
② Jordan은 중동에 위치해 있다.
③ Petra는 바위를 깎아 만든 도시이다.
④ 화자는 실제로 Petra를 보았다.
⑤ Nabataeans는 Petra의 시민들을 일컫는다.

1 다음 담화의 주제로 가장 적절한 것은?

Good afternoon, everyone. I'm Carol Dweck, a professor and researcher of psychology. Recently, I heard about a special school. In this school, if students don't pass a class, they aren't given an F. Instead, their grade is "Not Yet." I think that's fantastic. If you get a failing grade, you think, "I'm a loser." However, if your grade is "Not Yet," you understand that you're still on a learning path. It gives you hope for the future. In other words, it makes you have a "growth mindset." With a growth mindset, you understand your abilities are still growing. You become more confident and steadier when you face challenges. So, if you're not good at something now, it's important to believe that it's not your limit. Look toward the future and make an effort, and you'll find yourself making progress.

① how to pass a class
② the meaning of challenges
③ the value of a growth mindset
④ the importance of knowing your limits
⑤ the difficulty of making an effort

[2~4] 다음 글을 읽고, 물음에 답하시오.

Tom Michell is a British teacher. In the 1970s, he worked at an English language boarding school in Argentina. One day he visited a beach and found a penguin that was injured and alone. Michell decided ① to help the bird. He cleaned it, fed it, and even gave it a name— Juan Salvado. From that day on, Juan Salvado lived on the terrace of his room in the school dormitory. The following is part of the story, ② written by Tom Michell, about the penguin and a boy at the school.

From the first day ③ that I brought a penguin to live at the school, one student in particular wanted to help with his care. His name was Diego Gonzales. Diego was a shy boy ④ whom seemed to be frightened of his own shadow. He struggled with his classes, and none of the after-school activities seemed ⑤ to suit him. He was neither strong nor athletic. On the rugby field, nobody passed the ball to him or involved him in the game, except to (A) make fun of him.

2 윗글의 내용과 일치하는 것은?

① Juan is a British teacher.
② A penguin was found on a beach.
③ Tom didn't live in the school dormitory.
④ Nobody wanted to help Juan.
⑤ Diego was strong enough to play the rugby.

3 윗글의 밑줄 친 ①~⑤ 중, 어법상 틀린 것은?

① ② ③ ④ ⑤

4 윗글의 밑줄 친 (A)와 바꿔 쓸 수 있는 것은?

① praise
② tease
③ chase
④ encourage
⑤ approach

Diego's early education had not prepared him well for life at his new school. His knowledge of English was limited, so he avoided conversation. _____, Diego enjoyed the company of Juan Salvado. Indeed, on the terrace, Diego could relax. He had some friends who also had trouble fitting in. Looking after Juan Salvado was good for those boys. They fed him fish, swept the terrace, and spent time with him.

One day, I took Juan Salvado to the school swimming pool with the boys. As soon as the other swimmers left, we brought Juan Salvado to the water to see if he would swim. Juan Salvado had been living at the school for several months by then. However, in all that time, he had never been able to swim 그의 깃털들이 상처를 <u>입은 상태였기 때문에</u>.

5 윗글의 빈칸에 들어갈 말로 가장 적절한 것은?

① Similarly ② Besides
③ However ④ Unless
⑤ For example

6 윗글의 밑줄 친 우리말과 일치하도록 주어진 단어를 이용하여 문장을 완성하시오. (필요 시 형태를 변형할 것)

(because, feather, have damage)

"Go on!" I said. The penguin stared at me and then at the pool, like he was asking, "Ah! Is this where the fish come from?" (①) Without further encouragement, he jumped in. (②) With a single movement of his wings, he flew like an arrow across the water and knocked into the wall on the opposite side. (③)

I had never had the opportunity to study a penguin in the water before. (④) I was familiar with the awkward way that Juan Salvado walked on land, but now I watched in awe. (⑤) Using only a stroke or two, he flew at great speed from one end of the pool to the other, turning swiftly before touching the sides. It was amazing! Everyone _____.

"Ooh! Aah!" The boys shouted, as though they were watching a fireworks display. After a while, Diego came over and asked quietly, "Can I swim, too?"

7 윗글의 흐름으로 보아, 주어진 문장이 들어가기에 가장 적절한 곳은?

Luckily, he was not hurt!

① ② ③ ④ ⑤

8 〈보기〉에 주어진 말을 배열하여 윗글의 빈칸을 완성하시오.

〈보기〉 was / how much / could / himself see / he / enjoying

I was astonished. Diego had never gone near the pool before. I was not even sure _____ he could swim.

"The water is cold, and it's getting late. Are you sure you want to go in?" I asked.

"Please!"

"All right then," I said, "but be quick!"

I had never seen him so ⓐ <u>exciting</u> before. His eyes were shining with joy, and he seemed to be truly alive for the first time. Without hesitating, he dived into the cold water. I was ready to jump in and rescue him _____

he could not swim.

However, I soon realized that I did not have anything ⓑ worry about. Not only could Diego swim, but he swam magnificently! He chased after Juan Salvado, and they swam in perfect harmony. It was like a duet ⓒ writing for violin and piano. Sometimes Juan Salvado took the lead and Diego followed after him.

9 윗글의 주제로 가장 적절한 것은?

① 수영장에서의 연주
② 안전 교육의 중요성
③ 펭귄과의 수영 시합
④ Diego를 구한 선생님
⑤ Diego의 놀라운 수영 실력

10 윗글의 빈칸에 공통으로 들어갈 말로 가장 적절한 것은?

① if ② while
③ since ④ after
⑤ because

11 윗글의 밑줄 친 ⓐ~ⓒ를 어법에 맞게 고쳐 쓰시오.

ⓐ exciting → _____

ⓑ worry → _____

ⓒ writing → _____

[12~13] 다음 글을 읽고, 물음에 답하시오.

At other times Diego went ahead and the penguin swam around the boy. (A) Occasionally they swam so close that they almost touched.

I was almost speechless. Suddenly Diego was not the sad little boy we had become used to. He was a very normal boy with a very special talent.

"Diego! You can swim!"

"Yes, I can swim."

"I mean you are able to swim really well. Brilliantly, in fact!"

① "Do you think so?" ② He asked without look directly at me, but I saw a smile on his face. ③ As we returned to the dormitory, Diego told me that his father had taught him how to swim in the river by their home. ④ It was the first time he had talked about his life. ⑤ I listened in silence, without make any corrections to his English, as he talked nonstop all the way back to the dormitory.

12 윗글의 밑줄 친 (A)를 우리말로 해석하시오.

13 윗글의 ①~⑤ 중, 어법상 <u>틀린</u> 표현이 있는 문장을 <u>모두</u> 고르시오.

① ② ③ ④ ⑤

14 (A), (B), (C)의 각 네모 안에서 어법에 맞는 표현으로 가장 적절한 것은?

I had always dreamed of going to Jordan, in the Middle East, and last year I finally got the chance (A) go / to go . I had wanted to go there to see Petra, a city carved out of rock. When I saw it, I (B) felt / had felt a connection with its distant past. The ancient people of Jordan, the Nabataeans, built Petra long ago, but it is still well known today. (C) Seeing / Seen the city in real life was a terrific experience.

	(A)		(B)		(C)
①	go	…	felt	…	Seeing
②	go	…	had felt	…	Seeing
③	go	…	had felt	…	Seen
④	to go	…	felt	…	Seeing
⑤	to go	…	had felt	…	Seen

1 다음 대화의 빈칸에 들어갈 말로 가장 적절한 것은?

G: What are you reading?

B: I'm reading *Don Quixote*, a novel by Miguel de Cervantes. Have you read it?

G: Yes. I've read it twice. Do you know how old Cervantes was when *Don Quixote* was published?

B: I haven't got a clue.

G: He was 57. He earned his reputation as a writer late in life.

B: Aha. He was a late bloomer.

G: Yes. He wrote some other novels before *Don Quixote*, but they didn't get much attention. He suffered from constant financial and physical hardships in his thirties and forties.

B: But he endured those hard times and wrote this masterpiece.

G: You're right. I think that shows _____.

① the earlier, the better

② a good book is a great friend

③ it's important to try many things

④ happiness lies first of all in health

⑤ it's never too late to reach our potential

[2~3] 다음 글을 읽고, 물음에 답하시오.

Tom Michell is a British teacher. In the 1970s, he worked at an English language boarding school in Argentina.

(A) From the first day that I brought a penguin ① to live at the school, one student in particular wanted to help with his care. His name was Diego Gonzales. Diego was a shy boy who seemed ② to be frightened of his own shadow.

(B) From that day on, Juan Salvado lived on the terrace of his room in the school dormitory. The ③ following is part of the story, written by Tom Michell, about the penguin and a boy at the school.

(C) One day he visited a beach and ④ finding a penguin that was injured and alone. Michell decided to help the bird. He cleaned it, fed it, and even ⑤ gave it a name—Juan Salvado.

2 주어진 글 다음에 이어질 글의 순서로 가장 적절한 것은?

① (A) – (C) – (B)　　② (B) – (A) – (C)

③ (B) – (C) – (A)　　④ (C) – (A) – (B)

⑤ (C) – (B) – (A)

3 윗글의 밑줄 친 ①~⑤ 중, 어법상 틀린 것은?

①　　②　　③　　④　　⑤

[4~5] 다음 글을 읽고, 물음에 답하시오.

Diego's early education had not prepared him well for life at his new school. His knowledge of English was (A) rich / limited , so he avoided conversation. However, Diego enjoyed the company of Juan Salvado. Indeed, on the terrace, Diego could relax. He had some friends who also had trouble fitting in. (B) Looking after / Kicking out Juan Salvado was good for those boys. They fed him fish, swept the terrace, and spent time with him.

One day, I took Juan Salvado to the school swimming pool with the boys. As soon as the other swimmers left, we brought Juan Salvado to the water to see if he would swim. Juan Salvado ⓐ (live) at the school for several months by then. However, in all that time, he had never been able to swim because his feathers had been (C) damaged / recovered .

4 (A), (B), (C)의 각 네모에서 문맥에 맞는 낱말로 가장 적절한 것은?

	(A)		(B)		(C)
①	rich	⋯	Looking after	⋯	damaged
②	rich	⋯	Kicking out	⋯	recovered
③	limited	⋯	Looking after	⋯	recovered
④	limited	⋯	Looking after	⋯	damaged
⑤	limited	⋯	Kicking out	⋯	damaged

5 윗글의 ⓐ에 주어진 단어를 알맞은 형태로 바꿔 쓰시오.

_____ _____ _____

[6~7] 다음 글을 읽고, 물음에 답하시오.

"Go on!" I said. The penguin stared at me and then at the pool, like he was asking, "Ah! Is this where the fish come from?" Without further encouragement, he jumped in. With a single movement of his wings, he flew like an arrow across the water and knocked into the wall on the opposite side. Luckily, he was not hurt!

I had never had the opportunity to study a penguin in the water before. I was familiar with the awkward way that Juan Salvado walked on land, but now I watched in awe. Using only a stroke or two, he flew at great speed from one end of the pool to the other, ⓐ turning swiftly before touching the sides. It was amazing! Everyone could see how much he was enjoying himself.

"Ooh! Aah!" The boys shouted, as though they were watching a fireworks display. After a while, Diego came over and asked quietly, "Can I swim, too?"

6 윗글의 주제로 가장 적절한 것은?

① 펭귄 조련사의 역할
② 학교 수영 대회
③ 멋지게 수영하는 펭귄
④ 수영 연습을 하는 소녀들
⑤ 소년들의 장난

7 윗글의 밑줄 친 ⓐ를 and를 이용하여 바꿔 쓰시오.

_____ _____ _____

[8~10] 다음 글을 읽고, 물음에 답하시오.

I was astonished. Diego had never gone near the pool before. I was not even sure if he could swim.

"The water is cold, and it's getting late. Are you sure you want to go in?" I asked.

"Please!"

"All right then," I said, "but be quick!"

I had never seen him so excited before. His eyes were shining with joy, and ⓐ he seemed to be truly alive for the first time. Without hesitating, he dived into the cold water. I was ready to jump in and rescue him if he could not swim.

However, I soon realized that I did not have anything to worry about. Not only could Diego swim, but he swam magnificently! He chased after Juan Salvado, and they swam in perfect harmony. It was like a duet written for violin and piano. Sometimes Juan Salvado took the lead and Diego followed after him.

8 윗글의 내용과 일치하지 <u>않는</u> 것은?

① The water in the pool was cold.
② Diego wanted to swim.
③ Diego waited some time before jumping into the pool.
④ Diego was able to swim.
⑤ Diego and Juan swam together.

9 다음 영영 뜻풀이에 해당하는 단어를 윗글에서 찾아 쓰시오.

to remove someone or something from a bad situation

10 윗글의 밑줄 친 ⓐ를 주어진 단어로 시작하는 표현으로 바꿔 쓰시오.

→ it _____

[11~12] 다음 글을 읽고, 물음에 답하시오.

Occasionally they swam so close that they almost touched.

I was almost speechless. Suddenly ⓐ Diego was not the sad little boy (A) whom / whose we had become used to. ⓑ He was a very normal boy with a very special talent.

"Diego! ⓒ You can swim!"

"Yes, I can swim."

"I mean you are able (B) swimming / to swim really well. Brilliantly, in fact!"

"Do ⓓ you think so?" He asked without looking directly at me, but I saw a smile on ⓔ his face.

As we returned to the dormitory, Diego told me (C) which / that his father had taught him how to swim in the river by their home. It was the first time he had talked about his life. I listened in silence, without making any corrections to his English, as he talked nonstop all the way back to the dormitory.

11 윗글의 밑줄 친 ⓐ~ⓔ 중, 가리키는 대상이 나머지 넷과 다른 것은?

① ⓐ ② ⓑ ③ ⓒ ④ ⓓ ⑤ ⓔ

12 (A), (B), (C)의 각 네모 안에서 어법에 맞는 표현으로 가장 적절한 것은?

	(A)		(B)		(C)
①	whom	···	swimming	···	which
②	whom	···	swimming	···	that
③	whom	···	to swim	···	that
④	whose	···	to swim	···	which
⑤	whose	···	swimming	···	that

[13~14] 다음 글을 읽고, 물음에 답하시오.

The events of that day were extraordinary. A child had gone down to the water ① swim with a penguin, and shortly afterward, a young man had emerged. The ugly duckling ② had become a swan.

It was definitely a turning point. Diego's confidence grew ③ quickly after that day. When the school had a swimming competition, he won every race he participated in. The encouragement and acknowledgement given by the other boys was genuine. He ④ had earned the respect of his classmates. Over the next few weeks, his grades improved and he became ⑤ more popular. Thanks to a swim with a penguin, a lonely boy's life was changed forever.

13 윗글의 밑줄 친 ①~⑤ 중, 어법상 틀린 것은?

① ② ③ ④ ⑤

14 Diego에 관한 윗글의 내용과 일치하지 않는 것은?

① 자신감이 커졌다.
② 참가한 수영 대회에서 우승을 했다.
③ 학급 친구들의 존경을 받았다.
④ 성적이 향상되었다.
⑤ 외로운 펭귄의 삶을 바꿔주었다.

1 다음 대화의 밑줄 친 ①~⑤ 중, 문맥상 낱말의 쓰임이 적절하지 <u>않은</u> 것은?

> G: Let's go watch a movie.
> B: Sorry. I'm not really in the mood. I failed my piano audition again. This was the third time.
> G: Don't be ① <u>depressed</u>. There's always next time.
> B: Yes, but I don't think I have any ② <u>talent</u> for music.
> G: Don't think that way. You have ③ <u>potential</u>! As long as you keep trying, you'll eventually ④ <u>abandon</u>.
> B: Do you really think so?
> G: Sure. Just ⑤ <u>trust</u> in yourself!
> B: Thanks. I feel much better now.

① ② ③ ④ ⑤

[2~3] 다음 글을 읽고, 물음에 답하시오.

> Tom Michell is a British teacher. In the 1970s, he worked at an English language boarding school in Argentina. One day he visited a beach and found a penguin that was injured and alone. Michell decided to help the bird. He cleaned it, fed it, and even gave it a name—Juan Salvado. From that day on, Juan Salvado lived on the terrace of his room in the school dormitory. The following is part of the story, written by Tom Michell, about the penguin and a boy at the school.
>
> From the first day that I brought a penguin to live at the school, one student in particular wanted to help with his care. His name was Diego Gonzales. Diego was a shy boy who seemed to be frightened of his own shadow. He struggled with his classes, and none of the after-school activities seemed to suit him. He was neither strong _____ athletic. On the rugby field, nobody passed the ball to him or involved him in the game, except to make fun of him.

2 윗글을 읽고 답할 수 <u>없는</u> 질문으로 가장 적절한 것은?

① What does Tom do?
② Where was the penguin found?
③ What did Tom do for the penguin?
④ How did Diego help the penguin?
⑤ What kind of personality does Diego have?

3 윗글의 빈칸에 들어갈 말을 한 단어로 쓰시오.

[4~5] 다음 글을 읽고, 물음에 답하시오.

> Diego's early education had not prepared him well for life at his new school. His knowledge of English was limited, so _____. However, Diego enjoyed the company of Juan Salvado. Indeed, on the terrace, Diego could relax. He had some friends who also had trouble fitting in. ⓐ <u>Take</u> care of Juan Salvado was good for those boys. They fed him fish, swept the terrace, and spent time with him.
>
> One day, I took Juan Salvado to the school swimming pool with the boys. As soon as the other swimmers left, we brought Juan Salvado to the water to see if he would swim. Juan Salvado had been living at the school for several months by then. However, in all that time, he had never ⓑ <u>be</u> able to swim because his feathers had been damaged.

4 윗글의 빈칸에 들어갈 말로 가장 적절한 것은?

① he was good at English
② he talked with friends
③ he avoided conversation
④ he liked to take classes
⑤ he made many friends

5 윗글의 밑줄 친 ⓐ, ⓑ를 어법에 맞게 고쳐 쓰시오.

ⓐ Take → _____

ⓑ be → _____

[6~8] 다음 글을 읽고, 물음에 답하시오.

"Go on!" I said. The penguin stared at me and then at the pool, like he was asking, "Ah! Is this where the fish come from?" Without (A) farther / further encouragement, he jumped in. With a single movement of his wings, he flew like an arrow across the water and knocked into the wall on the opposite side. (B) Sadly / Luckily , he was not hurt!
 I _____ in the water before. I was familiar with the awkward way that Juan Salvado walked on land, but now I watched in awe. Using only a stroke or two, he flew at great speed from one end of the pool to the other, turning swiftly before touching the sides. It was amazing! Everyone could see how much he was enjoying himself.
 "Ooh! Aah!" The boys shouted, as though they were watching a fireworks display. After a while, Diego came over and asked quietly, "Can I swim, too?"

6 윗글의 내용과 일치하지 않는 것은?

① 펭귄은 물속으로 뛰어들었다.
② Juan은 육지에서 걸어 다녔다.
③ Juan은 물 속에서 빠른 속도로 날아갔다.
④ 소년들은 불꽃놀이를 보고 있었다.
⑤ Diego는 수영을 해도 되는지 물었다.

7 〈보기〉에 주어진 말을 배열하여 윗글의 빈칸을 완성하시오.

〈보기〉 had / to study / the opportunity / never / a penguin / had

8 (A), (B)의 각 네모 안에서 문맥에 맞는 낱말로 가장 적절한 것을 쓰시오.

(A) _____

(B) _____

[9~11] 다음 글을 읽고, 물음에 답하시오.

I was astonished. Diego had never gone near the pool before. I was not even sure if he could swim.
 "The water is cold, and it's getting late. Are you sure you want to go in?" I asked.
 "Please!"
 "All right then," I said, "but be quick!"
 I had never seen him so ⓐ excited before. His eyes were shining with joy, and he seemed to be truly ⓑ alive for the first time. (①) Without hesitating, he dived into the cold water. (②) I was ready to jump in and ⓒ rescued him if he could not swim.
 (③) Not only could Diego swim, but he swam magnificently! (④) He chased after Juan Salvado, and they swam in perfect harmony. (⑤) It was like a duet ⓓ written for violin and piano. Sometimes Juan Salvado took the lead and Diego followed after him. At ⓔ other times Diego went ahead and the penguin swam around the boy.

9 윗글의 흐름으로 보아, 주어진 문장이 들어가기에 가장 적절한 곳은?

> However, I soon realized that I did not have anything to worry about.

① ② ③ ④ ⑤

10 윗글에서 I의 심경 변화로 가장 적절한 것은?

① happy → worried
② pleased → shocked
③ lonely → happy
④ angry → calm
⑤ worried → amazed

11 윗글의 밑줄 친 ⓐ~ⓔ 중, 어법상 틀린 것은?

① ⓐ ② ⓑ ③ ⓒ ④ ⓓ ⑤ ⓔ

[12~13] 다음 글을 읽고, 물음에 답하시오.

> I was almost speechless. Suddenly Diego was not the sad little boy we had become used to.

(A) It was the first time he had talked about his life. I listened in silence, without making any corrections to his English, as he talked nonstop all the way back to the dormitory.

(B) He was a very normal boy with a very special talent. "Diego! You can swim!" "Yes, I can swim." "I mean you are able to swim really well. Brilliantly, in fact!" "Do you think so?"

(C) He asked without looking directly at me, but I saw a smile on his face. As we returned to the dormitory, <u>Diego는 그의 아버지가 집 근처에 있는 강에서 그에게 수영하는 법을 가르쳐 주셨다고 나에게 말했다.</u>

12 주어진 글 다음에 이어질 글의 순서로 가장 적절한 것은?

① (A) - (C) - (B) ② (B) - (A) - (C)
③ (B) - (C) - (A) ④ (C) - (A) - (B)
⑤ (C) - (B) - (A)

13 윗글의 밑줄 친 우리말과 일치하도록 〈보기〉에 주어진 말을 배열하여 문장을 완성하시오.

> 〈보기〉 had / swim / to / his father / how / him / taught

Diego told me that _____

in the river by their home

[14~15] 다음 글을 읽고, 물음에 답하시오.

> The events of that day were extraordinary. A child had gone down to the water to swim with a penguin, and shortly afterward, a young man had emerged. The ugly duckling had become a swan.
>
> It was definitely a turning point. Diego's confidence grew quickly after that day. When the school had a swimming competition, ⓐ <u>he</u> won every race he participated in. The encouragement and acknowledgement given by the other boys was _____. ⓑ <u>He</u> had earned the respect of his classmates. Over the next few weeks, ⓒ <u>his</u> grades improved. ⓓ <u>He</u> became more popular. Thanks to a swim with ⓔ <u>him</u>, a lonely boy's life was changed forever.

14 윗글의 빈칸에 들어갈 말로 가장 적절한 것은?

① tough
② boring
③ useless
④ genuine
⑤ aggressive

15 윗글의 밑줄 친 ⓐ~ⓔ 중, 가리키는 대상이 나머지 넷과 다른 것은?

① ⓐ ② ⓑ ③ ⓒ ④ ⓓ ⑤ ⓔ

정답 및 해설 p.6

1 다음 담화의 빈칸에 공통으로 들어갈 말로 가장 적절한 것은? (대소문자는 관계 없음)

This week's movie is *One Chance*. It is based on the true story of Paul Potts, who was shy and bullied but had a talent for singing opera. He sang in church choirs and was determined to become an opera singer. _____, his dream almost ended when a world-famous opera singer told him that he wasn't talented enough. After that, he battled cancer and nearly died in a bicycle accident. At the age of 37, _____, he auditioned for a TV show called *Britain's Got Talent*. His singing impressed the judges, and he eventually won the show. *One Chance* will touch your heart with the tale of a man who refused to quit despite facing difficulties and proved that you should never give up on yourself.

① Therefore
② Instead
③ However
④ Moreover
⑤ For instance

[2~3] 다음 글을 읽고, 물음에 답하시오.

Tom Michell is a British teacher. In the 1970s, he worked at an English language boarding school in Argentina. One day he visited a beach and found a penguin (A) what / that was injured and alone. Michell decided to help the bird. He cleaned it, fed it, and even gave it a name—Juan Salvado. From that day on, Juan Salvado lived on the terrace of his room in the school dormitory. The following is part of the story, written by Tom Michell, about the penguin and a boy at the school.

From the first day that I brought a penguin to live at the school, one student in particular wanted to help with his care. His name was Diego Gonzales. Diego was a shy boy (B) that

/ what seemed to be frightened of his own shadow. He struggled with his classes, and 방과후 활동들 중 그 어느 것도 그에게 적합해 보이지 않았다. He was neither strong nor athletic. On the rugby field, nobody passed the ball to him or (C) involving / involved him in the game, except to make fun of him.

2 (A), (B), (C)의 각 네모 안에서 어법에 맞는 표현으로 가장 적절한 것은?

	(A)		(B)		(C)
①	what	…	what	…	involving
②	what	…	what	…	involved
③	that	…	that	…	involving
④	that	…	that	…	involved
⑤	that	…	what	…	involved

3 윗글의 밑줄 친 우리말과 일치하도록 〈보기〉에 주어진 단어를 이용하여 문장을 완성하시오. (필요 시 형태를 변형할 것)

〈보기〉 none, the after-school activity, suit

[4~6] 다음 글을 읽고, 물음에 답하시오.

Diego's early education had not prepared him well for life at his new school. His knowledge of English was limited, so he avoided conversation. However, Diego enjoyed the company of Juan Salvado. Indeed, on the terrace, Diego could relax. He had some friends who also (A) (fit in / trouble / had). ① Looking after Juan Salvado was good for those boys. ② They fed him fish, swept the terrace, and spent time with him. ③ Diego and his friends often fought for the same reason. ④ One day, I took Juan Salvado to the school

swimming pool with the boys. ⑤ As soon as the other swimmers left, we brought Juan Salvado to the water to see if he would swim. Juan Salvado had been living at the school for several months by then. However, in all that time, he had never been able to swim because his feathers had been _____(B)_____ .

4 윗글의 밑줄 친 ①~⑤ 중, 전체 흐름과 관계 없는 문장은?

① ② ③ ④ ⑤

5 윗글의 (A)에 주어진 말을 알맞게 배열하시오. (필요 시 형태를 변형할 것)

6 윗글의 빈칸 (B)에 들어갈 말로 가장 적절한 것은?

① cleaned ② raised
③ decorated ④ damaged
⑤ lightened

[7~8] 다음 글을 읽고, 물음에 답하시오.

 "Go on!" I said. The penguin stared at me and then at the pool, like he was asking, "Ah! Is this ⓐ what the fish come from?" (①) With a single movement of his wings, he flew like an arrow across the water and knocked into the wall on the opposite side. (②) Luckily, he was not hurt!

 (③) I had never had the opportunity to study a penguin in the water before. (④) I was familiar with the awkward way that Juan Salvado walked on land, but now I watched in awe. (⑤) Using only a stroke or two, he flew at great speed from one end of the pool to the other, ⓑ turned swiftly before touching the sides. It was ⓒ amazing! Everyone could see how much he was enjoying himself.

 "Ooh! Aah!" The boys ⓓ shouting, as though they were watching a fireworks display. After a while, Diego came over and ⓔ asking quietly, "Can I swim, too?"

7 윗글의 흐름으로 보아, 주어진 문장이 들어가기에 가장 적절한 곳은?

> Without further encouragement, he jumped in.

① ② ③ ④ ⑤

8 윗글의 밑줄 친 ⓐ~ⓔ 중, 어법상 옳은 것은?

① ⓐ ② ⓑ ③ ⓒ ④ ⓓ ⑤ ⓔ

[9~11] 다음 글을 읽고, 물음에 답하시오.

 I was astonished. He had never gone near the pool before. 나는 그가 수영할 수 있는지 확신할 수 조차 없었다.

 "The water is cold, and it's getting late. Are you sure you want to go in?" I asked.

 "Please!"

 "All right then," I said, "but be quick!"

 I had never seen him so ⓐ exciting before. His eyes were shining with joy, and he seemed to be truly alive for the first time. Without hesitating, he dived into the cold water. I was ready to jump in and rescue him if he could not swim.

 However, I soon realized ⓑ what I did not have anything to worry about. Not only could Diego swim, but he swam magnificently! He chased after Juan Salvado, and they swam in perfect harmony. It was like a duet ⓒ writing for violin and piano. Sometimes Juan Salvado took the lead and Diego followed after him.

9 윗글의 밑줄 친 우리말과 일치하도록 〈보기〉에 주어진 말을 배열하여 문장을 완성하시오.

> 〈보기〉 could / was / if / sure / swim / he / not even

I _____

_____ .

10 윗글의 밑줄 친 ⓐ~ⓒ를 어법에 맞게 고쳐 쓰시오.

ⓐ exciting → _____

ⓑ what → _____

ⓒ writing → _____

11 윗글의 내용을 한 문장으로 요약할 때, 빈칸에 들어갈 단어를 찾아 쓰시오.

> Contrary to my expectations, Diego swam magnificently and in _____ with Juan; it was like a musical duet.

[12~13] 다음 글을 읽고, 물음에 답하시오.

> Occasionally they swam so close that they almost touched.
>
> I was almost speechless. <u>Suddenly Diego was not the sad little boy we had become used to.</u> He was a very normal boy with a very special _____(A)_____.
>
> "Diego! You can swim!"
>
> "Yes, I can swim."
>
> "I mean you are able to swim really well. Brilliantly, in fact!"
>
> "Do you think so?" He asked without looking directly at me, but I saw a smile on his face.
>
> As we returned to the dormitory, Diego told me that his father had taught him how to swim in the river by their home. It was the first time he had talked about his life. I listened in silence, without making any _____(B)_____ to his English, as he talked nonstop all the way back to the dormitory.

12 윗글의 빈칸 (A), (B)에 들어갈 말로 가장 적절한 것은?

	(A)		(B)
①	talent	⋯	corrections
②	talent	⋯	decisions
③	appearance	⋯	decisions
④	appearance	⋯	mistakes
⑤	appearance	⋯	corrections

13 윗글의 밑줄 친 문장을 우리말로 해석하시오.

[14~15] 다음 글을 읽고, 물음에 답하시오.

> The events of that day were extraordinary. A child had gone down to the water to swim with a penguin, and shortly afterward, a young man had emerged. The ugly duckling had become a swan.
>
> It was definitely a turning point. Diego's confidence grew quickly after that day. When the school had a swimming competition, he won every race he participated in. The encouragement and acknowledgement given by the other boys was genuine. He had earned the respect of his classmates. Over the next few weeks, his grades improved and he became more popular. Thanks to a(n) _____, a lonely boy's life was changed forever.

14 윗글의 바로 앞에 올 수 있는 내용으로 가장 적절한 것은?

① Diego를 혼내는 선생님
② 물을 두려워하고 있는 Diego
③ 수영을 훌륭하게 해내는 Diego
④ 수영 연습을 빠진 Diego
⑤ 물에 빠진 Diego를 구한 펭귄

15 윗글의 빈칸에 들어갈 말을 본문에서 찾아 쓰시오. (4단어)

1 다음 대화의 밑줄 친 ①~⑤ 중, 문맥상 낱말의 쓰임이 적절하지 <u>않은</u> 것은?

B: Hello, Susan. Do you have a minute?

G: Sure, David.

B: Would you draw an advertisement poster for our club's performance?

G: I'm really sorry. I don't think I have the skill to do that. You should look for a more ① <u>appropriate</u> person.

B: What are you talking about? I think you're the ② <u>best</u> artist in our school.

G: That's nice of you to say, but this morning I found out that I didn't win the district drawing contest.

B: Don't be ③ <u>pleased</u>. All of us know that you are a talented artist.

G: What if my drawing doesn't help our club ④ <u>attract</u> people to the performance?

B: Don't worry. I'm sure your drawing will be wonderful.

G: Okay. I'll try. Thank you for ⑤ <u>encouraging</u> me.

① ② ③ ④ ⑤

[2~3] 다음 글을 읽고, 물음에 답하시오.

Tom Michell is a British teacher. In the 1970s, he ① <u>worked</u> at an English language boarding school in Argentina. One day he visited a beach and found a penguin that was injured and alone. Michell ② <u>decided</u> to help the bird. He cleaned it, fed it, and even gave it a name— Juan Salvado. From that day on, Juan Salvado lived on the terrace of his room in the school dormitory. The following is part of the story, written by Tom Michell, about the penguin and a boy at the school.

From the first day that I brought a penguin to live at the school, one student in particular wanted to help with his care. His name was Diego Gonzales. Diego was a shy boy who seemed to be ③ <u>frightened</u> of his own shadow. He ④ <u>struggled</u> with his classes, and none of the after-school activities seemed to suit him. He was neither strong nor athletic. On the rugby field, nobody passed the ball to him or ⑤ <u>excluded</u> him in the game, except to make fun of him.

2 윗글의 내용과 일치하지 <u>않는</u> 것은?

① Tom은 펭귄 무리를 발견했다.

② 펭귄은 상처를 입은 상태였다.

③ Tom은 펭귄에게 이름을 지어주었다.

④ Tom은 펭귄을 자신의 기숙사에 데려왔다.

⑤ Diego는 강하지도 체격이 좋지도 않았다.

3 윗글의 밑줄 친 ①~⑤ 중, 문맥상 낱말의 쓰임이 적절하지 <u>않은</u> 것은?

① ② ③ ④ ⑤

[4~6] 다음 글을 읽고, 물음에 답하시오.

Diego's early education had not prepared him well for life at his new school. His knowledge of English was limited, _____ (A) _____ he avoided conversation. However, Diego enjoyed the company of Juan Salvado. Indeed, on the terrace, Diego could relax. He had some friends who also had trouble fitting in. Looking after Juan Salvado was good for those boys. They fed him fish, swept the terrace, and spent time with him.

One day, I took Juan Salvado to the school swimming pool with the boys. As soon as the

other swimmers left, we brought Juan Salvado to the water to see if he would swim. Juan Salvado had been living at the school for several months by then. However, in all that time, he had never been able to swim ____(B)____ his feathers had been damaged.

4 윗글의 빈칸 (A), (B)에 들어갈 말로 가장 적절한 것은?

	(A)		(B)
①	so	…	because
②	after	…	while
③	while	…	before
④	though	…	so
⑤	because	…	though

5 다음 영영 뜻풀이에 해당하는 단어를 윗글에서 찾아 쓰시오.

having been harmed or negatively affected

6 윗글에서 Juan을 물로 데리고 간 목적을 찾아 쓰시오. (6단어)

[7~8] 다음 글을 읽고, 물음에 답하시오.

"Go on!" I said. The penguin stared at me and then at the pool, like he was asking, "Ah! Is this where the fish come from?" Without further encouragement, he jumped in. With a single movement of his wings, he flew like an arrow across the water and ① knocking into the wall on the opposite side. Luckily, he was not hurt!

I had never had the opportunity ② study a penguin in the water before. I was _____, but now I watched in awe. ③ Using only a stroke or two, he flew at great speed from one end of the pool to the other, turning swiftly before ④ touched the sides. It was amazing! Everyone could see how

much ⑤ was he enjoying himself.

"Ooh! Aah!" The boys shouted, as though they were watching a fireworks display.

7 윗글의 밑줄 친 ①~⑤ 중, 어법상 옳은 것은?

① ② ③ ④ ⑤

8 〈보기〉에 주어진 말을 배열하여 윗글의 빈칸을 완성하시오.

〈보기〉 walked / that / on land / the awkward / familiar / Juan Salvado / with / way

[9~11] 다음 글을 읽고, 물음에 답하시오.

After a while, Diego came over and asked quietly, "Can ⓐ I swim, too?"

I was (A) astonished / frustrated. He had never gone near the pool before. I was not even sure if he could swim.

"The water is cold, and it's getting late. Are ⓑ you sure you want to go in?" I asked.

"Please!"

"All right then," I said, "but be quick!"

I had never seen ⓒ him so excited before. His eyes were shining with joy, and he seemed to be truly alive for the first time. Without hesitating, ⓓ he dived into the cold water. I was ready to jump in and (B) rescue / reveal him if he could not swim.

However, I soon realized that I did not have anything to worry about.

Not only could Diego swim, but he swam magnificently! He chased after Juan Salvado, and they swam in perfect harmony. It was like a duet written for violin and piano. Sometimes Juan Salvado took the lead and Diego followed after ⓔ him.

9 윗글의 밑줄 친 ⓐ~ⓔ 중, 가리키는 대상이 나머지 넷과 다른 것은?

① ⓐ　　② ⓑ　　③ ⓒ　　④ ⓓ　　⑤ ⓔ

10 (A), (B)의 각 네모 안에서 문맥에 맞는 낱말을 골라 쓰시오.

(A) _____

(B) _____

11 윗글의 밑줄 친 문장을 우리말로 해석하시오.

12 다음 글의 밑줄 친 ①~⑤ 중, 어법상 틀린 표현이 있는 문장은?

At other times Diego went ahead and the penguin swam around the boy. ① Occasionally they swam so close that they almost touched.

I was almost speechless. Suddenly Diego was not the sad little boy we had become used to. ② He was a very normal boy with a very special talent.

"Diego! You can swim!"

"Yes, I can swim."

"I mean you are able to swim really well. Brilliantly, in fact!"

"Do you think so?" ③ He asked without looking directly at me, but I saw a smile on his face.

④ As we returned to the dormitory, Diego told me what his father had taught him how to swim in the river by their home. It was the first time he had talked about his life. ⑤ I listened in silence, without making any corrections to his English, as he talked nonstop all the way back to the dormitory.

①　　② ③　　④　　⑤

[13~14] 다음 글을 읽고, 물음에 답하시오.

The events of that day were (A) extraordinary. A child had gone down to the water to swim with a penguin, and shortly afterward, a young man had emerged. The ugly duckling had become a swan.

It was definitely a turning point. Diego's confidence grew quickly after that day. When the school had a swimming competition, he won every race he participated in. ① Therefore, Diego had to move to another school. ② The encouragement and acknowledgement given by the other boys was genuine. ③ He had earned the respect of his classmates. ④ Over the next few weeks, his grades improved and he became more popular. ⑤ Thanks to a swim with a penguin, a lonely boy's life was changed forever.

13 윗글의 ①~⑤ 중, 전체 흐름과 관계 없는 문장은?

①　　②　　③　　④　　⑤

14 윗글의 밑줄 친 (A)와 바꿔 쓸 수 있는 것은?

① typical
② passionate
③ remarkable
④ separate
⑤ conventional

[1~3] 다음 글을 읽고, 물음에 답하시오.

> Tom Michell is a British teacher. In the 1970s, he worked at an English language boarding school in Argentina. One day ① he visited a beach and (A) 상처 입고 홀로 있는 펭귄을 발견했다. Michell decided to help the bird. ② He cleaned it, fed it, and even gave it a name—Juan Salvado. From that day on, Juan Salvado lived on the terrace of ③ his room in the school dormitory. The following is part of the story, written by Tom Michell, about the penguin and a boy at the school.
>
> From the first day that ④ I brought a penguin to live at the school, one student in particular wanted to help with his care. His name was Diego Gonzales. Diego was a shy boy who seemed to be frightened of his own shadow. He struggled with his classes, and none of the after-school activities seemed to suit him. (B) He was neither strong nor athletic. On the rugby field, nobody passed the ball to him or involved him in the game, except to make fun of ⑤ him.

1 윗글의 밑줄 친 (A)와 일치하도록 〈보기〉에 주어진 단어를 이용하여 문장을 완성하시오.

> 〈보기〉 that, injure, alone
>
> 〈조건〉
> • 8단어로 쓸 것
> • 필요 시 형태를 변형할 것

2 윗글의 밑줄 친 (B)를 우리말로 해석하시오.

3 윗글의 밑줄 친 ①~⑤ 중, 가리키는 대상이 다른 하나를 찾아 그 대상이 지칭하는 것을 쓰시오. (단, 기호, 지칭하는 것이 모두 맞을 때만 정답으로 인정함)

기호	지칭하는 것

[4~5] 다음 글을 읽고, 물음에 답하시오.

> Diego's early education had not prepared him well for life at his new school. His knowledge of English was limited, so he avoided conversation. However, Diego enjoyed the company of Juan Salvado. Indeed, on the terrace, Diego could relax. He had some friends who also had trouble fitting in. Juan Salvado를 돌보는 것은 이 소년들에게 좋은 일이었다. They fed him fish, swept the terrace, and spent time with him.

4 윗글을 읽고 아래 물음에 답하시오.

Q: Why didn't Diego want to have conversations with others?

A: It was because _____

_____.

5 윗글의 밑줄 친 우리말과 일치하도록 〈보기〉에 주어진 말을 배열하여 문장을 완성하시오.

〈보기〉
Juan Salvado / looking / those / was / boys / for / good / after

6 다음 글의 밑줄 친 ⓐ~ⓓ 중, 어법상 틀린 것을 찾아 바르게 고치고, 수정해야 하는 이유를 쓰시오. (단, 기호, 고친 것, 이유가 모두 맞을 때만 정답으로 인정함)

"Go on!" I said. The penguin stared at me and then at the pool, like he was asking, "Ah! Is this ⓐ where the fish come from?" Without further encouragement, he jumped in. With a single movement of his wings, he flew like an arrow across the water and knocked into the wall on the opposite side. Luckily, he was not hurt!

I had never had the opportunity ⓑ to study a penguin in the water before. I was familiar with the awkward way that Juan Salvado walked on land, but now I watched in awe. ⓒ Used only a stroke or two, he flew at great speed from one end of the pool to the other, turning swiftly before ⓓ touching the sides. It was amazing! Everyone could see how much he was enjoying ⓔ himself.

기호	고친 것	이유

7 다음 글에 주어진 ⓐ~ⓒ를 알맞은 형태로 쓰시오.

I was astonished. He had never ⓐ (go) near the pool before. I was not even sure if he could swim.

"The water is cold, and it's getting late. Are you sure you want to go in?"

I asked.

"Please!"

"All right then," I said, "but be quick!"

I had never seen him so ⓑ (excite) before. His eyes were shining with joy, and he seemed to be truly alive for the first time. Without hesitating, he dived into the cold water. I was ready ⓒ (jump) in and rescue him if he could not swim.

ⓐ _____

ⓑ _____

ⓒ _____

8 다음 글의 밑줄 친 ⓐ~ⓔ 중, 어법상 **틀린** 것을 3개 찾아 바르게 고쳐 쓰시오. (단, 기호, 틀린 것, 고친 것이 모두 맞을 때만 정답으로 인정함)

> ⓐ However, I soon realized that I did not have something to worry about. ⓑ Not only could Diego swim, but he swam magnificently! He chased after Juan Salvado, and they swam in perfect harmony. ⓒ It was like a duet write for violin and piano. ⓓ Sometimes Juan Salvado took the lead and Diego followed after him. At other times Diego went ahead and the penguin swam around the boy. ⓔ Occasionally they swam so close that they almost touch.

	기호	틀린 것 (틀린 부분만 쓸 것)	고친 것
(1)			
(2)			
(3)			

[9~10] 다음 글을 읽고, 물음에 답하시오.

> The events of that day were extraordinary. A child had gone down to the water to swim with a penguin, and shortly afterward, a young man had emerged. The ugly duckling had become a swan.
>
> It was definitely a turning point. Diego's confidence grew quickly after that day. When the school had a swimming competition, he won every race he participated in. The encouragement and acknowledgement given by the other boys was genuine. He had earned the respect of his classmates. Over the next few weeks, his grades improved and he became more popular.

9 윗글의 내용을 한 문장으로 요약할 때, 빈칸에 들어갈 말을 〈보기〉에서 찾아 쓰시오.

> Diego proved his (1) _____ talent in swimming and was (2) _____ by his classmates.

> 〈보기〉 excellent ignored ordinary respected

(1) _____

(2) _____

10 다음 두 문장의 참(True)과 거짓(False)를 구분하고, 판단의 근거가 되는 문장을 윗글에서 찾아 쓰시오.

(1) Diego won all of his races at the school swimming competition.

(2) Diego's grades went down because he was busy swimming.

번호	True / False	근거 문장
(1)		
(2)		

Lesson

02

Embracing Our Differences

Words

- attempt 명 시도
- categorize 동 분류하다
- introvert 명 내성[내향]적인 사람
- extrovert 명 외향적인 사람
- internal 형 내부의
- external 형 외부의
- recharge 동 (에너지 등을) 재충전하다
- socialize 동 (사람들과) 사귀다, 어울리다
 - social 형 사회의, 사회적인
- concentrate 동 집중하다 (= focus)
- assignment 명 과제, 임무
- deliberately 부 신중하게
- complement 동 보완하다
- accomplish 동 성취하다 (= achieve, fulfill)
- collaborate 동 협력하다
 - collaboration 명 협력, 협업
- civil rights 시민의 평등권
- passenger 명 승객
- resist 동 저항하다
- injustice 명 부당함 (↔ justice)
- furious 형 분노한
- arrest 동 체포하다
- resistance 명 저항
- inspirational 형 영감[감화/자극]을 주는
- assemble 동 모이다 (= gather)
- rally 명 (대규모) 집회[대회]
- assertive 형 적극적인
- sociable 형 사교적인 (↔ unsociable)

- motivate 동 ~에게 동기를 주다, 자극하다
- trample 동 짓밟다
- bravery 명 용기
- mere 형 단지 ~만의
- presence 명 존재 (↔ absence)
- strengthen 동 ~을 강화하다
- inspire 동 고무[격려]하다
- boycott 동 (항의의 표시로) 이용을 거부하다 명 거부 운동
- crucial 형 중대한, 결정적인
- integrate 동 통합시키다 (↔ segregate)
 - integration 명 통합
- trait 명 (성격상의) 특성
- combine 동 결합하다
- charisma 명 카리스마, 사람을 휘어잡는 매력
- tap 동 (가볍게) 톡톡 두드리다[치다]
- simultaneously 부 동시에 (= at the same time)
- device 명 장치
- era 명 시대
- engineering 명 공학
- polish 동 다듬다, 손질하다
- small talk 잡담, 한담
- feature 명 특성 (= attribute, quality)
- enable 동 ~을 할 수 있게[가능하게] 하다
 - enable A to-v A가 ~을 할 수 있게 하다
- outstanding 형 뛰어난
- daring 형 대담한
- entrepreneur 명 사업가, 기업가
- obviously 부 명백하게 (= clearly)

Phrases

- cope with ~에 대처[대응]하다, ~을 처리하다
- take risks 위험을 감수하다
- stand out 두드러지다
- get tired of ~에 싫증 나다

- have an impact on ~에 영향을 끼치다
- at the sight of ~을 보고
- come up with (해답 등을) 찾아 내다[내놓다]

Vocabulary Check-Up

다음 영어는 우리말로, 우리말은 영어로 쓰시오.

01 obviously (부) _____

02 extrovert (명) _____

03 daring (형) _____

04 trample (동) _____

05 enable (동) _____

06 inspire (동) _____

07 strengthen (동) _____

08 polish (동) _____

09 engineering (명) _____

10 presence (명) _____

11 have an impact on _____

12 mere (형) _____

13 simultaneously (부) _____

14 resistance (명) _____

15 outstanding (형) _____

16 combine (동) _____

17 motivate (동) _____

18 integrate (동) _____

19 crucial (형) _____

20 collaborate (동) _____

21 at the sight of _____

22 come up with _____

23 (동) 이용을 거부하다 _____

24 ~에 싫증 나다 _____

25 (동) 성취하다 _____

26 (형) 적극적인 _____

27 (부) 신중하게 _____

28 (명) 과제, 임무 _____

29 (동) 집중하다 _____

30 (명) 사업가, 기업가 _____

31 ~에 대처[대응]하다, ~을 처리하다 _____

32 (동) 보완하다 _____

33 (명) (대규모) 집회[대회] _____

34 (동) 모이다 _____

35 (형) 영감[감화/자극]을 주는 _____

36 위험을 감수하다 _____

37 (동) (에너지 등을) 재충전하다 _____

38 (동) 체포하다 _____

39 (형) 분노한 _____

40 (명) 부당함 _____

41 두드러지다 _____

42 (동) 분류하다 _____

43 (명) 내성[내향]적인 사람 _____

44 시민의 평등권 _____

 The short documentary **encouraged** people **to save** energy.

┌「encourage+목적어+to부정사」

그 짧은 다큐멘터리는 사람들에게 에너지를 절약할 것을 권장했다.

 Then the driver **ordered** her **to give** her seat to a white passenger.

┌「order+목적어+to부정사」

그러자 기사가 그녀에게 그녀의 자리를 백인 승객에게 양보하라고 명령했다.

▶ 목적격 보어는 목적어 뒤에서 목적어의 성질이나 상태·행동을 보충 설명하는 말로, 동사에 따라 목적격 보어로 형용사, 명사, to부정사, 동사원형, 분사 등이 올 수 있다.

▶ to부정사를 목적격 보어로 취하는 동사에는 advise, order, allow, encourage, ask, cause, enable, expect, force 등이 있다.

내신출제 Point

Test Point 1 목적격 보어로 to부정사를 취하는 동사

advise, order, allow, enable 등의 동사 외에도 to부정사를 목적격 보어로 취하는 동사에는 **get**, **help**가 있다. get은 사역의 의미이지만 목적격 보어로 to부정사를 취하며, help는 동사원형과 to부정사 둘 다 취한다.

The surgery has **enabled** the patient ~~walk~~ / to walk again. 그 수술은 환자를 다시 걸을 수 있게 했다.

The coach **got** the players ~~jump~~ / to jump into the river. 그 코치는 선수들을 강으로 뛰어들게 했다.

They **helped** him move / to move the bookshelf. 그들은 그가 책장 옮기는 것을 도와주었다.

Test Point 2 목적격 보어로 동사원형을 취하는 동사

사역동사(make, have, let)와 지각동사(see, watch, hear, smell, feel, notice 등)는 목적어와 목적격 보어가 능동 관계일 때 목적격 보어로 동사원형을 취한다. 단, 지각동사는 진행의 의미를 강조할 때 목적격 보어로 현재분사를 쓸 수도 있다.

His parents **let** him **decide** where to go for vacation.
그의 부모님은 그에게 어디로 휴가를 갈지 결정하게 하셨다.

We **saw** her **dance** on the stage. 우리는 그녀가 무대 위에서 춤추는 것을 보았다.

We **saw** her **dancing** on the stage. 우리는 그녀가 무대 위에서 춤추고 있는 것을 보았다.

Point Check-Up

정답 및 해설 p.8

1 다음 네모 안에서 어법상 알맞은 것을 고르시오.

(1) She helped me find / finding the answer to the complex math problem.

(2) He allowed me turn / to turn on the TV after finishing my homework.

(3) I heard the team members to laugh / laughing out loud in the meeting room.

예제	**It was** a skirt **that** Kate and her mom bought at the store.

Kate와 그의 엄마가 가게에서 산 것은 바로 치마였다.

교과서	**It was** these features of his introverted personality **that** enabled him to focus on inventing things.

그가 물건들을 발명하는 데 집중할 수 있게 해 준 것은 바로 이런 그의 내향적인 성격 특성이었다.

▶ 「It is[was] ~ that ...」 강조 구문은 '…하는 것은 바로 ~이다[였다]'라는 의미로, 강조하고 싶은 말을 It is[was]와 that 사이에 쓴다. 이때, 강조 대상이 사람이면 that 대신 who를 쓸 수 있다.

내신출제 Point

 that을 대신하는 관계대명사 who

It is <u>Joe</u> **who[that]** is planning his coworker's farewell party.
⤷ 강조 대상

동료의 송별회를 준비하는 사람은 바로 Joe이다.

It was <u>David</u> **who[that]** crashed into the police car yesterday night.
⤷ 강조 대상

어젯밤 경찰차를 들이받은 것은 바로 David였다.

 It is[was]와 that 사이에 오는 강조 어구

It is[was]와 that 사이에 들어갈 수 있는 강조 어구에는 주어, 목적어, 부사구, 부사절이 있다.

It was <u>Melissa</u> **that** met Dr. Miller in Sydney. 시드니에서 Miller 박사를 만난 것은 바로 Melissa였다.
⤷ 주어 강조

It was <u>Dr. Miller</u> **that** Melissa met in Sydney. Melissa가 시드니에서 만난 사람은 바로 Miller 박사였다.
⤷ 목적어 강조

It was <u>in Sydney</u> **that** Melissa met Dr. Miller. Melissa가 Miller 박사를 만난 곳은 바로 시드니에서였다.
⤷ 부사구 강조

Point Check-Up

정답 및 해설 p.8

2 다음 문장이 어법상 올바르면 O, 틀리면 X 표시하시오.

(1) It was my brother that gave me hope for the future. _____

(2) It was not until yesterday that she checked her email. _____

(3) It was the uniform in his locker who he lost last weekend. _____

01 다음 괄호 안에서 어법상 알맞은 것을 고르시오.

(1) The teacher made him (clean / to clean) the classroom for being late.

(2) It is my husband (that / which) usually takes our kids to school in the morning.

(3) Jenny asked her sister (to prepare / preparing) a special cake for her birthday party.

02 다음 밑줄 친 부분을 강조하여 쓸 때, 빈칸에 알맞은 말을 쓰시오.

(1) My grandfather takes a walk every morning <u>in this park</u>.

→ It is _____ my grandfather takes a walk every morning.

(2) <u>Peter</u> went to the department store to fix his new watch.

→ It was _____ went to the department store to fix his new watch.

(3) I started to write a diary <u>on New Year's Day</u>.

→ It was _____ I started to write a diary.

03 다음 밑줄 친 부분을 어법에 맞게 고쳐 쓰시오.

(1) He advised me <u>avoid</u> taking the highway during rush hour.　　→ _____

(2) We encourage students <u>take advantage of</u> this mentoring program.　　→ _____

(3) Many parents would never let their children <u>to play</u> violent games.　　→ _____

04 주어진 우리말과 일치하도록 단어를 바르게 배열하여 문장을 완성하시오.

(1) 그가 그의 결혼 반지를 찾은 곳은 바로 부엌이었다. (was / he / in the kitchen / that / it / found)

→ _____ his wedding ring.

(2) 그 왕은 경비병들에게 그를 사자 우리에 넣으라고 명령했다. (put / ordered / to / the guards / him)

→ The king _____ in the lion's cage.

(3) 지하철역에서 내 여권을 찾아준 사람은 바로 이 남자이다. (it / found / this man / who / my passport / is)

→ _____ in the subway station.

(4) 그녀는 그녀의 오빠가 그의 교수님에 대해 불평하고 있는 것을 들었다.

(her brother / heard / about / complaining)

→ She _____ his professor.

05 다음 괄호 안의 단어를 활용하여 빈칸을 채우시오. (교과서 p.51)

> To whom it may concern:
>
> Last month, I asked you (1) _____ (deliver) a printer by June 10. However, it arrived a week late. What's more, when I opened the box, I saw that the printer was damaged. In fact, it appeared to have been used before. I want you (2) _____ (explain) why these problems occurred. Moreover, I expect you (3) _____ (replace) the delivered printer with a new one.
>
> <div align="right">Regards,
Edward Johnson</div>

06 주어진 우리말과 일치하도록 괄호 안의 단어를 활용하여 문장을 완성하시오. (교과서 p.51)

> A: (1) _____ from the store, wasn't it?
> (steal, the cash)
> (그 가게에서 돈을 훔친 건 바로 당신이었어, 그렇지?)
> B: No, I swear! I've never even been there.
> A: You'd better be honest.
> B: I'm telling you—it wasn't me!
> A: There's a witness who saw you there on Tuesday.
> B: I didn't go there on Tuesday! (2) _____!
> (on, go, there)
> (전 화요일에 거기에 가지 않았다니까요! 제가 거기에 간 건 바로 월요일이었어요!)

(1) _____

(2) _____

07 다음 중 밑줄 친 It의 쓰임이 다른 하나는?

> ⓐ <u>It</u> was Dan's retirement party that I went to with Jane.
> ⓑ <u>It</u> is his career at this company that Rob wants to discuss.
> ⓒ <u>It</u> was my grandmother who taught me how to play piano.
> ⓓ <u>It</u> is obvious that there will be heavy rain in a few hours.
> ⓔ <u>It</u> was then that her daughter woke up and started crying.

① ⓐ ② ⓑ ③ ⓒ ④ ⓓ ⑤ ⓔ

Opposite Personalities, Great Partnerships

01 Everybody is unique. However, there have been many attempts [to categorize people's
주어 (단수 취급) 동사　　　　　　　　　　현재완료　　　　　　많은 시도　　　　형용사적 용법
personalities].

모든 사람은 유일무이하다. 그러나 사람들의 성격을 분류하려는 시도가 많이 있어 왔다.

02 one of the+최상급+복수명사: 가장 ~한 … 중 하나
One of the most common methods divides people into two types, introverts and extroverts.
주어 (단수)　　　　　　　　　　　　　동사

가장 흔한 방법 중 하나는 사람들을 내향적인 사람과 외향적인 사람 두 가지 유형으로 구분하는 것이다.

03 According to this division, introverts tend to be drawn to the internal world of thoughts and
~에 따르면　　　　　　　　　　tend to-v: ~하는 경향이 있다
feelings, while extroverts are drawn to the external world of people and activities.
~인 반면 (= whereas)

이 분류에 따르면, 외향적인 사람들은 사람과 활동이라는 외적인 세계에 이끌리는 반면, 내향적인 사람들은 생각과 감정이라는 내면세계에 이끌리는 경향이 있다.

04 Introverts recharge their batteries by spending some time alone; extroverts need to recharge
by v-ing: ~함으로써
when they do not socialize enough.
~할 때　　　　　　　　　　충분히 (부사)

내향적인 사람들은 혼자 시간을 보내며 배터리를 재충전하는 반면, 외향적인 사람들은 사교 활동을 충분히 하지 못했을 때 재충전이 필요하다.

05 Extroverts are good at performing tasks under pressure and coping with multiple jobs at once.
　　　　　　　　　　　　└────── 병렬 구조 ──────┘　　　　　　　　동시에

외향적인 사람들은 압박감 속에서 일을 해내는 것과 여러 가지 일을 동시에 처리하는 것에 능하다.

06 Introverts, on the other hand, like [to focus on one task at a time] and can concentrate very
　　　　　　　　반면에　　　　　명사적 용법 (like의 목적어)
well.

반면, 내향적인 사람들은 한 번에 한 가지 일에 집중하는 것을 좋아하고 매우 잘 집중할 수 있다.

07 Extroverts tend to do assignments quickly. They make fast decisions and are comfortable with
　　　　　　　　　　　　　　　　　　　　　make a decision: 결정하다
[taking risks].
동명사구 (전치사 with의 목적어)

외향적인 사람들은 과제를 빨리하는 경향이 있다. 그들은 결정을 빨리 내리며, 위험을 감수하는 것을 편안해한다.

08 Introverts often work more slowly and <u>deliberately</u>. <u>They</u> <u>think</u> before they act, <u>give up</u> less
신중하게 주어 동사1 동사2

easily, and <u>work</u> more accurately.
동사3

내향적인 사람들은 보통 더 천천히 그리고 신중하게 일한다. 그들은 행동하기 전에 생각하고, 덜 쉽게 포기하며, 더 정확하게 일한다.

09 <u>Based on</u> all this information, you <u>might</u> think [that introverts and extroverts do not get along].
~에 기반하여 ~할지도 모른다 명사절 (think의 목적어)

이 모든 정보를 기반으로, 당신은 내향적인 사람과 외향적인 사람이 서로 잘 지내지 못한다고 생각할지도 모른다.

10 However, <u>they</u> actually work well together <u>because</u> their personalities <u>complement</u> each other.
= introverts and extroverts ~ 때문에 보완하다

Sometimes they can <u>even</u> accomplish great things when they collaborate. Let's <u>take a look at</u>
심지어 ~을 보다

some famous examples!

그러나 그들은 실제로 잘 협력하는데, 그들의 성격이 서로를 보완하기 때문이다. 심지어 그들은 협력할 때 때때로 위대한 일들을 성취하기도 한다. 유명한 몇 가지 사례들을 보자!

Case One: Working Together for Civil Rights 사례 1: 시민의 평등권을 위해 협력하다

11 On December 1, 1955, in the American city of Montgomery, Alabama, <u>a black woman</u> [named
과거분사구

Rosa Parks] got on a bus.

1955년 12월 1일, 미국의 앨라배마 주 몽고메리 시에서, Rosa Parks라는 이름의 흑인 여성이 버스에 탔다.

12 At that time in Montgomery, buses <u>were divided into</u> two zones: one for black people and the
be divided into: ~로 나누어지다 하나는 ~, 다른 하나는 …

other for white people.

당시 몽고메리에서는, 버스가 흑인을 위한 곳과 백인을 위한 곳 두 구역으로 나뉘어 있었다.

13 She <u>took</u> a seat in the black zone and <u>watched</u> quietly [<u>as</u> more and more passengers got on the
주어 동사1 동사2 ~하는 동안 (접속사) 비교급+and+비교급: 점점 더 ~한

bus].

그녀는 흑인 구역에 앉아서 점점 더 많은 승객들이 버스에 타는 동안 조용히 지켜보았다.

14 Soon, all the seats in the white zone <u>were taken</u>. Then the driver <u>ordered</u> her <u>to give</u> her seat to
수동태 order+목적어+to-v: ~에게 …하라고 명령하다

a white passenger.

곧 백인 구역의 모든 좌석들이 찼다. 그러자 기사가 그녀에게 그녀의 자리를 백인 승객에게 양보하라고 명령했다.

15 Rosa Parks was a shy, mild-mannered introvert. She avoided <u>standing</u> out in public or drawing
avoid v-ing: ~을 피하다
━━━━ 병렬 구조 ━━━━

attention to herself.

Rosa Parks는 수줍어하고 온화한 내향적인 사람이었다. 그녀는 사람들 앞에서 두드러지거나 자신에게 관심이 집중되는 것을 피했다.

16 However, she had <u>the courage</u> [to resist injustice], so she answered calmly with a single word—
↑━━━━━┘ 형용사적 용법

"No." The furious driver called the police, and she <u>was arrested</u>.
수동태

그러나 그녀는 불의에 저항할 용기가 있었다. 그래서 그녀는 차분하게 한 단어로 대답했다. "싫어요." 분노한 기사는 경찰을 불렀고, 그녀는 체포됐다.

17 <u>Parks's calm response to the situation</u> <u>impressed</u> many people.
주어 (단수) 동사

그 상황에 대한 Parks의 차분한 반응은 많은 사람들에게 깊은 인상을 주었다.

18 <u>Soon after</u>, her quiet resistance came together with the <u>inspirational</u> speechmaking of Martin
곧 영감을 주는

Luther King Jr. When 5,000 people <u>assembled</u> at a rally [to support Parks's act of courage],
모이다 부사적 용법 〈목적〉

King <u>made a speech</u> to the crowd.
make a speech: 연설하다

곧, 그녀의 조용한 저항은 Martin Luther King Jr.의 인상적인 연설로 이어졌다. 5,000명의 사람들이 Parks의 용감한 행동을 지지하기 위해 집회에 모였을 때, King은 군중에게 연설을 했다.

19 He was an extrovert—assertive, sociable, and good at [motivating people].
dash(—)로 부연 설명 동명사구 (전치사 at의 목적어)

그는 외향적인 사람으로, 적극적이고, 사교적이며, 사람들에게 동기를 부여하는 데에 뛰어났다.

20 "There comes a time [when people get tired of [being trampled]]," he told them.
↑━━━┘ 관계부사절 ~에 싫증 나다 동명사구 (전치사 of의 목적어)

"사람들이 짓밟히는 데에 진력나는 순간이 옵니다." 그는 그들에게 말했다.

21 "There comes a time [when people get tired of [being pushed out of the sunlight]]."
↑━━━┘ 관계부사절 동명사구 (전치사 of의 목적어)

"사람들이 햇빛으로부터 밀려나는 것에 진력나는 순간이 옵니다."

22 King was an amazing speaker, and his words filled the people with pride and hope. He then
현재분사 · fill A with B: A를 B로 채우다 · 주어

praised Parks's bravery and hugged her.
동사1 · 동사2

King은 놀라운 연설가였고, 그의 말은 사람들을 자부심과 희망으로 채웠다. 그리고 나서 그는 Parks의 용기를 칭송하고는 그녀를 포옹했다.

23 She stood silently. Her mere presence was enough to strengthen the crowd.
단지 ~만의 · enough to-v: ~하기에 충분한

그녀는 조용히 서 있었다. 그녀의 존재는 그 자체만으로도 군중에게 힘을 주기에 충분했다.

24 Rosa Parks's act and Martin Luther King Jr.'s speech inspired Montgomery's black community
inspire+목적어+to-v: ~가 …하도록 고무[격려]하다

to boycott the buses, a crucial turning point in the struggle for civil rights.
중대한, 결정적인

Rosa Parks의 행동과 Martin Luther King Jr.의 연설은 몽고메리의 흑인 공동체가 버스 이용을 거부하도록 고무했고, 그것은 시민 평등권을 위한 투쟁의 중요한 전환점이었다.

25 The boycott lasted for 381 days. It was a difficult time for everyone, but eventually the buses
~ 동안 (전치사) · 마침내

were integrated.
수동태

그 거부 운동은 381일 동안 계속되었다. 모두에게 힘든 시간이었지만, 마침내 버스는 통합되었다.

26 Think about [how the partnership of these two people accomplished this].
간접의문문 (「의문사+주어+동사」의 어순)

어떻게 이 두 사람의 동반자 관계가 이것을 이뤄 냈는지에 대해 생각해 보라.

27 A powerful speaker [refusing to give up his seat on a bus] would not have had the same effect.
현재분사구 · 주어 ('If there had been a powerful speaker ~'가 함축) · 가정법 과거완료

버스에서 자신의 자리를 양보하기를 거부하는 강력한 연설가는 (Rosa Parks와) 같은 효과를 내지는 못했을 것이다.

28 Similarly, Rosa Parks could not have excited the crowd at the rally with her words.
가정법 과거완료

마찬가지로, Rosa Parks는 집회에서 그녀의 말로 군중을 흥분시키지 못했을 것이다.

29 When their introverted and extroverted traits were combined, however, his charisma attracted
주어 (복수) · 동사 (수동태)

attention to her quiet bravery. In the end, this partnership had a huge impact on society.
have an impact on: ~에 영향을 끼치다

그러나 그들의 내향적인 성질과 외향적인 성질이 결합하자, 그의 사람을 휘어잡는 매력은 그녀의 조용한 용기에 관심을 끌어 모았다. 결국, 이 동반자 관계는 사회에 큰 영향을 끼쳤다.

Case Two: A Business Partnership 사례 2: 사업 동반자 관계

30 On June 29, 1975, Steve Wozniak tapped a few keys on his keyboard, and letters appeared on a
a few+셀 수 있는 명사의 복수형 *나타나다 (자동사)*
screen.

1975년 6월 29일, Steve Wozniak은 그의 키보드의 키를 몇 개 두드렸고, 글자들이 화면에 나타났다.

31 He had just created a personal computer [that allowed people to type on a keyboard and see
과거완료 *주격 관계대명사절* *목적격 보어 1* *목적격 보어 2*
 allow+목적어+to-v: ~가 …하게 하다 *to*
the results on a monitor simultaneously].

그는 사람들이 키보드를 치는 동시에 모니터에서 결과를 볼 수 있게 해 주는 개인용 컴퓨터를 갓 만들어 낸 것이었다.

32 At the sight of the brilliant device, Steve Jobs suggested to Wozniak [that they start a business].
~을 보고 *제안하다* *명사절 (suggested의 목적어)* *should 동사원형*

이 기가 막힌 장치를 보면서, Steve Jobs는 Wozniak에게 함께 사업을 시작할 것을 제안했다.

33 Wozniak was a great inventor. When he partnered with Jobs, however, he was able to do much
be able to-v: ~할 수 있다
more. In fact, the two men formed one of the most famous partnerships of the digital era.
one of the+최상급+복수명사: 가장 ~한 … 중 하나

Wozniak은 뛰어난 발명가였다. 그러나 그는 Jobs와 함께했을 때 훨씬 더 많은 것을 할 수 있었다. 사실, 이 두 사람은 디지털 시대에 가장 유명한 동반자 관계 중 하나를 형성했다.

34 Wozniak would come up with a clever engineering idea, and Jobs would find a way [to polish,
~하곤 했다 *(해답 등을) 찾아 내다[내놓다]* *형용사적 용법*
package, and sell it].

Wozniak은 영리한 공학 아이디어를 내놓고, Jobs는 그것을 다듬고 포장해서 팔 방법을 찾아내곤 했다.

35 The two men had opposite personalities. Wozniak hated small talk and often worked alone.
주어 *동사1* *동사2*

두 사람은 정반대의 성격을 가지고 있었다. Wozniak은 한담을 싫어했고 보통 혼자 일했다.

36 It was these features of his introverted personality that enabled him to focus on inventing
「It is[was] ~ that …」 강조 구문 *enable+목적어+to-v: ~가 …할 수 있게 하다*
things.

그가 물건들을 발명하는 데 집중할 수 있게 해 준 것은 바로 이런 그의 내향적인 성격 특성이었다.

37 Jobs, <u>on the other hand</u>, had outstanding social skills. <u>According to</u> Wozniak, he was good at
반면에 ~에 따르면
[communicating with people].
동명사구 (전치사 at의 목적어)

반면에, Jobs에게는 뛰어난 사교 기술이 있었다. Wozniak에 따르면, 그는 사람들과 의사소통을 잘했다고 한다.

38 Wozniak was a shy inventor, <u>whereas</u> Jobs was a <u>daring</u> entrepreneur, but they were alike
반면에 (= while) 대담한
<u>in that</u> neither was afraid to face <u>challenges</u> [that seemed impossible].
~라는 점에서 (접속사) 주격 관계대명사절

Jobs가 대담한 사업가인 반면, Wozniak은 수줍은 발명가였지만, 두 사람 모두 불가능해 보이는 도전에 맞서는 것을 두려워
하지 않았다는 점에서 그들은 비슷했다.

39 So <u>which</u> personality type is better? Obviously, the answer is <u>neither</u>. The world needs both
어떤 ~ 둘 중 어느 쪽도 ~ 아니다
introverts and extroverts, and they often make a terrific team.

그래서 어떤 성격 유형이 더 좋은 것일까? 명백하게도, 대답은 둘 중 어느 것도 아니라는 것이다. 세상은 내향적인 사람과 외
향적인 사람 모두를 필요로 하며, 그들은 자주 훌륭한 팀을 이룬다.

40 We simply need to respect different personalities <u>as well as</u> our own.
A as well as B: B뿐만 아니라 A도 (= not only B but also A)

우리는 그저 우리 자신의 성격뿐만 아니라 다른 성격도 존중할 필요가 있다.

41 Then, when we have <u>a chance</u> [to work together], we might be able to do great things!
형용사적 용법

그러면, 우리가 함께 일할 기회가 있을 때 위대한 일을 할 수 있을지도 모른다!

다음 빈칸을 채우시오.

Everybody is unique. However, there have been many attempts (1) _____ _____ _____
_____.

모든 사람은 유일무이하다. 그러나 사람들의 성격들을 분류하려는 시도가 많이 있어 왔다.

(2) _____ _____ _____ _____ methods divides people into two
types, introverts and extroverts.

가장 흔한 방법 중 하나는 사람들을 내향적인 사람과 외향적인 사람 두 가지 유형으로 구분하는 것이다.

According to this division, introverts (3) _____ _____ _____ _____ to the
internal world of thoughts and feelings, while extroverts are drawn to the external world of people and
activities.

이 분류에 따르면, 외향적인 사람들은 사람과 활동이라는 외적인 세계에 이끌리는 반면, 내향적인 사람들은 생각과 감정이라는 내면세계
에 이끌리는 경향이 있다.

Introverts recharge their batteries (4) _____ _____ some time alone; extroverts need to
recharge when they do not socialize enough.

내향적인 사람들은 혼자 시간을 보냄으로써 배터리를 재충전하는 반면, 외향적인 사람들은 사교 활동을 충분히 하지 못했을 때 재충전이
필요하다.

Extroverts (5) _____ _____ _____ _____ tasks under pressure and coping with
multiple jobs at once. Introverts, (6) _____ _____ _____ _____, like to focus on
one task at a time and can concentrate very well.

외향적인 사람들은 압박감 속에서 일을 해내는 것과 여러 가지 일을 동시에 처리하는 것에 능하다. 반면, 내향적인 사람들은 한 번에 한
가지 일에 집중하는 것을 좋아하고 매우 잘 집중할 수 있다.

Extroverts tend to do assignments quickly. They make fast decisions and (7) _____ _____
_____ _____ _____.

외향적인 사람들은 과제를 빨리하는 경향이 있다. 그들은 결정을 빨리 내리며, 위험을 감수하는 것을 편안해한다.

Introverts often work more slowly and deliberately. They think before they act, (8) _____
_____ _____ _____, and work more accurately.

내향적인 사람들은 보통 더 천천히 그리고 신중하게 일한다. 그들은 행동하기 전에 생각하고, 덜 쉽게 포기하며, 더 정확하게 일한다.

(9) _____ _____ _____ _____ _____, you might think that introverts and
extroverts do not get along.

이 모든 정보를 기반으로, 당신은 내향적인 사람과 외향적인 사람이 서로 잘 지내지 못한다고 생각할지도 모른다.

However, they actually work well together because (10) _____ _____ _____
_____ _____.

그러나 그들은 실제로 잘 협력하는데, 그들의 성격들이 서로를 보완하기 때문이다.

Sometimes they can even accomplish great things (11) _____ _____ _____. Let's take a look at some famous examples!

심지어 그들은 협력할 때 때때로 위대한 일들을 성취하기도 한다. 유명한 몇 가지 사례들을 보자!

On December 1, 1955, in the American city of Montgomery, Alabama, (12) _____ _____ _____ _____ Rosa Parks got on a bus.

1955년 12월 1일, 미국의 앨라배마 주 몽고메리 시에서, Rosa Parks라는 이름의 흑인 여성이 버스에 탔다.

At that time in Montgomery, buses (13) _____ _____ _____ two zones: one for black people and the other for white people.

당시 몽고메리에서는, 버스들이 흑인을 위한 곳과 백인을 위한 곳 두 구역으로 나뉘어 있었다.

She took a seat in the black zone and watched quietly as (14) _____ _____ _____ got on the bus.

그녀는 흑인 구역에 앉아서 점점 더 많은 승객들이 버스에 타는 동안 조용히 지켜보았다.

Soon, all the seats in the white zone were taken. Then the driver (15) _____ _____ _____ _____ her seat to a white passenger.

곧 백인 구역의 모든 좌석들이 찼다. 그러자 기사가 그녀에게 그녀의 자리를 백인 승객에게 주라고 명령했다.

Rosa Parks was a shy, mild-mannered introvert. She (16) _____ _____ _____ _____ _____ or drawing attention to herself.

Rosa Parks는 수줍어하고 온화한 내향적인 사람이었다. 그녀는 사람들 앞에서 두드러지거나 자신에게 관심이 집중되는 것을 피했다.

However, she (17) _____ _____ _____ _____ _____ _____, so she answered calmly with a single word— "No."

그러나 그녀는 불의에 저항할 용기가 있었다. 그래서 그녀는 차분하게 한 단어로 대답했다. "싫어요."

The furious driver called the police, and (18) _____ _____ _____.

분노한 기사는 경찰을 불렀고, 그녀는 체포됐다.

Parks's calm response to the situation (19) _____ _____ _____.
Soon after, (20) _____ _____ _____ came together with the inspirational speechmaking of Martin Luther King Jr.

그 상황에 대한 Parks의 차분한 반응은 많은 사람들에게 깊은 인상을 주었다. 곧, 그녀의 조용한 저항은 Martin Luther King Jr.의 인상적인 연설로 이어졌다.

When 5,000 people assembled at a rally (21) _____ _____ _____ _____, King made a speech to the crowd.

5,000명의 사람들이 Parks의 용감한 행동을 지지하기 위해 집회에 모였을 때, King은 군중에게 연설을 했다.

He was an extrovert—assertive, sociable, and (22) _____ _____ _____.
"There comes a time when people get tired of being trampled," he told them.

그는 외향적인 사람으로, 적극적이고, 사교적이며, 사람들에게 동기를 부여하는 데에 뛰어났다. "사람들이 짓밟히는 데에 진력나는 순간이 옵니다." 그는 그들에게 말했다.

"There comes a time (23) _____ _____ _____ _____ _____

_____ out of the sunlight."

"사람들이 햇빛으로부터 밀려나는 것에 진력나는 순간이 옵니다."

King was an amazing speaker, and his words filled the people (24) _____ _____ _____

_____. He then praised Parks's bravery and hugged her. She stood silently. Her mere presence

(25) _____ _____ _____ _____ the crowd.

King은 놀라운 연설가였고, 그의 말은 사람들을 자부심과 희망으로 채웠다. 그리고 나서 그는 Parks의 용기를 칭송하고는 그녀를 포옹

했다. 그녀는 조용히 서 있었다. 그녀의 존재는 그 자체만으로도 군중에게 힘을 주기에 충분했다.

Rosa Parks's act and Martin Luther King Jr.'s speech inspired Montgomery's black community to

boycott the buses, a crucial turning point in the (26) _____ _____ _____ _____.

Rosa Parks의 행동과 Martin Luther King Jr.의 연설은 몽고메리의 흑인 공동체가 버스 이용을 거부하도록 고무했고, 그것은 시민

평등권을 위한 투쟁의 중요한 전환점이었다.

The boycott lasted for 381 days. It was a difficult time for everyone, but eventually (27) _____

_____ _____ _____.

그 거부 운동은 381일 동안 계속되었다. 모두에게 힘든 시간이었지만, 마침내 버스들은 통합되었다.

(28) _____ _____ _____ the partnership of these two people accomplished this.

어떻게 이 두 사람의 동반자 관계가 이것을 이뤄 냈는지에 대해 생각해 보라.

A powerful speaker refusing to give up his seat on a bus (29) _____ _____ _____

_____ the same effect. Similarly, Rosa Parks could not have excited the crowd at the rally (30)

_____ _____ _____.

버스에서 자신의 자리를 양보하기를 거부하는 강력한 연설가는 (Rosa Parks와) 같은 효과를 내지는 못했을 것이다. 마찬가지로, Rosa

Parks는 집회에서 그녀의 말들로 군중을 흥분시키지 못했을 것이다.

When their (31) _____ _____ _____ _____ were combined, however, his

charisma attracted attention to her quiet bravery. In the end, this partnership (32) _____

_____ _____ _____ society.

그러나 그들의 내향적인 성질과 외향적인 성질이 결합하자, 그의 사람을 휘어잡는 매력은 그녀의 조용한 용기에 관심을 끌어모았다.

결국, 이 동반자 관계는 사회에 큰 영향을 끼쳤다.

On June 29, 1975, Steve Wozniak tapped a few keys on his keyboard, and (33) _____ _____

_____ _____ _____.

1975년 6월 29일, Steve Wozniak은 그의 키보드의 키를 몇 개 두드렸고, 글자들이 화면에 나타났다.

He had just created a personal computer that (34) _____ _____ _____ _____ on

a keyboard and see the results on a monitor simultaneously.

그는 사람들이 키보드를 치는 동시에 모니터에서 결과를 볼 수 있게 해 주는 개인용 컴퓨터를 갓 만들어 낸 것이었다.

(35) _____ _____ _____ _____ the brilliant device, Steve Jobs suggested to Wozniak that they start a business.

이 기가 막힌 장치를 보고, Steve Jobs는 Wozniak에게 함께 사업을 시작할 것을 제안했다.

Wozniak was a great inventor. (36) _____ _____ _____ _____ _____, however, he was able to do much more.

Wozniak은 뛰어난 발명가였다. 그러나 그는 Jobs와 함께했을 때 훨씬 더 많은 것을 할 수 있었다.

In fact, the two men formed one of (37) _____ _____ _____ _____ of the digital era.

사실, 이 두 사람은 디지털 시대에 가장 유명한 동반자 관계들 중 하나를 형성했다.

Wozniak would come up with a clever engineering idea, and Jobs would find (38) _____ _____ _____ _____, package, and sell it.

Wozniak은 영리한 공학 아이디어를 내놓고, Jobs는 그것을 다듬고 포장해서 팔 방법을 찾아내곤 했다.

The two men (39) _____ _____ _____. Wozniak hated small talk and often worked alone.

두 사람은 정반대의 성격들을 가지고 있었다. Wozniak은 한담을 싫어했고 보통 혼자 일했다.

It was these features of his introverted personality that (40) _____ _____ _____ _____ _____ _____ things.

그가 물건들을 발명하는 데 집중할 수 있게 해 준 것은 바로 이런 그의 내향적인 성격 특성이었다.

Jobs, on the other hand, (41) _____ _____ _____ _____. According to Wozniak, he was good at communicating with people.

반면에, Jobs에게는 뛰어난 사교 기술들이 있었다. Wozniak에 따르면, 그는 사람들과 의사소통을 잘했다고 한다.

Wozniak was a shy inventor, whereas Jobs was a daring entrepreneur, but they were alike in that neither was afraid to (42) _____ _____ _____ _____ _____.

Jobs가 대담한 사업가인 반면, Wozniak은 수줍은 발명가였지만, 두 사람 모두 불가능해 보이는 도전들에 맞서는 것을 두려워하지 않았다는 점에서 그들은 비슷했다.

So which personality type is better? Obviously, (43) _____ _____ _____ _____.
The world (44) _____ _____ introverts and extroverts, and they often make a terrific team.

그래서 어떤 성격 유형이 더 좋은 것일까? 명백하게도, 대답은 둘 중 어느 것도 아니라는 것이다. 세상은 내향적인 사람과 외향적인 사람 모두를 필요로 하며, 그들은 자주 훌륭한 팀을 이룬다.

We simply need to respect different personalities (45) _____ _____ _____ our own.
Then, when we (46) _____ _____ _____ _____ _____ _____, we might be able to do great things!

우리는 그저 우리 자신의 성격뿐만 아니라 다른 성격도 존중할 필요가 있다. 그러면, 우리가 함께 일할 기회가 있을 때 위대한 일을 할 수 있을지도 모른다!

다음 네모 안에서 옳은 것을 고르시오.

01 One of the most common [methods / method] divides people into two types, introverts and extroverts.

02 Introverts recharge their batteries by spending some time alone; extroverts need to recharge when they do not [realize / socialize] enough.

03 Extroverts are good at performing tasks under pressure and [coped / coping] with multiple jobs at once.

04 Based on all this information, you might think [that / what] introverts and extroverts do not get along.

05 However, they actually work well together because their personalities [complement / compliment] each other.

06 Sometimes they can even [accomplish / neglect] great things when they collaborate.

07 On December 1, 1955, in the American city of Montgomery, Alabama, a black woman [named / naming] Rosa Parks got on a bus.

08 At that time in Montgomery, buses were divided into two zones: one for black people and [the other / the others] for white people.

09 She avoided standing out in public or [drew / drawing] attention to herself.

10 When 5,000 people [assembled / resembled] at a rally to support Parks's act of courage, King made a speech to the crowd.

11 He was an extrovert—assertive, sociable, and good at motivating people. "There comes a time [which / when] people get tired of being trampled," he told them.

12 King was an amazing speaker, and his words [filled / were filled] the people with pride and hope.

13 He then praised Parks's bravery and hugged her. She stood silently. Her mere [absence / presence] was enough to strengthen the crowd.

14 Rosa Parks's act and Martin Luther King Jr.'s speech inspired Montgomery's black community [boycott / to boycott] the buses, a crucial turning point in the struggle for civil rights.

15 A powerful speaker refusing to give up his seat on a bus would not have [have / had] the same effect.

16 Similarly, Rosa Parks could not have [excited / been excited] the crowd at the rally with her words.

17 He had just created a personal computer that allowed people to type on a keyboard and [see / seeing] the results on a monitor simultaneously.

18 At the sight of the brilliant [device / devise], Steve Jobs suggested to Wozniak that they start a business.

19 It was these features of his introverted personality [what / that] enabled him to focus on inventing things.

20 Wozniak was a shy inventor, [where / whereas] Jobs was a daring entrepreneur, but they were alike in that neither was afraid to face challenges that seemed impossible.

다음 문장이 옳으면 O, 틀리면 X 표시하고 바르게 고치시오.

01 Everybody is unique. However, there has been many attempts to categorize people's personalities.

02 One of the most common methods divide people into two types, introverts and extroverts.

03 According to this division, introverts tend to be drawn to the internal world of thoughts and feelings, during extroverts are drawn to the external world of people and activities.

04 Introverts recharge their batteries by spend some time alone; extroverts need to recharge when they do not socialize enough.

05 Extroverts are good at performing tasks under pressure and coping with multiple jobs at once.

06 Introverts, on the other hand, like to focusing on one task at a time and can concentrate very well.

07 Extroverts tend to do assignments quickly. They make fast decisions and are comfortable with taking risks.

08 Introverts often work more slowly and deliberately. They think before they act, give up less easily, and work more accurate.

09 Based on all this information, you might think that introverts and extroverts do not get along.

10 However, they actually work well together because of their personalities complement each other.

11 Sometimes they can even accomplish great things when they collaborate. Let's taking a look at some famous examples!

Case One: Working Together for Civil Rights

12 On December 1, 1955, in the American city of Montgomery, Alabama, a black woman named Rosa Parks got on a bus.

13 At that time in Montgomery, buses were divided into two zones: one for black people and the other for white people.

14 She took a seat in the black zone and watched quiet as more and more passengers got on the bus.

15 Soon, all the seats in the white zone were taken. Then the driver ordered her give her seat to a white passenger.

16 Rosa Parks was a shy, mild-mannered introvert. She avoided standing out in public or drawing attention to herself.

17 However, she had the courage to resisting injustice, so she answered calmly with a single word—"No."

18 The furious driver called the police, and she was arrested.

19 Parks's calm response to the situation was impressed many people. Soon after, her quiet resistance came together with the inspirational speechmaking of Martin Luther King Jr.

20 When 5,000 people assembled at a rally to support Parks's act of courage, King made a speech to the crowd.

21 He was an extrovert—assertive, sociable, and good at motivate people. "There comes a time when people get tired of being trampled," he told them.

22 "There comes a time when people get tired of being pushed out of the sunlight."

23 King was an amazed speaker, and his words filled the people with pride and hope.

24 He then praised Parks's bravery and hugged her. She stood silently. Her mere presence was to enough strengthen the crowd.

25 Rosa Parks's act and Martin Luther King Jr.'s speech inspired Montgomery's black community to boycott the buses, a crucial turning point in the struggle for civil rights.

26 The boycott lasted for 381 days. It was a difficult time for everyone, but eventually the buses were integrated.

27 Think about how the partnership of these two people accomplished this.

28 A powerful speaker refusing to give up his seat on a bus would not have had the same effect.

29 Similarly, Rosa Parks could not have exciting the crowd at the rally with her words.

30 When their introverted and extroverted traits were combined, however, his charisma attracted attention to her quiet bravery.

31 In the end, this partnership had a huge impact on society.

Case Two: A Business Partnership

32 On June 29, 1975, Steve Wozniak tapped a few keys on his keyboard, and letters were appeared on a screen.

33 He had just created a personal computer that allowed people to type on a keyboard and see the results on a monitor simultaneously.

34 At the sight of the brilliant device, Steve Jobs suggested to Wozniak what they start a business.

35 Wozniak was a great inventor. When he partnered with Jobs, however, he was able to do much more.

36 In fact, the two men formed one of the more famous partnerships of the digital era.

37 Wozniak would come up with a clever engineering idea, and Jobs would find a way to polish, package, and sell it.

38 The two men had opposite personalities. Wozniak hated small talk and often worked alone.

39 It was these features of his introverted personality that enabled him focus on inventing things.

40 Jobs, on the other hand, had outstanding social skills. According to Wozniak, he was good at communicating with people.

41 Wozniak was a shy inventor, whereas Jobs was a daring entrepreneur, but they were alike in which neither was afraid to face challenges that seemed impossible.

42 So which personality type is better? Obviously, the answer is neither.

43 The world needs both introverts and extroverts, and they often make a terrific team.

44 We simply need to respect different personalities as well as our own.

45 Then, when we have a chance to work together, we might be able to do great things!

1 다음 대화가 자연스럽게 이어지도록 (A)~(C)를 올바른 순서로 배열하시오.

> B: Amy, you look concerned. What's wrong?
> G: Actually, I'm having a little trouble with Dylan. He is mad at me.
> B: That's too bad. What did you do?
> G: _____
> B: _____
> G: _____
> B: Amy, everyone has their own taste. You should respect it. In my opinion, you should call Dylan right away and apologize to him.
> G: Okay. I will.

〈보기〉
(A) Actually, I did. Who wears yellow shoes? They looked like huge bananas!
(B) You didn't make fun of them, did you?
(C) He showed me his new shoes this morning, but they looked ridiculous to me.

_____ → _____ → _____

[2~4] 다음 글을 읽고, 물음에 답하시오.

Everybody is unique. However, there ⓐ has been many attempts to categorize people's personalities. One of the most common methods ⓑ divides people into two types, introverts and extroverts. According to this division, introverts tend to be drawn to the internal world of thoughts and feelings, while extroverts are drawn to the external world of people and activities. Introverts recharge their batteries by ⓒ spending some time alone; extroverts need to recharge when they do not socialize enough.

Extroverts (A) (perform / be / at / good / tasks) under pressure and coping with multiple jobs at once. (①) Introverts, on the other hand, like to focus on one task at a time and can concentrate very well. (②) They make fast decisions and are comfortable with taking risks. (③) Introverts often work more ⓓ slowly and deliberately. (④) They think before they act, ⓔ give up less easily, and work more accurately. (⑤)

2 윗글의 흐름으로 보아, 주어진 문장이 들어가기에 가장 적절한 곳은?

Extroverts tend to do assignments quickly.

① ② ③ ④ ⑤

3 윗글의 (A)에 주어진 말을 알맞게 배열하시오. (필요 시 형태를 변형할 것)

4 윗글의 밑줄 친 ⓐ~ⓔ 중, 어법상 틀린 것은?

① ⓐ ② ⓑ ③ ⓒ ④ ⓓ ⑤ ⓔ

5 다음 글의 빈칸에 들어갈 단어를 영영 뜻풀이를 참고하여 쓰시오.

Based on all this information, you might think that introverts and extroverts do not get along. However, they actually work well together because their personalities _____ each other. Sometimes they can even accomplish great things when they collaborate. Let's take a look at some famous examples!

• to make a good combination with someone or something else
• to make something else seem better or more attractive when combining with it

On December 1, 1955, in the American city of Montgomery, Alabama, a black woman ⓐ name Rosa Parks got on a bus. At that time in Montgomery, buses were divided into two zones: one for black people and the other for white people. She took a seat in the black zone and watched quietly as more and more passengers got on the bus. Soon, all the seats in the white zone were taken. Then the driver ordered her ⓑ give her seat to a white passenger. Rosa Parks was a shy, mild-mannered introvert. She avoided ⓒ stand out in public. However, she had the courage to _____ injustice, so she answered calmly with a single word— "No." The furious driver called the police, and she was arrested.

6 윗글의 빈칸에 들어갈 단어로 가장 적절한 것은?

① accept ② resist ③ permit
④ encourage ⑤ give up

7 윗글의 밑줄 친 ⓐ~ⓒ를 어법에 맞게 고쳐 쓰시오.

ⓐ name → _____

ⓑ give → _____

ⓒ stand → _____

8 윗글의 내용과 일치하지 않는 것은?

① Rosa Parks는 흑인 구역에 앉았다.
② 점점 더 많은 승객들이 버스에 탑승했다.
③ 버스 내 백인 구역에 자리가 남지 않았다.
④ Rosa Parks는 노약자에게 자리를 양보하지 않았다.
⑤ Rosa Parks는 체포되었다.

[9~10] 다음 글을 읽고, 물음에 답하시오.

Parks's calm response to the situation ① impressed many people. Soon after, her quiet resistance came together with the ② inspirational speechmaking of Martin Luther King Jr.

(A) "There comes a time when people get tired of being trampled," he told them. "There comes a time when people get tired of being pushed out of the sunlight." King was an amazing speaker, and his words ③ filled the people with pride and hope.

(B) He then praised Parks's bravery and hugged her. She stood silently. Her mere presence was enough to ④ strengthen the crowd.

(C) When 5,000 people assembled at a rally to support Parks's act of courage, King made a speech to the crowd. He was an ⑤ introvert—assertive, sociable, and good at motivating people.

9 주어진 글 다음에 이어질 글의 순서로 가장 적절한 것은?

① (A) − (B) − (C) ② (B) − (A) − (C)
③ (B) − (C) − (A) ④ (C) − (A) − (B)
⑤ (C) − (B) − (A)

10 윗글의 밑줄 친 ①~⑤ 중, 문맥상 낱말의 쓰임이 적절하지 않은 것은?

① ② ③ ④ ⑤

11 다음 글의 내용을 한 문장으로 요약할 때, 빈칸 (A), (B)에 들어갈 말로 가장 적절한 것은?

Rosa Parks's act and Martin Luther King Jr.'s speech inspired Montgomery's black community to boycott the buses, a crucial turning point in the struggle for civil rights. The boycott lasted for 381 days. It was a difficult time for everyone, but eventually the buses were integrated. Think about how the partnership of these two people accomplished this. A powerful speaker refusing to give up his seat on a bus would not have had the same effect. Similarly, Rosa Parks could not have excited the crowd at the rally with her words. When their introverted and extroverted traits were combined, however, his charisma attracted attention to her quiet bravery. In the end, this partnership had a huge impact on society.

↓

Thanks to the ____(A)____ between Rosa Parks and Martin Luther King Jr., black passengers were not forced to ____(B)____ their seats to white passengers any more.

	(A)		(B)
①	partnership	…	give up
②	synergies	…	confirm
③	negotiations	…	purchase
④	peace	…	yield
⑤	agreement	…	leave

12 다음 글의 밑줄 친 ⓐ~ⓔ 중, 어법상 틀린 것을 모두 고르시오.

On June 29, 1975, Steve Wozniak tapped a few keys on his keyboard, and letters ⓐ appeared on a screen. He ⓑ had just created a personal computer that allowed people to type on a keyboard and see the results on a monitor simultaneously. At the sight of the brilliant device, Steve Jobs suggested to Wozniak that they ⓒ started a business.

Wozniak was a great inventor. When he partnered with Jobs, however, he was able to do much more. In fact, the two men ⓓ forming one of the most famous partnerships of the digital era. Wozniak would come up with a clever engineering idea, and Jobs ⓔ would find a way to polish, package, and sell it.

① ⓐ, ⓒ ② ⓐ, ⓑ ③ ⓑ, ⓔ
④ ⓒ, ⓓ ⑤ ⓓ, ⓔ

13 다음 글의 내용과 일치하지 않는 것은?

The two men had opposite personalities. Wozniak hated small talk and often worked alone. It was these features of his introverted personality that enabled him to focus on inventing things. Jobs, on the other hand, had outstanding social skills. According to Wozniak, he was good at communicating with people. Wozniak was a shy inventor, whereas Jobs was

a daring entrepreneur, but they were alike in that neither was afraid to face challenges that seemed impossible.

So which personality type is better? Obviously, the answer is neither. The world needs both introverts and extroverts, and they often make a terrific team. We simply need to respect different personalities as well as our own. Then, when we have a chance to work together, we might be able to do great things!

① Wozniak은 보통 혼자 일했다.
② Jobs는 사교 기술이 뛰어났다.
③ Wozniak은 불가능해 보이는 도전에 맞서는 것을 두려워했다.
④ 내향적인 사람과 외향적인 사람은 종종 훌륭한 팀을 이룬다.
⑤ 우리는 다른 성격들을 존중해야 한다.

14 다음 글의 빈칸 (A), (B)에 들어갈 말로 가장 적절한 것은?

Dear Mia,

I would like to apologize for what I did yesterday. I yelled at you and said you were not putting enough effort into the project.

The reason I acted that way was because you didn't speak much during the discussion and I thought that meant you weren't focusing. ____(A)____, I was embarrassed to see how much research you had done. As a careful person, you needed time to organize your thoughts before expressing them. ____(B)____, I didn't give you that chance. I feel really sorry.

I regret my thoughtless actions as the group leader, and I promise nothing like this will ever happen again. Our team needs your competence. I hope you will forgive me and keep up the excellent work.

	(A)		(B)
①	However	…	Fortunately
②	For example	…	Therefore
③	However	…	However
④	In addition	…	Therefore
⑤	For example	…	However

1 다음 글의 빈칸에 들어갈 말로 가장 적절한 것은?

Recently, a research team surveyed 50 high school students. The students were asked to name a(n) _____ of cultural diversity. The most common response was that cultural diversity helps us perceive the world more broadly. Twenty-one students said this was the reason why they enjoyed interacting with other cultures. The second-most common answer was getting to eat delicious foods from different countries. Next, there were ten students who said cultural diversity makes the community more dynamic. They said that where there are different cultures, there are more new things to see and do. Finally, six students think getting to experience various festivals is an advantage of cultural diversity. What is your opinion? Whatever it is, it is important to have an open mind and to respect different cultures.

① cause
② positive effect
③ example
④ disadvantage
⑤ process

[2~4] 다음 글을 읽고, 물음에 답하시오.

Everybody is unique. However, there have been many attempts to categorize people's personalities. One of the most common methods divides ① people into two types, introverts and extroverts. ____(A)____ this division, introverts tend to be drawn to the internal world of thoughts and feelings, while extroverts are drawn to the external world of people and activities. Introverts recharge ② their batteries by spending some time alone; extroverts need to recharge when ③ they do not socialize enough.

Extroverts are good at performing tasks under pressure and coping with multiple jobs at once. Introverts, ____(B)____, like to focus on one task at a time and can concentrate very well. ④ Extroverts tend to do assignments quickly. They make fast decisions and are comfortable with taking risks. Introverts often work more slowly and deliberately. (C) They think before they act, give up less easily, and work more accurately.

Based on all this information, you might think that introverts and extroverts do not get along. However, ⑤ they actually work well together because their personalities complement each other.

2 윗글의 빈칸 (A), (B)에 들어갈 말로 가장 적절한 것은?

	(A)		(B)
①	Due to	…	on the other hand
②	Due to	…	in addition
③	Instead of	…	therefore
④	According to	…	on the other hand
⑤	According to	…	in addition

3 윗글의 밑줄 친 (C)와 가리키는 대상이 같은 것은?

①　　②　　③　　④　　⑤

4 다음 영영 뜻풀이에 해당하는 단어를 윗글에서 찾아 쓰시오.

to do something, such as relaxing, in order to get one's energy back

[5~6] 다음 글을 읽고, 물음에 답하시오.

On December 1, 1955, in the American city of Montgomery, Alabama, a black woman named Rosa Parks got on a bus. At that time in Montgomery, buses ① were divided into two zones: one for black people and the other for white people. She took a seat in the black zone and watched ② quietly as more and more passengers got on the bus. Soon, all the seats in the white zone ③ was taken. Then the driver ordered her to ＿＿＿＿＿＿＿＿＿. Rosa Parks was a shy, mild-mannered introvert. She avoided standing out in public or ④ drawing attention to herself. However, she had the courage ⑤ to resist injustice, so she answered calmly with a single word—"No." The furious driver called the police, and she was arrested.

5 윗글의 빈칸에 들어갈 말로 가장 적절한 것은?

① be quiet on the bus
② speak in front of passengers
③ sit in the seat while driving
④ move to the black zone
⑤ give her seat to a white passenger

6 윗글의 밑줄 친 ①~⑤ 중, 어법상 틀린 것은?

①　　②　　③　　④　　⑤

[7~8] 다음 글을 읽고, 물음에 답하시오.

Parks's calm response to the situation impressed many people. Soon after, her ① quiet resistance came together with the inspirational speechmaking of Martin Luther King Jr. When 5,000 people ② scattered at a rally to support Parks's act of courage, King made a speech to the crowd. He was an extrovert—assertive, sociable, and good at ③ motivating people. "There comes a time when people get tired of being trampled," he told them. "There comes a time when people get tired of being pushed out of the sunlight." King was an amazing speaker,

and his words filled the people with ④ pride and hope. He then ⑤ praised Parks's bravery and hugged her. She stood silently. 그녀의 존재는 그 자체만으로도 군중에게 힘을 주기에 충분했다.

7 윗글의 밑줄 친 ①~⑤ 중, 문맥상 낱말의 쓰임이 적절하지 않은 것은?

①　　②　　③　　④　　⑤

8 윗글의 밑줄 친 우리말과 일치하도록 〈보기〉에 주어진 말을 배열하여 문장을 완성하시오.

〈보기〉 crowd / enough / her / strengthen / mere / the / to / was / presence

＿＿＿＿＿＿＿＿＿＿＿＿＿＿＿＿＿＿＿

＿＿＿＿＿＿＿＿＿＿＿＿＿＿＿＿＿＿＿

[9~10] 다음 글을 읽고, 물음에 답하시오.

Rosa Parks's act and Martin Luther King Jr.'s speech inspired Montgomery's black community to boycott the buses, a crucial turning point in the struggle for civil rights. (①) The boycott lasted for 381 days. (②) It was a difficult time for everyone, but eventually the buses were integrated. (③) Think about how the partnership of these two people accomplished this. (④) Similarly, Rosa Parks could not have excited the crowd at the rally with her words. (⑤) When their introverted and extroverted traits were combined, however, his charisma attracted attention to her quiet bravery. In the end, this partnership had a huge impact on society.

9 윗글의 흐름으로 보아, 주어진 문장이 들어가기에 가장 적절한 곳은?

A powerful speaker refusing to give up his seat on a bus would not have had the same effect.

①　　②　　③　　④　　⑤

10 윗글의 내용과 일치하지 <u>않는</u> 것은?

① King은 연설로 사람들을 고무시켰다.
② 버스 거부 운동은 시민 평등권 투쟁의 전환점이 되었다.
③ 버스 거부 운동은 381일 동안 계속되었다.
④ 버스 거부 운동으로 인해 버스는 완전히 분리되었다.
⑤ Parks와 King의 결합이 사회에 큰 영향을 끼쳤다.

11 다음 글의 내용과 일치하지 <u>않는</u> 것은?

On June 29, 1975, Steve Wozniak tapped a few keys on his keyboard, and letters appeared on a screen. He had just created a personal computer that allowed people to type on a keyboard and see the results on a monitor simultaneously. At the sight of the brilliant device, Steve Jobs suggested to Wozniak that they start a business.

Wozniak was a great inventor. When he partnered with Jobs, however, he was able to do much more. In fact, the two men formed one of the most famous partnerships of the digital era. Wozniak would come up with a clever engineering idea, and Jobs would find a way to polish, package, and sell it.

① Wozniak은 개인용 컴퓨터를 만들어 냈다.
② Jobs는 Wozniak에게 사업을 시작하자고 제안했다.
③ Wozniak은 뛰어난 발명가였다.
④ Wozniak과 Jobs는 디지털 시대에 동반자 관계를 형성했다.
⑤ Jobs는 공학 아이디어를 내고, Wozniak은 이를 판매할 방법을 찾았다.

[12~13] 다음 글을 읽고, 물음에 답하시오.

The two men had opposite personalities. Wozniak hated small talk and often worked alone. It was these features of his introverted personality that enabled him to focus on inventing things. Jobs, on the other hand, had outstanding social skills. (①) According to Wozniak, he was good at communicating with people. (②) Wozniak was a shy inventor, whereas Jobs was a daring entrepreneur, but they were alike in that neither was afraid to face challenges that seemed impossible. (③)

So which personality type is better? (④) The world needs both introverts and extroverts, and they often make a terrific team. (⑤) We simply need to respect different personalities as well as our own. Then, when we have a chance to _____, we might be able to do great things!

12 윗글의 흐름으로 보아, 주어진 문장이 들어가기에 가장 적절한 곳은?

Obviously, the answer is neither.

① ② ③ ④ ⑤

13 윗글의 빈칸에 들어갈 말로 가장 적절한 것은?

① work together
② reach our potential
③ get a good reputation
④ change our personalities
⑤ realize for our lack of ability

14 다음 글의 밑줄 친 ⓐ~ⓒ를 어법에 맞게 고쳐 쓰시오.

Last month, I asked you ⓐ deliver a printer by June 10. However, it arrived a week late. What's more, when I opened the box, I saw that the printer was damaged. In fact, it appeared to have been used before. I want you ⓑ explain why these problems occurred. Moreover, I expect you ⓒ replace the delivered printer with a new one.

ⓐ deliver → _____

ⓑ explain → _____

ⓒ replace → _____

1 다음 대화의 요지로 가장 적절한 것은?

> G: Nick, I heard that your team won first prize in the science contest. Congratulations!
>
> B: Thank you, Jane.
>
> G: It must have been difficult! How did your team do it?
>
> B: Well, we worked together very well! Each person had a different strength. Patrick suggested ideas since he is creative, and Kate made presentation slides since she is artistic.
>
> G: I see! You gave the presentation since you are a good speaker, right?
>
> B: Yes. I think we did well because we all have different strengths and interests.
>
> G: That's true! People who are different can really complement one another.

① 비슷한 특성을 가진 사람들이 잘 맞는다.
② 자신의 장점과 약점을 잘 파악해야 한다.
③ 다른 사람의 의견을 존중해야 한다.
④ 강점이 다른 사람들끼리 서로를 보완할 수 있다.
⑤ 자신의 능력에 대해 자신감을 가져야 한다.

[2~3] 다음 글을 읽고, 물음에 답하시오.

> (①) Everybody is unique. (②) However, there have been many attempts to categorize people's personalities. (③) According to this division, introverts tend to ⓐ draw to the internal world of thoughts and feelings, while extroverts are drawn to the external world of people and activities. (④) Introverts recharge their batteries by spending some time alone; extroverts need to recharge when they do not socialize enough. (⑤)

2 윗글의 흐름으로 보아, 주어진 문장이 들어가기에 가장 적절한 곳은?

> One of the most common methods divides people into two types, introverts and extroverts.

① ② ③ ④ ⑤

3 윗글의 밑줄 친 ⓐ를 어법에 맞게 고쳐 쓰시오.

ⓐ draw → _____

[4~5] 다음 글을 읽고, 물음에 답하시오.

> Extroverts are good at performing tasks under pressure and coping with multiple jobs at once. Introverts, 반면에, like to focus on one task at a time and can concentrate very well. Extroverts tend to do assignments quickly. They make fast decisions and are comfortable with taking risks. Introverts often work more slowly and deliberately. They think before they act, give up less easily, and work more accurately.

4 윗글의 밑줄 친 우리말을 영어로 쓰시오. (4단어)

5 다음 영영 뜻풀이에 해당하는 단어를 윗글에서 찾아 쓰시오.

> in a way that shows care or attention to small details

Based on all this information, (A) (introverts and extroverts / think / do / might / you / that / not / get along). However, they actually work well together because their personalities complement each other. Sometimes they can even accomplish great things when they collaborate. Let's take a look at some famous examples!

Case One: Working Together for Civil Rights

On December 1, 1955, in the American city of Montgomery, Alabama, a black woman named Rosa Parks got on a bus. At that time in Montgomery, buses were divided into two zones: one for black people and the other for white people. She took a seat in the black zone and ① watched quietly as more and more passengers got on the bus. Soon, ② all the seats in the white zone were taken. Then the driver ordered her to give her seat to a white passenger. Rosa Parks was a shy, mild-mannered introvert. She avoided standing out in public or ③ drew attention to herself. However, she had the courage ④ to resist injustice, so she answered calmly with a single word—"No." The furious driver called the police, and she ⑤ was arrested.

6 윗글을 읽고 답할 수 있는 질문으로 가장 적절한 것은?

① What kind of jobs do introverts have?
② How old was Rosa Parks?
③ Where did Rosa Parks go by bus?
④ How many people were on the bus?
⑤ Why was Rosa Parks arrested?

7 윗글의 (A)에 주어진 말을 알맞게 배열하시오.

8 윗글의 밑줄 친 ①~⑤ 중, 어법상 틀린 것은?

① ② ③ ④ ⑤

Parks's calm response to the situation impressed many people. Soon after, her quiet resistance came together with the inspirational speechmaking of Martin Luther King Jr. When 5,000 people assembled at a rally to support Parks's act of courage, King made a speech to the crowd. He was an extrovert—assertive, sociable, and good at motivating people. "There comes a time _____ people get tired of being trampled," he told them. "There comes a time _____ people get tired of being pushed out of the sunlight." King was an ⓐ amazed speaker, and his words filled the people with pride and hope. He then praised Parks's bravery and hugged her. She stood silently. Her mere presence was enough to strengthen the crowd.

9 윗글의 내용과 일치하는 것을 모두 고르시오.

① Parks는 많은 사람들에게 깊은 감명을 받았다.
② 5,000명의 사람들이 집회에 모였다.
③ Parks는 적극적이고 사교적이었다.
④ King의 말은 사람들을 희망으로 채웠다.
⑤ King은 군중들을 안아주었다.

10 윗글의 밑줄 친 ⓐ를 어법에 맞게 고쳐 쓰시오.

ⓐ amazed → _____

11 윗글의 빈칸에 공통으로 들어갈 말로 가장 적절한 것은?

① who ② when ③ where
④ what ⑤ which

Rosa Parks's act and Martin Luther King Jr.'s speech inspired Montgomery's black community (A) boycott / to boycott the buses, a crucial turning point in the struggle for civil rights. The boycott lasted for 381 days. It was a difficult time for everyone, but eventually the buses were integrated. 어떻게 이 두 사람의 동반자 관계가 이것을 이뤄 냈는지에 대해 생각해보라. A powerful speaker refusing (B) gave / to give up his seat on a bus would not have had the same effect. Similarly, Rosa Parks could not have (C) excite / excited the crowd at the rally with her words. When their introverted and extroverted traits were combined, however, his charisma attracted attention to her quiet bravery. In the end, this partnership had a huge impact on society.

12 (A), (B), (C)의 각 네모 안에서 어법에 맞는 표현으로 가장 적절한 것은?

	(A)	(B)	(C)
①	boycott	… gave	… excite
②	boycott	… to give	… excited
③	to boycott	… to give	… excite
④	to boycott	… to give	… excited
⑤	to boycott	… gave	… excited

13 윗글의 밑줄 친 우리말과 일치하도록 〈보기〉에 주어진 단어를 배열하여 문장을 완성하시오.

〈보기〉 these / accomplished / the / people / this / two / how / partnership / of

Think about _____
_____ .

Wozniak was a great inventor. When he partnered with Jobs, however, he was able to do much more. In fact, the two men formed one of the most famous partnerships of the digital era. Wozniak would come up with a clever engineering idea, and ⓐ his partner would find a way (A) to polish, package, and sell it.

The two men had opposite personalities. Wozniak hated small talk and often worked alone. It was these features of his introverted personality that enabled ⓑ him to focus on inventing things. ⓒ The other man, on the other hand, had outstanding social skills. According to Wozniak, ⓓ he was good at communicating with people. Wozniak was a shy inventor, whereas ⓔ Jobs was a daring entrepreneur, _____ they were alike in that neither was afraid to face challenges that seemed impossible.

14 윗글의 밑줄 친 ⓐ~ⓔ 중, 가리키는 대상이 나머지 넷과 다른 것은?

① ⓐ ② ⓑ ③ ⓒ ④ ⓓ ⑤ ⓔ

15 윗글의 밑줄 친 (A) to polish와 쓰임이 같은 것은?

① He was planning to travel to Prague.
② The company wants to enter the Asian market.
③ She finally had someone to talk to.
④ I awoke to find my pet sitting beside me.
⑤ They were disappointed to lose the final match.

1 다음 담화의 빈칸에 들어갈 말로 가장 적절한 것은?

Recently, a research team surveyed 50 high school students. The students were asked to name a positive effect of cultural diversity. The most common response was that cultural diversity helps us perceive the world more broadly. Twenty-one students said this was the reason why they enjoyed interacting with other cultures. The second-most common answer was getting to eat delicious foods from different countries. Next, there were ten students who said cultural diversity makes the community more dynamic. They said that where there are different cultures, there are more new things to see and do. Finally, six students think getting to experience various festivals is an advantage of cultural diversity. What is your opinion? Whatever it is, it is important to have an open mind and _____.

① to avoid others' advice
② to respect different cultures
③ to protect traditional culture
④ to accept other religions freely
⑤ to make others adopt our beliefs

[2~3] 다음 글을 읽고, 물음에 답하시오.

There have been many attempts ① to categorize people's personalities. One of the most common methods ② divide people into two types, introverts and extroverts. According to this division, introverts tend ③ to be drawn to the internal world of thoughts and feelings, while extroverts are drawn to the external world of people and activities. Introverts recharge their batteries by ④ spending some time alone; extroverts need ⑤ to recharge when they do not socialize enough.

2 윗글의 주제로 가장 적절한 것은?

① 외향적인 성격의 장단점
② 성격과 세계관의 상관 관계
③ 성격을 분류하는 다양한 방법
④ 충분한 휴식을 가져야 하는 이유
⑤ 외향적인 사람과 내향적인 사람의 특징

3 윗글의 밑줄 친 ①~⑤ 중, 어법상 틀린 것은?

① ② ③ ④ ⑤

[4~5] 다음 글을 읽고, 물음에 답하시오.

Extroverts are good at performing tasks under pressure and coping with multiple jobs ___(A)___ . Introverts, on the other hand, like to focus on one task at a time and can concentrate very well. Extroverts tend to do assignments quickly. ⓐ They make fast decisions and are comfortable with taking risks. Introverts often work more slowly and deliberately. ⓑ They think before they act, give up ___(B)___ easily, and work more accurately.

4 윗글의 빈칸 (A), (B)에 들어갈 말로 가장 적절한 것은?

	(A)		(B)
①	at once	⋯	less
②	at once	⋯	more
③	respectively	⋯	more
④	in turn	⋯	less
⑤	in turn	⋯	more

5 윗글의 밑줄 친 ⓐ, ⓑ가 지칭하는 것을 찾아 쓰시오.

ⓐ _____

ⓑ _____

(A) Basing / Based on all this information, you might think that introverts and extroverts do not get along. However, they actually work well together because their personalities complement each other. Sometimes they can even accomplish great things when they collaborate. Let's take a look at some famous examples!

Case One: Working Together for Civil Rights
On December 1, 1955, in the American city of Montgomery, Alabama, a black woman (B) naming / named Rosa Parks got on a bus. At that time in Montgomery, buses were divided into two zones: one for black people and the other for white people. She took a seat in the black zone and watched quietly as more and more passengers got on the bus. Soon, all the seats in the white zone were taken. Then the driver ordered her (C) giving / to give her seat to a white passenger. Rosa Parks was a shy, mild-mannered introvert. She avoided standing out in public or drawing attention to herself. However, 그녀는 불의에 저항할 용기가 있었다, so she answered calmly with a single word—"No." The furious driver called the police, and she was arrested.

6 (A), (B), (C)의 각 네모 안에서 어법에 맞는 표현으로 가장 적절한 것은?

	(A)		(B)		(C)
①	Basing	…	naming	…	giving
②	Basing	…	named	…	to give
③	Based	…	named	…	to give
④	Based	…	named	…	giving
⑤	Based	…	naming	…	giving

7 윗글의 밑줄 친 우리말과 일치하도록 주어진 단어를 이용하여 문장을 완성하시오.

(the courage, resist)

8 윗글의 내용과 일치하지 않는 것은?

① Introverts and extroverts can work well together.
② The bus was separated into two zones based on gender.
③ Every seat in the white zone got taken.
④ Rosa Parks was forced to give up her seat.
⑤ She refused to follow the driver's orders.

Parks's calm response to the situation impressed many people. Soon after, her quiet resistance came together with the inspirational speechmaking of Martin Luther King Jr. When 5,000 people assembled at a rally to support Parks's act of courage, King made a speech to the crowd. He was an extrovert—assertive, sociable, and good at motivating people. "There comes a time when people (A) get tired of being trampled," he told them. "There comes a time when people get tired of being pushed out of the sunlight." King was an amazing speaker, and his words filled the people with pride and hope. He then praised Parks's bravery and hugged her. She stood silently. Her mere presence was enough to strengthen the crowd.

9 윗글의 밑줄 친 (A)와 바꿔 쓸 수 있는 것은?

① get involved in ② bring out
③ make fun of ④ get sick of
⑤ look forward to

10 윗글에서 집회의 목적으로 가장 알맞은 것은?

① 모금 활동을 하기 위해
② Parks와 King이 더 많은 표를 얻기 위해
③ Parks의 행동을 지지하기 위해
④ Parks의 행동을 비판하기 위해
⑤ 사람들에게 연설가 King을 소개하기 위해

ⓐ little →　_____

ⓑ what →　_____

11 주어진 글 다음에 이어질 글의 순서로 가장 적절한 것은?

> Rosa Parks's act and Martin Luther King Jr.'s speech inspired Montgomery's black community to boycott the buses, a crucial turning point in the struggle for civil rights.

(A) When their introverted and extroverted traits were combined, however, his charisma attracted attention to her quiet bravery. In the end, this partnership had a huge impact on society.

(B) A powerful speaker refusing to give up his seat on a bus would not have had the same effect. Similarly, Rosa Parks could not have excited the crowd at the rally with her words.

(C) The boycott lasted for 381 days. It was a difficult time for everyone, but eventually the buses were integrated. Think about how the partnership of these two people accomplished this.

① (A) - (C) - (B)　　② (B) - (A) - (C)
③ (B) - (C) - (A)　　④ (C) - (A) - (B)
⑤ (C) - (B) - (A)

12 다음 글의 밑줄 친 ⓐ, ⓑ를 어법에 맞게 고쳐 쓰시오.

> On June 29, 1975, Steve Wozniak tapped a ⓐ little keys on his keyboard, and letters appeared on a screen. He had just created a personal computer that allowed people to type on a keyboard and see the results on a monitor simultaneously. At the sight of the brilliant device, Steve Jobs suggested to Wozniak ⓑ what they start a business.
>
> Wozniak was a great inventor. When he partnered with Jobs, however, he was able to do much more. In fact, the two men formed one of the most famous partnerships of the digital era. Wozniak would come up with a clever engineering idea, and Jobs would find a way to polish, package, and sell it.

[13~14] 다음 글을 읽고, 물음에 답하시오.

> The two men had ① similar personalities. Wozniak hated small talk and often worked alone. It was these features of his introverted personality that ② enabled him to focus on inventing things. Jobs, on the other hand, had outstanding social skills. According to Wozniak, he was good at communicating with people. Wozniak was a shy inventor, whereas Jobs was a ③ daring entrepreneur, but they were alike in that neither was afraid to face challenges that seemed impossible.
>
> So which personality type is better? Obviously, the answer is ④ neither. The world needs both introverts and extroverts, and they often make a ⑤ terrific team. 우리는 그저 우리 자신의 것뿐만 아니라 다른 성격들도 존중할 필요가 있다. Then, when we have a chance to work together, we might be able to do great things!

13 윗글의 밑줄 친 ①~⑤ 중, 문맥상 낱말의 쓰임이 적절하지 않은 것은?

①　　②　　③　　④　　⑤

14 윗글의 밑줄 친 우리말 뜻에 맞도록 〈보기〉에 주어진 말을 배열하여 문장을 완성하시오.

> 〈보기〉 personalities / need / our own / as well as/ respect / to / different

We simply _____

_____.

[1~2] 다음 대화를 읽고, 물음에 답하시오.

> W: Tell me about your problem.
> B: Well, I had a fight with my father.
> W: What happened?
> B: I was playing a computer game in my room when my dad came in to talk to me. It was a really important part of the game. So I said, "Not now, Dad!"
> W: How did your father react?
> B: He got upset. He said I play games too often. He even threatened to take away my computer.
> W: Do you think he overreacted to the situation?
> B: Yes. I had only been playing for half an hour.
> W: It is frustrating when your parents don't seem to understand you. _____(A)_____ , your father probably felt you were being disrespectful. In my opinion, you should _____(B)_____ . Explain why you acted that way and tell him how you want him to treat you.
> B: I see. Thank you.
> W: My pleasure. You're always welcome in the school counseling room.

1 위 대화의 빈칸 (A)에 들어갈 말로 가장 적절한 것은?

① However
② Otherwise
③ For instance
④ In general
⑤ Fortunately

2 위 대화의 빈칸 (B)에 들어갈 말로 가장 적절한 것은?

① not play computer games
② not threaten other people
③ try to understand your father
④ be respectful of the elderly all the time
⑤ talk with your father about the situation

[3~6] 다음 글을 읽고, 물음에 답하시오.

> Everybody is unique. However, there have been many attempts to categorize people's personalities. 가장 흔한 방법들 중 하나는 사람들을 내향적인 사람과 외향적인 사람 두 가지 유형들로 구분한다. (①) According to this division, introverts tend to be drawn to the internal world of thoughts and feelings, while extroverts are drawn to the external world of people and activities. (②) Introverts recharge their batteries by spending some time alone; extroverts need to recharge when they do not socialize enough.
> (③) Extroverts are good at performing tasks under pressure and coping with multiple jobs at once. (④) Extroverts tend to do assignments quickly. (⑤) They make fast decisions and are comfortable with taking risks. Introverts often work more slowly and deliberately. They think before they act, give up less easily, and work more accurately.

3 윗글의 밑줄 친 우리말과 일치하도록 주어진 단어를 이용하여 문장을 완성하시오. (필요 시 형태를 변형할 것)

_____ , introverts and extroverts.

(common, method, divide, type)

4 윗글의 흐름으로 보아, 주어진 문장이 들어가기에 가장 적절한 곳은?

> Introverts, on the other hand, like to focus on one task at a time and can concentrate very well.

① ② ③ ④ ⑤

5 윗글의 내용과 일치하지 <u>않는</u> 것은?

① 사람들의 성격을 분류하려는 시도가 있었다.
② 외향적인 사람들은 외적인 세계에 이끌린다.
③ 사교 활동을 충분히 하지 못했을 때 재충전이 필요한 사람이 있다.
④ 내향적인 사람들은 과제를 빨리 하는 경향이 있다.
⑤ 내향적인 사람들은 더 정확하게 일한다.

6 다음 영영 뜻풀이에 해당하는 단어를 윗글에서 찾아 쓰시오.

> to label as a type or put in a group, based on certain characteristics

[7~9] 다음 글을 읽고, 물음에 답하시오.

> Based on all this information, you might think that introverts and extroverts do not get along. 그러나 그들은 실제로 잘 협력하는데 그들의 성격이 서로를 보완하기 때문이다. Sometimes they can even accomplish great things when they ① <u>collaborate</u>. Let's take a look at some famous examples!
>
> Case One: Working Together for Civil Rights
> On December 1, 1955, in the American city of Montgomery, Alabama, a black woman named Rosa Parks got on a bus. At that time in Montgomery, buses were divided into two zones. One was for black people and _____ was for white people. She took a seat in the black zone and watched quietly as ② <u>more and more</u> passengers got on the bus. Soon, all the seats in the white zone were taken. Then the driver ③ <u>ordered</u> her to give her seat to a white passenger. Rosa Parks was a shy, mild-mannered introvert. She ④ <u>enjoyed</u> standing out in public or drawing attention to herself. However, she had the ⑤ <u>courage</u> to resist injustice, so she answered calmly with a single word—"No." The furious driver called the police, and she was arrested.

7 윗글의 밑줄 친 ①~⑤ 중, 문맥상 낱말의 쓰임이 적절하지 <u>않은</u> 것은?

① ② ③ ④ ⑤

8 윗글의 밑줄 친 우리말과 일치하도록 〈보기〉에 주어진 말을 배열하여 완성하시오.

> 〈보기〉 each other / together / because / complement / work well / their personalities

However, they actually _____

_____.

9 윗글의 빈칸에 들어갈 말로 가장 적절한 것은?

① other ② others
③ another ④ the other
⑤ the others

[10~11] 다음 글을 읽고, 물음에 답하시오.

> Parks's calm response to the situation ① <u>impressed</u> many people. Soon after, her quiet resistance came together with the inspirational speechmaking of Martin Luther King Jr. When 5,000 people assembled at a rally to support Parks's act of courage, King made a speech to the crowd. He was an extrovert—assertive, sociable, and good at motivating people. "There comes a time ② <u>when</u> people get tired of being trampled," he told them. "There comes a time when people get tired of ③ <u>being pushed</u> out of the sunlight." King was an amazing speaker, and his words filled the people with pride and hope. He then praised Parks's bravery and hugged her. She stood ④ <u>silently</u>. Her mere presence was ⑤ <u>to enough</u> strengthen the crowd.

10 윗글을 읽고 답할 수 없는 질문을 모두 고르시오.

① What was the purpose of the rally?
② What was King good at?
③ Where did the crowd gather?
④ What did Parks say after King's speech?
⑤ Who hugged Parks?

11 윗글의 밑줄 친 ①~⑤ 중, 어법상 틀린 것은?

① ② ③ ④ ⑤

[12~13] 다음 글을 읽고, 물음에 답하시오.

Rosa Parks's act and Martin Luther King Jr.'s speech inspired Montgomery's black community to boycott the buses, a crucial turning point in the struggle for civil rights. The boycott lasted for 381 days. It was a difficult time for everyone, but eventually the buses were integrated. Think about how the partnership of these two people accomplished this. A powerful speaker refusing to give up his seat on a bus would not have had the same effect. _____(A)_____, Rosa Parks could not have excited the crowd at the rally with her words. When their introverted and extroverted traits were combined, however, his charisma attracted attention to her quiet bravery. _____(B)_____, this partnership had a huge impact on society.

12 윗글의 빈칸 (A), (B)에 들어갈 말로 가장 적절한 것은?

	(A)		(B)
①	However	...	Finally
②	Similarly	...	Finally
③	Similarly	...	On the other hand
④	For example	...	Besides
⑤	For example	...	On the other hand

13 윗글의 밑줄 친 The boycott의 결과를 우리말로 쓰시오.
(10자 내외)

[14~15] 다음 글을 읽고, 물음에 답하시오.

On June 29, 1975, Steve Wozniak tapped a few keys on his keyboard, and letters appeared on a screen. He had just created a personal computer that allowed people ⓐ type on a keyboard and see the results on a monitor simultaneously. At the sight of the brilliant device, Steve Jobs suggested to Wozniak that they start a business.

Wozniak was a great inventor. When he partnered with Jobs, however, he was able to do much more. In fact, the two men formed one of the most famous partnerships of the digital era. Wozniak would _____, and Jobs would find a way ⓑ polish, package, and sell it.

14 윗글의 빈칸에 들어갈 말로 가장 적절한 것은?

① quit their partnership
② take others' advice
③ borrow some money
④ invest in old-fashioned device
⑤ come up with a clever engineering idea

15 윗글의 밑줄 친 ⓐ, ⓑ를 어법에 맞게 고쳐 쓰시오.

ⓐ type → _____

ⓑ polish → _____

1 다음 대화의 빈칸 (A)~(C)에 들어갈 말로 가장 적절한 것은?

B: Amy, you look concerned. What's wrong?

G: Actually, I'm having a little trouble with Dylan. He is mad at me.

B: That's too bad. _____(A)_____

G: He showed me his new shoes this morning, but they looked ridiculous to me.

B: _____(B)_____

G: As a matter of fact, I did. Who wears yellow shoes? They looked like huge bananas!

B: _____(C)_____ You should respect it. In my opinion, you should call Dylan right away and apologize to him.

G: Okay. I will.

〈보기〉

ⓐ What did you do?

ⓑ Everyone has their own taste.

ⓒ You didn't make fun of them, did you?

	(A)		(B)		(C)
①	ⓐ	…	ⓑ	…	ⓒ
②	ⓐ	…	ⓒ	…	ⓑ
③	ⓑ	…	ⓐ	…	ⓒ
④	ⓑ	…	ⓒ	…	ⓐ
⑤	ⓒ	…	ⓐ	…	ⓑ

[2~3] 다음 글을 읽고, 물음에 답하시오.

① Everybody is unique. ② However, there have been many attempts to categorize people's personalities. ③ One of the most common methods divides people into two types, introverts and extroverts. ④ According to this division, introverts tend to be drawn to the internal world of thoughts and feelings, while extroverts are drawn to the external world of people and activities. ⑤ Introverts recharge their batteries by spend some time alone; extroverts need to recharge when they do not socialize enough.

2 윗글의 내용과 일치하지 <u>않는</u> 것은?

① Everybody is not the same.

② Some try to divide people's personalities into categories.

③ Introverts tend to be interested in thoughts and feelings.

④ External activities appeal more to extroverts.

⑤ Extroverts need to spend some time alone to recharge.

3 윗글의 ①~⑤ 중, 어법상 <u>틀린</u> 표현이 있는 문장은?

① ② ③ ④ ⑤

[4~5] 다음 글을 읽고, 물음에 답하시오.

<u>외향적인 사람들은 압박감 속에서 일을 해내는 것과 여러 가지 일을 동시에 처리하는 것에 능하다.</u> Introverts, on the other hand, like to focus on one task at a time and can concentrate very well. Extroverts tend to do assignments quickly. They make (A) fast / slow decisions and are comfortable with taking risks. Introverts often work more slowly and deliberately. They think before they act, give up less easily, and work more (B) accurately / carelessly .

4 (A), (B)의 각 네모 안에서 문맥에 맞는 낱말을 골라 쓰시오.

(A) _____

(B) _____

5 윗글의 밑줄 친 우리말과 일치하도록 주어진 말을 이용하여 문장을 완성하시오. (필요 시 형태를 변형할 것)

and coping with multiple jobs at once.
(good, perform tasks, pressure)

[6~7] 다음 글을 읽고, 물음에 답하시오.

① On December 1, 1955, in the American city of Montgomery, Alabama, a black woman named Rosa Parks got on a bus. ② At that time in Montgomery, buses were divided into two zones: one for black people and the other for white people. ③ Some people had no money to pay their bus fare. ④ She took a seat in the black zone and watched quietly as more and more passengers got on the bus. ⑤ Soon, all the seats in the white zone were taken. Then the driver ordered her to give her seat to a white passenger. Rosa Parks was a shy, mild-mannered introvert. She avoided standing out in public or drawing attention to herself. However, she had the courage to resist injustice, so she answered calmly with a single word— "No." The furious driver called the police, and (A) she was arrested.

6 윗글의 밑줄 친 ①~⑤ 중, 전체 흐름과 관계 없는 문장은?

① ② ③ ④ ⑤

7 윗글의 밑줄 친 (A)의 이유로 가장 적절한 것은?

① 백인 승객과 다퉈서
② 승객들에게 화를 내서
③ 버스 기사에게 욕설을 해서
④ 버스 기사의 명령을 거절해서
⑤ 사람들 앞에 나서지 않아서

[8~10] 다음 글을 읽고, 물음에 답하시오.

① Parks's calm response to the situation impressed many people. Soon after, ② her quiet resistance came together with the inspirational speechmaking of Martin Luther King Jr. When 5,000 people assembled _____ a rally to support ③ Parks's act of courage, King made a speech to the crowd. He was an extrovert—assertive, sociable, and good _____ motivating people. "There comes a time when people get tired _____ being trampled," he told them. "There comes a time when people get tired _____ being pushed out of the sunlight." King was an amazing speaker, and his words filled the people _____ pride and hope. He then praised ④ Parks's bravery and hugged her. She stood silently. ⑤ Her mere presence was enough to strengthen the crowd.

8 윗글의 빈칸 어디에도 들어갈 수 없는 것을 모두 고르시오. (순서는 상관없음)

① at ② by ③ to ④ of ⑤ with

9 윗글의 밑줄 친 ①~⑤ 중, 의미하는 바가 다른 것은?

① ② ③ ④ ⑤

10 윗글의 내용과 일치하지 않는 것은?

① 사람들은 Parks의 반응에 깊은 인상을 받았다.
② King은 군중에게 연설을 했다.
③ King은 사교적인 사람이었다.
④ King은 Parks를 포용했다.
⑤ Parks의 말은 사람들에게 힘을 주었다.

11 다음 글의 내용을 한 문장으로 요약할 때, 빈칸 (A), (B)에 들어갈 말로 가장 적절한 것은?

Rosa Parks's act and Martin Luther King Jr.'s speech inspired Montgomery's black community to boycott the buses, a crucial turning point in the struggle for civil rights. The boycott lasted for 381 days. It was a difficult time for everyone, but eventually the buses were integrated. Think about how the partnership of these two people accomplished this. A powerful speaker refusing to give up his seat on a bus would not have had the same effect. Similarly, Rosa Parks could not have excited the crowd at the rally with her words.

↓

When Parks and King's introverted and extroverted traits were ____(A)____, this partnership had a huge ____(B)____ on society.

	(A)		(B)
①	combined	⋯	influence
②	combined	⋯	disaster
③	separated	⋯	influence
④	separated	⋯	disaster
⑤	added	⋯	damage

12 다음 글의 밑줄 친 ⓐ, ⓑ를 어법에 맞게 고쳐 쓰시오.

On June 29, 1975, Steve Wozniak tapped a few keys on his keyboard, and letters ⓐ were appeared on a screen. He had just created a personal computer that allowed people to type on a keyboard and see the results on a monitor simultaneously. At the sight of the brilliant device, Steve Jobs suggested to Wozniak that they ⓑ started a business.

ⓐ were appeared → _____

ⓑ started → _____

[13~15] 다음 글을 읽고, 물음에 답하시오.

The two men had opposite personalities. Wozniak hated small talk and often worked alone. It was these features of his introverted personality that enabled him to focus on inventing things. Jobs, on the other hand, had outstanding social skills. According to Wozniak, he was good at communicating with people. (①) Wozniak was a shy inventor, _____ Jobs was a daring entrepreneur, but they were alike in that neither was afraid to face challenges that seemed impossible.

(②) Obviously, the answer is neither. (③) The world needs both introverts and extroverts, and they often make a terrific team. (④) We simply need to respect different personalities as well as our own. (⑤) Then, when we have a chance to work together, we might be able to do great things!

13 윗글의 밑줄 친 문장을 우리말로 해석하시오.

14 윗글의 흐름으로 보아, 주어진 문장이 들어가기에 가장 적절한 곳은?

So which personality type is better?

① ② ③ ④ ⑤

15 윗글의 빈칸에 들어갈 말로 가장 적절한 것은?

① so ② if
③ whereas ④ since
⑤ as long as

1 다음 대화의 밑줄 친 ①~⑤ 중, 문맥상 낱말의 쓰임이 적절하지 <u>않은</u> 것은?

> G: Charlie, you look a little bit ① <u>upset</u>. What's up?
>
> B: Hi, Cindy. Bill got angry with me because I ② <u>posted</u> a picture on social media.
>
> G: What picture was that?
>
> B: It was just a picture of Bill and me taken in an amusement park.
>
> G: Is there something wrong with the picture?
>
> B: Nothing. Bill looks really ③ <u>handsome</u> in it, but he says he wants me to take it down.
>
> G: It seems he hates it when his pictures are made ④ <u>public</u>. In my opinion, you should ⑤ <u>upload</u> the picture.

① ② ③ ④ ⑤

[2~3] 다음 글을 읽고, 물음에 답하시오.

> Everybody is unique. ① However, there have been many attempts to categorize people's personalities. ② One of the most common methods divides people into two types, introverts and extroverts. ③ Some people distinguish personalities according to blood type. ④ According to this division, introverts tend to be drawn to the internal world of thoughts and feelings, (A) <u>while</u> extroverts are drawn to the external world of people and activities. ⑤ Introverts recharge their batteries by spending some time alone; extroverts need to recharge when they do not socialize enough.

2 윗글의 ①~⑤ 중, 전체 흐름과 관계 <u>없는</u> 문장은?

① ② ③ ④ ⑤

3 윗글의 밑줄 친 (A) while과 의미가 같은 것은?

① I need to relax for a while.
② Stop bothering me while I'm trying to study!
③ Some people like juice, while others don't.
④ He's eating while he uses a computer.
⑤ Please look after the baby while I'm away.

[4~5] 다음 글을 읽고, 물음에 답하시오.

> Extroverts are good at performing tasks under pressure and coping with multiple jobs 동시에. Introverts, on the other hand, like to focus on one task at a time and can concentrate very well. Extroverts tend to do assignments quickly. They make fast decisions and are comfortable with taking risks. Introverts often work more slowly and deliberately. They think before they act, give up less easily, and work more accurately.

4 윗글에 나온 외향적인 사람들의 특징을 〈보기〉에서 바르게 고른 것은?

> 〈보기〉
> ⓐ doing tasks quickly
> ⓑ giving up tasks less easily
> ⓒ thinking before doing something
> ⓓ focusing on a single task at one time

① ⓐ ② ⓐ, ⓒ ③ ⓑ, ⓒ ④ ⓑ, ⓓ ⑤ ⓒ

5 윗글의 밑줄 친 우리말을 주어진 글자로 시작하는 표현으로 쓰시오.

→ a＿＿＿＿＿＿ o＿＿＿＿＿＿

Based on all this information, you might think that introverts and extroverts do not get along. However, they actually work well together because their personalities complement each other. Sometimes they can even accomplish great things when they collaborate. Let's take a look at some famous examples!

Case One: Working Together for Civil Rights

On December 1, 1955, in the American city of Montgomery, Alabama, a black woman named Rosa Parks got on a bus. At that time in Montgomery, buses were divided into two zones: one for black people and the other for white people. She took a seat in the black zone and watched quietly as more and more passengers got on the bus. Soon, all the seats in the white zone were taken. Then the driver ordered her to give her seat to a white passenger. Rosa Parks was a shy, mild-mannered introvert. 그녀는 사람들 앞에서 두드러지거나 자신에게 관심이 집중되는 것을 피했다. However, she had the courage to resist injustice, so she answered calmly with a single word—"No." The furious driver called the police, and she was arrested.

6 윗글의 내용과 일치하지 않는 것은?

① 내향적인 사람과 외향적인 사람은 잘 협력한다.
② 몽고메리의 버스는 두 구역으로 나뉘어 있었다.
③ 백인 구역의 모든 좌석들이 찼다.
④ 기사는 Parks에게 좌석을 양보하라고 명령했다.
⑤ Parks는 불의에 저항할 수 없었다.

7 윗글의 밑줄 친 우리말과 일치하도록 〈보기〉에 주어진 말을 배열하여 문장을 완성하시오. (필요 시 형태를 변형할 것)

〈보기〉 or / to / stand out / draw / in / she / herself / public / attention / avoid

Parks's calm response to the situation impressed many people. Soon after, her quiet resistance came together with the inspirational speechmaking of Martin Luther King Jr. When 5,000 people assembled at a rally to support Parks's act of courage, King made a speech to the crowd. He was an extrovert—assertive, sociable, and good at ⓐ to motivate people. "There comes a time when people get tired of ⓑ trampling," he told them. "There comes a time when people get tired of being pushed out of the sunlight." King was an amazing speaker, and his words filled the people with pride and hope. He then praised Parks's bravery and hugged her. She stood silently. (A) Her mere presence was enough to strengthen the crowd.

8 윗글의 밑줄 친 (A)를 우리말로 해석하시오.

9 윗글의 밑줄 친 ⓐ, ⓑ를 어법에 맞게 고쳐 쓰시오.

ⓐ to motivate → _____

ⓑ trampling → _____

Rosa Parks's act and Martin Luther King Jr.'s speech inspired Montgomery's black community to boycott the buses, a crucial turning point in the struggle for civil rights. The boycott lasted for 381 days. It was a difficult time for everyone, but eventually the buses were integrated. Think about how the partnership of these two people accomplished this. A powerful speaker refusing to give up his seat on a bus

would not have had the same effect. Similarly, Rosa Parks could not have excited the crowd at the rally with her words. When their introverted and extroverted traits were combined, however, his charisma attracted attention to her quiet bravery. In the end, this partnership had a huge impact on society.

10 윗글을 읽고 답할 수 없는 질문을 모두 고르시오.

① What was the crucial turning point in the struggle for civil rights?
② How many days did the boycott last for?
③ What was the result of the boycott?
④ How were the buses divided?
⑤ What did King do after his speech?

11 다음 영영 뜻풀이에 해당하는 단어를 윗글에서 찾아 쓰시오.

a lack of fear in the face of danger

[12~13] 다음 글을 읽고, 물음에 답하시오.

On June 29, 1975, Steve Wozniak tapped a few keys on his keyboard, and letters appeared on a screen. He ① had just created a personal computer that allowed people to type on a keyboard and ② to see the results on a monitor simultaneously. At the sight of the brilliant device, Steve Jobs suggested to Wozniak that they start a business.

Wozniak was a great inventor. When he partnered with Jobs, however, he was able to do ③ much more. In fact, the two men formed one of the most famous ④ partnership of the digital era. Wozniak would _____ a clever engineering idea, and Jobs would find a way to polish, package, and ⑤ sell it.

12 윗글의 밑줄 친 ①~⑤ 중, 어법상 틀린 것은?

① ② ③ ④ ⑤

13 윗글의 빈칸에 들어갈 말로 가장 적절한 것은?

① turn over
② take care of
③ come up with
④ make fun of
⑤ look forward to

14 다음 글의 주제로 가장 적절한 것은?

The two men had opposite personalities. Wozniak hated small talk and often worked alone. It was these features of his introverted personality that enabled him to focus on inventing things. Jobs, on the other hand, had outstanding social skills. According to Wozniak, he was good at communicating with people. Wozniak was a shy inventor, whereas Jobs was a daring entrepreneur, but they were alike in that neither was afraid to face challenges that seemed impossible.

So which personality type is better? Obviously, the answer is neither. The world needs both introverts and extroverts, and they often make a terrific team. We simply need to respect different personalities as well as our own. Then, when we have a chance to work together, we might be able to do great things!

① 불가능해 보이는 것에 맞서라.
② 성격을 조금만 바꾸면 성공할 수 있다.
③ 내향적인 사람들은 변화가 필요하다.
④ 서로 다른 성격을 존중하고 협력해야 한다.
⑤ 외향적인 사람들은 도전을 두려워하지 않는다.

1 다음 글의 밑줄 친 우리말과 일치하도록 〈보기〉에 주어진 말을 배열하여 문장을 완성하시오.

Extroverts are good at performing tasks under pressure and coping with multiple jobs at once. Introverts, on the other hand, like to focus on one task at a time and can concentrate very well. Extroverts tend to do assignments quickly. 그들은 빠른 결정을 하며 위험을 감수하는 것을 편안해한다. Introverts often work more slowly and deliberately. They think before they act, give up less easily, and work more accurately.

〈보기〉 fast decisions / comfortable / taking / with / and / make / are / risks / they

2 다음 글에서 내향적인 사람과 외향적인 사람이 잘 협력하는 이유를 찾아 우리말로 쓰시오. (15자 내외)

Based on all this information, you might think that introverts and extroverts do not get along. However, they actually work well together because their personalities complement each other. Sometimes they can even accomplish great things when they collaborate. Let's take a look at some famous examples!

[3~4] 다음 글을 읽고, 물음에 답하시오.

On December 1, 1955, in the American city of Montgomery, Alabama, a black woman named Rosa Parks got on a bus. At that time in Montgomery, buses ⓐ (divide into) two zones: one for black people and the other for white people. She took a seat in the black zone and ⓑ (watch) quietly as more and more passengers got on the bus. Soon, all the seats in the white zone were taken. (A) Then the driver ordered her to give her seat to a white passenger. Rosa Parks was a shy, mild-mannered introvert. She avoided ⓒ (stand) out in public or drawing attention to herself. However, she had the courage ⓓ (resist) injustice, so she answered calmly with a single word—"No." The furious driver called the police, and she was arrested.

3 윗글에 주어진 ⓐ~ⓓ를 알맞은 형태로 쓰시오.

ⓐ _____

ⓑ _____

ⓒ _____

ⓓ _____

4 밑줄 친 (A)에 대한 Rosa Parks의 행동을 윗글에서 찾아 쓰시오.

5 다음 글의 밑줄 친 ⓐ~ⓕ 중, 어법상 틀린 것을 3개 찾아 바르게 고치고, 수정해야 하는 이유를 쓰시오. (단, 기호, 고친 것, 이유가 모두 맞을 때만 정답으로 인정함)

Parks's calm response to the situation ⓐ impressed many people. Soon after, her quiet resistance came together with the inspirational speechmaking of Martin Luther King Jr. When 5,000 people assembled at a rally ⓑ to support Parks's act of courage, King made a speech to the crowd. He was an extrovert—assertive, sociable, and good at ⓒ motivating people. "There comes a time ⓓ what people get tired of being trampled," he told them. "There comes a time when people get tired of ⓔ being push out of the sunlight." King was an amazing speaker, and his words filled the people with pride and hope. He then praised Parks's bravery and hugged her. She stood silently. Her mere presence was enough ⓕ strengthen the crowd.

	기호	고친 것	이유
(1)			
(2)			
(3)			

[6~7] 다음 글을 읽고, 물음에 답하시오.

On June 29, 1975, Steve Wozniak tapped a few keys on his keyboard, and letters appeared on a screen. He had just created a personal computer that allowed people ⓐ (type) on a keyboard and see the results on a monitor simultaneously. At the sight of the brilliant device, Steve Jobs suggested to Wozniak that they ⓑ (start) a business.

Wozniak was a great inventor. When he partnered with Jobs, however, he was able to do much more. 사실, 두 남자는 디지털 시대의 가장 유명한 동반자 관계들 중 하나를 형성했다. Wozniak would come up with a clever engineering idea, and Jobs would find a way ⓒ (polish), package, and sell it.

6 윗글에 주어진 ⓐ~ⓒ를 알맞은 형태로 쓰시오. (단, 고칠 필요가 없으면 그대로 쓸 것)

ⓐ type → _____

ⓑ start → _____

ⓒ polish → _____

7 윗글의 밑줄 친 우리말과 일치하도록 주어진 단어를 이용하여 문장을 완성하시오. (필요 시 형태를 변형할 것)

In fact, the two men _____

_____.

(form, famous, of the digital era)

8 다음 글의 밑줄 친 ⓐ~ⓔ 중, 어법상 <u>틀린</u> 것을 3개 찾아 바르게 고치시오. (단, 기호, 틀린 것, 고친 것이 모두 맞을 때만 정답으로 인정함)

The two men had opposite personalities. ⓐ <u>Wozniak hated small talk and often working alone.</u> ⓑ <u>It was these features of his introverted personality what enabled him to focus on inventing things.</u> ⓒ <u>Jobs, on the other hand, had outstanding social skills.</u> According to Wozniak, ⓓ <u>he was good at communicate with people.</u> Wozniak was a shy inventor, whereas Jobs was a daring entrepreneur, ⓔ <u>but they were alike in that neither was afraid to face challenges that seemed impossible.</u>

	기호	틀린 것 (틀린 부분만 쓸 것)	고친 것
(1)			
(2)			
(3)			

[9~10] 다음 글을 읽고, 물음에 답하시오.

So which personality type is better? (A) <u>Obviously, the answer is neither.</u> The world needs both introverts and extroverts, and they often make a terrific team. <u>우리는 그저 우리 자신의 것뿐만 아니라 다른 성격들도 존중할 필요가 있다.</u> Then, when we have a chance to work together, we might be able to do great things!

9 윗글의 밑줄 친 (A)를 우리말로 해석하시오.

10 윗글의 밑줄 친 우리말과 일치하도록 〈보기〉에 주어진 말을 배열하여 문장을 완성하시오.

〈보기〉 our / as well as / need / different respect / personality / own

〈조건〉
• 필요 시 문맥과 어법에 맞게 어휘를 변형할 것
• 주어진 단어 이외의 필요한 단어 1개를 추가하여 문장을 완성할 것

We simply _____

_____ .

We Are All Connected

Words

- [] endangered 형 (동식물이) 멸종 위기에 처한
- [] species 명 종(생물 분류의 기초 단위)
- [] despite 전 ~에도 불구하고 (= in spite of)
- [] dominant 형 지배적인, 우세한
- [] predator 명 포식자
- [] habitat 명 서식지
 - habitable 형 살 수 있는, 거주할 수 있는
- [] ancient 형 고대의 (↔ modern)
- [] encounter 동 접하다, 마주치다
- [] worship 동 숭배하다
- [] depict 동 (그림으로) 그리다, 묘사하다
- [] shrink 동 줄어들다
- [] illegal 형 불법적인 (↔ legal)
- [] decrease 명 감소 (↔ increase)
- [] estimate 동 추산[추정]하다
- [] approximately 부 대략
- [] subspecies 명 아종(亞種)
- [] extinct 형 멸종된
 - extinction 명 멸종, 사멸
- [] predict 동 예측[예견]하다 (= foresee)
- [] interconnected 형 상호 연결된
- [] maintain 동 유지하다
 - maintenance 명 유지, 지속
- [] boar 명 멧돼지
- [] vegetation 명 초목

- [] affect 동 영향을 끼치다 (= influence, have an effect on)
- [] exception 명 예외
 - except 전 ~을 제외하고는
- [] threaten 동 위협하다
 - threat 명 위협, 협박
- [] ecological 형 생태학의
 - ecology 명 생태학, 생태계
- [] term 명 용어
- [] conserve 동 보존하다 (= preserve)
 - conservation 명 보존, 보호
- [] obvious 형 명백한 (= clear) (↔ ambiguous)
- [] require 동 필요로 하다
- [] electricity 명 전기
- [] fossil fuel 화석 연료
- [] carbon dioxide 이산화탄소
- [] release 동 배출[방출]하다
- [] climate change 기후 변화
- [] inhabit 동 서식[거주]하다
- [] instant 형 인스턴트의
- [] plantation 명 대농장
- [] sustainable 형 (환경 파괴 없이) 지속 가능한
 - sustain 동 보유하다, 유지하다
- [] volunteer 동 자원봉사로 하다
- [] nonprofit 형 비영리의
- [] organization 명 조직, 단체

Phrases

- [] prey on ~을 잡아먹다
- [] run out of ~이 없어지다, 떨어지다
- [] rely on ~에 의존하다
- [] make an effort 노력하다

- [] refer to ~을 나타내다
- [] contribute to ~의 원인이 되다
- [] wipe out ~을 완전히 파괴하다, 없애 버리다

Vocabulary Check-Up

다음 영어는 우리말로, 우리말은 영어로 쓰시오.

01 species (명) _____

02 carbon dioxide _____

03 wipe out _____

04 dominant (형) _____

05 obvious (형) _____

06 contribute to _____

07 conserve (동) _____

08 term (명) _____

09 refer to _____

10 ecological (형) _____

11 threaten (동) _____

12 make an effort _____

13 affect (동) _____

14 vegetation (명) _____

15 maintain (동) _____

16 interconnected (형) _____

17 subspecies (명) _____

18 endangered (형) _____

19 shrink (동) _____

20 encounter (동) _____

21 habitat (명) _____

22 despite (전) _____

23 (형) 불법적인 _____

24 (동) (그림으로) 그리다, 묘사하다 _____

25 (동) 숭배하다 _____

26 (명) 조직, 단체 _____

27 (동) 예측[예견]하다 _____

28 (동) 자원봉사로 하다 _____

29 ~에 의존하다 _____

30 (동) 배출[방출]하다 _____

31 (명) 대농장 _____

32 (동) 서식[거주]하다 _____

33 ~이 없어지다, 떨어지다 _____

34 기후 변화 _____

35 (형) (환경 파괴 없이) 지속 가능한 _____

36 화석 연료 _____

37 ~을 잡아먹다 _____

38 (명) 전기 _____

39 (명) 예외 _____

40 (명) 포식자 _____

41 (형) 비영리의 _____

42 (형) 멸종된 _____

43 (동) 추산[추정]하다 _____

44 (명) 감소 _____

 예제 ▶ **While talking** with the engineer, Eva tried to improve the quality of the power supply.
기술자와 대화하는 동안, Eva는 전력 공급의 질을 향상시키도록 노력했다.

교과서 ▶ Imagine how ancient people must have felt **when encountering** tigers in the wild!
고대인들이 야생에서 호랑이와 마주쳤을 때 어떻게 느꼈을지 상상해 보십시오!

--

▶ 「시간을 나타내는 접속사 when, while 등이 이끄는 부사절의 주어가 주절의 주어와 같고 동사가 be동사일 때, 부사절의 「주어 + be동사」는 종종 생략된다. 따라서, 부사절은 「접속사 + 분사」, 「접속사 + 형용사」, 「접속사 + 전치사(구)」로 시작할 수 있다.

내신출제 Point

 Test Point 1 「접속사 + 분사」, 「접속사 + 형용사」, 「접속사 + 전치사(구)」로 시작하는 부사절

While throwing the dice, he looked at the game board. 주사위를 던지면서, 그는 게임판을 보았다.
▶ 「접속사 + 현재분사」의 형태로, While 뒤에 he was가 생략됨

When sad, she pretended to be cheerful. 슬플 때, 그녀는 명랑한 척을 했다.
▶ 「접속사 + 형용사」의 형태로, When 뒤에 she was가 생략됨

My friend and I study best **when at the library**.
내 친구와 나는 도서관에 있을 때 공부를 가장 열심히 한다.
▶ 「접속사 + 전치사구」의 형태로, when 뒤에 we[my friend and I are]가 생략됨

 Test Point 2 조건 · 양보를 나타내는 부사절에서의 생략

if, unless, though, although 등 조건이나 양보를 나타내는 접속사가 이끄는 부사절의 「주어 + be동사」도 생략 가능하다.
Though sick, he went to school as usual. 아팠지만, 그는 평상시처럼 학교에 갔다.
▶ 양보의 접속사 Though 뒤에 he was가 생략됨

Point Check-Up

정답 및 해설 p.15

1 다음 문장에서 생략 가능한 부분에 밑줄 치고, 없다면 X를 쓰시오.

(1) While my aunt was waiting in line for a hamburger, I tried to get Wi-Fi.

(2) While you are doing the laundry, you should not forget to add some soap.

(3) Though they were hungry, they didn't eat anything after a late lunch.

예제 ▶ He acted **as if** he **were** my boss.
그는 마치 그가 나의 상사인 것처럼 행동했다.

교과서 ▶ As a result, the other species that share this habitat, including trees and insects, are protected too, **as if** there **were** a large umbrella being held over them.
결과적으로, 나무와 곤충을 포함해 이 서식지를 공유하는 다른 종들도 마치 그들 위에 큰 우산이 씌워져 있는 것처럼 보호를 받게 됩니다.

▶ 「as if+주어+동사의 과거형」은 주절의 시점과 같은 때의 사실과 반대되거나 사실일 가능성이 희박한 일을 가정할 때 사용하며, '(실제로 그렇지 않지만) 마치 ~인 것처럼'이라는 의미를 나타낸다.

내신출제 Point

 직설법과 가정법의 구분

직설법은 as if가 이끄는 절의 내용이 사실인지 가정인지 불확실한 경우에 사용하며, as if절의 동사를 현재 시제로 쓴다.

They look **as if** they **are** angry at me. 그들은 내게 화난 것처럼 보인다.
↳ 동사의 현재형

▶ 직설법: 화났을 수도 있는 경우

They look **as if** they **were** angry at me. 그들은 (화나지 않았지만) 마치 내게 화난 것처럼 보인다.
↳ 동사의 과거형

▶ 가정법: 실제로는 화나지 않은 경우

He talks **as if** he [is / were] not a thief. The police officer is not sure whether he is a thief yet. 그는 마치 그가 도둑이 아닌 것처럼 말한다. 경찰은 그가 도둑인지 아직 확신하지 못한다.

▶ 직설법: 이어지는 문장으로 보아, 그가 도둑인지 아닌지 불확실함

It seemed **as if** she [reads / read] people's minds. In fact, she didn't read people's minds.
그녀가 마치 사람들의 마음을 읽는 것처럼 보였다. 사실, 그녀는 사람들의 마음을 읽지 못했다.

▶ 가정법: 이어지는 문장으로 보아, 실제로 그녀가 사람들의 마음을 읽지 못했던 것이 확실함

Point Check-Up

정답 및 해설 p.15

2 다음 네모 안에서 어법상 알맞은 것을 고르시오.

(1) The statue looked as if it [is / were] alive.

(2) Stop looking at me as if I [had / have had] the answer to the question.

(3) She treats me as if she [is / were] older than me. But I don't know if she is older than me.

01 다음 문장에서 생략된 부분을 찾아 쓰시오.

(1) Although sick, my brother participated in the marathon.

(2) While traveling in Europe, she met many people from different countries.

(3) When in the theater, I turn off my cell phone and concentrate on the movie.

02 다음 괄호 안에 단어를 바르게 배열하여 문장을 완성하시오.

(1) _____, she spent most of her time in Seoul.
(Korea / while / staying / in).

(2) My sister sometimes behaves _____.
(if / mother / were / as / my / she).

(3) He talks _____ on new technology.
(an / expert / as / he / if / were).

03 다음 보기 에서 적절한 단어를 골라 빈칸에 알맞은 형태로 고쳐 쓰시오.

보기	cry	wash	know	announce

(1) While _____ loudly, the baby crawled towards a young woman.

(2) Tom talks as if he _____ a lot of actors personally, but he doesn't.

(3) When _____ the dishes, you should wear rubber gloves to protect your skin.

04 주어진 우리말과 일치하도록 as if를 이용하여 문장을 완성하시오.

(1) Helen은 부자인 것처럼 보인다. 사실, 아무도 그녀가 부자인지 아닌지 모른다.

Helen looks _____. In fact, nobody
knows whether she is rich or not.

(2) Kevin은 이 프로젝트에 관련이 있는 것처럼 행동한다. 사실, 그는 이 프로젝트에 관련이 없다.

Kevin acts _____ in this project.
In fact, he isn't involved in this project.

(3) 그 웨이터는 그것이 거기에 없는 것처럼 테이블을 지나쳐 갔다. 사실, 그것은 거기에 있었다.

The waiter walked past the table _____.
In fact, it was there.

05 빈칸 (A), (B), (C)에 들어갈 말로 가장 적절한 것은? (교과서 p.77)

> **Baked Pork Chops Recipe**
> <u>Ingredients</u>: boneless pork chops, olive oil, garlic, salt, pepper
> <u>Instructions</u>: Preheat the oven to 350 degrees. While you are ____(A)____ for your oven to heat up, smash the garlic and mix it with the olive oil. Put the mixture in an oven-safe pan. Add the trimmed pork chops to the mixture. Season the pork chops with some salt and pepper. When ____(B)____, make sure you don't use too much salt. Bake them for 25 minutes, turning the chops twice while ____(C)____.

	(A)		(B)		(C)			(A)		(B)		(C)
①	wait	…	to season	…	cooking		②	wait	…	seasoning	…	cook
③	waiting	…	to season	…	cook		④	waiting	…	seasoning	…	cook
⑤	waiting	…	seasoning	…	cooking							

06 다음 괄호 안의 단어를 바르게 배열하여 문장을 완성하시오. (교과서 p.77)

> **jay95:** Did you have an argument with David?
> **kw_lee:** No, I just get annoyed with him sometimes. He talks (1) (if / knew / he / as / everything).
> **jay95:** What were you guys talking about?
> **kw_lee:** It was related to our homework. He kept explaining the problems to me (2) (do / as / I / to / know / how / didn't / if) them myself.
> **jay95:** Oh. I guess that's just his personality.
> **kw_lee:** Yeah. Anyway, we're fine now.

(1) _____

(2) _____

07 다음 중 어법상 <u>틀린</u> 것으로 바르게 짝지어진 것은?

> ⓐ John looks as if he were happy, but he's actually sad.
> ⓑ He is an adult. You shouldn't speak to him as if he is a child.
> ⓒ While talking on the phone, I heard the doorbell ring.
> ⓓ The old photographs make him feel as if he were in the past.
> ⓔ Though was angry, she pretended that she was fine.

① ⓐ, ⓒ ② ⓐ, ⓓ ③ ⓑ, ⓒ ④ ⓑ, ⓔ ⑤ ⓑ, ⓓ, ⓔ

TURN OFF THE LIGHTS AND SAVE A TIGER

01 You can protect tigers simply by switching off the lights.
by v-ing: ~함으로써

단지 불을 끄는 것만으로도 당신은 호랑이를 보호할 수 있습니다.

02 This may sound strange, but it is actually true.
= 앞 문장 전체

이것이 이상하게 들릴지도 모르겠지만, 그것은 정말로 사실입니다.

03 help + (목적어) + 동사원형: (~가) …하는 것을 돕다

An everyday action [that helps us save energy] can also help save an endangered species.
주격 관계대명사절

How does this work? Let's take a look.
작용하다

우리가 에너지를 아끼는 데 도움이 되는 일상적인 행동이 멸종 위기에 처한 동물을 구하는 데에도 도움을 줄 수 있습니다. 이것이 어떻게 작용하는 것일까요? 같이 한번 보도록 하겠습니다.

A SPECIES IN DANGER 위험에 빠진 종

04 one of the + 최상급 + 복수명사: 가장 ~한 … 중 하나

Tigers, one of the world's largest feline species, have long been the kings of Asia's forests.
= 현재완료

세계에서 가장 큰 고양잇과 동물 중 하나인 호랑이는 오랫동안 아시아 숲의 왕이었습니다.

05 Despite [being the dominant predators of their habitats], they move silently and remain unseen
~에도 불구하고 동명사구 (전치사 Despite의 목적어) 주어 동사1 동사2 보어
(계속 ~한 상태이다)
most of the time.

그들의 서식지에서 지배적인 포식자임에도 불구하고, 그들은 조용히 움직이며 대부분의 시간을 눈에 띄지 않는 상태로 지냅니다.

06 must have v-ed: ~했음이 틀림없다

Imagine [how ancient people must have felt when encountering tigers in the wild]!
간접의문문 (「의문사 + 주어 + 동사」의 어순) they were

고대인들이 야생에서 호랑이와 마주쳤을 때 어떻게 느꼈을지 상상해 보십시오!

07 It is no surprise [that tigers have been feared and worshipped by humans for centuries],
가주어 〈It〉 진주어 〈that절〉
standing as symbols of power and courage.
분사구문 〈이유〉

힘과 용기의 상징으로 존재하여, 호랑이가 수 세기 동안 인간에게 두려움과 숭배의 대상이었던 것은 그리 놀라운 일이 아닙니다.

08

The fact that ancient rock paintings feature images of tigers shows [how closely tigers have
주어 └ = ┘ 동사 간접의문문 (shows의 목적어)

been related to humans throughout history].

고대 암각화에 호랑이의 모습이 그려져 있다는 사실은 역사에 걸쳐서 호랑이가 인간과 얼마나 밀접하게 관련되어 있는지를 보여줍니다.

09

At one time, tigers were found all across Asia, from Korea to Turkey. However, the world's tiger
수동태 from A to B: A에서 B까지

population has been shrinking rapidly.
현재완료 진행형 「have[has] been v-ing」

한때 호랑이는 한국에서 터키에 이르는 아시아 전역에서 발견되었습니다. 하지만 전 세계의 호랑이 수는 급격히 감소하고 있습니다.

10

Illegal hunting and habitat loss are the main reasons behind this decrease. At the start of the
주어 동사

20th century, it was estimated [that there were approximately 100,000 wild tigers].
가주어 〈it〉 진주어 〈that절〉 대략

불법 사냥과 서식지 상실이 이러한 (개체 수) 감소의 주요 원인입니다. 20세기 초에는, 약 10만 마리의 야생 호랑이가 있었던 것으로 추정되었습니다.

11

In recent years, however, [three of the nine subspecies of tigers] have become extinct.
주어 동사 (현재완료)

그러나 최근 몇 년간 9개의 호랑이 아종(亞種) 중 3개의 종은 멸종되었습니다.

12

In fact, it is now estimated [that there are fewer than 4,000 tigers living in the wild].
가주어 〈it〉 진주어 〈that절〉 ↑ └──┘ 현재분사구

실제로 현재는 야생에서 사는 호랑이가 4,000마리 미만인 것으로 추정됩니다.

13

Some experts even predict [that the last of the world's wild tigers will disappear within the
명사절 (predict의 목적어)

next 10 years].

어떤 전문가들은 심지어 전 세계의 마지막 야생 호랑이가 향후 10년 안에 사라질 것으로 예상합니다.

OUR INTERCONNECTED WORLD 서로 연결된 우리 세상

14

It would be very sad if there were no more wild tigers.
가정법 과거 「주어+조동사의 과거형+동사원형 … if+주어+동사의 과거형」

만약 야생 호랑이가 더는 존재하지 않는다면 매우 슬플 것입니다.

15

Would it really matter, though? After all, we could still see them in zoos or watch programs
주어 동사1 could 동사2

about them on TV.

그런데 그게 정말로 중요한 일일까요? 어쨌든, 우리는 여전히 그들을 동물원에서 보거나, TV에서 그들에 관한 프로그램을 시청할 수 있으니까요.

16 Shouldn't we be more worried about [protecting human beings]?
　　　　　　　　　~에 대해 걱정하다　　　　　　　동명사구 (전치사 about의 목적어)

우리는 인간을 보호하는 것에 대해 더 걱정해야 하는 것 아닐까요?

17 The fact is, however, [that we need to protect tigers in order to protect ourselves]. This is
　　　　　　　　　　　　명사절 (주격 보어)　　　　　　　　in order to-v: ~하기 위하여　　　　이것은 ~이기 때문이다
because all of Earth's species are interconnected.
　　　　　　　　　　　　　　　　　　상호 연결된

그러나 사실은 우리 자신을 보호하기 위해 우리는 호랑이를 보호할 필요가 있습니다. 이것은 지구의 모든 종이 서로 연결되어
있기 때문입니다.

18 Think about [what would happen if tigers became extinct].
　　　　　명사절
　　　　　　　　　　가정법 과거

호랑이가 멸종된다면 어떤 일이 일어날지 생각해 보십시오.

19 [Existing at the top of the food chain], they maintain the populations of animals [they prey on],
　　　분사구문 〈동시동작〉　　　　　　　　　　　= tigers　　　　　　　　　　　　　which[that]
　　　　　　　　　　　　　　　　　　　　　　　　　　　　　　　　　　　　　　↑　　　목적격 관계대명사절
such as deer and boar.

그들은 먹이 사슬의 정점에 존재하며 사슴과 멧돼지같이 그들이 잡아먹는 동물들의 개체 수를 유지합니다.

20 = If it were not for ~, But for ~
Without tigers, these species would rapidly increase in number. As a result, their food source,
가정법 과거 「Without ~, 주어＋조동사의 과거형＋동사원형」: ~이 없다면, …할 텐데
vegetation, would begin to disappear.

호랑이가 없다면, 이러한 종들의 수가 급격히 증가할 것입니다. 그 결과로, 그들의 먹이인 초목이 사라지기 시작할 것입니다.

21 This would cause birds and insects to lose their homes, and bigger animals [that prey on them]
　　　　　　cause＋목적어＋to-v: ~가 …하는 것을 야기하다[초래하다]　　　　　　　= birds and insects
　　　　　　　　　　　　　　　　　　　　　　　　　　　　　　　　　↑　　　주격 관계대명사절
would soon run out of food. Eventually, the entire ecosystem would be affected.
　　　　　~이 없어지다, 떨어지다

이것은 새들과 곤충들이 그들의 집을 잃는 사태를 일으킬 것이고, 그것들을 잡아먹는 더 큰 동물들은 곧 먹이가 바닥나게 될
것입니다. 결국, 생태계 전체가 영향을 받게 될 것입니다.

22 Humans are no exception, as we rely on nature for everything [we need to survive, including
　　　　　　　　　　　　　　　~ 때문에 (접속사)　　　　　　　　　　　　　　　　that　　목적격 관계대명사절
air, food, and water].

인간도 예외가 아닌데, 우리는 공기, 음식 그리고 물을 포함하여 살아가는 데 필요한 모든 것을 자연에 의존하고 있기 때문입
니다.

23 This is [how the disappearance of a single species can threaten the whole planet].
　　　　관계부사절

이렇게 해서 하나의 종이 사라지는 것이 지구 전체를 위협할 수도 있는 것입니다.

24

명사절
Now imagine [what would happen if we made the effort to save tigers].
가정법 과거 부사적 용법 〈목적〉

이제 우리가 호랑이를 보호하기 위해 노력한다면 어떤 일이 일어날지 상상해 보십시오.

25

Tigers are considered an "umbrella species." This is an ecological term [referring to species [that
현재분사구 주격
live in a large area containing a variety of different ecosystems]].
현재분사구 관계대명사절

호랑이는 '우산종'으로 여겨집니다. 이것은 서로 다른 다양한 생태계를 포함하는 넓은 지역에 사는 종을 일컫는 생태학적 용어입니다.

26

If we choose [to protect these species], we must conserve their habitat.
명사적 용법 (choose의 목적어)

만약 우리가 이러한 종들을 보호하기로 결정한다면, 우리는 그들의 서식지를 보호해야만 합니다.

27

주격 관계대명사절
As a result, the other species [that share this habitat], including trees and insects, are protected
주어 현재분사구 〈삽입어구〉 동사
too, [as if there were a large umbrella [being held over them]].
가정법 과거 「as if+주어+동사의 과거형」: 마치 ~인 것처럼 현재분사구

결과적으로, 나무와 곤충을 포함해 이 서식지를 공유하는 다른 종들도 마치 그들 위에 큰 우산이 씌워져 있는 것처럼 보호를 받게 됩니다.

SMALL EFFORTS WITH BIG RESULTS 작은 노력으로 큰 결과를

28

Now, it is obvious [that we must protect tigers].
가주어 〈it〉 진주어 〈that절〉

이제, 우리가 호랑이를 보호해야만 한다는 것은 명백합니다.

29

You may, however, still wonder [how switching off the lights helps].
간접의문문 (wonder의 목적어)

하지만 당신은 아마 불을 끄는 일이 어떻게 도움이 되는지가 여전히 궁금할 것입니다.

30

Well, the lights in our homes require electricity, and [more than half of the world's electricity]
주어 동사 주어 셀 수 없는 명사
is created by burning fossil fuels.
동사 (수동태) by v-ing: ~함으로써

그러니까, 우리의 집에 있는 불은 전기를 필요로 하고, 전 세계 전기의 절반 이상은 화석 연료를 태움으로써 만들어집니다.

31 When fossil fuels are burned, carbon dioxide is released into the air, and this contributes to
<u>수동태</u> ~의 원인이 되다
climate change.

화석 연료가 탈 때 이산화탄소가 공기 중으로 배출되는데, 이것은 기후 변화의 원인이 됩니다.

32 Climate change has a number of negative effects, including rising sea levels [that threaten
현재분사
a number of+복수명사: 많은 ~ 주격 관계대명사절
many parts of the world].

기후 변화는 세계의 많은 지역에 위협을 가하는 해수면 상승을 포함하여 많은 부정적인 영향을 미칩니다.

33 [One of these places], called the Sundarbans, is an area on the coast of Bangladesh [inhabited
주어 (단수) 과거분사구 〈삽입어구〉 동사 과거분사구
by a large number of tigers].

이러한 지역 중 한 곳은 순다르반스(Sundarbans)라는, 다수의 호랑이가 서식하는 방글라데시의 해안에 있는 지역입니다.

34 If Earth's oceans continue to rise, this area could be wiped out and its tiger population
wipe out: ~을 완전히 파괴하다, 없애버리다
could be reduced by as much as 96%.
~만큼이나

만약 지구의 해수가 계속 상승한다면, 이 지역은 완전히 파괴될 수 있고 그곳의 호랑이 개체 수는 96%만큼이나 감소할 수 있습니다.

35 By conserving energy, however, we can slow climate change, and this will slow the rise of the
by v-ing: ~함으로써
oceans.

하지만 에너지를 아낌으로써 우리는 기후 변화를 늦출 수 있고, 이것은 해수의 상승을 늦출 것입니다.

36 So keep switching off the lights whenever you're the last person [to leave a room]!
keep v-ing: 계속해서 ~하다 ~할 때는 언제든지 형용사적 용법

그러므로 당신이 방을 나가는 마지막 사람일 때마다 계속 불을 끄도록 하십시오!

37 You can also protect tigers [when shopping].
you are

당신은 또한 장을 볼 때도 호랑이를 보호할 수 있습니다.

38 Many popular products, including chocolate, instant noodles, and soap, are made with palm
주어 〈삽입어구〉 동사
oil.

초콜릿, 라면, 그리고 비누를 포함해서 많은 대중적인 제품들은 팜유로 만들어집니다.

39

= in which

Unfortunately, forests [where tigers live] are being destroyed to build more and more palm oil

 ↑━━━┘ 관계부사절 진행형 수동태 「be동사+being+v-ed」 비교급+and+비교급: 점점 더 ~한

plantations.

불행하게도, 호랑이들이 사는 숲이 점점 더 많은 팜유 농장을 짓기 위해 파괴되고 있습니다.

40

 주격 관계대명사절

Some palm oil, however, is produced in a more sustainable way. Products [that use this

 수동태 지속 가능한 주어 ↑━┘

environmentally friendly palm oil] usually have a special mark on the label.

 동사

하지만 어떤 팜유들은 (환경 파괴 없이) 보다 지속 가능한 방식으로 생산됩니다. 이러한 환경친화적인 팜유를 사용한 제품들은
보통 상표에 특별한 표시가 되어 있습니다.

41

 = a special mark

Look for it the next time you go shopping!

 the next time+주어+동사: 다음에 ~할 때

다음에 장을 보러 갈 때 그것을 찾아보세요!

GET INVOLVED 참여하세요

42

 which[that]

There are many other things [you can do to protect tigers and other endangered species].

 ↑━┘ 목적격 관계대명사절 부사적 용법 〈목적〉

호랑이와 다른 멸종 위기의 종들을 보호하기 위해 당신이 할 수 있는 다른 많은 일이 있습니다.

43

You could volunteer at a nonprofit organization or share important information on social

주어 동사1 could 동사2

networking sites.

당신은 비영리 단체에서 봉사활동을 하거나 소셜 네트워킹 사이트(SNS)에 중요한 정보를 공유할 수도 있습니다.

44

However small your actions may seem, they can help make a big difference.

however+형용사+주어+동사: 아무리 ~할지라도 =no matter how+형용사+주어+동사

당신의 활동이 아무리 사소한 것처럼 보일지라도, 그것들은 큰 변화를 만드는 데 도움이 될 수 있습니다.

45

Most importantly, you must remember [that we all share the same planet].

 명사절 (remember의 목적어)

무엇보다 중요한 것은, 우리 모두가 같은 지구를 공유하고 있다는 사실을 기억해야 한다는 것입니다.

46

If a single species disappears, every other living creature, including human beings, could be

 〈삽입어구〉

affected.

만약 하나의 종이 사라지면, 인간을 포함한 다른 모든 살아 있는 생명체가 영향을 받을 것입니다.

다음 빈칸을 채우시오.

You can protect tigers simply (1) _____ _____ _____ the lights.

단지 불을 끄는 것만으로도 당신은 호랑이를 보호할 수 있습니다.

This may sound strange, but it is actually true. An everyday action that (2) _____ _____ _____ _____ can also help save an endangered species.

이것이 이상하게 들릴지도 모르겠지만, 그것은 정말로 사실입니다. 우리가 에너지를 아끼는 데 도움이 되는 일상적인 행동이 멸종 위기에 처한 동물을 구하는 데에도 도움을 줄 수 있습니다.

(3) _____ _____ _____ _____? Let's take a look.

이것이 어떻게 작용하는 것일까요? 같이 한번 보도록 하겠습니다.

Tigers, (4) _____ _____ _____ _____ _____ feline species, have long been the kings of Asia's forests.

세계에서 가장 큰 고양잇과 동물 중 하나인 호랑이는 오랫동안 아시아 숲의 왕이었습니다.

Despite being the dominant predators of their habitats, they (5) _____ _____ _____ _____ most of the time.

그들의 서식지에서 지배적인 포식자임에도 불구하고, 그들은 조용히 움직이며 대부분의 시간을 눈에 띄지 않는 상태로 지냅니다.

(6) _____ _____ _____ _____ must have felt when encountering tigers in the wild!

고대인들이 야생에서 호랑이와 마주쳤을 때 어떻게 느꼈을지 상상해 보십시오!

(7) _____ _____ _____ _____ _____ tigers have been feared and worshipped by humans for centuries, standing as symbols of power and courage.

힘과 용기의 상징으로 존재하여, 호랑이가 수 세기 동안 인간에게 두려움과 숭배의 대상이었던 것은 그리 놀라운 일이 아닙니다.

(8) _____ _____ _____ ancient rock paintings feature images of tigers shows how closely tigers have been related to humans throughout history.

고대 암각화에 호랑이의 모습이 그려져 있다는 사실은 역사에 걸쳐서 호랑이가 인간과 얼마나 밀접하게 관련되어 있는지를 보여줍니다.

At one time, (9) _____ _____ _____ _____ _____ _____ _____, from Korea to Turkey.

한때 호랑이들은 한국에서 터키에 이르는 아시아 전역에서 발견되었습니다.

However, the world's tiger population (10) _____ _____ _____ rapidly.

하지만 전 세계의 호랑이 수는 급격히 감소하고 있습니다.

Illegal hunting and habitat loss (11) _____ _____ _____ _____ behind this decrease.

불법 사냥과 서식지 상실이 이러한 (개체 수) 감소의 주요 원인들입니다.

At the start of the 20th century, (12) _____ _____ _____ _____ there were approximately 100,000 wild tigers.

20세기 초에는, 약 10만 마리의 야생 호랑이가 있었던 것으로 추정되었습니다.

In recent years, however, three of the nine subspecies of tigers (13) _____ _____ _____.

그러나 최근 몇 년간 9개의 호랑이 아종(亞種) 중 3개의 종은 멸종되었습니다.

In fact, it is now estimated that there are fewer than 4,000 tigers (14) _____ _____

_____ _____.

실제로 현재는 야생에서 사는 호랑이가 4,000마리 미만인 것으로 추정됩니다.

Some experts even predict that the last of the world's wild tigers (15) _____ _____ within the next 10 years.

어떤 전문가들은 심지어 전 세계의 마지막 야생 호랑이가 향후 10년 안에 사라질 것으로 예상합니다.

(16) _____ _____ _____ _____ _____ if there were no more wild tigers. Would it really matter, though?

만약 야생 호랑이가 더는 존재하지 않는다면 매우 슬플 것입니다. 그런데 그게 정말로 중요한 일일까요?

After all, we could still see them in zoos or (17) _____ _____ _____ _____ on TV.

어쨌든, 우리는 여전히 그들을 동물원에서 보거나, TV에서 그들에 관한 프로그램들을 시청할 수 있으니까요.

Shouldn't we be more (18) _____ _____ _____ _____ _____?

우리는 인간을 보호하는 것에 대해 더 걱정해야 하는 것 아닐까요?

The fact is, however, that we need to protect tigers (19) _____ _____ _____

_____ _____.

그러나 사실은 우리 자신을 보호하기 위해 우리는 호랑이를 보호할 필요가 있습니다.

(20) _____ _____ _____ all of Earth's species are interconnected.

이것은 지구의 모든 종이 서로 연결되어 있기 때문입니다.

Think about what would happen (21) _____ _____ _____ _____.

호랑이가 멸종된다면 어떤 일이 일어날지 생각해 보십시오.

Existing at the top of the food chain, they maintain the populations of animals (22) _____

_____ _____, such as deer and boar.

그들은 먹이 사슬의 정점에 존재하며 사슴과 멧돼지같이 그들이 잡아먹는 동물들의 개체 수를 유지합니다.

(23) _____ _____, these species would rapidly increase in number.

호랑이가 없다면, 이러한 종들의 수가 급격히 증가할 것입니다.

As a result, their food source, vegetation, would (24) _____ _____ _____.

그 결과로, 그들의 먹이인 초목이 사라지기 시작할 것입니다.

This would cause (25) _____ _____ _____ _____ _____ their homes, and bigger animals that prey on them would soon run out of food.

이것은 새들과 곤충들이 그들의 집을 잃게 할 것이고, 그것들을 잡아먹는 더 큰 동물들은 곧 먹이가 바닥나게 될 것입니다.

Eventually, the entire ecosystem would be affected. Humans are no exception, as (26) _____ _____ _____ _____ _____ we need to survive, including air, food, and water.

결국, 생태계 전체가 영향을 받게 될 것입니다. 인간도 예외가 아닌데, 우리는 공기, 음식 그리고 물을 포함하여 살아가는 데 필요한 모든 것을 자연에 의존하고 있기 때문입니다.

This is how the disappearance of a single species (27) _____ _____ the whole planet.

이렇게 해서 하나의 종이 사라지는 것이 지구 전체를 위협할 수도 있는 것입니다.

Now (28) _____ _____ _____ _____ if we made the effort to save tigers.

이제 우리가 호랑이를 보호하기 위해 노력한다면 어떤 일이 일어날지 상상해 보십시오.

Tigers are considered an "umbrella species." This is an ecological term (29) _____ _____ _____ that live in a large area containing a variety of different ecosystems.

호랑이는 '우산종'으로 여겨집니다. 이것은 서로 다른 다양한 생태계를 포함하는 넓은 지역에 사는 종을 일컫는 생태학적 용어입니다.

If we choose to protect these species, we (30) _____ _____ _____ _____ .

만약 우리가 이러한 종들을 보호하기로 결정한다면, 우리는 그들의 서식지를 보호해야만 합니다.

As a result, the other species that share this habitat, including trees and insects, are protected too, as if there were a large umbrella (31) _____ _____ _____ _____ .

결과적으로, 나무와 곤충을 포함해 이 서식지를 공유하는 다른 종들도 마치 그들 위에 큰 우산이 씌워져 있는 것처럼 보호를 받게 됩니다.

Now, (32) _____ _____ _____ _____ we must protect tigers. You may, however, still wonder how switching off the lights helps.

이제, 우리가 호랑이를 보호해야만 한다는 것은 명백합니다. 하지만 당신은 아마 불을 끄는 일이 어떻게 도움이 되는지가 여전히 궁금할 것입니다.

Well, the lights in our homes require electricity, and more than half of the world's electricity (33) _____ _____ _____ _____ fossil fuels.

그러니까, 우리의 집에 있는 불은 전기를 필요로 하고, 전 세계 전기의 절반 이상은 화석 연료를 태움으로써 만들어집니다.

When fossil fuels are burned, carbon dioxide (34) _____ _____ _____ the air, and this contributes to climate change.

화석 연료가 탈 때 이산화탄소가 공기 중으로 배출되는데, 이것은 기후 변화의 원인이 됩니다.

Climate change has (35) _____ _____ _____ _____ _____ , including rising sea levels that threaten many parts of the world.

기후 변화는 세계의 많은 지역에 위협을 가하는 해수면 상승을 포함하여 많은 부정적인 영향을 미칩니다.

(36) _____ _____ _____ _____ , called the Sundarbans, is an area on the coast of Bangladesh inhabited by a large number of tigers. If Earth's oceans continue to rise, this area could be wiped out and its tiger population could be reduced by (37) _____ _____ _____ 96%.

이러한 장소들 중 한 곳은 순다르반스(Sundarbans)라는, 다수의 호랑이가 서식하는 방글라데시의 해안에 있는 지역입니다. 만약 지구의 해수가 계속 상승한다면, 이 지역은 완전히 파괴될 수 있고 그곳의 호랑이 개체 수는 96%만큼이나 감소할 수 있습니다.

(38) _____ _____ _____ , however, we can slow climate change, and this will slow the rise of the oceans.

하지만 에너지를 아낌으로써 우리는 기후 변화를 늦출 수 있고, 이것은 해수의 상승을 늦출 것입니다.

So keep switching off the lights whenever you're (39) _____ _____ _____ _____ _____ a room!

그러므로 당신이 방을 나가는 마지막 사람일 때마다 계속 불을 끄도록 하십시오!

You can also protect tigers (40) _____ _____ . Many popular products, including chocolate, instant noodles, and soap, (41) _____ _____ _____ palm oil.

당신은 또한 쇼핑할 때도 호랑이를 보호할 수 있습니다. 초콜릿, 라면, 그리고 비누를 포함해서 많은 대중적인 제품들은 팜유로 만들어집니다.

Unfortunately, forests where tigers live (42) _____ _____ _____ _____ _____ more and more palm oil plantations.

불행하게도, 호랑이들이 사는 숲이 점점 더 많은 팜유 농장을 짓기 위해 파괴되고 있습니다.

Some palm oil, however, (43) _____ _____ _____ _____ _____ _____ _____ .

하지만 어떤 팜유들은 (환경 파괴 없이) 보다 지속 가능한 방식으로 생산됩니다.

Products that use (44) _____ _____ _____ palm oil usually have a special mark on the label.

이러한 환경친화적인 팜유를 사용한 제품들은 보통 상표에 특별한 표시가 되어 있습니다.

(45) _____ _____ _____ _____ _____ _____ you go shopping!

다음에 쇼핑하러 갈 때 그것을 찾아보세요!

There are (46) _____ _____ _____ _____ _____ _____ to protect tigers and other endangered species.

호랑이와 다른 멸종 위기의 종들을 보호하기 위해 당신이 할 수 있는 다른 많은 일들이 있습니다.

You could volunteer at a nonprofit organization or (47) _____ _____ _____ on social networking sites.

당신은 비영리 단체에서 봉사활동을 하거나 소셜 네트워킹 사이트(SNS)에 중요한 정보를 공유할 수도 있습니다.

(48) _____ _____ _____ _____ may seem, they can help make a big difference.

당신의 활동들이 아무리 사소한 것처럼 보일지라도, 그것들은 큰 변화를 만드는 데 도움이 될 수 있습니다.

Most importantly, (49) _____ _____ _____ _____ we all share the same planet.

무엇보다 중요한 것은, 우리 모두가 같은 지구를 공유하고 있다는 사실을 당신은 기억해야 한다는 것입니다.

If a single species disappears, every other living creature, (50) _____ _____ _____ , could be affected.

만약 하나의 종이 사라지면, 인간을 포함한 다른 모든 살아 있는 생명체가 영향을 받을 것입니다.

다음 네모 안에서 옳은 것을 고르시오.

01 Tigers, one of the world's largest feline species, [has / have] long been the kings of Asia's forests.

02 Despite being the [dominant / minor] predators of their habitats, they move silently and remain unseen most of the time.

03 Imagine how ancient people must have felt when [encounter / encountering] tigers in the wild!

04 The fact that ancient rock paintings feature images of tigers [show / shows] how closely tigers have been related to humans throughout history.

05 However, the world's tiger population has been shrinking rapidly. Illegal hunting and habitat loss are the main reasons behind this [decrease / increase].

06 In fact, it is now estimated that there are fewer [as / than] 4,000 tigers living in the wild.

07 Some experts even predict [that / what] the last of the world's wild tigers will disappear within the next 10 years.

08 Think about what would happen if tigers became [extinct / instinct].

09 [Existed / Existing] at the top of the food chain, tigers maintain the populations of animals they prey on, such as deer and boar.

10 Eventually, the entire ecosystem would be affected. Humans are no [exception / expectation], as we rely on nature for everything we need to survive, including air, food, and water.

11 Tigers are considered an "umbrella species." This is an ecological term referring to species that live in a large area [contains / containing] a variety of different ecosystems.

12 As a result, the other species that share this habitat, including trees and insects, are protected too, [as if / even if] there were a large umbrella being held over them.

13 When fossil fuels are burned, carbon dioxide is released into the air, and this [contributes / distributes] to climate change.

14 Climate change has [a number of / the number of] negative effects, including rising sea levels that threaten many parts of the world.

15 One of these places, called the Sundarbans, is an area on the coast of Bangladesh [inhabit / inhabited] by a large number of tigers.

16 If Earth's oceans continue to [arise / rise], this area could be wiped out and its tiger population could be reduced by as much as 96%.

17 So keep switching off the lights [whatever / whenever] you're the last person to leave a room!

18 Unfortunately, forests [where / which] tigers live are being destroyed to build more and more palm oil plantations.

19 Products that use this environmentally friendly palm oil usually [has / have] a special mark on the label.

20 There are many other things you can do to protect tigers and other [endanger / endangered] species.

다음 문장이 옳으면 O, 틀리면 X 표시하고 바르게 고치시오.

01 You can protect tigers simply by switch off the lights.

02 This may sound strangely, but it is actually true. An everyday action that helps us save energy can also help save an endangered species.

03 How does this work? Let's take a look.

A SPECIES IN DANGER

04 Tigers, one of the world's largest feline species, have long been the kings of Asia's forests.

05 Despite being the dominant predators of their habitats, they move silently and remain unseen most of the time.

06 Imagine how ancient people must have feel when encountering tigers in the wild!

07 It is no surprise that tigers have been feared and worshipped by humans for centuries, stand as symbols of power and courage.

08 The fact that ancient rock paintings featuring images of tigers shows how closely tigers have been related to humans throughout history.

09 At one time, tigers were found all across Asia, from Korea to Turkey.

10 However, the world's tiger population has being shrinking rapidly.

11 Illegal hunting and habitat loss are the main reasons behind this decrease.

12 At the start of the 20th century, it was estimated that there was approximately 100,000 wild tigers.

13 In recent years, however, three of the nine subspecies of tigers have become extinct.

14 In fact, it is now estimated that there are few than 4,000 tigers living in the wild.

15 Some experts even predict that the last of the world's wild tigers will disappear within the next 10 years.

OUR INTERCONNECTED WORLD

16 It would be very sad if there were no more wild tigers. Would it really matter, though?

17 After all, we could still see them in zoos or watch programs about them on TV.

18 Shouldn't we be more worried about to protect human beings?

19 The fact is, however, which we need to protect tigers in order to protect ourselves.

20 This is because all of Earth's species are interconnected.

21 Think about that would happen if tigers became extinct.

22 Existing at the top of the food chain, tigers maintain the populations of animals they prey on, such as deer and boar.

23 Without tigers, these species would rapidly increase in number.

24 As a result, their food source, vegetation, would begin to disappear.

25 This would cause birds and insects lose their homes, and bigger animals that prey on them would soon run out of food.

26 Eventually, the entire ecosystem would be affected. Humans are no exception, as we rely on nature for everything we need to survive, including air, food, and water.

27 This is how the disappearance of a single species can threaten the whole planet.

28 Now imagine that would happen if we made the effort to save tigers.

29 Tigers are considered an "umbrella species." This is an ecological term referring to species that live in a large area containing a variety of different ecosystems.

30 If we choose protecting these species, we must conserve their habitat.

31 As a result, the other species that share this habitat, including trees and insects, are protected too, as if there were a large umbrella being held over them.

SMALL EFFORTS WITH BIG RESULTS

32 Now, it is obvious that we must protect tigers. You may, however, still wonder how switching off the lights help.

33 Well, the lights in our homes require electricity, and more than half of the world's electricity is created by burning fossil fuels.

34 When fossil fuels are burned, carbon dioxide is released into the air, and this contributes to climate change.

35 Climate change has a number of negative effects, including rising sea levels that threaten many parts of the world.

36 One of these place, called the Sundarbans, is an area on the coast of Bangladesh inhabited by a large number of tigers.

37 If Earth's oceans continue to rise, this area could be wiped out and its tiger population could be reduced by as much as 96%.

38 By conserving energy, however, we can slow climate change, and this will slow the rise of the oceans.

39 So keep switch off the lights whenever you're the last person to leave a room!

40 You can also protect tigers when shopping. Many popular products, including chocolate, instant noodles, and soap, are made with palm oil.

41 Unfortunately, forests where tigers live are being destroy to build more and more palm oil plantations.

42 Some palm oil, however, is produced in a more sustainable way.

43 Products that uses this environmentally friendly palm oil usually have a special mark on the label.

44 Look for it the next time you go shopping!

GET INVOLVED

45 There are many other things you can do to protect tigers and other endanger species.

46 You could volunteering at a nonprofit organization or share important information on social networking sites.

47 However small your actions may seem, they can help make a big difference.

48 Most importantly, you must remember that we all share the same planet.

49 If a single species disappears, every other living creature, including human beings, could be affected.

1 다음 대화가 자연스럽게 이어지도록 (A)~(C)를 올바른 순서로 배열하시오.

> M: Ouch! Did you see that? A man bumped right into me and just kept walking.
> W: How annoying! He didn't even slow down.
>
> (A) You're right. We should be more thoughtful of one another because we're living together in a community.
> (B) At least he could have stopped and said, "I'm sorry."
> (C) I agree with you. Well, I guess we all need to try harder. That includes you and me.
>
> W: Exactly. It starts with us. I'm going to show more consideration from now on.

_____ → _____ → _____

[2~3] 다음 글을 읽고, 물음에 답하시오.

> Tigers, one of the world's largest feline species, have long been the kings of Asia's forests. _____ being the dominant predators of their habitats, they move silently and remain ⓐ unsee most of the time. Imagine how ancient people must have felt when encountering tigers in the wild! It is no surprise that tigers have been feared and worshipped by humans for centuries, ⓑ stood as symbols of power and courage. The fact that ancient rock paintings feature images of tigers shows how closely tigers have been related to humans throughout history.

2 윗글의 빈칸에 들어갈 말로 가장 적절한 것은?

① Thanks to
② In spite of
③ Because of
④ But for
⑤ According to

3 윗글의 밑줄 친 ⓐ, ⓑ를 어법에 맞게 고쳐 쓰시오.

ⓐ unsee → _____

ⓑ stood → _____

[4~5] 다음 글을 읽고, 물음에 답하시오.

> At one time, tigers ① were found all across Asia, from Korea to Turkey. However, the world's tiger population has been _____. Illegal hunting and habitat loss are the main reasons behind this decrease. At the start of the 20th century, it was estimated that there ② were approximately 100,000 wild tigers. In recent years, however, three of the nine subspecies of tigers ③ have become extinct. In fact, it is now estimated that there are fewer than 4,000 tigers ④ lived in the wild. Some experts even predict ⑤ that the last of the world's wild tigers will disappear within the next 10 years.

4 윗글의 밑줄 친 ①~⑤ 중, 어법상 틀린 것은?

① ② ③ ④ ⑤

5 윗글의 빈칸에 들어갈 말로 가장 적절한 것은?

① shrinking rapidly
② called into question
③ suffering from hunger
④ living in a thick forest
⑤ stable for a decade

[6~8] 다음 글을 읽고, 물음에 답하시오.

It would be very sad if there were no more wild tigers. Would it really matter, though? After all, we could still see them in zoos or watch programs about them on TV. Shouldn't we be more worried about protecting human beings? The fact is, however, that we need to (A) endanger / protect tigers in order to protect ourselves. This is because all of Earth's species are interconnected.

Think about what would happen if tigers became extinct. Existing at the top of the food chain, they maintain the populations of animals they prey on, such as deer and boar. Without tigers, these species would rapidly increase in number. As a result, their food source, vegetation, would begin to disappear. This would cause birds and insects to (B) gain / lose their homes, and bigger animals that prey on them would soon run out of food. _____, the entire ecosystem would be affected. Humans are no exception, as we rely on nature for everything we need to survive, including air, food, and water. This is how the (C) disappearance / emergence of a single species can threaten the whole planet.

6 (A), (B), (C)의 각 네모 안에서 문맥에 맞는 낱말로 가장 적절한 것은?

	(A)		(B)		(C)
①	endanger	⋯	gain	⋯	disappearance
②	endanger	⋯	lose	⋯	emergence
③	protect	⋯	gain	⋯	emergence
④	protect	⋯	lose	⋯	disappearance
⑤	protect	⋯	lose	⋯	emergence

7 윗글의 빈칸에 들어갈 말로 가장 적절한 것은?

① Luckily
② Nevertheless
③ Eventually
④ However
⑤ For instance

8 윗글의 내용을 한 문장으로 요약할 때, 빈칸에 들어갈 말을 찾아 쓰시오.

As all the species on earth are closely _____, the extinction of tigers will affect the entire ecosystem.

[9~11] 다음 글을 읽고, 물음에 답하시오.

Now, it is obvious that we must protect tigers. You may, (A) , still wonder how switching off the lights helps. Well, the lights in our homes ① require electricity, and more than half of the world's electricity is created by burning fossil fuels. When fossil fuels are burned, carbon dioxide is ② released into the air, and this contributes to climate change. Climate change has a number of ③ negative effects, including rising sea levels that threaten many parts of the world. One of these places, called the Sundarbans, is an area on the coast of Bangladesh ④ prohibited by a large number of tigers. If Earth's oceans continue to rise, this area could be wiped out and its tiger

population could be reduced by as much as 96%. By conserving energy, (B) , we can slow climate change, and this will ⑤ slow the rise of the oceans. So keep switching off the lights whenever you're the last person to leave a room!

9 윗글의 빈칸 (A), (B)에 공통으로 들어갈 말로 가장 적절한 것은?

① therefore
② however
③ to sum up
④ similarly
⑤ rather

10 윗글의 밑줄 친 ①~⑤ 중, 문맥상 낱말의 쓰임이 적절하지 않은 것은?

①　　②　　③　　④　　⑤

11 윗글의 제목으로 가장 적절한 것은?

① Dangers of Climate Change
② Habitat of Asian Tigers
③ Don't Release Carbon Dioxide
④ Turn Off Lights and Help Save Tigers
⑤ Why We Should Use Clean Energy

12 다음 글의 밑줄 친 ①~⑤ 중, 전체 흐름과 관계 없는 문장은?

You can also protect tigers when shopping. ① Many popular products, including chocolate, instant noodles, and soap, are made with palm oil. ② Unfortunately, forests where tigers live are being destroyed to build more and more palm oil plantations. ③ Palm oil prices have doubled since last year. ④ Some palm oil,

however, is produced in a more sustainable way. ⑤ Products that use this environmentally friendly palm oil usually have a special mark on the label. Look for it the next time you go shopping!

①　　②　　③　　④　　⑤

[13~14] 다음 글을 읽고, 물음에 답하시오.

There are many other things you can do to protect tigers and other endangered species. You could volunteer at a nonprofit organization or share important information on social networking sites. However small your actions may seem, they can help make a big difference. Most importantly, you must remember that we all share the same planet. If a single species disappears, every other living creature, including human beings, could be affected.

13 윗글의 바로 앞에 올 수 있는 내용으로 가장 적절한 것은?

① 호랑이의 먹잇감과 사냥 방식
② 호랑이 보호에 도움이 되는 행동
③ 멸종 위기에 처한 동물들의 개체 수
④ 호랑이가 서식하는 장소의 특징
⑤ 멸종 위기종을 소개하는 SNS 사이트

14 윗글의 밑줄 친 부분을 우리말로 해석하시오.

1 다음 대화의 주제로 가장 적절한 것은?

B: Hi, Subin. What are you reading?

G: I'm reading an article about urban mining.

B: Oh, I've never heard of that. Could you explain what that is?

G: According to the article, electronic products are dumped in large quantities every year. However, lots of components in them can be reused. Urban mining is the process of finding and making use of them.

B: That sounds great! That way, we can reduce waste and save the environment.

G: We can also cut down on expenses from producing and importing metal.

B: Wow, it seems like reusing resources can do a lot of good.

① 재활용이 가능한 자원의 종류
② 전자 제품 쓰레기 문제의 심각성
③ 도시 광산업의 긍정적인 효과
④ 금속 제품의 낮은 재활용 비율
⑤ 오염 물질을 많이 배출하는 산업

[2~3] 다음 글을 읽고, 물음에 답하시오.

Tigers, one of the world's largest feline species, have long been the kings of Asia's forests. Despite being the dominant predators of their habitats, they move silently and remain unseen most of the time. 야생에서 호랑이와 마주쳤을 때 고대인들이 어떻게 느꼈음에 틀림없을지 상상해 보십시오! It is no surprise that tigers have been feared and worshipped by humans for centuries, standing as symbols of power and courage. The fact that ancient rock paintings feature images of tigers shows how closely tigers have been related to humans throughout history.

2 윗글의 밑줄 친 우리말과 일치하도록 주어진 단어를 이용하여 문장을 완성하시오.

Imagine _____
when encountering tigers in the wild!
(ancient people, must)

3 호랑이에 대한 윗글의 내용과 일치하지 <u>않는</u> 것은?

① They are one of the largest feline species.
② They live by preying on other animals.
③ It is quite easy to find them in the forest.
④ They have long been worshipped by people.
⑤ There are some ancient rock paintings of them.

[4~5] 다음 글을 읽고, 물음에 답하시오.

At one time, tigers were ① <u>found</u> all across Asia, from Korea to Turkey. However, the world's tiger population has been shrinking rapidly. Illegal hunting and habitat ② <u>loss</u> are the main reasons behind this decrease. At the start of the 20th century, it was ③ <u>estimated</u> that there were approximately 100,000 wild tigers. In recent years, however, three of the nine subspecies of tigers have become ④ <u>extinct</u>. In fact, it is now estimated that there are fewer than 4,000 tigers living in the wild. Some experts even predict that the last of the world's wild tigers will ⑤ <u>appear</u> within the next 10 years.

4 윗글의 밑줄 친 ①~⑤ 중, 문맥상 낱말의 쓰임이 적절하지 <u>않은</u> 것은?

① ② ③ ④ ⑤

5 윗글의 제목으로 가장 적절한 것은?

① Dangers of Wild Animals
② How to Save Wild Tigers
③ The Necessity of Protecting Wildlife
④ The Destruction of the Habitat of Tigers
⑤ The Decrease in the Number of Tigers

It would be very sad if there were no more wild tigers. (①) Would it really matter, though? (②) After all, we could still see them in zoos or watch programs about them on TV. (③) Shouldn't we be more worried about protecting human beings? (④) This is because all of Earth's species are interconnected. (⑤)

Think about what would happen if tigers became extinct. Existing at the top of the food chain, they maintain the populations of animals they prey on, such as deer and boar. Without tigers, these species would rapidly increase in number. ____(A)____, their food source, vegetation, would begin to disappear. This would cause birds and insects to lose their homes, and bigger animals that prey on them would soon run out of food. Eventually, the entire ecosystem would be affected. Humans are no exception, as we rely on nature for everything we need to survive, including air, food, and water. This is ____(B)____ the disappearance of a single species can threaten the whole planet.

6 윗글의 흐름으로 보아, 주어진 문장이 들어가기에 가장 적절한 곳은?

The fact is, however, that we need to protect tigers in order to protect ourselves.

① ② ③ ④ ⑤

7 윗글의 빈칸 (A)에 들어갈 말로 가장 적절한 것은?

① Instead ② Nonetheless
③ However ④ Consequently
⑤ For instance

8 윗글의 빈칸 (B)에 들어갈 말로 가장 적절한 것은?

① who ② what
③ which ④ how
⑤ where

9 다음 글의 (A)에 주어진 말을 알맞게 배열하여 문장을 완성하시오.

Now imagine what would happen if we made the effort to save tigers. Tigers are considered an "umbrella species." This is an ecological term (A) (large / to / that / area / a / referring / in / species / live) containing a variety of different ecosystems. If we choose to protect these species, we must conserve their habitat. As a result, the other species that share this habitat, including trees and insects, are protected too, as if there were a large umbrella being held over them.

This is an ecological term _____

containing a variety of different ecosystems.

[10~12] 다음 글을 읽고, 물음에 답하시오.

Now, it is obvious that we must protect tigers. You may, however, still wonder how switching off the lights (A) help / helps . Well, the lights in our homes require electricity, and more than half of the world's electricity is created by burning fossil fuels. When fossil fuels are burned, carbon dioxide is released into the air, and this contributes to climate change. Climate change has a number of negative effects, including rising sea levels that threaten many parts of the world. One of these places, called the Sundarbans, (B) are / is an area on the coast of Bangladesh inhabited by a large number of tigers. If Earth's oceans continue to rise, this area could be wiped out and its tiger population could be reduced by as much as 96%. By conserving energy, however, we can slow climate change, and this will slow the rise of the oceans. So (C) keep / to keep switching off the lights whenever you're the last person to leave a room!

10 윗글의 바로 앞에 올 수 있는 내용으로 가장 적절한 것은?

① 지구온난화의 부정적인 결과
② 증가하는 화석 연료 사용량
③ 호랑이를 보호해야 하는 이유
④ 해수면 상승을 방지하는 방법
⑤ 기후 변화가 생태계에 미치는 영향

11 윗글의 내용과 일치하는 것은?

① Turning off the lights isn't related to protecting tigers.
② More than half of the world's electricity is made from the sun.
③ Burning fossil fuels can cause climate change.
④ Rising sea levels won't affect the habitat of tigers.
⑤ Climate change can help to increase the number of tigers.

12 (A), (B), (C)의 각 네모 안에서 어법에 맞는 표현을 쓰시오.

(A) _____

(B) _____

(C) _____

13 다음 글의 내용을 한 문장으로 요약할 때, 빈칸에 들어갈 말을 찾아 쓰시오.

> You can also protect tigers when shopping. Many popular products, including chocolate, instant noodles, and soap, are made with palm oil. Unfortunately, forests where tigers live are being destroyed to build more and more palm oil plantations. Some palm oil, however, is produced in a more sustainable way. Products that use this environmentally friendly palm oil usually have a special mark on the label. Look for it the next time you go shopping!

↓

> You are able to help _____ _____ by using products made with environmentally friendly palm oil.

14 다음 글의 빈칸에 들어갈 말로 가장 적절한 것은?

> There are many other things you can do to protect tigers and other endangered species. You could volunteer at a nonprofit organization or share important information on social networking sites. However small your actions may seem, they can help make a big difference. Most importantly, you must remember that we all share the same planet. If a single species disappears, every other living creature, including human beings, _____.

① could be affected
② would live peacefully
③ must defend itself
④ will increase in number
⑤ can adapt to the situation

15 다음 도표의 내용과 일치하지 <u>않는</u> 것은?

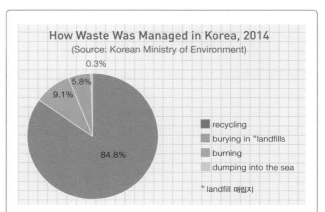

How Waste Was Managed in Korea, 2014
(Source: Korean Ministry of Environment)
- recycling
- burying in *landfills
- burning
- dumping into the sea

* landfill 매립지

① This graph shows how waste was managed in Korea in 2014. ② According to the graph, the primary method of managing waste in Korea was recycling, accounting for 84.8%. ③ The second-most common method was burying in landfills at 9.1%, followed by burning at 5.8%. ④ Dumping into the sea accounted for 0.3%. ⑤ From the graph, we can see that most waste was burned, so waste was still managed in ways that harm the environment.

① ② ③ ④ ⑤

1 다음 대화의 빈칸에 들어갈 말로 가장 적절한 것은?

> B: Ouch! Did you see that? A man bumped right into me and just kept walking.
>
> G: How annoying! He didn't even slow down.
>
> B: At least he could have stopped and said, "I'm sorry."
>
> G: You're right. We should be more thoughtful of one another because we're living together in a community.
>
> B: _____ Well, I guess we all need to try harder. That includes you and me.
>
> G: Exactly. It starts with us. I'm going to show more consideration from now on.

① You're welcome.
② I agree with you.
③ I'm sorry to hear that.
④ Don't waste your time.
⑤ It's out of the question.

[2~3] 다음 글을 읽고, 물음에 답하시오.

> Tigers, one of the world's largest feline species, have long been the kings of Asia's forests. Despite being the dominant predators of their habitats, they move silently and remain unseen most of the time. Imagine how ancient people must have felt (A) (in / tigers / encountering / the wild / when)! It is no surprise that tigers have been feared and worshipped by humans for centuries, standing as symbols of power and courage. The fact that ancient rock paintings feature images of tigers shows how closely tigers have been related to humans throughout history.

2 윗글의 내용과 일치하지 <u>않는</u> 것은?

① 호랑이는 고양잇과 동물이다.
② 서식지에서 호랑이는 눈에 잘 띄지 않는다.
③ 사람들은 호랑이를 두려워하지 않았다.
④ 호랑이는 힘과 용기의 상징이었다.
⑤ 역사에 걸쳐 호랑이는 인간과 밀접하게 관련되었다.

3 윗글의 (A)에 주어진 단어를 배열하여 문장을 완성하시오.

Imagine how ancient people must have felt _____

_____!

[4~5] 다음 글을 읽고, 물음에 답하시오.

> At one time, tigers were found all across Asia, from Korea to Turkey. (①) Illegal hunting and habitat loss are the main reasons behind this decrease. (②) At the start of the 20th century, it was estimated that there were approximately 100,000 wild tigers. (③) In recent years, however, three of the nine subspecies of tigers have become extinct. (④) In fact, it is now estimated that there are fewer than 4,000 tigers living in the wild. (⑤) Some experts even predict that the last of the world's wild tigers will disappear within the next 10 years.

4 윗글의 흐름으로 보아, 주어진 문장이 들어가기에 가장 적절한 곳은?

> However, the world's tiger population has been shrinking rapidly.

① ② ③ ④ ⑤

5 윗글의 주제로 가장 적절한 것은?

① the daily activities of tigers
② strategies to conserve wildlife
③ the changes in tiger population
④ tips for solving human-wildlife conflict
⑤ the importance of protecting tigers' habitat

[6~8] 다음 글을 읽고, 물음에 답하시오.

It would be very sad if there were no more wild tigers. Would it really matter, though? After all, we could still see them in zoos or watch programs about (a) them on TV. Shouldn't we be more worried about ① protecting human beings? The fact is, however, that we need to protect tigers in order to protect ② ourselves. This is because all of Earth's species are ___(A)___.

Think about what would happen if tigers became extinct. ③ Existed at the top of the food chain, (b) they maintain the populations of animals (c) they prey on, such as deer and boar. Without tigers, these species would rapidly increase in number. As a result, (d) their food source, vegetation, would begin to disappear. This would cause birds and insects ④ to lose (e) their homes, and bigger animals that prey on (f) them would soon run out of food. Eventually, the entire ecosystem would be affected. Humans are no exception, as we rely on nature for everything we need to survive, ⑤ including air, food, and water. This is how the disappearance of a single species can threaten the whole planet.

6 윗글의 빈칸 (A)에 들어갈 말로 가장 적절한 것은?

① equal ② conserved
③ on the move ④ interconnected
⑤ programmed

7 윗글의 밑줄 친 (a)~(f) 중, 호랑이를 가리키지 않는 것을 모두 적고, 가리키는 대상을 찾아 쓰시오.

8 윗글의 밑줄 친 ①~⑤ 중, 어법상 틀린 것은?

① ② ③ ④ ⑤

9 주어진 문장 다음에 이어질 글의 순서로 가장 적절한 것은?

Now imagine what would happen if we made the effort to save tigers.

(A) As a result, the other species that share this habitat, including trees and insects, are protected too, as if there were a large umbrella being held over them.

(B) This is an ecological term referring to species that live in a large area containing a variety of different ecosystems. If we choose to protect these species, we must conserve their habitat.

(C) Tigers are considered an "umbrella species."

① (A) − (B) − (C) ② (B) − (A) − (C)
③ (B) − (C) − (A) ④ (C) − (A) − (B)
⑤ (C) − (B) − (A)

[10~12] 다음 글을 읽고, 물음에 답하시오.

Now, it is obvious that we must protect tigers. You may, however, still wonder how switching off the lights helps. Well, the lights in our homes require electricity, and more than half of the world's electricity (A) are / is created by burning fossil fuels. When fossil fuels are ① burned, carbon dioxide is released into the

air, and this ② contributes to climate change. Climate change has a number of ③ positive effects, including rising sea levels that threaten many parts of the world. One of these places, called the Sundarbans, is an area on the coast of Bangladesh (B) inhabited / inhabiting by a large number of tigers. If Earth's oceans continue to rise, this area could be ④ wiped out and its tiger population could be reduced by as much as 96%. By conserving energy, however, we can slow climate change, and this will slow the rise of the oceans. So keep (C) switching / to switch off the lights whenever you're the ⑤ last person to leave a room!

10 윗글의 밑줄 친 ①~⑤ 중, 문맥상 낱말의 쓰임이 적절하지 않은 것은?

① ② ③ ④ ⑤

11 (A), (B), (C)의 각 괄호 안에서 어법에 맞는 표현으로 가장 적절한 것은?

	(A)		(B)		(C)
①	is	⋯	inhabited	⋯	to switch
②	is	⋯	inhabited	⋯	switching
③	is	⋯	inhabiting	⋯	switching
④	are	⋯	inhabited	⋯	switching
⑤	are	⋯	inhabiting	⋯	to switch

12 윗글의 내용을 다음과 같이 요약할 때, 빈칸 (A), (B)에 들어갈 말로 가장 적절한 것은?

By turning off the lights, we can reduce the amount of ____(A)____ released into the air, which can slow climate change. Thus, we can conserve the ____(B)____ of tigers.

	(A)		(B)
①	light	⋯	prey
②	breath	⋯	species
③	carbon dioxide	⋯	habitats
④	pollutants	⋯	predators
⑤	electricity	⋯	population

[13~14] 다음 글을 읽고, 물음에 답하시오.

You can also protect tigers when shopping. Many popular products, including chocolate, ① instant noodles, and soap, are made with palm oil. Unfortunately, forests where tigers live are being destroyed to build more and more palm oil ② plantations. Some palm oil, however, is produced in a more ③ sustainable way. Products that use this environmentally friendly palm oil usually (A) has a special mark on the label. Look for it the next time you go shopping!

There are many other things you can do to protect tigers and other endangered species. You could volunteer at a ④ nonprofit organization or share important information on social networking sites. (B) Whatever small your actions may seem, they can help make a big difference. Most importantly, you must remember that we all share the same planet. If a single species disappears, every other living ⑤ creature, including human beings, could be affected.

13 윗글의 밑줄 친 ①~⑤의 영영 뜻풀이가 적절하지 않은 것은?

① instant : made to be prepared and eaten quickly

② plantation : the action of inserting a device or tissue into the body

③ sustainable : able to be continued long into the future, often because of careful resource management

④ nonprofit : not intended to earn money

⑤ creature : anything that is living, such as an animal, fish, or insect

14 윗글의 밑줄 친 (A), (B)를 어법에 맞게 고쳐 쓰시오.

(A) has → _____

(B) Whatever → _____

1 다음 담화의 흐름으로 보아, 주어진 문장이 들어가기에 가장 적절한 곳은?

> However, both groups have benefited.

Good afternoon. I'm standing in front of a nursing home for the elderly. This seemingly ordinary nursing home has drawn people's attention by joining with a preschool. (①) At first, the goal was to make the seniors feel more lively and less isolated by placing them in programs shared with young students. (②) In one of the programs, each child is matched with a senior. (③) Then they read books aloud to each other. (④) Helping the children read reminds the seniors that they can still help others. (⑤) Meanwhile, the kids benefit by becoming better readers. Other programs include physical activities. By playing with the kids, the seniors can improve their health. The kids learn core values, such as responsibility and respect. This unique partnership shows how people can help one another and live better together.

① ② ③ ④ ⑤

[2~3] 다음 글을 읽고, 물음에 답하시오.

Tigers, one of the world's largest feline species, have long been the kings of Asia's forests. Despite ⓐ be the dominant predators of their habitats, they move silently and remain unseen most of the time. Imagine how ancient people must have felt when ⓑ encounter tigers in the wild! (A) It is no surprise that tigers have been feared and ⓒ worship by humans for centuries, standing as symbols of power and courage. The fact that ancient rock paintings feature images of tigers shows how closely tigers have been related to humans throughout history.

2 윗글의 밑줄 친 (A) It과 쓰임이 같은 것은?

① I found it easy to find the way.
② It's four kilometers from the station to the school.
③ He bought a new watch, and it was expensive.
④ It is already 9 o'clock. The class begins soon.
⑤ It is believed that number 4 is unlucky.

3 윗글의 밑줄 친 ⓐ~ⓒ를 어법에 맞게 한 단어로 고쳐 쓰시오.

ⓐ be → _____

ⓑ encounter → _____

ⓒ worship → _____

[4~5] 다음 글을 읽고, 물음에 답하시오.

At one time, tigers were found all across Asia, from Korea to Turkey. However, the world's tiger population has been (A) growing / shrinking rapidly. Illegal hunting and habitat loss are the main reasons behind this decrease. At the start of the 20th century, it was estimated that there were approximately 100,000 wild tigers. In recent years, however, three of the nine subspecies of tigers have become (B) distinct / extinct. In fact, it is now estimated that there are fewer than 4,000 tigers living in the wild. Some experts even predict that the last of the world's wild tigers will _____ _____.

4 (A), (B)의 각 네모 안에서 문맥에 맞는 낱말을 쓰시오.

(A) _____

(B) _____

5 윗글의 빈칸에 들어갈 말로 가장 적절한 것은?

① lead largely solitary lives
② disappear within the next 10 years
③ give birth to two to four cubs every two years
④ be voted the world's favorite animals in a poll
⑤ feed on large or medium-sized animals

[6~8] 다음 글을 읽고, 물음에 답하시오.

It would be very sad if there were no more wild tigers. Would it really matter, though? After all, we could still see them in zoos or watch programs about them on TV. Shouldn't we be more worried about protecting human beings? The fact is, however, that we need to protect tigers in order to protect ourselves. This is because all of Earth's species are interconnected.

Think about what would happen if tigers became extinct.

(A) This would cause birds and insects to lose their homes, and bigger animals that prey on them would soon run out of food. Eventually, the entire ecosystem would be affected.

(B) Existing at the top of the food chain, tigers maintain the populations of animals they prey on, such as deer and boar.

(C) 호랑이가 없다면, 이러한 종들의 수가 급격히 증가할 것입니다. As a result, their food source, vegetation, would begin to disappear.

6 주어진 글 다음에 이어질 글의 순서로 가장 적절한 것은?

① (A) − (B) − (C) ② (B) − (A) − (C)
③ (B) − (C) − (A) ④ (C) − (A) − (B)
⑤ (C) − (B) − (A)

7 윗글의 밑줄 친 우리말과 일치하도록 〈보기〉에 주어진 말을 배열하여 문장을 완성하시오.

〈보기〉 these species / in number / tigers / without / would / rapidly increase

8 다음 영영 뜻풀이에 해당하는 단어를 윗글에서 찾아 쓰시오.

all the living things in an area and the way they affect each other and the environment

[9~11] 다음 글을 읽고, 물음에 답하시오.

Humans are no exception, as we rely on nature for everything we need to survive, ⓐ including air, food, and water. (①) This is ⓑ how the disappearance of a single species can threaten the whole planet. (②)

Now imagine what ⓒ would happen if we made the effort to save tigers. (③) This is an ecological term ⓓ referring to species that live in a large area containing a variety of different ecosystems. (④) If we choose to protect these species, we must conserve their habitat. (⑤) As a result, the other species that share this habitat, including trees and insects, are protected too, as if there ⓔ is a large umbrella being held over them.

9 윗글의 바로 앞에 올 수 있는 내용으로 가장 적절한 것은?

① 인간이 초래한 환경 오염 문제
② 인간이 자연에 의존하는 이유
③ 호랑이가 서식하는 지역의 특성
④ 호랑이가 멸종 위기에 처하게 된 원인
⑤ 호랑이의 멸종이 생태계에 미치는 영향

10 윗글의 흐름으로 보아, 주어진 문장이 들어가기에 가장 적절한 곳은?

> Tigers are considered an "umbrella species."

① ② ③ ④ ⑤

11 윗글의 밑줄 친 ⓐ~ⓔ 중, 어법상 틀린 것은?

① ⓐ ② ⓑ ③ ⓒ ④ ⓓ ⑤ ⓔ

[12~14] 다음 글을 읽고, 물음에 답하시오.

Climate change has a number of negative effects, including rising sea levels that threaten many parts of the world. One of these places, called the Sundarbans, is an area on the coast of Bangladesh inhabited by a large number of tigers. If Earth's oceans continue to rise, this area could be wiped out and its tiger population could be reduced by as much as 96%. By conserving energy, (A) , we can slow climate change, and ⓐ this will slow the rise of the oceans. So keep switching off the lights whenever you're the last person to leave a room!

_____(C)_____ Many popular products, including chocolate, instant noodles, and soap, are made with palm oil. Unfortunately, forests where tigers live are being destroyed to build more and more palm oil plantations. Some palm oil, (B) , is produced in a more sustainable way. Products that use this environmentally friendly palm oil usually have a special mark on the label. Look for it the next time you go shopping!

12 윗글의 빈칸 (A), (B)에 들어갈 말로 가장 적절한 것은?

	(A)		(B)
①	likewise	…	therefore
②	however	…	therefore
③	in fact	…	for example
④	however	…	however
⑤	likewise	…	however

13 밑줄 친 ⓐ this가 가리키는 내용을 윗글에서 찾아 우리말로 쓰시오. (25자 내외)

14 〈보기〉에 주어진 말을 배열하여 윗글의 빈칸 (C)를 완성하시오.

〈보기〉 can / tigers / shopping / when / you / also protect

15 다음 글의 요지로 가장 적절한 것은?

There are many other things you can do to protect tigers and other endangered species. You could volunteer at a nonprofit organization or share important information on social networking sites. However small your actions may seem, they can help make a big difference. Most importantly, you must remember that we all share the same planet. If a single species disappears, every other living creature, including human beings, could be affected.

① SNS를 통해 야생 동물에 대한 관심을 불러일으킬 수 있다.
② 호랑이를 보호하기 위해 자원을 절약해야 한다.
③ 멸종 위기 동물을 돕는 가장 좋은 방법은 봉사활동에 참여하는 것이다.
④ 작은 행동이라도 멸종 위기 동물을 보호하는 것을 도울 수 있다.
⑤ 하나의 종이 사라져도 생태계 전체에 큰 변화가 일어나는 것은 아니다.

1 다음 담화를 읽고 답할 수 <u>없는</u> 질문으로 가장 적절한 것은?

Good afternoon. I'm standing in front of a nursing home for the elderly. This seemingly ordinary nursing home has drawn people's attention by joining with a preschool. At first, the goal was to make the seniors feel more lively and less isolated by placing them in programs shared with young students. However, both groups have benefited. In one of the programs, each child is matched with a senior. Then they read books aloud to each other. Helping the children read reminds the seniors that they can still help others. Meanwhile, the kids benefit by becoming better readers. Other programs include physical activities. By playing with the kids, the seniors can improve their health. The kids learn core values, such as responsibility and respect. This unique partnership shows how people can help one another and live better together.

① Where is the nursing home for the elderly?
② What was the goal of the program?
③ Who has benefited from the program?
④ What can the seniors improve by playing with the kids?
⑤ What can the kids learn by playing with the seniors?

2 다음 글의 밑줄 친 ①~⑤의 영영 뜻풀이가 적절하지 <u>않은</u> 것은?

You can protect tigers simply by switching off the lights. This may sound strange, but it is actually true. An everyday action that helps us save energy can also help save an ① endangered species. How does this work? Let's take a look.

Tigers, one of the world's largest feline ② species, have long been the kings of Asia's forests. Despite being the dominant predators of their ③ habitats, they move silently and remain unseen most of the time. Imagine how ancient people must have felt when ④ encountering tigers in the wild! It is no surprise that tigers have been feared and worshipped by humans for centuries, standing as symbols of power and courage. The fact that ⑤ ancient rock paintings feature images of tigers shows how closely tigers have been related to humans throughout history.

① endangered : likely to damage or destroy something
② species : a group of animals considered to be one type because they are very similar
③ habitat : the area where a living thing is naturally located
④ encounter : to meet someone or something by chance
⑤ ancient : related to a long-past era; very old

[3~4] 다음 글을 읽고, 물음에 답하시오.

At one time, tigers were found all across Asia, from Korea to Turkey. However, the world's tiger population has been shrinking rapidly. Illegal hunting and habitat loss are the main reasons behind this decrease. At the start of the 20th century, it was estimated _____ there were approximately 100,000 wild tigers. In recent years, however, three of the nine subspecies of tigers have become extinct. In fact, it is now estimated _____ there are fewer than 4,000 tigers living in the wild. Some experts even predict that the last of the world's wild tigers will disappear within the next 10 years.

3 윗글의 빈칸에 공통으로 들어갈 말을 쓰시오.

4 윗글의 내용과 일치하지 <u>않는</u> 것을 <u>2개</u> 고르시오.

① 한때 호랑이는 세계 전역에서 발견됐다.
② 불법 사냥으로 인해 호랑이의 수가 줄었다.
③ 20세기 초에는 약 10만 마리의 야생 호랑이가 있었던 것으로 추정된다.
④ 최근에 9개의 호랑이 아종(亞種) 중 3개 종만 생존했다.
⑤ 10년 이내에 야생 호랑이가 사라질 것이라 예상되기도 한다.

[5~6] 다음 글을 읽고, 물음에 답하시오.

It would be very sad if there were no more wild tigers. Would it really matter, though? After all, we could still see them in zoos or watch programs about them on TV. Shouldn't we be more worried about ⓐ protect human beings? The fact is, however, that we need to protect tigers in order to protect ourselves. This is because all of Earth's species are interconnected.

Think about what would ⓑ have happened if tigers became extinct. ① Existing at the top of the food chain, they maintain the populations of animals they prey on, such as deer and boar. ② Without tigers, these species would rapidly increase in number. ③ As a result, their food source, vegetation, would begin to disappear. ④ So people would need to grow more crops for animals. ⑤ This would cause birds and insects to lose their homes, and bigger animals that prey on them would soon run out of food.

5 윗글의 ①~⑤ 중, 전체 흐름과 관계 <u>없는</u> 문장은?

① ② ③ ④ ⑤

6 윗글의 밑줄 친 ⓐ, ⓑ를 어법에 맞게 고쳐 쓰시오.

ⓐ protect → _____

ⓑ have happened → _____

[7~8] 다음 글을 읽고, 물음에 답하시오.

Eventually, the entire ecosystem would be ① affected. Humans are no exception, as we rely on nature for everything we need to survive, ② including air, food, and water. This is how the disappearance of a single species can threaten the whole planet.

Now ③ imagine what would happen if we made the effort to save tigers. Tigers are considered an "umbrella species." This is an ecological term referring to species that live in a large area containing a variety of different ecosystems. If we choose to protect these species, we must ④ conserve their habitat. As a result, the other species that ⑤ avoid this habitat, including trees and insects, are protected too, as if there were a large umbrella being held over them.

7 윗글의 밑줄 친 ①~⑤ 중, 문맥상 낱말의 쓰임이 적절하지 <u>않은</u> 것은?

① ② ③ ④ ⑤

8 밑줄 친 umbrella species의 의미를 윗글에서 찾아 우리말로 쓰시오. (20자 내외)

[9~11] 다음 글을 읽고, 물음에 답하시오.

Now, it is obvious that we must protect tigers. 하지만, 당신은 아마 불을 끄는 일이 어떻게 도움이 되는지 여전히 궁금할 것입니다. Well, the lights in our homes require electricity, and more than half of the world's electricity is created by burning fossil fuels. When fossil fuels are burned, carbon dioxide is released into the air, and this _____ to climate change. Climate change has a number of negative effects, including rising sea levels that threaten many parts of the world. One of these places, called the Sundarbans, is an area on the coast of Bangladesh inhabited by a large number of tigers. If Earth's oceans continue to rise, this area could be wiped out and its tiger population could be reduced by as much as

96%. By conserving energy, however, we can slow climate change, and this will slow the rise of the oceans. So keep switching off the lights whenever you're the last person to leave a room!

9 윗글을 읽고 알 수 <u>없는</u> 것은?

① 전 세계 전기의 절반 이상이 화석 연료를 태워 만들어진다.
② 화석 연료가 탈 때 이산화탄소가 공기 중에 배출된다.
③ 많은 호랑이들이 방글라데시의 해안가 지역에 서식한다.
④ 기후변화로 인해 자연재해가 더 자주 발생한다.
⑤ 에너지 절약을 통해 해수면 상승을 늦출 수 있다.

10 윗글의 밑줄 친 우리말과 일치하도록 주어진 말을 배열하여 문장을 완성하시오. (필요 시 형태를 변형할 것)

You may, however, still wonder _____

_____ .

(help / the / how / switch / off / lights)

11 윗글의 빈칸에 들어갈 말로 가장 적절한 것은?

① adapts ② contributes
③ sticks ④ belongs
⑤ responds

12 주어진 문장 다음에 이어질 글의 순서로 가장 적절한 것은?

You can also protect tigers when shopping.

(A) Some palm oil, however, is produced in a more sustainable way.
(B) Products that use this environmentally friendly palm oil usually have a special mark on the label. Look for it the next time you go shopping!
(C) Many popular products, including chocolate, instant noodles, and soap, are made with palm oil. Unfortunately, forests where tigers live are being destroyed to build more and more palm oil plantations.

① (A) – (B) – (C) ② (B) – (A) – (C)
③ (B) – (C) – (A) ④ (C) – (A) – (B)
⑤ (C) – (B) – (A)

13 다음 글의 밑줄 친 부분을 바르게 배열한 것은?

There are many other things you can do to protect tigers and other endangered species. You could volunteer at a nonprofit organization or share important information on social networking sites. (<u>actions / however / may / seem / small / your</u>), they can help make a big difference. Most importantly, you must remember that we all share the same planet. If a single species disappears, every other living creature, including human beings, could be affected.

① However your actions may seem small
② Your actions may seem however small
③ However small may seem your actions
④ May seem small your actions however
⑤ However small your actions may seem

14 다음 도표의 내용과 일치하지 <u>않는</u> 것은?

World Electricity Production by Fuel Type, 2014
(Source: International Energy Agency)

2.1% 4.2%
10.6%
16.4%
66.7%

■ fossil fuels
■ *hydroelectric plants
■ nuclear plants
■ biofuels and waste
□ others

* hydroelectric plant
수력 발전소

This graph shows how electricity was generated globally in 2014. ① According to the graph, the primary source of electricity was fossil fuels, accounting for 66.7%. ② Next was hydroelectric plants at 16.4%, followed by nuclear plants at 10.6%. ③ Biofuels and waste produced only 2.1%. ④ From this graph, we can see that fossil fuels are the world's main power source. ⑤ They are producing much less electricity than renewable sources, such as hydroelectric plants and biofuels.

① ② ③ ④ ⑤

1 다음 대화의 밑줄 친 ⓐ~ⓔ 중, 어법상 틀린 것의 개수는?

W: Today, we are going to talk about ecological footprints with Professor Eric Wright. First, could you explain what an ecological footprint is?

M: Certainly. An ecological footprint is an index ⓐ that shows how much of an impact we have on the environment.

W: I see. So, the ⓑ big the footprint, the bigger the impact?

M: Precisely. The average person's ecological footprint nowadays is so big ⓒ what the environment can't recover and heal itself.

W: Really? What about the footprint of the average Korean? Is it big?

M: Yes, and it's getting bigger every year. The main reasons are the use of fossil fuels, higher energy consumption, and the ⓓ increased demand for meat. We need to shrink our footprints!

W: Yes. We should remember we share Earth with many other species and also ⓔ with future generations.

M: That's right!

W: Thank you for coming on the show.

① 1개 ② 2개 ③ 3개 ④ 4개 ⑤ 5개

[2~3] 다음 글을 읽고, 물음에 답하시오.

You can protect tigers simply by switching off the lights. This may sound strange, but it is actually true. An everyday action that helps us save energy can also help save an endangered species. How does this work? Let's take a look.

Tigers, one of the world's largest feline species, have long been the kings of Asia's forests. Despite _____, they move silently and remain unseen most of the time. Imagine how ancient people must have felt when encountering tigers in the wild! It is no surprise that tigers have been feared and worshipped by humans for centuries, standing as symbols of power and courage. The fact that ancient rock paintings feature images of tigers shows how closely tigers have been related to humans throughout history.

2 윗글의 빈칸에 들어갈 말로 가장 적절한 것은?

① being protected by other animals
② being victims of climate change
③ being captured and locked in cages
④ being the best friends of ancient people
⑤ being the dominant predators of their habitats

3 다음 질문에 대한 대답을 윗글에서 찾아 우리말로 쓰시오. (30자 내외)

Q: What do ancient rock paintings featuring images of tigers show?

A: _____

[4~5] 다음 글을 읽고, 물음에 답하시오.

At one time, tigers were found all across Asia, from Korea to Turkey. ① However, the world's tiger population has been shrinking rapidly. ② Illegal hunting and habitat loss are the main reasons behind this decrease. ③ Illegal hunting is the unlawful killing or capturing of wildlife. ④ At the start of the 20th century, it was estimated that there were approximately 100,000 wild tigers. ⑤ In recent years, however, three of the nine subspecies of tigers have become extinct. In fact, it is now estimated that there are fewer than 4,000 tigers living in the wild.

4 윗글의 밑줄 친 ①~⑤ 중, 전체 흐름과 관계 <u>없는</u> 문장은?

① ② ③ ④ ⑤

5 윗글의 마지막 문장 바로 뒤에 이어질 내용으로 가장 적절한 것은?

① 호랑이의 하루 섭취량
② 호랑이 서식지의 조건
③ 미래의 호랑이 수 예측
④ 호랑이가 사냥하는 방법
⑤ 호랑이가 무리 생활을 하는 이유

[6~7] 다음 글을 읽고, 물음에 답하시오.

> Think about what would happen if tigers became extinct. (①) Existing at the top of the food chain, they maintain the populations of animals they prey on, such as deer and boar. (②) Without tigers, these species would rapidly (A) decrease / increase in number. (③) As a result, their food source, vegetation, would begin to disappear. (④) Eventually, the entire ecosystem would be affected. (⑤) Humans are no exception, as we rely on nature for everything we need to (B) struggle / survive, including air, food, and water. This is how the disappearance of a single species can threaten the whole planet.

6 윗글의 흐름으로 보아, 주어진 문장이 들어가기에 가장 적절한 곳은?

> This would cause birds and insects to lose their homes, and bigger animals that prey on them would soon run out of food.

① ② ③ ④ ⑤

7 (A), (B)의 각 네모 안에서 문맥에 맞는 낱말로 가장 적절한 것을 쓰시오.

(A) _____

(B) _____

8 다음 글의 주제로 가장 적절한 것은?

> Now imagine what would happen if we made the effort to save tigers. Tigers are considered an "umbrella species." This is an ecological term referring to species that live in a large area containing a variety of different ecosystems. If we choose to protect these species, we must conserve their habitat. As a result, the other species that share this habitat, including trees and insects, are protected too, as if there were a large umbrella being held over them.

① the necessity of having a large umbrella
② the origin of the term "umbrella species"
③ how to protect umbrella species
④ other species living with tigers
⑤ effects of protecting umbrella species

[9~11] 다음 글을 읽고, 물음에 답하시오.

> Now, it is obvious (A) that / what we must protect tigers. You may, however, still wonder how switching off the lights (B) help / helps. Well, the lights in our homes require ① electricity, and more than half of the world's electricity is created by burning ② fossil fuels. When fossil fuels are burned, carbon dioxide is ③ released into the air, and this contributes to climate change. Climate change has a number of negative effects, including _____ that threaten many parts of the world. One

of these places, called the Sundarbans, is an area on the coast of Bangladesh ④ inhabited by a large number of tigers. If Earth's oceans continue to rise, this area could be ⑤ wiped out and its tiger population could be reduced by as much as 96%. By (C) conserve / conserving energy, however, we can slow climate change, and this will slow the rise of the oceans. So keep switching off the lights whenever you're the last person to leave a room!

9 윗글의 빈칸에 들어갈 말로 가장 적절한 것은?

① food shortages
② rising sea levels
③ human activities
④ terrorism and war
⑤ hurricanes and earthquakes

10 윗글의 밑줄 친 ①~⑤의 영영 뜻풀이가 적절하지 <u>않은</u> 것은?

① electricity : energy that is formed by a stream of electrons
② fossil fuel : a category of fuel that includes oil and coal
③ release : to state what you think will happen in the future
④ inhabit : to live in a place or area
⑤ wipe out : to completely destroy; to cause to disappear

11 (A), (B), (C)의 각 네모 안에서 어법에 맞는 표현으로 가장 적절한 것은?

	(A)		(B)		(C)
①	that	…	help	…	conserving
②	that	…	helps	…	conserve
③	that	…	helps	…	conserving
④	what	…	help	…	conserve
⑤	what	…	helps	…	conserve

12 다음 글의 밑줄 친 ①~⑤ 중, 어법상 <u>틀린</u> 것은?

You can also protect tigers when ① shopping. Many popular products, including chocolate, instant noodles, and soap, ② are made with palm oil. Unfortunately, forests ③ which tigers live are being destroyed to build more and more palm oil plantations. Some palm oil, however, is produced in a more sustainable way. Products ④ that use this environmentally friendly palm oil usually have a special mark on the label. Look for it the next time you go ⑤ shopping!

① ② ③ ④ ⑤

[13~14] 다음 글을 읽고, 물음에 답하시오.

There are many other things you can do to protect tigers and other endangered species. You could volunteer at a nonprofit organization or share important information on social networking sites. However small your actions may seem, <u>그것들은 큰 변화를 만드는 데 도움이 될 수 있습니다</u>. Most importantly, you must remember that we all share the same planet. If a single species disappears, every other living creature, including human beings, could be affected.

13 윗글의 목적으로 가장 적절한 것은?

① 동물 보호 봉사활동 참가자를 모집하려고
② 동물이 가진 능력의 우수성을 알리려고
③ 호랑이가 멸종 위기에 처한 이유를 설명하려고
④ 소셜 네트워킹 사이트(SNS)의 위험성을 경고하려고
⑤ 호랑이 보호를 위한 행동을 실천할 것을 독려하려고

14 윗글의 밑줄 친 우리말과 일치하도록 〈보기〉에 주어진 말을 배열하여 문장을 완성하시오.

〈보기〉 help / big / a / can / they / make / difference

1 다음 대화의 빈칸 (A)~(C)에 들어갈 말로 가장 적절한 것은?

> G: Hey! How was your trip?
> B: It was fun! I went on an eco-tour.
> G: An eco-tour? _____ (A)
> B: It's a kind of tourism. It helps people understand and enjoy nature without harming it. Unfortunately, regular tourism often has a negative effect on the environment.
> G: Oh, I see. _____ (B)
> B: I tried to make more responsible decisions. I chose hostels that use renewable energy, and I traveled around by bicycle. Also, I didn't participate in programs that harm animals.
> G: I get it. _____ (C)
> B: Yes. Earth is home for all of us, so we should take care of it.

> 〈보기〉
> ⓐ I guess there's more to traveling than just having fun.
> ⓑ Could you explain what that is?
> ⓒ Then how was your trip different from a regular tour?

	(A)	(B)	(C)
①	ⓐ	ⓑ	ⓒ
②	ⓑ	ⓐ	ⓒ
③	ⓑ	ⓒ	ⓐ
④	ⓒ	ⓐ	ⓑ
⑤	ⓒ	ⓑ	ⓐ

[2~3] 다음 글을 읽고, 물음에 답하시오.

You can protect tigers simply by switching off the lights. This may sound strange, but it is actually true. An everyday action that helps us save energy can also help ① save an endangered species. How does this (A) work? Let's take a look.

Tigers, one of the world's largest feline species, have long been the kings of Asia's forests. Despite being the dominant predators of their habitats, they move silently and remain ② unseen most of the time. Imagine how ancient people ③ must have felt when encountering tigers in the wild! It is no surprise that tigers have been feared and worshipped by humans for centuries, ④ standing as symbols of power and courage. The fact that ancient rock paintings feature images of tigers ⑤ show how closely tigers have been related to humans throughout history.

2 윗글의 밑줄 친 (A) work와 쓰임이 같은 것은?

① I don't know how to work this machine.
② The pills will work within a few minutes.
③ She worked as a cleaner at the hospital.
④ He works out at the gym three times a week.
⑤ You need to work on your pronunciation to pass the exam.

3 윗글의 밑줄 친 ①~⑤ 중, 어법상 틀린 것은?

① ② ③ ④ ⑤

At one time, tigers were found all across Asia, from Korea to Turkey. However, the world's tiger population has been shrinking ① rapidly. Illegal hunting and habitat loss are the main reasons behind this decrease. At the start of the 20th century, it was estimated ② that there were approximately 100,000 wild tigers. In recent years, however, three of the nine subspecies of tigers ③ has become extinct. In fact, it is now estimated that there ④ are fewer than 4,000 tigers living in the wild. Some experts even predict that the last of the world's wild tigers will ⑤ be disappeared within the next 10 years.

4 윗글에서 호랑이 수가 감소하는 원인을 2개 찾아 우리말로 쓰시오.

_____ , _____

5 윗글의 밑줄 친 ①~⑤ 중, 어법상 틀린 것을 2개 찾아 바르게 고치시오.

	번호	고친 것
(1)		
(2)		

It would be very sad if there were no more wild tigers. (①) Would it really matter, though? (②) After all, we could still see them in zoos or watch programs about them on TV. (③) Shouldn't we be more worried about protecting human beings? (④) The fact is, however, that we need to protect tigers in order to protect ourselves. (⑤)

Think about what would happen if tigers became extinct. Existing at the top of the food chain, ⓐ they maintain the populations of animals ⓑ they prey on, such as deer and boar. Without tigers, ⓒ these species would rapidly

increase in number. As a result, their food source, vegetation, would begin to disappear. This would cause birds and insects to lose ⓓ their homes, and bigger animals that prey on ⓔ them would soon run out of food. Eventually, the entire ecosystem would be affected. Humans are no exception, as we rely on nature for everything we need to survive, including air, food, and water. This is how the disappearance of a single species can _____.

6 윗글의 흐름으로 보아, 주어진 문장이 들어가기에 가장 적절한 곳은?

This is because all of Earth's species are interconnected.

① ② ③ ④ ⑤

7 윗글의 밑줄 친 ⓐ~ⓔ 중, 가리키는 대상이 같은 것끼리 바르게 묶인 것을 고르시오.

① ⓐ, ⓔ ② ⓑ, ⓒ ③ ⓒ, ⓔ
④ ⓓ, ⓔ ⑤ ⓑ, ⓓ

8 윗글의 빈칸에 들어갈 말로 가장 적절한 것은?

① affect its predators
② cause global warming
③ balance an ecosystem
④ prevent years of famine
⑤ threaten the whole planet

9 윗글의 내용과 일치하는 것은?

① With no more wild tigers, we would not see tigers in the future.
② Tigers should not be protected in order to protect human beings.
③ Tigers are at the bottom of the food chain in their ecosystem.
④ If tigers became extinct, deer would easily find vegetation to eat.
⑤ Human beings depend on nature for most things, including air.

10 다음 글의 밑줄 친 ⓐ, ⓑ를 어법에 맞게 고쳐 쓰시오.

Now imagine what would happen if we made the effort to save tigers. Tigers are considered an "umbrella species." This is an ecological term referring to species that live in a large area ⓐ contain a variety of different ecosystems. If we choose to protect these species, we must conserve their habitat. As a result, the other species that share this habitat, including trees and insects, are protected too, as if there ⓑ be a large umbrella being held over them.

ⓐ contain → _____

ⓑ be → _____

[11~13] 다음 글을 읽고, 물음에 답하시오.

Now, it is obvious that we must protect tigers. You may, however, still wonder how switching off the lights helps. ① Well, the lights in our homes require electricity, and more than half of the world's electricity is created by burning fossil fuels. ② When fossil fuels are burned, carbon dioxide is released into the air, and this contributes to climate change. ③ Climate change has a number of negative effects, including rising sea levels that threaten many parts of the world. ④ Burning fossil fuels is bad for the air we breathe. ⑤ One of these places, called the Sundarbans, is an area on the coast of Bangladesh inhabited by a large number of tigers. If Earth's oceans continue to rise, this area could be wiped out and its tiger population could be reduced (A) by as much as 96%. By conserving energy, however, we can slow climate change, and this will slow the rise of the oceans. 그러므로 당신이 방을 나가는 마지막 사람일 때마다 계속 불을 끄도록 하라!

11 윗글의 밑줄 친 ①~⑤ 중, 전체 흐름과 관계 없는 문장은?

① ② ③ ④ ⑤

12 윗글의 밑줄 친 (A) by와 쓰임이 같은 것은?

① She stood by the window.
② They traveled to Chicago by train.
③ Their wages were increased by 15 percent.
④ She had promised to be back by five o'clock.
⑤ The book was translated by a well-known author.

13 윗글의 밑줄 친 우리말과 일치하도록 〈보기〉에 주어진 말을 배열하여 문장을 완성하시오. (필요 시 형태를 변형할 것)

〈보기〉 whenever / last person / to leave

So keep switching off the lights _____

_____!

14 다음 글의 빈칸에 들어갈 말로 가장 적절한 것은?

You can also protect tigers when shopping. Many popular products, including chocolate, instant noodles, and soap, are made with palm oil. Unfortunately, forests where tigers live are being destroyed to build more and more palm oil plantations. Some palm oil, _____, is produced in a more sustainable way. Products that use this environmentally friendly palm oil usually have a special mark on the label. Look for it the next time you go shopping!

① unfortunately ② in addition
③ however ④ for instance
⑤ moreover

1 주어진 질문에 대한 대답을 다음 대화에서 찾아 쓰시오.

> A: Our modern lifestyles are damaging the environment.
> B: You're right. We should take action.
> A: Do you have any ideas about what we can do?
> B: We can buy seasonal and local fruits and vegetables.
> A: Could you explain how that helps reduce our impact on the environment?
> B: Yes. Seasonal and local foods require less energy and packaging when they're stored and transported. Therefore, they're better for the environment.
> A: I see. I'll keep that in mind when I go grocery shopping.

Q: What can we do to protect our environment?

A: _____

2 다음 글의 밑줄 친 우리말과 일치하도록 〈보기〉에 주어진 말을 배열하여 문장을 완성하시오.

> Tigers, one of the world's largest feline species, have long been the kings of Asia's forests. Despite being the dominant predators of their habitats, they move silently and remain unseen most of the time. Imagine how ancient people must have felt when encountering tigers in the wild! It is no surprise that tigers have been feared and worshipped by humans for centuries, standing as symbols of power and courage. The fact that ancient rock paintings feature images of tigers shows 역사에 걸쳐서 호랑이들이 인간과 얼마나 밀접하게 관련되어 왔는지.

〈보기〉 have been related / closely / tigers / to / humans / how

_____ throughout history

3 다음 글의 밑줄 친 ⓐ~ⓓ 중, 어법 상 틀린 것을 2개 찾아 바르게 고치시오. (단, 기호, 틀린 것, 고친 것이 모두 맞을 때만 정답으로 인정함)

> ⓐ At one time, tigers were found all across Asia, from Korea to Turkey. ⓑ However, the world's tiger population has been shrinking rapid. Illegal hunting and habitat loss are the main reasons behind this decrease. At the start of the 20th century, it was estimated that there were approximately 100,000 wild tigers. ⓒ In recent years, however, three of the nine subspecies of tigers have become extinct. In fact, it is now estimated that there are fewer than 4,000 tigers living in the wild. ⓓ Some experts even predict what the last of the world's wild tigers will disappear within the next 10 years.

	기호	틀린 것 (틀린 부분만 쓸 것)	고친 것
(1)			
(2)			

It would be very sad if there were no more wild tigers. Would it really matter, though? After all, we could still see them in zoos or watch programs about them on TV. Shouldn't we be more worried about protecting human beings? The fact is, however, that we need to protect tigers in order to protect ourselves. This is because all of Earth's species are interconnected.

Think about what would happen if tigers became extinct. Existing at the top of the food chain, they maintain the populations of animals they prey on, such as deer and boar. Without tigers, these species would rapidly increase in number. As a result, their food source, vegetation, would begin to disappear. This would cause birds and insects to lose their homes, and bigger animals that prey on them would soon run out of food. Eventually, the entire ecosystem would be affected. Humans are no exception, as we rely on nature for everything we need to survive, including air, food, and water. This is how the disappearance of a single species can threaten the whole planet.

4 윗글의 제목으로 빈칸에 들어가기에 가장 적절한 단어를 찾아 쓰시오.

Entirely _____ World

5 윗글의 밑줄 친 문장을 다음과 같이 바꿔 쓸 때, 빈칸에 알맞은 말을 쓰시오.

Without tigers, these species would rapidly increase in number.
→ (1) _____ _____ _____ ,
these species would rapidly increase in number.
→ (2) _____ _____
_____ _____ _____ , these
species would rapidly increase in number.

6 다음 글의 빈칸에 들어갈 단어를 영영 뜻풀이를 참고하여 쓰시오. (단, 주어진 글자로 시작할 것)

Now imagine what would happen if we made the effort to save tigers. Tigers are considered an "umbrella species." This is an ecological term referring to species that live in a large area containing a variety of different ecosystems. If we choose to protect these species, we must _____ their habitat. As a result, the other species that share this habitat, including trees and insects, are protected too, as if there were a large umbrella being held over them.

to make sure that something such as the environment is not used, damaged, or destroyed

c_____

Now, it is obvious that we must protect tigers. You may, however, still wonder how switching off the lights helps. Well, the lights in our homes require electricity, and more than half of the world's electricity is created by burning fossil fuels. When fossil fuels are burned, carbon dioxide is released into the air, and this contributes to climate change. Climate change has a number of negative effects, including rising sea levels that threaten many parts of the world. One of these places is an area on the coast of Bangladesh inhabited by a large number of tigers. If Earth's oceans continue to rise, (A) this area could be wiped out and its tiger population could be reduced by as much as 96%. By conserving energy, however, we can slow climate change, and this will slow the rise of the oceans. So keep switching off the lights whenever you're the last person to leave a room!

7 다음은 방의 불을 켜는 행동이 호랑이 개체 수 감소에 영향을 미치는 과정을 정리한 내용이다. 빈칸에 들어갈 내용을 윗글에서 찾아 우리말로 쓰시오. (15자 내외)

> 전기를 생산하기 위해 화석 연료를 태움 → ___(1)___
> → 기후 변화를 야기함 → 해수면이 상승함 →
> ___(2)___ → 호랑이 개체 수가 줄어듦

(1) _____

(2) _____

8 윗글의 밑줄 친 (A) this area가 가리키는 것을 찾아 쓰시오. (7단어)

9 다음 글의 내용을 한 문장으로 요약할 때, 빈칸에 들어갈 말을 찾아 쓰시오.

> You can also protect tigers when shopping. Many popular products, including chocolate, instant noodles, and soap, are made with palm oil. Unfortunately, forests where tigers live are being destroyed to build more and more palm oil plantations. Some palm oil, however, is produced in a more sustainable way. Products that use this environmentally friendly palm oil usually have a special mark on the label. Look for it the next time you go shopping!

↓

> Even buying products made with _____
> _____ palm oil can help you protect tigers.

10 다음 밑줄 친 우리말과 일치하도록 〈보기〉에 주어진 말을 배열하여 문장을 완성하시오.

> There are many other things you can do to protect tigers and other endangered species. You could volunteer at a nonprofit organization or share important information on social networking sites. 당신의 활동들이 아무리 사소한 것처럼 보일지라도, they can help make a big difference. Most importantly, you must remember that we all share the same planet. If a single species disappears, every other living creature, including human beings, could be affected.

〈보기〉 may / small / your / seem / however / actions

11 다음 밑줄 친 우리말과 일치하도록 〈보기〉에 주어진 말을 배열하여 문장을 완성하시오.

> Baked Pork Chops Recipe
> Ingredients: boneless pork chops, olive oil, garlic, salt, pepper
> Instructions: Preheat the oven to 350 degrees. 여러분의 오븐이 뜨거워지기를 기다리는 동안, smash the garlic and mix it with the olive oil. Put the mixture in an oven-safe pan. Add the trimmed pork chops to the mixture. Season the pork chops with some salt and pepper. When seasoning, make sure you don't use too much salt. Bake them for 25 minutes, turning the chops twice while cooking.

〈보기〉 wait for / your / heat up / to / oven / while

〈조건〉
• 주어진 표현만 사용할 것
• 필요 시 형태를 변형할 것

1 다음 대화의 빈칸에 들어가기에 적절하지 <u>않은</u> 것은?

> A: Lisa, you look down. What's the matter?
>
> B: I want to sing well, but I'm not good at it.
>
> A: Don't be discouraged. You'll get better if you try to improve.
>
> B: Yeah, you are right. Maybe I should practice breathing properly while singing.
>
> A: That sounds like a good idea. I think you can also _____.
>
> B: All right, I'll try that, too.

① find free voice training videos on the Internet
② find someone who can teach you how to sing
③ ask your music teacher to help you sing better
④ give up trying to sing well and forget about it
⑤ record your voice so that you can check it out

2 (A), (B), (C)의 각 네모 안에서 문맥에 맞는 낱말로 가장 적절한 것은?

> Paul used to be a member of church choirs, and he (A) inspired / aspired to be an opera singer. One day, he was told by a world-famous opera singer that he wasn't talented enough. Although he had suffered from cancer and had been in a bicycle accident, he auditioned for Britain's Got Talent when he was 37. He won the show with his (B) ordinary / impressive singing. This is a heart-touching movie about a man who pursued his dream in spite of (C) adversity / assistance.

	(A)		(B)		(C)
①	inspired	···	ordinary	···	adversity
②	inspired	···	impressive	···	adversity
③	aspired	···	ordinary	···	assistance
④	aspired	···	impressive	···	adversity
⑤	aspired	···	impressive	···	assistance

3 다음 글의 밑줄 친 ⓐ~ⓔ 중, 가리키는 대상이 나머지 넷과 <u>다른</u> 것은?

> From the first day that I brought ⓐ <u>a penguin</u> to live at the school, one student in particular wanted to help with his care. His name was Diego Gonzales. Diego was a shy boy who seemed to be frightened of his own shadow. ⓑ <u>He</u> struggled with his classes, and none of the after-school activities seemed to suit him. ⓒ <u>He</u> was neither strong nor athletic. On the rugby field, nobody passed the ball to ⓓ <u>him</u> or involved him in the game, except to make fun of ⓔ <u>him</u>.

① ⓐ ② ⓑ ③ ⓒ ④ ⓓ ⑤ ⓔ

4 다음 글의 밑줄 친 ①~⑤ 중, 어법상 <u>틀린</u> 것은?

> Diego's early education had not ① <u>prepared</u> him well for life at his new school. His knowledge of English was limited, so he avoided conversation. However, Diego enjoyed the company of Juan Salvado. Indeed, on the terrace, Diego could relax. He had some friends who also had trouble ② <u>fitting in</u>. Looking after Juan Salvado was good for those boys. They fed him fish, swept the terrace, and ③ <u>spending</u> time with him.
>
> One day, I took Juan Salvado to the school swimming pool with the boys. As soon as the other swimmers left, we brought Juan Salvado to the water to see ④ <u>if</u> he would swim. Juan Salvado had been living at the school for several months by then. However, in all that time, he had never been able to swim because his feathers had ⑤ <u>been damaged</u>.

① ② ③ ④ ⑤

5 다음 글의 밑줄 친 (A) that과 쓰임이 같은 것은?

I had never had the opportunity to study a penguin in the water before. I was familiar with the awkward way (A) that Juan Salvado walked on land, but now I watched in awe. Using only a stroke or two, he flew at great speed from one end of the pool to the other, turning swiftly before touching the sides. It was amazing! Everyone could see how much he was enjoying himself.

"Ooh! Aah!" The boys shouted, as though they were watching a fireworks display. After a while, Diego came over and asked quietly, "Can I swim, too?"

① I think that milk is good for my health.
② No one can deny the fact that you're guilty.
③ We need a person that is right for the job.
④ It's true that she will leave the company.
⑤ This is the reason that he solved the puzzle quickly.

6 다음 글의 밑줄 친 우리말과 일치하도록 빈칸을 완성하시오. (단, not으로 시작할 것)

However, I soon realized that I did not have anything to worry about. Diego는 수영을 할 수 있었을 뿐만 아니라, 훌륭하게 수영을 해냈다! He chased after Juan Salvado, and they swam in perfect harmony. It was like a duet written for violin and piano. Sometimes Juan Salvado took the lead and Diego followed after him. At other times Diego went ahead and the penguin swam around the boy. Occasionally they swam so close that they almost touched.

_____ _____ _____ _____
_____, but he swam magnificently!

7 다음 글의 밑줄 친 ①~⑤ 중, 문맥상 낱말의 쓰임이 적절하지 않은 것은?

The events of that day were ① extraordinary. A child had gone down to the water to swim with a penguin, and shortly afterward, a young

man had emerged. The ugly duckling had become a swan. It was definitely a ② turning point. Diego's ③ confidence grew quickly after that day. When the school had a swimming competition, he won every race he participated in. The ④ discouragement and acknowledgement given by the other boys was genuine. He had earned the respect of his classmates. Over the next few weeks, his grades improved and he became more ⑤ popular. Thanks to a swim with a penguin, a lonely boy's life was changed forever.

① ② ③ ④ ⑤

8 다음 글의 흐름으로 보아, 주어진 문장이 들어가기에 가장 적절한 곳은?

At first, I wasn't a fast runner or a good kicker.

(①) In high school, I achieved my goal of becoming a skilled soccer player. (②) When I was a first-year student, I joined my school's soccer team. (③) However, I didn't let my limitations hold me back. (④) I practiced everyday, and I was always the last student to leave the field. (⑤) It was hard work, but I kept believing that I would reach my goal. However, I got better and better. By the end of my junior year, I was the team's top scorer. This experience helped me believe in my own potential. Now I believe I can achieve my goals if I try my hardest.

① ② ③ ④ ⑤

9 다음 글의 흐름으로 보아, 주어진 문장이 들어가기에 가장 적절한 곳은?

Soon, all the seats in the white zone were taken.

On December 1, 1955, in the American city of Montgomery, Alabama, a black woman named Rosa Parks got on a bus. At that time in Montgomery, buses were divided into two

zones: one for black people and the other for white people. (①) She took a seat in the black zone and watched quietly as more and more passengers got on the bus. (②) Then the driver ordered her to give her seat to a white passenger. Rosa Parks was a shy, mild-mannered introvert. (③) She avoided standing out in public or drawing attention to herself. (④) However, she had the courage to resist injustice, so she answered calmly with a single word—"No." The furious driver called the police, and she was arrested. (⑤)

① ② ③ ④ ⑤

10 (A), (B), (C)의 각 네모 안에서 문맥에 맞는 낱말로 가장 적절한 것은?

Parks's calm response to the situation impressed many people. Soon after, her quiet resistance came together with the inspirational speechmaking of Martin Luther King Jr. When 5,000 people assembled at a rally to support Parks's act of courage, King made a speech to the crowd. He was an (A) introvert / extrovert —assertive, sociable, and good at motivating people. "There comes a time when people get tired of being (B) trampled / obeyed ," he told them. "There comes a time when people get tired of being pushed out of the sunlight." King was an amazing speaker, and his words filled the people with pride and hope. He then praised Parks's (C) bravery / slavery and hugged her. She stood silently. Her mere presence was enough to strengthen the crowd.

	(A)	(B)	(C)
①	extrovert	⋯ trampled	⋯ slavery
②	introvert	⋯ trampled	⋯ bravery
③	extrovert	⋯ trampled	⋯ bravery
④	introvert	⋯ obeyed	⋯ slavery
⑤	extrovert	⋯ obeyed	⋯ bravery

11 다음 글의 빈칸 (A), (B)에 공통으로 들어갈 말로 가장 적절한 것은?

Rosa Parks's act and Martin Luther King

Jr.'s speech inspired Montgomery's black community to boycott the buses, a crucial turning point in the struggle for civil rights. The boycott lasted for 381 days. It was a difficult time for everyone, but eventually the buses were integrated. Think about how the ___(A)___ of these two people accomplished this. A powerful speaker refusing to give up his seat on a bus would not have had the same effect. Similarly, Rosa Parks could not have excited the crowd at the rally with her words. When their introverted and extroverted traits were combined, however, his charisma attracted attention to her quiet bravery. In the end, this ___(B)___ had a huge impact on society.

① research ② patience
③ opportunity ④ partnership
⑤ development

12 다음 글의 밑줄 친 우리말과 일치하도록 〈보기〉에 주어진 말을 배열하여 문장을 완성하시오.

On June 29, 1975, Steve Wozniak tapped a few keys on his keyboard, and letters appeared on a screen. 그는 사람들이 키보드를 치는 동시에 모니터에서 결과를 볼 수 있게 해주는 개인용 컴퓨터를 갓 만들어 냈다. At the sight of the brilliant device, Steve Jobs suggested to Wozniak that they start a business. Wozniak was a great inventor. When he partnered with Jobs, however, he was able to do much more. In fact, the two men formed one of the most famous partnerships of the digital era. Wozniak would come up with a clever engineering idea, and Jobs would find a way to polish, package, and sell it.

〈보기〉 see / allowed / the results / people / on a monitor / and / on a keyboard / to type

He had just created a personal computer that

simultaneously.

13 (A), (B)의 각 네모 안에서 문맥에 맞는 낱말을 쓰시오.

> Wozniak was a shy inventor, whereas Jobs was a daring entrepreneur, but they were (A) different / alike in that neither was afraid to face challenges that seemed impossible. So which personality type is better? Obviously, the answer is neither. The world needs both introverts and extroverts, and they often make a (B) terrible / terrific team. We simply need to respect different personalities as well as our own. Then, when we have a chance to work together, we might be able to do great things!

(A) _____ (B) _____

14 다음 글의 밑줄 친 우리말과 일치하도록 〈보기〉에 주어진 말을 배열하여 문장을 완성하시오. (필요 시 형태를 변형할 것)

> To whom it may concern:
>
> Last month, I asked you to deliver a printer by June 10. However, it arrived a week late. What's more, when I opened the box, I saw that the printer was damaged. 사실, 그것은 이전에 사용된 적이 있던 것처럼 보였다. I want you to explain why these problems occurred. Moreover, I expect you to replace the delivered printer with a new one.

> 〈보기〉 be used / to / it / appear / have / before

In fact, _____.

15 다음 글의 밑줄 친 부분과 같이 행동한 이유를 40자 내외의 우리말로 쓰시오. (단, 영단어는 한 글자로 취급)

> Dear Mia,
>
> I would like to apologize for what I did yesterday. I yelled at you and said you were not putting enough effort into the project.
>
> The reason I acted that way was because you didn't speak much during the discussion and I thought that meant you weren't focusing. However, I was embarrassed to see how much research you had done. As a careful person, you needed time to organize your thoughts

before expressing them. However, I didn't give you that chance. I feel really sorry. I hope you will forgive me and keep up the excellent work.

16 다음 대화의 내용을 나타내는 속담으로 가장 적절한 것은?

> A: Look at this! A college student and a senior citizen are living together.
> B: Really? Why are they doing that?
> A: It's because they can help each other. The senior citizen provides the student with a room to stay in, and the student helps him feel less lonely.
> B: Wow. That sounds good. By living together, they both can be happier.
> A: Exactly. I think it's important to understand that we can live better if we help each other.
> B: I agree with you.

① Don't cry over spilled milk.
② A friend in need is a friend indeed.
③ Don't judge a book by its cover.
④ A good book is your best friend.
⑤ You scratch my back, I'll scratch yours.

17 다음 대화의 빈칸에 들어갈 말로 적절하지 <u>않은</u> 것은?

> A: Our modern lifestyles are damaging the environment.
> B: You're right. _____
> A: Do you have any ideas about what we can do?
> B: Well, we can buy seasonal and local fruits and vegetables.
> A: Could you explain how that helps reduce our impact on the environment?
> B: Yes, seasonal and local foods require less energy and packaging when they're stored and transported. Therefore, they're better for the environment.
> A: I see. I'll keep that in mind when I go grocery shopping.

① It's time to do something for the environment.
② We should take action before it's too late.
③ The problem is that we don't know what to do.
④ We should do what we can to preserve the environment.
⑤ People are indifferent to environmental problems.

18 다음 글의 밑줄 친 ①~⑤ 중, 어법상 옳은 것을 2개 고르시오.

Tigers, one of the world's largest feline species, ① <u>has</u> long been the kings of Asia's forests. Despite ② <u>being</u> the dominant predators of their habitats, they move silently and remain unseen most of the time. Imagine how ancient people must have felt when ③ <u>encountering</u> tigers in the wild! It is no surprise that tigers have been feared and worshipped by humans for centuries, ④ <u>stand</u> as symbols of power and courage. The fact ⑤ <u>which</u> ancient rock paintings feature images of tigers shows how closely tigers have been related to humans throughout history.

① ② ③ ④ ⑤

19 다음 글의 흐름으로 보아, 주어진 문장이 들어가기에 가장 적절한 곳은?

In recent years, however, three of the nine subspecies of tigers have become extinct.

At one time, tigers were found all across Asia, from Korea to Turkey. (①) However, the world's tiger population has been shrinking rapidly. (②) Illegal hunting and habitat loss are the main reasons behind this decrease. (③) At the start of the 20th century, it was estimated that there were approximately 100,000 wild tigers. (④) In fact, it is now estimated that there are fewer than 4,000 tigers living in the wild. (⑤) Some experts even predict that the last of the world's wild tigers will disappear within the next 10 years.

① ② ③ ④ ⑤

20 (A), (B), (C)의 각 네모 안에서 문맥에 맞는 낱말로 가장 적절한 것은?

Think about what would happen if tigers became extinct. Existing at the top of the food chain, they maintain the populations of animals they prey on, such as deer and boar. Without tigers, these species would rapidly (A) decrease / increase in number. As a result, their food source, vegetation, would begin to disappear. This would cause birds and insects to lose their homes, and bigger animals that prey on them would soon run out of food. Eventually, the entire ecosystem would be (B) affected / protected . Humans are no exception, as we rely on nature for everything we need to survive, including air, food, and water. This is how the (C) appearance / disappearance of a single species can threaten the whole planet.

	(A)		(B)		(C)
①	increase	⋯	affected	⋯	appearance
②	decrease	⋯	affected	⋯	disappearance
③	increase	⋯	affected	⋯	disappearance
④	decrease	⋯	protected	⋯	disappearance
⑤	decrease	⋯	protected	⋯	appearance

21 다음 글의 빈칸 (A), (B), (C)에 공통으로 들어갈 말을 한 단어로 쓰시오. (대소문자는 관계 없음)

Now imagine what would happen _____(A)_____ we made the effort to save tigers. Tigers are considered an "umbrella species." This is an ecological term referring to species that live in a large area containing a variety of different ecosystems. _____(B)_____ we choose to protect these species, we must conserve their habitat. As a result, the other species that share this habitat, including trees and insects, are protected too, as _____(C)_____ there were a large umbrella being held over them.

22 주어진 문장 다음에 이어질 글의 순서로 가장 적절한 것은?

Now, it is obvious that we must protect tigers.

(A) If Earth's oceans continue to rise, this area could be wiped out and its tiger population could be reduced by as much as 96%. By conserving energy, however, we can slow climate change, and this will slow the rise of the oceans.

(B) When fossil fuels are burned, carbon dioxide is released into the air, and this contributes to climate change. Climate change has a number of negative effects, including rising sea levels that threaten many parts of the world. One of these places, called the Sundarbans, is an area on the coast of Bangladesh inhabited by a large number of tigers.

(C) You may, however, still wonder how switching off the lights helps. Well, the lights in our homes require electricity, and more than half of the world's electricity is created by burning fossil fuels.

① (A) – (C) – (B) ② (B) – (A) – (C)
③ (B) – (C) – (A) ④ (C) – (B) – (A)
⑤ (C) – (A) – (B)

23 다음 영영 뜻풀이에 해당하는 단어를 찾아 쓰시오.

There are many other things you can do to protect tigers and other endangered species. You could volunteer at a nonprofit organization or share important information on social networking sites. However small your actions may seem, they can help make a big difference.

seriously at risk of extinction; almost extinct

24 다음 대화의 빈칸에 들어갈 말로 적절하지 <u>않은</u> 것은?

A: Did you have an argument with David?
B: No, I just get annoyed with him sometimes. He talks as if he knew everything.
A: What were you guys talking about?
B: It was related to our homework. He kept explaining the problems to me as if I didn't know how to do them myself.
A: Oh. _____
B: Yeah. Anyway, we're fine now.

① I would have felt that way, too.
② It seems that he is still mad at you.
③ That's how he talks all the time.
④ I guess that's just his personality.
⑤ I don't think he had any bad intention.

25 다음 도표의 내용과 일치하지 <u>않는</u> 것은?

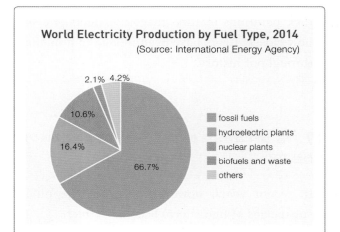

World Electricity Production by Fuel Type, 2014
(Source: International Energy Agency)

2.1% 4.2%
10.6%
16.4%
66.7%

fossil fuels
hydroelectric plants
nuclear plants
biofuels and waste
others

This graph shows how electricity was generated globally in 2014. ① According to the graph, the primary source of electricity was fossil fuels, accounting for 66.7%. ② Next was hydroelectric plants at 16.4%, followed by nuclear plants at 10.6%. ③ Biofuels and waste produced only 2.1%. ④ Other sources account for 4.2%, which makes up the smallest portion among all fuel types. ⑤ From this graph, we can see that fossil fuels are the world's main power source, producing much more electricity than renewable sources, such as hydroelectric plants and biofuels.

① ② ③ ④ ⑤

Lesson

04

Build a Better World

핵심 단어 · 숙어

Words

- heritage 명 (국가 · 사회의) 유산
- exhibition 명 전시회
 - exhibit 동 전시하다, 진열하다
- occupation 명 점령
- inherit 동 상속받다, 물려받다
 - inheritance 명 상속 (재산); 유산
- massive 형 거대한
- independence 명 독립 (↔ dependence)
- keen 형 예리한
- insight 명 통찰력
- conviction 명 (강한) 신념
 - convince 동 확신[납득]시키다
- devote 동 (~에) 바치다, 쏟다 (= dedicate)
- represent 동 나타내다, 상징하다 (= stand for, symbolize)
- scenery 명 경치, 풍경
- surrounding 형 인근의, 주위의 (= nearby)
- inviting 형 유혹[매력]적인
- kindling 명 불쏘시개
- rescue 동 (위험에서) 구하다
- purchase 동 구입하다
- ash 명 재
- appreciate 동 진가를 알아보다, 감상하다
 - appreciation 명 감상; 감사
- gorgeous 형 아주 멋진
- porcelain 명 자기(磁器)
- celadon 명 청자(색)

- inlaid 형 무늬를 새긴
- crane 명 학, 두루미
- shade 명 색조
- encircle 동 둘러싸다, 두르다
- breathtaking 형 (너무 아름답거나 놀라워서) 숨이 막히는[멎는 듯한]
- occupy 동 점령하다
- colonial 형 식민(지)의
 - colony 명 식민지
- intend 동 의도하다
- forbid 동 금(지)하다 (= ban, prohibit)
- scholar 명 학자
- obtain 동 얻다
- defeat 동 패배시키다
- origin 명 기원, 근원
- fundamental 명 기본 원칙
- designate 동 지정하다
- register 명 기록부, 명부
- commitment 명 전념, 헌신
- preserve 동 지키다, 보호하다 (= protect)
- identity 명 독자성
- harsh 형 혹독한
- regain 동 되찾다
- defend 동 방어하다 (= guard, protect)
- essential 형 극히 중요한
- found 동 설립하다 (found-founded-founded)

Phrases

- cannot help but ~하지 않을 수 없다
 - (= cannot help v-ing)
- in search of ~을 찾아서

- part with ~을 내주다
- get rid of ~을 없애다
- at all costs 무슨 수를 써서라도

Vocabulary Check-Up

정답 및 해설 p.25

다음 영어는 우리말로, 우리말은 영어로 쓰시오.

01	found	통	___	23	명 (강한) 신념	___
02	essential	형	___	24	명 학자	___
03	at all costs		___	25	통 의도하다	___
04	defend	통	___	26	~을 없애다	___
05	surrounding	형	___	27	명 독립	___
06	part with		___	28	명 전념, 헌신	___
07	identity	명	___	29	통 지정하다	___
08	encircle	통	___	30	명 기원, 근원	___
09	register	명	___	31	통 패배시키다	___
10	fundamental	명	___	32	명 통찰력	___
11	occupation	명	___	33	형 예리한	___
12	forbid	통	___	34	형 식민(지)의	___
13	breathtaking	형	___	35	통 점령하다	___
14	preserve	통	___	36	~을 찾아서	___
15	shade	명	___	37	~하지 않을 수 없다	___
16	inlaid	형	___	38	통 상속받다, 물려받다	___
17	heritage	명	___	39	통 진가를 알아보다, 감상하다	___
18	porcelain	명	___	40	명 전시회	___
19	celadon	명	___	41	통 구입하다	___
20	rescue	통	___	42	명 경치, 풍경	___
21	kindling	명	___	43	통 나타내다, 상징하다	___
22	inviting	형	___	44	통 (~에) 바치다, 쏟다	___

예제 ▶ The repairman finally opened the door **locked from the inside**.
수리공은 마침내 안에서 잠긴 문을 열었다. ┗━━ 명사 the door를 뒤에서 수식하는 과거분사구

교과서 ▶ Last week, I visited an exhibition of artwork and ancient items **selected from the Kansong Art Museum's collection**.
┗━ 명사구 artwork and ancient items를 뒤에서 수식하는 과거분사구
지난주, 나는 간송 미술관 소장품에서 선별된 미술품과 골동품 전시회에 방문했다.

▶ 분사가 명사를 수식할 때, 명사와 분사가 수동 관계이면 과거분사를 쓴다. 과거분사가 단독으로 쓰이는 경우에는 대개 명사 앞에서 수식하지만, 과거분사에 수식어(구)나 목적어, 보어 등이 이어져 구를 이룰 경우에는 명사 뒤에서 수식한다.

내신출제 Point

 분사(구)의 위치

the **hidden** treasure 숨겨진 보물

▶ 과거분사 hidden이 단독으로 명사를 수식하므로 명사 앞에 위치

the treasure **hidden in the sand** 모래에 숨겨진 보물

▶ 과거분사 hidden에 수식어구 in the sand가 함께 쓰여 과거분사구를 이루므로 명사 뒤에 위치

Test Point 2 **명사와 분사와의 관계**

명사와 분사와의 관계가 능동·진행이면 현재분사를, 수동·동작의 완료이면 과거분사를 쓴다.
He came into the garage to see a **barking** dog. 그는 짖고 있는 개를 보기 위해 차고로 들어갔다.

The vet examined the **abandoned** dog for a long time. 수의사는 버려진 개를 오랫동안 진찰했다.

Point Check-Up

정답 및 해설 p.25

1 다음 괄호 안의 단어를 활용하여 빈칸을 완성하시오.

(1) They surrounded the pedestrian _____ by a car. (hit)

(2) There are a lot of people _____ fake items on the Internet. (sell)

(3) The students in the literature class were reading a book _____ in French. (write)

Point 2 if절 대신 without구가 쓰인 가정법 과거완료

예제 **Without** your advice, I **couldn't have finished** the project.
네 조언이 없었다면, 나는 프로젝트를 끝마칠 수 없었을 것이다.

교과서 **Without** his actions, they **would have been destroyed or taken** overseas.
그의 행동이 없었다면, 그것들은 파괴되거나 해외로 반출되었을 것이다.

--

▶ 과거 사실의 반대를 가정할 때 쓰는 가정법 과거완료는 「If+주어+had v-ed, 주어+조동사의 과거형+have v-ed」로 나타낸다.

▶ if절에 '~이 없었다면'의 의미를 나타내는 「if it had not been for ~」가 쓰일 때 이를 「without+명사(구)」로 바꿔 쓸 수 있다. 이때 without구는 「but for ~」로 바꿔 쓸 수도 있다.

내신출제 Point

 가정법 과거완료 구문에서 쓰인 without 대체 어구

If it had not been for her, we **would have lost** the final game.

= **Without** her, we **would have lost** the final game.

= **But for** her, we **would have lost** the final game.

그녀가 없었다면, 우리는 결승전에서 졌을 것이다.

 if절 대신 without구가 쓰인 가정법 과거

가정법 과거는 「If+주어+동사의 과거형, 주어+조동사의 과거형+동사원형」으로 나타내며, 현재 사실의 반대를 가정할 때 쓴다. if절이 「if it were not for ~」일 때, 이를 「without ~」이나 「but for ~」로 바꿔 쓸 수 있다.

If it were not for the Sun, nothing **could live** on Earth.

= **Without** the Sun, nothing **could live** on Earth.

= **But for** the Sun, nothing **could live** on Earth.

태양이 없다면, 아무 것도 지구에 살 수 없을 것이다.

Point Check-Up

정답 및 해설 p.25

2 다음 네모 안에서 어법상 알맞은 것을 고르시오.

(1) Without her help, I wouldn't be / wouldn't have been the person I am today.

(2) If it had not been for CCTV, the criminal wouldn't be / wouldn't have been caught.

(3) Without your warning, we would be / would have been unaware of the danger yesterday.

01 다음 괄호 안의 단어를 빈칸에 알맞은 형태로 고쳐 쓰시오.

(1) She tested a new alert system _____ to keep people safe. (design)

(2) There used to be lots of people _____ to learn foreign languages. (want)

(3) The _____ soldiers were carried from the battlefield to hospitals. (wound)

02 다음 밑줄 친 부분을 어법에 맞게 고쳐 쓰시오.

(1) If it <u>were not for</u> the receipt, he couldn't have gotten a full refund for the shoes yesterday.

→ _____

(2) Without my parent's support, I <u>couldn't travel</u> around Europe last year.

→ _____

(3) If it <u>had not been for</u> the GPS, Karl would always get lost.

→ _____

03 다음 괄호 안의 단어를 바르게 배열하여 문장을 완성하시오.

(1) Kelly met (people / interested / some / in) classical music at the party.

→ _____

(2) He took a picture of (by / loved / a famous actor) many people.

→ _____

(3) This movie is based on (languages / a book / translated into / twelve).

→ _____

04 주어진 우리말과 일치하도록 괄호 안의 단어를 활용하여 문장을 완성하시오.

(1) 그의 부상이 없었다면, 그는 국가대표 축구팀의 멤버가 될 수 있었을 것이다. (can, become)

→ But for his injury, he _____ a member of the national football team.

(2) 휴대전화가 없다면, 나는 여기서 외로울 텐데. (would, be)

→ Without my cell phone, I _____ lonely here.

(3) 오빠의 조언이 없었다면, 나는 나의 목표를 포기했을 것이다. (it, be)

→ If _____ my brother's advice, I would have given up on my goal.

05 주어진 우리말과 일치하도록 보기 에서 적절한 단어를 골라 빈칸에 알맞은 형태로 쓰시오. 교과서 p.103

> 보기 inspire produce direct instruct

> *Beautiful Heart* is a new movie (1) _____ by Twin Pictures.
> (「아름다운 마음」은 Twin Pictures에 의해 제작된 새 영화이다.)
> • A movie (2) _____ by a true story
> (실화에서 영감을 받은 영화)
> • The third movie (3) _____ by Andrew Holmes
> (Andrew Holmes에 의해 연출된 세 번째 영화)

06 다음 괄호 안의 단어를 바르게 배열하여 문장을 완성하시오. 교과서 p.103

> I am honored to receive this year's school volunteerism award. I want to thank my teacher, Mr. Johnson. Without his encouragement, (1) (have / not / volunteering I / started / would) at local libraries. I also want to ask my fellow students to volunteer in our community. Without volunteers, (2) (not / have / could / become / our community) such a lovely place. Thank you so much for this award, and I hope that you will all join me in volunteering in our community.

(1) _____

(2) _____

07 다음 중 어법상 <u>틀린</u> 것으로 바르게 짝지어진 것은?

> ⓐ One of the foods enjoyed by foreigners in Korea is *samgyeopsal*.
> ⓑ She developed the profiles of the criminals arresting in the case.
> ⓒ If it had not been for your call, I would have been late for the meeting.
> ⓓ But for this flashlight, they couldn't have found the exit in the darkness.
> ⓔ Without the coupon, she couldn't buy this bag at a cheaper price last week.

① ⓐ, ⓒ ② ⓐ, ⓓ ③ ⓑ, ⓒ ④ ⓑ, ⓔ ⑤ ⓑ, ⓓ, ⓔ

A Protector of Our National Heritage

01 *Yunju, a high school student, went to a Korean art exhibition. She wrote a report about her*
〈삽입어구〉
experience [to share with her class].
부사적 용법 〈목적〉

고등학생인 윤주는 한국 미술 전시회에 갔었다. 그녀는 반 친구들과 공유하기 위해 그녀의 경험에 대한 보고서를 작성했다.

02 Last week, I visited an exhibition of artwork and ancient items [selected from the Kansong Art
과거분사구
Museum's collection].

지난주, 나는 간송 미술관 소장품에서 선별된 미술품과 골동품 전시회에 방문했다.

03 The exhibition included information about the man [who gathered all of the artwork [displayed
주격 관계대명사절 · · · · 과거분사구
there]].

그 전시회는 그곳에 전시된 모든 미술품을 모은 남자에 대한 정보를 포함했다.

04 His name was Jeon Hyeongpil, but he is better known by his pen name, Kansong. He was born
=
into a rich family in 1906 and lived through the Japanese occupation of Korea.
live through: ~을 겪다

그의 이름은 전형필이지만, 그는 필명인 간송으로 더 잘 알려져 있다. 그는 1906년 부유한 집안에서 태어났고 한국의 일제 강점기를 겪었다.

05 At the age of 24, he inherited a massive fortune. After carefully thinking about [what he could
~의 나이에 · · · · · 간접의문문
do for his country], he decided to use the money [to protect Korea's cultural heritage from the
명사적 용법 (decided의 목적어) · · · 부사적 용법 〈목적〉
Japanese].

24세에, 그는 막대한 재산을 물려받았다. 조국을 위해 자신이 무엇을 할 수 있을지에 대해 심사숙고한 후에, 그는 일본으로부터 한국의 문화유산을 보호하는 데 그 돈을 쓰기로 결심했다.

06 This decision was greatly influenced by his mentor, Oh Sechang, [who was an independence
= · · · · 계속적 용법의 주격 관계대명사절
activist and had keen insight into Korean art].
예리한

이 결정은 그의 스승인 오세창에 의해 크게 영향을 받았는데, 오세창은 독립운동가이면서 한국 미술에 날카로운 통찰력을 가지고 있었다.

07

With Oh's guidance and his own convictions, Kansong devoted most of his fortune to [acquiring

devote+목적어+to v-ing: ~을 …하는 데 바치다

old books, paintings, and other works of art].
동명사구 (전치사 to의 목적어)

오세창의 지도와 자신의 강한 신념으로, 간송은 그의 재산 대부분을 오래된 책, 그림, 그리고 다른 미술품을 획득하는 데 바쳤다.

08

주어　　동사1

He considered these items the pride of the nation and believed [they represented the national

동사2

consider A B: A를 B로 여기다　　접속사 that　　명사절 (believed의 목적어)

spirit].

그는 이러한 물품들을 나라의 긍지로 여겼고, 그것들이 민족혼을 나타낸다고 믿었다.

09

= If it had not been for ~, But for ~

Without his actions, they would have been destroyed or taken overseas.

가정법 과거완료 「Without ~, 주어+조동사의 과거형+have v-ed」: ~이 없었다면, …했을 텐데

그의 행동이 없었다면, 그것들은 파괴되거나 해외로 반출되었을 것이다.

10

cannot help but+동사원형: ~하지 않을 수 없다(= cannot help v-ing)

As soon as I walked in, I could not help but admire some ink-and-water paintings by Jeong

~하자마자

Seon, a famous Korean artist [also known as Gyeomjae].
과거분사구
=

나는 들어가자마자 겸재로도 알려진 유명한 한국 화가 정선이 그린 수묵화 몇 점을 감탄하여 바라보지 않을 수 없었다.

11

These paintings were kept in an album [called the *Haeak jeonsincheop*]. They depict the

수동태　　과거분사구

beautiful scenery of Geumgangsan Mountain and its surrounding areas.

이 그림들은 「해악전신첩」이라고 불리는 화첩에 들어 있었다. 그것들은 금강산과 주변 지역의 아름다운 경치를 묘사한다.

12

that

The way [Gyeomjae painted the mountains, rivers, and valleys] makes them look very inviting.

make+목적어+동사원형: ~가 …하게 하다

주어　　관계부사절　　동사　　유혹[매력]적인

겸재가 산과 강, 계곡을 그린 방식은 그것들을 매우 매력적으로 보이게 한다.

13

I was shocked when the museum tour guide said [that the album was almost burned as

과거분사 (I가 감정의 주체)　　명사절 (said의 목적어)

kindling].

나는 미술관 안내원이 그 화첩이 불쏘시개로 태워질 뻔했다고 말했을 때 충격을 받았다.

14

= the album

Fortunately, it was rescued at the last minute and later purchased by Kansong.

동사1　　was　동사2

다행히도, 그것은 마지막 순간에 구해졌고 후에 간송에 의해 매입되었다.

15 [Knowing [that these beautiful paintings were nearly turned to ashes]] made me feel very sad.

주어 (동명사구) 명사절 (Knowing의 목적어) 동사

make + 목적어 + 동사원형: ~가 ···하게 하다

이 아름다운 그림들이 재가 될 뻔했다는 것을 알고 나는 매우 슬펐다.

16 I am thankful that these paintings are still around so that future generations can also

~하기 위하여, ~하도록

appreciate them.

= these paintings

나는 미래 세대 또한 이 그림들을 감상할 수 있게 그것들이 여전히 주변에 존재한다는 것에 감사한다.

17 The next item [that impressed me] was a gorgeous porcelain vase [called the *Celadon Prunus*

주어 동사 주격 관계대명사절 과거분사구

Vase with Inlaid Cloud and Crane Design].

나에게 감명을 준 다음 물품은 「청자 상감운학문 매병」이라고 불리는 아주 멋진 자기 화병이었다.

18 It is a pleasant shade of green, with a lovely pattern of clouds and cranes encircling the entire

분사구문 「with + 목적어 + v-ing」: ~가 ···하고 있는 (능동)

vase.

그것은 아름다운 구름과 학 무늬가 화병 전체를 둘러싸고 있으며 기분 좋은 녹색 계열의 색을 띠고 있다.

19 The cranes seem to be alive and stretching their wings in search of freedom.

seem to-v: ~인 것처럼 보이다

병렬구조 ~을 찾아서

그 학들은 살아서 자유를 찾아 날개를 뻗고 있는 것처럼 보인다.

20 Kansong bought the vase from a Japanese art dealer in 1935. With the money [he spent on it],

목적격 관계대명사절

which[that] = the vase

Kansong could have bought 20 nice houses!

could have v-ed: ~ 했을 수도 있다 (추측)

간송은 1935년에 일본인 미술상으로부터 그 화병을 샀다. 간송은 그것에 쓴 돈으로 좋은 집 20채를 살 수도 있었다!

21 Later, a different Japanese collector offered double the price [Kansong had paid for the vase].

목적격 관계대명사절

double + the + 명사: 두 배의 ~ which[that] 과거완료

후에, 다른 일본인 수집가가 간송이 그 화병에 지급했던 금액의 두 배를 제안했다.

22 However, Kansong refused to part with it because he knew [that it was the most magnificent

= the vase

명사절 (knew의 목적어)

vase of its kind].

하지만, 간송은 그것이 그런 종류의 화병 중에서 가장 아름다운 화병이라는 것을 알고 있었기 때문에 그것을 내주는 것을 거절했다.

23 Today it is listed as one of Korea's National Treasures. [Seeing it in person] was an absolutely
— = the vase —
주어 (동명사구) 동사
breathtaking experience!

오늘날 그것은 한국의 국보 중 하나로 등록되어 있다. 그것을 직접 보는 것은 정말로 숨이 막히는 경험이었다!

24 Finally, I saw the one item in the museum [that I will never forget]—an original copy of the
목적격 관계대명사절
Hunminjeongeum Haerye.

마지막으로 나는 미술관에서 절대 잊을 수 없는 한 물품을 보았다. 바로 「훈민정음 해례본」의 원본이다.

25 This ancient book was written in 1446, and it explains the ideas and principles [behind the
수동태 전치사구
creation of Hangeul, the writing system of the Korean language].
=

이 아주 오래된 책은 1446년에 쓰였고, 그것은 한국어의 문자 체계인 한글 창제의 바탕이 되는 발상과 원리를 설명한다.

26 It was found in Andong in 1940. At that time, however, Korea was still occupied by Japan. The
수동태 ~을 없애다 수동태
Japanese colonial government intended to get rid of the Korean language.
intend to-v: ~할 작정이다, 고의로 ~하다

그것은 1940년에 안동에서 발견되었다. 하지만, 그 당시에 한국은 여전히 일본에 의해 점령된 상태였다. 일본 식민 정부는 한국어를 없애려 했다.

27 Schools were forbidden to teach lessons in Korean, and scholars [who studied Korean] were
「forbid A to-v」 → 수동태 「A is forbidden to-v」 주격 관계대명사절
arrested.

학교들은 한국어로 수업하는 것을 금지당했고, 한국어를 연구하는 학자들은 체포되었다.

28 From the moment [he heard that the *Hunminjeongeum Haerye* had been discovered], Kansong
when[that] 과거완료 수동태
관계부사절
couldn't stop thinking about it. He knew [he had to protect it at all costs].
stop v-ing: ~하는 것을 멈추다 명사절 (knew의 목적어) 무슨 수를 써서라도
that

「훈민정음 해례본」이 발견되었다는 것을 들은 순간부터, 간송은 그것에 대한 생각을 멈출 수 없었다. 그는 무슨 수를 써서라도 그것을 지켜야만 한다는 것을 알았다.

29 After years of waiting, he was finally able to obtain the book.
= the Hunminjeongeum Haerye

수년간의 기다림 후에, 그는 마침내 그 책을 얻을 수 있었다.

30 He purchased it at ten times the price [the owner was asking] and carefully hid it in his house.
= the book which[that] 목적격 관계대명사절 = the book

그는 그것을 소유자가 요구한 가격의 10배에 샀고 그것을 그의 집에 조심스럽게 숨겼다.

31 When the Japanese were finally defeated, he was able to share it with the rest of Korea.
수동태

마침내 일본이 패망하자, 그는 그것을 한국 국민과 공유할 수 있었다.

32 The guide said [that the *Hunminjeongeum Haerye* is the museum's most precious treasure].
명사절 (said의 목적어)

그 안내원은「훈민정음 해례본」이 미술관의 가장 소중한 보물이라고 말했다.

= If it had not been for ~, But for ~

33 Without it, the origins and fundamentals of Hangeul would have been lost to history.
가정법 과거완료

그것이 없었다면, 한글의 기원과 기본 원칙은 전해지지 않았을 것이다.

~ 이후에 (부사) 병렬구조

34 It has since been designated a National Treasure of Korea and included in the UNESCO
「designate A (as) B」→ 수동태「A is designated (as) B」

Memory of the World Register.

그것은 이후에 한국의 국보로 지정되었으며 유네스코 세계기록유산에 포함되었다.

전치사

35 Looking at the ancient book, I could feel Kansong's strong commitment to preserving Korean
분사구문 〈동시동작〉 commitment to v-ing: ~에의 전념, 헌신

history.

그 오래된 책을 보면서, 나는 한국 역사를 보호하려는 간송의 강한 의지를 느낄 수 있었다.

36 Standing in the middle of the exhibition hall, surrounded by Korean art, I could not stop
분사구문 〈동시동작〉 분사구문 〈동시동작〉

thinking about Kansong. He was an amazing person!

한국 미술품에 둘러싸여 전시장 한가운데에 서서, 나는 간송에 대해 생각하는 것을 멈출 수가 없었다. 그는 놀라운 사람이었다!

부사적 용법 〈목적〉

37 He did not collect art for his personal enjoyment. He did it [to protect Korea's cultural identity
= collected art

during the harsh Japanese colonial period].

그는 자신의 개인적인 즐거움을 위해 미술품을 수집하지 않았다. 그는 혹독한 일제 강점기 동안 한국의 문화적 독자성을 보호하기 위해 그 일을 했다.

명사절 (knew의 목적어)

38 After Korea regained its independence, he stopped collecting art, as he knew [it would safely
~ 때문에 (접속사) that

remain in Korea].

한국이 독립을 되찾은 후에, 그는 미술품을 수집하는 것을 그만두었는데, 그는 미술품이 안전하게 한국에 남아 있으리라는 것을 알고 있었기 때문이다.

39 During our country's worst time, a single man was able to defend Korea's national spirit and
~ 동안　　　　　　　　　　　　　　　　　be able to-v: ~할 수 있다
pride. Thanks to him, we are still able to experience an essential part of Korean culture today.
~ 덕분에

우리나라의 가장 힘든 시기 동안에, 한 남자가 홀로 한국의 민족혼과 자부심을 지켜낼 수 있었다. 그 덕분에, 우리는 오늘날 한국 문화에서 대단히 중요한 부분을 여전히 경험할 수 있다.

40 Founded in 1938, the Kansong Art Museum was Korea's first private museum.
과거분사구

1938년에 설립된 간송 미술관은 한국 최초의 사립 미술관이었다.

41 When Kansong built it, he named it Bohwagak.
name A B: A를 B라고 이름 짓다

간송이 그것을 지었을 때, 그는 그것을 보화각이라고 이름 지었다.

42 He used the building as a place [to store all of the important cultural items [he had collected
　　　　　　　　　　　　　　　　　　　　　　　　that　　과거완료
　　　　　　　　　　　　　　↑　형용사적 용법　　　　　　　　　↑　목적격 관계대명사절
over the years]].

그는 그 건물을 그가 수년 동안 수집한 모든 중요한 문화적 물품들을 보관하는 장소로 사용했다.

43 Kansong died in 1962, and Bohwagak was renamed the Kansong Art Museum in 1966. It now
　　　　　　　　　　　　　　　　　　「rename A B」→ 수동태 「A is renamed B」
holds about 5,000 items, including 12 Korean National Treasures.
　　　약

간송은 1962년에 사망했고, 보화각은 1966년에 간송 미술관으로 개명되었다. 그것은 현재 한국의 국보 12점을 포함하여 약 5,000점의 물품을 소장하고 있다.

다음 빈칸을 채우시오.

Yunju, a high school student, went to a Korean art exhibition. She wrote a report about (1) _____ _____ _____ _____ with her class.

고등학생인 윤주는 한국 미술 전시회에 갔었다. 그녀는 반 친구들과 공유하기 위해 그녀의 경험에 대한 보고서를 작성했다.

Last week, I visited an exhibition of artwork and ancient items (2) _____ _____ the Kansong Art Museum's collection.

지난주, 나는 간송 미술관 소장품에서 선별된 미술품과 골동품 전시회에 방문했다.

The exhibition included information about the (3) _____ _____ _____ all of the artwork displayed there.

그 전시회는 그곳에 전시된 모든 미술품을 모은 남자에 대한 정보를 포함했다.

His name was Jeon Hyeongpil, but he (4) _____ better _____ _____ his pen name, Kansong.

그의 이름은 전형필이지만, 그는 필명인 간송으로 더 잘 알려져 있다.

He was born into a rich family in 1906 and (5) _____ _____ the Japanese occupation of Korea. At the age of 24, he (6) _____ _____ _____ _____.

그는 1906년 부유한 집안에서 태어났고 한국의 일제 강점기를 겪었다. 24세에, 그는 막대한 재산을 물려받았다.

After carefully thinking about what he could do for his country, he (7) _____ _____ _____ the money to protect Korea's cultural heritage from the Japanese.

조국을 위해 자신이 무엇을 할 수 있을지에 대해 심사숙고한 후에, 그는 일본으로부터 한국의 문화유산을 보호하는 데 그 돈을 쓰기로 결심했다.

This decision (8) _____ greatly _____ _____ _____ _____, Oh Sechang, who was an independence activist and had keen insight into Korean art.

이 결정은 그의 스승인 오세창에 의해 크게 영향을 받았는데, 오세창은 독립운동가이면서 한국 미술에 날카로운 통찰력을 가지고 있었다.

With Oh's guidance and his own convictions, Kansong (9) _____ _____ _____ _____ _____ _____ old books, paintings, and other works of art.

오세창의 지도와 자신의 강한 신념으로, 간송은 그의 재산 대부분을 오래된 책, 그림, 그리고 다른 미술품을 획득하는 데 바쳤다.

(10) _____ _____ _____ _____ the pride of the nation and believed they represented the national spirit. Without his actions, they (11) _____ _____ _____ _____ or taken overseas.

그는 이러한 물품들을 나라의 긍지로 여겼고, 그것들이 민족혼을 나타낸다고 믿었다. 그의 행동이 없었다면, 그것들은 파괴되거나 해외로 반출되었을 것이다.

As soon as I walked in, I (12) _____ _____ _____ _____ _____ some ink-and-water paintings by Jeong Seon, a famous Korean artist also known as Gyeomjae.

나는 들어가자마자 겸재로도 알려진 유명한 한국 화가 정선이 그린 수묵화 몇 점을 감탄하여 바라보지 않을 수 없었다.

These paintings were kept in an (13) _____ _____ the *Haeak jeonsincheop*. They (14) _____ _____ _____ _____ of Geumgangsan Mountain and its surrounding areas.

이 그림들은 「해악전신첩」이라고 불리는 화첩에 들어 있었다. 그것들은 금강산과 주변 지역의 아름다운 경치를 묘사한다.

The way Gyeomjae painted the mountains, rivers, and valleys (15) _____ _____ _____ _____ _____. (16) _____ _____ _____ _____ the museum tour guide said that the album was almost burned as kindling.

겸재가 산과 강, 계곡을 그린 방식은 그것들을 매우 매력적으로 보이게 한다. 나는 미술관 안내원이 그 화첩이 불쏘시개로 태워질 뻔했다고 말했을 때 충격을 받았다.

Fortunately, (17) _____ _____ _____ at the last minute and later purchased by Kansong. Knowing that these beautiful paintings were nearly turned to ashes (18) _____ _____ _____ _____ _____.

다행히도, 그것은 마지막 순간에 구해졌고 후에 간송에 의해 매입되었다. 이 아름다운 그림들이 재가 될 뻔했다는 것을 알고 나는 매우 슬펐다.

I am thankful that these paintings are still around (19) _____ _____ future generations can also appreciate them.

나는 미래 세대 또한 이 그림들을 감상할 수 있게 그것들이 여전히 주변에 존재한다는 것에 감사한다.

(20) _____ _____ _____ _____ _____ _____ a gorgeous porcelain vase called the *Celadon Prunus Vase with Inlaid Cloud and Crane Design*.

나에게 감명을 준 다음 물품은 「청자 상감운학문 매병」이라고 불리는 아주 멋진 자기 화병이었다.

It is a pleasant shade of green, with a lovely pattern of clouds and cranes (21) _____ _____ _____ _____. The cranes seem to be alive and stretching their wings (22) _____ _____ _____ _____.

그것은 아름다운 구름과 학무늬가 화병 전체를 둘러싸고 있으며 기분 좋은 녹색 계열의 색을 띠고 있다. 그 학들은 살아서 자유를 찾아 날개를 뻗고 있는 것처럼 보인다.

Kansong bought the vase from a Japanese art dealer in 1935. With the money he spent on it, Kansong (23) _____ _____ _____ 20 nice houses! Later, a different Japanese collector offered (24) _____ _____ _____ Kansong had paid for the vase.

간송은 1935년에 일본인 미술상으로부터 그 화병을 샀다. 간송은 그것에 쓴 돈으로 좋은 집 20채를 살 수도 있었다! 후에, 다른 일본인 수집가가 간송이 그 화병에 지급했던 금액의 두 배를 제안했다.

However, Kansong (25) _____ _____ _____ _____ _____ because he knew that it was the most magnificent vase of its kind.

하지만, 간송은 그것이 그런 종류의 화병 중에서 가장 아름다운 화병이라는 것을 알고 있었기 때문에 그것을 내주는 것을 거절했다.

Today it is listed as one of Korea's National Treasures. (26) _____ _____ _____ _____ was an absolutely breathtaking experience!

오늘날 그것은 한국의 국보 중 하나로 등록되어 있다. 그것을 직접 보는 것은 정말로 숨이 막히는 경험이었다!

Finally, I saw the one item in the museum (27) _____ _____ _____ _____ _____ —an original copy of the *Hunminjeongeum Haerye*.

마지막으로 나는 미술관에서 절대 잊을 수 없는 한 물품을 보았다. 바로 「훈민정음 해례본」의 원본이다.

This ancient book was written in 1446, and it explains the ideas and principles (28) _____ _____ _____ of Hangeul, the writing system of the Korean language.

이 아주 오래된 책은 1446년에 쓰였고, 그것은 한국어의 문자 체계인 한글 창제의 바탕이 되는 발상과 원리를 설명한다.

It was found in Andong in 1940. At that time, however, Korea was still (29) _____ _____ _____ . The Japanese colonial government intended (30) _____ _____ _____ _____ the Korean language.

그것은 1940년에 안동에서 발견되었다. 하지만, 그 당시에 한국은 여전히 일본에 의해 점령된 상태였다. 일본 식민 정부는 한국어를 없애려 했다.

Schools (31) _____ _____ _____ _____ lessons in Korean, and scholars who studied Korean were arrested.

학교들은 한국어로 수업하는 것을 금지당했고, 한국어를 연구하는 학자들은 체포되었다.

From the moment he heard that the *Hunminjeongeum Haerye* had been discovered, Kansong (32) _____ _____ _____ about it.

「훈민정음 해례본」이 발견되었다는 것을 들은 순간부터, 간송은 그것에 대한 생각을 멈출 수 없었다.

He knew he had to protect it (33) _____ _____ _____ . After years of waiting, he was finally able to obtain the book.

그는 무슨 수를 써서라도 그것을 지켜야만 한다는 것을 알았다. 수년간의 기다림 후에, 그는 마침내 그 책을 얻을 수 있었다.

He purchased it at ten times the price (34) _____ _____ _____ _____ and carefully hid it in his house. When the Japanese were finally defeated, he (35) _____ _____ _____ _____ it with the rest of Korea.

그는 그것을 소유자가 요구한 가격의 10배에 샀고 그것을 그의 집에 조심스럽게 숨겼다. 마침내 일본이 패망하자, 그는 그것을 한국 국민과 공유할 수 있었다.

The guide said that the *Hunminjeongeum Haerye* is the museum's (36) _____ _____ _____ . Without it, the origins and fundamentals of Hangeul (37) _____ _____ _____ to history.

그 안내원은 「훈민정음 해례본」이 미술관의 가장 소중한 보물이라고 말했다. 그것이 없었다면, 한글의 기원과 기본 원칙은 전해지지 않았을 것이다.

It (38) _____ since _____ _____ a National Treasure of Korea and included in the UNESCO Memory of the World Register.

그것은 이후에 한국의 국보로 지정되었으며 유네스코 세계기록유산에 포함되었다.

Looking at the ancient book, I could feel Kansong's strong commitment (39) _____ _____ _____ _____.

그 오래된 책을 보면서, 나는 한국 역사를 보호하려는 간송의 강한 의지를 느낄 수 있었다.

Standing in the middle of the exhibition hall, (40) _____ _____ _____ _____, I could not stop thinking about Kansong.

한국 미술품에 둘러싸여 전시장 한가운데에 서서, 나는 간송에 대해 생각하는 것을 멈출 수가 없었다.

He was an amazing person! He did not collect art (41) _____ _____ _____ _____. He did it (42) _____ _____ Korea's cultural identity during the harsh Japanese colonial period.

그는 놀라운 사람이었다! 그는 자신의 개인적인 즐거움을 위해 미술품을 수집하지 않았다. 그는 혹독한 일제 강점기 동안 한국의 문화적 독자성을 보호하기 위해 그 일을 했다.

After Korea regained its independence, (43) _____ _____ _____ _____, as he knew it would safely remain in Korea.

한국이 독립을 되찾은 후에, 그는 미술품을 수집하는 것을 그만두었는데, 그는 미술품이 안전하게 한국에 남아 있으리라는 것을 알고 있었기 때문이다.

During our country's worst time, a single man (44) _____ _____ _____ _____ Korea's national spirit and pride. (45) _____ _____ _____, we are still able to experience an essential part of Korean culture today.

우리나라의 가장 힘든 시기 동안에, 한 남자가 홀로 한국의 민족혼과 자부심을 지켜낼 수 있었다. 그 덕분에, 우리는 오늘날 한국 문화에서 대단히 중요한 부분을 여전히 경험할 수 있다.

(46) _____ _____ _____, the Kansong Art Museum was Korea's first private museum. When Kansong built it, (47) _____ _____ _____ Bohwagak.

1938년에 설립된 간송 미술관은 한국 최초의 사립 미술관이었다. 간송이 그것을 지었을 때, 그는 그것을 보화각이라고 이름 지었다.

He used the building as a place to store all of the important cultural items (48) _____ _____ _____ over the years.

그는 그 건물을 그가 수년 동안 수집한 모든 중요한 문화적 물품들을 보관하는 장소로 사용했다.

Kansong died in 1962, and Bohwagak (49) _____ _____ the Kansong Art Museum in 1966. It now (50) _____ _____ _____ _____, including 12 Korean National Treasures.

간송은 1962년에 사망했고, 보화각은 1966년에 간송 미술관으로 개명되었다. 그것은 현재 한국의 국보 12점을 포함하여 약 5,000점의 물품을 소장하고 있다.

다음 네모 안에서 옳은 것을 고르시오.

01 The exhibition included information about the man who gathered all of the artwork [displayed / displaying] there.

02 At the age of 24, he [was inherited / inherited] a massive fortune.

03 After carefully [think / thinking] about what he could do for his country, he decided to use the money to protect Korea's cultural heritage from the Japanese.

04 This decision was greatly influenced by his mentor, Oh Sechang, [that / who] was an independence activist and had keen insight into Korean art.

05 With Oh's guidance and his own [contradictions / convictions], Kansong devoted most of his fortune to acquiring old books, paintings, and other works of art.

06 He considered these items the pride of the nation and believed they [distorted / represented] the national spirit.

07 [As soon as / As well as] I walked in, I could not help but admire some ink-and-water paintings by Jeong Seon, a famous Korean artist also known as Gyeomjae.

08 The way Gyeomjae painted the mountains, rivers, and valleys makes them [look / to look] very inviting.

09 [Known / Knowing] that these beautiful paintings were nearly turned to ashes made me feel very sad.

10 The cranes seem to be alive and [stretched / stretching] their wings in search of freedom.

11 Kansong bought the vase from a Japanese art dealer in 1935. With the money he spent on [it / them], Kansong could have bought 20 nice houses!

12 Today it is listed as one of Korea's National Treasures. Seeing it in person [was / were] an absolutely breathtaking experience!

13 Schools were forbidden to teach lessons in Korean, and scholars who studied Korean were [arrested / arranged].

14 From the moment he heard that the *Hunminjeongeum Haerye* [has / had] been discovered, Kansong couldn't stop thinking about it.

15 Without it, the origins and [funds / fundamentals] of Hangeul would have been lost to history.

16 [Standing / Stood] in the middle of the exhibition hall, surrounded by Korean art, I could not stop thinking about Kansong.

17 He did not collect art for his personal enjoyment. He did it [protect / to protect] Korea's cultural identity during the harsh Japanese colonial period.

18 After Korea regained its [dependence / independence], he stopped collecting art, as he knew it would safely remain in Korea.

19 During our country's worst time, a single man was able to [offend / defend] Korea's national spirit and pride. Thanks to him, we are still able to experience an essential part of Korean culture today.

20 [Founding / Founded] in 1938, the Kansong Art Museum was Korea's first private museum.

다음 문장이 옳으면 O, 틀리면 X 표시하고 바르게 고치시오.

01 Yunju, a high school student, went to a Korean art exhibition. She wrote a report about her experience to share with her class.

02 Last week, I visited an exhibition of artwork and ancient items select from the Kansong Art Museum's collection.

03 The exhibition included information about the man whom gathered all of the artwork displayed there.

04 His name was Jeon Hyeongpil, but he is better known by his pen name, Kansong.

05 He was born into a rich family in 1906 and lived through the Japanese occupation of Korea.

06 At the age of 24, he inherited a massive fortune.

07 After carefully thinking about what he could do for his country, he decided to use the money to protecting Korea's cultural heritage from the Japanese.

08 This decision was greatly influenced by his mentor, Oh Sechang, who was an independence activist and had keen insight into Korean art.

09 With Oh's guidance and his own convictions, Kansong devoted most of his fortune to acquiring old books, paintings, and other works of art.

10 He considered these items the pride of the nation and believed they represented the national spirit.

11 Without his actions, they would have been destroyed or taking overseas.

12 As soon as I walked in, I could not help but admire some ink-and-water paintings by Jeong Seon, a famous Korean artist also known as Gyeomjae.

13 These paintings were kept in an album called the *Haeak jeonsincheop*.

14 They depict the beautiful scenery of Geumgangsan Mountain and its surrounding areas.

15 The way Gyeomjae painted the mountains, rivers, and valleys makes them to look very inviting.

16 I was shocking when the museum tour guide said that the album was almost burned as kindling.

17 Fortunately, it was rescued at the last minute and later purchased by Kansong.

18 Knowing that these beautiful paintings was nearly turned to ashes made me feel very sad.

19 I am thankful that these paintings are still around so which future generations can also appreciate them.

20 The next item that impressed me was a gorgeous porcelain vase calling the *Celadon Prunus Vase with Inlaid Cloud and Crane Design*.

21 It is a pleasant shade of green, with a lovely pattern of clouds and cranes encircled the entire vase.

22 The cranes seem to be alive and stretching their wings in search of freedom.

23 Kansong bought the vase from a Japanese art dealer in 1935. With the money he spent on it, Kansong could have bought 20 nice houses!

24 Later, a different Japanese collector offered double the price Kansong had paid for the vase.

25 However, Kansong refused parting with it because he knew that it was the most magnificent vase of its kind.

26 Today it is listed as one of Korea's National Treasures. Seeing it in person was an absolutely breathtaking experience!

27 Finally, I saw the one item in the museum that I will never forget — an original copy of the *Hunminjeongeum Haerye*.

28 This ancient book is written in 1446, and it explains the ideas and principles behind the creation of Hangeul, the writing system of the Korean language.

29 It was found in Andong in 1940. At that time, however, Korea was still occupying by Japan.

30 The Japanese colonial government intended to get rid of the Korean language.

31 Schools were forbidden to teach lessons in Korean, and scholars who studied Korean was arrested.

32 From the moment he heard that the *Hunminjeongeum Haerye* had been discovered, Kansong couldn't stop thinking about it.

33 He knew he had to protect it at all costs. After years of waiting, he was finally able to obtain the book.

34 He purchased it at ten times the price the owner was asking and carefully hid it in his house.

35 When the Japanese were finally defeat, he was able to share it with the rest of Korea.

36 The guide said that the *Hunminjeongeum Haerye* is the museum's most precious treasure.

37 Without it, the origins and fundamentals of Hangeul would have been lost to history.

38 It has since been designating a National Treasure of Korea and included in the UNESCO Memory of the World Register.

39 Looked at the ancient book, I could feel Kansong's strong commitment to preserving Korean history.

40 Standing in the middle of the exhibition hall, surrounded by Korean art, I could not stop think about Kansong.

41 He was an amazing person! He did not collect art for his personal enjoyment. He does it to protect Korea's cultural identity during the harsh Japanese colonial period.

42 After Korea regained its independence, he stopped collecting art, as he knew it would safely remain in Korea.

43 While our country's worst time, a single man was able to defend Korea's national spirit and pride.

44 Thanks to him, we are still able to experience an essential part of Korean culture today.

45 Founded in 1938, the Kansong Art Museum was Korea's first private museum.

46 When Kansong built it, he was named it Bohwagak.

47 He used the building as a place to store all of the important cultural items he had collected over the years.

48 Kansong died in 1962, and Bohwagak was renamed the Kansong Art Museum in 1966.

49 It now holds about 5,000 items, including 12 Korean National Treasures.

1 다음 대화의 빈칸에 들어갈 말로 가장 적절한 것은?

> B: Hey, Sumi. What are you doing this weekend?
>
> G: Hi, Junho. I'm going to do some volunteer work.
>
> B: Oh, what kind of work are you doing?
>
> G: I get my voice recorded while reading books aloud. Then, people who have trouble reading can listen to the books.
>
> B: That's a brilliant way to contribute. You have such a beautiful voice.
>
> G: Thanks! I'm glad that I can be helpful to someone.
>
> B: _____
>
> G: Let me think. Why don't you teach elementary school students math? You like children and are good at math.
>
> B: Sounds good! I'll have to look up some information about where I can do that.

① I can't concentrate on reading.

② It's always fun to meet students.

③ Please tell me how to take care of my voice.

④ Reading aloud is an effective way to study.

⑤ I wish I could do something like that, too.

[2~4] 다음 글을 읽고, 물음에 답하시오.

> Yunju, a high school student, went to a Korean art exhibition. She wrote a report about her experience to share with her class.
>
> Last week, I visited an exhibition of artwork and ancient items ① selected from the Kansong Art Museum's collection. The exhibition included information about the man ② that gathered all of the artwork displayed there.

His name was Jeon Hyeongpil, but he is better known by his pen name, Kansong. He was born into a rich family in 1906 and lived through the Japanese occupation of Korea. At the age of 24, he inherited a massive fortune. After carefully ③ thinking about what he could do for his country, he decided to use the money to protect Korea's cultural heritage from the Japanese. This decision was greatly influenced by his mentor, Oh Sechang, who was an independence activist and had keen _____ into Korean art. With Oh's guidance and his own convictions, Kansong devoted most of his fortune ④ to acquiring old books, paintings, and other works of art. He considered these items the pride of the nation and believed they represented the national spirit. Without his actions, they would have been ⑤ destroying or taken overseas.

2 윗글의 내용과 일치하지 <u>않는</u> 것은?

① 윤주는 한국 미술 전시회에 다녀왔다.

② 전형필은 그의 필명으로 더 잘 알려져 있다.

③ 오세창은 막대한 재산을 물려받았다.

④ 오세창은 전형필의 스승이자 독립운동가이다.

⑤ 전형필은 한국 미술품이 민족혼을 나타낸다고 믿었다.

3 윗글의 밑줄 친 ①~⑤ 중, 어법상 <u>틀린</u> 것은?

① ② ③ ④ ⑤

4 윗글의 빈칸에 들어갈 단어를 영영 뜻풀이를 참고하여 쓰시오. (단, 주어진 글자로 시작할 것)

> the ability to understand something well, or to think of new and unique ideas

i _____

[5~6] 다음 글을 읽고, 물음에 답하시오.

(A) I walked in, I could not help but admire some ink-and-water paintings by Jeong Seon, a famous Korean artist also known as Gyeomjae. These paintings were kept in an album called the _Haeak jeonsincheop_. They depict the beautiful scenery of Geumgangsan Mountain and its surrounding areas. The way Gyeomjae painted the mountains, rivers, and valleys makes them look very inviting. I was shocked when the museum tour guide said that the album was almost burned as kindling. _(B)_ , it was rescued at the last minute and later purchased by Kansong. Knowing that these beautiful paintings were nearly turned to ashes made me feel very sad. I am thankful that these paintings are still around 미래 세대들 또한 이것들을 감상할 수 있도록.

5 윗글의 빈칸 (A), (B)에 들어갈 말로 가장 적절한 것은?

| | (A) | | (B) |
① Although ··· Fortunately
② Although ··· Unfortunately
③ As soon as ··· Fortunately
④ As soon as ··· Unfortunately
⑤ Because ··· Sadly

6 윗글의 밑줄 친 우리말과 일치하도록 주어진 단어를 이용하여 문장을 완성하시오.

(so that, can also, appreciate)

[7~8] 다음 글을 읽고, 물음에 답하시오.

The next item that impressed me was a gorgeous porcelain vase called the _Celadon Prunus Vase with Inlaid Cloud and Crane_

Design. It is a pleasant shade of green, with a lovely pattern of clouds and cranes ⓐ encircle the entire vase. The cranes seem to be alive and stretching their wings in search of freedom. Kansong bought the vase from a Japanese art dealer in 1935. With the money he spent on it, Kansong could have bought 20 nice houses! Later, a different Japanese collector offered double the price Kansong had paid for the vase. However, Kansong refused to part with it because he knew that it was the most magnificent vase of its kind. Today it is ⓑ listing as one of Korea's National Treasures. Seeing it in person was an absolutely breathtaking experience!

7 간송이 도자기를 다른 수집가에게 내주지 않은 이유를 우리말로 쓰시오. (35자 내외)

8 윗글의 밑줄 친 ⓐ, ⓑ를 어법에 맞게 고쳐 쓰시오.

ⓐ encircle →

ⓑ listing →

[9~11] 다음 글을 읽고, 물음에 답하시오.

From the moment he heard that the _Hunminjeongeum Haerye_ had been discovered, Kansong couldn't stop thinking about it. 그는 무슨 수를 써서라도 그것을 지켜야만 한다는 것을 알았다. After years of waiting, he was finally able to obtain the book. He purchased it at ten times the price the owner was asking and carefully hid it in his house. When the Japanese were finally defeated, he was able to share it with the rest of Korea. The guide said that the _Hunminjeongeum Haerye_ is the museum's most _(A)_ treasure. Without

it, the origins and fundamentals of Hangeul would have been lost to history. It has since been designated a National Treasure of Korea and included in the UNESCO Memory of the World Register. Looking at the ancient book, I could feel Kansong's strong commitment to preserving Korean history.

9 윗글의 밑줄 친 우리말과 일치하도록 〈보기〉에 주어진 말을 배열하여 문장을 완성하시오.

〈보기〉 at / he / it / protect / costs / he / all / had to / knew

10 Hunminjeongeum Haerye에 관한 윗글의 내용과 일치하는 것은?

① 발견 직후에 간송이 그것을 구매했다.
② 간송은 그것을 얻기 위해 소유자가 요구한 금액의 2배를 지불했다.
③ 패망 후 일본은 그것을 가져갔다.
④ 그것의 일부가 손실되어 한글의 기본 원칙이 전해지지 못했다.
⑤ 그것은 한국의 국보로 지정되었다.

11 윗글의 빈칸 (A)에 들어갈 말로 가장 적절한 것은?

① common
② artificial
③ precious
④ convenient
⑤ colorful

[12~13] 다음 글을 읽고, 물음에 답하시오.

Standing in the middle of the exhibition hall, _____ by Korean art, I could not stop thinking about Kansong. He was an amazing person! He did not collect art for his personal enjoyment. He did it to (A) protect / conceal

Korea's cultural identity during the harsh Japanese colonial period. After Korea regained its independence, he (B) started / stopped collecting art, as he knew it would safely remain in Korea. During our country's (C) worst / best time, a single man was able to defend Korea's national spirit and pride. Thanks to him, we are still able to experience an essential part of Korean culture today.

12 윗글의 빈칸에 들어갈 말로 가장 적절한 것은?

① surround
② surrounds
③ surrounding
④ surrounded
⑤ to surround

13 (A), (B), (C)의 각 네모 안에서 문맥에 맞는 낱말로 가장 적절한 것은?

	(A)		(B)		(C)
①	protect	...	started	...	worst
②	protect	...	started	...	best
③	protect	...	stopped	...	worst
④	conceal	...	started	...	best
⑤	conceal	...	stopped	...	best

14 다음 글에서 전체 흐름과 관계 없는 문장은?

Founded in 1938, the Kansong Art Museum was Korea's first private museum. ① There are many private museums in Korea. ② When Kansong built it, he named it Bohwagak. ③ He used the building as a place to store all of the important cultural items he had collected over the years. ④ Kansong died in 1962, and Bohwagak was renamed the Kansong Art Museum in 1966. ⑤ It now holds about 5,000 items, including 12 Korean National Treasures.

① ② ③ ④ ⑤

1 다음 담화의 주제로 가장 적절한 것은?

I'm chef Daniel Wood. I want to make a real difference, but I need your help. The world is facing a major health problem. Currently, there are millions of children around the world under the age of five who are overweight. We need to initiate small changes to fix this urgent problem. You can start by signing this petition. It shows that you advocate educating kids about food in schools around the world. All children have the right to be happy and healthy. This basic education will help them lead better lives. This is something that I passionately believe in. Food education can make a big difference in millions of young lives. Please get involved. We can't succeed without your help.

① 건강 검진 안내
② 탄원서 서명 장려
③ 음식 기부 운동 독려
④ 급식 메뉴 변경 안내
⑤ 올바른 식습관 관리 안내

[2~4] 다음 글을 읽고, 물음에 답하시오.

Yunju, a high school student, went to a Korean art exhibition. She wrote a report about her experience to share with her class.

(A) With Oh's guidance and his own convictions, Kansong devoted most of his fortune to acquiring old books, paintings, and other works of art. He considered these items the pride of the nation and believed they represented the national spirit. ⓐ Without his actions, they would have been destroyed or taken overseas.

(B) Last week, I visited an exhibition of artwork and ancient items selected from the Kansong Art Museum's collection. The exhibition included information about the man who gathered all of the artwork displayed there.

(C) His name was Jeon Hyeongpil, but he is better known by his pen name, Kansong. He was born into a rich family in 1906 and lived through the Japanese occupation of Korea. At the age of 24, he inherited a massive fortune. After carefully thinking about what he could do for his country, he decided to use the money to protect Korea's cultural heritage from the Japanese. ⓑ This decision was greatly influenced by his mentor, Oh Sechang, who was an independence activist and had keen insight into Korean art.

2 윗글의 주어진 글 다음에 이어질 글의 순서로 가장 적절한 것은?

① (A) − (B) − (C) ② (B) − (A) − (C)
③ (B) − (C) − (A) ④ (C) − (A) − (B)
⑤ (C) − (B) − (A)

3 윗글의 밑줄 친 ⓐ를 주어진 글자로 시작하는 표현으로 바꿔 쓰시오.

→ If _____,
they would have been destroyed or taken overseas.

4 윗글의 밑줄 친 ⓑ가 의미하는 것은?

① 재산을 물려받지 않는 것
② 한국의 물품을 해외로 반출하는 것
③ 책, 그림, 미술품 등을 제작하는 것
④ 스승인 오세창의 지도를 받아들이는 것
⑤ 한국 문화유산을 보호하는 데 재산을 쓰는 것

As soon as I walked in, I could not help but ① <u>admire</u> some ink-and-water paintings by Jeong Seon, a famous Korean artist also known as Gyeomjae. These paintings were kept in an album ② <u>called</u> the *Haeak jeonsincheop*. They depict the beautiful scenery of Geumgangsan Mountain and its surrounding areas. The way Gyeomjae painted the mountains, rivers, and valleys makes them ③ <u>looking</u> very inviting. I was shocked when the museum tour guide said that the album was almost burned as kindling. Fortunately, it was rescued at the last minute and later ④ <u>purchased</u> by Kansong. ⑤ <u>Knowing</u> that these beautiful paintings were nearly turned to ashes made me feel very sad. I am thankful that these paintings are still around so that future generations can also appreciate them.

5 윗글의 밑줄 친 ①~⑤ 중, 어법상 **틀린** 것은?

① ② ③ ④ ⑤

6 윗글의 내용과 일치하는 것은?

① 정선과 겸재는 동시대 인물이 아니다.
② 해악전신첩은 겸재가 그린 수묵화이다.
③ 겸재의 수묵화는 백두산 경치를 묘사하고 있다.
④ 간송은 해악전신첩을 태울 뻔했다.
⑤ 현 시대에도 겸재의 수묵화를 감상할 수 있다.

The next item that (A) disappointed / impressed me was a gorgeous porcelain vase called the *Celadon Prunus Vase with Inlaid Cloud and Crane Design*. It is a pleasant shade of green, with a lovely pattern of clouds and cranes encircling the entire vase. <u>The cranes seem to be alive and stretching their wings in search of freedom.</u> Kansong bought the vase from a Japanese art dealer in 1935. _____ ⓐ _____, Kansong could have bought 20 nice houses! Later, a different Japanese collector (B) expected / offered double the price Kansong had paid for the vase. However, Kansong refused to part with it because he knew that it was the most (C) humble / magnificent vase of its kind. Today it is listed as one of Korea's National Treasures. Seeing it in person was an absolutely breathtaking experience!

7 (A), (B), (C)의 각 네모에서 문맥에 맞는 낱말로 가장 적절한 것을 쓰시오.

(A) _____

(B) _____

(C) _____

8 〈보기〉에 주어진 말을 배열하여 윗글의 빈칸 ⓐ를 완성하시오.

〈보기〉 it / he / with / on / the money / spent

9 윗글의 밑줄 친 문장을 우리말로 해석하시오.

From the moment he heard (A) | that / which | the *Hunminjeongeum Haerye* had been discovered, Kansong couldn't stop thinking about it. ⓐ He knew he had to protect it at all costs. After years of waiting, he was finally able to obtain the book. He purchased it at ten times the price the owner was asking and carefully (B) | hiding / hid | it in his house. ① When the Japanese were finally defeated, he was able to share it with the rest of Korea. ② The guide said that the *Hunminjeongeum Haerye* is the museum's most precious treasure. ③ Without it, the origins and fundamentals of Hangeul would have been lost to history. ④ It has since been designated a National Treasure of Korea and included in the UNESCO Memory of the World Register. ⑤ Korea has 16 entries in the UNESCO Memory of the World Register. Looking at the ancient book, I could feel Kansong's strong commitment to (C) | preserve / preserving | Korean history.

10 (A), (B), (C)의 각 네모 안에서 어법에 맞는 표현으로 가장 적절한 것은?

	(A)		(B)		(C)
①	that	…	hiding	…	preserve
②	that	…	hid	…	preserving
③	which	…	hiding	…	preserving
④	which	…	hid	…	preserving
⑤	which	…	hid	…	preserve

11 윗글의 밑줄 친 ⓐ를 우리말로 해석하시오.

12 윗글의 밑줄 친 ①~⑤ 중, 전체 흐름과 관계 <u>없는</u> 문장은?

① ② ③ ④ ⑤

Founded in 1938, the Kansong Art Museum was Korea's first private museum. When Kansong built it, he named it Bohwagak. He used the building as a place to store all of the important cultural items he had collected over the years. Kansong died in 1962, and Bohwagak was renamed the Kansong Art Museum in 1966. It now holds about 5,000 items, including 12 Korean National Treasures.

13 윗글의 주제로 가장 적절한 것은?

① the history of the Kansong Art Museum
② how Kansong gathered Korean artwork
③ the collection of the Kansong Art Museum
④ why Kansong established an art museum
⑤ the importance of Korean cultural items

14 간송 미술관에 관한 윗글의 내용과 일치하는 것은?

① 한국 최초의 국립 미술관이다.
② 간송은 이곳을 보화각이라고 이름 지었다.
③ 간송은 중요한 물품은 이곳에 두지 않고 숨겼다.
④ 간송이 죽기 전에 개명되었다.
⑤ 현재 한국의 국보 5,000점을 소장하고 있다.

1 다음 대화의 빈칸에 들어갈 말로 가장 적절한 것은?

> B: Hey, Sumi. What are you doing this weekend?
>
> G: Hi, Junho. I'm going to do some volunteer work.
>
> B: Oh, what kind of work are you doing?
>
> G: I get my voice recorded while reading books aloud. Then, people who have trouble reading can listen to the books.
>
> B: That's a brilliant way to contribute. You have such a beautiful voice.
>
> G: Thanks! I'm glad that I can be helpful to someone.
>
> B: I wish I could do something like that, too.
>
> G: Let me think. _____ You like children and are good at math.
>
> B: Sounds good! I'll have to look up some information about where I can do that.

① I cannot go with you because there are many volunteers.

② Where did you do volunteer work last week?

③ Why don't you teach elementary school students math?

④ It is not easy for me to do volunteer work.

⑤ Why do you want to do volunteer work?

[2~3] 다음 글을 읽고, 물음에 답하시오.

> Last week, I visited an exhibition of artwork and ancient items (A) selecting / selected from the Kansong Art Museum's collection. The exhibition included information about the man who gathered all of the artwork (B) displaying / displayed there. His name was Jeon Hyeongpil, but he is better known (C) by / to his pen name, Kansong. He was born into a rich family in 1906 and lived through the Japanese occupation of Korea. At the age of 24, he inherited a massive fortune. After carefully thinking about what he could do for his country, he decided to use the money to protect Korea's cultural heritage from the Japanese. This decision was greatly influenced by his mentor, Oh Sechang, who was an independence activist and had keen insight into Korean art. With Oh's guidance and his own convictions, Kansong devoted most of his fortune to acquiring old books, paintings, and other works of art. He considered these items the pride of the nation and believed they represented the national spirit. Without his actions, they would have been destroyed or taken overseas.

2 (A), (B), (C)의 각 네모 안에서 어법에 맞는 표현으로 가장 적절한 것은?

	(A)		(B)		(C)
①	selecting	⋯	displaying	⋯	by
②	selecting	⋯	displayed	⋯	to
③	selected	⋯	displaying	⋯	to
④	selected	⋯	displayed	⋯	by
⑤	selected	⋯	displayed	⋯	to

3 전형필에 대한 윗글의 내용과 일치하는 것은?

① 본명은 간송이다.

② 25세에 막대한 재산을 물려받았다.

③ 제자인 오세창을 가르쳤다.

④ 오래된 책과 그림들을 획득했다.

⑤ 자신의 돈으로 독립운동가를 지원했다.

[4~5] 다음 글을 읽고, 물음에 답하시오.

> As soon as I walked in, I could not help but ⓐ admiring some ink-and-water paintings by Jeong Seon, a famous Korean artist also known as Gyeomjae. (①) These paintings were kept in an album ⓑ calling the *Haeak jeonsincheop*. (②) They depict the beautiful scenery of Geumgangsan Mountain and its surrounding

areas. (③) The way Gyeomjae painted the mountains, rivers, and valleys makes them look very inviting. (④) I was shocked when the museum tour guide said that the album was almost burned as kindling. (⑤) ⓒ <u>Known</u> that these beautiful paintings were nearly turned to ashes made me feel very sad. I am thankful that these paintings are still around so that future generations can also appreciate them.

4 윗글의 흐름으로 보아, 주어진 문장이 들어가기에 가장 적절한 곳은?

> Fortunately, it was rescued at the last minute and later purchased by Kansong.

①　　　②　　　③　　　④　　　⑤

5 윗글의 밑줄 친 ⓐ~ⓒ를 어법에 맞게 고쳐 쓰시오.

ⓐ admiring → _____

ⓑ calling → _____

ⓒ Known → _____

[6~7] 다음 글을 읽고, 물음에 답하시오.

The next item that ⓐ <u>impressed</u> me was a gorgeous porcelain vase called the *Celadon Prunus Vase with Inlaid Cloud and Crane Design*. It is a pleasant shade of green, with a lovely pattern of clouds and cranes ⓑ <u>encircling</u> the entire vase. The cranes seem to be ⓒ <u>alive</u> and stretching their wings in search of freedom. Kansong bought the vase from a Japanese art dealer in 1935. With the money he spent on it, Kansong could have ⓓ <u>bought</u> 20 nice houses! Later, a different Japanese collector offered double the price Kansong had paid for the vase. However, Kansong _____ because he knew that it was the most magnificent vase of its kind. Today it is listed as one of Korea's National Treasures. Seeing it in person was an absolutely ⓔ <u>disappointing</u> experience!

6 윗글의 빈칸에 들어갈 말로 가장 적절한 것은?

① sold it off secretly
② refused to part with it
③ gave him a discount
④ purchased the houses
⑤ met the Japanese collector

7 윗글의 밑줄 친 ⓐ~ⓔ 중, 문맥상 낱말의 쓰임이 적절하지 않은 것은?

① ⓐ　　② ⓑ　　③ ⓒ　　④ ⓓ　　⑤ ⓔ

[8~10] 다음 글을 읽고, 물음에 답하시오.

Finally, I saw the one item in the museum that I will never forget—an original copy of the *Hunminjeongeum Haerye*. This ancient book was written in 1446, and it explains the ideas and principles behind the creation of Hangeul, the writing system of the Korean language. It was found in Andong in 1940. At that time, however, Korea was still occupied by Japan. The Japanese colonial government intended to get rid of the Korean language. <u>학교들은 한국어로 수업하는 것을 금지당했다</u>, and scholars who studied Korean were arrested.

From the moment he heard that the *Hunminjeongeum Haerye* had been discovered, Kansong couldn't stop thinking about it. He knew he had to protect it at all costs. After years of waiting, he was finally able to obtain the book. He purchased it at ten times the price the owner was asking and carefully hid it in his house. When _____(A)_____, he was able to share it with the rest of Korea. The guide said that the *Hunminjeongeum Haerye* is the museum's most precious treasure. Without it, the origins and fundamentals of Hangeul (B) (to / have / lost / history / been / would). It has since been designated a National Treasure of Korea and included in the UNESCO Memory of the World Register. Looking at the ancient book, I could feel Kansong's strong commitment to preserving Korean history.

8 윗글의 밑줄 친 우리말과 일치하도록 〈보기〉에 주어진 말을 배열하여 문장을 완성하시오. (필요 시 형태를 변형할 것)

〈보기〉 be / schools / forbid / teach lessons / to / in Korean

9 윗글의 빈칸 (A)에 들어갈 말로 가장 적절한 것은?

① he preserved it in the museum
② he was arrested by the Japanese
③ the book was purchased by him
④ the Japanese were finally defeated
⑤ he understood the importance of it

10 윗글의 (B)에 주어진 말을 알맞게 배열하시오.

[11~12] 다음 글을 읽고, 물음에 답하시오.

Standing in the middle of the exhibition hall, surrounded by Korean art, (A) I could not stop thinking about Kansong. He was an amazing person! He did not collect art for his personal enjoyment. He did it to protect Korea's cultural identity during the harsh Japanese colonial period. After Korea regained its independence, he stopped collecting art, as he knew it would safely remain in Korea. During our country's worst time, a single man was able to defend Korea's national spirit and pride. (B) him, we are still able to experience an essential part of Korean culture today.

11 윗글의 밑줄 친 (A)를 우리말로 해석하시오.

12 윗글의 빈칸 (B)에 들어갈 말로 가장 적절한 것은?

① As to
② Thanks to
③ In spite of
④ In front of
⑤ According to

13 다음 글의 ①~⑤ 중, 어법상 틀린 표현이 있는 문장은?

① Founded in 1938, the Kansong Art Museum was Korea's first private museum. ② When Kansong built it, he named it Bohwagak. ③ He used the building as a place to store all of the important cultural items where he had collected over the years. ④ Kansong died in 1962, and Bohwagak was renamed the Kansong Art Museum in 1966. ⑤ It now holds about 5,000 items, including 12 Korean National Treasures.

① ② ③ ④ ⑤

14 다음 글의 목적으로 가장 적절한 것은?

Today, I want to tell you about Dasan Chodang House, a historical site in Korea. It is located in Gangjin-gun, Jeollanam-do.

It is the place where Jeong Yakyong lived during his ten-year exile. He was a scholar of the late Joseon Dynasty who contributed to the development of Silhak. He dedicated himself to studying and teaching young students at Dasan Chodang House. He also wrote more than 500 books there, including Mongminsimseo, which provided local officers with governing guidelines.

When I visited Dasan Chodang House, I felt moved by Jeong Yakyong's great passion for education. Why don't you visit it sometime?

① 강진 관광을 홍보하려고
② 정약용의 책을 알리려고
③ 실학의 내용을 문의하려고
④ 다산 초당을 소개하려고
⑤ 조선의 건축 기술을 자랑하려고

1 다음 대화의 밑줄 친 우리말과 일치하도록 주어진 단어를 이용하여 문장을 완성하시오. (4단어)

> B: We're going to be late for school!
> G: Should we run or wait for the bus?
> B: 우리 기다리는 게 어때? This app says the bus will arrive in two minutes.
> G: Okay. I'm glad that we have this app. It's really convenient and practical.
> B: I heard that the inventor was a high school student when he made it.
> G: You mean he was our age? Wow! I wonder how he conceived of the idea for it.

(why, wait)

[2~4] 다음 글을 읽고, 물음에 답하시오.

> Last week, I visited an exhibition of artwork and ancient items selected from the Kansong Art Museum's collection. The exhibition included information about the man (A) who / which gathered all of the artwork displayed there. His name was Jeon Hyeongpil, but he is better known by his pen name, Kansong. He was born into a rich family in 1906 and lived through the Japanese occupation of Korea. At the age of 24, he inherited a massive fortune. After carefully thinking about what he could do for his country, he decided (B) using / to use the money to protect Korea's cultural heritage from the Japanese. This decision was greatly influenced by his mentor, Oh Sechang, who was an independence activist and had keen insight into Korean art. With Oh's guidance and his own convictions, 간송은 그의 재산의 대

> 부분을 오래된 책들, 그림들, 그리고 다른 미술품들을 획득하는 데 바쳤다. He considered these items the pride of the nation and believed they represented the national spirit. Without his actions, they would have been destroyed or taken overseas.

2 (A), (B)의 각 네모 안에서 어법에 맞는 표현을 골라 쓰시오.

(A) _____

(B) _____

3 다음 영영 뜻풀이에 해당하는 단어를 윗글에서 찾아 쓰시오.

> the art, traditions, and beliefs that a society considers important to its history and culture

4 윗글의 밑줄 친 우리말과 일치하도록 〈보기〉에 주어진 말을 배열하여 문장을 완성하시오. (필요 시 형태를 변형할 것)

> 〈보기〉 his fortune / to / Kansong / most / acquire / devote / of

_____ old books, paintings, and other works of art

[5~6] 다음 글을 읽고, 물음에 답하시오.

> As soon as I walked in, I could not help but admire some ink-and-water paintings by Jeong Seon, a famous Korean artist also known as Gyeomjae. These paintings were kept in an

album called the *Haeak jeonsincheop*. They depict the beautiful scenery of Geumgangsan Mountain and its surrounding areas. The way Gyeomjae painted the mountains, rivers, and valleys makes (A) them look very inviting. I was shocked when the museum tour guide said that the album was almost burned as kindling.

Fortunately, (B) it was rescued at the last minute and later purchased by Kansong. Knowing that these beautiful paintings were nearly turned to ashes made me feel very sad. I am thankful that these paintings are still around so that future generations can also ⓐ appreciate them.

5 밑줄 친 (A), (B)가 가리키는 것을 윗글에서 찾아 쓰시오.

(A) _____

(B) _____

6 다음 중 윗글의 밑줄 친 ⓐ appreciate와 의미가 같은 것은?

① Thanks for your help. I appreciate it.
② I appreciate your cooperation again.
③ Appreciate the grand exhibition with your friends.
④ We would appreciate it if you could attend.
⑤ I didn't fully appreciate that he was seriously sick.

[7~8] 다음 글을 읽고, 물음에 답하시오.

The next item that impressed me was a gorgeous porcelain vase called the *Celadon Prunus Vase with Inlaid Cloud and Crane Design*. It is a pleasant shade of green, with a lovely pattern of clouds and cranes (A) encircle / encircling the entire vase. The cranes seem to be alive and (B) stretched / stretching their wings in search of freedom. Kansong bought

the vase from a Japanese art dealer in 1935. _____ the money he spent on it, Kansong could have bought 20 nice houses! Later, a different Japanese collector offered double the price Kansong had paid for the vase. However, Kansong refused to part with it because he knew that it was the most magnificent vase of its kind. Today it is listed as one of Korea's National Treasures. (C) Seeing / Seen it in person was an absolutely breathtaking experience!

7 (A), (B), (C)의 각 네모 안에서 어법에 맞는 표현으로 가장 적절한 것은?

	(A)		(B)		(C)
①	encircle	⋯	stretched	⋯	Seeing
②	encircle	⋯	stretching	⋯	Seen
③	encircling	⋯	stretched	⋯	Seeing
④	encircling	⋯	stretched	⋯	Seen
⑤	encircling	⋯	stretching	⋯	Seeing

8 윗글의 빈칸에 들어갈 말로 가장 적절한 것은?

① With ② Thanks to
③ On ④ Due to
⑤ Owing to

9 다음 글의 밑줄 친 ⓐ~ⓔ 중, 어법상 틀린 것은?

Finally, I saw the one item in the museum ⓐ that I will never forget—an original copy of the *Hunminjeongeum Haerye*. This ancient book was written in 1446, and it explains the ideas and principles behind the creation of Hangeul, the writing system of the Korean language. It ⓑ founded in Andong in 1940. At that time, however, Korea was still ⓒ occupied by Japan. The Japanese colonial government intended ⓓ to get rid of the Korean language. Schools were forbidden to teach lessons in Korean, and scholars who studied Korean ⓔ were arrested.

① ⓐ ② ⓑ ③ ⓒ ④ ⓓ ⑤ ⓔ

From the moment he heard that the *Hunminjeongeum Haerye* had been discovered, Kansong couldn't stop thinking about it. He knew he had to protect it ⓐ at all costs.

(A) When the Japanese were finally defeated, he was able to share it with the rest of Korea. ⓑ The guide said that the *Hunminjeongeum Haerye* is the museum's most precious treasure.

(B) After years of waiting, he was finally able to obtain the book. He purchased it at ten times the price the owner was asking and carefully hid it in his house.

(C) Without it, the origins and fundamentals of Hangeul would have been lost to history. It has since been designated a National Treasure of Korea and included in the UNESCO Memory of the World Register.

10 주어진 글 다음에 이어질 글의 순서로 가장 적절한 것은?

① (A) – (C) – (B) ② (B) – (A) – (C)
③ (B) – (C) – (A) ④ (C) – (A) – (B)
⑤ (C) – (B) – (A)

11 윗글의 밑줄 친 ⓐ와 의미가 같은 것은?

① after all ② as well
③ all along ④ by all means
⑤ without cost

12 윗글의 밑줄 친 ⓑ와 같은 의미가 되도록 빈칸에 알맞은 말을 쓰시오.

→ The guide said that nothing is _____ _____ than the *Hunminjeongeum Haerye* in the museum.

Standing in the middle of the exhibition hall, surrounded by Korean art, I could not stop thinking about Kansong. He was an amazing person! He did not collect art for his personal enjoyment. He did it to protect Korea's cultural (A) identity / identification during the harsh Japanese colonial period. After Korea regained its independence, he stopped collecting art, as he knew it would (B) safely / rarely remain in Korea. During our country's worst time, a single man was able to (C) defend / offend Korea's national spirit and pride. Thanks to him, we are still able to experience an essential part of Korean culture today.

13 윗글의 제목으로 가장 적절한 것은?

① Korea's Cultural Identity
② A Protector of Korean Art
③ High Level of Korean Art
④ Japanese Colonial Period in Korea
⑤ The Relationship between Korea and Japan

14 (A), (B), (C)의 각 네모에서 문맥에 맞는 낱말로 가장 적절한 것은?

	(A)	(B)	(C)
①	identity	safely	defend
②	identity	rarely	defend
③	identity	rarely	offend
④	identification	safely	offend
⑤	identification	rarely	offend

1 다음 대화의 빈칸 (A), (B)에 들어갈 말로 가장 적절한 것은?

> G: Minjun! _____ (A)
> B: Yes. I've decided to write about Songam.
> G: Who is Songam?
> B: He invented the Korean Braille system, a reading and writing system for blind people.
> G: Wow! _____ (B)
> B: He taught blind students when Korea was ruled by Japan. He didn't want to teach them the Japanese Braille system. So he developed a Korean one and named it Hunmaengjeongeum.
> G: What a great person!

> 〈보기〉
> ⓐ Have you chosen a topic for your history report?
> ⓑ Have you finished your report on Songam?
> ⓒ What made him do that?
> ⓓ What caused him to become blind?

	(A)	(B)		(A)	(B)
①	ⓐ	… ⓑ	②	ⓐ	… ⓒ
③	ⓑ	… ⓒ	④	ⓑ	… ⓓ
⑤	ⓒ	… ⓐ			

[2~4] 다음 글을 읽고, 물음에 답하시오.

The exhibition included information about the man who gathered all of the artwork displayed there. His name was Jeon Hyeongpil, but he is better known by his pen name, Kansong. He was born into a rich family in 1906 and lived through the Japanese ① occupation of Korea. At the age of 24, he ② inherited a massive fortune. After carefully thinking about what he could do for his country, he decided to use the money to protect Korea's cultural heritage from the Japanese. (A) This decision was greatly influenced by his mentor, Oh Sechang, who was an ③ independence activist and had keen insight into Korean art. With Oh's guidance and his own ④ indifference, Kansong devoted most of his fortune to acquiring old books, paintings, and other works of art. He considered these items the pride of the nation and believed they ⑤ represented the national spirit. (B) Without his actions, they would have been destroyed or taken overseas.

2 윗글의 밑줄 친 ①~⑤ 중, 문맥상 낱말의 쓰임이 적절하지 않은 것은?

① ② ③ ④ ⑤

3 윗글의 밑줄 친 (A) This decision이 의미하는 것을 우리말로 쓰시오. (25자 내외)

4 윗글의 밑줄 친 (B)와 같은 의미가 되도록 빈칸에 알맞은 말을 쓰시오.

→ _____ _____ his actions, they would have been destroyed or taken overseas.

As soon as I walked in, I could not help but admire ⓐ some ink-and-water paintings by Jeong Seon, a famous Korean artist also known as Gyeomjae. These paintings were kept in an album called the *Haeak jeonsincheop*. They (A) depict / are depicted the beautiful scenery of Geumgangsan Mountain and its surrounding areas. The way Gyeomjae painted the mountains, rivers, and valleys makes them look very (B) invite / inviting. I was shocked when the museum tour guide said that the album was almost burned as kindling. Fortunately, it was rescued at the last minute and later purchased by Kansong. Knowing that these beautiful paintings were nearly turned to ashes made me (C) feel / to feel very sad. I am thankful that these paintings are still around so that future generations can also appreciate them.

5 (A), (B), (C)의 각 네모 안에서 어법에 맞는 표현으로 가장 적절한 것은?

	(A)	(B)	(C)
①	depict	… invite	… feel
②	depict	… inviting	… feel
③	depict	… inviting	… to feel
④	were depicted	… invite	… to feel
⑤	were depicted	… inviting	… to feel

6 윗글에서 밑줄 친 ⓐ에 대해 언급되지 <u>않은</u> 것은?

① 그린 사람　　　　② 그림의 배경
③ 매입한 인물　　　　④ 매입 과정
⑤ 현재 존재하는지의 여부

7 다음 글의 흐름으로 보아 주어진 문장이 들어가기에 가장 적절한 곳은?

However, Kansong refused to part with it because he knew that it was the most magnificent vase of its kind.

The next item that impressed me was a gorgeous porcelain vase called the *Celadon Prunus Vase with Inlaid Cloud and Crane Design*. (①) It is a pleasant shade of green, with a lovely pattern of clouds and cranes encircling the entire vase. (②) The cranes seem to be alive and stretching their wings in search of freedom. Kansong bought the vase from a Japanese art dealer in 1935. (③) With the money he spent on it, Kansong could have bought 20 nice houses! (④) Later, a different Japanese collector offered double the price Kansong had paid for the vase. (⑤) Today it is listed as one of Korea's National Treasures. Seeing it in person was an absolutely breathtaking experience!

①　　　　②　　　　③　　　　④　　　　⑤

Finally, I saw the one item in the museum that I will never forget — an original copy of the *Hunminjeongeum Haerye*. This ancient book was written in 1446, and it explains the ideas and principles behind the creation of Hangeul, the writing system of the Korean language. It was found in Andong in 1940. At that time, however, Korea was still occupied by Japan. The Japanese colonial government intended to _____ the Korean language. Schools were forbidden to teach lessons in Korean, and scholars who studied Korean were arrested.

8 Hunminjeongeum Haerye에 대한 윗글의 내용과 일치하지 <u>않는</u> 것은?

① 미술관에서 볼 수 있다.
② 1446년에 쓰여졌다.
③ 한글 창제의 바탕이 되는 원리를 담고 있다.
④ 안동에서 발견되었다.
⑤ 발견 당시, 한국은 해방된 상태였다.

9 윗글의 빈칸에 들어갈 말로 적절하지 <u>않은</u> 것은?

① get rid of ② eliminate
③ remove ④ enhance
⑤ abolish

[10~12] 다음 글을 읽고, 물음에 답하시오.

From the moment he heard that the *Hunminjeongeum Haerye* (A) <u>discover</u>, Kansong couldn't stop thinking about it. He knew he had to protect it at all costs. After years of waiting, he was finally able to obtain the book. He purchased it at ten times the price the owner was asking and carefully hid it in his house. When the Japanese were finally defeated, he was able to share it with the rest of Korea. The guide said that the *Hunminjeongeum Haerye* is the museum's most precious treasure. Without it, the origins and fundamentals of Hangeul would have been lost to history. It has since been designated a National Treasure of Korea and (B) <u>including</u> in the UNESCO Memory of the World Register. Looking at the ancient book, I could feel Kansong's strong commitment to preserving Korean history.

10 윗글의 밑줄 친 (A)를 어법상 알맞은 형태로 고친 것은?

① discovering
② is discovered
③ has been discovered
④ had been discovering
⑤ had been discovered

11 윗글의 주제로 가장 적절한 것은?

① 일제의 잔혹한 식민지 지배 정책
② 훈민정음 해례본의 학술적 중요성
③ 훈민정음 해례본이 발견된 과정
④ 일제 식민지 시대의 한국어 연구의 어려움
⑤ 훈민정음 해례본을 지키려 한 간송의 노력

12 윗글의 밑줄 친 (B)를 어법에 맞게 한 단어로 고쳐 쓰시오.

[13~14] 다음 글을 읽고, 물음에 답하시오.

ⓐ <u>To Stand</u> in the middle of the exhibition hall, ⓑ <u>surrounding</u> by Korean art, I could not stop thinking about Kansong. He was an amazing person! He did not collect art for his personal enjoyment. He did it to protect Korea's cultural identity during the harsh Japanese colonial period. After Korea regained its independence, he stopped collecting art, as he knew it would safely remain in Korea. During our country's worst time, a single man was able to defend Korea's national spirit and pride. Thanks to him, we are still able to experience an essential part of Korean culture today.

13 윗글의 밑줄 친 ⓐ, ⓑ를 어법에 맞게 고쳐 쓰시오.

ⓐ To stand → _____

ⓑ surrounding → _____

14 윗글에 드러난 I의 심경으로 가장 적절한 것은?

① envious ② proud
③ thrilled ④ regretful
⑤ exhausted

1 다음 대화의 빈칸에 들어갈 말로 적절하지 <u>않은</u> 것은?

> A: What volunteer activity are you going to do this year?
>
> B: I don't know. Do you have any suggestions?
>
> A: _____ your talent? I know that you are good at taking pictures.
>
> B: Yes, but what can I do?
>
> A: You can take pictures of elderly people in nursing homes.
>
> B: Great idea! Why didn't I think of that before? Thanks!

① Why don't you use
② How about using
③ What about using
④ Why not use
⑤ How can I use

[2~4] 다음 글을 읽고, 물음에 답하시오.

> Last week, I visited an exhibition of artwork and ancient items selected from the Kansong Art Museum's collection. The exhibition included information about the man ___(A)___ gathered all of the artwork displayed there. His name was Jeon Hyeongpil, but he is better known by his pen name, Kansong. He was born into a rich family in 1906 and lived through the Japanese occupation of Korea. At the age of 24, he inherited a massive fortune. After carefully thinking about what he could do for his country, he decided to use the money to protect Korea's cultural heritage from the Japanese. This decision was greatly influenced by his mentor, Oh Sechang, ___(B)___ was an independence activist and had keen insight into Korean art. With Oh's guidance and his

> own convictions, Kansong devoted most of his fortune to acquiring old books, paintings, and other works of art. He considered these items the pride of the nation and believed they represented the national spirit. Without <u>his actions</u>, they would have been destroyed or taken overseas.

2 윗글의 빈칸 (A), (B)에 공통으로 들어갈 말로 가장 적절한 것은?

① who ② which
③ whom ④ what
⑤ that

3 다음 영영 뜻풀이에 해당하는 단어를 윗글에서 찾아 쓰시오. (명사인 경우 단수형으로, 동사인 경우 동사원형으로 쓸 것)

> put all of something, especially time or energy, toward a task or goal

4 윗글의 밑줄 친 his actions가 의미하는 것으로 가장 적절한 것은?

① 간송 박물관을 설립한 것
② 예술품을 보는 안목을 기른 것
③ 일제에 대항하여 독립 운동을 한 것
④ 우리나라의 예술품을 해외로 반출한 것
⑤ 자신의 재산으로 우리나라의 미술품을 산 것

[5~7] 다음 글을 읽고, 물음에 답하시오.

> As soon as I walked in, I ___(A)___ some ink-and-water paintings by Jeong Seon, a famous Korean artist also known as Gyeomjae. These paintings were kept in an

album called the *Haeak jeonsincheop*. They depict the beautiful scenery of Geumgangsan Mountain and its surrounding areas. The way Gyeomjae painted the mountains, rivers, and valleys makes them look very inviting. I was ⓐ shocking when the museum tour guide said that the album was almost burned as kindling. Fortunately, it ⓑ rescued at the last minute and later purchased by Kansong. Knowing that these beautiful paintings were nearly turned to ashes made me feel very sad. I am _____ (B) _____ that these paintings are still around so that future generations can also appreciate them.

5 윗글의 빈칸 (A)에 들어갈 말로 적절하지 <u>않은</u> 것을 <u>모두</u> 고르시오.

① could not admire
② could not help admire
③ could not but admire
④ could not help admiring
⑤ could not help but admire

6 윗글의 밑줄 친 ⓐ, ⓑ를 어법에 맞게 고쳐 쓰시오.

ⓐ shocking → _____

ⓑ rescued → _____

7 윗글의 빈칸 (B)에 들어갈 말로 가장 적절한 것은?

① ashamed
② depressed
③ curious
④ ignorant
⑤ grateful

[8~9] 다음 글을 읽고, 물음에 답하시오.

The next item (A) | that / what | impressed me was a gorgeous porcelain vase called the *Celadon Prunus Vase with Inlaid Cloud and Crane Design*. It is a pleasant shade of green, with a lovely pattern of clouds and cranes encircling the entire vase. The cranes seem (B) | to alive / to be alive | and stretching their

wings in search of freedom. Kansong bought the vase from a Japanese art dealer in 1935. With the money he spent on it, ⓐ (could / Kansong / 20 nice houses / bought / have)! Later, a different Japanese collector offered double the price Kansong had paid for the vase. However, Kansong refused to part with (C) | him / it | because he knew that it was the most magnificent vase of its kind. Today it is listed as one of Korea's National Treasures. Seeing it in person was an absolutely breathtaking experience!

8 (A), (B), (C)의 각 네모 안에서 어법에 맞는 표현으로 가장 적절한 것은?

	(A)		(B)		(C)
①	that	…	to alive	…	him
②	that	…	to be alive	…	him
③	that	…	to be alive	…	it
④	what	…	to alive	…	him
⑤	what	…	to be alive	…	it

9 윗글의 ⓐ에 주어진 말을 알맞게 배열하시오.

[10~12] 다음 글을 읽고, 물음에 답하시오.

Finally, I saw ⓐ the one item in the museum that I will never forget—an original copy of the *Hunminjeongeum Haerye*. This ancient book was written in 1446, and it explains the ideas and principles behind the creation of Hangeul, ⓑ the writing system of the Korean language. It was found in Andong in 1940. At that time, however, Korea was still occupied by Japan. The Japanese colonial government intended to _____ (A) _____. Schools were forbidden to teach lessons in Korean, and scholars who studied Korean were arrested.

From the moment he heard that the *Hunminjeongeum Haerye* had been discovered, Kansong couldn't stop thinking about ⓒ it. He knew he had to protect it at all costs. After years of waiting, he was finally able to obtain the book. He purchased it at ten times the price the owner was asking and carefully hid it in his house. When the Japanese were finally defeated, he was able to share ⓓ it with the rest of Korea. The guide said that the *Hunminjeongeum Haerye* is ⓔ the museum's most precious treasure. Without it, the origins and fundamentals of Hangeul would have been lost to history. It has since been designated a National Treasure of Korea and included in the UNESCO Memory of the World Register. Looking at the ancient book, I could feel
_____(B)_____.

10 윗글의 밑줄 친 ⓐ~ⓔ 중, 가리키는 대상이 나머지 넷과 다른 것은?

① ⓐ ② ⓑ ③ ⓒ ④ ⓓ ⑤ ⓔ

11 윗글의 빈칸 (A)에 들어갈 말로 가장 적절한 것은?

① protect the ancient Korean items
② take Korean people's property
③ know the principle of Hangeul
④ get rid of the Korean language
⑤ throw Korean people into prison

12 〈보기〉에 주어진 말을 배열하여 윗글의 빈칸 (B)를 완성하시오. (필요 시 형태를 변형할 것)

〈보기〉 preserve / Kansong's / to / Korean / strong commitment / history

13 독립 후 간송이 한국의 미술품을 수집하지 <u>않은</u> 이유를 우리말로 쓰시오. (30자 내외)

Standing in the middle of the exhibition hall, surrounded by Korean art, I could not stop thinking about Kansong. He was an amazing person! He did not collect art for his personal enjoyment. He did it to protect Korea's cultural identity during the harsh Japanese colonial period. After Korea regained its independence, he stopped collecting art, as he knew it would safely remain in Korea. During our country's worst time, a single man was able to defend Korea's national spirit and pride. Thanks to him, we are still able to experience an essential part of Korean culture today.

14 다음 글의 밑줄 친 우리말과 일치하도록 주어진 단어를 이용하여 문장을 완성하시오. (필요 시 형태를 변형할 것)

I am honored to receive this year's school volunteerism award. I want to thank my teacher, Mr. Johnson. <u>그의 격려가 없었다면, 나는 지역 도서관에서 자원봉사하는 것을 시작하지 않았을 것이다.</u> I also want to ask my fellow students to volunteer in our community. Without volunteers, our community could not have become such a lovely place. Thank you so much for this award, and I hope that you will all join me in volunteering in our community.

Without his encouragement, _____

_____ at local libraries.

(will start / volunteering)

1 다음 대화의 빈칸 (A), (B)에 들어갈 말로 가장 적절한 것은?

B: We're going to be late for school!

G: Should we run or wait for the bus?

B: _____(A)_____ This app says the bus will arrive in two minutes.

G: Okay. I'm glad that we have this app. It's really convenient and practical.

B: I heard that the inventor was a high school student when he made it.

G: You mean he was our age? Wow! I wonder how he conceived of the idea for it.

B: Just like us, he needed to know when the bus would arrive so he could get to school on time. He thought, "What if I used my programming knowledge to make a mobile app?" So he did!

G: _____(B)_____ He used his talent to improve his daily life.

B: Yes, and he offered the app to the public for free.

G: I'm really grateful that he did. Look, the bus is coming! The app saved us!

〈보기〉

ⓐ Why don't we wait?

ⓑ I don't know the reason.

ⓒ What a wonderful person!

ⓓ How can we take the bus?

(A)	(B)		(A)	(B)
① ⓐ	… ⓑ		② ⓐ	… ⓒ
③ ⓑ	… ⓒ		④ ⓒ	… ⓓ
⑤ ⓓ	… ⓐ			

[2~5] 다음 글을 읽고, 물음에 답하시오.

Yunju, a high school student, went to a Korean art exhibition. She wrote a report about her experience to ① <u>share</u> with her class.

Last week, I visited an exhibition of artwork and ancient items selected from the Kansong Art Museum's collection. The exhibition included information about the man who gathered all of the artwork ② <u>displayed</u> there. His name was Jeon Hyeongpil, but he is better ③ <u>known</u> by his pen name, Kansong. He was born into a rich family in 1906 and lived through the Japanese occupation of Korea. At the age of 24, he inherited a massive fortune. After carefully thinking about what he could do for his country, he decided to use the money to ④ <u>provide</u> Korea's cultural heritage from the Japanese. This decision _____ his mentor, Oh Sechang, (A) who / whom was an independence activist and had keen insight into Korean art. With Oh's guidance and his own convictions, Kansong devoted most of his fortune to acquiring old books, paintings, and other works of art. He considered these items the ⑤ <u>pride</u> of the nation and believed they represented the national spirit. Without his actions, (B) it / they would have been destroyed or taken overseas.

2 윗글의 밑줄 친 ①~⑤ 중, 문맥상 낱말의 쓰임이 적절하지 <u>않은</u> 것은?

① ② ③ ④ ⑤

3 다음 영영 뜻풀이에 해당하는 단어를 윗글에서 찾아 쓰시오.

a situation where an army takes control of another country and stays there to manage it

4 윗글의 빈칸에 들어갈 말로 가장 적절한 것은?

① was announced by
② had a great impact on
③ was suddenly made by
④ had been a bad one to
⑤ was greatly influenced by

5 (A), (B)의 각 네모 안에서 어법에 맞는 표현을 골라 쓰시오.

(A) _____

(B) _____

[6~7] 다음 글을 읽고, 물음에 답하시오.

As soon as I walked in, I could not help but admire ⓐ some ink-and-water paintings by Jeong Seon, a famous Korean artist also known as Gyeomjae. ⓑ They were kept in an album called the *Haeak jeonsincheop*. ⓒ They depict the beautiful scenery of Geumgangsan Mountain and its surrounding areas. The way Gyeomjae painted the mountains, rivers, and valleys makes ⓓ them look very inviting. I was shocked when the museum tour guide said that the album was almost burned as kindling. Fortunately, it was rescued at the last minute and later purchased by Kansong. Knowing that ⓔ these beautiful paintings were nearly turned to ashes made me feel very sad. I am thankful that these paintings are still around 미래 세대 또한 그것들을 감상할 수 있도록 하기 위해서.

6 윗글의 밑줄 친 ⓐ~ⓔ 중, 가리키는 대상이 나머지 넷과 다른 것은?

① ⓐ ② ⓑ ③ ⓒ ④ ⓓ ⑤ ⓔ

7 윗글의 밑줄 친 우리말과 일치하도록 〈보기〉에 주어진 말을 배열하여 문장을 완성하시오.

〈보기〉 future / so / also appreciate / that / can / generations / them

[8~9] 다음 글을 읽고, 물음에 답하시오.

The next item that impressed me was a gorgeous porcelain vase called the (A) *Celadon Prunus Vase with Inlaid Cloud and Crane Design*. It is a pleasant shade of green, with a lovely pattern of clouds and cranes encircling the entire vase. (B) The cranes seem to be alive and stretching their wings in search of freedom. Kansong bought the vase from a Japanese art dealer in 1935. With the money he spent on it, Kansong could have bought 20 nice houses! Later, a different Japanese collector offered double the price Kansong had paid for the vase. However, Kansong refused to part with it because he knew that it was the most magnificent vase of its kind. Today it is listed as one of Korea's National Treasures. Seeing it in person was an absolutely breathtaking experience!

8 밑줄 친 (A)에 대한 윗글의 내용과 일치하지 <u>않는</u> 것은?

① It is decorated with a pattern of cranes.
② A Japanese art dealer sold it to Kansong in 1935.
③ Kansong bought 20 nice houses to protect it.
④ Kansong didn't sell it to the Japanese collector.
⑤ It is designated as a Korean National Treasure.

9 윗글의 밑줄 친 (B)를 주어진 단어로 시작하는 표현으로 바꿔 쓰시오.

→ It _____ _____

_____ _____ and

stretching their wings in search of freedom.

[10~11] 다음 글을 읽고, 물음에 답하시오.

From the moment he heard that the *Hunminjeongeum Haerye* had been discovered, Kansong couldn't stop thinking about it. He knew he had to protect it at all costs. After years of waiting, he was finally able to obtain the book. He purchased it 열 배의 가격에 the owner

was asking and carefully hid it in his house. When the Japanese were finally defeated, he was able to share it with the rest of Korea. The guide said that the *Hunminjeongeum Haerye* is the museum's most precious treasure. Without it, the origins and fundamentals of Hangeul would have been lost to history. It has since been designated a National Treasure of Korea and included in the UNESCO Memory of the World Register. Looking at the ancient book, I could feel Kansong's _____.

Standing in the middle of the exhibition hall, surrounded by Korean art, I could not stop thinking about Kansong. He was an amazing person! He did not collect art for his personal enjoyment. He did it to protect Korea's cultural identity during the harsh Japanese colonial period.

10 윗글의 밑줄 친 우리말과 일치하도록 주어진 단어를 이용하여 문장을 완성하시오. (필요 시 형태를 변형할 것)

(time, the price)

11 윗글의 빈칸에 들어갈 말로 가장 적절한 것은?

① ability to purchase the ancient items
② effort to be remembered in history
③ curiosity about the invention of Hangeul
④ strong desire to preserve Korean history
⑤ deep attachment to rare antique items

[12~13] 다음 글을 읽고, 물음에 답하시오.

ⓐ Founding in 1938, the Kansong Art Museum was Korea's first private museum. When Kansong built it, he named it Bohwagak. He used the building as a place to store all of the important cultural items he had collected over the years. Kansong died in 1962, and Bohwagak was renamed the Kansong Art Museum in 1966. It now ⓑ is held about 5,000 items, including 12 Korean National Treasures.

12 윗글의 밑줄 친 ⓐ, ⓑ를 어법에 맞게 고쳐 쓰시오.

ⓐ Founding → _____

ⓑ is held → _____

13 간송이 보화각을 사용한 목적을 우리말로 쓰시오. (30자 내외)

14 다음 글의 내용과 일치하지 <u>않는</u> 것은?

Today, I want to tell you about Dasan Chodang House, a historical site in Korea. It is located in Gangjin-gun, Jeollanam-do.

It is the place where Jeong Yakyong lived during his ten-year exile. He was a scholar of the late Joseon Dynasty who contributed to the development of Silhak. He dedicated himself to studying and teaching young students at Dasan Chodang House. He also wrote more than 500 books there, including *Mongminsimseo*, which provided local officers with governing guidelines.

When I visited Dasan Chodang House, I felt moved by Jeong Yakyong's great passion for education. Why don't you visit it sometime?

① 다산 초당은 강진에 있다.
② 정약용은 다산 초당에서 일생을 보냈다.
③ 정약용은 조선 후기 학자이다.
④ 정약용은 500권이 넘는 책을 썼다.
⑤ 목민심서는 지역 관리들을 위한 책이다.

1 다음 우리말과 일치하도록 〈보기〉에 주어진 단어를 이용하여 문장을 완성하시오.

> 엄마의 헌신적인 노력이 없었다면, 나는 이 위치에 올 수 없었을 것이다.

> 〈보기〉 would / I / committed effort / not / my mother's / able to / have / be / without
>
> 〈조건〉
> • 주어진 단어를 모두 사용할 것
> • 필요 시 형태를 변형할 것

_____,

_____ get to

this position.

2 다음 글의 밑줄 친 우리말과 일치하도록 〈보기〉에 주어진 단어를 배열하여 문장을 완성하시오.

> Last week, I visited an exhibition of artwork and ancient items selected from the Kansong Art Museum's collection. The exhibition included information about the man who gathered all of the artwork displayed there. His name was Jeon Hyeongpil, but he is better known by his pen name, Kansong. He was born into a rich family in 1906 and lived through the Japanese occupation of Korea. At the age of 24, he inherited a massive fortune. 그가 그의 나라를 위해 무엇을 할 수 있을지에 대해 신중하게 생각한 후에, he decided to use the money to protect Korea's cultural heritage from the Japanese.

> 〈보기〉 carefully thinking / his / do / what / country / for / could / he / after / about

[3~4] 다음 글을 읽고, 물음에 답하시오.

> As soon as I walked in, ⓐ I could not help admire some ink-and-water paintings by Jeong Seon, a famous Korean artist also known as Gyeomjae. ⓑ These paintings were kept in an album called the *Haeak jeonsincheop*. They depict the beautiful scenery of Geumgangsan Mountain and its surrounding areas. The way Gyeomjae painted the mountains, rivers, and valleys makes them look very inviting. I was shocked when the museum tour guide said that ⓒ the album was almost burned as kindling. Fortunately, it was rescued at the last minute and later purchased by Kansong. ⓓ Knowing that these beautiful paintings were nearly turned to ashes made me feeling very sad. I am thankful that these paintings are still around so that future generations can also appreciate them.

3 윗글의 마지막 부분에서 화자가 감사함을 느끼는 이유를 우리말로 쓰시오. (30자 내외)

4 윗글의 밑줄 친 ⓐ~ⓓ 중, 어법상 <u>틀린</u> 것을 <u>2개</u> 찾아 바르게 고치시오. (단, 기호, 틀린 것, 고친 것이 모두 맞을 때만 정답으로 인정함)

	기호	틀린 것 (틀린 부분만 쓸 것)	고친 것
(1)			
(2)			

The next item that impressed me was a gorgeous porcelain vase ⓐ calling the *Celadon Prunus Vase with Inlaid Cloud and Crane Design*. It is a pleasant shade of green, with a lovely pattern of clouds and cranes ⓑ encircling the entire vase. (A) It seems that the cranes are alive and stretching their wings in search of freedom. Kansong bought the vase from a Japanese art dealer in 1935. With the money he spent on it, Kansong could have bought 20 nice houses! Later, a different Japanese collector offered double the price Kansong had paid for the vase. However, Kansong refused ⓒ parting with it because he knew that it was the most magnificent vase of its kind. Today it is listed as one of Korea's National Treasures. ⓓ Seeing it in person was an absolutely breathtaking experience!

5 윗글의 밑줄 친 (A)와 같은 의미가 되도록 빈칸에 알맞은 말을 쓰시오.

→ _____ _____ _____ _____

_____ _____ and stretching their wings in search of freedom.

6 윗글의 밑줄 친 ⓐ~ⓓ 중, 어법상 틀린 것을 2개 찾아 바르게 고치고, 수정해야 하는 이유를 쓰시오. (단, 기호, 고친 것, 이유가 모두 맞을 때만 정답으로 인정함)

	기호	고친 것	이유
(1)			
(2)			

7 다음 글의 밑줄 친 우리말과 일치하도록 〈보기〉에 주어진 단어를 배열하시오.

Standing in the middle of the exhibition hall, surrounded by Korean art, I could not stop thinking about Kansong. He was an amazing person! He did not collect art for his personal enjoyment. 그는 혹독한 일제 강점기 동안 한국의 문화적 독자성을 보호하기 위해 그것을 했다. After Korea regained its independence, he stopped collecting art, as he knew it would safely remain in Korea. During our country's worst time, a single man was able to defend Korea's national spirit and pride. Thanks to him, we are still able to experience an essential part of Korean culture today.

〈보기〉 it / protect / identity / cultural / did / Korea's / he

〈조건〉
• to부정사를 포함하여 8단어로 쓸 것

during the harsh Japanese colonial period.

[8~9] 다음 글을 읽고, 물음에 답하시오.

Finally, I saw the one item in the museum that I will never forget—an original copy of the *Hunminjeongeum Haerye*. This ancient book was written in 1446, and it explains the ideas and <u>principles</u> behind the creation of Hangeul, the writing system of the Korean language. It was found in Andong in 1940. At that time, however, Korea was still occupied by Japan. The Japanese colonial government intended to get rid of the Korean language. Schools were <u>forbidden</u> to teach lessons in Korean, and scholars who studied Korean were arrested.

From the moment he heard that the *Hunminjeongeum Haerye* had been discovered, Kansong couldn't stop thinking about it. He knew he had to protect it at all costs. After years of waiting, he was finally able to <u>obtain</u> the book. He purchased it at ten times the price the owner was asking and carefully hid it in his house. When the Japanese were finally defeated, he was able to share it with the rest of Korea. The guide said that the *Hunminjeongeum Haerye* is the museum's most precious <u>treasure</u>. Without it, the origins and fundamentals of Hangeul would have been lost to history. It has since been <u>designated</u> a National Treasure of Korea and included in the UNESCO Memory of the World Register. Looking at the ancient book, I could feel Kansong's strong <u>commitment</u> to preserving Korean history.

8 아래 질문에 대한 대답을 윗글에서 찾아 쓰시오.

Q: What does the *Hunminjeongeum Haerye* explain?

A: _____

9 윗글의 밑줄 친 단어 중, 주어진 영영 뜻풀이에 해당하는 것을 찾아 퍼즐을 완성하시오.

〈조건〉
본문의 단어를 찾고, 필요 시 원형으로 쓸 것
예) 복수명사 → 단수명사, 분사 → 동사원형

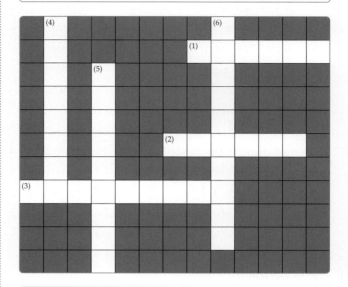

Across
(1) to say that something is not allowed; to prohibit
(2) to receive something, usually as a result of requesting it or searching for it; to get
(3) to choose something or someone for a specific purpose

Down
(4) a collection of precious things
(5) a rule or standard that can be used as a basis
(6) the quality or situation of being devoted to something

Lesson
05

Look, Think, and Create!

Words

□ inspiration 명 영감
　inspire 동 (감정 · 사상 등을) 불어넣다, 영감을 주다
□ architect 명 건축가
□ biomimicry 명 자연 모방 (기술)
□ term 명 용어
□ imitation 명 모방
□ incredibly 부 믿을 수 없을 정도로, 놀랍게도
□ aspect 명 측면
□ innovative 형 혁신적인
□ architectural 형 건축학의, 건축술의
□ enormous 형 거대한 (= huge, vast) (↔ tiny)
□ prominent 형 유명한 (= famous)
□ construction 명 건설, 공사
　construct 동 건설하다, 세우다
□ remarkable 형 놀라운
□ artificial 형 인공의 (↔ natural)
□ incorporate 동 포함하다
□ spire 명 첨탑
□ sphere 명 구
□ column 명 기둥
□ spiral 형 나선형의
□ ceiling 명 천장
□ beam 동 비추다
□ distribute 동 나누어 퍼뜨리다

□ evenly 부 균등하게
□ recognize 동 인지하다
□ superiority 명 우월성
　superior 형 우수한, 보다 나은
□ functional 형 기능적인
□ visually 부 시각적으로
　visual 형 시각의
□ install 동 설치하다
□ mound 명 흙더미, 언덕
□ alternative 명 대안
□ constant 형 끊임없는
　constantly 부 끊임없이, 항상
□ chimney 명 굴뚝
□ generate 동 발생시키다
□ escape 동 빠져나가다
□ absorb 동 흡수하다 (= take[suck] in)
□ relatively 부 비교적 (= comparatively)
□ conventional 형 전형적인
　convention 명 관습, 인습
□ automatic 형 자동의
□ pollution 명 오염
□ utilize 동 이용하다
□ robotics 명 로봇공학
□ agriculture 명 농업

Phrases

□ supply ~ with ...　~에게 …을 제공하다
□ be derived from　~에서 파생되다
□ come up with　~을 찾아내다
□ take over　~을 이어받다

□ look to　(개선 방안을 찾기 위해) ~을 고려해 보다,
　　　　　~로 눈을 돌리다
□ prefer ~ to ...　…보다 ~을 선호하다
□ split off　쪼개지다
□ turn to　(도움 · 조언 등을 위해) ~에 의지하다, ~로 눈을 돌리다

Vocabulary Check-Up

다음 영어는 우리말로, 우리말은 영어로 쓰시오.

01 robotics 명 _____	23 명 건설, 공사 _____	
02 distribute 동 _____	24 형 혁신적인 _____	
03 constant 형 _____	25 명 모방 _____	
04 turn to _____	26 부 균등하게 _____	
05 relatively 부 _____	27 명 용어 _____	
06 generate 동 _____	28 동 빠져나가다 _____	
07 conventional 형 _____	29 명 농업 _____	
08 look to _____	30 명 오염 _____	
09 mound 명 _____	31 ~에게 …을 제공하다 _____	
10 superiority 명 _____	32 형 자동의 _____	
11 utilize 동 _____	33 명 기둥 _____	
12 take over _____	34 동 흡수하다 _____	
13 beam 동 _____	35 명 대안 _____	
14 remarkable 형 _____	36 …보다 ~을 선호하다 _____	
15 incorporate 동 _____	37 쪼개지다 _____	
16 come up with _____	38 동 설치하다 _____	
17 spiral 형 _____	39 명 영감 _____	
18 prominent 형 _____	40 형 기능적인 _____	
19 spire 명 _____	41 동 인지하다 _____	
20 be derived from _____	42 명 건축가 _____	
21 aspect 명 _____	43 명 구 _____	
22 architectural 형 _____	44 형 인공의 _____	

Point 1 과거분사로 시작하는 수동형 분사구문

예제 (**Being**) **Stuck** in traffic, he was late for the concert.
교통 체증으로 꼼짝 못해서, 그는 콘서트에 늦었다.

교과서 (**Being**) **Inspired** by trees, Gaudi gave the columns a single base that splits off into branches near the top.
나무에 영감을 받아서, 가우디는 꼭대기 가까이에서 나뭇가지로 갈라지는 하나의 토대가 기둥에 있게 했다.

▶ 분사구문을 이끄는 분사와 주절의 주어가 능동 관계이면 현재분사가 이끄는 분사구문을, 수동 관계이면 과거분사가 이끄는 분사구문을 쓴다.

▶ 과거분사가 이끄는 분사구문을 만들 때, 부사절의 시제가 주절과 같으면 「being v-ed」, 주절의 시제보다 앞서면 「having been v-ed」로 나타낸다. 이때 being이나 having been은 대부분 생략되어 과거분사만 남는다.

내신출제 Point

 Test Point 1 수동형 분사구문의 시제

When she was left alone in the cave, she began to cry.
→ (**Being**) **Left** alone in the cave, she began to cry.
동굴에 혼자 남겨졌을 때, 그녀는 울기 시작했다.

▶ 그녀가 동굴에 혼자 남겨진 것과 울기 시작한 것은 같은 시점에 일어난 일이므로 「being v-ed」로 나타냄

As I was born and brought up in the UK, I can speak English fluently.
→ (**Having been**) **Born** and **brought** up in the UK, I can speak English fluently.
영국에서 태어나고 자랐기 때문에, 나는 영어를 유창하게 할 수 있다.

▶ 내가 영국에서 태어나고 자란 것은 영어를 유창하게 할 수 있기 전부터 일어난 일이므로 「having been v-ed」로 나타냄

Point Check-Up

정답 및 해설 p.32

1 다음 문장이 어법상 올바르면 O, 틀리면 X 표시하시오.

(1) Being released in 2018, the movie became a big hit around the world. _____

(2) Having been bitten by that dog, he is afraid of it. _____

(3) Being finished preparing for the trip yesterday, she has nothing to do now. _____

Point 2 계속적 용법의 관계대명사 which

예제 You left your wallet in the car yesterday, **which** was careless of you.
└ = and it
너는 어제 차에 네 지갑을 두고 갔는데, 너는 부주의했어.

교과서 More importantly, the Eastgate Centre uses far less energy than other buildings, **which**
saves money and helps protect the environment from pollution.
└ = and this
더 중요한 것은, Eastgate Centre가 다른 건물들보다 훨씬 더 적은 에너지를 사용해서, 돈을 절약해 주고
오염으로부터 환경을 보호하는 데 도움을 준다는 점이다.

▶ 계속적 용법의 관계대명사 which는 앞에 콤마(,)를 쓰거나 삽입절로 표현하며 선행사에 대한 부가적인 설명을 한다.
이때, 선행사는 앞 절의 일부 또는 전체가 되며, 계속적 용법으로 쓰인 관계대명사는 생략할 수 없다. 계속적 용법의
관계대명사 which는 「접속사+대명사」로 바꿔 쓸 수 있으며, 접속사는 문맥에 따라 and, but 등이 될 수 있다.

내신출제 Point

Test Point 1 「접속사＋대명사」로 바꿔 쓰는 계속적 용법의 관계대명사

He said he was terribly ill, **which** was a lie.
= He said he was terribly ill, **but this** was a lie.
그는 그가 매우 아프다고 말했는데, 그것은 거짓말이었다.

▶ 앞 절의 he was terribly ill을 선행사로 하는 주격 관계대명사 which의 계속적 용법

My favorite book is *My Little Town*, **which** I've read eight times so far.
= My favorite book is *My Little Town*, **and** I've read **it** eight times so far.
내가 가장 좋아하는 책은 「나의 작은 마을」인데, 나는 지금까지 그 책을 8번 읽었다.

▶ 앞 절의 *My Little Town*을 선행사로 하는 목적격 관계대명사 which의 계속적 용법

Test Point 2 관계대명사 that

관계대명사 that은 계속적 용법으로 쓸 수 없다.
My mom gave me her ring, ~~that~~ / which used to be my grandmother's.
엄마는 나에게 엄마의 반지를 주었는데, 그것은 할머니 것이었다.

▶ 계속적 용법이므로 관계대명사 that이 아닌 which를 써야 함

Point Check-Up

정답 및 해설 p.32

2 다음 네모 안에서 어법상 알맞은 것을 고르시오.

(1) Karen was very hungry, [which / that] led her to steal the bread.

(2) He blamed me for everything, [which I thought / which I thought it] was very unfair.

(3) I had heard that Jeff broke his leg while skiing, [but / but it] was not true.

01 다음 괄호 안에서 어법상 알맞은 것을 고르시오.

(1) My teacher didn't say a word about my mistake, (that / which) was a relief.

(2) (Giving / Having been given) lots of homework yesterday, he has no time to play online games tonight.

(3) (Having surrounded / Having been surrounded) by the enemy for several weeks, we are now short of supplies.

02 다음 밑줄 친 부분을 분사구문으로 바꾸시오.

(1) <u>As it had been cooked too quickly,</u> food from the microwave was burned on the edges.

→ _____ , food from the microwave was burned on the edges.

(2) <u>Since it is written in large letters,</u> the sign is easy to notice and read.

→ _____ , the sign is easy to notice and read.

(3) <u>When they are looked at through a magnifying glass,</u> ants appear much bigger.

→ _____ , ants appear much bigger.

03 다음 두 문장이 같은 뜻이 되도록 문장을 완성하시오.

(1) He pretended not to hear me, and it was really annoying.

→ He pretended not to hear me, _____ .

(2) She made a lot of picture books, and they are still loved by many children.

→ She made a lot of picture books, _____ .

(3) I stayed at the luxurious hotel, and some celebrities have visited it.

→ I stayed at the luxurious hotel, _____ .

04 주어진 우리말과 일치하도록 괄호 안의 단어를 활용하여 문장을 완성하시오.

(1) 여동생에게 방을 나가달라는 요구를 받고, 그녀는 당황스러웠다. (ask to, leave)

→ _____ _____ _____ _____ the room by her sister, she was embarrassed.

(2) Brian은 고열이 있었는데, 그것은 그를 귀가 멀도록 했다. (cause)

→ Brian had a high fever, _____ _____ _____ to become deaf.

(3) Amy는 나의 허락 없이 내 신발을 신었고, 그것이 나를 화나게 했다. (make)

→ Amy wore my shoes without my permission, _____ _____ _____ angry.

05 빈칸 (A), (B)에 들어갈 말로 가장 적절한 것은? 교과서 p.129

> ___(A)___ from flying around, a thirsty crow landed in a park. It saw a pitcher of water on a small table, so it flew over and tried to drink. Unfortunately, the pitcher was only half full, so the crow couldn't reach the water. ___(B)___, it was about to accept its fate, but then it had an idea. It began picking up rocks and dropping them into the pitcher. The water level got higher and higher, until the crow could finally drink!

	(A)		(B)		(A)		(B)
①	Tired	···	Frustrated	④	Tiring	···	Frustrating
②	Tired	···	Being frustrating	⑤	Tiring	···	Being frustrated
③	Being tired	···	Frustrating				

06 다음 괄호 안의 단어를 바르게 배열하여 문장을 완성하시오. 교과서 p.129

> One day, a girl was playing in the park. She saw a photograph on the ground and picked it up. She saw a cute boy in the photograph, (1) (her / turn red / cheeks / which / made). She took the photograph home and put it in a box. Eventually, she forgot about it. Twenty years later, she got married. One day, her husband opened the box and found the photograph. He asked, "Who is the little boy in this picture?" She answered that it was her first love, (2) (husband / smile / which / her / made). He said, "I lost this photograph when I was nine years old."

(1) _____

(2) _____

07 다음 중 어법상 **틀린** 것으로 바르게 짝지어진 것은?

> ⓐ Driven carefully, the car can run for 15 kilometers on a liter of gas.
> ⓑ Olivia added more milk, which it made the bread softer.
> ⓒ Chose to be the team captain, he was very proud of himself.
> ⓓ The bridge, which was built in the 15th Century, is 140 meters long.
> ⓔ Having been hit by a car, she is in the hospital now.

① ⓐ, ⓒ ② ⓐ, ⓓ ③ ⓑ, ⓒ ④ ⓑ, ⓓ, ⓔ ⑤ ⓑ, ⓔ

Nature: The Great Inspiration of Architects

01 Nature is all around us. It impresses us with its beauty and supplies us with everything [we
주어　　　동사1　　　　　　　　　　　　　　　　동사2　　　　　　　　　　　　that
　　　　　　　　　　　　　　　　　　　　　　　　　　　　　　　　　　　목적격 관계대명사절

need to survive].
부사적 용법 〈목적〉

자연은 우리 주변 모든 곳에 있다. 자연은 아름다움으로 우리에게 감동을 주고 우리가 생존하는 데 필요한 모든 것을 우리에게
제공해 준다.

02 It also provides some people with the inspiration [to create things in a new way].
= Nature　　　　　　　　　　　　　　　　　　　　　　　　형용사적 용법

자연은 또한 어떤 사람들에게는 새로운 방식으로 어떤 것들을 창조해 내는 데 영감을 주기도 한다.

03 The act of creating things based on nature is called "biomimicry."
수동태

자연에 기초해서 어떤 것들을 창조해 내는 행위를 '자연 모방 (기술)'이라고 부른다.

04 This term is derived from the Greek words *bios*, meaning "life," and *mimesis*, meaning
~에서 파생되다　　　　　　　　　　　　　　　현재분사구　　　　　　　　　　　　현재분사구

"imitation."

이 용어는 '생명'을 뜻하는 그리스어인 bios와 '모방'을 뜻하는 그리스어인 mimesis에서 파생되었다.

05 Architects [who use biomimicry] look at nature as an incredibly successful engineer [who has
주어　　↑　　　　주격 관계대명사절　　　동사　　　　　　　　　　　　　　　　which[that]　　　　　　　　주격 관계대명사절

already come up with answers to some of the problems [they now face]].
~을 찾아내다　　　　　　　　　　　　　　　　　　　　↑　　　목적격 관계대명사절

자연 모방 (기술)을 활용하는 건축가들은 자연을 그들이 현재 직면해 있는 몇몇 문제들의 해답을 이미 찾아낸 놀랄 만큼 성공
적인 기술자로 본다.

06 　　　　　　　　　　　　　　　　　　　　　　　　　　　　　　부사적 용법 〈목적〉
They carefully study plants, animals, and other aspects of nature [to learn [how they work]].
주어　　　　　동사　　　　　　　　　　　　　　　　　　　　　　　　간접의문문 (「의문사 + 주어 + 동사」의 어순)

그들은 그것들이 어떻게 작동하는지 알기 위해 식물, 동물, 그리고 자연의 다른 면들을 세밀하게 연구한다.

07 As a result, they have been able to find some innovative solutions to engineering and architectural
현재완료　　　　　　　　　　　　　　　　　~에 대한 (전치사)

challenges.

그 결과로, 그들은 공학 기술이나 건축학적 문제들에 대해서 몇몇 혁신적인 해결책을 찾을 수 있었다.

The Curving Beauty of Nature 곡선으로 이루어진 자연의 아름다움

08 The Sagrada Familia is an enormous church in Barcelona, Spain. [Designed by the world-
거대한 과거분사구

famous architect Antoni Gaudi], the church is one of the most prominent buildings in the world.
「one of the+최상급+복수명사」: 가장 ~한 … 중 하나

Sagrada Familia는 스페인의 바르셀로나에 있는 거대한 성당이다. 세계적으로 유명한 건축가인 안토니 가우디에 의해 설계된 이 성당은 세계에서 가장 유명한 건물 중의 하나이다.

09 Construction of this remarkable building began in 1882, and Gaudi took over responsibility for
= the Sagrada Familia take over: ~을 이어받다

its design in 1883. Believe it or not, the building is still under construction.
공사중인

이 놀라운 건물의 건설은 1882년에 시작됐고, 가우디가 1883년에 설계에 대한 책임을 이어받았다. 믿을지 모르겠지만, 이 건물은 아직도 공사가 진행 중이다.

10 Some people love the Sagrada Familia and others hate it, but nearly everyone is fascinated by
막연한 복수의 사람들을 지칭 ~에 매혹되다, 매력을 느끼다

its unique design.

어떤 이들은 Sagrada Familia를 좋아하고 또 어떤 이들은 싫어하지만, 거의 모든 이들이 이 건물의 독특한 디자인에 매력을 느낀다.

11 Gaudi believed [that all architects should look to nature for inspiration].
명사절 (believed의 목적어) ~을 고려해 보다, ~로 눈을 돌리다

가우디는 모든 건축가들이 영감을 얻기 위해 자연으로 눈을 돌려야 한다고 믿었다.

12 He preferred the curves [found in natural objects] to the straight lines [found in artificial ones].
과거분사구 과거분사구
prefer A to B: B보다 A를 선호하다 = objects

그는 인공물에서 발견되는 직선보다는 자연물에서 발견되는 곡선을 선호했다.

13 This preference can be seen in all his buildings, including the Sagrada Familia. Many parts of
수동태 주어 (복수)

the church incorporate images and forms from nature.
동사

이런 선호는 Sagrada Familia를 포함한 그의 모든 건물에서 볼 수 있다. 성당의 많은 부분은 자연에서 온 이미지와 형태를 포함하고 있다.

14 For example, the church's spires are topped with spheres [that resemble fruits].
수동태 주격 관계대명사절

예를 들어, 성당의 첨탑들은 꼭대기에 과일을 닮은 구들이 있다.

15 There are also turtles [carved into the stone bases of columns] and spiral stairs [that resemble
과거분사구 주격 관계대명사절

the shells of sea creatures].

또한 기둥들의 초석에는 거북이가 새겨져 있으며 바다 생물들의 껍데기를 닮은 나선형 계단도 있다.

16 Perhaps the most impressive feature of the Sagrada Familia is the ceiling.
주어 (단수) 동사

아마도 Sagrada Familia의 가장 인상적인 점은 천장일 것이다.

17 Gaudi designed the columns inside the church to resemble trees and branches, so visitors [who
주격 관계대명사절

look up] can feel as if they were standing in a great forest.
가정법 과거 「as if+주어+동사의 과거형」: 마치 ~인 것처럼

가우디는 성당 안의 기둥을 나무와 나뭇가지들을 닮게 디자인하여, 위를 올려다보는 관람객들은 마치 그들이 울창한 숲속에 서 있는 것처럼 느끼게 된다.

18 The light [that comes through the small holes all over the ceiling] even resembles the light
주어 (단수) 주격 관계대명사절 동사

[beaming through leaves in a forest].
현재분사구

천장 곳곳에 있는 작은 구멍들 사이로 들어오는 빛은 숲 속의 잎들 사이로 비추는 빛을 닮기까지 했다.

19 These tree-like columns are not just for decoration, though.
하지만 (부사)

하지만 이 나무를 닮은 기둥들은 단순히 장식용이 아니다.

20 Being
Inspired by trees, Gaudi gave the columns a single base [that splits off into branches near the
수동형 분사구문 주격 관계대명사절
top].

가우디는 나무에 영감을 받아 꼭대기 가까이에서 (여러 개의) 나뭇가지로 갈라지는 하나의 토대가 기둥에 있게 했다.

21 This allows them to support the roof better by distributing its weight evenly.
allow+목적어+to-v: ~가 …하게 하다 by v-ing: ~함으로써

이것은 지붕의 무게가 균등하게 나누어지도록 해서 기둥이 지붕을 더 잘 지탱할 수 있게 해 준다.

22 Because Gaudi recognized the superiority of natural forms, he was able to design a building [that
주격 관계대명사절

is both beautiful and functional].
both A and B: A와 B 둘 다

가우디는 자연이 지닌 형태의 우월성을 인지했기 때문에 아름다우면서도 기능적인 건물을 설계할 수 있었다.

A Lesson from Insects 곤충으로부터의 교훈

23 The Eastgate Centre is an office building and shopping complex in Harare, Zimbabwe. Built in
과거분사구

1996, it might not be as visually impressive as the Sagrada Familia.
as+형용사[부사]의 원급+as: ~만큼 …한[하게]

Eastgate Centre는 짐바브웨의 하라레에 있는 사무실 건물이자 쇼핑 단지이다. 1996년에 지어진 이 건물은 Sagrada Familia만큼 시각적으로 인상적이지는 않을 수도 있다.

24

However, the building is an excellent example of biomimicry. Due to the hot climate of Harare,
= Because of

air conditioning systems can be very costly to install, run, and maintain.
병렬구조

하지만 그 건물은 자연 모방 (기술)을 보여주는 훌륭한 예이다. 하라레의 뜨거운 기후 때문에 (그곳에) 냉방 장치를 설치하고, 작동하고, 유지하는 것이 매우 비쌀 수 있다.

25

To solve this problem, the building's architect, Mick Pearce, turned to termite mounds for an
부사적 용법〈목적〉 = ~에 의지하다, ~로 눈을 돌리다
alternative.
대안

이 문제를 해결하기 위해 이 건물의 건축가인 Mick Pearce는 대안을 찾기 위해 흰개미집에 눈을 돌렸다.

26

Termite mounds are large structures [built by certain termite species].
 과거분사구

흰개미집은 특정 흰개미 종에 의해 지어진 큰 구조물이다.

27

Scientists believe [that the mounds stay cool due to a constant flow of air].
 명사절 (believe의 목적어)

과학자들은 흰개미집이 끊임없는 공기의 흐름 때문에 시원하게 유지된다고 믿는다.

28

Each mound has a network of holes [referred to as chimneys].
 과거분사구
「refer to ~ as ...」 → 수동태 「~ be referred to as ...」

각각의 집에는 굴뚝이라고 일컬어지는 구멍들이 망처럼 연결되어 있다.

29

It has a large central chimney and smaller outer chimneys [that are close to the ground].
 주격 관계대명사절

중앙에 큰 굴뚝이 있고 지면 가까이에는 더 작은 외부 굴뚝들이 있다.

30

The heat [generated by the daily activity of the termites] rises up through the central chimney,
주어 (단수) 과거분사구 동사
eventually escaping through the top of the mound.
분사구문〈연속동작〉

흰개미의 일상 활동으로 인해 생기는 열은 중앙 굴뚝을 통해 위로 올라가서, 결국에는 흰개미집 꼭대기를 통해 빠져나가게 된다.

31

In the meantime, cooler air is pulled in through the smaller chimneys, [keeping the termites'
 현재분사구
home at a comfortable temperature during the hot day].

그러는 사이에, 더 시원한 공기가 더 작은 굴뚝들을 통해 들어오고, 뜨거운 낮 동안 흰개미의 집을 쾌적한 온도로 유지해 준다.

32

Also, the soil [surrounding the mound] absorbs heat in the hot daytime hours.
 주어 (단수) 현재분사구 동사

또한, 흰개미집을 둘러싸고 있는 흙은 뜨거운 낮 동안 열을 흡수한다.

33

Therefore, the temperature [inside the mound] does not increase greatly and stays relatively
　　　　　　주어　　　↑└전치사구　　　　　　　　동사1　　　　　　　　　동사2　부사└
cool. At night, when the outside temperature goes down, the heat is finally released.
↑┘　　　　　　　　　　　　　　　　　　　　　　　　　　　└┘─ 수동태 ─┘

그래서 흰개미집 안의 온도는 크게 올라가지 않고, 비교적 서늘하게 유지된다. 밤에 바깥 온도가 내려가면 마침내 열은 방출된다.

34

This process inspired Pearce to design an innovative climate control system.
　　　　　　inspire+목적어+to-v: ~가 …하도록 영감을 주다

이 과정은 Pearce로 하여금 혁신적인 온도 조절 시스템을 고안해 내도록 영감을 주었다.

35

The Eastgate Centre was constructed without a conventional cooling system. Instead, Pearce
　　　　　　　　　└ 수동태 ┘
used building materials [that can store large amounts of heat].
　　　　↑───┘　　주격 관계대명사절

Eastgate Centre는 전형적인 냉방 시스템 없이 건설되었다. 대신 Pearce는 많은 양의 열기를 저장할 수 있는 건축 자재를 사용했다.

36

The floors and walls of the building absorb heat during the day, just like the soil of a termite
　　주어 (복수)　　　　　　　　　　동사　　　　　　　　　　　　　　~처럼 (전치사)
mound.

건물의 바닥과 벽은 흰개미집의 흙처럼 낮 동안 열을 흡수한다.

37

　　　　　　　　　　　　　　　　　　　　　　　　being　　　　　　　　　~쯤에는 (전치사)
The heat is released at night, and the walls cool down, [ready to store heat again by the next
　　　└ 수동태 ┘　　　　　　　　　　　　　　　　　　분사구문 〈연속동작〉
morning].

그 열이 밤에 방출되면 벽은 서늘해지며, 다음 날 아침쯤에는 다시 열을 저장할 준비가 된다.

38

　　　　　　　　　　　　　　　　help+동사원형: ~하는 것을 돕다
The structure of the building also helps keep the building cool.
　　　　　　　　　　　　　　　　　　keep+목적어+형용사: ~을 …한 상태로 유지하다

건물의 구조 또한 건물이 서늘하게 유지되는 데 도움이 된다.

39

There are openings near the base of the building, and outside air comes into the building
　　　　　= openings (near the base of the building)　　　　　　　　　　자동의
through them. This air is moved through the building by a system of automatic fans.

건물의 바닥 근처에 열린 공간이 있는데, 바깥 공기가 그곳을 통해 건물 안으로 들어온다. 이 공기는 자동 팬 장치에 의해 건물을 통과하여 이동한다.

40
Eventually, the air, [along with heat [generated by human activity during the day]], rises upward
　　　　　주어　　　＜삽입어구＞　　　　　　　　　　　과거분사구　　　　　　　　　　　　　　　　동사1
through the building's internal open spaces and is released through chimneys on the roof.
　　　　　　　　　　　　　　　　　　　　　　　　　　　　동사2 (수동태)

결국, 이 공기는 낮 동안 사람들의 활동으로 인해 생기는 열기와 함께 건물 내부의 열린 공간을 통해 위로 올라가서 지붕에 있
는 굴뚝을 통해 빠져나가게 된다.

41
As a result, the building has not only cool temperatures but also fresh air.
　　　　　　　　　　　　　　　└─ not only A but also B: A뿐만 아니라 B도 ─┘

그 결과, 건물은 시원한 온도뿐 아니라 신선한 공기 또한 가지게 된다.

42
More importantly, the Eastgate Centre uses far less energy than other buildings, [which saves
　　　　　　　　　　　　　　　　　　　　　훨씬 (비교급 강조 부사)　　　　　　　　　　　　계속적 용법의
　　주격 관계대명사
money and helps protect the environment from pollution].

더 중요한 것은, Eastgate Centre가 다른 건물들보다 훨씬 더 적은 에너지를 사용해서, 돈을 절약해 주고 오염으로부터 환경
을 보호하는 데 도움을 준다는 점이다.

43
　　　　　　　　　　　　┌ which[that] │ 목적격 관계대명사절
Without the inspiration [Pearce received from tiny termites], none of this would have been
가정법 과거완료 「Without ~, 주어+조동사의 과거형+have v-ed」: ~이 없었다면, …했을 텐데
possible.

Pearce가 작은 흰개미에게서 받은 영감이 없었더라면, 이 어떤 것도 가능하지 않았을 것이다.

44
[Using biomimicry in architecture] is just one way [that humans are utilizing the lessons of
　　주어 (동명사구)　　　　　　　　　　　동사　　　　　　　　　　　　관계부사절
nature to improve the way [we do things]].
　　　　　　　　　　　　　　　　관계부사절

건축에서 자연 모방 (기술)을 사용하는 것은 인간이 무언가를 하는 방식을 향상시키는 데 자연의 가르침을 이용하고 있는 한
가지 방식에 불과하다.

45
　　　　　　　　　　　　　부사적 용법 ＜목적＞
Biomimicry is also being used to solve problems in the fields of robotics, agriculture, and many
　　　　　　　└─ 현재 진행형 수동태 ─┘
others.

자연 모방 (기술)은 또한 로봇공학, 농업, 그리고 많은 다른 분야에서 문제점들을 해결하기 위해 사용되고 있다.

46
　　　　　　　　　　　　　　　　　help+동사원형: ~하는 것을 돕다　　　　　　make+목적어+동사원형: ~가 …하게 하다
[Imitating the ideas of nature] not only helps solve problems, but it also makes us feel closer to
　　주어 (단수)　　　　　　　　　　　　　　동사1　　　　　　　　　　　　　　　　　동사2
nature.

자연이 주는 아이디어를 모방하는 것은 문제를 해결하도록 도와줄 뿐 아니라, 우리가 자연을 더 가깝게 느끼도록 해 준다.

47
　　　　　　　　　　　　　　　stop v-ing: ~하는 것을 멈추다
As a result, humans are more likely to stop destroying the environment and start becoming
　　　　　　　　　　　be likely to-v: ~할 것 같다　　　　　　　　　　　　　　　　　to
part of it instead.

그 결과로, 인간은 환경을 파괴하는 것을 멈추고 대신 환경의 일부가 되기 시작할 가능성이 더 커진다.

다음 빈칸을 채우시오.

Nature is all around us. It impresses us with its beauty and supplies us with everything (1) _____
_____ _____ _____.
자연은 우리 주변 모든 곳에 있다. 자연은 아름다움으로 우리에게 감동을 주고 우리가 생존하는 데 필요한 모든 것을 우리에게 제공해 준다.

It also provides some people with the (2) _____ _____ _____ things in a new way.
자연은 또한 어떤 사람들에게는 새로운 방식으로 어떤 것들을 창조해 내는 데 영감을 주기도 한다.

The act of creating things (3) _____ _____ _____ is called "biomimicry."
자연에 기초해서 어떤 것들을 창조해 내는 행위를 '자연 모방 (기술)'이라고 부른다.

This term is (4) _____ _____ the Greek words *bios*, meaning "life," and *mimesis*, meaning
"imitation."
이 용어는 '생명'을 뜻하는 그리스어인 bios와 '모방'을 뜻하는 그리스어인 mimesis에서 파생되었다.

Architects who use biomimicry look at nature as an incredibly successful engineer who has
(5) _____ _____ _____ _____ _____ to some of the problems they now
face.
자연 모방 (기술)을 활용하는 건축가들은 자연을 그들이 현재 직면해 있는 몇몇 문제들의 해답들을 이미 찾아낸 놀랄 만큼 성공적인 기술
자로 본다.

They carefully study plants, animals, and other aspects of nature (6) _____ _____
_____ _____ _____.
그들은 그것들이 어떻게 작동하는지 배우기 위해 식물, 동물, 그리고 자연의 다른 면들을 세밀하게 연구한다.

As a result, they have (7) _____ _____ _____ _____ some innovative solutions
to engineering and architectural challenges.
그 결과로, 그들은 공학 기술이나 건축학적 문제들에 대해서 몇몇 혁신적인 해결책을 찾을 수 있었다.

The Sagrada Familia is an enormous church in Barcelona, Spain. Designed by the world-famous
architect Antoni Gaudi, the church is (8) _____ _____ _____ _____
_____ _____ in the world.
Sagrada Familia는 스페인의 바르셀로나에 있는 거대한 성당이다. 세계적으로 유명한 건축가인 안토니 가우디에 의해 설계된 이 성당
은 세계에서 가장 유명한 건물들 중의 하나이다.

Construction of this remarkable building began in 1882, and Gaudi (9) _____ _____
_____ for its design in 1883. Believe it or not, the building is still (10) _____ _____.
이 놀라운 건물의 건설은 1882년에 시작됐고, 가우디가 1883년에 설계에 대한 책임을 이어받았다. 믿을지 모르겠지만, 이 건물은 아직
도 공사가 진행 중이다.

Some people love the Sagrada Familia and others hate it, but nearly (11) _____ _____
_____ _____ its unique design.
어떤 이들은 Sagrada Familia를 좋아하고 또 어떤 이들은 싫어하지만, 거의 모든 이들이 이 건물의 독특한 디자인에 매력을 느낀다.

Gaudi believed that all architects (12) _____ _____ _____ _____ for inspiration.
가우디는 모든 건축가들이 영감을 얻기 위해 자연으로 눈을 돌려야 한다고 믿었다.

He preferred the curves found in natural objects (13) _____ _____ _____ _____
found in artificial ones.

그는 인공물에서 발견되는 직선들보다는 자연물에서 발견되는 곡선을 선호했다.

This preference (14) _____ _____ _____ in all his buildings, including the Sagrada
Familia.

이런 선호는 Sagrada Familia를 포함한 그의 모든 건물에서 보여질 수 있다.

Many parts of the church (15) _____ _____ _____ _____ from nature.

성당의 많은 부분은 자연에서 온 이미지들과 형태들을 포함한다.

For example, the church's spires are topped with (16) _____ _____ _____ _____.

예를 들어, 성당의 첨탑들은 꼭대기에 과일들을 닮은 구들이 있다.

There are also (17) _____ _____ into the stone bases of columns and spiral stairs that
resemble the shells of sea creatures.

또한 기둥들의 초석에는 거북이들이 새겨져 있으며 바다 생물들의 껍데기를 닮은 나선형 계단도 있다.

Perhaps (18) _____ _____ _____ _____ of the Sagrada Familia is the ceiling.

아마도 Sagrada Familia의 가장 인상적인 특징은 천장일 것이다.

Gaudi designed the columns inside the church to resemble trees and branches, so visitors
(19) _____ _____ _____ _____ _____ as if they were standing in a great
forest.

가우디는 성당 안의 기둥을 나무와 나뭇가지들을 닮게 디자인하여, 위를 올려다보는 관람객들은 마치 그들이 울창한 숲속에 서 있는 것처
럼 느낄 수 있다.

(20) _____ _____ _____ _____ _____ the small holes all over the ceiling
even resembles the light beaming through leaves in a forest.

천장 곳곳에 있는 작은 구멍들 사이로 들어오는 빛은 숲 속의 잎들 사이로 비추는 빛을 닮기까지 했다.

These tree-like columns are not just for decoration, though. (21) _____ _____ _____,
Gaudi gave the columns a single base that splits off into branches near the top.

하지만 이 나무를 닮은 기둥들은 단순히 장식용이 아니다. 가우디는 나무에 영감을 받아 꼭대기 가까이에서 (여러 개의) 나뭇가지로 갈라
지는 하나의 토대가 기둥에 있게 했다.

This allows them to support the roof better (22) _____ _____ _____ _____
evenly.

이것은 그것(지붕)의 무게가 균등하게 나누어지게 함으로써 기둥이 지붕을 더 잘 지탱할 수 있게 해 준다.

Because Gaudi recognized the superiority of natural forms, he was able to design a building that is
(23) _____ _____ _____ _____.

가우디는 자연이 지닌 형태의 우월성을 인지했기 때문에 아름다우면서도 기능적인 건물을 설계할 수 있었다.

The Eastgate Centre is (24) _____ _____ _____ and shopping complex in Harare,
Zimbabwe.

Eastgate Centre는 짐바브웨의 하라레에 있는 사무실 건물이자 쇼핑 단지이다.

Built in 1996, it might not be (25) _____ _____ _____ _____ the Sagrada Familia.

1996년에 지어진 이 건물은 Sagrada Familia만큼 시각적으로 인상적이지는 않을 수도 있다.

However, the building is an (26) _____ _____ of biomimicry.

하지만 그 건물은 자연 모방 (기술)을 보여주는 훌륭한 예이다.

Due to the hot climate of Harare, air conditioning systems can be very costly (27) _____ _____, _____, _____ _____.

하라레의 뜨거운 기후 때문에 (그곳에) 냉방 장치를 설치하고, 작동하고, 그리고 유지하는 것이 매우 비쌀 수 있다.

(28) _____ _____ _____ _____, the building's architect, Mick Pearce, turned to termite mounds for an alternative.

이 문제를 해결하기 위해 이 건물의 건축가인 Mick Pearce는 대안을 찾기 위해 흰개미집에 눈을 돌렸다.

Termite mounds are large structures (29) _____ _____ certain termite species. Scientists believe that the mounds (30) _____ _____ _____ _____ a constant flow of air.

흰개미집은 특정 흰개미 종에 의해 지어진 큰 구조물이다. 과학자들은 흰개미집이 끊임없는 공기의 흐름 때문에 시원하게 유지된다고 믿는다.

Each mound has a network of holes (31) _____ _____ as chimneys.

각각의 집에는 굴뚝이라고 일컬어지는 구멍들이 망처럼 연결되어 있다.

It has a large central chimney and smaller outer chimneys that (32) _____ _____ _____ _____ _____.

중앙에 큰 굴뚝이 있고 지면 가까이에는 더 작은 외부 굴뚝들이 있다.

(33) _____ _____ _____ _____ the daily activity of the termites rises up through the central chimney, eventually escaping through the top of the mound.

흰개미의 일상 활동으로 인해 생기는 열은 중앙 굴뚝을 통해 위로 올라가서, 결국에는 흰개미집 꼭대기를 통해 빠져나가게 된다.

In the meantime, cooler air is pulled in through the smaller chimneys, keeping the termites' home (34) _____ _____ _____ _____ during the hot day.

그러는 사이에, 더 시원한 공기가 더 작은 굴뚝들을 통해 들어오고, 뜨거운 낮 동안 흰개미의 집을 쾌적한 온도로 유지해 준다.

Also, the soil (35) _____ _____ _____ absorbs heat in the hot daytime hours.

또한, 흰개미집을 둘러싸고 있는 흙은 뜨거운 낮 동안 열을 흡수한다.

Therefore, the temperature inside the mound does not increase greatly and (36) _____ _____ _____.

그래서 흰개미집 안의 온도는 크게 올라가지 않고, 비교적 서늘하게 유지된다.

At night, when the outside temperature goes down, the heat (37) _____ _____ _____.

밤에 바깥 온도가 내려가면 마침내 열은 방출된다.

This process (38) _____ _____ _____ _____ an innovative climate control system.

이 과정은 Pearce로 하여금 혁신적인 온도 조절 시스템을 고안해 내도록 영감을 주었다.

The Eastgate Centre (39) _____ _____ _____ a conventional cooling system.

Eastgate Centre는 전형적인 냉방 시스템 없이 건설되었다.

Instead, Pearce used building materials (40) _____ _____ _____ large amounts of heat.

대신 Pearce는 많은 양의 열기를 저장할 수 있는 건축 자재를 사용했다.

The floors and walls of the building (41) _____ _____ _____ _____ _____, just like the soil of a termite mound.

건물의 바닥과 벽은 흰개미집의 흙처럼 낮 동안 열을 흡수한다.

The heat is released at night, and the walls cool down, ready (42) _____ _____ again by the next morning.

그 열이 밤에 방출되면 벽은 서늘해지며, 다음 날 아침쯤에는 다시 열을 저장할 준비가 된다.

The structure of the building also helps (43) _____ _____ _____ _____.

건물의 구조 또한 건물이 서늘하게 유지되는 데 도움이 된다.

There are openings near the base of the building, and outside air (44) _____ _____ _____ _____ through them.

건물의 바닥 근처에 열린 공간이 있는데, 바깥 공기가 그곳을 통해 건물 안으로 들어온다.

This air is moved (45) _____ _____ _____ _____ a system of automatic fans.

이 공기는 자동 팬 장치에 의해 건물을 통과하여 이동한다.

Eventually, the air, along with heat (46) _____ _____ _____ _____ during the day, rises upward through the building's internal open spaces and is released through chimneys on the roof.

결국, 이 공기는 낮 동안 사람들의 활동으로 인해 생기는 열기와 함께 건물 내부의 열린 공간을 통해 위로 올라가서 지붕에 있는 굴뚝을 통해 빠져나가게 된다.

As a result, the building has not only cool temperatures (47) _____ _____ _____ _____. More importantly, the Eastgate Centre uses far (48) _____ _____ _____ _____, which saves money and helps protect the environment from pollution.

그 결과, 건물은 시원한 온도뿐 아니라 신선한 공기 또한 가지게 된다. 더 중요한 것은, Eastgate Centre가 다른 건물들보다 훨씬 더 적은 에너지를 사용해서, 돈을 절약해 주고 오염으로부터 환경을 보호하는 데 도움을 준다는 점이다.

(49) _____ _____ _____ _____ _____ from tiny termites, none of this would have been possible.

Pearce가 작은 흰개미에게서 받은 영감이 없었더라면, 이 어떤 것도 가능하지 않았을 것이다.

(50) _____ _____ _____ _____ is just one way that humans are utilizing the lessons of nature to improve the way we do things.

건축에서 자연 모방 (기술)을 사용하는 것은 인간이 무언가를 하는 방식을 향상시키는 데 자연의 가르침을 이용하고 있는 한 가지 방식에 불과하다.

Biomimicry is also being (51) _____ _____ _____ in the fields of robotics, agriculture, and many others.

자연 모방 (기술)은 또한 로봇공학, 농업, 그리고 많은 다른 분야에서 문제점들을 해결하기 위해 사용되고 있다.

Imitating the ideas of nature not only helps solve problems, but it also (52) _____ _____ _____ _____ _____ .

자연이 주는 아이디어를 모방하는 것은 문제를 해결하도록 도와줄 뿐 아니라, 우리가 자연을 더 가깝게 느끼도록 해 준다.

As a result, humans are more likely to stop (53) _____ _____ _____ and start becoming part of it instead.

그 결과로, 인간은 환경을 파괴하는 것을 멈추고 대신 환경의 일부가 되기 시작할 가능성이 더 커진다.

다음 네모 안에서 옳은 것을 고르시오.

01 Nature is all around us. It [depresses / impresses] us with its beauty and supplies us with everything we need to survive.

02 It also provides some people [with / to] the inspiration to create things in a new way.

03 Architects who use biomimicry look at nature as an incredibly [successful / unsuccessful] engineer who has already come up with answers to some of the problems they now face.

04 [Designing / Designed] by the world-famous architect Antoni Gaudi, the church is one of the most prominent buildings in the world.

05 Gaudi believed that all architects should look to nature for [expiration / inspiration].

06 He preferred the curves found in natural objects [to / with] the straight lines found in artificial ones.

07 Many parts of the church [incorporate / incorporates] images and forms from nature. For example, the church's spires are topped with spheres that resemble fruits.

08 There are also turtles carved into the stone bases of columns and spiral stairs [that / where] resemble the shells of sea creatures.

09 Gaudi designed the columns inside the church to resemble trees and branches, so visitors who look up can feel [as if / even if] they were standing in a great forest.

10 The light that comes through the small holes all over the ceiling even [resemble / resembles] the light beaming through leaves in a forest.

11 This allows them [to support / supporting] the roof better by distributing its weight evenly.

12 [Due to / Since] the hot climate of Harare, air conditioning systems can be very costly to install, run, and maintain.

13 The heat generated by the daily activity of the termites rises up through the central chimney, eventually [escaped / escaping] through the top of the mound.

14 Eventually, the air, along with heat generated by human activity during the day, rises upward through the building's internal open spaces and [released / is released] through chimneys on the roof.

15 As a result, the building has not only cool temperatures [but also / as well as] fresh air.

16 More importantly, the Eastgate Centre uses [far / farther] less energy than other buildings, which saves money and helps protect the environment from pollution.

17 Without the inspiration Pearce received from tiny termites, none of this would [have / have been] possible.

18 Biomimicry is also [being / been] used to solve problems in the fields of robotics, agriculture, and many others.

19 [Imitate / Imitating] the ideas of nature not only helps solve problems, but it also makes us feel closer to nature.

20 As a result, humans are more likely [to stop / stopping] destroying the environment and start becoming part of it instead.

다음 문장이 옳으면 O, 틀리면 X 표시하고 바르게 고치시오.

01 Nature is all around us. It impresses us with its beauty and supplies us with everything we need to survive.

02 It also provides some people with the inspiration to create things in a new way.

03 The act of creating things base on nature is called "biomimicry."

04 This term is derived from the Greek words *bios*, meaning "life," and *mimesis*, meaning "imitation."

05 Architects who use biomimicry look at nature as an incredibly successful engineer who have already come up with answers to some of the problems they now face.

06 They carefully study plants, animals, and other aspects of nature to learn how do they work.

07 As a result, they have been able to find some innovative solutions to engineering and architectural challenges.

The Curving Beauty of Nature

08 The Sagrada Familia is an enormous church in Barcelona, Spain.

09 Designed by the world-famous architect Antoni Gaudi, the church is one of the most prominent building in the world.

10 Construction of this remarkable building began in 1882, and Gaudi took over responsibility for its design in 1883.

11 Believe it or not, the building is still under construction.

12 Some people love the Sagrada Familia and others hate it, but nearly everyone are fascinated by its unique design.

13 Gaudi believed that all architects should look to nature for inspiration.

14 He preferred the curves found in natural objects to the straight lines found in artificial ones.

15 This preference can be saw in all his buildings, including the Sagrada Familia.

16 Many parts of the church incorporate images and forms from nature. For example, the church's spires are topped with spheres that resemble fruits.

17 There are also turtles carving into the stone bases of columns and spiral stairs that resemble the shells of sea creatures.

18 Perhaps the most impressive feature of the Sagrada Familia is the ceiling.

19 Gaudi designed the columns inside the church to resemble trees and branches, so visitors who look up can feel as if they are standing in a great forest.

20 The light that comes through the small holes all over the ceiling even resembles the light beaming through leaves in a forest.

21 These tree-like columns are not just for decoration, though. Inspired by trees, Gaudi gave the columns a single base that splits off into branches near the top.

22 This allows them to support the roof better by distributing its weight evenly.

23 Because Gaudi recognized the superiority of natural forms, he was able to design a building where is both beautiful and functional.

A Lesson from Insects

24 The Eastgate Centre is an office building and shopping complex in Harare, Zimbabwe.

25 Built in 1996, it might not be as visual impressive as the Sagrada Familia.

26 However, the building is an excellent example of biomimicry.

27 Due to the hot climate of Harare, air conditioning systems can be very cost to install, run, and maintain.

28 To solve this problem, the building's architect, Mick Pearce, turned to termite mounds for an alternative.

29 Termite mounds are large structures build by certain termite species.

30 Scientists believe that the mounds stay cool due to a constant flow of air.

31 Each mound have a network of holes referred to as chimneys.

32 It has a large central chimney and smaller outer chimneys that are close to the ground.

33 The heat generated by the daily activity of the termites rises up through the central chimney, eventually escaping through the top of the mound.

34 In the meantime, cooler air is pulled in through the smaller chimneys, keeping the termites' home at a comfortable temperature during the hot day.

35 Also, the soil surrounding the mound absorb heat in the hot daytime hours.

36 Therefore, the temperature inside the mound does not increase greatly and stays relatively coolly.

37 At night, when the outside temperature goes down, the heat is finally released.

38 This process inspired Pearce designing an innovative climate control system.

39 The Eastgate Centre was constructed without a conventional cooling system.

40 Instead, Pearce used building materials that can store large amounts of heat.

41 The floors and walls of the building absorb heat during the day, just like the soil of a termite mound.

42 The heat is released at night, and the walls cool down, ready to storing heat again by the next morning.

43 The structure of the building also helps keep the building cool.

44 There are openings near the base of the building, and outside air comes into the building through them.

45 This air is moved through the building by a system of automatic fans.

46 Eventually, the air, along with heat generated by human activity during the day, rises upward through the building's internal open spaces and are released through chimneys on the roof.

47 As a result, the building has not only cool temperatures but also fresh air.

48 More importantly, the Eastgate Centre uses far less energy than other buildings, which save money and helps protect the environment from pollution.

49 Without the inspiration Pearce receive from tiny termites, none of this would have been possible.

50 Using biomimicry in architecture is just one way that humans are utilizing the lessons of nature to improve the way we do things.

51 Biomimicry is also being used to solve problems in the fields of robotics, agriculture, and many others.

52 Imitating the ideas of nature not only helps solve problems, but it also makes us to feel closer to nature.

53 As a result, humans are more likely to stop destroying the environment and start becoming part of it instead.

1 다음 담화의 주제로 가장 적절한 것은?

When you hear the word "inspiration," you might think it's something only artists or designers need. However, all of us face situations that require new ideas, such as planning a school event or making a poster. These are the times when you need inspiration. Being inspired is usually an unexpected event that happens like a sudden flash. It can be caused by an object, a person, or an ordinary experience. You can get inspired while you're working out or reading books. As in the famous case of the Greek scientist Archimedes, inspiration can even come while bathing! To summarize, inspiration is everywhere. So, the next time you need a creative solution to a problem, why don't you start by simply opening your eyes? The answers you need are all around you!

① 예술가들에게 영감은 필수적이다.
② 독서를 통해 영감을 얻을 수 있다.
③ 영감은 우리 주변 어디에나 있다.
④ 영감을 받는 것은 예상 가능한 일이다.
⑤ 창의적인 사고를 길러야 한다.

[2~3] 다음 글을 읽고, 물음에 답하시오.

ⓐ Nature is all around us. ⓑ It impresses us with its beauty and (A) supply / supplies us with everything we need to survive. ⓒ It also provides some people with the inspiration to create things in a new way. The act of creating things based on nature is (B) called / calling "biomimicry." ⓓ This term is derived from the Greek words *bios*, meaning "life," and *mimesis*, meaning "imitation."
Architects who use biomimicry look at ⓔ it as an incredibly successful engineer who has already come up with answers to some of the problems they now face. They carefully study plants, animals, and (C) another / other aspects of nature to learn how they work. As a result, they have been able to find some innovative solutions to engineering and architectural challenges.

2 (A), (B), (C)의 각 네모 안에서 어법에 맞는 표현으로 가장 적절한 것은?

	(A)	(B)	(C)
①	supply	… called	… other
②	supply	… calling	… another
③	supplies	… called	… another
④	supplies	… called	… other
⑤	supplies	… calling	… other

3 윗글의 밑줄 친 ⓐ~ⓔ 중 가리키는 대상이 나머지 넷과 다른 것은?

① ⓐ ② ⓑ ③ ⓒ ④ ⓓ ⑤ ⓔ

[4~5] 다음 글을 읽고, 물음에 답하시오.

The Sagrada Familia is an enormous church in Barcelona, Spain. Designed by the world-famous architect Antoni Gaudi, the church is one of the most prominent buildings in the world. Construction of this _____ building began in 1882, and Gaudi took over responsibility for its design in 1883. Believe it or not, the building is still under construction. Some people love the Sagrada Familia and others hate it, but nearly everyone is fascinated by its unique design.
Gaudi believed that all architects should look to nature for inspiration. ① He preferred the curves found in natural objects to the straight lines found in artificial ones. ② Many people preferred a number of buildings designed by

Gaudi. ③ This preference can be seen in all his buildings, including the Sagrada Familia. ④ Many parts of the church incorporate images and forms from nature. ⑤ For example, the church's spires are topped with spheres that resemble fruits. There are also turtles carved into the stone bases of columns and spiral stairs that resemble the shells of sea creatures.

4 윗글의 밑줄 친 ①~⑤ 중, 전체 흐름과 관계 <u>없는</u> 문장은?

① ② ③ ④ ⑤

5 윗글의 빈칸에 들어갈 단어를 영영 뜻풀이를 참고하여 쓰시오. (단, 주어진 글자로 시작할 것)

> noticeable because of something that is unusually good

r_____

[6~7] 다음 글을 읽고, 물음에 답하시오.

Perhaps the most impressive feature of the Sagrada Familia is the ceiling. Gaudi designed the columns inside the church to resemble trees and branches, so visitors who look up _____. The light that comes through the small holes all over the ceiling even ⓐ <u>resemble</u> the light beaming through leaves in a forest. These tree-like columns are not just for decoration, though. ⓑ <u>Inspiring</u> by trees, Gaudi gave the columns a single base that splits off into branches near the top. This allows them ⓒ <u>support</u> the roof better by distributing its weight evenly. Because Gaudi recognized the superiority of natural forms, he was able to design a building that is both beautiful and functional.

6 〈보기〉에 주어진 말을 배열하여 윗글의 빈칸을 완성하시오.

> 〈보기〉 as / in a great forest / can / standing / were / feel / they / if

7 윗글의 밑줄 친 ⓐ~ⓒ를 어법에 맞게 고쳐 쓰시오.

ⓐ resemble → _____

ⓑ Inspiring → _____

ⓒ support → _____

[8~10] 다음 글을 읽고, 물음에 답하시오.

The Eastgate Centre is an office building and shopping complex in Harare, Zimbabwe. Built in 1996, it might not be as visually impressive as the Sagrada Familia. However, the building is an excellent example of biomimicry. Due to the hot climate of Harare, air conditioning systems can be very costly to install, run, and maintain. To solve this problem, the building's architect, Mick Pearce, turned to termite mounds for an alternative.

Termite mounds are large structures built by certain termite species. Scientists believe that the mounds stay cool due to _____ _____. Each mound has a network of holes referred to as chimneys. It has a large central chimney and smaller outer chimneys that are close to the ground. The heat generated by the daily activity of the termites rises up through the central chimney, (A) <u>and eventually the heat escapes through the top of the mound</u>. In the meantime, cooler air is pulled in through the smaller chimneys, keeping the termites' home at a comfortable temperature during the hot day.

8 윗글의 빈칸에 들어갈 말로 가장 적절한 것은?

① their large size
② a constant flow of air
③ the materials used to build them
④ the relatively hot temperatures
⑤ the cooler air generated by termites

9 윗글의 내용과 일치하지 <u>않는</u> 것은?

① The Eastgate Centre may not be visually impressive.
② Maintaining air conditioning in Harare is cheap.
③ There is a big chimney in the center of the mound.
④ The daily activities of termites produce heat.
⑤ Cool air comes into the mounds through the smaller chimneys.

10 윗글의 밑줄 친 (A)를 분사구문으로 바꿔 쓰시오.

eventually _____

[11~12] 다음 글을 읽고, 물음에 답하시오.

Also, the soil surrounding the mound absorbs heat in the hot daytime hours. Therefore, the temperature inside the mound does not increase greatly and stays relatively cool. At night, when the outside temperature goes down, the heat is finally released. ① <u>This process inspired Pearce to design an innovative climate control system.</u>

② <u>The Eastgate Centre was constructed without a conventional cooling system.</u> Instead, Pearce used building materials that can store large amounts of heat. The floors and walls of the building absorb heat during the day, just like the soil of a termite mound. ③ <u>The heat is released at night, and the walls cool down, ready to store heat again by the next morning.</u>

④ <u>The structure of the building also helps keeping the building cool.</u> There are openings near the base of the building, and outside air comes into the building through them. ⑤ <u>This air is moved through the building by a system of automatic fans.</u>

11 윗글의 밑줄 친 ①~⑤ 중, 어법상 <u>틀린</u> 표현이 있는 문장은?

① ② ③ ④ ⑤

12 다음 질문에 대한 답을 윗글에서 찾아 쓰시오.

Q: Why doesn't the temperature go up significantly in the mound?

A: It is because _____

_____ .

[13~14] 다음 글을 읽고, 물음에 답하시오.

As a result, the building has not only cool temperatures but also fresh air. More importantly, the Eastgate Centre uses far less energy than other buildings, which (A) wastes / saves money and helps protect the environment from pollution. Without the inspiration Pearce received from tiny termites, none of this would have been (B) possible / impossible.

Using biomimicry in architecture is just one way that humans are utilizing the lessons of nature to (C) improve / ignore the way we do things. Biomimicry is also being used ⓐ <u>solve</u> problems in the fields of robotics, agriculture, and many others. Imitating the ideas of nature not only helps solve problems, but it also makes us feel closer to nature. As a result, humans are more likely to stop ⓑ <u>destroy</u> the environment and start becoming part of it instead.

13 (A), (B), (C)의 각 네모 안에서 문맥에 맞는 낱말로 가장 적절한 것은?

	(A)		(B)		(C)
①	wastes	…	possible	…	improve
②	wastes	…	impossible	…	ignore
③	saves	…	possible	…	improve
④	saves	…	possible	…	ignore
⑤	saves	…	impossible	…	ignore

14 윗글의 밑줄 친 ⓐ, ⓑ를 어법에 맞게 고쳐 쓰시오.

ⓐ solve → _____

ⓑ destroy → _____

1 다음 대화의 빈칸에 들어갈 말로 가장 적절한 것은?

> G: What are you doing, David?
>
> B: I'm reading an article about how the airbag was invented.
>
> G: Sounds interesting. Can you explain it to me?
>
> B: The airbag was invented by John Hetrick. He was inspired to invent it after crashing his car while out on a drive with his wife and daughter in 1952.
>
> G: Oh, no! They weren't hurt, were they?
>
> B: Well, his daughter wasn't seriously hurt because Hetrick protected her with his arms. This scary experience inspired him to create the airbag.
>
> G: Wow. It's surprising that he turned a bad experience into an _____!
>
> B: Yes, it is. We can get ideas even from car accidents.

① adversity ② influence
③ agreement ④ opportunity
⑤ insurance

[2~3] 다음 글을 읽고, 물음에 답하시오.

> Nature is all around us. It impresses us with its beauty and supplies us with everything we need to survive. It also provides some people with the inspiration ① to create things in a new way. The act of creating things based on nature ② are called "biomimicry." This term ③ is derived from the Greek words *bios*, meaning "life," and *mimesis*, meaning "imitation."
>
> Architects ④ who use biomimicry look at nature as an incredibly successful engineer who has already come up with answers to some of the problems they now face. They carefully study plants, animals, and other aspects of nature to learn ⑤ how they work. _____, they have been able to find some innovative solutions to engineering and architectural challenges.

2 윗글의 빈칸에 들어갈 말로 가장 적절한 것은?

① Likewise ② However
③ As a result ④ For instance
⑤ On the other hand

3 윗글의 밑줄 친 ①~⑤ 중, 어법상 틀린 것은?

① ② ③ ④ ⑤

[4~6] 다음 글을 읽고, 물음에 답하시오.

> The Sagrada Familia is an enormous church in Barcelona, Spain. ⓐ Designed by the world-famous architect Antoni Gaudi, the church is one of the most (A) prominent buildings in the world. Construction of this remarkable building began in 1882, and Gaudi took over responsibility for its design in 1883. Believe it or not, the building is still under construction. Some people love the Sagrada Familia and others hate it, but nearly everyone is fascinated by its unique design.
>
> Gaudi believed ⓑ that all architects should look to nature for inspiration. 그는 인공물에서 발견되는 직선들보다는 자연물들에서 발견되는 곡선들을 선호했다. This preference can ⓒ see in all his buildings, including the Sagrada Familia. Many parts of the church ⓓ incorporate images and forms from nature. For example, the church's spires are topped with spheres that resemble fruits. There are also turtles carved into the stone bases of columns and spiral stairs that ⓔ resemble the shells of sea creatures.

4 윗글의 밑줄 친 (A)와 바꿔 쓸 수 있는 것은?

① vast ② persistent
③ inevitable ④ famous
⑤ contemporary

5 윗글의 밑줄 친 ⓐ~ⓔ 중, 어법상 틀린 것은?

① ⓐ ② ⓑ ③ ⓒ ④ ⓓ ⑤ ⓔ

6 윗글의 밑줄 친 우리말과 일치하도록 〈보기〉에 주어진 말을 배열하여 문장을 완성하시오. (필요 시 단어를 중복해서 쓸 것)

〈보기〉 found / in / preferred / objects / to / the straight lines / he / natural / the curves

_____ in artificial ones.

[7~8] 다음 글을 읽고, 물음에 답하시오.

Perhaps the most impressive feature of the Sagrada Familia is the ceiling. Gaudi designed the columns inside the church to resemble trees and branches, so visitors who look up can feel ___(A)___ they were standing in a great forest. The light that comes through the small holes all over the ceiling even resembles the light beaming through leaves in a forest. These tree-like columns are not just for decorations, though. Inspired by trees, Gaudi gave the columns a single base that splits off into branches near the top. ⓐ This allows them to support the roof better by distributing its weight evenly. ___(B)___ Gaudi recognized the superiority of natural forms, he was able to design a building that is both beautiful and functional.

7 윗글의 빈칸 (A), (B)에 들어갈 말로 가장 적절한 것은?

	(A)	(B)		(A)	(B)
①	before	… Though	②	after	… When
③	as if	… Because	④	because	… While
⑤	although	… Since			

8 윗글의 밑줄 친 ⓐ가 의미하는 것을 찾아 우리말로 쓰시오. (35자 내외)

[9~10] 다음 글을 읽고, 물음에 답하시오.

However, the building is an excellent example of biomimicry. Due to the hot climate of Harare, air conditioning systems can be very costly to install, run, and maintain. To solve this problem, the building's architect, Mick Pearce, turned to termite mounds for an alternative.

① Termite mounds are large structures built by certain termite species. ② Scientists believe that the mounds stay cool due to a constant flow of air. ③ Besides, termite mounds are being used in other experiments. ④ Each mound has a network of holes referred to as chimneys. ⑤ It has a large central chimney and smaller outer chimneys that are close to the ground. The heat generated by the daily activity of the termites ⓐ rise up through the central chimney, eventually escaping through the top of the mound. In the meantime, cooler air is pulled in through the smaller chimneys, ⓑ keep the termites' home at a comfortable temperature during the hot day.

9 윗글의 밑줄 친 ①~⑤ 중, 전체 흐름과 관계 없는 문장은?

① ② ③ ④ ⑤

10 윗글의 밑줄 친 ⓐ, ⓑ를 어법에 맞게 한 단어로 고쳐 쓰시오.

ⓐ rise → _____

ⓑ keep → _____

Also, the soil surrounding the mound absorbs heat in the hot daytime hours. Therefore, the temperature inside the mound does not ① increase greatly and stays relatively cool. At night, when the outside temperature goes down, the heat is finally ② released. This process inspired Pearce to design an innovative climate control system.

The Eastgate Centre was constructed without a conventional cooling system. Instead, Pearce used building materials that can store large amounts of heat. The floors and walls of the building ③ emit heat during the day, just like the soil of a termite mound. The heat is released at night, and the walls ④ cool down, ready to store heat again by the next morning.

The structure of the building also helps keep the building cool. There are openings near the base of the building, and outside air comes into the building through them. This air is moved through the building by a system of automatic fans. Eventually, the air, along with heat generated by human activity during the day, rises upward through the building's internal open spaces and is ⑤ released through chimneys on the roof.

11 Eastgate Centre에 관한 윗글의 내용과 일치하지 <u>않는</u> 것은?

① 열기를 저장하는 건축 자재가 사용되었다.
② 건물의 구조 덕분에 서늘하게 유지된다.
③ 바깥 공기를 완벽하게 차단한다.
④ 자동 팬 장치가 있다.
⑤ 사람들의 활동으로 인해 내부에 열기가 생긴다.

12 윗글의 밑줄 친 ①~⑤ 중, 문맥상 낱말의 쓰임이 적절하지 <u>않은</u> 것은?

① ② ③ ④ ⑤

13 다음 영영 뜻풀이에 해당하는 단어를 윗글에서 찾아 쓰시오.

normal, or based on common standards; traditional

[14~15] 다음 글을 읽고, 물음에 답하시오.

As a result, the building has not only cool temperatures ① but also fresh air. More importantly, the Eastgate Centre uses far (A) less / more energy than other buildings, ② that saves money and helps protect the environment from pollution. Without the inspiration Pearce (B) rejected / received from tiny termites, none of this would have been possible.

③ Using biomimicry in architecture is just one way that humans are utilizing the lessons of nature to improve the way we do things. Biomimicry is also ④ being used to solve problems in the fields of robotics, agriculture, and many others. Imitating the ideas of nature not only helps ⑤ solve problems, but it also makes us feel closer to nature. As a result, humans are more likely to stop (C) protecting / destroying the environment and start becoming part of it instead.

14 (A), (B), (C)의 각 네모 안에서 문맥에 맞는 낱말로 가장 적절한 것은?

	(A)		(B)		(C)
①	less	…	rejected	…	protecting
②	less	…	rejected	…	destroying
③	less	…	received	…	destroying
④	more	…	received	…	protecting
⑤	more	…	received	…	destroying

15 윗글의 밑줄 친 ①~⑤ 중, 어법상 <u>틀린</u> 것은?

① ② ③ ④ ⑤

1 다음 대화의 빈칸에 들어갈 말로 가장 적절한 것은?

B: Hey, Julie. Did you have a nice weekend?

G: Hi, Tyler. I just stayed at home and relaxed. You went to Stacy Barrett's book signing, right? I saw the photos on your social media page.

B: Yes. I read her new book and found it very powerful.

G: What's it about?

B: It's about creativity. The author explains how to think creatively.

G: That sounds useful. Can you give me some advice on how to _____?

B: Well, you can start a conversation about a topic you're interested in. According to the book, you can sometimes get unexpected ideas when listening to others.

G: Thanks for the tip!

① make many friends
② become a better author
③ come up with good ideas
④ choose an interesting book
⑤ be popular on social media

[2~3] 다음 글을 읽고, 물음에 답하시오.

Nature is all around us. (①) It impresses us with its beauty and supplies us with everything we need to survive. (②) It also provides some people with the inspiration to create things in a new way. (③) The act of creating things based on nature is called "biomimicry." (④)

Architects ___(A)___ use biomimicry look at nature as an incredibly successful engineer who has already come up with answers to some of the problems ___(B)___ they now face. (⑤) They carefully study plants, animals, and other aspects of nature to learn how they work. As a result, they have been able to find some innovative solutions to engineering and architectural challenges.

2 윗글의 흐름으로 보아, 주어진 문장이 들어가기에 가장 적절한 곳은?

This term is derived from the Greek words *bios*, meaning "life," and *mimesis*, meaning "imitation."

① ② ③ ④ ⑤

3 윗글의 빈칸 (A), (B)에 들어갈 말로 가장 적절한 것은?

	(A)		(B)
①	who	…	what
②	that	…	that
③	that	…	of which
④	which	…	which
⑤	which	…	that

4 Sagrada Familia에 관한 다음 글의 내용과 일치하는 것은?

The Sagrada Familia is an enormous church in Barcelona, Spain. Designed by the world-famous architect Antoni Gaudi, the church is one of the most prominent buildings in the world. Construction of this remarkable building began in 1882, and Gaudi took over responsibility for its design in 1883. Believe it or not, the building is still under construction. Some people love the Sagrada Familia and others hate it, but nearly everyone is fascinated by its unique design.

① 바르셀로나에 있는 작은 성당이다.
② Antoni Gaudi의 제자가 설계했다.
③ 아직 잘 알려지지 않은 건축물이다.
④ 1883년에 건설이 시작되었다.
⑤ 여전히 공사가 진행 중이다.

5 주어진 글 다음에 이어질 글의 순서로 가장 적절한 것은?

> Gaudi believed that all architects should look to nature for inspiration.

> (A) For example, the church's spires are topped with spheres that resemble fruits. There are also turtles carved into the stone bases of columns and spiral stairs that resemble the shells of sea creatures.
> (B) This preference can be seen in all his buildings, including the Sagrada Familia. Many parts of the church incorporate images and forms from nature.
> (C) He preferred the curves found in natural objects to the straight lines found in artificial ones.

① (A) − (B) − (C) ② (B) − (A) − (C)
③ (B) − (C) − (A) ④ (C) − (A) − (B)
⑤ (C) − (B) − (A)

[6~7] 다음 글을 읽고, 물음에 답하시오.

> Perhaps the most impressive feature of the Sagrada Familia is the ceiling. Gaudi designed the columns inside the church ① to resemble trees and branches, so visitors who look up can feel as if they ② are standing in a great forest. The light that comes through the small holes all over the ceiling even resembles the light ③ beaming through leaves in a forest. These tree-like columns are not just for decoration, though. ④ Inspired by trees, Gaudi gave the columns a single base that splits off into branches near the top. This allows them ⑤ to support the roof better by distributing its weight evenly. Because Gaudi recognized the superiority of natural forms, he was able to design a building that is both beautiful and _____.

6 윗글의 밑줄 친 ①~⑤ 중, 어법상 틀린 것은?

① ② ③ ④ ⑤

7 윗글의 빈칸에 들어갈 단어를 영영 뜻풀이를 참고하여 쓰시오. (단, 주어진 글자로 시작할 것)

> having a purpose or use; able to serve a purpose

f_____

[8~9] 다음 글을 읽고, 물음에 답하시오.

> Termite mounds are large structures built by certain termite species. Scientists believe that the mounds _____ due to a constant flow of air. Each mound has a network of holes referred to as chimneys. It has a large central chimney and smaller outer chimneys (A) that / what are close to the ground. The heat generated by the daily activity of the termites rises up through the central chimney, eventually (B) escaped / escaping through the top of the mound. In the meantime, cooler air is pulled in through the smaller chimneys, keeping the termites' home at a comfortable temperature during the hot day.
> Also, the soil surrounding the mound absorbs heat in the hot daytime hours. Therefore, the temperature inside the mound does not increase greatly and stays (C) relative / relatively cool. At night, when the outside temperature goes down, the heat is finally released. This process inspired Pearce to design an innovative climate control system.

8 윗글의 빈칸에 들어갈 말로 가장 적절한 것은?

① are dark ② are weak
③ stay cool ④ are protected
⑤ collapse down

9 (A), (B), (C)의 각 네모 안에서 어법에 맞는 표현으로 가장 적절한 것은?

	(A)		(B)		(C)
①	that	···	escaped	···	relative
②	that	···	escaping	···	relative
③	that	···	escaping	···	relatively
④	what	···	escaped	···	relatively
⑤	what	···	escaping	···	relatively

The Eastgate Centre was constructed without a conventional cooling system.

(A) The structure of the building also helps keep the building cool. There are openings near the base of the building, and outside air comes into the building through them.

(B) Instead, Pearce used building materials that can store large amounts of heat. The floors and walls of the building absorb heat during the day, just like the soil of a termite mound.

(C) The heat is released at night, and the walls cool down, ready to store heat again ⓐ by the next morning.

10 주어진 문장 다음에 이어질 글의 순서로 가장 적절한 것은?

① (A) − (B) − (C) ② (B) − (A) − (C)
③ (B) − (C) − (A) ④ (C) − (A) − (B)
⑤ (C) − (B) − (A)

11 윗글의 밑줄 친 ⓐ by와 쓰임이 같은 것은?

① She was hit by a truck.
② Food prices went up by 10%.
③ You can reserve the tickets by phone.
④ He walked right by me without saying anything.
⑤ By the time we got home, we were tired and hungry.

12 다음 글의 밑줄 친 우리말과 일치하도록 〈보기〉에 주어진 말을 배열하여 문장을 완성하시오. (필요 시 형태를 변형할 것)

그 결과, 건물은 시원한 온도뿐 아니라 신선한 공기 또한 가지게 된다. More importantly, the Eastgate Centre uses far less energy than other buildings, which saves money and helps protect the environment from pollution. Without the inspiration Pearce received from tiny termites, none of this would have been possible.

〈보기〉 air / also / the building / but / cool / fresh / have / not / only / temperatures

As a result, _____

_____.

13 다음 글의 주제로 가장 적절한 것은?

Using biomimicry in architecture is just one way that humans are utilizing the lessons of nature to improve the way we do things. Biomimicry is also being used to solve problems in the fields of robotics, agriculture, and many others. Imitating the ideas of nature not only helps solve problems, but it also makes us feel closer to nature. As a result, humans are more likely to stop destroying the environment and start becoming part of it instead.

① various architectural techniques
② the importance of studying robotics
③ positive effects of biomimicry
④ ways to protect the environment
⑤ food shortage problems in the future

14 다음 글의 (A)에 주어진 말을 알맞게 배열하시오. (단, 분사구문으로 시작할 것)

Tired from flying around, a thirsty crow landed in a park. It saw a pitcher of water on a small table, so it flew over and tried to drink. Unfortunately, the pitcher was only half full, so the crow couldn't reach the water. (A) (about / being / accept / fate / it / its / frustrated / to / was), but then it had an idea. It began picking up rocks and dropping them into the pitcher. The water level got higher and higher, until the crow could finally drink!

1 다음 담화의 빈칸 (A), (B)에 들어갈 말로 가장 적절한 것은?

When you hear the word "inspiration," you might think it's something only artists or designers need. ____(A)____, all of us face situations that require new ideas, such as planning a school event or making a poster. These are the times when you need inspiration. Being inspired is usually an unexpected event that happens like a sudden flash. It can be caused by an object, a person, or an ordinary experience. You can get inspired while you're working out or reading books. As in the famous case of the Greek scientist Archimedes, inspiration can even come while bathing! ____(B)____, inspiration is everywhere. So, the next time you need a creative solution to a problem, why don't you start by simply opening your eyes? The answers you need are all around you!

	(A)		(B)
①	Similarly	…	In short
②	Similarly	…	Moreover
③	However	…	In short
④	However	…	Moreover
⑤	For example	…	Therefore

[2~3] 다음 글을 읽고, 물음에 답하시오.

Nature is all around us. It impresses us with its beauty and supplies us with everything we need to survive. It also provides some people with the inspiration to create things in a new way. 자연에 기초해서 어떤 것들을 창조해 내는 행위는 '자연 모방'이라고 불린다. This term is derived from the Greek words *bios*, meaning "life," and *mimesis*, meaning "imitation."

ⓐ Architects who use biomimicry look at nature as an incredibly successful engineer who has already come up with answers to some of the problems ⓑ they now face. ⓒ They carefully study plants, animals, and other aspects of nature to learn how ⓓ they work. As a result, ⓔ they have been able to find some innovative solutions to engineering and architectural challenges.

2 윗글의 밑줄 친 우리말과 일치하도록 〈보기〉에 주어진 말을 배열하여 문장을 완성하시오. (필요 시 형태를 변형할 것)

〈보기〉 the act of / based / create / nature / on / things

_____ is called "biomimicry."

3 윗글의 밑줄 친 ⓐ~ⓔ 중, 가리키는 대상이 나머지 넷과 다른 것은?

① ⓐ ② ⓑ ③ ⓒ ④ ⓓ ⑤ ⓔ

[4~5] 다음 글을 읽고, 물음에 답하시오.

The Sagrada Familia is an enormous church in Barcelona, Spain. Designed by the world-famous architect Antoni Gaudi, 성당은 세계에서 가장 유명한 건물들 중 하나이다. Construction of this remarkable building began in 1882, and Gaudi took over responsibility for its design in 1883. Believe it or not, the building is still under construction. Some people love the Sagrada Familia and others hate it, but nearly everyone is fascinated by its unique design.

Gaudi believed that all architects should look to nature for (A) depression / inspiration. He preferred the curves found in natural objects to the straight lines found in artificial ones. This (B) inference / preference can be seen in all his buildings, including the Sagrada Familia. Many

parts of the church (C) corporate / incorporate images and forms from nature. For example, the church's spires are topped with spheres that resemble fruits. There are also turtles carved into the stone bases of columns and spiral stairs that resemble the shells of sea creatures.

4 (A), (B), (C)의 각 네모 안에서 문맥에 맞는 낱말로 가장 적절한 것은?

	(A)		(B)		(C)
①	depression	⋯	inference	⋯	corporate
②	depression	⋯	inference	⋯	incorporate
③	inspiration	⋯	inference	⋯	corporate
④	inspiration	⋯	preference	⋯	corporate
⑤	inspiration	⋯	preference	⋯	incorporate

5 윗글의 밑줄 친 우리말과 일치하도록 주어진 단어를 이용하여 문장을 완성하시오.

(the church, prominent, in the world)

[6~7] 다음 글을 읽고, 물음에 답하시오.

Perhaps the most impressive feature of the Sagrada Familia is the ceiling. Gaudi designed the columns inside the church to resemble trees and branches, so visitors who look up can feel as if (A) they were standing in a great forest. The light that comes through the small holes all over the ceiling even resembles the light beaming through leaves in a forest. These tree-like columns are not just for decoration, though. Inspired by trees, Gaudi gave the columns a single base that splits off into branches near the top. This allows them to support the roof better by distributing (B) its weight evenly. Because Gaudi recognized the superiority of natural forms, he was able to design a building that is both beautiful and functional.

6 윗글의 밑줄 친 (A)와 (B)가 가리키는 대상을 찾아 쓰시오.

(A) _____

(B) _____

7 다음 영영 뜻풀이에 해당하는 단어를 윗글에서 찾아 쓰시오.

> to look like or be similar to someone or something

[8~9] 다음 글을 읽고, 물음에 답하시오.

The Eastgate Centre is an office building and shopping complex in Harare, Zimbabwe. (①) Built in 1996, it might not be as visually impressive as the Sagrada Familia. (②) However, the building is an excellent example of biomimicry. (③) To solve this problem, the building's architect, Mick Pearce, turned to termite mounds for an alternative. (④)

Termite mounds are large structures built by certain termite species. (⑤) Scientists believe that the mounds stay cool __(A)__ a constant flow of air. Each mound has a network of holes referred to as chimneys. It has a large central chimney and smaller outer chimneys that are close to the ground. The heat generated by the daily activity of the termites rises up through the central chimney, eventually escaping through the top of the mound. In the meantime, cooler air is pulled in through the smaller chimneys, keeping the termites' home at a comfortable temperature during the hot day.

Also, the soil surrounding the mound absorbs heat in the hot daytime hours. __(B)__ , the temperature inside the mound does not increase greatly and stays relatively cool. At night, when the outside temperature goes down, the heat is finally released. This process inspired Pearce to design an innovative climate control system.

8 윗글의 흐름으로 보아, 주어진 문장이 들어가기에 가장 적절한 곳은?

> Due to the hot climate of Harare, air conditioning systems can be very costly to install, run, and maintain.

① ② ③ ④ ⑤

9 윗글의 빈칸 (A), (B)에 들어갈 말로 가장 적절한 것은?

	(A)		(B)		(A)		(B)
①	but for	…	However	②	due to	…	Similarly
③	due to	…	Therefore	④	despite	…	However
⑤	despite	…	Therefore				

10 다음 글의 밑줄 친 ①~⑤ 중, 어법상 틀린 것은?

> The Eastgate Centre ① was constructed without a conventional cooling system. Instead, Pearce used building materials ② that can store large amounts of heat. The floors and walls of the building absorb heat during the day, just like the soil of a termite mound. The heat is released at night, and the walls cool down, ready to store heat again by the next morning.
>
> The structure of the building also helps ③ keep the building cool. There are openings near the base of the building, and outside air comes into the building through ④ them. This air is moved through the building by a system of automatic fans. Eventually, the air, along with heat generated by human activity during the day, rises upward through the building's internal open spaces and ⑤ releases through chimneys on the roof.

① ② ③ ④ ⑤

[11~12] 다음 글을 읽고, 물음에 답하시오.

> As a result, the building has not only cool temperatures but also fresh air. More importantly, the Eastgate Centre uses ① very less energy than other buildings, which saves money and helps protect the environment from pollution. Without the inspiration Pearce received from tiny termites, none of this ② would have been possible.
>
> Using biomimicry in architecture is just one way that humans are utilizing the lessons of nature to improve the way we do things. Biomimicry is also ③ being used to solve problems in the fields of robotics, agriculture, and many others. _____(A)_____ not only helps solve problems, but it also makes us feel ④ closer to nature. As a result, humans are more likely to stop ⑤ destroying the environment and start becoming part of it instead.

11 윗글의 빈칸 (A)에 들어갈 말로 가장 적절한 것은?

① Growing plants
② Purifying the air
③ Imitating the ideas of nature
④ Getting some help from others
⑤ A natural material like wood

12 윗글의 밑줄 친 ①~⑤ 중, 어법상 틀린 것은?

① ② ③ ④ ⑤

13 다음 글의 밑줄 친 두 문장을 관계대명사의 계속적 용법을 이용하여 한 문장으로 쓰시오.

> One day, a girl was playing in the park. She saw a photograph on the ground and picked it up. She saw a cute boy in the photograph. This made her cheeks turn red. She took the photograph home and put it in a box. Eventually, she forgot about it. Twenty years later, she got married. One day, her husband opened the box and found the photograph. He asked, "Who is the little boy in this picture?" She answered that it was her first love. This made her husband smile. He said, "I lost this photograph when I was nine years old."

정답 및 해설 p.37

1 다음 대화가 자연스럽게 이어지도록 (A)~(C)를 올바른 순서로 배열하시오.

> A: Look at this poster! There is going to be a writing contest.
> B: _____
> A: _____
> B: _____
> A: Have you tried listening to music? I think it can help stimulate your imagination.
> B: Okay, I will give it a try.

> (A) Do you have any ideas for your poem?
> (B) I saw it yesterday. I'm going to write a poem and submit it.
> (C) I'm trying to think of one, but it is difficult. Can you give me some advice?

_____ → _____ → _____

2 다음 글의 요지로 가장 적절한 것은?

> Nature is all around us. It impresses us with its beauty and supplies us with everything we need to survive. It also provides some people with the inspiration to create things in a new way. The act of creating things based on nature is called "biomimicry." This term is derived from the Greek words *bios*, meaning "life," and *mimesis*, meaning "imitation."
>
> Architects who use biomimicry look at nature as an incredibly successful engineer who has already come up with answers to some of the problems they now face. They carefully study plants, animals, and other aspects of nature to learn how they work. As a result, they have been able to find some innovative solutions to engineering and architectural challenges.

① 자연과 창의력은 밀접하게 연관되어 있다.
② 자연을 이용하는 행위는 금지되어야 한다.
③ 자연 보호의 중요성이 점점 더 증대되고 있다.
④ 건축가들이 직면한 문제를 시급하게 해결해야 한다.
⑤ 자연을 통해 건축가들이 직면한 문제를 해결할 수 있다.

[3~4] 다음 글을 읽고, 물음에 답하시오.

> The Sagrada Familia is an enormous church in Barcelona, Spain. ① Designed by the world-famous architect Antoni Gaudi, the church is one of the most prominent buildings in the world. Construction of this remarkable building ② began in 1882, and Gaudi took over responsibility for its design in 1883. Believe it or not, the building is still under construction. Some people love the Sagrada Familia and others hate it, but nearly everyone ③ is fascinated by its unique design.
>
> Gaudi believed that all architects should look to nature for inspiration. He preferred the curves found in natural objects ④ to the straight lines found in artificial ones. This preference can be seen in all his buildings, including the Sagrada Familia. Many parts of the church incorporate images and forms from nature. For example, the church's spires are topped with spheres that resemble fruits. There are also turtles ⑤ carving into the stone bases of columns and spiral stairs that resemble the shells of sea creatures.

3 윗글을 읽고 답할 수 <u>없는</u> 질문으로 가장 적절한 것은?

① Who began building the Sagrada Familia?
② When did Gaudi take over responsibility for the church's design?
③ What makes people fascinated by the Sagrada Familia?
④ Which did Gaudi prefer, curves or straight lines?
⑤ What are examples of Gaudi's incorporating images and forms from nature?

4 윗글의 밑줄 친 ①~⑤ 중, 어법상 틀린 것은?

① ② ③ ④ ⑤

[5~6] 다음 글을 읽고, 물음에 답하시오.

> Perhaps the most impressive feature of the Sagrada Familia is the ceiling. Gaudi designed the columns inside the church to resemble trees and branches, so visitors who look up can feel as if they were standing in a great forest. The light that comes through the small holes all over the ceiling even ⓐ <u>resemble with</u> the light beaming through leaves in a forest. These tree-like columns are not just for decoration, though. Inspired by trees, Gaudi gave the columns a single base that splits off into branches near the top. This allows them to support the roof better by ⓑ <u>distribute</u> its weight evenly. Because Gaudi recognized the superiority of natural forms, he was able to design a building that is _____.

5 윗글의 빈칸에 들어갈 말로 가장 적절한 것은?

① open to the community
② both beautiful and functional
③ not comfortable but cost effective
④ strong enough to withstand natural disasters
⑤ in harmony with its surrounding environment

6 윗글의 밑줄 친 ⓐ, ⓑ를 어법에 맞게 고쳐 쓰시오.

ⓐ resemble with → _____

ⓑ distribute → _____

7 다음 글의 밑줄 친 this problem이 의미하는 것을 우리말로 쓰시오. (40자 내외)

> The Eastgate Centre is an office building and shopping complex in Harare, Zimbabwe. Built in 1996, it might not be as visually impressive as the Sagrada Familia. However, the building is an excellent example of biomimicry. Due to the hot climate of Harare, air conditioning systems

> can be very costly to install, run, and maintain. To solve <u>this problem</u>, the building's architect, Mick Pearce, turned to termite mounds for an alternative.

[8~9] 다음 글을 읽고, 물음에 답하시오.

> Termite mounds are large structures built by certain termite species. ① <u>Scientists believe that the mounds stay cool due to a constant flow of air.</u> ② <u>The mounds come in a wide variety of sizes and colors.</u> ③ <u>Each mound has a network of holes referred to as chimneys.</u> ④ <u>It has a large central chimney and smaller outer chimneys that are close to the ground.</u> ⑤ <u>The heat generated by the daily activity of the termites rises up through the central chimney, eventually escaping through the top of the mound.</u> In the meantime, cooler air is pulled in through the smaller chimneys, keeping the termites' home at a (A) comfortable / convenient temperature during the hot day.
>
> Also, the soil surrounding the mound absorbs heat in the hot daytime hours. Therefore, the temperature inside the mound does not (B) decrease / increase greatly and stays relatively cool. At night, when the outside temperature goes down, the heat is finally released. This process inspired Pearce to design an innovative climate control system.

8 윗글의 밑줄 친 ①~⑤ 중, 전체 흐름과 관계 <u>없는</u> 문장은?

① ② ③ ④ ⑤

9 (A), (B)의 각 네모 안에서 문맥에 맞는 낱말을 쓰시오.

(A) _____

(B) _____

10 다음 글의 흐름으로 보아, 주어진 문장이 들어가기에 가장 적절한 곳은?

> This air is moved through the building by a system of automatic fans.

The Eastgate Centre was constructed without a conventional cooling system. Instead, Pearce used building materials that can store large amounts of heat. (①) The floors and walls of the building absorb heat during the day, just like the soil of a termite mound. (②) The heat is released at night, and the walls cool down, ready to store heat again by the next morning. (③)

The structure of the building also helps keep the building cool. (④) There are openings near the base of the building, and outside air comes into the building through them. (⑤) Eventually, the air, along with heat generated by human activity during the day, rises upward through the building's internal open spaces and is released through chimneys on the roof.

① ② ③ ④ ⑤

[11~12] 다음 글을 읽고, 물음에 답하시오.

As a result, the building has not only cool temperatures but also fresh air. More importantly, the Eastgate Centre uses far less energy than other buildings, _____ saves money and helps protect the environment from pollution. Without the inspiration Pearce received from tiny termites, none of this would have been possible.

Using biomimicry in architecture is just one way that humans are utilizing the lessons of nature to improve the way we do things. Biomimicry is also being used to solve problems in the fields of robotics, agriculture, and many others. Imitating the ideas of nature not only

helps solve problems, but (A) it also makes us feel closer to nature. As a result, humans are more likely to stop destroying the environment and start becoming part of (B) it instead.

11 윗글의 빈칸에 들어갈 말로 가장 적절한 것은?

① who ② what
③ where ④ which
⑤ that

12 밑줄 친 (A), (B)가 가리키는 것을 윗글에서 찾아 쓰시오.

(A) _____

(B) _____

13 영화 Inside Out에 관한 다음 글의 내용과 일치하지 않는 것은?

The premiere for the movie *Inside Out* was held in New York on June 19. It is an American movie directed by Pete Docter. It is set inside the mind of a girl named Riley. Five personified emotions—Joy, Sadness, Fear, Anger, and Disgust—lead Riley through life after she moves to a new city. At the premiere, Docter said he was inspired to produce the movie by his own parenting experiences. He first began developing *Inside Out* after noticing changes in his daughter's personality as she grew older. He said, "Trying to figure out what's going on in our kids' heads is what led to this movie." People who have seen the movie say it is one of the most imaginative masterpieces they've ever seen.

① 시사회가 6월 19일 뉴욕에서 열렸다.
② Riley라는 소녀의 마음속을 배경으로 한다.
③ 5개의 의인화된 감정이 나온다.
④ 감독은 주위의 육아 경험에서 영감을 얻었다.
⑤ 사람들은 이 작품을 창의적이라고 생각한다.

1 다음 대화가 자연스럽게 이어지도록 (A)~(C)를 올바른 순서로 배열하시오.

G: What are you doing, David?
B: I'm reading an article about how the airbag was invented.
G: Sounds interesting. Can you explain it to me?
B: _____
G: _____
B: _____
G: Wow. It's surprising that he turned a bad experience into an opportunity!
B: Yes, it is. We can get ideas even from car accidents.

(A) Oh, no! They weren't hurt, were they?
(B) The airbag was invented by John Hetrick. He was inspired to invent it after crashing his car while out on a drive with his wife and daughter in 1952.
(C) Well, his daughter wasn't seriously hurt because Hetrick protected her with his arms. This scary experience inspired him to create the airbag.

_____ → _____ → _____

2 다음 대화의 빈칸 (A)~(C)에 들어갈 말로 가장 적절한 것을 〈보기〉에서 고르시오.

W: Hello, everyone. I'm at the Horizon Theater in Los Angeles. The premiere of the movie *Interstellar* is being held here. Let's hear from the director, Christopher Nolan. Nice to meet you, Mr. Nolan.
M: Nice to meet you, too. I'm happy to be here.
W: _____(A)_____
M: It is about a group of astronauts who travel through space in search of a new home for humanity. The characters discover a place that consists of five dimensions.
W: _____(B)_____
M: I was inspired by a work of art by M.C. Escher called *Relativity*. The work of art made me think of a fantasy world that could exist outside normal time and space.
W: _____(C)_____
M: Thank you.

〈보기〉

ⓐ I see. Audiences are saying it's one of the most amazing movies ever. I hope it will be a big hit.
ⓑ Please tell us what your movie is about.
ⓒ What a unique idea! How did you create the scenes?

[3~4] 다음 글을 읽고, 물음에 답하시오.

Nature is all around us. ① It impresses us with its beauty and supplies us with everything we need to survive. ② It also provides some people with the inspiration to create things in a new way. ③ To enhance creativity, people need to learn something new. ④ The act of creating things based on nature is called "biomimicry." ⑤ This term is derived from the Greek words *bios*, meaning "life," and *mimesis*, meaning "imitation."

Architects who use biomimicry look at nature as an incredibly successful engineer who has already _____ answers to some of the problems they now face. They carefully study plants, animals, and other aspects of nature to learn how they work. As a result, they have been able to find some innovative solutions to engineering and architectural challenges.

3 윗글의 밑줄 친 ①~⑤ 중, 전체 흐름과 관계 <u>없는</u> 문장은?

① ② ③ ④ ⑤

4 윗글의 빈칸에 들어갈 말로 가장 적절한 것은?

① fit in
② run out of
③ come up with
④ got tired of
⑤ put up with

[5~6] 다음 글을 읽고, 물음에 답하시오.

Gaudi believed that all architects should look to nature for inspiration. He preferred the curves found in natural objects to the straight lines found in artificial ones. (A) This preference can be seen in all his buildings, including the Sagrada Familia. Many parts of the church _____ images and forms from nature. For example, the church's spires are topped with spheres that resemble fruits. There are also turtles carved into the stone bases of columns and spiral stairs that resemble the shells of sea creatures.

5 윗글의 빈칸에 들어갈 단어를 영영 뜻풀이를 참고하여 쓰시오. (단, 주어진 글자로 시작할 것)

to include something as part of a bigger thing

i _____

6 윗글의 밑줄 친 (A) This preference가 의미하는 것을 우리말로 쓰시오. (30자 내외)

[7~8] 다음 글을 읽고, 물음에 답하시오.

Perhaps the most impressive feature of the Sagrada Familia is the ceiling. (①) Gaudi designed the columns inside the church to resemble trees and branches, so visitors who

look up can feel as if they were standing in a great forest. (②) The light that comes through the small holes all over the ceiling even resembles the light beaming through leaves in a forest. (③) These tree-like columns are not just for decoration, though. (④) Inspired by trees, Gaudi gave the columns a single base that splits off into branches near the top. (⑤) Because Gaudi recognized the superiority of natural forms, he was able to design a building that is both beautiful and functional.

7 윗글의 흐름으로 보아, 주어진 문장이 들어가기에 가장 적절한 곳은?

This allows them to support the roof better by distributing its weight evenly.

① ② ③ ④ ⑤

8 Sagrada Familia에 관한 윗글의 내용과 일치하지 <u>않는</u> 것은?

① 기둥이 나무를 닮게 디자인되었다.
② 내부에서 위를 보면 숲속에 서 있는 것처럼 느끼게 된다.
③ 천장의 구멍들 사이로 공기가 들어온다.
④ 기둥의 토대는 나뭇가지로 갈라진다.
⑤ Gaudi가 기능적으로 설계했다.

[9~10] 다음 글을 읽고, 물음에 답하시오.

The Eastgate Centre is an office building and shopping complex in Harare, Zimbabwe. ① <u>Build</u> in 1996, it might not be as visually impressive as the Sagrada Familia. However, the building is an excellent example of biomimicry. Due to the hot climate of Harare, air conditioning systems can be very costly to install, run, and maintain. To solve this problem, the building's architect, Mick Pearce, turned to termite mounds for an alternative.

Termite mounds are large structures built by certain termite species. Scientists believe that the mounds stay cool ② <u>due to</u> a constant flow of air. Each mound has a network of holes

referred to as chimneys. It has a large central chimney and smaller outer chimneys that are close to the ground. The heat generated by the daily activity of the termites ③ rises up through the central chimney, eventually escaping through the top of the mound. In the meantime, cooler air is pulled in through the smaller chimneys, keeping the termites' home at a comfortable temperature during the hot day.

Also, the soil ④ surrounding the mound absorbs heat in the hot daytime hours. Therefore, the temperature inside the mound does not increase greatly and stays relatively cool. At night, when the outside temperature goes down, the heat is finally released. This process inspired Pearce ⑤ to design an innovative climate control system.

9 윗글을 읽고 답할 수 없는 질문으로 가장 적절한 것은?

① Where is the Eastgate Centre located?
② Why can air conditioning systems in Harare be expensive to run?
③ How do termites build their mounds?
④ What absorbs heat in the hot daytime hours?
⑤ When is the heat absorbed in the hot daytime released?

10 윗글의 밑줄 친 ①~⑤ 중, 어법상 틀린 것은?

① ② ③ ④ ⑤

[11~12] 다음 글을 읽고, 물음에 답하시오.

The Eastgate Centre was constructed without a conventional cooling system. Instead, Pearce used building materials that can ① produce large amounts of heat. The floors and walls of the building absorb heat during the day, just like the soil of a termite mound. The heat is ② released at night, and the walls cool down, ready to store heat again by the next morning.

The structure of the building also (A) (building / cool / help / keep / the). There are

openings near the base of the building, and outside air ③ comes into the building through them. This air is moved through the building by a system of automatic fans. Eventually, the air, ④ along with heat generated by human activity during the day, ⑤ rises upward through the building's internal open spaces and is released through chimneys on the roof.

11 윗글의 밑줄 친 ①~⑤ 중, 문맥상 낱말의 쓰임이 적절하지 않은 것은?

① ② ③ ④ ⑤

12 윗글의 (A)에 주어진 말을 알맞게 배열하시오. (필요 시 형태를 변형할 것)

13 다음 글의 내용과 일치하지 않는 것은?

As a result, the Eastgate Centre has not only cool temperatures but also fresh air. More importantly, the Eastgate Centre uses far less energy than other buildings, which saves money and helps protect the environment from pollution. Without the inspiration Pearce received from tiny termites, none of this would have been possible.

Using biomimicry in architecture is just one way that humans are utilizing the lessons of nature to improve the way we do things. Biomimicry is also being used to solve problems in the fields of robotics, agriculture, and many others. Imitating the ideas of nature not only helps solve problems, but it also makes us feel closer to nature. As a result, humans are more likely to stop destroying the environment and start becoming part of it instead.

① Eastgate Centre의 공기는 신선하다.
② Eastgate Centre는 다른 건물보다 더 적은 에너지를 사용한다.
③ Pearce는 흰개미에게서 영감을 받았다.
④ 자연 모방은 로봇공학 분야에도 사용된다.
⑤ 자연 모방으로 환경이 파괴될 수 있다.

정답 및 해설 p.38

1 다음 대화의 빈칸에 들어갈 말로 가장 적절한 것은?

> G: Jinho, look at my new sneakers!
> B: Wow, they have Velcro on them! That must be convenient.
> G: Yeah, it is. Did you know that Velcro was inspired by nature?
> B: What do you mean?
> G: In the 1940s, a Swiss engineer went for a walk to the woods with his dog. Afterwards, he noticed burrs clinging to his clothes and the dog's fur. He studied the burrs and discovered that tiny hooks enabled them to grab onto clothes. He then used this knowledge to invent Velcro.
> B: It's surprising _____!

① why he named it Velcro
② that pets can help people a lot
③ that people have damaged nature
④ that people can find useful ideas from nature
⑤ why burrs clung to his clothes and the dog's fur

[2~3] 다음 글을 읽고, 물음에 답하시오.

> Nature is all around us. It impresses us with its beauty and supplies us __(A)__ everything we need ⓐ to survive. It also provides some people __(B)__ the inspiration ⓑ to create things in a new way. The act of creating things based on nature is called "biomimicry." This term is derived __(C)__ the Greek words *bios*, meaning "life," and *mimesis*, meaning "imitation."
> Architects who use biomimicry look at nature as an incredibly successful engineer who has already come up with answers ⓒ to some of the problems they now face. They carefully study plants, animals, and other aspects of nature ⓓ to learn how they work. As a result, they have been able to find some innovative solutions ⓔ to engineering and architectural challenges.

2 윗글의 빈칸 (A)~(C)에 들어갈 전치사를 쓰시오.

(A) _____

(B) _____

(C) _____

3 윗글의 밑줄 친 ⓐ~ⓔ 중, 쓰임이 같은 것끼리 바르게 묶인 것은?

① ⓐ, ⓒ ② ⓑ, ⓔ ③ ⓑ, ⓒ
④ ⓒ, ⓔ ⑤ ⓓ, ⓔ

4 Sagrada Familia에 관한 다음 글의 내용과 일치하지 않는 것은?

> Gaudi believed that all architects should look to nature for inspiration. He preferred the curves found in natural objects to the straight lines found in artificial ones. This preference can be seen in all his buildings, including the Sagrada Familia. Many parts of the church incorporate images and forms from nature. For example, the church's spires are topped with spheres that resemble fruits. There are also turtles carved into the stone bases of columns and spiral stairs that resemble the shells of sea creatures.

① 선에 대한 가우디의 선호가 드러나 있다.
② 자연에서 온 형태를 포함하고 있다.
③ 첨탑의 구는 과일을 닮았다.
④ 거북이가 새겨진 초석이 있다.
⑤ 바다 생물의 껍데기를 닮은 직선 계단이 있다.

Perhaps the most impressive feature of the Sagrada Familia is the ceiling. Gaudi designed the columns inside the church to resemble trees and branches, so visitors ___ⓐ___ look up can feel as if they were standing in a great forest. The light ___ⓑ___ comes through the small holes all over the ceiling even resembles the light beaming through leaves in a forest. These tree-like columns are not just for decoration, though. Inspired by trees, Gaudi gave the columns a single base ___ⓒ___ splits off into branches near the top. 이것은 그 무게가 균등하게 나누어지도록 해서 그것들이 지붕을 더 잘 지탱하도록 해 준다. Because Gaudi recognized the superiority of natural forms, he was able to design a building ___ⓓ___ is both beautiful and functional.

5 윗글의 밑줄 친 ⓐ~ⓓ에 공통으로 들어가는 단어를 쓰시오.

6 윗글의 밑줄 친 우리말과 일치하도록 주어진 단어를 이용하여 문장을 완성하시오. (필요 시 형태를 변형할 것)

better by distributing its weight evenly.

(this, allow, support)

[7~8] 다음 글을 읽고, 물음에 답하시오.

The Eastgate Centre is an office building and shopping complex in Harare, Zimbabwe.

(A) To solve this problem, the building's architect, Mick Pearce, turned to termite mounds for an alternative.
(B) Built in 1996, it might not be as visually impressive as the Sagrada Familia.

(C) However, the building is an excellent example of biomimicry. Due to the hot climate of Harare, air conditioning systems can be very costly to install, run, and maintain.

7 주어진 문장 다음에 이어질 글의 순서로 가장 적절한 것은?

① (A) – (B) – (C) ② (B) – (A) – (C)
③ (B) – (C) – (A) ④ (C) – (A) – (B)
⑤ (C) – (B) – (A)

8 다음 영영 뜻풀이에 해당하는 단어를 윗글에서 찾아 쓰시오.

to put something in a place and make it ready to use

9 다음 글의 주제로 가장 적절한 것은?

Termite mounds are large structures built by certain termite species. Scientists believe that the mounds stay cool due to a constant flow of air. Each mound has a network of holes referred to as chimneys. It has a large central chimney and smaller outer chimneys that are close to the ground. The heat generated by the daily activity of the termites rises up through the central chimney, eventually escaping through the top of the mound. In the meantime, cooler air is pulled in through the smaller chimneys, keeping the termites' home at a comfortable temperature during the hot day.

① how termites keep their body heat
② why hot air is lighter than cold air
③ why people should protect termites
④ how a termite mound controls its temperature
⑤ what scientists did to make the termite mound cool

The Eastgate Centre was constructed without a conventional cooling system. Instead, Pearce used building materials that can store large amounts of heat. The floors and walls of the building absorb heat during the day, just like the soil of a termite mound. The heat is released at night, and the walls cool down, ready to store heat again by the next morning.

The structure of the building also helps keep the building cool. There are openings near the base of the building, and outside air comes into the building through (A) them. This air is moved through the building by a system of automatic fans. Eventually, the air, along with heat generated by human activity during the day, rises upward through the building's internal open spaces and is released through chimneys on the roof.

10 윗글의 내용을 한 문장으로 요약할 때, 빈칸에 들어갈 단어를 찾아 쓰시오.

Without a typical cooling system, the Eastgate Centre was designed to keep the internal air _____.

11 윗글의 밑줄 친 (A) them이 가리키는 것은?

① openings
② automatic fans
③ human activities
④ internal open spaces
⑤ chimneys

12 다음 글의 밑줄 친 우리말과 일치하도록 〈보기〉에 주어진 단어를 배열하여 문장을 완성하시오.

As a result, the building has not only cool temperatures but also fresh air. More importantly, the Eastgate Centre uses far less energy than other buildings, which saves money and helps protect the environment from pollution. Without the inspiration Pearce received from tiny termites, 이 어떤 것도 가능하지 않았을 것이다.

〈보기〉 been / have / none / of / possible / would / this

13 다음 글의 ①~⑤ 중, 전체 흐름과 관계 없는 문장은?

① Using biomimicry in architecture is just one way that humans are utilizing the lessons of nature to improve the way we do things. ② Biomimicry is also being used to solve problems in the fields of robotics, agriculture, and many others. ③ The first step in solving a problem is correctly identifying it. ④ Imitating the ideas of nature not only helps solve problems, but it also makes us feel closer to nature. ⑤ As a result, humans are more likely to stop destroying the environment and start becoming part of it instead.

①　　②　　③　　④　　⑤

14 다음 글의 밑줄 친 두 문장을 관계대명사의 계속적 용법을 이용하여 한 문장으로 바꾸시오.

One day, a girl was playing in the park. She saw a photograph on the ground and picked it up. She saw a cute boy in the photograph. This made her cheeks turn red. She took the photograph home and put it in a box. Eventually, she forgot about it. Twenty years later, she got married. One day, her husband opened the box and found the photograph. He asked, "Who is the little boy in this picture?" She answered that it was her first love. This made her husband smile. He said, "I lost this photograph when I was nine years old."

1 밑줄 친 (A), (B)가 가리키는 것을 다음 글에서 찾아 쓰시오.

Architects who use biomimicry look at nature as an incredibly successful engineer who has already come up with answers to some of the problems they now face. (A) They carefully study plants, animals, and other aspects of nature to learn how (B) they work. As a result, they have been able to find some innovative solutions to engineering and architectural challenges.

(A) _____

(B) _____

2 다음 글의 밑줄 친 ⓐ~ⓔ 중, 어법상 **틀린** 것을 2개 골라 바르게 고치시오. (단, 기호, 틀린 것, 고친 것이 모두 맞을 때만 정답으로 인정함)

The Sagrada Familia is an enormous church in Barcelona, Spain. ⓐ Designed by the world-famous architect Antoni Gaudi, the church is one of the most prominent building in the world. Construction of this remarkable building began in 1882, and Gaudi took over responsibility for its design in 1883. Believe it or not, the building is still under construction. ⓑ Some people love the Sagrada Familia and others hate it, but nearly everyone is fascinated by its unique design.

Gaudi believed that all architects should look to nature for inspiration. ⓒ He preferred the curves finding in natural objects to the straight lines found in artificial ones. This preference can be seen in all his buildings, including the Sagrada Familia. Many parts of the church incorporate images and forms from nature. ⓓ For example, the church's spires are topped with spheres that resemble fruits. ⓔ There are also turtles carved into the stone bases of columns and spiral stairs that resemble the shells of sea creatures.

	기호	틀린 것 (틀린 부분만 쓸 것)	고친 것
(1)			
(2)			

[3~4] 다음 글을 읽고, 물음에 답하시오.

Perhaps the most impressive feature of the Sagrada Familia is the ceiling. Gaudi designed the columns inside the church to resemble trees and branches, so visitors who look up can feel as if they were standing in a great forest. The light that comes through the small holes all over the ceiling even resembles the light

beaming through leaves in a forest. These tree-like columns are not just for decoration, though. Inspired by trees, Gaudi gave the columns a single base that splits off into branches near the top. This allows them to support the roof better 그것의 무게를 균등하게 나눔으로써. Because Gaudi recognized the superiority of natural forms, he was able to design a building that is both beautiful and functional.

3 윗글의 밑줄 친 우리말과 일치하도록 주어진 단어를 이용하여 문장을 완성하시오. (필요 시 형태를 변형할 것)

_____ evenly

(distribute, weight)

4 Sagrada Familia의 천장을 올려다보는 관람객들이 어떻게 느낄 수 있는지 우리말로 쓰시오. (20자 내외)

[5~6] 다음 글을 읽고, 물음에 답하시오.

Termite mounds are large structures ⓐ built by certain termite species. Scientists believe that the mounds stay cool due to a constant flow of air. Each mound has a network of holes ⓑ referred to as chimneys. It has a large central chimney and smaller outer chimneys ⓒ where are close to the ground. The heat generated by the daily activity of the termites rises up through the central chimney, eventually escaping through the top of the mound. In the meantime, cooler air is pulled in through the smaller chimneys, keeping the termites' home at a comfortable temperature during the hot day.

Also, the soil surrounding the mound absorbs heat in the hot daytime hours. Therefore, the temperature inside the mound does not increase greatly and ⓓ stays relatively cool. At night, when the outside temperature goes down, the heat is finally released. This process inspired Pearce ⓔ designing an innovative climate control system.

5 흰개미집에서 공기가 순환하는 과정을 다음과 같이 정리할 때, 빈칸에 들어갈 내용을 우리말로 쓰시오. (15자 내외)

흰개미의 일상 활동으로 열이 발생함 → 열이 중앙 굴뚝을 통해 위로 올라감 → _____ → 그러는 사이에, 더 시원한 공기가 작은 굴뚝을 통해 들어옴

6 윗글의 밑줄 친 ⓐ~ⓔ 중, 어법상 틀린 것을 2개 찾아 바르게 고치고, 수정해야 하는 이유를 쓰시오. (단, 기호, 고친 것, 이유가 모두 맞을 때만 정답으로 인정함)

	기호	고친 것	이유
(1)			
(2)			

The Eastgate Centre was constructed without a conventional cooling system. Instead, Pearce used building materials that can store large amounts of heat. The floors and walls of the building absorb heat during the day, just like the soil of a termite mound. The heat is released at night, and the walls cool down, ready to store heat again by the next morning.

The structure of the building also helps keep the building cool. There are openings near the base of the building, and outside air comes into the building through them. This air is moved through the building by a system of _____ fans. Eventually, the air, along with heat generated by human activity during the day, rises upward through the building's internal open spaces and is released through chimneys on the roof.

As a result, the building has not only cool temperatures but also fresh air. More importantly, the Eastgate Centre uses far less energy than other buildings. This saves money and helps protect the environment from pollution. Without the inspiration Pearce received from tiny termites, none of this would have been possible.

7 윗글의 빈칸에 들어갈 단어를 영영 뜻풀이를 참고하여 쓰시오. (단, 주어진 글자로 시작할 것)

happening or functioning without commands or help from people

a_____

8 윗글의 밑줄 친 두 문장을 관계대명사의 계속적 용법을 이용하여 한 문장으로 바꾸시오.

9 다음 두 문장의 참(True)과 거짓(False)를 구분하고, 거짓인 경우에는 그 근거를 우리말로 쓰시오.

(1) The soil of a termite mound absorbs heat during the day.

(2) The heat generated by human activity goes down and finally escapes through open spaces.

번호	True / False	근거
(1)		
(2)		

10 밑줄 친 Biomimicry의 뜻을 다음 글에서 찾아 쓰시오.

Biomimicry is also being used to solve problems in the fields of robotics, agriculture, and many others. Imitating the ideas of nature not only helps solve problems, but it also makes us feel closer to nature. As a result, humans are more likely to stop destroying the environment and start becoming part of it instead.

Special Lesson

Coach Carter

Words

- [] lack 동 ~이 없다, 부족하다
- [] respect 명 존경, 존중
- [] ignore 동 무시하다 (= neglect)
- [] toss 동 (가볍게) 던지다
- [] term 명 용어; (지급·계약 등의) 조건, 조항
- [] abuse 동 남용[오용]하다
- [] contract 명 계약(서)
- [] honor 동 (약속 등을) 지키다, 이행하다
- [] state 동 명시하다
- [] attend 동 참석하다
- [] maintain 동 유지하다
- [] grade point average(GPA) 평균 평점
- [] treat 동 대하다, 다루다
 - treatment 명 치료; 대우
- [] bounce 동 (공을) 튀기다
- [] quit 동 (직장·학교 등을) 그만두다
- [] rejoin 동 다시 합류하다
- [] lap 명 (트랙의) 한 바퀴
- [] struggle 동 고투하다, 힘겹게 나아가다
- [] triumph 동 승리를 거두다, 이기다
- [] impress 동 감명[감동]을 주다

- [] undefeated 형 (스포츠에서) 무패의
 - defeat 동 패배시키다
- [] tournament 명 대회, 경기
- [] discover 동 발견하다, 알아내다
- [] skip 동 거르다, 빼먹다
- [] cancel 동 취소하다
- [] academic 형 학업의, 학교의
- [] progress 명 진전, 진척
- [] satisfy 동 만족[충족]시키다
 - satisfaction 명 만족
- [] athlete 명 (운동)선수
- [] neglect 동 (돌보지 않고) 방치하다
- [] realize 동 깨닫다
- [] school board 학교운영위원회
- [] confront 동 맞서다, 직면하다 (= face)
- [] chairman 명 의장, 회장
- [] discipline 명 규율, 훈육
- [] vote 동 투표하다
- [] resign 동 사직[사임]하다, 물러나다
 - resignation 명 사직, 사임
- [] fulfill 동 실행하다, 준수하다
- [] compete 동 (시합 등에) 참가하다

Phrases

- [] drop out 중퇴하다
- [] end up 결국 ~한 처지가 되다
- [] blame ~ for ... …에 대해 ~을 탓하다

- [] adjust to ~에 적응하다 (= adapt to)
- [] graduate from ~을 졸업하다

Vocabulary Check-Up

정답 및 해설 p.40

다음 영어는 우리말로, 우리말은 영어로 쓰시오.

01 compete	동 _____	23 동 사직[사임]하다, 물러나다	_____
02 fulfill	동 _____	24 동 투표하다	_____
03 chairman	명 _____	25 명 규율, 훈육	_____
04 school board	_____	26 명 계약(서)	_____
05 neglect	동 _____	27 명 (운동)선수	_____
06 tournament	명 _____	28 동 감명[감동]을 주다	_____
07 undefeated	형 _____	29 명 진전, 진척	_____
08 end up	_____	30 ~에 적응하다	_____
09 triumph	동 _____	31 형 학업의, 학교의	_____
10 lap	명 _____	32 동 취소하다	_____
11 rejoin	동 _____	33 …에 대해 ~을 탓하다	_____
12 grade point average	_____	34 동 거르다, 빼먹다	_____
13 drop out	_____	35 동 (직장·학교 등을) 그만두다	_____
14 state	동 _____	36 ~을 졸업하다	_____
15 honor	동 _____	37 동 맞서다, 직면하다	_____
16 toss	동 _____	38 동 남용[오용]하다	_____
17 lack	동 _____	39 동 무시하다	_____
18 realize	동 _____	40 동 (공을) 튀기다	_____
19 term	명 _____	41 동 만족[충족]시키다	_____
20 maintain	동 _____	42 동 발견하다, 알아내다	_____
21 treat	동 _____	43 동 참석하다	_____
22 struggle	동 _____	44 명 존경, 존중	_____

Coach Carter

01 Coach Ken Carter takes over the head coaching job for the Richmond High School basketball
맡다, 이어받다
team. The school is located in a poor neighborhood.
~에 위치하다

Ken Carter 코치는 리치먼드 고등학교의 농구 팀에서 수석 코치직을 맡게 된다. 이 학교는 가난한 지역에 있다.

02 Many students at the school drop out and end up living difficult lives.
중퇴하다 end up v-ing: 결국 ~한 처지가 되다

이 학교의 많은 학생들은 중퇴를 하고 결국 어려운 삶을 살게 된다.

03 The team has had a losing record for several years, and the team members keep blaming each
현재완료 수년 간 keep v-ing: 계속해서 ~하다
other for losing.

그 팀은 지난 몇 년 동안 패배한 기록을 갖고 있으며, 팀원들은 (경기에서) 지는 것에 대해 계속해서 서로를 탓한다.

04 Carter finds out [that their problem is not [how they play basketball], but [that they lack
 명사절 명사절
 명사절 (finds out의 목적어) └── not A but B: A가 아니라 B ──┘
respect for themselves]]. He comes up with an idea.
 생각해내다

Carter는 그들의 문제가 이들이 농구를 하는 방식이 아니라 그들 자신에 대한 존중이 부족하다는 점에 있다는 것을 알게 된다. 그는 아이디어 하나를 생각해낸다.

05 Carter: Good afternoon, gentlemen. I'm your new basketball coach, Ken Carter. (*The players
 └────────── = ──────────┘
ignore him and chat with each other.*) Maybe I should speak louder. I'm Ken Carter, your new
= Carter └────── = ──────┘
basketball coach.

Carter: 안녕하세요, 여러분. 나는 여러분의 새로운 농구 코치, Ken Carter이다. (선수들은 그를 무시하고 서로 잡담을 나눈다.) 더 크게 말해야겠군. 나는 여러분의 새로운 농구 코치 Ken Carter이다.

06 one of+복수명사: ~ 중의 하나
(*One of the players tosses a ball to another player, ignoring Coach Carter.*) You, what's your
주어 (단수) 동사 분사구문 〈동시동작〉
name, sir?

(선수들 중 한 명이 Carter 코치를 무시한 채 다른 선수에게 공을 던진다.) 거기, 자네는 이름이 뭐지?

07 Lyle: Jason Lyle, but I'm not a sir. Carter: Starting today, you are a sir. You all are. "Sir" is a

term of respect. All of you will have my respect until you abuse it.
용어 ~까지 = my respect

Lyle: Jason Lyle이요. 하지만 저는 자네가 아닌데요. Carter: 오늘부터 너는 'sir(자네)'이다. 여러분 모두가 마찬가지이다. '자네'는 존중의 용어이다. 여러분 모두는 그것(나의 존중)을 악용하기 전까지는 나의 존중을 받을 것이다.

8 (*He gives out some pieces of paper.*) These are contracts. If you sign and honor this, we'll be
piece of+셀 수 없는 명사 지키다, 이행하다
successful.

(그는 종이 몇 장을 나눠 준다.) 이것들은 계약서이다. 이것에 서명하고 이행한다면, 우리는 성공할 것이다.

9
명사절 (states의 목적어)
It states [that you will attend all of your classes and maintain a 2.3 grade point average].
주어 동사1 will 동사2

여기에는 여러분이 모든 수업에 출석할 것과 평균 2.3학점을 유지할 것이 명시되어 있다.

10 Cruz: This is crazy! By the way, why are you wearing a suit and tie? Carter: What's your name,
그런데
sir? Cruz: Timo Cruz, sir.

Cruz: 이건 말도 안 돼! 그나저나, 코치님은 왜 양복을 입고 넥타이를 매고 있는 거죠? Carter: 자네는 이름이 뭐지?
Cruz: Timo Cruz요, 코치님.

11 Carter: Well, Mr. Cruz, when we treat ourselves with respect ... (*Cruz does not listen and starts*
재귀대명사
[*bouncing the ball*].) All right, Mr. Cruz, leave the gym right now.
동명사구 (starts의 목적어)

Carter: 음, Cruz군, 우리가 우리 자신을 존중하며 대할 때 … (Cruz는 듣지 않고 공을 튕기기 시작한다.) Carter: 그래,
Cruz군, 지금 당장 체육관에서 나가 주게.

12 Cruz: Fine. I don't need to listen to you anymore. I quit. (*He walks out of the gym.*)
need to-v: ~할 필요가 있다

Cruz: 좋아요. 전 코치님 얘기를 더는 들을 필요가 없어요. 제가 그만두죠. (그는 체육관 밖으로 걸어 나간다.)

13 Carter: Is there anybody else [who doesn't want to sign this contract]?
주격 관계대명사절

Carter: 이 계약서에 서명하고 싶지 않은 사람이 더 있는가?

14 (*Students look at each other. Two more students leave the gym and the others stay.*)
= the other students

(학생들은 서로를 쳐다본다. 두 명의 학생이 추가로 체육관을 떠나고 나머지 학생들은 남는다.)

15 Carter teaches the players to stay focused and play together as a team.
to
teach+목적어+to-v: ~에게 …하는 것을 가르치다

Carter는 선수들에게 집중할 것과 한 팀으로서 경기할 것을 가르친다.

16 Cruz realizes [how tough life is off the court] and [how much basketball means to him].
간접의문문 (목적어 1) 간접의문문 (목적어 2)

Cruz는 경기장 밖의 삶이 얼마나 힘든지를, 그리고 농구가 그에게 얼마나 큰 의미가 있는 것인지를 깨닫는다.

17 Later, the team wins an inspiring victory while Cruz watches from the crowd. Eventually, he
현재분사 ⌞____↑ ~하는 동안

decides [to come back].
명사적 용법 (decides의 목적어)

이후에 Cruz가 관중들 사이에서 (경기를) 지켜보는 가운데, 팀은 감동적인 승리를 거두게 된다. 결국, 그는 돌아가기로 마음 먹는다.

18 (*Cruz comes into the gym.*) Cruz: How can I get back on the team? Carter: If you want to rejoin
돌아오다 다시 합류하다

the team, you need to do 1,000 push-ups and 1,000 laps around the gym—by Friday. Other
~까지

players: That's impossible!
대명사

(Cruz가 체육관 안으로 들어선다.) Cruz: 어떻게 하면 제가 팀에 돌아올 수 있나요? Carter: 팀에 다시 합류하기를 원한다 면, 자네는 1,000개의 팔굽혀펴기를 하고 체육관 1,000바퀴를 뛰어야 한다. 금요일까지. 다른 선수들: 그건 불가능해요!

19 ⌜ 동명사, to부정사 둘 다 목적어로 취하는 동사 ⌝
(*Cruz starts doing push-ups. Carter continues coaching.*)
동명사구 (starts의 목적어) 동명사 (continues의 목적어)

(Cruz는 팔굽혀펴기를 하기 시작한다. Carter는 계속해서 (다른 선수들을) 지도한다.)

20 (*On Friday*) Carter: It's Friday, but you still have 100 push-ups and 100 laps to go.
 ↑__| 형용사적 용법

It's time to give up, Mr. Cruz.
It's time to-v: ~할 때이다

(금요일) Carter: 금요일인데, 자네는 아직 팔굽혀펴기 100개와 100바퀴 뛰는 것이 남았군. 이제 포기할 시간이다, Cruz군.

21 Lyle: I'll do them for him, Coach. You said [we're a team]. When one person struggles, we all
 = 100 push-ups and 100 laps that
 명사절 (said의 목적어)

struggle. When one player triumphs, we all triumph, right?

Lyle: 코치님, 제가 그를 위해 그것들을 하겠습니다. 코치님이 우리는 한 팀이라고 하셨죠. 한 사람이 힘들어 하면 우리 모두 가 힘들다고요. 한 사람이 승리하면 우리 모두가 승리한 거고요. 맞죠?

22 Kenyon: I'll do some, too. Come on, guys, let's help him out! (*Other players do push-ups*
 = Cruz

together with Cruz. Carter seems impressed.)
 seem+형용사(보어): ~인 것처럼 보이다

Kenyon: 저도 조금 하겠습니다. 애들아, 우리 같이 Cruz를 도와주자! (다른 선수들도 Cruz와 함께 팔굽혀펴기를 한다. Carter는 감명받은 듯 보인다.)

23 being
With Cruz back on the team, they go undefeated for the rest of the season, and they even win a
with+목적어+분사: ~가 …하면서 무패의
big tournament.

Cruz가 팀에 복귀하며, 그들은 남은 시즌 동안 무패를 이어나가고, 심지어 큰 대회에서도 우승한다.

24 However, Carter later discovers [that some of the students have been skipping classes and
have been
getting failing grades]. He decides [to do something].

명사절 (discovers의 목적어) 현재완료 진행형
명사적 용법 (decides의 목적어)

하지만 Carter는 몇몇 학생들이 수업을 빼먹으며 낙제 점수를 받고 있다는 사실을 나중에 알게 된다. 그는 무언가를 하기로 결심한다.

25 (*In front of the gym door*) Kenyon: What's up, Cruz? Cruz: I don't know. This note says

[that practice has been canceled and the coach is waiting in the school library].
명사절 (says의 목적어) 현재완료 수동태

(체육관 문 앞에서) Kenyon: 무슨 일이야, Cruz? Cruz: 모르겠어. 이 쪽지에 연습이 취소되었고 코치님이 학교 도서관에서 기다리고 있다고 쓰여 있어.

26 Kenyon: The library? I don't even know [where the library is]!
간접의문문 (「의문사 + 주어 + 동사」의 어순)

Kenyon: 도서관? 난 도서관이 어디 있는지도 모르는데!

27 (*In the school library*) Carter: Gentlemen, in this hand, I have the contracts [you signed].
which[that]
목적격 관계대명사절

(도서관에서) Carter: 여러분, 이쪽 손에는, 여러분이 서명한 계약서가 있다.

28 In this hand, I have academic progress reports from your teachers. The gym will stay locked
학업 성취 보고서 stay + 형용사: ~한 상태를 유지하다
until we all satisfy the terms of this contract.
만족시키다 조건

이쪽 손에는, 여러분의 선생님들로부터 받은 학업 성취 보고서가 있다. 체육관은 우리 모두가 이 계약서의 조건을 충족시킬 때까지 잠겨 있을 것이다.

29 Cruz: But why? We're undefeated, and we won the tournament. Didn't you want us to win?
want + 목적어 + to-v: ~가 …하기를 원하다

Cruz: 하지만 왜요? 우리는 (경기에서) 진 적이 없고 대회에서 우승까지 했잖아요. 코치님은 우리가 이기기를 바란 것 아니었나요?

30 Carter: That's not the point. [What's more important than winning] is [respecting the rules]
관계대명사
주어 동사 동명사구 (보어 1)
and [taking responsibility for your behavior].
동명사구 (보어 2)

Carter: 그게 중요한 게 아니다. 이기는 것보다 더 중요한 것은 규칙을 존중하고 여러분의 행동에 책임을 지는 것이다.

31 If you don't realize that, you'll never succeed or even adjust to the real world.
~에 적응하다

만약 여러분이 그것을 깨닫지 못한다면, 여러분은 결코 성공하지 못할 것이며 현실 사회에서 적응조차 하지 못할 것이다.

32 I believe [honoring this contract is the first step for you [to take responsibility in your life]].
명사절 (believe의 목적어) to부정사의 의미상의 주어
접속사 that 주어 (동명사구) 동사 형용사적 용법

나는 이 계약을 준수하는 것이 여러분이 자신의 인생에서 책임을 지는 첫 단계라고 생각한다.

33 Now, I want you to go home, look at your lives tonight, and ask yourself, "Do I want a better life?"
to ——— 병렬구조 ——— *to*

이제 집에 가서 오늘 밤 여러분의 삶을 돌아보고 스스로에게 물어봐라. '나는 더 나은 삶을 원하는가?'

34 If the answer is yes, then I promise you [I will do everything in my power to get you to a better
접속사 that
명사절 (promise의 직접목적어) 부사적 용법 〈목적〉

life]. (*The athletes are deep in thought.*)

만약 그 대답이 '그렇다'라면, 그럼 내가 여러분에게 약속하건대, 나는 여러분이 더 나은 삶을 살 수 있도록 내 힘이 닿는 한 모든 것을 할 것이다. (선수들은 깊이 생각에 잠긴다.)

35 (*In Carter's office*) Principal: You locked the gym? Are you crazy? Carter: Nobody expects

them to go to college, Ms. Garrison. Nobody even expects them to graduate from high school.
——— expect + 목적어 + to-v: ~가 …하기를 기대하다 ———

(Carter의 사무실에서) 교장: 선생님이 체육관을 잠갔다고요? 제정신입니까? Carter: Garrison 선생님, 아무도 그들이 대학에 갈 거라고 기대하지 않습니다. 심지어 아무도 그들이 고등학교를 졸업할 거라고 기대하지도 않아요.

36 stop v-ing: ~하는 것을 멈추다 명사절 (realize의 목적어)
We need to stop neglecting them and make them realize [that they can do more].
to make + 목적어 + 동사원형: ~가 … 하게 하다

우리는 그들을 방치하는 것을 멈추고 그들이 더 해낼 수 있다는 것을 깨닫게 해 줄 필요가 있어요.

37 Principal: So you take away the one thing [that they're good at]? We both know [that for some
↑———— 목적격 관계대명사절 명사절 (know의 목적어)

of these boys, this basketball season will be the best part of their lives].

교장: 그래서 그들이 잘하는 유일한 것을 빼앗아 버린다고요? 이 아이들 중 몇몇에게 있어서는, 이번 농구 시즌이 그들 인생의 정점이 되리라는 것을 우리 둘 다 알고 있잖아요.

38 접속사 that
Carter: Don't you think [that's the problem]?
주어 (대명사)

Carter: 그게 바로 문제라는 생각이 들지 않습니까?

39 The coach's act angers the parents [who expected the team to keep winning]. Eventually, the
↑———— 주격 관계대명사절 keep v-ing: 계속해서 ~하다

school board confronts Carter.
맞서다, 직면하다

코치의 행동은 팀이 계속해서 이기기를 기대했던 학부모들을 화나게 한다. 결국, 학교운영위원회가 Carter와 대립하게 된다.

40 *that* 「allow + 목적어 + to-v」 → 수동태 「be allowed to-v」
Parent 1: Basketball is all [these boys have]. Should Carter be allowed to take that away from
목적격 관계대명사절 = basketball

them? Other parents: (*shouting*) No! Board Chairman: Quiet! Let's hear from Coach Carter.

학부모 1: 농구는 이 아이들이 가진 전부입니다. Carter 씨가 그들에게서 농구를 빼앗도록 두어도 되는 것입니까?
다른 학부모들: (소리 지르며) 안 됩니다! 학교운영위원장: 조용히 하세요! Carter 코치의 말을 듣겠습니다.

41

Carter: You really need to consider the message [that you're sending these boys]: [that they are 　　　　　　　　　　　　　　　　　　　　　　목적격 관계대명사절　　　　　　　　　　　　　　　　　=　　　　　　　　　　　　　　　동격의 명사절

above the law]. I'm trying to teach them discipline.
　　　　　　　　　try to-v: ~하려고 애쓰다

Carter: 여러분이 이 아이들에게 보내는 메시지에 대해 정말로 심사숙고해 봐야 합니다. 그들이 법 위에 있다는 메시지 말입니다. 저는 이 아이들에게 규율을 가르치려고 합니다.

42

If these kids don't honor a simple contract, it won't be long before they're out there in society
　　　　　　　　　　　　　　　　　　　　　　　　　　　머지않아 ~할 것이다

[breaking laws].
분사구문 〈동시동작〉

만약 이 아이들이 간단한 계약조차 지키지 못한다면, 머지않아 아이들은 (학교) 바깥세상 속에서 법을 어기게 될 것입니다.

43

Despite Carter's speech, the board votes to unlock the gym.
~에도 불구하고 (전치사)　　　　　　　　　　　　　vote to-v: ~하기로 투표로 결정하다

Carter의 연설에도 불구하고, 운영위원회는 투표를 하여 체육관을 개방하기로 결정한다.

44

Carter is about to resign, but he decides to visit the gym one last time. There, he sees something
　　　be about to-v: 막 ~하려던 참이다

shocking. All the players are studying together.
-thing으로 끝나는 대명사: 형용사가 뒤에서 수식

Carter는 사직하려고 하지만, 마지막으로 체육관을 한 번 가 보기로 한다. 그곳에서, 그는 놀라운 것을 보게 된다. 모든 선수들이 함께 공부를 하고 있는 것이다.

45

Cruz: Sir, they can open the doors of the gym, but they can't make us play. We're going to
　　　　　　　　　　　　　　　　　　　　　　　　　　make+목적어+동사원형: ~가 …하게 하다

fulfill the contract, sir. Now we know [what's important in life], and it's all because of you.
　　　　　　　　　　　　　　　　　명사절 (know의 목적어)　　　　　　　　　　　　　　~ 때문에, 덕분에
　　(= owing to)

Thank you, sir.

Cruz: 코치님, 그들이 체육관 문을 열 수는 있지만, 우리가 농구를 하게 만들 수는 없습니다. 코치님, 우리는 계약을 이행하겠습니다. 이제 우리는 인생에서 중요한 것을 알았습니다. 그리고 그것은 모두 코치님 덕분입니다. 감사합니다, 코치님.

46

Carter: Gentlemen, there's only one way to say this: We've achieved our goal.
　　　　　　　　　　　　　　　　　　　형용사적 용법　　　　현재완료

Carter: 여러분, 이것을 표현할 길은 하나밖에 없는 것 같군. 우리는 우리의 목표를 달성한 거야.

47

The team members study hard and raise their grades enough to fulfill the contract. Later, the
　　　　　　　주어　　　동사1　　　　　　동사2　　　　　　　enough to-v: ~할 만큼 (충분히)

team competes in the state basketball tournament.

팀원들은 열심히 공부해서 계약을 이행할 수 있을 만큼 충분히 학점을 높인다. 이후에, 팀은 주(州) 농구 대회에 출전한다.

48

The players fail to win the final, but they achieve something far more important: [belief in
　　　　　　　fail to-v: ~하지 못하다　　　　　　　　　　　　　　　　　　　비교급 강조

themselves], as well as [hope for a brighter future in life beyond the basketball court].
　　　A as well as B: B뿐만 아니라 A도

선수들은 결승전에서 지지만 훨씬 더 중요한 무언가를 얻게 된다. 그것은 농구 경기장 밖의 삶에 있어 더 밝은 미래에 대한 희망뿐만 아니라 그들 자신에 대한 믿음이었다.

다음 빈칸을 채우시오.

Coach Ken Carter (1) _____ _____ the head coaching job for the Richmond High School basketball team. The school (2) _____ _____ in a poor neighborhood.

Ken Carter 코치는 리치먼드 고등학교의 농구 팀에서 수석 코치직을 맡게 된다. 이 학교는 가난한 지역에 있다.

Many students at the school drop out and (3) _____ _____ _____ difficult lives.

이 학교의 많은 학생들은 중퇴를 하고 결국 어려운 삶을 살게 된다.

The team has had a losing record for several years, and the team members (4) _____ _____ _____ _____ for losing.

그 팀은 지난 몇 년 동안 패배한 기록을 갖고 있으며, 팀원들은 (경기에서) 지는 것에 대해 계속해서 서로를 탓한다.

Carter finds out that their problem is not how they play basketball, (5) _____ _____ _____ _____ respect for themselves. He (6) _____ _____ _____ an idea.

Carter는 그들의 문제가 이들이 농구를 하는 방식이 아니라 그들 자신에 대한 존중이 부족하다는 점에 있다는 것을 알게 된다. 그는 아이디어 하나를 생각해낸다.

Carter: Good afternoon, gentlemen. I'm your new basketball coach, Ken Carter. (The players (7) _____ _____ and chat with each other.) Maybe I (8) _____ _____ _____. I'm Ken Carter, your new basketball coach. ((9) _____ _____ _____ _____ tosses a ball to another player, ignoring Coach Carter.)

Carter: 안녕하세요, 여러분. 나는 여러분의 새로운 농구 코치, Ken Carter이다. (선수들은 그를 무시하고 서로 잡담을 나눈다.) 더 크게 말해야겠군. 나는 여러분의 새로운 농구 코치 Ken Carter이다. (선수들 중 한 명이 Carter 코치를 무시한 채 다른 선수에게 공을 던진다.)

Carter: You, what's your name, sir? Lyle: Jason Lyle, but I'm not a sir.

Carter: 거기, 자네는 이름이 뭐지? Lyle: Jason Lyle이요. 하지만 저는 자네가 아닌데요.

Carter: Starting today, you are a sir. You all are. "Sir" is (10) _____ _____ _____ _____. (11) _____ _____ _____ _____ _____ _____ _____ until you abuse it. (He (12) _____ _____ some pieces of paper.)

Carter: 오늘부터 너는 'sir(자네)'이다. 여러분 모두가 마찬가지이다. '자네'는 존중의 용어다. 여러분 모두는 그것(나의 존중)을 악용하기 전까지는 나의 존중을 받을 것이다. (그는 종이 몇 장을 나눠 준다.)

These are contracts. (13) _____ _____ _____ _____ _____ this, we'll be successful. (14) _____ _____ _____ you will attend all of your classes and maintain a 2.3 grade point average.

이것들은 계약서이다. 여러분이 이것에 서명하고 이행한다면, 우리는 성공할 것이다. 여기에는 여러분이 모든 수업에 출석할 것과 평균 2.3학점을 유지할 것이 명시되어 있다.

Cruz: This is crazy! By the way, (15) _____ _____ _____ _____ a suit and tie?

Carter: What's your name, sir? Cruz: Timo Cruz, sir.

Cruz: 이건 말도 안 돼! 그나저나, 코치님은 왜 양복을 입고 넥타이를 매고 있는 거죠? Carter:자네는 이름이 뭐지? Cruz: Timo Cruz요, 코치님.

Carter: Well, Mr. Cruz, (16) _____ _____ _____ _____ with respect …
(Cruz does not listen and (17) _____ _____ the ball.) All right, Mr. Cruz, (18) _____ _____ _____ right now.

Carter: 음, Cruz군, 우리가 우리 자신을 존중하며 대할 때 … (Cruz는 듣지 않고 공을 튕기기 시작한다.) 그래, Cruz군, 지금 당장 체육관을 떠나 주게.

Cruz: Fine. I don't need to listen to you anymore. I quit. (He walks out of the gym.)
Cruz: 좋아요. 전 코치님 얘기를 더는 들을 필요가 없어요. 제가 그만두죠. (그는 체육관 밖으로 걸어 나간다.)

Carter: Is there anybody else (19) _____ _____ _____ _____ _____
this contract? (Students look at each other. Two more students leave the gym and (20) _____
_____ _____.)
Carter: 이 계약서에 서명하고 싶지 않은 사람이 더 있는가? (학생들은 서로를 쳐다본다. 두 명의 학생이 추가로 체육관을 떠나고 나머지들은 남는다.)

Carter teaches the players (21) _____ _____ _____ and play together as a team.
Carter는 선수들에게 집중할 것과 한 팀으로서 경기할 것을 가르친다.

Cruz realizes how tough life is off the court and (22) _____ _____
to him. Later, the team wins an inspiring victory (23) _____ _____ _____ from the
crowd. Eventually, he (24) _____ _____ _____ _____ _____.
Cruz는 경기장 밖의 삶이 얼마나 힘든지를, 그리고 농구가 그에게 얼마나 큰 의미가 있는 것인지를 깨닫는다. 이후에 Cruz가 관중들 사이에서 (경기를) 지켜보는 가운데, 팀은 감동적인 승리를 거두게 된다. 결국, 그는 돌아가기로 마음먹는다.

(Cruz comes into the gym.) Cruz: (25) _____ _____ _____ _____
on the team?
(Cruz가 체육관 안으로 들어선다.) Cruz: 어떻게 하면 제가 팀에 돌아올 수 있나요?

Carter: (26) _____ _____ _____ _____ _____ the team, you need to do
1,000 push-ups and 1,000 laps around the gym—by Friday.
Carter: 네가 팀에 다시 합류하기를 원한다면, 자네는 1,000개의 팔굽혀펴기를 하고 체육관 1,000바퀴를 뛰어야 한다. 금요일까지.

Other players: That's impossible! (Cruz starts doing push-ups. Carter (27) _____ _____.)
Other players: 그건 불가능해요! (Cruz는 팔굽혀펴기를 하기 시작한다. Carter는 계속해서 지도한다.)

(On Friday) Carter: It's Friday, but you still have 100 push-ups and 100 laps to go. (28) _____
_____ _____ _____, Mr. Cruz.
(금요일) Carter: 금요일인데, 자네는 아직 팔굽혀펴기 100개와 100바퀴 뛰는 것이 남았군. 이제 포기할 시간이다, Cruz군.

Lyle: I'll do them for him, Coach. You said we're a team. When one person struggles, we all struggle.
When one player triumphs, we all triumph, right?
Lyle: 코치님, 제가 그를 위해 그것들을 하겠습니다. 코치님이 우리는 한 팀이라고 하셨죠. 한 사람이 힘들어 하면 우리 모두가 힘들다고요. 한 사람이 승리하면 우리 모두가 승리한 거고요. 맞죠?

Kenyon: I'll do some, too. Come on, guys, (29) _____ _____ _____ _____! (Other
players do push-ups together with Cruz. (30) _____ _____ _____.)
Kenyon: 저도 조금 하겠습니다. 얘들아, 우리 같이 Cruz를 도와주자! (다른 선수들도 Cruz와 함께 팔굽혀펴기를 한다. Carter는 감명받은 듯 보인다.)

(31) _____ _____ _____ on the team, they go undefeated for the rest of the season, and
they even win a big tournament. However, Carter later discovers that some of the students have been
(32) _____ _____ and getting failing grades. He (33) _____ _____ _____
_____.
Cruz가 팀에 복귀하며, 그들은 남은 시즌 동안 무패를 이어나가고, 심지어 큰 대회에서도 우승한다. 하지만 Carter는 몇몇 학생들이 수업들을 빼먹으며 낙제 점수를 받고 있다는 사실을 나중에 알게 된다. 그는 무언가를 하기로 결심한다.

(In front of the gym door) Kenyon: What's up, Cruz? Cruz: I don't know. This note says that practice has been canceled and the coach (34) _____ _____ in the school library.
Kenyon: The library? I don't even know (35) _____ _____ _____!
(체육관 문 앞에서) Kenyon: 무슨 일이야, Cruz? Cruz: 모르겠어. 이 쪽지에 연습이 취소되었고 코치님이 학교 도서관에서 기다리고 있다고 쓰여 있어. Kenyon: 도서관? 난 도서관이 어디 있는지도 모르는데!

(In the school library) Carter: Gentlemen, in this hand, I have the contracts (36) _____ _____. In this hand, I have academic progress reports (37) _____ _____ _____. The gym will stay locked (38) _____ _____ _____ the terms of this contract.
(도서관에서) Carter: 여러분, 이쪽 손에는, 여러분이 서명한 계약서가 있다. 이쪽 손에는, 여러분의 선생님들로부터 받은 학업 성취 보고서가 있다. 체육관은 우리 모두가 이 계약서의 조건을 충족시킬 때까지 잠겨 있을 것이다.

Cruz: But why? We're undefeated, and we won the tournament. Didn't you (39) _____ _____ _____ _____?
Cruz: 하지만 왜요? 우리는 (경기에서) 진 적이 없고 대회에서 우승까지 했잖아요. 코치님은 우리가 이기기를 바란 것 아니었나요?

Carter: That's not the point. (40) _____ _____ _____ _____ _____ is respecting the rules and taking responsibility for your behavior. If you don't realize that, you'll never succeed or even (41) _____ _____ _____ _____ _____. I believe honoring this contract is the first step (42) _____ _____ _____ _____ in your life. Now, (43) _____ _____ _____ _____ _____ _____, look at your lives tonight, and ask yourself, "Do I want a better life?" If the answer is yes, then I promise you (44) _____ _____ _____ _____ in my power to get you to a better life. (The athletes are deep in thought.)
Carter: 그게 중요한 게 아니다. 이기는 것보다 더 중요한 것은 규칙을 존중하고 여러분의 행동에 책임을 지는 것이다. 만약 여러분이 그것을 깨닫지 못한다면, 여러분은 결코 성공하지 못할 것이며 현실 사회에서 적응조차 하지 못할 것이다. 나는 이 계약을 준수하는 것이 여러분이 자신의 인생에서 책임을 지는 첫 단계라고 생각한다. 이제 나는 여러분들이 집에 가서 오늘 밤 여러분의 삶을 돌아보고 스스로에게 물어보기를 원한다. '나는 더 나은 삶을 원하는가?' 만약 그 대답이 '그렇다'라면, 그럼 내가 여러분에게 약속하건대, 나는 여러분이 더 나은 삶을 살 수 있도록 내 힘이 닿는 한 모든 것을 할 것이다. (선수들은 깊이 생각에 잠긴다.)

(In Carter's office) Principal: You locked the gym? Are you crazy?
(Carter의 사무실에서) Principal: 선생님이 체육관을 잠갔다고요? 제정신입니까?

Carter: Nobody expects them (45) _____ _____ _____ _____, Ms. Garrison. Nobody even expects them (46) _____ _____ _____ _____ _____. We need to (47) _____ _____ them and make them realize that they can do more.
Carter: Garrison 선생님, 아무도 그들이 대학에 갈 거라고 기대하지 않습니다. 심지어 아무도 그들이 고등학교를 졸업할 거라고 기대하지도 않아요. 우리는 그들을 방치하는 것을 멈추고 그들이 더 해낼 수 있다는 것을 깨닫게 해 줄 필요가 있어요.

Principal: So you take away the one thing that (48) _____ _____ _____? We both know that for some of these boys, this basketball season will be (49) _____ _____ _____ _____ _____.
Principal: 그래서 그들이 잘하는 유일한 것을 빼앗아 버린다고요? 이 아이들 중 몇몇에게 있어서는, 이번 농구 시즌이 그들 인생의 최고의 부분이 되리라는 것을 우리 둘 다 알고 있잖아요.

Carter: (50) _____ _____ _____ that's the problem? The coach's act angers the parents who expected the team (51) _____ _____ _____.

Carter: 여러분은 그게 바로 문제라는 생각이 들지 않습니까? 코치의 행동은 팀이 계속해서 이기기를 기대했던 학부모들을 화나게 한다.

Eventually, the school board (52) _____ _____.

결국, 학교운영위원회가 Carter와 대립하게 된다.

Parent 1: Basketball is all these boys have. Should Carter (53) _____ _____ _____ that away from them? Other parents: (shouting) No! Board Chairman: Quiet! Let's hear from Coach Carter.

Carter: 농구는 이 아이들이 가진 전부입니다. Carter 씨가 그들에게서 농구를 빼앗도록 두어도 되는 것입니까? Other parents: (소리 지르며) 안 됩니다! Board Chairman: 조용히 하세요! Carter 코치의 말을 듣겠습니다.

Carter: You really need to (54) _____ _____ _____ _____ you're sending these boys: that they are above the law. I'm (55) _____ _____ _____ _____. If these kids don't honor a simple contract, (56) _____ _____ _____ _____ they're out there in society breaking laws.

Carter: 여러분이 이 아이들에게 보내는 메시지에 대해 정말로 심사숙고해 봐야 합니다. 그들이 법 위에 있다는 메시지 말입니다. 저는 그들에게 규율을 가르치려고 합니다. 만약 이 아이들이 간단한 계약조차 지키지 못한다면, 머지않아 아이들은 (학교) 바깥세상 속에서 법을 어기게 될 것입니다.

(57) _____ _____ _____, the board votes to unlock the gym.

Carter의 연설에도 불구하고, 운영위원회는 투표를 하여 체육관을 개방하기로 결정한다.

Carter (58) _____ _____ _____ _____, but he decides to visit the gym one last time. There, (59) _____ _____ _____ _____. All the players are studying together.

Carter는 사직하려고 하지만, 마지막으로 체육관을 한 번 가 보기로 한다. 그곳에서, 그는 놀라운 것을 보게 된다. 모든 선수들이 함께 공부를 하고 있는 것이다.

Cruz: Sir, they can open the doors of the gym, but they (60) _____ _____ _____ _____. We're going to fulfill the contract, sir. Now we know (61) _____ _____ _____ _____, and it's all because of you. Thank you, sir.

Cruz: 코치님, 그들이 체육관 문을 열 수는 있지만, 우리가 농구를 하게 만들 수는 없습니다. 코치님, 우리는 계약을 이행하겠습니다. 이제 우리는 인생에서 중요한 것을 알았습니다. 그리고 그것은 모두 코치님 덕분입니다. 감사합니다, 코치님.

Carter: Gentlemen, there's only (62) _____ _____ _____ _____: We've achieved our goal.

Carter: 여러분, 이것을 표현할 길은 하나밖에 없는 것 같군. 우리는 우리의 목표를 달성한 거야.

The team members study hard and raise their grades (63) _____ _____ _____ the contract. Later, the team (64) _____ _____ the state basketball tournament.

팀원들은 열심히 공부해서 계약을 이행할 수 있을 만큼 충분히 학점을 높인다. 이후에, 팀은 주(州) 농구 대회에 출전한다.

The players fail to win the final, but they achieve something far more important: belief in themselves, (65) _____ _____ _____ _____ for a brighter future in life beyond the basketball court.

선수들은 결승전에서 지지만 훨씬 더 중요한 무언가를 얻게 된다. 그것은 농구 경기장 밖의 삶에 있어 더 밝은 미래에 대한 희망뿐만 아니라 그들 자신에 대한 믿음이었다.

다음 네모 안에서 옳은 것을 고르시오.

01 The team has [have / had] a losing record for several years, and the team members keep blaming each other for losing.

02 Carter finds out that their problem is not how they play basketball, but that they lack [aspect / respect] for themselves.

03 (One of the players tosses a ball to another player, [ignore / ignoring] Coach Carter.)

04 It states that you will [attract / attend] all of your classes and maintain a 2.3 grade point average.

05 Is there anybody else [who / whom] doesn't want to sign this contract?

06 Carter teaches the players to stay focused and [play / playing] together as a team.

07 Later, the team wins an [inspiring / inspired] victory while Cruz watches from the crowd.

08 It's Friday, but you still have 100 push-ups and 100 laps [go / to go]. It's time to give up, Mr. Cruz.

09 (Other players do push-ups together with Cruz. Carter seems [impressing / impressed].)

10 I don't know. This note says that practice has been [canceling / canceled] and the coach is waiting in the school library.

11 Gentlemen, in this hand, I have the contracts / conflicts you signed.

12 If you don't realize that, you'll never succeed or even adjust / adjusted to the real world.

13 I believe honor / honoring this contract is the first step for you to take responsibility in your life.

14 We need to stop to neglect / neglecting them and make them realize that they can do more.

15 The coach's act angers the parents who expected the team to keep winning. Eventually, the school board confronts / comforts Carter.
Parent 1: Basketball is all these boys have. Should Carter be allowed to take that away from them?

16 If these kids don't honor a simple contract, it won't be long before they're out there in society break / breaking laws.

17 Despite / Though Carter's speech, the board votes to unlock the gym.

18 There, he sees something shocked / shocking. All the players are studying together.

19 The team members study hard and raise their grades enough / too to fulfill the contract.

20 The players fail winning / to win the final, but they achieve something far more important: belief in themselves, as well as hope for a brighter future in life beyond the basketball court.

다음 문장이 옳으면 O, 틀리면 X 표시하고 바르게 고치시오.

01 Coach Ken Carter takes over the head coaching job for the Richmond High School basketball team.

02 The school is locate in a poor neighborhood.

03 Many students at the school drop out and end up living difficult lives.

04 The team has had a losing record for several years, and the team members keep blame each other for losing.

05 Carter finds out what their problem is not how they play basketball, but that they lack respect for themselves. He comes up with an idea.

06 Carter: Good afternoon, gentlemen. I'm your new basketball coach, Ken Carter.
(The players ignore him and chat with each other.)

07 Maybe I should speak louder. I'm Ken Carter, your new basketball coach.

08 (One of the players toss a ball to another player, ignoring Coach Carter.) You, what's your name, sir?

09 Lyle: Jason Lyle, but I'm not a sir.
Carter: Starting today, you are a sir. You all are. "Sir" is a term of respect. All of you will have my respect until you abuse it.

10 (He gives out some pieces of paper.) These are contracts. If you sign and honor this, we'll be successful.

11 It states that you will attend all of your classes and maintains a 2.3 grade point average.

12 Cruz: This is crazy! By the way, why are you wearing a suit and tie?
Carter: What's your name, sir?
Cruz: Timo Cruz, sir.

13 Carter: Well, Mr. Cruz, when we treat ourselves with respect ...
(Cruz does not listen and starts bouncing the ball.) All right, Mr. Cruz, leave the gym right now.

14 Cruz: Fine. I don't need to listen to you anymore. I quit. (He walks out of the gym.)

15 Carter: Is there anybody else which doesn't want to sign this contract? (Students look at each other. Two more students leave the gym and the others stay.)

16 Carter teaches the players stay focused and play together as a team.

17 Cruz realizes how tough life is off the court and how much basketball means to him.

18 Later, the team wins an inspiring victory while Cruz watches from the crowd.

19 Eventually, he decides coming back.
(Cruz comes into the gym.)
Cruz: How can I get back on the team?

20 Carter: If you want to rejoin the team, you need to do 1,000 push-ups and 1,000 laps around the gym—by Friday.

21 Other players: That's impossible!
(Cruz starts doing push-ups. Carter continues coaching.)

(On Friday)
22 Carter: It's Friday, but you still have 100 push-ups and 100 laps to go. It's time to giving up, Mr. Cruz.

23 Lyle: I'll do them for him, Coach. You said we're a team. When one person struggles, we all struggle. When one player triumphs, we all triumph, right?

24 Kenyon: I'll do some, too. Come on, guys, let's help him out! (Other players do push-ups together with Cruz. Carter seems impressing.)

25 With Cruz back on the team, they go undefeated for the rest of the season, and they even win a big tournament.

26 However, Carter later discovers that some of the students have been skipped classes and getting failing grades. He decides to do something.

(In front of the gym door)
27 Kenyon: What's up, Cruz?
Cruz: I don't know. This note says that practice has been canceled and the coach is waiting in the school library.

28 Kenyon: The library? I don't even know where is the library!

(In the school library)
29 Carter: Gentlemen, in this hand, I have the contracts you signed. In this hand, I have academic progress reports from your teachers.

30 The gym will stay lock until we all satisfy the terms of this contract.

31 Cruz: But why? We're undefeated, and we won the tournament. Didn't you want us win?

32 Carter: That's not the point. What's more important than winning is respecting the rules and take responsibility for your behavior.

33 If you don't realize that, you'll never succeed or even adjust to the real world. I believe honoring this contract are the first step for you to take responsibility in your life.

34 Now, I want you go home, look at your lives tonight, and ask yourself, "Do I want a better life?"

35 If the answer is yes, then I promise you I will do everything in my power to get you to a better life. (The athletes are deep in thought.)

(In Carter's office)
36 Principal: You locked the gym. Are you crazy?
Carter: Nobody expects them going to college, Ms. Garrison.

37 Nobody even expects them graduating from high school. We need to stop neglecting them and make them realize that they can do more.

38 Principal: So you take away the one thing that they're good at.

39 We both know that for some of these boys, this basketball season will be the best part of their lives.

40 Carter: Don't you think that's the problem?

41 The coach's act angers the parents which expected the team to keep winning. Eventually, the school board confronts Carter.

42 Parent 1: Basketball is all these boys have. Should Carter is allowed to take that away from them?
Other parents: (shouting) No!
Board Chairman: Quiet! Let's hear from Coach Carter.

43 Carter: You really need to consider the message that you're sending these boys: that they are above the law. I'm trying to teach them discipline.

44 If these kids don't honor a simple contract, it won't be long before they're out there in society breaking laws.

45 Despite Carter's speech, the board votes to unlock the gym. Carter is about to resign, but he decides to visit the gym one last time.

46 There, he sees shocking something. All the players are studying together.

47 Cruz: Sir, they can open the doors of the gym, but they can't make us playing.

48 We're going to fulfill the contract, sir. Now we know what's important in life, and it's all because you. Thank you, sir.

49 Carter: Gentlemen, there's only one way to say this: We've achieved our goal.

50 The team members study hard and raise their grades enough to fulfill the contract.

51 Later, the team competes in the state basketball tournament.

52 The players fail to win the final, but they achieve something very more important: belief in themselves, as well as hope for a brighter future in life beyond the basketball court.

[1~2] 다음 글을 읽고, 물음에 답하시오.

Coach Ken Carter takes over the head coaching job for the Richmond High School basketball team. The school is (A) locating / located in a poor neighborhood. Many students at the school drop out and end up (B) to live / living difficult lives. The team has had a losing record for several years, and the team members keep (C) blame / blaming each other for losing. Carter는 그들의 문제가 그들이 농구를 하는 방식이 아니라 그들 자신에 대한 존중이 부족하다는 점에 있다는 것을 알게 된다. He comes up with an idea.

1 (A), (B), (C)의 각 네모 안에서 어법에 맞는 표현으로 가장 적절한 것은?

	(A)		(B)		(C)
①	locating	…	living	…	blame
②	locating	…	to live	…	blaming
③	located	…	living	…	blame
④	located	…	living	…	blaming
⑤	located	…	to live	…	blaming

2 윗글의 밑줄 친 우리말과 일치하도록 주어진 단어를 이용하여 문장을 완성하시오.

Carter finds out that their problem is

_____, but that they lack respect for themselves.
(how)

3 다음 글에서 Carter가 밑줄 친 (A)와 같이 말한 이유로 가장 적절한 것은?

Carter: Good afternoon, gentlemen. I'm your new basketball coach, Ken Carter.
(*The players ignore him and chat with each other.*)
(A) Maybe I should speak louder. I'm Ken

Carter, your new basketball coach.
(*One of the players tosses a ball to another player, ignoring Coach Carter.*)
You, what's your name, sir?
Lyle: Jason Lyle, but I'm not a sir.

① because the basketball court is too noisy
② because the players don't seem to pay attention to him
③ because one of the players tosses a ball to another player
④ because the players don't understand what he said
⑤ because he doesn't know the names of the players

[4~5] 다음 글을 읽고, 물음에 답하시오.

Carter: Starting today, you are a sir. You all are. "Sir" is a term of ____(A)____. All of you will have my ____(B)____ until you abuse it. (*He gives out some pieces of paper.*) These are contracts. If you sign and fulfill this, we'll be successful. It states that you will attend all of your classes and maintain a 2.3 grade point average.
Cruz: This is crazy! By the way, why are you wearing a suit and tie?
Carter: What's your name, sir?
Cruz: Timo Cruz, sir.
Carter: Well, Mr. Cruz, when we treat ourselves with respect …
(*Cruz does not listen and starts bouncing the ball.*)
All right, Mr. Cruz, leave the gym right now.
Cruz: Fine. I don't need to listen to you anymore. I quit. (*He walks out of the gym.*)
Carter: Is there anybody else who doesn't want to sign this contract?
(*Students look at each other. Two more students leave the gym and the others stay.*)

4 윗글의 내용과 일치하지 <u>않는</u> 것은?

① Carter는 학생들에게 계약서를 나눠 주었다.
② Carter는 정장과 넥타이를 착용했다.
③ Carter는 Cruz에게 이름을 물어봤다.
④ Cruz는 Carter의 말을 듣지 않고 공을 튕겼다.
⑤ Cruz를 제외한 나머지 학생들은 체육관에 남았다.

5 빈칸 (A), (B)에 공통으로 들어갈 단어를 윗글에서 찾아 쓰시오.

6 다음 글의 밑줄 친 ①~⑤ 중, 문맥상 낱말의 쓰임이 적절하지 <u>않은</u> 것은?

> Carter teaches the players to stay ① focused and play together as a team. Cruz realizes how ② comfortable life is off the court and how much basketball means to him. Later, the team wins an inspiring ③ victory while Cruz watches from the crowd. Eventually, he decides to come back.
>
> (*Cruz comes into the gym.*)
> Cruz: How can I get back on the team?
> Carter: If you want to ④ rejoin the team, you need to do 1,000 push-ups and 1,000 laps around the gym—by Friday.
> Other players: That's impossible!
> (*Cruz starts doing ⑤ push-ups. Carter continues coaching.*)

① ② ③ ④ ⑤

7 다음 글의 밑줄 친 ⓐ~ⓔ 중, 가리키는 대상이 나머지 넷과 <u>다른</u> 것은?

> (*On Friday*)
> Carter: It's Friday, but ⓐ you still have 100 push-ups and 100 laps to go. It's time to give up, Mr. Cruz.
> Lyle: I'll do them for ⓑ him, Coach. ⓒ You said we're a team. When one person struggles, we all struggle. When one player triumphs, we all triumph, right?

> Kenyon: I'll do some, too. Come on, guys, let's help ⓓ him out!
> (*Other players do push-ups together with ⓔ Cruz. Carter seems impressed.*)

① ⓐ ② ⓑ ③ ⓒ ④ ⓓ ⑤ ⓔ

8 다음 글의 빈칸에 들어갈 말로 가장 적절한 것은?

> With Cruz back on the team, they go undefeated for the rest of the season, and they even win a big tournament. _____, Carter later discovers that some of the students have been skipping classes and getting failing grades. He decides to do something.
> (*In front of the gym door*)
> Kenyon: What's up, Cruz?
> Cruz: I don't know. This note says that practice has been canceled and the coach is waiting in the school library.
> Kenyon: The library? I don't even know where the library is!

① Therefore ② Finally
③ In addition ④ Luckily
⑤ However

9 다음 글의 빈칸 (A), (B)에 공통으로 들어갈 말로 가장 적절한 것은?

> (*In the school library*)
> Carter: Gentlemen, in this hand, I have the contracts you signed. In this hand, I have academic progress reports from your teachers. The gym will stay locked until we all satisfy the terms of this contract.
> Cruz: But why? We're undefeated, and we won the tournament. Didn't you want us to win?
> Carter: That's not the point. What's more important than winning is respecting the rules and taking ___(A)___ for your behavior. If you don't realize that, you'll never succeed or even adjust to the real world. I believe honoring this contract is the first step for you to take ___(B)___ in

your life. Now, I want you to go home, look at your lives tonight, and ask yourself, "Do I want a better life?" If the answer is yes, then I promise you I will do everything in my power to get you to a better life.

(*The athletes are deep in thought.*)

① risks ② revenge
③ action ④ control
⑤ responsibility

10 다음 글의 밑줄 친 the one thing이 가리키는 것을 찾아 한 단어로 쓰시오.

(*In Carter's office*)
Principal: You locked the gym? Are you crazy?
Carter: Nobody expects them to go to college, Ms. Garrison. Nobody even expects them to graduate from high school. We need to stop neglecting them and make them realize that they can do more.
Principal: So you take away the one thing that they're good at? We both know that for some of these boys, this basketball season will be the best part of their lives.
Carter: Don't you think that's the problem?

11 (A), (B)의 각 네모 안에서 문맥에 맞는 낱말로 가장 적절한 것을 쓰시오.

Carter's act angers the parents who expected the team to keep winning. Eventually, the school board (A) confronts / agrees with Carter.
Parent 1: Basketball is all these boys have. Should Carter be allowed to take that away from them?
Other parents: (*shouting*) No!
Board Chairman: Quiet! Let's hear from Coach Carter.
Carter: You really need to consider the message that you're sending these boys: that they are above the law. I'm trying to teach them

discipline. If these kids don't honor a simple contract, it won't be long before they're out there in society (B) following / breaking laws.

(A) _____

(B) _____

12 다음 글의 밑줄 친 ①~⑤ 중, 어법상 알맞은 것은?

① Although Carter's speech, the board votes to unlock the gym. Carter is about to resign, but he decides to visit the gym one last time. There, he sees something shocking. All the players are studying together.
Cruz: Sir, they can open the doors of the gym, but they can't make us ② playing. We're going to fulfill the contract, sir. Now we know what's important in life, and it's all because of you. Thank you, sir.
Carter: Gentlemen, there's only one way ③ say this: We've achieved our goal.

The team members study hard and raise their grades enough to fulfill the contract. Later, the team competes in the state basketball tournament. The players fail ④ winning the final, but they achieve something ⑤ far more important: belief in themselves, as well as hope for a brighter future in life beyond the basketball court.

① ② ③ ④ ⑤

[1~2] 다음 글을 읽고, 물음에 답하시오.

Coach Ken Carter ① takes over the head coaching job for the Richmond High School basketball team. The school is located in a poor neighborhood. Many students at the school drop out and end up living difficult lives. The team has had a losing record for several years, and the team members keep blaming each other for losing. Carter finds out that their problem is not how they play basketball, but that they lack respect for themselves. He comes up with an idea.

Carter: Good afternoon, gentlemen. I'm your new basketball coach, Ken Carter.

(*The players ignore him and chat with each other.*)

Maybe I should speak louder. I'm Ken Carter, your new basketball coach.

(*One of the players tosses a ball to another player, ignoring Coach Carter.*)

You, what's your name, sir?

Lyle: Jason Lyle, but I'm not a sir.

Carter: Starting today, you are a sir. You all are. "Sir" is a ② term of respect. All of you will have my respect until you abuse it. (*He gives out some pieces of paper.*) These are contracts. If you sign and ③ honor this, we'll be successful. It states that you will attend all of your classes and maintain a 2.3 grade point average.

Cruz: This is crazy! By the way, why are you wearing a suit and tie?

Carter: What's your name, sir?

Cruz: Timo Cruz, sir.

Carter: Well, Mr. Cruz, when we treat ourselves with respect ...

(*Cruz does not listen and starts bouncing the ball.*)

All right, Mr. Cruz, leave the gym right now.

Cruz: Fine. I don't need to listen to you anymore.

I ④ quit. (*He walks out of the gym.*)

Carter: Is there anybody else who doesn't want to sign this ⑤ contract?

(*Students look at each other. Two more students leave the gym and the others stay.*)

1 윗글을 읽고 답할 수 <u>없는</u> 질문으로 가장 적절한 것은?

① Does Carter know the problem the basketball team has?
② What does the term "sir" express?
③ What do the contracts say?
④ Why does Carter wear a suit and tie?
⑤ How many students leave the gym?

2 윗글의 밑줄 친 ①~⑤ 중, 다음 영영 뜻풀이에 해당하는 것은?

to stop or discontinue what someone was doing

① ② ③ ④ ⑤

[3~4] 다음 글을 읽고, 물음에 답하시오.

Carter teaches the players to stay focused and play together as a team. <u>Cruz는 경기장 밖의 삶이 얼마나 힘든지 그리고 농구가 그에게 얼마나 큰 의미가 있는 것인지를 깨닫는다.</u> Later, the team wins an inspiring victory while Cruz watches from the crowd. Eventually, he decides to come back.

(*Cruz comes into the gym.*)

Cruz: How can I get back on the team?

Carter: If you want to rejoin the team, you need to do 1,000 push-ups and 1,000 laps around the gym—by Friday.

Other players: That's impossible!

(*Cruz starts doing push-ups. Carter continues coaching.*)

(*On Friday*)

Carter: It's Friday, but you still have 100 push-

ups and 100 laps to go. It's time to give up, Mr. Cruz.

Lyle: I'll do them for him, Coach. You said we're a team. When one person struggles, we all struggle. When one player triumphs, we all triumph, right?

Kenyon: I'll do some, too. Come on, guys, let's help him out!

(*Other players do push-ups together with Cruz. Carter seems _____.*)

3 윗글의 밑줄 친 우리말과 일치하도록 〈보기〉에 주어진 말을 배열하여 문장을 완성하시오.

〈보기〉 means / basketball / life / much / is / how / tough / how

Cruz realizes _____ _____ _____ _____ off the court and _____ _____ _____ _____ to him.

4 윗글의 빈칸에 들어갈 말로 가장 적절한 것은?

① urgent
② depressed
③ impressed
④ disappointed
⑤ enthusiastic

[5~6] 다음 글을 읽고, 물음에 답하시오.

With Cruz back on the team, they go (A) undervalued / undefeated for the rest of the season, and they even win a big tournament. However, Carter later discovers that some of the students have been skipping classes and getting failing grades. He decides to do something.

(*In front of the gym door*)

Kenyon: What's up, Cruz?

Cruz: I don't know. This note says that practice has been canceled and the coach is waiting in the school library.

Kenyon: The library? I don't even know where the library is!

(*In the school library*)

Carter: Gentlemen, in this hand, I have the

contracts you signed. In this hand, I have academic progress reports from your teachers. The gym will stay locked until we all satisfy the (B) forms / terms of this contract.

Cruz: But why? We won the tournament. Didn't you want us to win?

Carter: That's not the point. What's more important than winning is respecting the rules and taking responsibility for your behavior. (①) If you don't realize that, you'll never succeed or even (C) adopt / adjust to the real world. (②) I believe honoring this contract is the first step for you to take responsibility in your life. (③) Now, I want you to go home, look at your lives tonight. (④) Then, ask yourself, "Do I want a better life?" (⑤)

(*The athletes are deep in thought.*)

5 (A), (B), (C)의 각 네모 안에서 문맥에 맞는 낱말로 가장 적절한 것은?

	(A)	(B)	(C)
①	undervalued	⋯ forms	⋯ adopt
②	undervalued	⋯ terms	⋯ adjust
③	undefeated	⋯ forms	⋯ adjust
④	undefeated	⋯ terms	⋯ adopt
⑤	undefeated	⋯ terms	⋯ adjust

6 윗글의 흐름으로 보아, 주어진 문장이 들어가기에 가장 적절한 곳은?

If the answer is yes, then I promise you I will do everything in my power to get you to a better life.

① ② ③ ④ ⑤

[7~10] 다음 글을 읽고, 물음에 답하시오.

(*In Carter's office*)

Principal: (ⓐ) You locked the gym? Are you crazy?

Carter: Nobody expects them to go to college,

Ms. Garrison. Nobody even expects them to graduate from high school. We need to stop neglecting them and (A) make / making them realize that they can do more.

Principal: So you take away the one thing (B) what / that they're good at? We both know that for some of these boys, this basketball season will be the best part of their lives.

Carter: Don't you think that's the problem?

The coach's act angers the parents who expected the team to keep winning. Eventually, the school board confronts Carter.

Parent 1: Basketball is all these boys have. Should Carter be allowed to take that away from them?

Other parents: (*shouting*) No!

Board Chairman: Quiet! Let's hear from Coach Carter.

Carter: You really need to consider the message that you're sending these boys: that they are above the law. I'm trying to teach them _____ⓑ_____ . If these kids don't honor a simple contract, it won't be long before they're out there in society (C) break / breaking laws.

7 실제 연극으로 하기 위해 윗글에 지시문을 넣을 때, 빈칸 ⓐ 에 들어갈 말로 가장 적절한 것은?

① hesitantly
② with rage
③ gently
④ pleasantly whispering
⑤ with lovely tone of voice

8 (A), (B), (C)의 각 네모 안에서 어법에 맞는 표현으로 가장 적절한 것을 쓰시오.

(A) _____
(B) _____
(C) _____

9 윗글의 빈칸 ⓑ에 들어갈 말로 가장 적절한 것은?

① discipline
② empathy
③ self-esteem
④ courage
⑤ competence

10 윗글을 읽고 추론할 수 <u>없는</u> 것은?

① The principal has a different opinion to Carter.
② No one expects that the basketball team members would enter college.
③ Parents are angry about the coach's behavior.
④ Parents teach their kids to take responsibility for losing.
⑤ The coach wants the basketball team members to honor a contract.

[11~12] 다음 글을 읽고, 물음에 답하시오.

Despite Carter's speech, the board votes to unlock the gym. Carter is about to resign, but he decides to visit the gym one last time. There, he sees something shocking. All the players are studying together.

Cruz: Sir, they can open the doors of the gym, but they can't make us play. We're going to fulfill the contract, sir. Now we know what's important in life, and it's all because of you. Thank you, sir.

Carter: Gentlemen, there's only one way to say this: We've achieved our goal.

The team members study hard and raise their grades (A) (fulfill / contract / enough / the / to). Later, the team competes in the state basketball tournament. The players fail to win the final, but they achieve something far more important: belief in themselves, as well as hope for a brighter future in life beyond the basketball court.

11 윗글의 내용과 일치하지 <u>않는</u> 것은?

① 운영위원회는 체육관 개방에 대한 투표를 했다.
② 코치는 사직하기 전에 체육관에 방문했다.
③ 선수들은 체육관에서 농구 연습을 하고 있었다.
④ 선수들은 인생에서 중요한 것을 알게 되었다.
⑤ 농구팀은 주(州) 농구 대회 결승전에서 졌다.

12 윗글의 (A)에 주어진 단어를 알맞게 배열하시오.

[1~2] 다음 글을 읽고, 물음에 답하시오.

Coach Ken Carter takes ___(A)___ the head coaching job for the Richmond High School basketball team. The school is located in a poor neighborhood. Many students at the school drop ___(B)___ and end up living difficult lives. The team has had a losing record for several years, and the team members keep blaming each other ___(C)___ losing. Carter finds out that their problem is not how they play basketball, but that they lack respect for themselves. He comes up with an idea.

1 윗글 바로 뒤에 이어질 내용으로 가장 적절한 것은?

① 농구팀의 몇 년간의 경기 기록
② 선수들이 서로를 탓하게 된 계기
③ Carter가 수석 코치직을 맡은 이유
④ 선수들이 농구하는 방식을 분석한 자료
⑤ 선수들이 그들 자신에 대해 존중하도록 하는 방안

2 윗글의 빈칸 (A)~(C)에 들어갈 말로 가장 적절한 것은?

	(A)		(B)		(C)
①	off	…	in	…	for
②	off	…	in	…	to
③	over	…	in	…	with
④	over	…	out	…	for
⑤	over	…	out	…	with

[3~4] 다음 글을 읽고, 물음에 답하시오.

Carter: Good afternoon, gentlemen. I'm your new basketball coach, Ken Carter.

(*The players ignore him and chat with each other.*)
Maybe I should speak louder. I'm Ken Carter, your new basketball coach.
(*One of the players tosses a ball to another player, ignoring Coach Carter.*)
You, what's your name, sir?
Lyle: Jason Lyle, but I'm not a sir.
Carter: Starting today, you are a sir. You all are. "Sir" is a term of respect. All of you will have my respect until you abuse it. (*He gives out some pieces of paper.*) These are contracts. If you sign and honor this, we'll be successful. It states that you will attend all of your classes and maintain a 2.3 grade point average.
Cruz: This is crazy! By the way, why are you wearing a suit and tie?
Carter: What's your name, sir?
Cruz: Timo Cruz, sir.
Carter: Well, Mr. Cruz, when we treat ourselves with respect …
(*Cruz does not listen and starts bouncing the ball.*)
All right, Mr. Cruz, leave the gym right now.
Cruz: Fine. I don't need to listen to you anymore. I quit. (*He walks out of the gym.*)
Carter: Is there anybody else who doesn't want to sign this contract?
(*Students look at each other. Two more students leave the gym and the others stay.*)

3 윗글의 내용과 일치하지 <u>않는</u> 것을 <u>모두</u> 고르시오.

① Carter introduces himself to the players.
② The players seem to ignore what Carter says.
③ Carter tosses a ball to the players.
④ The terms of the contract are easy for Cruz to fulfill.
⑤ Cruz and two students leave the gym.

4 다음 영영 뜻풀이에 해당하는 단어를 윗글에서 찾아 쓰시오.

> to use something in a way that it was not meant to be used

5 다음 글의 밑줄 친 ①~⑤ 중, 어법상 틀린 것을 찾아 바르게 고치시오.

> Carter teaches the players ① to stay focused and play together as a team. Cruz realizes ② how tough life is off the court and how much basketball ③ means to him. Later, the team wins an ④ inspired victory while Cruz watches from the crowd. Eventually, he decides ⑤ to come back.

_____ → _____

6 주어진 글 다음에 이어질 글의 순서로 가장 적절한 것은?

> Cruz: How can I get back on the team?
> Carter: If you want to rejoin the team, you need to do 1,000 pushups and 1,000 laps around the gym—by Friday.
> Other players: That's impossible!
> (*Cruz starts doing push-ups. Carter continues coaching.*)

> (A) Carter: It's Friday, but you still have 100 push-ups and 100 laps to go. It's time to give up, Mr. Cruz.
> (B) Kenyon: I'll do some, too. Come on, guys, let's help him out!

> (*Other players do push-ups together with Cruz. Carter seems impressed.*)
> (C) Lyle: I'll do them for him, Coach. You said we're a team. When one person struggles, we all struggle. When one player triumphs, we all triumph, right?

① (A) – (B) – (C) ② (A) – (C) – (B)
③ (B) – (A) – (C) ④ (C) – (A) – (B)
⑤ (C) – (B) – (A)

[7~8] 다음 글을 읽고, 물음에 답하시오.

> Carter: Gentlemen, in this hand, I have the contracts you signed. In this hand, I have academic progress reports from your teachers. 체육관은 우리 모두가 이 계약서의 조건들을 충족시킬 때까지 잠겨 있을 것이다.
> Cruz: But why? We're undefeated, and we won the tournament. Didn't you want us to win?
> Carter: That's not the point. What's more important than winning is respecting the rules and taking responsibility for your behavior. If you don't realize that, you'll never succeed or even adjust to the real world. I believe honoring this contract is the first step for you to take responsibility in your life. Now, I want you to go home, look at your lives tonight, and ask yourself, "Do I want a better life?" If the answer is yes, then I promise you I will do everything in my power to get you to a better life.

7 윗글에 제시된 Carter의 의견으로 가장 적절한 것은?

① 시합에서 이기려면 경기 규칙을 준수해라.
② 언제나 자신보다는 남을 배려하는 삶을 살아라.
③ 규칙을 준수하고 자신의 행동에 책임을 져라.
④ 학생에게 성적보다 더 중요한 것은 없다.
⑤ 더 나은 삶을 위해 매사에 자신감을 가져라.

8 윗글의 밑줄 친 우리말과 일치하도록 〈보기〉에 주어진 단어를 이용하여 문장을 완성하시오. (필요 시 형태를 변형할 것)

〈보기〉 lock, the term, satisfy, stay

The gym will _____ until we all _____ of this contract.

9 다음 글의 밑줄 친 ⓐ~ⓔ 중, 어법상 틀린 것의 개수는?

(*In Carter's office*)

Principal: You locked the gym? Are you crazy?

Carter: Nobody ⓐ expects them going to college, Ms. Garrison. Nobody even expects that they'll graduate from high school. We need to stop neglecting them and ⓑ make them realize that they can do more.

Principal: So you take away the one thing ⓒ what they're good at? We both know that for some of these boys, this basketball season will be the best part of their lives.

Carter: Don't you think that's the problem?

The coach's act angers ⓓ the parents who expected the team to keep winning. Eventually, the school board confronts Carter.

Parent 1: Basketball is all these boys have. Should Carter be allowed ⓔ to take that away from them?

Other parents: (*shouting*) No!

Board Chairman: Quiet! Let's hear from Coach Carter.

① 1개 ② 2개 ③ 3개
④ 4개 ⑤ 5개

[10~11] 다음 글을 읽고, 물음에 답하시오.

Carter: You really need to consider the message that you're sending these boys: that they are above the law. I'm trying to teach them (A) discipline / dissatisfaction. If these kids don't honor a simple contract, it won't be long before they're out there in society breaking laws.

Despite Carter's speech, the board votes to unlock the gym. Carter is about to (B) assign / resign, but he decides to visit the gym one last time. There, he sees something shocking. All the players are studying together.

Cruz: Sir, they can open the doors of the gym, but they can't make us play. We're going to (C) cancel / fulfill the contract, sir. Now we know what's important in life, and it's all because of you. Thank you, sir.

Carter: Gentlemen, there's only one way to say this: We've achieved our goal.

10 (A), (B), (C)의 각 네모 안에서 문맥에 맞는 낱말로 가장 적절한 것은?

	(A)	(B)	(C)
①	discipline	… assign	… fulfill
②	discipline	… resign	… cancel
③	discipline	… resign	… fulfill
④	dissatisfaction	… assign	… cancel
⑤	dissatisfaction	… resign	… fulfill

11 윗글의 밑줄 친 문장을 우리말로 해석하시오.

정답 및 해설 p.43

1 다음 글의 밑줄 친 ①~⑤ 중, 어법상 틀린 것은?

Coach Ken Carter takes over the head coaching job for the Richmond High School basketball team. The school ① is located in a poor neighborhood. Many students at the school drop out and end up ② living difficult lives. The team ③ has had a losing record for several years, and the team members keep blaming each other for losing. Carter finds out ④ what their problem is not how they play basketball, but that they lack respect for ⑤ themselves. He comes up with an idea.

① ② ③ ④ ⑤

2 다음 글의 내용을 한 문장으로 요약할 때, 빈칸 (A), (B)에 들어갈 말로 가장 적절한 것은?

Carter: Good afternoon, gentlemen. I'm your new basketball coach, Ken Carter.
(*The players ignore him and chat with each other.*)
Maybe I should speak louder. I'm Ken Carter, your new basketball coach.
(*One of the players tosses a ball to another player, ignoring Coach Carter.*)
You, what's your name, sir?

Lyle: Jason Lyle, but I'm not a sir.

Carter: Starting today, you are a sir. You all are. "Sir" is a term of respect. All of you will have my respect until you abuse it. (*He gives out some pieces of paper.*) These are contracts. If you sign and honor this, we'll be successful. It states that you will attend all of your classes and maintain a 2.3 grade point average.

Cruz: This is crazy! By the way, why are you wearing a suit and tie?

Carter: What's your name, sir?

Cruz: Timo Cruz, sir.

Carter: Well, Mr. Cruz, when we treat ourselves with respect ...
(*Cruz does not listen and starts bouncing the ball.*)
All right, Mr. Cruz, leave the gym right now.

Cruz: Fine. I don't need to listen to you anymore. I quit. (*He walks out of the gym.*)

Carter: Is there anybody else who doesn't want to sign this contract? (*Students look at each other. Two more students leave the gym and the others stay.*)

↓

Introducing himself as a new basketball coach, Carter tries to ____(A)____ the players whereas some of them deliberately ____(B)____ him and leave the gym.

 (A) (B) (A) (B)
① esteem ··· honor ② oppress ··· neglect
③ honor ··· deceive ④ value ··· disregard
⑤ ignore ··· respect

3 다음 글의 내용과 일치하지 않는 것을 모두 고르시오.

Carter teaches the players to stay focused and play together as a team. Cruz realizes how tough life is off the court and how much basketball means to him. Later, the team wins an inspiring victory while Cruz watches from the crowd. Eventually, he decides to come back.
(*Cruz comes into the gym.*)

Cruz: How can I get back on the team?

Carter: If you want to rejoin the team, you need to do 1,000 push-ups and 1,000 laps around the gym—by Friday.

Other players: That's impossible!
(*Cruz starts doing push-ups. Carter continues coaching.*)
(*On Friday*)

Carter: It's Friday, but you still have 100 push-ups and 100 laps to go. It's time to give up, Mr. Cruz.

Lyle: I'll do them for him, Coach. You said we're a team. When one person struggles, we all struggle. When one player triumphs, we all triumph, right?

Kenyon: I'll do some, too. Come on, guys, let's help him out!

(*Other players do push-ups together with Cruz. Carter seems impressed.*)

① Cruz thinks that his life off the court is not easy.
② With Cruz coming back, the team begins to win an inspiring victory.
③ Some players are required to do 1,000 push-ups and 1,000 laps around the gym.
④ Lyle says he will do push-ups for Cruz.
⑤ Carter doesn't allow other players to help Cruz.

4 다음 글의 내용으로 알 수 없는 것을 모두 고르시오.

With Cruz back on the team, they go undefeated for the rest of the season, and they even win a big tournament. However, Carter later discovers that some of the students have been skipping classes and getting failing grades. He decides to do something.

(*In front of the gym door*)

Kenyon: What's up, Cruz?

Cruz: I don't know. This note says that practice has been canceled and the coach is waiting in the school library.

Kenyon: The library? I don't even know where the library is!

① the result of the big tournament
② names of some players who skip classes
③ the place where the conversation takes place
④ specific content of the note
⑤ the location of the library

5 (A), (B), (C)의 각 네모 안에서 문맥에 맞는 낱말로 가장 적절한 것은?

(*In the school library*)

Carter: Gentlemen, in this hand, I have the contracts you signed. In this hand, I have academic progress reports from your teachers. The gym will stay locked until we all (A) dissatisfy / meet the terms of this contract.

Cruz: But why? We're undefeated, and we won the tournament. Didn't you want us to win?

Carter: That's not the point. What's more important than winning is (B) breaking / respecting the rules and taking responsibility for your behavior. If you don't realize that, you'll never succeed or even adjust to the real world. I believe (C) honoring / refusing this contract is the first step for you to take responsibility in your life.

	(A)	(B)	(C)
①	dissatisfy	··· breaking	··· honoring
②	dissatisfy	··· respecting	··· honoring
③	dissatisfy	··· respecting	··· refusing
④	meet	··· breaking	··· refusing
⑤	meet	··· respecting	··· honoring

[6~7] 다음 글을 읽고, 물음에 답하시오.

(*In Carter's office*)

Principal: You locked the gym? Are you crazy?

Carter: Nobody expects them to go to college, Ms. Garrison. Nobody even expects them to graduate from high school. 우리는 그들을 방치하는 것을 멈출 필요가 있고 그들이 더 해낼 수 있다는 것을 깨닫게 해 줄 필요가 있다.

Principal: So you take away ⓐ the one thing that they're good at? We both know that for some of these boys, this basketball season will be the best part of their lives.

Carter: Don't you think that's the problem?

6 윗글에 밑줄 친 우리말과 일치하도록 주어진 단어를 이용하여 문장을 완성하시오. (필요 시 형태를 변형할 것)

We _____ (need, neglect) and make them realize _____

_____ (that, do more).

7 윗글의 밑줄 친 ⓐ가 의미하는 것으로 가장 적절한 것은?

① the gym ② the college
③ the high school ④ basketball
⑤ the problem

[8~9] 다음 글을 읽고, 물음에 답하시오.

Carter's act angers the parents who expected the team to keep winning. _____, the school board confronts Carter.

Parent 1: Basketball is all these boys have. Should Carter be ⓐ allow take that away from them?

Other parents: (*shouting*) No!

Board Chairman: Quiet! Let's hear from Coach Carter.

Carter: You really need to consider the message that you're sending these boys: that they are above the law. I'm trying to teach them discipline. If these kids don't honor a simple contract, it won't be long before they're out there in society breaking laws.

8 윗글의 빈칸에 들어갈 말로 가장 적절한 것은?

① Instead ② Nevertheless
③ Eventually ④ However
⑤ In contrast

9 윗글의 밑줄 친 ⓐ를 어법에 맞게 고쳐 쓰시오.

[10~11] 다음 글을 읽고, 물음에 답하시오.

Carter ① is about to resign, but he decides to visit the gym one last time. There, he sees something shocking. All the players are studying together.

Cruz: Sir, they can open the doors of the gym, but they can't ② make us to play. We're going to fulfill the contract, sir. Now we know what's important in life, and it's all because of you. Thank you, sir.

Carter: Gentlemen, there's only one way to say this: Our goal ③ has been achieved.

The team members study hard and raise their grades ④ enough to fulfill the contract. Later, the team competes in the state basketball tournament. The players fail to win the final, but they achieve ⑤ far more important something: belief in themselves, as well as hope for a brighter future in life beyond the basketball court.

10 윗글의 밑줄 친 ①~⑤ 중, 어법상 틀린 것을 모두 고르시오.

① ② ③ ④ ⑤

11 윗글의 내용을 한 문장으로 요약할 때, 빈칸 (A), (B)에 들어갈 말로 가장 적절한 것은?

When Cruz expressed his ____(A)____ to Carter, Carter may have found what he had taught ____(B)____ .

	(A)		(B)
①	appreciation	⋯	ashamed
②	anxiety	⋯	beneficial
③	rage	⋯	trustworthy
④	gratitude	⋯	rewarding
⑤	depression	⋯	regretful

1 다음 글의 빈칸 (A)~(C)에 들어갈 말을 〈보기〉에서 찾아 쓰시오.

> Carter: I'm Ken Carter, your new basketball coach.
> (*One of the players tosses a ball to another player, ignoring Coach Carter.*)
> You, what's your name, sir?
> Lyle: _____ (A)
> Carter: Starting today, you are a sir. You all are. "Sir" is a term of respect. All of you will have my respect until you abuse it. (*He gives out some pieces of paper.*) These are contracts. If you sign and honor this, we'll be successful.
> _____ (B)
> Cruz: This is crazy! By the way, why are you wearing a suit and tie?
> Carter: What's your name, sir?
> Cruz: Timo Cruz, sir.
> Carter: Well, Mr. Cruz, when we treat ourselves with respect ...
> (*Cruz does not listen and starts bouncing the ball.*)
> _____ (C)
> Cruz: Fine. I don't need to listen to you anymore. I quit. (*He walks out of the gym.*)

> 〈보기〉
> ⓐ It states that you will attend all of your classes and maintain a 2.3 grade point average.
> ⓑ All right, Mr. Cruz, leave the gym right now.
> ⓒ Jason Lyle, but I'm not a sir.

(A) _____

(B) _____

(C) _____

2 다음 글의 밑줄 친 ⓐ~ⓓ를 어법에 맞게 고쳐 쓰시오.

> Carter teaches the players ⓐ stay focused and play together as a team. Cruz realizes how tough life is off the court and how much basketball means to him. Later, the team wins an inspiring victory while Cruz watches from the crowd. Eventually, he decides to come back.
> (*Cruz comes into the gym.*)
> Cruz: How can I get back on the team?
> Carter: If you want to rejoin the team, you need to do 1,000 pushups and 1,000 laps around the gym—by Friday.
> Other players: That's impossible!
> (*Cruz starts doing push-ups. Carter continues ⓑ coach.*)
> (*On Friday*)
> Carter: It's Friday, but you still have 100 push-ups and 100 laps ⓒ go. It's time to give up, Mr. Cruz.
> Lyle: I'll do them for him, Coach. You said we're a team. When one person struggles, we all struggle. When one player triumphs, we all triumph, right?
> Kenyon: I'll do some, too. Come on, guys, let's help him out!
> (*Other players do push-ups together with Cruz. Carter seems ⓓ impress.*)

ⓐ _____

ⓑ _____

ⓒ _____

ⓓ _____

Carter: Gentlemen, in this hand, I have the contracts you signed. In this hand, I have academic progress reports from your teachers. The gym will stay locked until we all satisfy the terms of this contract.

Cruz: But why? We're undefeated, and we won the tournament. Didn't you want us to win?

Carter: That's not the point. What's more important than winning is respecting the rules and taking responsibility for your behavior. If you don't realize that, you'll never succeed or even adjust to the real world. 나는 이 계약을 준수하는 것이 여러분이 여러분의 인생에서 책임을 지는 첫 단계라고 믿는다. Now, I want you to go home, look at your lives tonight, and ask yourself, "Do I want a better life?" If the answer is yes, then I promise you I will do everything in my power to get you to a better life.

(*The athletes are deep in thought.*)

3 윗글의 밑줄 친 우리말과 일치하도록 〈보기〉에 주어진 단어를 배열하시오. (필요 시 형태를 변형할 것)

〈보기〉 the first / responsibility / step / you / take / be / for / to

I believe honoring this contract _____

in your life.

4 다음 두 문장의 참(True)과 거짓(False)을 구분하고 판단의 근거가 되는 문장을 윗글에서 찾아 쓰시오.

(1) The gym won't be opened unless the athletes fulfill the contract.

(2) Carter thinks winning games is the best way to improve students' lives.

번호	True / False	근거 문장
(1)		
(2)		

5 다음 글의 밑줄 친 우리말과 일치하도록 주어진 단어를 이용하여 문장을 완성하시오.

Cruz: Sir, they can open the doors of the gym, but they can't make us play. We're going to fulfill the contract, sir. Now we know what's important in life, and it's all because of you. Thank you, sir.

Carter: Gentlemen, there's only one way to say this: We've achieved our goal.

The team members study hard and raise their grades enough to fulfill the contract. Later, the team competes in the state basketball tournament. The players fail to win the final, but they achieve something far more important: 농구 경기장 밖의 삶에 있어 더 밝은 미래에 대한 희망뿐만 아니라 그들 자신에 대한 믿음.

_____ _____ _____, _____

_____ _____ _____ _____

_____ _____ _____ in life beyond the basketball court.

(belief, in, as well as, a brighter future)

Last week, I visited an ① exhibition of artwork and ancient items selected from the Kansong Art Museum's collection. The exhibition included information about the man who gathered all of the artwork displayed there. His name was Jeon Hyeongpil, but he is better known by his pen name, Kansong. He was born into a rich family in 1906 and lived through the Japanese occupation of Korea. At the age of 24, he inherited a massive ② fortune. After carefully thinking about what he could do for his country, he decided to use the money to protect Korea's cultural heritage from the Japanese. This decision was greatly influenced by his mentor, Oh Sechang, who was an ③ independence activist and had keen ④ insight into Korean art. With Oh's guidance and his own ⑤ convictions, Kansong devoted most of his fortune to acquiring old books, paintings, and other works of art. He considered these items the pride of the nation and believed they represented the national spirit. 그의 행동이 없었다면, 그것들은 파괴되었거나 해외로 반출되었을지도 모른다.

1 윗글을 읽고 답할 수 없는 질문으로 가장 적절한 것은?

① What kind of exhibition did "I" go to last week?
② What was Kansong's real name?
③ Who influenced Kansong's decision to use his money?
④ What did Kansong do with his money?
⑤ Who donated the money to help Kansong?

2 윗글의 밑줄 친 우리말과 일치하도록 주어진 단어를 이용하여 문장을 완성하시오. (필요 시 형태를 변형할 것)

Without his actions, _____

(would, destroy, take overseas)

3 윗글의 밑줄 친 ①~⑤의 영영 뜻풀이가 적절하지 않은 것은?

① exhibition: a collection of items displayed for the public to see
② fortune: a large amount of money
③ independence: freedom from outside control
④ insight: the ability to imagine how another person feels
⑤ conviction: a deep, strong belief

4 다음 글의 밑줄 친 ①~⑤ 중, 어법상 틀린 것은?

As soon as I walked in, I could not help ① admiring some ink-and-water paintings by Jeong Seon, a famous Korean artist also ② known as Gyeomjae. These paintings were kept in an album called the *Haeak jeonsincheop*. They depict the beautiful scenery of Geumgangsan Mountain and ③ its surrounding areas. The way Gyeomjae painted the mountains, rivers, and valleys makes them look very inviting. I was shocked when the museum tour guide said that the album was almost burned as kindling. Fortunately, it ④ rescued at the last minute and later purchased by Kansong. ⑤ Knowing that these beautiful paintings were nearly turned to ashes made me feel very sad.

① ② ③ ④ ⑤

5 다음 글의 흐름으로 보아, 주어진 문장이 들어가기에 가장 적절한 곳은?

However, Kansong refused to part with it because he knew that it was the most magnificent vase of its kind.

The next item that impressed me was a gorgeous porcelain vase called the *Celadon Prunus Vase with Inlaid Cloud and Crane Design*. It is a pleasant shade of green, with a

lovely pattern of clouds and cranes encircling the entire vase. (①) The cranes seem to be alive and stretching their wings in search of freedom. (②) Kansong bought the vase from a Japanese art dealer in 1935. (③) With the money he spent on it, Kansong could have bought 20 nice houses! (④) Later, a different Japanese collector offered double the price Kansong had paid for the vase. (⑤) Today it is listed as one of Korea's National Treasures. Seeing it in person was an absolutely breathtaking experience!

① ② ③ ④ ⑤

[6~9] 다음 글을 읽고, 물음에 답하시오.

Finally, I saw the one item in the museum that I will never forget—an original copy of the *Hunminjeongeum Haerye*.

(A) When the Japanese were finally defeated, he was able to share it with the rest of Korea. The guide said that the *Hunminjeongeum Haerye* is the museum's most precious treasure. Without it, the origins and fundamentals of Hangeul would have been lost to history. It has since been ⓐ designated a National Treasure of Korea and included in the UNESCO Memory of the World Register.

(B) This ancient book write in 1446, and it explains the ideas and principles behind the creation of Hangeul, the writing system of the Korean language. It was found in Andong in 1940. At that time, however, Korea was still ⓑ occupied by Japan. The Japanese colonial government intended to get rid of the Korean language. Schools were forbidden to teach lessons in Korean, and scholars who studied Korean were arrested.

(C) From the moment he heard that the *Hunminjeongeum Haerye* had been discovered, Kansong couldn't stop thinking about it. He knew he had to ⓒ protect it at

all costs. After years of waiting, he was finally able to obtain the book. He purchased it at ten times the price the owner was asking and carefully ⓓ hid it in his house.

Looking at the ancient book, I could feel Kansong's strong commitment to ⓔ distorting Korean history.

6 윗글의 (A)~(C)를 바르게 배열하시오.

_____ → _____ → _____

7 윗글을 읽고, 추론할 수 없는 것은?

① "I" would never forget the Hunminjeongeum Haerye.
② Kansong showed what he possessed to the public after the Japanese were defeated.
③ In 1940, it was not permitted to teach lessons in Korean at school.
④ Kansong's mentor reminded him of the value of the Hunminjeongeum Haerye.
⑤ Kansong paid more money for the book than the owner was asking.

8 윗글의 밑줄 친 ⓐ~ⓔ 중, 문맥상 낱말의 쓰임이 적절하지 않은 것은?

① ⓐ ② ⓑ ③ ⓒ ④ ⓓ ⑤ ⓔ

9 윗글의 밑줄 친 write를 어법에 맞게 고쳐 쓰시오.

[10~11] 다음 글을 읽고, 물음에 답하시오.

Standing in the middle of the exhibition hall, surrounded by Korean art, I could not stop thinking about Kansong. He was an amazing person! ⓐ He did not collect art for his personal enjoyment. He (A) did it to protect Korea's cultural identity during the harsh Japanese colonial period. After Korea regained its independence, he stopped collecting art, as

he knew ⓑ <u>it</u> would safely remain in Korea. During our country's worst time, a single man was able to defend Korea's national spirit and pride. Thanks to him, we are still able to experience an essential part of Korean culture today.

Founded in 1938, the Kansong Art Museum was Korea's first private museum. When Kansong built ⓒ <u>it</u>, he named it Bohwagak. He used the building as a place to store all of the important cultural items he had collected over the years. Kansong died in 1962, and ⓓ <u>it</u> was renamed the Kansong Art Museum in 1966. ⓔ <u>It</u> now holds about 5,000 items, including 12 Korean National Treasures.

10 밑줄 친 (A)가 의미하는 것을 윗글에서 찾아 쓰시오. (단, 과거 시제로 변형할 것)

_____ _____

11 윗글의 밑줄 친 ⓐ~ⓔ가 가리키는 대상이 <u>잘못</u> 연결된 것은?

① ⓐ – Kansong
② ⓑ – independence
③ ⓒ – the Kansong Art Museum
④ ⓓ – Bohwagak
⑤ ⓔ – the Kansong Art Museum

12 다음 글의 제목으로 가장 적절한 것은?

The act of creating things based on nature is called "biomimicry." This term is derived from the Greek words *bios*, meaning "life," and *mimesis*, meaning "imitation."

Architects who use biomimicry look at nature as an incredibly successful engineer who has already come up with answers to some of the problems they now face. They carefully study plants, animals, and other aspects of nature to learn how they work. As a result, they have been able to find some innovative solutions to engineering and architectural challenges.

① Secrets of successful Engineers
② Nature as an Inspiration for Architects
③ Biomimicry: Good or Bad for Human Health?
④ Severe Conflict between Nature and Humans
⑤ Architectural Challenges Worldwide

[13~15] 다음 글을 읽고, 물음에 답하시오.

Gaudi believed that all architects should look to nature for inspiration. He preferred the curves found in natural objects to the straight lines found in artificial ones. This preference can be seen in all his buildings, including the Sagrada Familia. Many parts of the church incorporate images and forms from nature. For example, the church's spires are topped with spheres that resemble fruits. There are also turtles carved into the stone bases of columns and spiral stairs that resemble the shells of sea creatures.

Perhaps the most impressive feature of the Sagrada Familia is the ceiling. Gaudi designed the columns inside the church to resemble trees and branches, so visitors who look up can feel <u>마치 그들이 울창한 숲속에 서 있는 것처럼</u>. The light that comes through the small holes all over the ceiling even resembles the light beaming through leaves in a forest. These tree-like columns are not just for decoration, though. Inspired by trees, Gaudi gave the columns a single base that splits off into branches near the top. This allows them to support the roof better by distributing its weight evenly. Because Gaudi recognized the superiority of natural forms, he was able to design a building that is both beautiful and functional.

13 윗글의 내용을 한 문장으로 요약할 때, 빈칸 (A), (B)에 들어갈 말로 가장 적절한 것은?

Gaudi preferred the ____(A)____ beauty of nature, so he designed not only beautiful but also ____(B)____ buildings.

	(A)		(B)
①	straight	⋯	fabulous
②	straight	⋯	functional
③	curving	⋯	practical
④	curving	⋯	ordinary
⑤	curving	⋯	uniform

14 윗글을 읽고, 추론할 수 없는 것은?

① The Sagrada Familia resembled some features found in nature.
② The Sagrada Familia had spiral stairs resembling the shells of sea creatures.
③ The light from the ceiling of the Sagrada Familia is reflected back to leaves.
④ Gaudi got inspiration from trees when designing the church's columns.
⑤ The columns Gaudi designed are not just for beautifying buildings.

15 윗글의 밑줄 친 우리말을 바르게 영작한 것은?

① if they stand in a great forest
② as if they stand in a great forest
③ as if they have stood in a great forest
④ as if they were standing in a great forest
⑤ even if they were standing in a great forest

[16~17] 다음 글을 읽고, 물음에 답하시오.

The Eastgate Centre is an office building and shopping complex in Harare, Zimbabwe. Built in 1996, it might not be as (A) visual / visually impressive as the Sagrada Familia. However, the building is an excellent example of biomimicry. (B) Because / Due to Harare shows the hot climate, air conditioning systems can be very costly to install, run, and maintain. To solve this problem, the building's architect, Mick Pearce, turned to termite mounds for a(n) _____.

Termite mounds are large structures built by certain termite species. Scientists believe that the mounds stay cool because of a constant flow of air. Each mound has a network of holes referred to as chimneys. It has a large central chimney and smaller outer chimneys that are close to the ground. The heat generated by the

daily activity of the termites (C) rise / rises up through the central chimney, eventually escaping through the top of the mound.

16 (A), (B), (C)의 각 네모 안에서 어법에 맞는 표현으로 가장 적절한 것은?

	(A)		(B)		(C)
①	visual	⋯	Due to	⋯	rise
②	visual	⋯	Because	⋯	rises
③	visually	⋯	Because	⋯	rise
④	visually	⋯	Because	⋯	rises
⑤	visually	⋯	Due to	⋯	rise

17 윗글의 빈칸에 들어갈 단어를 영영 뜻풀이를 참고하여 쓰시오.

something that can be used instead of the usual choice

[18~19] 다음 글을 읽고, 물음에 답하시오.

Also, the soil ⓐ (둘러싸고 있는) the mound ① absorbs heat in the hot daytime hours. Therefore, the temperature inside the mound does not increase greatly and stays relatively ② hot. At night, when the outside temperature goes down, the heat is finally released. This process ③ inspired Pearce to design an innovative climate control system.

The Eastgate Centre was constructed without a ⓑ (전형적인) cooling system. Instead, Pearce used building materials that can ④ store large amounts of heat. The floors and walls of the building absorb heat during the day, just like the soil of a termite mound. The heat is released at night, and the walls cool down, ready to store heat again by the next morning.

The structure of the building also helps keep the building cool. There are openings near the base of the building, and outside air ⑤ comes into the building through them. This air is moved through the building by a system

of automatic fans. Eventually, the air, along with heat generated by human activity during the day, rises upward through the building's ⓒ (내부의) open spaces and is released through chimneys on the roof.

18 윗글의 밑줄 친 ①~⑤ 중, 문맥상 쓰임이 적절하지 않은 것은?

① ② ③ ④ ⑤

19 윗글에 주어진 ⓐ~ⓒ를 활용하여 문장을 완성하시오. (단, 주어진 글자로 시작할 것)

ⓐ s _____

ⓑ c _____

ⓒ i _____

20 다음 글의 빈칸에 들어갈 말로 가장 적절한 것은?

Using biomimicry in architecture is just one way that humans are utilizing the lessons of nature to improve the way we do things. Biomimicry is also being used to solve problems in the fields of robotics, agriculture, and many others. _____ not only helps solve problems, but it also makes us feel closer to nature. As a result, humans are more likely to stop destroying the environment and start becoming part of it instead.

① Imitating the ideas of nature
② Understanding the principles of architecture
③ Introducing an innovative cooling system
④ Applying inspirations from human culture
⑤ Protecting the environment from pollution

21 다음 글의 빈칸에 공통으로 들어갈 단어를 쓰시오.

One day, a girl was playing in the park. She saw a photograph on the ground and picked it up. She saw a cute boy in the photograph, _____ made her cheeks turn red. She took the photograph home and put it in a box. Eventually, she forgot about it. Twenty years

later, she got married. One day, her husband opened the box and found the photograph. He asked, "Who is the little boy in this picture?" She answered that it was her first love, _____ made her husband smile. He said, "I lost this photograph when I was nine years old."

22 다음 글의 흐름으로 보아 〈보기〉의 연극 지시문이 들어가기에 가장 적절한 곳은?

Carter: Good afternoon, gentlemen. I'm your new basketball coach, Ken Carter.
 (The players ignore him and chat with each other.)
 Maybe I should speak louder. I'm Ken Carter, your new basketball coach.
 (①)
 You, what's your name, sir?
Lyle: Jason Lyle, but I'm not a sir.
Carter: Starting today, you are a sir. You all are. "Sir" is a term of respect. All of you will have my respect until you abuse it.
 (②)
 These are contracts. If you sign and honor this, we'll be successful. It states that you will attend all of your classes and maintain a 2.3 grade point average.
Cruz: This is crazy! By the way, why are you wearing a suit and tie?
 (③)
Carter: What's your name, sir?
Cruz: Timo Cruz, sir.
Carter: Well, Mr. Cruz, when we treat ourselves with respect …
 (④)
 All right, Mr. Cruz, leave the gym right now.
Cruz: Fine. I don't need to listen to you anymore. I quit. (⑤)

〈보기〉
(A) (Cruz walks out of the gym.)
(B) (Carter gives out some pieces of paper.)

(C) (Cruz does not listen and starts bouncing the ball.)

	(A)	(B)	(C)		(A)	(B)	(C)
①	②	…	①	…	④	② ④ … ⑤ … ①	
③	④	…	④	…	②	④ ⑤ … ② … ④	
⑤	⑤	…	①	…	③		

23 다음 글을 읽고, 추론할 수 없는 것은?

Carter teaches the players to stay focused and play together as a team. Cruz realizes how tough life is off the court and how much basketball means to him. Later, the team wins an inspiring victory while Cruz watches from the crowd. Eventually, he decides to come back.

(Cruz comes into the gym.)

Cruz: How can I get back on the team?

Carter: If you want to rejoin the team, you need to do 1,000 push-ups and 1,000 laps around the gym—by Friday.

Other players: That's impossible!

(Cruz starts doing push-ups. Carter continues coaching.)

(On Friday)

Carter: It's Friday, but you still have 100 push-ups and 100 laps to go. It's time to give up, Mr. Cruz.

Lyle: I'll do them for him, Coach. You said we're a team. When one person struggles, we all struggle. When one player triumphs, we all triumph, right?

Kenyon: I'll do some, too. Come on, guys, let's help him out!

(Other players do push-ups together with Cruz. Carter seems impressed.)

① Cruz had a hard time outside the gym.
② Cruz wanted to join the basketball team again.
③ Some players refused to let Cruz come back to the team.
④ Cruz didn't finish the mission by Friday.
⑤ Carter was touched by the other players' effort to help Cruz.

24 다음 글의 흐름으로 보아 빈칸에 들어갈 말로 가장 적절한 것은?

Parent 1: Basketball is all these boys have. Should Carter be allowed to take that away from them?

Other parents: (*shouting*) No!

Board Chairman: Quiet! Let's hear from Coach Carter.

Carter: You really need to consider the message that you're sending these boys: that they are above the law. I'm trying to teach them _____. If these kids don't honor a simple contract, it won't be long before they're out there in society breaking laws.

① modesty
② emotions
③ sports
④ discipline
⑤ satisfaction

25 다음 글의 밑줄 친 ①~⑤를 바르게 고치지 않은 것은?

① Though Carter's speech, the board votes to unlock the gym. Carter is about to resign, but he decides to visit the gym one last time. There, he sees something ② shocked. All the players are studying together.

Cruz: Sir, they can open the doors of the gym, but they can't make us play. We're going to fulfill the contract, sir. Now we know what's important in life, and it's all ③ because you. Thank you, sir.

Carter: Gentlemen, there's only one way to say this: We've achieved our goal.

The team members study hard and ④ raised their grades enough to fulfill the contract. Later, the team competes in the state basketball tournament. The players fail to win the final, but they achieve something ⑤ very more important: belief in themselves, as well as hope for a brighter future in life beyond the basketball court.

① In spite of
② shocking
③ because of
④ raise
⑤ a lot of

Memo

지은이

김성곤	서울대학교 영어영문학과
윤진호	동덕여자고등학교
구은영	前 동덕여자고등학교
전형주	경기상업고등학교
서정환	여의도고등학교
이후고	용산고등학교
김윤자	구일고등학교
김지연	㈜NE능률 교과서개발연구소
백수자	㈜NE능률 교과서개발연구소

내신 100신 기출 예상 문제집
High School English I 능률(김성곤 외)

펴 낸 이	주민홍
펴 낸 곳	서울특별시 마포구 월드컵북로 396(상암동) 누리꿈스퀘어 비즈니스타워 10층 (주)NE능률 (우편번호 03925)
펴 낸 날	2019년 3월 5일 초판 제1쇄 2024년 12월 15일 제13쇄
전 화	02 2014 7114
팩 스	02 3142 0356
홈페이지	www.neungyule.com
등록번호	제 1-68호
I S B N	979-11-253-2654-0 53740
정 가	14,000원

NE 능률

고객센터

교재 내용 문의 : contact.nebooks.co.kr (별도의 가입 절차 없이 작성 가능)

제품 구매, 교환, 불량, 반품 문의 : 02-2014-7114

☎ 전화문의는 본사 업무시간 중에만 가능합니다.

빠른 독해를 위한 바른 선택

시리즈 구성

- 기초세우기
- 유형독해
- 구문독해
- 수능실전

1 최신 수능 경향 반영
최신 수능 경향에 맞춘 독해 지문 교체와
수능 기출 문장 중심으로 구성 된 구문 훈련

2 실전 대비 기능 강화
실제 사용에 기반한 사례별 구문 학습과 최신 수능 경향을 반영한
수능 독해 Mini Test로 수능 유형 훈련

3 서술형 주관식 문제
내신 및 수능 출제 경향에 맞춘 서술형 및 주관식 문제 재정비

NE능률 교재 MAP

아래 교재 MAP을 참고하여 본인의 현재 혹은 목표 수준에 따라 교재를 선택하세요.
NE능률 교재들과 함께 영어실력을 쑥쑥~ 올려보세요!
MP3 등 교재 부가 학습 서비스 및 자세한 교재 정보는 www.nebooks.co.kr에서 확인하세요.

교과서/
내신

중1	중2	중2-3	중3
중학영어1 자습서 [김성곤_2015 개정]	중학영어2 자습서 [김성곤_2015개정]	생활 일본어 자습서 [2015 개정]	중학영어3 자습서 [김성곤_2015 개정]
중학영어1 평가문제집 1학기 [김성곤_2015 개정]	중학영어2 평가문제집 1학기 [김성곤_2015개정]	생활 중국어 자습서 [2015 개정]	중학영어3 평가문제집 1학기 [김성곤_2015 개정]
중학영어1 평가문제집 2학기 [김성곤_2015 개정]	중학영어2 평가문제집 2학기 [김성곤_2015개정]		중학영어3 평가문제집 2학기 [김성곤_2015 개정]
중학영어1 자습서 [양현권_2015 개정]	중학영어2 자습서 [양현권_2015 개정]		중학영어3 자습서 [양현권_2015 개정]
중학영어1 평가문제집 1학기 [양현권_2015 개정]	중학영어2 평가문제집 1학기 [양현권_2015 개정]		중학영어3 평가문제집 1학기 [양현권_2015 개정]
중학영어1 평가문제집 2학기 [양현권_2015 개정]	중학영어2 평가문제집 2학기 [양현권_2015 개정]		중학영어3 평가문제집 2학기 [양현권_2015 개정]

고1	고1-2	고2	고2-3	고3
영어 자습서 [김성곤_2015 개정]	영어 I 자습서 [2015 개정]	영어 독해와 작문 자습서 [2015 개정]	영어 II 자습서 [2015 개정]	
영어 평가문제집 [김성곤_2015 개정]	영어 I 평가문제집 [2015 개정]	영어 독해와 작문 평가문제집 [2015 개정]	영어 II 평가문제집 [2015 개정]	
내신100신 기출예상문제집_영어1학기 [김성곤_2015]	내신100신 기출예상문제집_영어 I [2015 개정]	영어 회화 자습서 [2015 개정]	내신100신 기출예상문제집_영어II [2015 개정]	
내신100신 기출예상문제집_영어2학기 [김성곤_2015]	실용 영어 자습서 [2015 개정]			
영어 자습서 [양현권_2015 개정]	실용 영어 평가문제집 [2015 개정]			
영어 평가문제집 [양현권_2015 개정]	일본어 I 자습서 [2015 개정]			
	중국어 I 자습서 [2015 개정]			

High School
English I

능률(김성곤 외)

내신신

100

기출 예상 문제집

정답 및 해설

A Spark in You

어휘 만점 | **Vocabulary Check-Up** p. 7

01. 부상을 입은, 다친 **02.** ~에게 맞다 **03.** (몸이) 탄탄한 **04.** ~을 무서워하다 **05.** 다친 **06.** ~을 …에 참여시키다 **07.** ~을 응시하다 **08.** 서투른 **09.** 신속히, 빨리 **10.** ~하는 데 어려움을 겪다 **11.** 크게 놀란 **12.** 훌륭하게 **13.** 어울리다[맞다] **14.** ~에 익숙해지다[친숙]하다 **15.** 때때로 **16.** 말문이 막힌 **17.** 놀라서 **18.** 특히 **19.** 기이한, 놀라운 **20.** 선두에 서다 **21.** 불꽃놀이 **22.** (수영 등에서 팔을) 젓기 **23.** acknowledgement **24.** make a correction **25.** genuine **26.** improve **27.** participate in **28.** struggle **29.** on the opposite side **30.** become used to **31.** in silence **32.** all the way **33.** knock into **34.** sweep **35.** encouragement **36.** limited **37.** make fun of **38.** hesitate **39.** rescue **40.** look after **41.** as soon as **42.** emerge **43.** avoid **44.** chase after

문법 만점 | **Point Check-Up** pp. 8~9

1. (1) had been doing (2) had borrowed (3) had never been **2.** (1) that (2) which (3) whom

문법 만점 | **확인 문제** pp. 10~11

01. (1) had never seen (2) had been waiting (3) had been working **02.** (1) whom (2) that (3) X **03.** ④ **04.** (1) that he had been looking for (2) had been chatting online for an hour (3) had never given a speech in public (4) anything that I can do for you **05.** (1) had, dreamed (2) had wanted (3) felt **06.** ⓐ, ⓑ, ⓒ **07.** ③

01. (1) 판다를 본 적이 없는 것은 중국을 방문하기(visited) 전의 일이므로 과거완료 시제가 와야 한다.
(2) 그들이 도착한(arrived) 과거 시점 이전부터 그녀가 기다려 왔으므로 과거완료 진행형이 와야 한다.
(3) Harry가 우리 팀에서 일해온 것은 그가 다른 회사로 가기(went) 전의 일이므로, 과거완료 진행형이 와야 한다.

02. (1) whom은 the reporter를 선행사로 하는 목적격 관계대명사이므로 생략할 수 있다.
(2) that은 the test를 선행사로 하는 목적격 관계대명사이므로 생략할 수 있다.

(3) 전치사가 목적격 관계대명사 앞에 온 경우에는 목적격 관계대명사를 생략할 수 없다.

03. ④ 「전치사+관계대명사」의 형태에서 목적격 관계대명사를 생략할 수 없으므로 in 뒤에 which를 쓰거나, in을 관계대명사절 끝으로 옮겨야 한다.

05. (1) 내가 꿈꾼 것은 작년에 Jordan에 갈 기회를 얻기(got) 전의 일이므로 과거완료 시제를 쓰는 것이 적절하다.
(2) Petra를 보러 가기를 원했던 것은 그것을 보기(saw) 전의 일이므로 과거완료 시제를 쓰는 것이 적절하다.
(3) 그것을 본 것(saw)과 느낀 것이 같은 시점에서 일어난 일이므로 과거 시제를 쓰는 것이 적절하다.

06. ⓐ, ⓑ, ⓒ는 목적격 관계대명사이므로 생략할 수 있다. ⓓ, ⓔ는 the one을 선행사로 하는 주격 관계대명사이므로 생략할 수 없다.

07. ⓑ 「전치사+관계대명사」의 형태로 쓸 때는 관계대명사 that을 쓰지 않는다.
ⓓ 과거완료 부정형은 「had not[never] v-ed」로 쓴다.

본문 만점 | **빈칸 채우기** pp. 18~21

(1) a British teacher **(2)** was injured and alone **(3)** decided to help **(4)** in the school dormitory **(5)** written by **(6)** From the first day **(7)** seemed to be **(8)** struggled with **(9)** neither strong nor athletic **(10)** involved him in the game **(11)** had not prepared him **(12)** avoided conversation **(13)** had trouble fitting in **(14)** Looking after **(15)** to the school swimming pool **(16)** As soon as **(17)** had been living **(18)** had been damaged **(19)** where the fish come from **(20)** Without further encouragement **(21)** knocked into the wall **(22)** the opportunity to study **(23)** the awkward way that **(24)** turning swiftly **(25)** how much he was enjoying **(26)** they were watching **(27)** was astonished **(28)** if he could swim **(29)** Are you sure **(30)** him so excited **(31)** were shining with joy **(32)** Without hesitating **(33)** was ready to **(34)** Not only could **(35)** written for **(36)** took the lead **(37)** so close that **(38)** we had become used to **(39)** are able to **(40)** without looking directly at me **(41)** how to swim **(42)** the first time **(43)** without making any corrections **(44)** were extraordinary **(45)** to swim with a penguin **(46)** a turning point **(47)** grew quickly **(48)** he participated in **(49)** The encouragement and acknowledgement given by **(50)** became more popular **(51)** Thanks to

01. that **02.** shy **03.** nor **04.** limited **05.** Looking **06.** living **07.** because **08.** where **09.** had **10.** familiar **11.** Using **12.** as though **13.** to worry **14.** could Diego **15.** close **16.** making **17.** were **18.** had **19.** race **20.** encouragement

01. O **02.** X, were → was **03.** X, helping → to help **04.** X, give → gave **05.** O **06.** O **07.** O **08.** X, frightening → frightened **09.** X, strongly → strong **10.** O **11.** X, prepare → prepared **12.** O **13.** X, whom → who **14.** X, were → was **15.** O **16.** X, see → to see **17.** X, damaging → damaged **18.** O **19.** X, knock → knocked **20.** X, study → to study **21.** O **22.** O **23.** X, was he → he was **24.** X, astonishing → astonished **25.** X, lately → late **26.** O **27.** X, he → him **28.** O **29.** X, what → that **30.** X, magnificent → magnificently **31.** X, wrote → written **32.** O **33.** X, such → so **34.** X, became → become **35.** O **36.** O **37.** X, look → looking **38.** X, swimming → swim **39.** O **40.** X, make → making **41.** O **42.** X, went → had gone **43.** O **44.** O **45.** X, participate → participated **46.** X, giving → given **47.** X, week → weeks **48.** O

1. ③ 2. ⑤ 3. ④ 4. ② 5. ⓒ → ⓐ → ⓑ 6. ② 7. ② 8. ④ 9. (c)hased (a)fter 10. they swam so close that they almost touched 11. ⑤ 12. ⑤ 13. ① 14. (A) respect (B) popular 15. ④

1. 소녀가 피아노 오디션에서 계속 떨어지는 소년을 격려하는 상황이므로 ③ '너는 결국에는 성공할 거야'라고 하는 것이 자연스럽다.
 오답
 ① 네가 자초한 일이야
 ② 너는 정말 친절하구나
 ④ 너는 한번 해보는 게 좋겠어
 ⑤ 너는 그것을 하기 전에 재차 생각해야 해

2. ⓔ의 his는 Tom Michell을 가리키고, 나머지는 모두 Juan Salvado라는 이름의 펭귄을 가리킨다.

3. ③ Diego는 수업을 힘겨워했고 어떤 방과 후 활동도 그에게 적합

해 보이지 않았다.

4. 역접의 연결어 However(하지만)로 시작하는 주어진 문장 '하지만, Diego는 Juan Salvado와 함께 있는 것을 즐겼다.'는 Diego가 영어 지식이 부족해 대화를 피했다는 내용 뒤, 확실히 테라스에서는 긴장을 풀 수 있었다는 내용 앞인 ②에 오는 것이 가장 적절하다.

5. ⓒ 깃털이 다친 펭귄이 학교에서 몇 달간 지낸 후 ⓐ 화자가 펭귄을 학교 수영장으로 데려 갔고 ⓑ 다른 사람들이 수영장을 나가자마자 그를 물에 데려 갔다.

6. ② Juan Salvado가 물을 가로질러 수영장 반대쪽 벽에 부딪혔지만 다치지 않았다.

7. ② 선행사 the way와 관계부사 how는 함께 쓰지 않으므로 how를 that으로 고치거나 생략해야 한다.

8. 화자는 Diego가 수영을 못하면 구하려고 했으나 빈칸 뒤에 그가 훌륭하게 수영하는 내용이 나오므로, 빈칸에는 ④ '나는 걱정할 필요가 전혀 없었다'가 오는 것이 가장 적절하다.
 오답
 ① 그는 제대로 준비되지 않았다
 ② 수영은 배우기 어려웠다
 ③ Juan Salvado는 혼자 수영하는 것을 좋아했다
 ⑤ Diego는 몇몇 악기를 연주할 수 있었다

9. '따라잡기 위해서 빠르게 따라가다'라는 의미의 표현은 chase after(~을 쫓다)이며, 과거형인 chased after로 써야 한다.

10. '너무 ~해서 …하다'라는 의미의 「so ~ that …」 구문이 쓰인 문장이다.

11. ⑤ Diego가 자신의 이야기를 할 때 화자는 조용히 들었다고 했으므로 문맥상 Diego의 영어에 대해 지적했다고 하는 것은 적절하지 않다. 따라서 with(~와 함께)를 without(~ 없이) 등으로 고쳐야 한다.

12. (A)와 ⑤(그녀는 책장 옆에서 잡지를 읽기 시작했다.)의 by는 '~ 옆에'라는 의미이다.
 오답
 ① 우리는 모두 폭력 범죄의 증가로 인해 불안해한다.
 ② 너는 전화로 티켓을 예약할 수 있다.
 ③ 그녀는 보험을 파는 것으로 생계를 유지한다.
 ④ 서류들은 다음 주 금요일까지 준비되어야 한다.

13. ① 자동사 emerge(모습을 드러내다)는 수동태로 쓰지 않으므로 been emerged를 emerged로 고쳐야 한다.

14. (A) 다른 친구들이 진심으로 격려와 인정을 해주었다고 했으므로 그가 존경(respect)을 받았다고 하는 것이 적절하다. neglect는 '방치'라는 뜻이다.
 (B) 다른 친구들에게 인정을 받았고 성적도 올랐다고 했으므로 인기(popular)가 더 많아졌다고 하는 것이 적절하다. silent는 '조용

한'이라는 뜻이다.

15. (A) 앞에는 축구 선수로서 화자의 단점이 나오고 뒤에는 한계에 굴복하지 않았다는 내용이 나오므로, 역접을 나타내는 연결어 However(그러나)가 적절하다.

(B) 앞에는 화자의 노력이 나오고 뒤에는 점점 향상되어 팀에서 가장 많은 득점을 냈다는 결과가 나오므로, As a result(결과적으로)가 적절하다.

오답

moreover: 게다가 thus: 따라서 for example: 예를 들어
nonetheless: 그럼에도 불구하고

2회 내신 기출 문제 pp. 30~32

1. ② 2. ④ 3. ④ 4. (c)ompany 5. ③ 6. ③ 7. ④ 8. Not only could Diego swim 9. ② 10. ④ 11. without making any corrections to his English 12. ② 13. ⓐ had gone ⓑ given 14. ⑤

1. ② 소녀가 Cervantes는 57세에 소설 「돈키호테」를 출간했다고 말한 후에 소년이 그가 대기만성형이라고 했으므로, early(일찍)를 late(늦게) 등으로 고쳐야 한다.

2. ④ Michell이 그 새(펭귄)를 돕기로 결심했다는 내용 뒤에 주어진 문장 '그는 그것을 닦고 먹이고 Juan Salvado라는 이름까지 지어 주었다.'가 오는 것이 자연스럽다. 주어진 문장의 대명사 it이 가리키는 것은 ④의 앞 문장에 제시된 the bird이다.

3. ④ neither A nor B: A와 B 둘 다 아닌

4. '당신과 어떤 사람이 함께하는 상태, 당신과 함께 하는 사람 또는 사람들'이라는 의미의 단어는 company(함께 있음; 함께 있는 사람(들))이다.

5. 펭귄이 물에서 멋지게 수영하는 내용이므로, 분위기로는 ③(활기차고 즐거운)이 가장 적절하다.

오답

① 차분하고 아늑한 ② 긴장되고 긴박한
④ 시끄럽고 무서운 ⑤ 환상적이고 신비로운

6. ③ 화자는 Juan Salvado가 육지에서 걷는 어설픈 방식에만 익숙해져 있다가 능숙하게 수영하는 모습을 보는 내용이므로, 슬퍼하며(in sorrow) 보았다고 하는 것은 적절하지 않다. 따라서 sorrow를 awe(경이로움, 경외심) 등으로 고쳐야 한다.

7. ④ 화자는 Diego가 수영을 못할 경우 뛰어들어 구할 준비를 했으나 그는 수영을 매우 잘했다고 했다.

8. 'A뿐만 아니라, B도'를 나타내는 「not only A, but (also) B」 구문에서 부정을 나타내는 not only가 문장 맨 앞으로 나와 조동사 could와 주어 Diego가 도치되었다.

9. Juan Salvado와 Diego가 조화롭게 수영하는 모습을 묘사한 내용이므로 ② '발레와 피아노가 아름답고 떼어 놓을 수 없게 연결되어 있다.'는 흐름과 관계없다.

10. (A)와 ④(많은 사람들은 친구가 중요하다고 생각한다.)의 that은 명사절을 이끄는 접속사이다.

오답

① 나는 초를 파는 가게를 찾았다. (주격 관계대명사)
② 나는 그것을 슈퍼마켓에서 가져왔다. (대명사)
③ 수학 시험에서 A를 받은 사람은 바로 John이었다. (「It is[was] ... that」 강조 구문)
⑤ 나는 모자와 긴 드레스를 입고 있는 저 여성을 본 적이 있다. (지시형용사)

11. 전치사 without의 목적어 역할을 하는 동명사 making의 형태로 써야 한다.

12. 외로웠던 소년이 수영을 통해 자신감을 얻고 친구들에게 인정을 받아 인생이 바뀌게 된 내용으로, ② '미운 오리 새끼가 백조가 되었다.'가 들어가는 것이 가장 적절하다.

오답

① 펭귄은 그를 우울하게 만들었다.
③ 외로운 소년은 그가 가진 모든 것을 잃었다.
④ Diego는 수영 수업을 듣는 것을 멈췄다.
⑤ 젊은 청년은 그의 과거의 행동을 후회했다.

13. ⓐ 아이가 물속에 들어간 것은 청년이 되어 밖으로 나온(had emerged) 것보다 더 먼저 일어난 일이므로 과거완료 had gone을 써야 한다.

ⓑ 격려와 인정이 소년에게 '주어진' 것이므로 과거분사 given을 써야 한다.

14. ⑤ Nabataeans는 Jordan의 고대 사람들이다.

1회 실전 적중 문제 pp. 33~35

1. ③ 2. ② 3. ④ 4. ② 5. ③ 6. because his feathers had been damaged 7. ③ 8. could see how much he was enjoying himself 9. ⑤ 10. ① 11. ⓐ excited ⓑ to worry ⓒ written 12. 때때로 그들은 너무 가까이 수영을 해서 거의 닿을 뻔했다. 13. ②, ⑤ 14. ④

1. 현재 무언가를 잘하지 못하더라도 성장형 마음가짐을 갖고 노력하는 것이 필요하다는 내용이므로, 주제로 가장 적절한 것은 ③ '성장형 마음가짐의 가치'이다.

오답

① 수업을 통과하는 방법 ② 도전의 의미
④ 당신의 한계를 아는 것의 중요성 ⑤ 노력하는 것의 어려움

2. ② 펭귄은 해변에서 발견되었다.

① Juan은 영국인 교사이다. (영국인 교사는 Tom Michell이고, Juan은 펭귄임)

③ Tom은 학교 기숙사에서 살지 않았다. (Tom은 학교 기숙사에서 살았음)

④ 아무도 Juan을 돕고 싶어 하지 않았다. (Diego가 돕고 싶어함)

⑤ Diego는 럭비를 할 만큼 충분히 강했다. (Diego는 강하지 않음)

3. ④ a shy boy를 선행사로 하는 주격 관계대명사 who 또는 that 이 와야 한다.

4. make fun of는 '～을 놀리다[비웃다]'라는 뜻으로, ② tease(놀리다)와 바꿔 쓸 수 있다.

① 칭찬하다 ③ 뒤쫓다 ④ 격려하다 ⑤ 다가가다

5. ③ 빈칸 앞에는 Diego가 영어 지식이 부족해서 대화를 피했다는 내용이 오고 빈칸 뒤에는 이와 상반된 내용인 Juan과 함께 있는 것을 즐겼다는 내용이 나오므로, 빈칸에는 역접의 연결어 However(하지만)가 들어가야 한다.

① 마찬가지로 ② 게다가 ④ ～하지 않는다면 ⑤ 예를 들어

6. 상처를 '입은' 것이므로 수동태로 나타내며, 과거 시제보다 더 이전에 일어난 일이므로 과거완료를 써야 한다.

7. 주어진 문장인 '다행히도, 그는 다치지 않았다!'는 펭귄이 물속으로 뛰어들어 물을 가로질러 가다 반대쪽 벽에 부딪혔다는 내용 바로 뒤인 ③에 들어가는 것이 가장 자연스럽다.

8. 동사구 could see 뒤에 「의문사+주어+동사」 어순의 간접의문문을 쓴다.

9. ⑤ Diego가 예상과는 달리 펭귄과 함께 멋지게 수영했다는 내용의 글이다.

10. ① 첫 번째 빈칸에는 '～인지 아닌지'의 의미로 명사절을 이끄는 접속사 if가, 두 번째 빈칸에는 '만약 ～라면'의 의미로 부사절을 이끄는 접속사 if가 들어가야 한다.

② ～하는 동안 ③ ～부터, ～ 때문에

④ ～ 후에 ⑤ ～ 때문에

11. ⓐ 그(him)가 감정을 느끼는 주체이므로 과거분사 excited로 쓴다.

ⓑ anything을 수식하는 형용사적 용법의 to부정사 to worry가 와야 한다.

ⓒ 이중주곡이 '쓰여진' 것이므로 과거분사 written이 와야 한다.

12. '너무 ～해서 …하다'를 나타내는 「so ~ that」 구문이 쓰인 문장이다.

13. ②, ⑤ 전치사 without의 목적어 역할을 하는 (동)명사가 와야 하

므로 without 뒤에 있는 동사원형 look과 make를 동명사 looking과 making으로 고쳐야 한다.

14. (A) 명사 the chance를 수식하는 형용사적 용법의 to부정사 to go가 적절하다.

(B) 화자가 그것을 본 것과 먼 과거와의 연결을 느낀 것은 같은 시점에 일어난 일이므로 과거시제 felt가 적절하다.

(C) 문장의 주어 역할을 하는 동명사 Seeing이 적절하다.

2회 실전 적중 문제 pp. 36~38

1. ⑤ 2. ⑤ 3. ④ 4. ④ 5. had been living 6. ③ 7. and he turned 8. ③ 9. rescue 10. seemed that he was truly alive for the first time 11. ④ 12. ③ 13. ① 14. ⑤

1. Cervantes가 어려움을 견디고 57세의 나이에 마침내 소설 「돈키호테」를 써서 명성을 얻었다는 내용이므로, 빈칸에는 ⑤ '잠재력에 도달하는 데 결코 늦은 때는 없다'가 들어가는 것이 적절하다.

① 빠르면 빠를수록 더 좋다 ② 좋은 책은 훌륭한 친구다

③ 많은 것을 시도하는 게 중요하다 ④ 행복은 무엇보다 건강에 있다

2. Tom Michell에 대해 소개하는 주어진 글 다음에, 그가 해변에서 펭귄을 발견하고 도와주기로 한 (C), 펭귄이 그의 학교 기숙사 방에서 함께 살게 되는 (B), Tom이 화자(I)가 되어 펭귄을 도와주길 원한 한 소년에 대해 이야기하는 (A) 순으로 이어지는 것이 자연스럽다.

3. ④ 동사 visited와 and로 연결된 병렬 구조이므로, 과거형 found로 써야 한다.

4. (A) Diego의 영어 지식이 제한되어(limited) 대화를 피했다고 하는 것이 적절하다. rich는 '풍부한'이라는 뜻이다.

(B) 소년들이 펭귄을 도와주는 내용이 나오므로 펭귄을 돌보는 것(Looking after)이 소년들에게 좋은 일이었다고 하는 것이 자연스럽다. kick out은 '내쫓다'라는 뜻이다.

(C) 깃털에 상처를 입어(damaged) 수영을 할 수 없었다고 하는 것이 적절하다. recover는 '회복하다'라는 뜻이다.

5. Juan Salvado는 몇 달 전부터 이야기가 진행되는 과거 시점까지 계속 학교에 살고 있었으므로 과거완료 진행형을 쓴다.

6. ③ 육지에서는 어설프게 걸어 다녔던 펭귄이 물속에서 멋지게 수영하는 장면을 묘사하는 글이다.

7. 밑줄 친 turning은 연속동작을 나타내는 분사구문을 이끄는 현재분사로, 「접속사+주어+동사」인 and he turned로 바꿔 쓸 수 있다.

8. ③ Diego는 수영장에 뛰어들기 전 얼마 동안 기다렸다. (Diego는 망설임 없이 뛰어들었음)

① 수영장 물은 차가웠다.

② Diego는 수영하고 싶었다.

④ Diego는 수영을 할 수 있었다.

⑤ Diego와 Juan은 함께 수영했다.

9. '좋지 않은 상황에서 어떤 사람이나 어떤 것을 내보내다'라는 뜻의 단어는 rescue(구하다, 구조하다)이다.

10. '~인 것 같다'는 의미의 「주어+seem to-v」는 「it seems that+주어 ~」로 바꿔 쓸 수 있다.

11. ⓓ는 화자(I)를 가리키는 반면, 나머지는 모두 Diego를 가리킨다.

12. (A) the sad little boy를 선행사로 하는 목적격 관계대명사 whom이 와야 한다.
 (B) 「be able to-v」: ~할 수 있다
 (C) 동사 told의 직접목적어 역할을 하는 명사절을 이끄는 접속사 that이 와야 한다.

13. ① 목적을 나타내는 부사적 용법의 to부정사인 to swim이 되어 야 한다.

14. ⑤ 펭귄과의 수영 덕분에 외로웠던 Diego의 삶이 바뀌게 되었다.

3회 실전 적중 문제 pp. 39~41

1. ④ 2. ④ 3. nor 4. ③ 5. ⓐ Taking 또는 To take ⓑ been 6. ④ 7. had never had the opportunity to study a penguin 8. (A) further (B) Luckily 9. ③ 10. ⑤ 11. ③ 12. ③ 13. his father had taught him how to swim 14. ④ 15. ⑤

1. ④ 문맥상 노력하면 마침내 성공할 것이라고 하는 것이 자연스러 우므로 abandon(포기하다)을 succeed(성공하다) 등으로 고쳐야 한다.

2. ④ Diego는 펭귄을 어떻게 도왔는가? (알 수 없음)
 ① Tom의 직업은 무엇인가? (교사)
 ② 펭귄은 어디에서 발견되었는가? (해변)
 ③ Tom은 펭귄을 위해 무엇을 했는가? (닦고, 먹이고, 이름을 지 어줌)
 ⑤ Diego는 어떤 성격을 가졌는가? (수줍음을 탐)

3. neither A nor B: A와 B 둘 다 아닌

4. 빈칸 앞의 내용으로 보아 영어 지식이 부족해서 ③ '그는 대화를 피했다'고 하는 것이 자연스럽다. 또한 빈칸 뒤에 역접의 연결어 However로 이어지는 내용인 Diego가 Juan과 함께 있는 것을 즐겼다는 것과 대조되어야 한다.

① 그는 영어를 잘했다

② 그는 친구들과 이야기했다

④ 그는 수업 듣는 것을 좋아했다

⑤ 그는 많은 친구들을 사귀었다

5. ⓐ 문장의 주어로 쓰였으므로 동명사나 to부정사의 형태로 써야 한다.
 ⓑ 앞에 had가 있으므로 과거완료 시제임을 알 수 있다. 따라서 be를 been으로 써야 한다.

6. ④ 소년들은 수영하는 Juan을 보며 마치 불꽃놀이를 보고 있는 것처럼 소리친 것이다.

7. 과거완료 부정형 「had never v-ed」 뒤에 명사 the opportunity 가 오고, 명사를 수식하는 형용사적 용법의 to부정사를 써야 한다.

8. (A) further는 '(정도가) 심한, 더 많은'의 의미이므로 뒤에 추상명 사 encouragement와 함께 쓰이는 것이 자연스럽다. farther는 '(거리가) 더 먼'의 의미이다.
 (B) 벽에 부딪혔지만 다치지 않았으므로 운이 좋았다고(Luckily) 하는 것이 적절하다. sadly는 '슬프게도'의 의미이다.

9. 주어진 문장은 '그러나, 나는 곧 걱정할 필요가 전혀 없다는 것을 깨달았다.'라는 의미로 Diego가 수영을 못하면 구하려고 했던 문 장 뒤, 그가 훌륭하게 수영을 해낸 문장 앞인 ③에 오는 것이 자연 스럽다.

10. ⑤ 처음에는 Diego가 수영을 할 수 있는지 몰라서 걱정했다가 (worried) 그가 수영하는 모습을 보고 놀랐을(amazed) 것이다.
 ① 행복한 → 걱정하는 ② 기쁜 → 충격적인
 ③ 외로운 → 행복한 ④ 화난 → 침착한

11. ⓒ to jump와 and로 병렬 연결되어 있으므로 (to) rescue로 써 야 한다.

12. 평소와 다른 모습으로 보이는 Diego에 대한 주어진 글 뒤에 (B) Diego가 수영을 매우 잘했다는 내용이 이어지고 (C) Diego가 아 버지에게 수영을 배웠다고 얘기했다는 내용이 온 후 (A) 그것이 Diego가 자신의 삶에 대해 처음 얘기한 것이었다는 내용으로 이 어지는 것이 자연스럽다.

13. 동사구 had taught 뒤에 간접목적어 him, 직접목적어 how to swim이 와야 한다.

14. ④ 친구들이 Diego를 존경했다고 했으므로, 그들의 격려와 인정 이 진실했다(genuine)고 하는 것이 자연스럽다.
 ① 거친 ② 지루한 ③ 쓸모없는 ⑤ 공격적인

15. ⓔ는 펭귄을 가리키고 나머지는 모두 Diego를 가리킨다.

1. ③ 2. ④ 3. none of the after-school activities seemed to suit him 4. ③ 5. had trouble fitting in 6. ④ 7. ① 8. ③ 9. was not even sure if he could swim 10. ⓐ excited ⓑ that ⓒ written 11. harmony 12. ① 13. 갑자기 Diego는 우리가 익숙해 있었던 그 슬픈 소년이 아니었다. 14. ③ 15. swim with a penguin

1. ③ 각각의 빈칸 앞뒤에 서로 상반되는 내용이 제시되어 있으므로, 빈칸에는 However(하지만)가 적절하다.
 【오답】
 ① 그러므로 ② 대신에 ④ 게다가 ⑤ 예를 들어

2. (A) 선행사 a penguin을 수식하는 주격 관계대명사 that이 적절하다.
 (B) 선행사 a shy boy를 수식하는 주격 관계대명사 that이 적절하다.
 (C) passed와 or로 병렬 연결되어 있으므로 과거형 involved가 적절하다.

3. 「none of+한정사+복수명사」: 아무[하나]도 (~않다[없다])
 「seem to-v」: ~인 것처럼 보이다

4. Diego와 그의 친구들이 Juan을 돌보고 수영장에 데려갔다는 내용이므로 ③ 'Diego와 그의 친구들은 같은 이유로 자주 싸웠다.'는 흐름과 관계없다.

5. 「have trouble v-ing」: ~하는 데 어려움을 겪다

6. ④ 수영을 전혀 할 수 없었던 이유는 깃털에 상처를 입었기(damaged) 때문이라고 하는 것이 가장 적절하다.
 【오답】
 ① 씻겨진 ② 올려진 ③ 꾸며진 ⑤ 가벼워진

7. ① 주어진 문장은 '더 격려하지 않아도, 그는 뛰어들었다.'는 의미로, 펭귄이 수영장에 들어가기 전, 물을 가로질러 날았다는 내용 앞에 오는 것이 자연스럽다.

8. ⓒ It은 놀라움을 유발하는 대상이므로 현재분사 amazing으로 쓰는 것이 적절하다.
 【오답】
 ⓐ what → where, ⓑ turned → turning, ⓓ shouting → shouted, ⓔ asking → asked로 고쳐야 한다.

9. 동사구 뒤에 '~인지 아닌지'를 나타내는 접속사 if가 이끄는 절을 써야 한다.

10. ⓐ 그(him)가 신이 난 감정을 느끼는 주체이므로 과거분사 excited로 써야 한다.
 ⓑ 뒤의 절이 완전하므로 동사 realized의 목적어 역할을 하는 명사절을 이끄는 접속사 that이 와야 한다.

11. ⓒ 이중주곡이 '쓰인' 것이므로 과거분사 written으로 써야 한다.

11. 【요약문】
 나의 예상과는 달리, Diego는 멋지게 수영을 했고 Juan과 조화를 이루었다. 그것은 마치 음악의 이중주곡 같았다.

12. (A) Diego가 수영을 정말 잘한다는 내용이 나오므로 특별한 재능(talent)을 가졌다고 하는 것이 적절하다. appearance는 '모습, 외모'라는 뜻이다.
 (B) Diego가 계속 말할 때 필자는 조용히 들었다고 했으므로 지적(corrections)하지 않았다고 하는 것이 자연스럽다. make a decision은 '결정하다,' make a mistake는 '실수하다'라는 뜻이다.

13. become used to: ~에 익숙해지다

14. ③ 펭귄과의 수영을 하고 난 뒤 Diego에게 일어난 변화에 대한 글이므로 앞에는 수영을 잘 해낸 Diego에 관한 내용이 오는 것이 적절하다.

15. Diego의 인생이 바뀌게 된 것은 펭귄과의 수영(swim with a penguin) 덕분이다.

1. ③ 2. ① 3. ⑤ 4. ① 5. damaged 6. to see if he would swim 7. ③ 8. familiar with the awkward way that Juan Salvado walked on land 9. ⑤ 10. (A) astonished (B) rescue 11. Diego는 수영을 할 수 있었을 뿐만 아니라 훌륭하게 수영을 해냈다! 12. ④ 13. ① 14. ③

1. ③ 소녀는 지역 사생 대회에서 입상하지 못해서 속상해하고 있으므로 소년이 소녀에게 기뻐하지(pleased) 말라고 하는 것이 아닌 낙담하지(discouraged) 말라고 하는 것이 자연스럽다.

2. ① Tom은 해변에서 홀로 있는 펭귄 한 마리를 발견했다.

3. ⑤ 문맥상 놀릴 때를 제외하고는 아무도 공을 패스하거나 끼워 주지 않는다고 해야 한다. 앞에 부정어 nobody가 있으므로 excluded(제외했다)가 아닌 included(포함시켰다) 등이 되어야 한다.

4. (A) 영어 지식이 부족해서 결과적으로 대화를 피했다고 하는 것이 자연스러우므로, 빈칸에는 so(그래서)가 적절하다.
 (B) 수영을 할 수 없었던 이유가 빈칸 뒤에 제시되어 있으므로, 빈칸에는 because(~ 때문에)가 적절하다.

5. '해를 입거나 좋지 않게 병이 난'을 나타내는 단어는 damaged(다친)이다.

6. Tom은 소년들과 함께 Juan이 수영을 하려고 하는지를 보기 위해 수영장에 데려갔다.

7. ③ 동시동작을 나타내는 분사구문으로, 생략된 주어인 그(he)가

'이용하는' 것이므로 현재분사 Using이 적절하다.

오답

① knocking → knocked, ② study → to study, ④ touched → touching, ⑤ was he → he was로 바꿔 써야 한다.

8. 「be familiar with」: ~에 익숙하다

9. ⓔ는 Juan을 가리키고 나머지는 모두 Diego를 가리킨다.

10. (A) 화자는 Diego가 수영을 할 수 있는지 알지 못하는 상황에서 그가 수영해도 되는지 묻자 크게 놀랐다(astonished)고 하는 것이 적절하다. frustrated는 '좌절감을 느끼는'의 의미이다.
(B) 화자는 Diego가 수영을 하지 못하는 상황을 대비하고 있으므로 rescue(구하다)가 적절하다. reveal은 '드러내다'의 의미이다.

11. not only A but (also) B: A뿐만 아니라 B도

12. ④ what 뒤의 절이 완전하므로 what 대신 told의 직접목적어 역할을 하는 명사절을 이끄는 접속사 that이 적절하다.

13. ① '그래서, Diego는 다른 학교로 옮겨야 했다.'는 Diego가 자신감이 커지고 학교에서 적응을 잘하게 되었다는 글의 내용과 관계 없다.

14. 밑줄 친 단어 extraordinary(기이한, 놀라운)와 바꿔 쓸 수 있는 단어는 ③ remarkable(놀랄 만한)이다.

오답

① 전형적인 ② 열정적인 ④ 분리된 ⑤ 전통적인

서술형으로 내신 만점 · pp. 48~50

1. found a penguin that was injured and alone 2. 그는 강하지도 않았고 체격이 좋지도 않았다. 3. ⑤ Diego (Gonzales) 4. his knowledge of English was limited 5. Looking after Juan Salvado was good for those boys. 6. ⓒ Using, 동시동작을 나타내는 분사구문으로, 생략된 주어(he)가 '사용하는' 것이므로 현재분사를 써야 함 7. ⓐ gone ⓑ excited ⓒ to jump 8. (1) ⓐ something, anything (2) ⓒ write, written (3) ⓔ touch, touched 9. (1) excellent (2) respected 10. (1) True, When the school had a swimming competition, he won every race he participated in. (2) False, Over the next few weeks, his grades improved and he became more popular.

1. 선행사 a penguin을 수식하는 주격 관계대명사절을 써야 하며, 펭귄이 '상처 입은' 것이므로 수동태인 was injured로 쓴다.

2. neither A nor B: A와 B 둘 다 아닌

3. ⑤는 Diego (Gonzales)를 가리키는 반면, 나머지는 모두 Tom Michell을 가리킨다.

4. Q: Diego는 왜 다른 사람과 대화하는 것을 원하지 않나?

A: 그의 영어 지식이 부족했기 때문이었다.

5. 동명사 Looking after가 문장의 주어 역할을 한다.

6. ⓒ 겨우 '한두 번의 날갯짓을 사용하면서'라는 의미로 동시동작을 나타내는 현재분사 Using이 되어야 한다.

7. ⓐ 「had never v-ed」의 과거완료 부정형이므로 과거분사 gone을 써야 한다.
ⓑ 지각동사 see의 목적격 보어로, 그(him)가 감정을 느낀 주체이므로 과거분사 excited로 써야 한다.
ⓒ 「be ready to-v」: ~할 준비가 되다

8. (1) ⓐ 부정문에는 something이 아닌 anything이 쓰인다.
(2) ⓒ 이중주곡이 '쓰여진' 것이므로 과거분사 written이 되어야 한다.
(3) ⓔ swam과 같은 시점인 과거에 일어난 일이므로 과거형 touched가 되어야 한다.

9. **요약문**

Diego는 수영에서 그의 (1) 탁월한 재능을 증명했고 반 친구들에게 (2) 존경을 받았다.

오답

ignore: 무시하다 ordinary: 평범한

10. (1) 'Diego는 학교 수영 대회에서 모든 경기를 우승했다.'는 참이며, 그 근거가 되는 문장은 '학교에서 수영 대회가 있을 때, 그는 참가한 경기마다 우승을 했다.'이다.
(2) 'Diego가 수영하느라 바빠서 그의 성적이 떨어졌다.'는 거짓이며, 그 근거가 되는 문장은 '다음 몇 주에 걸쳐서, 그의 성적은 향상되었고 그는 인기가 더 많아졌다.'이다.

Lesson 02 Embracing Our Differences

어휘 만점	Vocabulary Check-Up	p. 53

01. 명백하게 **02.** 외향적인 사람 **03.** 대담한 **04.** 짓밟다 **05.** ~을 할 수 있게[가능하게] 하다 **06.** 고무[격려]하다 **07.** ~을 강화하다 **08.** 다듬다, 손질하다 **09.** 공학 **10.** 존재 **11.** ~에 영향을 끼치다 **12.** 단지 ~만의 **13.** 동시에 **14.** 저항 **15.** 뛰어난 **16.** 결합하다 **17.** ~에게 동기를 주다, 자극하다 **18.** 통합시키다 **19.** 중대한, 결정적인 **20.** 협력하다 **21.** ~을 보고 **22.** (해답 등을) 찾아 내다[내놓다] **23.** boycott **24.** get tired of **25.** accomplish **26.** assertive **27.** deliberately **28.** assignment **29.** concentrate **30.** entrepreneur **31.** cope with **32.** complement **33.** rally **34.** assemble **35.** inspirational **36.** take risks **37.** recharge **38.** arrest **39.** furious **40.** injustice **41.** stand out **42.** categorize **43.** introvert **44.** civil rights

문법 만점	Point Check-Up	pp. 54~55

1. (1) find (2) to turn (3) laughing **2.** (1) O (2) O (3) X

문법 만점	확인 문제	pp. 56~57

1. (1) clean (2) that (3) to prepare **2.** (1) in this park that (2) Peter that[who] (3) on New Year's Day that **3.** (1) to avoid (2) to take advantage of (3) play **4.** (1) It was in the kitchen that he found (2) ordered the guards to put him (3) It is this man who found my passport (4) heard her brother complaining about **5.** (1) to deliver (2) to explain (3) to replace **6.** (1) It was you that[who] stole the cash (2) It was on Monday that I went there **7.** ④

1. (1) 사역동사 make는 목적어와 목적격 보어가 능동 관계일 때 목적격 보어로 동사원형을 취하므로 clean이 적절하다.
(2) 「It is ~ that ...」 강조 구문이 쓰인 것이므로 that이 적절하다.
(3) 동사 ask는 목적격 보어로 to부정사를 취하므로 to prepare가 적절하다.

2. (1), (3) It is[was]와 that 사이에 강조하고자 하는 어구를 쓴다.
(2) 강조하고자 하는 어구가 사람(Peter)이므로, that 대신 who를 쓸 수 있다.

3. (1) 동사 advise는 목적격 보어로 to부정사를 취하므로 to avoid로 고쳐야 한다.
(2) 동사 encourage는 목적격 보어로 to부정사를 취하므로 to take advantage of로 고쳐야 한다.
(3) 사역동사 let은 목적어와 목적격 보어가 능동 관계일 때 목적격 보어로 동사원형을 취하므로 play로 고쳐야 한다.

5. 동사 ask, want, expect는 모두 목적격 보어로 to부정사를 취하므로 괄호 안의 단어를 to부정사로 써야 한다.

6. (1) It was 뒤에 강조하는 어구 you(당신)를 쓰고, 강조 대상이 사람이므로 뒤에 that[who] 이하를 쓴다.
(2) It was 뒤에 강조하는 어구 on Monday(월요일)를 쓰고, 뒤에 that 이하를 쓴다.

7. ⓓ는 가주어 It이고, 나머지는 모두 「It is[was] ~ that ...」 강조 구문의 It이다.

본문 만점	빈칸 채우기	pp. 64~67

(1) to categorize people's personalities **(2)** One of the most common **(3)** tend to be drawn **(4)** by spending **(5)** are good at performing **(6)** on the other hand **(7)** are comfortable with taking risks **(8)** give up less easily **(9)** Based on all this information **(10)** their personalities complement each other **(11)** when they collaborate **(12)** a black woman named **(13)** were divided into **(14)** more and more passengers **(15)** ordered her to give **(16)** avoided standing out in public **(17)** had the courage to resist injustice **(18)** she was arrested **(19)** impressed many people **(20)** her quiet resistance **(21)** to support Parks's act of courage **(22)** good at motivating people **(23)** when people get tired of being pushed **(24)** with pride and hope **(25)** was enough to strengthen **(26)** struggle for civil rights **(27)** the buses were integrated **(28)** Think about how **(29)** would not have had **(30)** with her words **(31)** introverted and extroverted traits **(32)** had a huge impact on **(33)** letters appeared on a screen **(34)** allowed people to type **(35)** At the sight of **(36)** When he partnered with Jobs **(37)** the most famous partnerships **(38)** a way to polish **(39)** had opposite personalities **(40)** enabled him to focus on inventing **(41)** had outstanding social skills **(42)** face challenges that seemed impossible **(43)** the answer is neither **(44)** needs both **(45)** as well as **(46)** have a chance to work together

01. methods **02.** socialize **03.** coping **04.** that **05.** complement **06.** accomplish **07.** named **08.** the other **09.** drawing **10.** assembled **11.** when **12.** filled **13.** presence **14.** to boycott **15.** had **16.** excited **17.** see **18.** device **19.** that **20.** whereas

01. X, has → have **02.** X, divide → divides **03.** X, during → while **04.** X, spend → spending **05.** O **06.** X, focusing → focus **07.** O **08.** X, accurate → accurately **09.** O **10.** X, because of → because **11.** X, taking → take **12.** O **13.** O **14.** X, quiet → quietly **15.** X, give → to give **16.** O **17.** X, resisting → resist **18.** O **19.** X, was impressed → impressed **20.** O **21.** X, motivate → motivating **22.** O **23.** X, amazed → amazing **24.** X, to enough → enough to **25.** O **26.** O **27.** O **28.** O **29.** X, exciting → excited **30.** O **31.** O **32.** X, were appeared → appeared **33.** O **34.** X, what → that **35.** O **36.** X, more → most **37.** O **38.** O **39.** X, focus → to focus **40.** O **41.** X, which → that **42.** O **43.** O **44.** O **45.** O

1회 내신 기출 문제 pp. 73~75

1. (C)→(B)→(A) 2. ② 3. are good at performing tasks 4. ① 5. complement 6. ② 7. ⓐ named ⓑ to give ⓒ standing 8. ④ 9. ④ 10. ⑤ 11. ① 12. ④ 13. ③ 14. ③

1. 어떤 행동을 했는지 묻는 말 뒤에 (C) '오늘 아침에 그 애가 나한테 새 신발을 보여줬는데, 그 신발이 나한테는 너무 우스꽝스러워 보였어.'라는 대답이 오고, 이를 듣고 (B) '너 그걸 가지고 놀리지는 않았겠지, 그렇지?'라고 묻는 말이 이어지고, 이에 대한 대답으로 (A) '사실은, 그랬어. 노란 신발을 신는 사람이 어디 있니? 그 신발은 마치 커다란 바나나처럼 보였다고!'가 오는 것이 적절하다.

2. 주어진 문장 '외향적인 사람들은 과제를 빨리 하는 경향이 있다.'는 그들(외향적인 사람들)이 빠른 결정을 내린다는 부가적인 설명 앞인 ②에 오는 것이 적절하다.

3. '~을 잘하다'의 의미의 「be good at」이 쓰인 구문으로, 전치사 at의 목적어 역할을 하는 동명사 performing을 써야 한다.

4. ① 문장의 주어가 복수명사 many attempts이므로 has를 have로 고쳐야 한다.

5. '누군가 혹은 무언가와 좋은 조합을 만들다. 어떤 것과 결합했을

때 더 낮거나 매력적으로 보이게 하다'라는 의미의 단어는 complement(보완하다)이다.

6. Rosa Parks가 백인에게 자리를 양보하라는 버스 기사의 요구를 거절했다는 내용이므로 빈칸에는 ② resist(저항하다)가 오는 것이 적절하다.

오답

① 받아들이다 ③ 허락하다 ④ 격려하다 ⑤ 포기하다

7. ⓐ Rosa Parks라고 '불리는' 것이므로 과거분사 named가 적절하다.
ⓑ 「order+목적어+to-v」: ~에게 …하라고 명령하다
ⓒ 동사 avoid는 동명사를 목적어로 취한다.

8. ④ Rosa Parks는 그녀의 자리를 백인 승객에게 양보하라는 명령을 거절했다.

9. 주어진 글에서 Parks의 저항이 Martin Luther King Jr.의 인상적인 연설로 이어졌다고 했으므로, 연설하는 상황을 묘사하는 (C), 연설의 구체적인 내용이 제시된 (A), 그 후 Martin Luther King Jr.가 Parks에게 한 행동에 대한 (B)로 이어지는 것이 자연스럽다.

10. ⑤ 뒤에서 King은 적극적이고 사교적이라고 했으므로 introvert (내성적인 사람)를 extrovert(외향적인 사람) 등으로 고쳐야 한다.

11. 요약문

Rosa Parks와 Martin Luther King Jr. 사이의 동반자 관계 덕분에, 흑인 승객들은 더 이상 백인 승객들에게 그들의 자리를 포기하도록 강요 받지 않았다.

오답

② 시너지 효과 - 확인해 주다 ③ 협상 - 구입하다
④ 평화 - 항복하다 ⑤ 합의 - 떠나다

12. ⓒ suggest와 같이 제안의 의미를 나타내는 동사 다음에 온 that 절이 '~해야 한다'는 당위성을 나타낼 경우 that절의 동사는 「(should)+동사원형」의 형태로 써야 한다. 따라서 started를 (should) start로 고쳐야 한다.
ⓓ 문장의 동사 역할을 해야 하므로 forming을 동사의 과거형 formed로 고쳐야 한다.

13. ③ Wozniak과 Jobs는 둘 다 불가능해 보이는 도전에 맞서는 것을 두려워하지 않았다.

14. (A) 앞에서 화자는 Mia가 토론에 집중하지 않는다고 생각했으나 뒤에는 오해였다는 것을 깨닫는 내용이 나오므로 빈칸에는 However(하지만)가 적절하다.
(B) 앞에는 Mia가 생각을 정리할 시간이 필요했다는 내용이 나오고 뒤에는 화자가 Mia에게 그런 기회를 주지 못했다는 내용이 나오므로 빈칸에는 However(하지만)가 적절하다.

오답

fortunately: 다행히도 for example: 예를 들어
therefore: 그러므로 in addition: 게다가

2회 내신 기출 문제 pp. 76~78

1. ② 2. ④ 3. ② 4. recharge 5. ⑤ 6. ③ 7. ② 8. Her mere presence was enough to strengthen the crowd. 9. ④ 10. ④ 11. ⑤ 12. ④ 13. ① 14. ⓐ to deliver ⓑ to explain ⓒ to replace

1. ② 문화적 다양성의 장점에 대한 설문조사 결과이므로 빈칸에는 '긍정적인 영향'이 오는 것이 적절하다.
 오답
 ① 원인 ③ 예시 ④ 불리한 점 ⑤ 과정

2. (A) 빈칸 뒤에서 성격을 내향적인 사람과 외향적인 사람으로 구분하는 이 분류(this division)에 대한 내용이 제시되므로 빈칸에는 According to(~에 따르면)가 적절하다.
 (B) 빈칸 앞에는 외향적인 사람의 특징이 나오고 뒤에는 내향적인 사람의 특징이 나오므로 빈칸에는 on the other hand(반면에)가 적절하다.
 오답
 due to: ~ 때문에 in addition: 게다가
 instead of: ~ 대신에 therefore: 그러므로

3. 밑줄 친 (C)와 ②는 내향적인 사람들(Introverts)을 가리킨다. ①은 사람들, ③과 ④는 외향적인 사람들(Extroverts), ⑤는 내향적인 사람들과 외향적인 사람들(introverts and extroverts)을 의미한다.

4. '휴식을 취하는 것과 같이 기운을 되찾기 위해 어떤 것을 하다'는 의미의 단어는 recharge((에너지 등을) 충전하다)이다.

5. 백인 구역의 모든 좌석이 찬 상황에서 버스 기사가 Rosa Parks에게 명령한 내용이며 빈칸 뒤에서 그녀가 부당함에 저항했다고 했으므로 빈칸에는 ⑤ '그녀의 자리를 백인 승객에게 주다'가 적절하다.
 오답
 ① 버스에서 조용히 하다 ② 승객들 앞에서 말하다
 ③ 운전 중에 자리에 앉아 있다 ④ 흑인 구역으로 옮기다

6. ③ 문장의 주어가 all the seats이므로 was를 were로 고쳐야 한다.

7. ② 5,000명의 사람들이 집회에 '흩어졌다'고 하는 것은 어색하므로, scattered를 assembled(모였다) 등으로 고쳐야 한다.

8. 「enough to-v」: ~하기에 충분한

9. 주어진 문장은 '버스에서 자신의 자리를 양보하기를 거부하는 강력한 연설가는 같은 효과를 내지는 못했을 것이다.' 라는 의미로, 두 사람의 동반자 관계에 대해 생각해보자는 문장과 마찬가지로 Rosa Parks도 말로는 (King처럼) 군중을 흥분시키지 못했을 것이라는 문장 사이인 ④에 오는 것이 자연스럽다.

10. ④ 버스 거부 운동으로 버스가 통합되었다.

11. ⑤ Wozniak이 공학 아이디어를 내고, Jobs가 그것을 다듬고 포장해서 팔 방법을 찾았다.

12. 주어진 문장은 '명백하게도, 대답은 둘 중 어느 것도 아니다.'라는 의미로, 어떤 성격 유형이 더 좋은 것인지 질문하는 문장 뒤인 ④에 오는 것이 적절하다.

13. 서로 상반된 성격이 훌륭한 팀을 이룰 수 있다는 글이므로, 빈칸에는 ① '함께 일하다'가 오는 것이 적절하다.
 오답
 ② 우리의 잠재력에 도달하다 ③ 좋은 명성을 얻다
 ④ 우리의 성격을 바꾸다 ⑤ 우리의 능력 부족을 깨닫다

14. 「ask+목적어+to-v」: ~에게 …하도록 요청하다
 「want+목적어+to-v」: ~가 …하기를 원하다
 「expect+목적어+to-v」: ~가 …할 것이라고 기대하다

1회 실전 적중 문제 pp. 79~81

1. ④ 2. ③ 3. be drawn 4. on the other hand 5. deliberately 6. ⑤ 7. you might think that introverts and extroverts do not get along 8. ③ 9. ②, ④ 10. amazing 11. ② 12. ④ 13. how the partnership of these two people accomplished this 14. ② 15. ③

1. 소년의 팀 구성원들이 각자의 강점을 발휘해서 대회에서 1등을 했고 소녀가 서로 다른 사람들이 서로를 보완한다고 했으므로 요지로는 ④가 적절하다.

2. ③ 주어진 문장은 '가장 흔한 방법 중 하나는 사람들을 내향적인 사람과 외향적인 사람 두 가지 유형으로 구분하는 것이다.'라는 의미로, 사람들의 성격을 분류하려는 시도가 있어 왔다는 문장 뒤, 사람들을 내향적인 사람과 외향적인 사람으로 나누어 설명하는 내용 앞에 오는 것이 자연스럽다.

3. 내향적인 사람들이 내면세계에 '이끌려지는' 것이므로 수동태인 be drawn으로 써야 한다.

4. on the other hand: 반면에

5. '작은 세부 사항에 관심이나 주의를 기울이는 방식으로'라는 의미의 단어는 deliberately(신중하게)이다.

6. ⑤ Rosa Parks는 왜 체포되었는가? (백인 승객에게 자리를 양보하기를 거부해서)
 오답
 ① 내성적인 사람은 어떤 직업을 가지고 있는가?
 ② Rosa Parks는 몇 살이었는가?
 ③ Rosa Parks는 버스로 어디에 갔는가?
 ④ 버스에 얼마나 많은 사람이 있었는가?

7. 접속사 that이 동사 think의 목적어 역할을 하는 명사절을 이끄는 구조를 써서 문장을 완성한다.

8. ③ avoided의 목적어 역할을 하는 동명사 standing과 접속사 or로 병렬 연결되어 있으므로 drawing이 되어야 한다.

9. ② 'When 5,000 people assembled at a rally'에 제시되어 있다.
④ 'his words ... pride and hope'에 제시되어 있다.
오답
① Parks가 많은 사람들에게 깊은 인상을 주었다.
③ King이 적극적이고 사교적이었다.
⑤ King이 Parks를 포옹했다.

10. 능동의 의미로 '놀라운' 연설가라고 해야 하므로 현재분사 amazing으로 써야 한다.

11. ② 시간을 나타내는 선행사 a time을 수식하는 관계부사 when이 적절하다.

12. (A) 「inspire+목적어+to-v」: (목적어)가 ~하도록 고무[격려]하다
(B) refusing의 목적어 역할을 하는 to부정사 to give가 적절하다.
(C) 가정법 과거완료 구문이므로, 조동사의 과거형 뒤에 「have v-ed」 형태가 와야 한다. 따라서 excited가 적절하다.

13. Think about의 목적어 역할을 하는 간접의문문으로 「의문사+주어+동사」의 어순으로 배열한다.

14. ⓑ는 Wozniak을 가리키는 반면, 나머지는 모두 Jobs를 가리킨다.

15. (A)와 ③(그녀는 마침내 이야기할 누군가가 생겼다.)는 앞의 명사를 수식하는 형용사적 용법의 to부정사이다.
오답
① 그는 프라하로 여행할 계획을 세우고 있었다. (명사적 용법)
② 그 회사는 아시아 시장에 진출하고 싶어 한다. (명사적 용법)
④ 나는 깨어나서 내 옆에 앉아있는 내 애완동물을 발견했다. (부사적 용법)
⑤ 그들은 결승전에 져서 실망했다. (부사적 용법)

2회 실전 적중 문제　　　　　pp. 82~84

1. ② 2. ⑤ 3. ② 4. ① 5. ⓐ Extroverts ⓑ Introverts 6. ③
7. she had the courage to resist injustice 8. ② 9. ④ 10.
③ 11. ⑤ 12. ⓐ few ⓑ that 13. ① 14. need to respect
different personalities as well as our own

1. 문화적 다양성의 긍정적인 영향에 대한 내용으로, 문맥상 열린 마음을 갖고 ② '다른 문화를 존중하는 것'이 중요하다고 하는 것이 자연스럽다.
오답
① 다른 사람들의 충고를 피하는 것

③ 전통 문화를 보호하는 것
④ 다른 종교를 기꺼이 받아들이는 것
⑤ 다른 사람들이 우리의 신념을 받아들이도록 하는 것

2. ⑤ 외향적인 사람과 내향적인 사람이 가진 특징을 비교하며 설명하고 있다.

3. ② 주어가 One이므로 단수형 divides가 와야 한다.

4. (A) 뒤에서 내향적인 사람은 한 번에 한 가지 일에 집중하는 것을 좋아한다고 했으므로, 이와 대조적으로 외향적인 사람은 여러가지 일을 동시에(at once) 한다고 하는 것이 자연스럽다.
(B) 내향적인 사람은 더 신중하게 일한다고 했으므로 문맥상 덜(less) 쉽게 포기한다고 하는 것이 자연스럽다.
오답
respectively: 각각 more: 더 in turn: 차례로

5. ⓐ, ⓑ는 각각 앞 문장에 제시된 Extroverts(외향적인 사람들)와 Introverts(내향적인 사람들)를 지칭한다.

6. (A) based on: ~에 근거하여
(B) 흑인 여성이 Rosa Parks라고 '이름 지어진' 것이므로 과거분사 named가 적절하다
(C) 「order+목적어+to-v」: ~에게 …하라고 명령하다

7. 명사 the courage를 수식하는 형용사적 용법의 to부정사 to resist를 써야 한다.

8. ② 버스는 성별에 따라 두 구역으로 분리되었다. (백인과 흑인으로 분리됨)
오답
① 내향적인 사람들과 외향적인 사람들은 잘 협력할 수 있다.
③ 백인 구역의 모든 자리는 채워졌다.
④ Rosa Parks는 자리를 포기하도록 강요받았다.
⑤ Rosa Parks는 기사의 명령을 따르기를 거절했다.

9. get tired[sick] of: ~에 싫증 나다
오답
① ~에 관여하다 ② ~을 꺼내다
③ ~을 놀리다 ⑤ ~을 기대하다

10. ③ 'When 5,000 people assembled at a rally to support Parks's act of courage'에 제시되어 있다.

11. Parks의 행동과 King의 연설이 버스 이용을 거부하도록 고무했다는 내용의 주어진 글 다음에 거부 운동에 대해 설명하는 (C), 두 사람이 각각 상대방처럼 행동했다면 그만큼의 효과를 내지 못했을 것이라는 (B), 결국 두 사람의 성격이 결합하여 사회적인 영향을 미쳤다는 (A)로 이어지는 것이 자연스럽다.

12. ⓐ keys는 셀 수 있는 명사이므로 little을 few로 고쳐 a few로 표현한다.
ⓑ 뒤의 절이 완전하므로 suggested의 목적어 역할을 하는 명사절을 이끄는 접속사 that이 적절하다.

13. 뒤에 두 사람의 상반된 성격을 설명하고 있으므로 ① similar(비슷한)를 opposite(정반대의) 등으로 고쳐야 한다.

14. A as well as B: B뿐만 아니라 A도

3회 실전 적중 문제 pp. 85~87

1. ① 2. ⑤ 3. One of the most common methods divides people into two types 4. ④ 5. ④ 6. categorize 7. ④ 8. work well together because their personalities complement each other 9. ④ 10. ③,④ 11. ⑤ 12. ② 13. 버스가 통합됨 14. ⑤ 15. ⓐ to type ⓑ to polish

1. ① 부모님이 소년을 이해하지 못하시는 것 같을 때 좌절감이 든다는 소년의 입장 뒤에 소년이 예의 없다고 느꼈을 것이라는 아버지의 입장이 나오므로, 빈칸에는 However(하지만)가 들어가야 한다.

 [오답]
 ② 그렇지 않으면 ③ 예를 들어 ④ 보통 ⑤ 다행히

2. 빈칸 뒤에서 소년이 그렇게 행동한 이유와 아버지가 어떻게 대해 주셨으면 좋겠는지를 설명하라고 했으므로, 빈칸에는 ⑤ '네 아버지와 그 상황에 대해 이야기하다'가 적절하다.

 [오답]
 ① 컴퓨터 게임을 하지 않는다
 ② 다른 사람을 위협하지 않는다
 ③ 네 아버지를 이해하려고 노력하다
 ④ 노인들을 항상 존중한다

3. '가장 ~한 ⋯ 중 하나'는 「one of the＋최상급＋복수명사」 구문으로 나타낸다.

4. 주어진 문장 '반면, 내향적인 사람들은 한 번에 한 가지 일에 집중하는 것을 좋아하고 매우 잘 집중할 수 있다.'는 역접을 나타내는 연결어 on the other hand를 포함하므로, 문맥상 외향적인 사람들이 여러 가지 일을 동시에 처리한다는 문장 뒤인 ④에 오는 것이 적절하다.

5. ④ 외향적인 사람들이 과제를 빨리하는 경향이 있다.

6. '어떤 특성에 기반하여 하나의 유형으로 명시하거나 그룹에 넣다'라는 의미의 단어는 categorize(분류하다)이다.

7. ④ 뒤에서 Rosa Parks는 내향적인 사람이라고 했으므로 사람들 앞에서 두드러지거나 자신에게 관심이 집중되는 것을 즐겼다(enjoyed)고 하는 것은 자연스럽지 않다. 따라서 enjoyed를 avoided(피했다) 등으로 고쳐야 한다.

8. '~ 때문이다'는 because로 시작하는 절로 나타낸다.

9. ④ 두 개의 특정한 대상을 언급할 때 둘 중 하나는 one, 나머지 하나는 the other로 나타낸다.

10. ③ 군중이 어디에서 모였나? (알 수 없음)
 ④ King의 연설 이후에 Parks는 무슨 말을 했나? (알 수 없음)

 [오답]
 ① 집회의 목적은 무엇이었나? (Parks의 용감한 행동을 지지하기 위함)
 ② King은 무엇을 잘했나? (사람들에게 동기를 부여하는 것)
 ⑤ 누가 Parks를 포옹했나? (King)

11. ⑤ '~하기에 충분한'은 「enough to-v」로 나타내므로, to enough를 enough to로 고쳐야 한다.

12. (A) 빈칸 앞에 King이 Parks와 같은 행동을 했어도 동일한 효과를 내지 못했을 것이라는 내용이 오고 빈칸 뒤는 Parks가 집회에서 말로 군중을 흥분시키지 못했을 것이라는 비슷한 사례가 제시되므로, 빈칸에는 Similarly(마찬가지로)가 오는 것이 적절하다.
 (B) 두 성격의 결합으로 인해 (대중의) 관심이 집중되었다는 내용에 이어 사회에 큰 영향을 끼쳤다는 내용이 나오므로, 빈칸에는 Finally(결국)가 오는 것이 적절하다.

 [오답]
 however: 그러나 on the other hand: 반면에
 for example: 예를 들어 besides: 게다가

13. 'eventually the buses were integrated'를 통해 알 수 있다.

14. Wozniak이 개인용 컴퓨터를 만들었으며 뛰어난 발명가였다고 했으므로 빈칸에는 ⑤ '영리한 공학 아이디어를 내놓다'가 들어가는 것이 적절하다.

 [오답]
 ① 그들의 동반자 관계를 그만두다
 ② 다른 사람들의 충고를 받아들이다
 ③ 돈을 빌리다
 ④ 구식 장치에 투자하다

15. ⓐ allow는 목적격 보어로 to부정사를 취한다.
 ⓑ 명사 a way를 수식하는 형용사적 용법의 to부정사인 to polish가 되어야 한다.

4회 실전 적중 문제 pp. 88~90

1. ② 2. ⑤ 3. ⑤ 4. (A) fast (B) accurately 5. Extroverts are good at performing tasks under pressure 6. ③ 7. ④ 8. ②, ③ 9. ⑤ 10. ⑤ 11. ① 12. ⓐ appeared ⓑ (should) start 13. 그가 물건들을 발명하는 데 집중할 수 있게 해 준 것은 바로 이런 그의 내향적인 성격 특성이었다. 14. ② 15. ③

1. (A) 뒤에 소녀가 Dylan에게 한 행동을 말하고 있으므로, 바로 앞에는 ⓐ '네가 어떻게 했니?'가 오는 것이 적절하다.
 (B) 빈칸 뒤에서 소녀가 Dylan을 놀렸다는 것을 알 수 있으므로 빈칸에 ⓒ '너 그걸 가지고 놀리지는 않았겠지, 그렇지?'가 오는 것이 적절하다.

(C) 소년이 뒤이어 그것(it)을 존중해야 하며 Dylan에게 사과하라고 충고하고 있으므로, 빈칸에는 ⓑ '모든 사람은 자기만의 취향이 있어.'가 오는 것이 적절하다. it이 가리키는 것은 ⓑ의 own taste 이다.

2. ⑤ 외향적인 사람들은 재충전하기 위해 혼자 시간을 가질 필요가 있다. (내향적인 사람들의 특성임)

> **오답**
>
> ① 모든 사람은 같지 않다.
> ② 어떤 이들은 사람들의 성격을 종류별로 나누려고 한다.
> ③ 내향적인 사람들은 생각과 감정에 흥미를 느끼는 경향이 있다.
> ④ 외적인 활동들은 외향적인 사람들에게 더 관심을 끈다.

3. ⑤ 「by v-ing」: ~함으로써

4. (A) 앞 문장에서 외향적인 사람들은 과제를 빨리한다고 했으므로 결정을 빠르게(fast) 내린다고 하는 것이 적절하다. slow는 '느린'이라는 의미이다.
(B) 내향적인 사람들은 신중하게 일한다고 했으므로 일을 더 정확하게(accurately) 한다고 하는 것이 적절하다. carelessly는 '부주의하게'라는 의미이다.

5. 「be good at v-ing」: ~에 능숙하다
under pressure: 압박감 속에서

6. 흑인과 백인 구역으로 자리가 나뉜 버스 안에서 흑인 여성이 겪은 상황에 대한 내용이므로, ③ '일부 사람들은 버스 요금을 지불할 돈이 없었다.'는 글의 흐름과 관계없다.

7. ④ 백인 승객을 위해 자리를 양보하라는 버스 기사의 명령을 흑인인 Parks가 거부하여 체포됐다.

8. ②, ③ 첫 번째와 두 번째 빈칸에는 각각 at((장소) ~에), be good at(~을 잘하다), 세 번째와 네 번째 빈칸에는 get tired of(~에 싫증 나다), 마지막 빈칸에는 fill A with B(A를 B로 채우다) 구문이 쓰인 것이다.

9. ⑤ '그녀의 존재 그 자체'를 제외한 나머지는 모두 Parks가 했던 행동을 의미한다.

10. ⑤ King이 연설을 했고 Parks의 존재가 군중에게 힘을 주었다.

11. **요약문**
Parks와 King의 내향적인 기질과 외향적인 기질이 <u>결합</u>하자, 이 동반자 관계는 사회에 큰 <u>영향</u>을 미쳤다.

> **오답**
>
> disaster: 재앙 separated: 분리된 added: 추가된
> damage: 손상

12. ⓐ 자동사 appear은 수동형으로 쓰지 않으므로 appeared로 고쳐야 한다.
ⓑ suggest(제안하다) 뒤의 that절이 '~해야 한다'는 당위성을 나타낼 경우, that절의 동사는 「(should)+동사원형」의 형태로 쓴다.

13. 「It is[was] ~ that …」 강조 구문으로, '…하는 것은 바로 ~이다[였다]'라고 해석한다.

14. 주어진 문장은 '그래서 어떤 성격 유형이 더 좋은 것일까?'라는 의미로, 이에 대한 대답 앞인 ②에 오는 것이 적절하다.

15. Wozniak과 Jobs의 성격을 대조적으로 설명하고 있으므로, 빈칸에는 ③ whereas(반면에)가 들어가는 것이 적절하다.

> **오답**
>
> ① 그래서 ② 만약 ~라면 ④ ~ 때문에 ⑤ ~하는 한

5회 실전 적중 문제

1. ⑤ 2. ③ 3. ③ 4. ① 5. (a)t (o)nce 6. ⑤ 7. She avoided standing out in public or drawing attention to herself.
8. 그녀의 존재는 그 자체만으로 군중에게 힘을 주기에 충분했다.
9. ⓐ motivating ⓑ being trampled 10. ④, ⑤ 11. bravery
12. ④ 13. ③ 14. ④

1. ⑤ 소년이 Bill과 찍은 사진을 소셜 미디어에 올려 Bill이 화가 났다는 내용이므로, 소녀가 소년에게 그 사진을 올려야(upload) 한다고 충고하는 것은 적절하지 않다. 따라서 upload를 remove(삭제하다) 등으로 바꿔야 한다.

2. 사람의 성격을 내향성과 외향성으로 나누어 설명하는 내용이므로, ③ '어떤 사람들은 성격을 혈액형에 따라 구별한다.'는 흐름과 관계 없다.

3. (A)와 ③(어떤 사람들은 주스를 좋아하는 반면, 다른 사람들은 좋아하지 않는다.)의 while은 '반면에'라는 의미이다.

> **오답**
>
> ① 나는 잠시 동안 휴식을 취할 필요가 있다.
> ② 내가 공부하려고 하는 동안 나를 괴롭히지 마!
> ④ 그는 컴퓨터를 사용하면서 먹고 있다.
> ⑤ 내가 떠나있는 동안 아기를 돌봐줘.

4. 외향적인 사람들이 과제를 빨리하는 경향이 있다고 했으므로 ⓐ '과제를 빨리함'이 적절하다. ⓑ~ⓓ는 모두 내향적인 사람들의 특징이다.

> **오답**
>
> ⓑ 과제를 덜 쉽게 포기함
> ⓒ 무언가를 하기 전에 생각함
> ⓓ 한 번에 하나의 일에 집중함

5. at once: 동시에

6. ⑤ Parks는 불의에 저항할 용기가 있었고, 기사의 명령을 거절했다.

7. 동사 avoid를 과거형 avoided로 바꾸고, avoided의 목적어 역할을 하는 동명사 standing out과 drawing을 접속사 or로 병렬 연결하여 문장을 완성한다.

정답 및 해설 **13**

8. mere: 단지 ~만의
「enough to-v」: ~하기에 충분한

9. ⓐ 전치사 at의 목적어 역할을 하는 동명사 motivating으로 써야
한다.
ⓑ 사람들이 '짓밟히는' 것이므로 수동형 be trampled로 써야 하
며, 전치사 of의 목적어 역할을 해야 하므로 동명사구 being
trampled가 적절하다.

10. ④ 버스는 어떻게 나누어졌나? (알 수 없음)
⑤ King은 연설 후에 무엇을 했나? (알 수 없음)
오답
① 시민 평등권을 위한 투쟁의 중요한 전환점은 무엇이었나? (몽
고메리 흑인 공동체의 버스 이용 거부)
② 거부 운동은 며칠 동안 지속되었나? (381일)
③ 거부 운동의 결과는 무엇이었나? (버스가 통합됨)

11. '위험에 직면했을 때 두려움이 없는 것'을 의미하는 단어는
bravery(용기)이다.

12. ④ '가장 ~한 … 중 하나'를 나타내는 「one of the+최상급+복수
명사」 구문이 쓰였으므로 partnerships로 고쳐야 한다.

13. ③ Wozniak은 뛰어난 발명가라고 했으므로 문맥상 공학 아이디
어를 '생각해 내다(come up with)'라고 하는 것이 적절하다.
오답
① 뒤집다 ② 돌보다 ④ 비웃다 ⑤ 기대하다

14. ④ 서로 다른 성격을 존중하고 함께 일할 때 위대한 일을 할 수 있
다는 내용의 글이다.

서술형으로 내신 만점 pp. 94~96

1. They make fast decisions and are comfortable with
taking risks. 2. 그들의 성격이 서로를 보완하기 때문에 3. ⓐ
were divided into ⓑ watched ⓒ standing ⓓ to resist 4.
she answered calmly with a single word—"No" 5. (1)
ⓓ when, 시간을 나타내는 선행사 a time을 수식하는 관계부사
when을 써야함 (2) ⓔ being pushed, 사람들이 햇빛으로부터
'밀려나는' 것이므로 수동형이 적절하며 전치사 of의 목적어 역
할을 해야 하므로 being은 동명사 형태로 유지함 (3) ⓕ to
strengthen, '~하기에 충분한'을 나타내는 「enough to-v」 구
문을 써야 함 6. ⓐ to type ⓑ (should) start ⓒ to polish
7. formed one of the most famous partnerships of the
digital era 8. (1) ⓐ working, worked (2) ⓑ what, that
(3) ⓓ communicate, communicating 9. 명백하게도, 대답
은 둘 중 어느 것도 아니다. 10. need to respect different
personalities as well as our own

1. 문장의 주어는 They로, 동사는 and로 병렬 연결된 make와 are
로 쓴다.

2. 'because their personalities complement each other'에 그
이유가 제시되어 있다.

3. ⓐ 버스가 '나누어진' 것이므로 수동태를 쓴다.
ⓑ took과 접속사 and로 병렬 연결되었으므로 과거형을 쓴다.
ⓒ avoid는 동명사를 목적어로 취하는 동사이다.
ⓓ 명사 the courage를 수식하는 형용사적 용법의 to부정사를
쓴다.

4. 'However, she had the courage ... a single word—"No."'에
Rosa Parks의 행동이 제시되어 있다.

5. ⓓ 시간을 나타내는 선행사 a time을 수식하는 관계부사 when이
적절하다.
ⓔ 사람들이 햇빛으로부터 '밀려나는' 것이므로 수동형으로 쓰며,
전치사 of의 목적어 역할을 하므로 being pushed가 적절하다.
ⓕ 「enough to-v」: ~하기에 충분한

6. ⓐ 「allow+목적어+to-v」: ~가 …하게 하다
ⓑ suggest와 같이 제안의 의미를 나타내는 동사 다음에 온 that
절이 '~해야 한다'는 당위성을 나타낼 경우 that절의 동사는
「(should)+동사원형」의 형태로 써야 하므로, 동사원형인 start 그
대로 유지하거나 앞에 should를 써도 된다.
ⓒ 명사 a way를 수식하는 형용사적 용법의 to부정사로 써야 한
다.

7. 「one of the 최상급+복수명사」: 가장 ~한 … 중 하나

8. ⓐ 문장의 동사 역할을 하며 hated와 접속사 and로 병렬 연결되
어 있으므로 worked로 고쳐야 한다.
ⓑ 「It is[was] ~ that …」 강조 구문이므로 what을 that으로 고
쳐야 한다.
ⓓ 전치사 at의 목적어 역할을 하는 동명사 communicating이
적절하다.

9. neither: (둘 중) 어느 것도 ~아니다

10. 「need to-v」: ~할 필요가 있다
A as well as B: B뿐만 아니라 A도

We Are All Connected

어휘 만점 Vocabulary Check-Up p. 99

01. 종 **02.** 이산화탄소 **03.** ~을 완전히 파괴하다, 없애 버리다 **04.** 지배적인, 우세한 **05.** 명백한 **06.** ~의 원인이 되다 **07.** 보존하다 **08.** 용어 **09.** ~을 나타내다 **10.** 생태학의 **11.** 위협하다 **12.** 노력하다 **13.** 영향을 끼치다 **14.** 초목 **15.** 유지하다 **16.** 상호 연결된 **17.** 아종 **18.** (동식물이) 멸종 위기에 처한 **19.** 줄어들다 **20.** 접하다, 마주치다 **21.** 서식지 **22.** ~에도 불구하고 **23.** illegal **24.** depict **25.** worship **26.** organization **27.** predict **28.** volunteer **29.** rely on **30.** release **31.** plantation **32.** inhabit **33.** run out of **34.** climate change **35.** sustainable **36.** fossil fuel **37.** prey on **38.** electricity **39.** exception **40.** predator **41.** nonprofit **42.** extinct **43.** estimate **44.** decrease

문법 만점 Point Check-Up pp. 100~101

1. (1) X (2) you are (3) they were **2.** (1) were (2) had (3) is

문법 만점 확인 문제 pp.102~103

01. (1) he[my brother] was (2) she was (3) I am **02.** (1) While staying in Korea (2) as if she were my mother (3) as if he were an expert **03.** (1) crying (2) knew (3) washing **04.** (1) as if she is rich (2) as if he were involved (3) as if it weren't[were not] there **05.** ⑤ **06.** (1) as if he knew everything (2) as if I didn't know how to do **07.** ④

1. 양보(although)나 시간(while, when)을 나타내는 부사절의 주어가 주절의 주어와 같고 동사가 be동사이므로, 부사절의 「주어+be동사」가 생략된 형태이다.

3. (1) 시간의 접속사 While 뒤에 the baby was가 생략된 형태이므로 현재분사 crying이 적절하다.
(2) 실제로 그가 배우들을 개인적으로 알지 못하지만 아는 것처럼 말하는 것이므로 동사의 과거형을 쓴다.
(3) 시간의 접속사 When 뒤에 you are가 생략된 형태이므로 현재분사 washing이 적절하다.

4. (1) Helen이 부자인지 아무도 모른다고 했으므로 직설법으로 나타낸다.

(2), (3) 주절과 같은 때의 사실이 아닌 일을 가정하고 있으므로 「as if+가정법 과거」로 나타낸다.

5. (A) 부사절에 「주어+be동사」가 있으므로 현재분사를 써서 진행을 나타내는 것이 적절하다.
(B), (C) 시간의 접속사(When, while)가 이끄는 절에서 「주어+be동사」가 생략된 형태이므로 현재분사가 오는 것이 적절하다.

7. ⓑ 실제로는 어른이지만 마치 그가 아이인 것처럼 말하지 말라는 내용이므로 「as if+가정법 과거」로 나타낸다. 따라서 is를 were로 고쳐야 한다.
ⓔ 양보의 접속사(Though)가 이끄는 부사절이므로 「주어+be동사」인 she was를 모두 생략하거나, was 앞에 she를 써야 한다.

본문 만점 빈칸 채우기 pp.110~113

(1) by switching off **(2)** helps us save energy **(3)** How does this work **(4)** one of the world's largest **(5)** move silently and remain unseen **(6)** Imagine how ancient people **(7)** It is no surprise that **(8)** The fact that **(9)** tigers were found all across Asia **(10)** has been shrinking **(11)** are the main reasons **(12)** it was estimated that **(13)** have become extinct **(14)** living in the wild **(15)** will disappear **(16)** It would be very sad **(17)** watch programs about them **(18)** worried about protecting human beings **(19)** in order to protect ourselves **(20)** This is because **(21)** if tigers became extinct **(22)** they prey on **(23)** Without tigers **(24)** begin to disappear **(25)** birds and insects to lose **(26)** we rely on nature for everything **(27)** can threaten **(28)** imagine what would happen **(29)** referring to species **(30)** must conserve their habitat **(31)** being held over them **(32)** it is obvious that **(33)** is created by burning **(34)** is released into **(35)** a number of negative effects **(36)** One of these places **(37)** as much as **(38)** By conserving energy **(39)** the last person to leave **(40)** when shopping **(41)** are made with **(42)** are being destroyed to build **(43)** is produced in a more sustainable way **(44)** this environmentally friendly **(45)** Look for it the next time **(46)** many other things you can do **(47)** share important information **(48)** However small your actions **(49)** you must remember that **(50)** including human beings

01. have **02.** dominant **03.** encountering **04.** shows
05. decrease **06.** than **07.** that **08.** extinct **09.** Existing
10. exception **11.** containing **12.** as if **13.** contributes
14. a number of **15.** inhabited **16.** rise **17.** whenever
18. where **19.** have **20.** endangered

01. X, switch → switching **02.** X, strangely → strange
03. O **04.** O **05.** O **06.** X, feel → felt **07.** X, stand →
standing **08.** X, featuring → feature **09.** O **10.** X, being
→ been **11.** O **12.** X, was → were **13.** O **14.** X, few →
fewer **15.** O **16.** O **17.** O **18.** X, to protect → protecting
19. X, which → that **20.** O **21.** X, that → what **22.** O
23. O **24.** O **25.** X, lose → to lose **26.** O **27.** O **28.** X,
that → what **29.** O **30.** X, protecting → to protect **31.**
O **32.** X, help → helps **33.** O **34.** O **35.** O **36.** X, place
→ places **37.** O **38.** O **39.** X, switch → switching **40.** O
41. X, destroy → destroyed **42.** O **43.** X, uses → use **44.**
O **45.** X, endanger → endangered **46.** X, volunteering →
volunteer **47.** O **48.** O **49.** O

1회 내신 기출 문제 pp. 119~121

1. (B)→(A)→(C) 2. ② 3. ⓐ unseen ⓑ standing 4. ④ 5. ①
6. ④ 7. ③ 8. interconnected 9. ② 10. ④ 11. ④ 12. ③
13. ② 14. 당신의 활동들이 아무리 사소한 것처럼 보일지라도

1. 남자에게 부딪힌 누군가가 속도도 줄이지 않았다는 말 뒤에 그 사람이 적어도 미안하다고 말할 수도 있었다는 (B)가 오고, 이에 공감하며 서로 배려해야 한다는 (A)가 온 후, 이에 동의하며 너와 나를 포함해서 노력하자는 (C)로 이어지며, 그 뒤에 우리부터 시작하자고 말하며 자신도 배려심을 보이겠다는 여자의 말이 오는 것이 자연스럽다.

2. ② 문맥상 아시아 숲의 왕이었던 호랑이가 그들의 서식지에서 지배적인 포식자임에도 불구하고(In spite of) 조용히 움직이며 대부분의 시간을 눈에 띄지 않는 상태로 지낸다는 것이 자연스럽다.
 오답
 ① ~ 덕분에 ③ ~ 때문에 ④ ~이 없다면 ⑤ ~에 따르면

3. ⓐ remain의 보어로 '눈에 띄지 않는' 상태를 나타내므로 형용사 unseen이 적절하다.
 ⓑ 이유를 나타내는 분사구문으로, 호랑이가 상징으로 '존재하는'

것이므로 현재분사 standing이 적절하다.

4. ④ 명사 tigers를 수식하는 분사이며 호랑이들이 야생에서 '사는' 것이므로 능동 · 진행을 나타내는 현재분사 living으로 써야 한다.

5. 빈칸 뒤에 호랑이의 수가 감소한 원인이 이어지므로, 빈칸에는 ① '급격히 감소하고 있는'이 가장 적절하다.
 오답
 ② 의문이 제기되는 ③ 굶주림을 겪고 있는
 ④ 울창한 숲에 사는 ⑤ 10년간 안정적인

6. (A) 호랑이가 존재하지 않는 상황보다 인간을 보호하는 것에 대해 더 걱정해야 하는 것이 아닐까라는 내용과 역접을 나타내는 however로 연결되어 있으며 뒤에는 모든 종이 연결되어 있다는 내용이 나오므로, 우리를 보호하기 위해 호랑이를 보호할 (protect) 필요가 있다고 하는 것이 자연스럽다. endanger는 '위험에 빠뜨리다'라는 뜻이다.
 (B) 초목이 사라지면 새들과 곤충들이 집을 잃는다(lose)는 것이 자연스럽다. gain은 '얻다'라는 뜻이다.
 (C) 호랑이가 멸종되는 상황을 가정하여 설명하고 있으므로, 하나의 종, 즉 호랑이가 사라지는 것(disappearance)이 지구 전체를 위협할 수도 있다고 하는 것이 자연스럽다. emergence는 '출현'이라는 뜻이다.

7. 먹이사슬의 정점에 있는 호랑이의 멸종으로 인해 다른 종들이 순차적으로 영향을 받아서 결국에는 생태계 전체가 영향을 받게 될 것이라는 내용이므로, 빈칸에는 ③ Eventually(결국)가 가장 적절하다.
 오답
 ① 다행히도 ② 그럼에도 불구하고 ④ 그러나 ⑤ 예를 들어

8. **요약문**
 지구상의 모든 생물 종은 밀접하게 <u>상호 연결되어 있기</u> 때문에, 호랑이의 멸종은 전체 생태계에 영향을 줄 것이다.

9. (A)의 빈칸 앞뒤로 호랑이를 보호해야만 한다는 것은 명백하지만, 불 끄는 것이 어떻게(호랑이 보호에) 도움이 되는지 궁금할 것이라고 했고, (B)의 빈칸 앞뒤로 해수가 상승하면 호랑이가 개체 수가 줄지만, 에너지를 아끼면 이를 늦출 수 있다고 했다. 따라서 빈칸 (A), (B)에는 서로 상반되는 내용을 연결해 주는 ② however(하지만)가 적절하다.
 오답
 ① 그러므로 ③ 요약하자면 ④ 유사하게 ⑤ 오히려

10. ④ 문맥상 Sundarbans가 호랑이들에 의해 금지된다 (prohibited)는 것은 어색하며 뒤에서 Sundarbans의 호랑이 수에 대해 언급하고 있으므로 prohibited를 inhabited(서식되는) 등으로 고쳐야 한다.

11. 전등을 끄는 노력이 해수의 상승을 늦춰 호랑이를 구할 수 있다는 내용이므로, 제목으로는 ④ '전등을 끄고 호랑이를 구하는 것을 도우세요'가 가장 적절하다.

오답

① 기후 변화의 위험

② 아시아 호랑이들의 서식지

③ 이산화탄소를 방출하지 마세요

⑤ 왜 우리는 청정에너지를 사용해야 하는가

12. 환경친화적인 팜유를 사용한 제품들을 구매하면 호랑이를 보호할 수 있다는 내용이므로, ③ '작년부터 팜유의 가격이 두 배가 되었다.'는 흐름과 관계없다.

13. 첫 문장에서 호랑이와 다른 멸종 위기종들을 보호하기 위해 할 수 있는 다른 많은 일들이 있다고 한 것으로 보아, 바로 앞에 제시될 내용은 ②임을 유추할 수 있다.

14. '아무리 ~할지라도'를 나타내는 「however+형용사+주어+동사」 구문이 쓰인 문장이다.

2회 내신 기출 문제 pp. 122~124

1. ③ 2. how ancient people must have felt 3. ③ 4. ⑤ 5. ⑤ 6. ④ 7. ④ 8. ④ 9. referring to species that live in a large area 10. ③ 11. ③ 12. (A) helps (B) is (C) keep 13. protect tigers 14. ① 15. ⑤

1. ③ 도시 광산업을 통해 전자 제품 쓰레기를 재활용하여 많은 이익을 얻을 수 있다는 내용의 대화이다.

2. 「must have v-ed」는 '~했음이 틀림없다'는 의미로 과거 사실에 대한 강한 추측을 나타낸다.

3. ③ 숲에서 그들을 발견하는 것은 꽤 쉽다. (호랑이는 조용히 움직이며 대부분의 시간을 눈에 띄지 않는 상태로 지냄)

 오답

 ① 그들은 가장 큰 고양잇과 동물 중 하나이다.

 ② 그들은 다른 동물들을 먹이로 먹고 산다.

 ④ 그들은 사람들에 의해 오랫동안 숭배되어 왔다.

 ⑤ 그들을 그린 몇몇 고대 암각화가 있다.

4. ⑤ 전 세계적으로 감소하는 호랑이 수에 관한 내용이므로 문맥상 appear(나타나다)를 disappear(사라지다) 등으로 고쳐야 한다.

5. 전 세계의 호랑이 수가 급격히 감소하는 상황에 대한 글이므로 ⑤ '호랑이 수의 감소'가 제목으로 가장 적절하다.

 오답

 ① 야생 동물의 위험성 ② 야생 호랑이를 구하는 방법

 ③ 야생 동물 보호의 필요성 ④ 호랑이 서식지의 파괴

6. 주어진 문장 '그러나, 사실은 우리 자신을 보호하기 위해 우리는 호랑이를 보호할 필요가 있다.'는 이에 대한 이유가 제시된 문장 바로 앞인 ④에 오는 것이 자연스럽다.

7. 호랑이가 잡아먹는 동물들의 개체 수 증가로 인해 그들의 먹이인 초목이 사라지는 결과가 나타나는 것이므로, 빈칸에는 ④ Consequently(결과적으로)가 적절하다.

 오답

 ① 대신 ② 그럼에도 불구하고 ③ 그러나 ⑤ 예를 들어

8. ④ 앞에서 호랑이의 멸종이 생태계 전체를 어떻게 위협하는지 설명하고 있으므로 빈칸에는 방법을 나타내는 관계부사 how가 적절하다.

9. '~을 나타내는'의 의미로 앞의 명사구 an ecological term을 수식하는 현재분사구 referring to species를 쓰고, 명사 species를 수식하는 관계대명사절을 이어서 쓴다.

10. 첫 문장에서 '이제, 우리가 호랑이를 보호해야만 한다는 것은 명백하다.'고 했으므로, 바로 앞에는 그것이 명백하다고 서술할 수 있는 근거인 ③이 오는 것이 적절하다.

11. 화석 연료가 탈 때 공기 중으로 이산화탄소가 배출되어 기후 변화를 초래한다고 했으므로, ③ '화석 연료를 태우는 것은 기후 변화를 초래한다.'는 글의 내용과 일치한다.

 오답

 ① 불을 끄는 것은 호랑이를 보호하는 것과 관련 없다. (불을 꺼서 에너지를 절약하면 호랑이 서식지의 해수면 상승을 늦출 수 있음)

 ② 전 세계 전기의 절반 이상이 햇빛에서 만들어진다. (화석 연료를 태움으로써 만들어짐)

 ④ 해수면 상승은 호랑이 서식지에 영향을 주지 않는다. (지구의 해수가 상승하면 호랑이 서식지인 Sundarbans가 파괴될 수 있음)

 ⑤ 기후 변화는 호랑이 수가 증가하도록 돕는다. (기후 변화로 인한 해수면 상승으로 호랑이 수가 감소할 수 있음)

12. (A) 주어 역할을 하는 동명사구(switching ... lights)는 단수 취급하므로 helps가 적절하다.

 (B) 주어가 One이므로 단수동사 is가 적절하다.

 (C) 명령문은 동사원형으로 문장이 시작하는 형태이므로 keep이 적절하다.

13. **요약문**

 당신은 친환경적인 팜유로 만들어진 제품을 사용함으로써 <u>호랑이들을 보호하는 것</u>을 도울 수 있다.

14. ① 멸종 위기종을 보호하기 위한 활동을 소개하며 우리 모두가 지구를 공유한다고 했으므로, 하나의 종이 사라지면 다른 모든 생명체도 '영향을 받을 수 있다'고 하는 것이 적절하다.

 오답

 ② 평화롭게 살 것이다 ③ 스스로를 방어해야 할 것이다

 ④ 수가 증가할 것이다 ⑤ 상황에 적응할 수 있다

15. 84.8%의 쓰레기가 재활용되었으므로 ⑤ '이 도표를 통해 우리는 대부분의 쓰레기가 태워져서, 여전히 환경을 해치는 방식으로 쓰레기가 처리되었다는 것을 알 수 있다.'는 내용은 일치하지 않는다.

1. ② 2. ③ 3. when encountering tigers in the wild 4. ① 5. ③ 6. ④ 7. (d) these species(deer and boar) (e) birds and insects (f) birds and insects 8. ③ 9. ⑤ 10. ③ 11. ② 12. ③ 13. ② 14. (A) have (B) However

1. 공동체 안에서 서로에게 더 배려심이 있어야 한다는 소녀의 의견에 소년이 우리 모두 노력해야 한다고 말한 것으로 보아, 빈칸에는 ② '너의 말에 동의해.'가 가장 적절하다.
 오답
 ① 천만에. ③ 안됐구나.
 ④ 시간 낭비하지마. ⑤ 그건 불가능해.

2. ③ 호랑이는 수 세기 동안 인간에게 두려움과 숭배의 대상이었다.

3. 접속사 when이 이끄는 부사절에서 「주어+be동사」가 생략된 형태로, when 뒤에 현재분사 encountering이 이어진다.

4. 주어진 문장은 '하지만, 전 세계의 호랑이 수는 급격히 감소하고 있다.'라는 의미로 이 감소의 원인을 설명하는 문장 앞인 ①에 들어가는 것이 적절하다.

5. 호랑이의 수가 급속도로 줄고 있고, 10년 후에 멸종될 수도 있다는 내용이므로 주제로는 ③ '호랑이 수의 변화'가 적절하다.
 오답
 ① 호랑이의 일상적인 활동들
 ② 야생 동물 보호 전략들
 ④ 인간과 야생 동물의 갈등 해결을 위한 조언들
 ⑤ 호랑이 서식지 보호의 중요성

6. ④ 두 번째 문단에서 호랑이의 멸종이 인간을 포함한 생태계 전체에 영향을 미칠 수 있다고 하는 것으로 보아, 문맥상 지구의 모든 종들이 서로 연결되어(interconnected) 있다고 하는 것이 적절하다.
 오답
 ① 동등한 ② 보호되는 ③ 이동하는 ⑤ 설정된

7. (d)는 바로 앞 문장의 these species, 또는 그 앞 문장에 예로 제시된 deer and boar를 가리키며, (e)와 (f)는 동일한 문장에 제시된 birds and insects를 가리킨다. (a)~(c)는 모두 wild tigers를 가리킨다.

8. ③ 동시동작을 나타내는 분사구문으로, 생략된 주어인 they(호랑이들)가 '존재하는' 것이므로 현재분사 Existing이 적절하다.

9. 우리가 호랑이 보호를 위해 노력하면 일어날 일을 상상해 보라는 주어진 문장 뒤에 호랑이를 일컫는 용어를 소개하는 (C), 이 용어(This)의 의미를 설명하고 서식지를 보호해야 한다고 서술하는 (B), 서식지 보호의 결과를 언급한 (A) 순으로 와야 한다.

10. 기후 변화가 미치는 영향의 예시로 세계의 많은 지역을 위협하는 해수면 상승을 언급하고 있으므로 ③ positive(긍정적인)를 negative(부정적인) 등으로 바꿔야 한다.

11. (A) 부분이나 수량을 나타내는 표현은 of 뒤의 명사에 수를 일치시키며 셀 수 없는 명사인 electricity는 단수 취급하므로 is가 적절하다.
 (B) 지역이 호랑이에 의해 '서식되는' 것이므로 과거분사 inhabited가 적절하다.
 (C) 「keep+v-ing」: 계속해서 ~하다

12. **요약문**
 불을 끔으로써, 우리는 공기 중으로 배출되는 이산화탄소의 양을 줄일 수 있는데, 이것은 기후 변화를 늦출 수 있다. 따라서, 우리는 호랑이의 서식지들을 보호할 수 있다.
 오답
 ① 빛 – 먹이 ② 호흡 – 종
 ④ 오염 물질들 – 포식자들 ⑤ 전기 – 인구

13. ② plantation은 '대농장'이며, '몸에 장치나 조직을 삽입하는 행동'이라는 의미의 단어는 'implantation(이식)'이다.
 오답
 ① 인스턴트의: 빨리 준비되어 먹도록 만들어진
 ③ 지속 가능한: 종종 세심한 자원 관리로 인해 미래에 오래 지속될 수 있는
 ④ 비영리의: 돈을 벌기 위해 의도된 것이 아닌
 ⑤ 생물: 동물, 물고기, 혹은 곤충 같은 살아있는 것

14. (A) 주어가 복수명사 Products이므로 have가 적절하다.
 (B) '아무리 ~할지라도'라는 의미를 나타내는 복합관계부사 However가 적절하다.

1. ② 2. ⑤ 3. ⓐ being ⓑ encountering ⓒ worshipped 4. (A) shrinking (B) extinct 5. ② 6. ③ 7. Without tigers, these species would rapidly increase in number. 8. ecosystem 9. ⑤ 10. ③ 11. ⑤ 12. ④ 13. 에너지를 아낌으로써 우리가 기후 변화를 늦출 수 있는 것 14. You can also protect tigers when shopping. 또는 When shopping you can also protect tigers. 15. ④

1. 주어진 문장은 '하지만, 두 집단 모두 이득을 보았다.'는 의미로, 어르신들이 아이들과 함께 참여하는 프로그램이 애초에는 어르신들을 위한 것이었다는 문장 뒤, 어르신들과 아이들 모두에게 이로웠다는 내용 앞인 ②에 오는 것이 자연스럽다.

2. (A)와 ⑤(숫자 4는 불길하다고 믿어진다.)의 It은 가주어이다.
 오답
 ① 나는 길을 찾는 것이 쉽다는 걸 알았다. (가목적어)
 ② 역에서 학교까지는 4킬로미터이다. (비인칭주어)

③ 그는 새 시계를 샀는데, 그것은 비싸다. (대명사)

④ 벌써 9시이다. 수업이 곧 시작한다. (비인칭주어)

3. ⓐ 전치사 Despite의 목적어 역할을 하는 동명사 being이 적절하다.

ⓑ 접속사 뒤에 「주어+be동사」가 생략된 형태로, 생략된 주어인 고대인들이 호랑이와 '마주치는' 것이므로 현재분사인 encountering이 적절하다.

ⓒ have been feared와 and로 병렬 연결되어 있고 호랑이가 '숭배 받는' 것이므로, 앞에 have been이 생략된 형태인 과거분사 worshipped가 적절하다.

4. (A) 다음 문장에서 감소의 원인을 설명하고 있으므로, 전 세계 호랑이 수가 감소한다(shrinking)고 하는 것이 적절하다. grow는 '증가하다'라는 뜻이다.

(B) 20세기 초의 호랑이 수를 언급한 바로 앞의 문장과 역접의 연결어 however(하지만)로 이어지고 있으므로, 문맥상 3개의 호랑이 종이 멸종되었다(extinct)고 하는 것이 자연스럽다. distinct는 '뚜렷한'이라는 뜻이다.

5. 최근 호랑이 수가 감소하는 상황에 전문가들의 예측을 덧붙이고 있으므로, 문맥상 ② '향후 10년 안에 사라지다'가 오는 것이 자연스럽다.

오답

① 대체로 고독한 삶을 산다

③ 2년마다 두 마리에서 네 마리의 새끼를 낳다

④ 투표에서 세계적으로 가장 좋아하는 동물로 뽑히다

⑤ 크기가 크거나 중간인 동물들을 먹이로 삼다

6. 호랑이가 멸종된다면 어떤 일이 일어날지 생각해 보라는 주어진 글 뒤에 호랑이가 먹이 사슬 정점에 있다는 (B), 호랑이가 없을 때 먹이 사슬에 미치는 영향에 대한 (C), 이 현상이 생태계 전체에 영향을 미친다는 (A)로 이어지는 것이 자연스럽다.

7. If절 대신 「Without+명사(구)」가 쓰인 가정법 과거 구문이다.

8. '어떤 지역의 모든 생물들과 그들이 서로와 환경에 영향을 미치는 방식'이라는 의미의 단어는 ecosystem(생태계)이다.

9. ⑤ 첫 번째 문단에서 인간도 모든 것을 자연에 의존하기 때문에 예외가 아니며, 하나의 종이 사라지는 것이 지구 전체를 위협할 수 있다고 설명했고, 두 번째 문단에서 그 하나의 종이 호랑이를 가리킨다는 것을 알 수 있다. 따라서 주어진 글 앞에 호랑이의 멸종이 생태계에 미치는 영향이 나오는 것이 적절하다.

10. 주어진 문장 '호랑이는 '우산종'으로 여겨진다.'는 '우산종'이라는 용어에 대한 설명 앞인 ③에 오는 것이 자연스럽다.

11. ⓔ 주절과 같은 시점(현재)의 사실이 아닌 일을 가정하는 as if 가정법 과거 구문이므로 is를 were로 고쳐야 한다.

12. (A) 빈칸 앞에는 해수면 상승으로 호랑이의 개체 수가 줄어들 수 있다는 내용이 나오고 빈칸 뒤에는 이를 늦출 수 있다는 대조되는

내용이 나오므로, 빈칸에는 however(하지만)가 적절하다.

(B) 빈칸 앞에는 팜유 농장을 지을 때 호랑이의 서식지가 파괴된다는 내용이 나오고 빈칸 뒤에는 지속 가능한 방식으로 생산되는 팜유도 있다는 대조되는 내용이 나오므로, 빈칸에는 however(하지만)가 적절하다.

오답

likewise: 비슷하게 therefore: 그러므로 in fact: 사실
for example: 예를 들어

13. this가 가리키는 것은 바로 앞 절에 제시되어 있다.

14. 시간의 접속사 when 뒤에 「주어+be동사」가 생략된 형태이며, when이 이끄는 부사절은 문장 맨 앞이나 뒤에 올 수 있다.

15. ④ 사소한 것처럼 보이는 행동이라도 멸종 위기의 동물을 보호하는 데 도움이 될 수 있다는 내용의 글이다.

3회 실전 적중 문제 pp. 131~133

1. ① 2. ① 3. that 4. ①, ④ 5. ④ 6. ⓐ protecting ⓑ happen 7. ⑤ 8. 서로 다른 다양한 생태계를 포함하는 넓은 지역에 사는 종 9. ④ 10. how switching off the lights helps 11. ② 12. ④ 13. ⑤ 14. ⑤

1. ① 어르신들을 위한 요양원은 어디에 있나? (알 수 없음)

오답

② 프로그램의 목적은 무엇이었나? (어르신들이 어린 학생들과 함께 하며 더 활기 넘치고 덜 소외된 느낌을 받게 하는 것)

③ 프로그램을 통해 누가 이익을 얻나? (어르신과 어린 학생 모두)

④ 아이들과 놀면서 어르신들은 무엇을 증진할 수 있나? (건강)

⑤ 어르신들과 놀며 아이들은 무엇을 배울 수 있나? (책임감이나 존중 같은 중요한 가치들)

2. ① endangered는 '멸종 위기에 처한'이라는 의미이며, '무언가를 손상시키거나 파괴할 것 같은'이라는 의미는 dangerous(위험한)이다.

오답

② 종: 아주 유사해서 하나의 종류로 여겨지는 한 무리의 동물들

③ 서식지: 생물이 자연적으로 위치된 장소

④ 접하다, 마주치다: 누군가 혹은 무언가를 우연히 만나다

⑤ 고대의: 오랜 과거의 시대와 관련된; 아주 오래된

3. 각각의 빈칸 뒤에 절이 나오고 it이 가주어 역할을 하고 있으므로, 빈칸에는 진주어 역할을 하는 명사절을 이끄는 접속사 that이 들어가야 한다.

4. ① 한때 호랑이는 아시아 전역에 걸쳐서 발견됐다.

④ 9개의 호랑이 아종(亞種) 중 3개 종이 멸종되었다.

5. 호랑이의 멸종이 생태계에 미치는 영향에 관한 내용이므로, ④ '그

래서 사람들은 동물들을 위해 더 많은 곡식을 재배할 필요가 있다.'는 흐름과 관계 없다.

6. ⓐ 전치사 about의 목적어 역할을 하는 동명사 protecting이 적절하다.
 ⓑ 현재 사실을 반대로 가정하는 가정법 과거 구문이므로, 주절에 「조동사의 과거형+동사원형」이 와야 한다. 따라서 happen이 되어야 한다.

7. ⑤ 호랑이와 같은 우산종을 보호하기로 결정하면 그 서식지도 보호해야 한다는 내용 뒤에 결과적으로 이 서식지를 피하는(avoid) 종들도 보호받게 된다고 하는 것은 어색하다. 따라서 avoid를 share(공유하다) 등으로 고쳐야 한다.

8. 바로 뒷 문장에 umbrella species의 의미가 언급되어 있다.

9. ④ 기후 변화가 자연재해의 발생 빈도에 미치는 영향은 언급되지 않았다.

10. 동사 wonder의 목적어 역할을 하는 간접의문문으로 「의문사+주어+동사」의 어순으로 쓰며, 주어 역할을 하는 동명사구는 단수 취급하므로 helps를 써야 한다.

11. ② 뒤에서 에너지를 절약하면 기후변화를 늦출 수 있다고 했으므로 전기 생산을 위해 화석 연료를 태우는 것이 기후변화의 원인이 된다(contribute)고 하는 것이 자연스럽다.
 오답
 ① adapt to: ~에 적응하다 ③ stick to: ~을 고수하다
 ④ belong to: ~에 속하다 ⑤ respond to: ~에 대응하다

12. '당신은 또한 장을 볼 때도 호랑이를 보호할 수 있다.'는 주어진 문장 뒤에 많은 제품들이 팜유로 만들어지는데 팜유 농장을 만들기 위해 호랑이 서식지가 파괴된다는 내용의 (C), 하지만 환경친화적으로 생산되는 팜유가 있다는 (A), 이러한 팜유를 사용한 제품을 찾아보라는 (B)의 흐름이 가장 적절하다.

13. 양보를 나타내는 복합관계부사 구문은 '아무리 ~할지라도'라는 의미이며 「however+형용사+주어+동사」의 어순으로 쓴다.

14. ⑤ 화석 연료는 재생 가능한 자원들보다 훨씬 더 많은 전기를 만들어 냈으므로, less(적은)를 more(많은) 등으로 고쳐야 한다.

4회 실전 적중 문제 pp.134~136

1. ② 2. ⑤ 3. 역사에 걸쳐서 호랑이가 인간과 얼마나 밀접하게 관련되어 있는지를 보여준다. 4. ③ 5. ③ 6. ④ 7. (A) increase (B) survive 8. ⑤ 9. ② 10. ③ 11. ③ 12. ③ 13. ⑤ 14. they can help make a big difference

1. ⓑ '~할수록, 더 …하다'라는 의미의 「the+비교급 ~, the+비교급 …」 구문이므로, bigger가 적절하다.
 ⓒ '너무 ~해서 …하다'라는 의미의 「so ~ that …」 구문이므로,

that이 적절하다.

2. 호랑이가 오랫동안 아시아 숲의 왕이었다는 문장 뒤에 전치사 Despite(~에도 불구하고)로 연결되어 있고 빈칸 뒤에는 호랑이가 조용히 움직이며 눈에 띄지 않는다는 내용이 나오므로, 문맥상 ⑤ '그들의 서식지에서 지배적인 포식자임'이 들어가는 것이 자연스럽다.
 오답
 ① 다른 동물들에 의해 보호됨 ② 기후 변화의 희생양임
 ③ 잡혀서 우리에 갇힘 ④ 고대인들의 가장 친한 친구임

3. Q: 호랑이의 모습이 그려져 있는 고대 암각화는 무엇을 보여주는가?
 마지막 문장의 'how closely tigers ... throughout history'에 제시되어 있다.

4. 호랑이 수의 감소 원인과 그 추이에 관한 내용이므로, 불법 사냥의 정의에 관한 ③ '불법 사냥은 불법적인 야생 동물 죽이기나 포획이다.'는 흐름과 관계없다.

5. ③ 20세기 초부터 현재까지 호랑이의 개체 수가 점점 줄어드는 상황을 설명하고 있으므로, 뒤에는 미래의 호랑이 수에 대한 예측이 오는 것이 가장 적절하다.

6. 주어진 문장은 '이것은 새들과 곤충들이 그들의 집을 잃는 사태를 일으킬 것이고, 그것들을 잡아먹는 더 큰 동물들은 곧 먹이가 바닥나게 될 것이다.'라는 의미로, 호랑이의 먹이인 사슴과 멧돼지와 같은 동물의 증가로 인해 새와 곤충의 집인 초목이 사라지는 내용 뒤인 ④에 오는 것이 자연스럽다.

7. (A) 먹이 사슬 정점에 있는 호랑이가 사라지면, 호랑이의 먹이가 되는 종의 수는 증가한다(increase)고 하는 것이 적절하다. decrease는 '감소하다'라는 뜻이다.
 (B) 뒤에 공기, 물, 음식을 나열했으므로 우리가 생존하기(survive) 위해 필요한 모든 것이라고 하는 것이 적절하다. struggle은 '투쟁하다'라는 의미이다.

8. 우산종인 호랑이를 보호하면 서식지를 공유하는 다른 종까지 보호된다는 내용이므로, 주제로는 ⑤ '우산종을 보호하는 것의 효과'가 적절하다.
 오답
 ① 큰 우산을 가질 필요성 ② '우산종'이라는 용어의 기원
 ③ 우산종을 보호하는 방법 ④ 호랑이와 함께 살아가는 다른 종들

9. 빈칸 뒤에 기후 변화의 부정적인 영향의 예로 해수의 상승으로 파괴될 수 있는 Sundarbans 지역이 언급되어 있으므로, 빈칸에는 ② '해수면 상승'이 가장 적절하다.
 오답
 ① 식량 부족 ③ 인간의 활동들 ④ 테러리즘과 전쟁
 ⑤ 허리케인과 지진

10. ③ '미래에 일어날 것이라고 생각하는 것을 말하다'라는 의미의 단

어는 predict(예측하다)이다. release는 '배출[방출]하다'라는 의미이다.

오답

① 전기: 전자의 흐름에 의해 형성되는 에너지
② 화석 연료: 석유와 석탄을 포함하는 연료의 범주
④ 서식[거주]하다: 어떤 장소 혹은 지역에 살다
⑤ ~을 완전히 파괴하다, 없애버리다: 완전히 파괴하다, 사라지게 만들다

11. (A) 뒤의 절이 완전하고 It이 가주어이므로 진주어 역할을 하는 명사절을 이끄는 접속사 that이 적절하다.
(B) 주어 역할을 하는 동명사구는 단수 취급하므로 helps가 적절하다.
(C) 「by v-ing」: ~함으로써

12. ③ 장소를 나타내는 선행사인 forests(숲들)를 수식하는 관계부사 where, 또는 「전치사+관계대명사」인 in which로 바꿔야 한다.

13. ⑤ 호랑이와 멸종 위기의 동물들을 보호하기 위해서 작은 행동부터 시작하라는 내용의 글이다.

14. 「help+동사원형」: ~하는 것을 돕다
make a difference: 변화를 일으키다

5회 실전 적중 문제 pp. 137~139

1. ③ 2. ② 3. ⑤ 4. 불법 사냥, 서식지 상실 5. (1) ③ have (2) ⑤ disappear 6. ⑤ 7. ④ 8. ⑤ 9. ⑤ 10. ⓐ containing ⓑ were 11. ④ 12. ③ 13. whenever you're[you are] the last person to leave a room 14. ③

1. (A) 뒤에 에코투어(eco-tour)에 대한 설명이 나오므로, 이에 대해 묻는 ⓑ(그게 뭔지 설명해 줄 수 있니?)가 와야 한다.
(B) 뒤에 환경과 관련하여 일반적인 여행과의 차별점을 설명하고 있으므로, 이에 대해 묻는 ⓒ(그럼 너의 여행은 일반적인 여행과 어떻게 달랐니?)가 와야 한다.
(C) 뒤에 에코 투어의 시사점이 이어지므로 ⓐ(여행에는 단지 재미를 느끼는 것 말고도 더 많은 것이 있구나.)가 와야 한다.

2. (A)와 ②(이 알약은 몇 분 내로 작용할 것입니다.)의 work는 '작용하다'라는 의미이다.

오답

① 나는 이 기계를 작동시키는 법을 모른다.
③ 그녀는 병원에서 청소부로 일했다.
④ 그는 일주일에 세 번 체육관에서 운동한다. (work out: 운동하다)
⑤ 너는 시험에 통과하기 위해서 발음에 공들일 필요가 있다. (work on: ~에 공들이다)

3. ⑤ 문장의 주어가 The fact이므로 동사는 단수형인 shows가 되

어야 한다.

4. 'Illegal hunting and habitat loss'에 이유가 제시되어 있다.

5. ③ 문장의 주어 three of ... tigers에서 three에 동사의 수를 일치시키므로, 복수형인 have로 고쳐야 한다.
⑤ 자동사는 수동태로 쓰지 않으므로, disappear로 고쳐야 한다.

6. 주어진 문장 '이것은 지구의 모든 종이 서로 연결되어 있기 때문이다.'는 우리를 보호하기 위해서 호랑이도 보호해야 한다는 내용에 대한 이유이므로, 그 바로 뒤인 ⑤에 오는 것이 적절하다.

7. ⓐ, ⓑ는 모두 tigers, ⓒ는 animals they prey on (such as deer and boar), ⓓ, ⓔ는 birds and insects를 가리키므로, 같은 대상끼리 묶인 것은 ④이다.

8. 빈칸 앞에서 호랑이의 멸종이 생태계 전체에 미치는 부정적인 영향을 설명하고 있으므로 빈칸에는 ⑤ '지구 전체를 위협하다'가 오는 것이 자연스럽다.

오답

① 그것의 포식자에게 영향을 미치다
② 지구 온난화를 야기하다
③ 생태계의 균형을 유지하다
④ 기근을 예방하다

9. ⑤ 인간은 공기를 포함한 대부분의 것들을 자연에 의존한다.

오답

① 야생 호랑이가 더는 없다면, 우리는 미래에 호랑이를 못 볼 것이다. (동물원이나 TV에서 볼 수 있음)
② 인간을 보호하기 위해서 호랑이가 보호되어서는 안 된다. (우리 자신을 보호하기 위해 호랑이를 보호할 필요가 있음)
③ 호랑이는 생태계 먹이 사슬의 가장 아래에 있다. (호랑이는 먹이 사슬의 정점에 존재함)
④ 호랑이가 멸종된다면, 사슴은 먹을 초목을 쉽게 찾을 것이다. (사슴과 같은 종의 수가 증가하여 초목이 사라지기 시작함)

10. ⓐ 넓은 지역이 다양한 생태계를 '포함하고 있는' 것이므로 현재분사 containing이 적절하다.
ⓑ 주절과 같은 시점(현재)의 사실이 아닌 일을 가정하고 있는 「as if+주어+동사의 과거형」의 가정법 과거 구문이 쓰인 것으로, be동사의 과거형인 were를 써야 한다.

11. 화석 연료가 탈 때 기후 변화가 야기되어 호랑이의 개체 수에 영향을 미친다는 내용으로, ④ '화석 연료를 태우는 것은 우리가 숨 쉬는 공기에 안 좋다.'는 흐름과 관계없다.

12. (A)와 ③(그들의 임금은 15%만큼 올랐다.)의 by는 '~만큼'의 의미로, 양·정도를 나타낸다.

오답

① 그녀는 창문 옆에 서 있었다.
② 그들은 기차로 시카고까지 여행했다.
④ 그녀는 5시까지 돌아오겠다고 약속했었다.

⑤ 그 책은 잘 알려진 작가에 의해 번역되었다.

13. '~할 때마다, ~할 때는 언제든지'는 복합관계부사 whenever로 나타내고, the last person을 수식하는 형용사적 용법의 to부정사구 to leave a room을 쓴다.

14. 호랑이 서식지에 부정적인 영향을 미치는 팜유 농장 건설에 대한 내용 뒤에 지속 가능한 방식으로 생산되는 환경친화적인 팜유에 대한 내용이 제시되었으므로, 빈칸에는 역접을 나타내는 연결어 ③ however(그러나)가 적절하다.

오답

① 불행히도 ② 게다가 ④ 예를 들어 ⑤ 더욱이

서술형으로 내신 만점 pp. 140~142

1. We can buy seasonal and local fruits and vegetables.
2. how closely tigers have been related to humans 3. (1) ⓑ rapid, rapidly (2) ⓓ what, that 4. Interconnected 5. (1) But for tigers (2) If it were not for tigers 6. (c)onserve 7. (1) 이산화탄소가 공기 중으로 배출됨 (2) (해안 지역의) 호랑이 서식지가 파괴됨 8. an area on the coast of Bangladesh 9. environmentally friendly 10. However small your actions may seem 11. While waiting for your oven to heat up

1. Q: 환경을 보호하기 위해 우리는 무엇을 할 수 있나?
B의 대답 중 'We can ... vegetables.'에 언급되어 있다.

2. shows의 목적어 역할을 하는 간접의문문을 「의문사＋주어＋동사」의 어순으로 쓴다.

3. ⓑ rapid는 의미상 동사구 has been shrinking을 수식하므로 부사 rapidly로 고쳐야 한다.
ⓓ what 뒤의 절이 완전하므로 what 대신 동사 predict의 목적어 역할을 하는 명사절을 이끄는 접속사 that이 적절하다. 관계대명사 what은 선행사를 포함하므로 뒤에 불완전한 문장이 온다.

4. 첫 번째 문단에서 지구의 모든 종들은 서로 연결되어 있기 때문에 우리를 보호하기 위해서는 호랑이도 보호해야 한다고 했고, 두 번째 문단에서 호랑이의 멸종이 생태계 전체에 미치는 영향을 설명하고 있으므로, 제목으로는 '완전히 상호 연결된(Interconnected) 세상'이 가장 적절하다.

5. 가정법 과거 구문에서 Without구는 「But for ~」나 「If it were not for ~」로 바꿔 쓸 수 있다.

6. '환경과 같은 것이 이용되거나, 훼손되거나, 또는 파괴되지 않도록 하다'라는 의미의 단어는 conserve(보존하다)이다.

7. (1)은 'carbon dioxide is released into the air'에, (2)는 'If Earth's oceans continue to rise, this area could be wiped out'에 제시되어 있다.

8. 바로 앞 문장에 this area가 가리키는 것이 제시되어 있다.

9. 요약문
친환경적인 팜유로 만들어진 제품을 사는 것조차도 당신이 호랑이를 보호하는 데 도움을 줄 수 있다.

10. '아무리 ~할지라도'라는 의미의 복합관계부사절은 「however＋형용사＋주어＋동사」의 어순으로 쓴다.

11. 접속사 While 뒤에 「주어＋be동사」가 생략되어 현재분사 waiting이 오는 형태이다.
「wait for＋목적어＋to부정사」: ~가 …하는 것을 기다리다

1. ④ 2. ④ 3. ① 4. ③ 5. ⑤ 6. Not only could Diego swim 7. ④ 8. ③ 9. ② 10. ③ 11. ④ 12. allowed people to type on a keyboard and see the results on a monitor 13. (A) alike (B) terrific 14. it appeared to have been used before 15. Mia가 논의하는 동안 말을 많이 안 했고 그게 집중하지 않고 있다는 걸 뜻한다고 생각했기 때문에 16. ⑤ 17. ③ 18. ②, ③ 19. ④ 20. ③ 21. if[If] 22. ④ 23. endangered 24. ② 25. ④

1. A가 B에게 노래를 잘할 수 있는 또 다른 방법을 조언하는 상황이므로 ④ '노래를 잘하려고 하는 것을 포기하고 잊어버리다'는 적절하지 않다.
오답
① 인터넷에서 무료 발성 연습 동영상을 찾다
② 너에게 노래하는 방법을 가르쳐줄 수 있는 누군가를 찾다
③ 네 음악 선생님께 너가 노래를 더 잘할 수 있게 도와달라고 한다
⑤ 네가 확인할 수 있도록 네 목소리를 녹음한다

2. (A) 오페라 가수가 되기를 열망했다(aspired)고 하는 것이 자연스럽다. inspire는 '영감을 주다'라는 의미이다.
(B) 쇼에서 우승을 했다고 했으므로, 인상적인(impressive) 노래라고 하는 것이 자연스럽다. ordinary는 '평범한'이라는 의미이다.
(C) 암 투병과 사고를 겪었으므로 역경(adversity)에도 불구하고 꿈을 좇았다고 하는 것이 자연스럽다. assistance는 '도움'이라는 의미이다.

3. ⓐ는 펭귄을 가리키는 반면, 나머지는 모두 Diego Gonzales를 가리킨다.

4. ③ 동사의 과거형 fed, swept와 접속사 and로 병렬 연결되어 있으므로, spent가 되어야 한다.

5. (A)와 ⑤(이것이 그가 퍼즐을 빨리 푼 이유이다.)의 that은 선행사를 수식하는 관계부사이다.
오답
① 나는 우유가 내 건강에 좋다고 생각한다. (접속사)
② 아무도 네가 유죄라는 사실을 부정할 수 없다. (접속사)
③ 우리는 그 일에 적합한 사람이 필요하다. (관계대명사)
④ 그녀가 회사를 떠날 것은 사실이다. (접속사)

6. 부정을 나타내는 말인 not only가 문두에 나와 주어와 조동사가 도치된 형태로 써야 한다.

7. ④ 그가 다른 친구들로부터 인정을 받았다고 한 내용이 뒤에 이어지므로, 낙담(discouragement)을 받았다고 하는 것은 적절하지 않다. 따라서 discouragement를 encouragement(격려) 등으로 고쳐야 한다.

8. ③ 주어진 문장 '처음에, 나는 달리기가 빠르지도 킥을 잘하지도 못했다.'는 화자가 축구팀에 가입했다는 내용 뒤, 자신의 한계가 자신을 방해하도록 두지 않았다는 내용 앞에 오는 것이 자연스럽다.

9. 주어진 문장 '곧, 백인 구역의 모든 좌석들이 찼다.'는 버스에 점점 더 많은 승객이 탔다는 내용 뒤, 운전기사가 Parks의 자리를 백인에게 양보하라고 명령한 내용 앞인 ②에 오는 것이 적절하다.

10. (A) 바로 뒤에 나오는 King의 특성인 assertive(적극적인), sociable(사교적인)로 보아, 그가 외향적인 사람(extrovert)이라고 하는 것이 적절하다. introvert는 '내향적인 사람'이라는 의미이다.
(B) 사람들이 햇빛으로부터 밀려나는 것에 진력이 난다는 내용이 뒤에 이어지고 있으므로, 문맥상 사람들이 짓밟히는(trampled) 것에 진력이 난다고 하는 것이 자연스럽다. obey는 '복종하다'라는 의미이다.
(C) 문맥상 King이 Parks의 용기(bravery)를 칭송했다고 하는 것이 자연스럽다. slavery는 '노예'라는 의미이다.

11. Parks와 King의 서로 다른 성향이 결합하여 사회적으로 큰 역할을 한 내용이므로, 빈칸에는 ④ partnership(동반자 관계)이 들어가는 것이 적절하다.
오답
① 연구 ② 인내 ③ 기회 ⑤ 발달, 성장

12. '~가 …하게 하다'를 나타내는 「allow+목적어+to-v」 구문을 이용하여 관계대명사절을 완성한다.

13. (A) Wozniak과 Jobs의 반대되는 성향을 언급한 뒤에 역접의 접속사 but이 나오므로 문맥상 그 뒤에는 비슷한(alike) 점을 언급하는 것이 적절하다. different는 '다른'이라는 의미이다.
(B) 외향적인 사람과 내향적인 사람이 조화를 이뤄 위대한 일을 할 수도 있다는 내용의 글이므로, 그들이 훌륭한(terrific) 팀을 이룬다고 하는 것이 적절하다. terrible은 '끔찍한'이라는 의미이다.

14. 과거 시점(appeared) 이전에 그것(프린터)이 사용된 적이 있었던 것이므로, 완료부정사 to have been used를 써야 한다.

15. 밑줄 친 문장 바로 뒤의 'because you ... weren't focusing'에 그 이유가 제시되어 있다.

16. 대학생과 어르신이 함께 살면서 서로 도울 수 있다고 하며 서로 도움을 주고받으며 더 나은 삶을 살 수 있다는 것을 이해하는 것이 중요하다는 내용이므로, 이를 나타내는 속담은 ⑤ '넌 내 등을 긁어줘, 난 네 등을 긁어 줄게.'이다.
오답
① 엎질러진 우유로 울지 마라(엎질러진 물은 다시 담을 수 없다).
② 어려울 때 친구가 진정한 친구이다.
③ 겉표지로 책을 판단하지 마라.
④ 좋은 책이 최고의 친구이다.

17. 빈칸 뒤에 A가 우리가 할 수 있는 것이 무엇일지 물었고 이에 대해 B는 환경을 위해 할 수 있는 아이디어들을 제시하고 있으므로, 빈칸에 ③ '문제는 무엇을 해야 할지 우리가 모른다는 거야.'는 적절하지 않다.

① 환경을 위해 무언가 해야 할 때야.

② 너무 늦기 전에 우리는 조치를 취해야 해.

④ 우리는 환경을 지키기 위해 우리가 할 수 있는 것을 해야 해.

⑤ 사람들은 환경 문제에 너무 무관심해.

18. ② 전치사 Despite 뒤에 동명사 형태인 being이 오는 것은 적절하다.

③ 시간을 나타내는 접속사 when 뒤에 「주어+be동사」인 they were가 생략된 형태이므로 적절하다.

① 주어가 Tigers이므로 복수형 have가 와야 한다.

④ 동시동작을 나타내는 분사구문이 되어야 하므로 현재분사 standing으로 써야한다.

⑤ The fact와 동격을 나타내는 명사절을 이끄는 접속사 that으로 써야 한다.

19. 주어진 문장 '그러나, 최근 몇 년간 9개의 호랑이 아종 중 3개의 종은 멸종되었다.'는 20세기 초 야생 호랑이 수가 약 10만 마리라는 내용 뒤, 현재 야생 호랑이 수는 4,000마리 미만이라는 내용 앞인 ④에 오는 것이 자연스럽다.

20. (A) 먹이 사슬의 정점에 있는 호랑이가 없으면 호랑이가 잡아먹는 종들이 증가한다(increase)고 하는 것이 적절하다. decrease는 '감소하다'라는 뜻이다.

(B) 앞에 호랑이의 멸종으로 동식물들이 겪는 변화가 나오므로 전체 생태계가 영향을 받는다(affected)고 하는 것이 적절하다. protect는 '보호하다'라는 의미이다.

(C) 앞에 제시된 내용으로 보아 한 종이 사라지는 것(disappearance)이 지구 전체를 위협한다고 하는 것이 적절하다. appearance는 '출현'이라는 뜻이다.

21. (A)는 가정법 과거 구문의 if, (B)는 조건을 나타내는 접속사 If, (C)는 가정법 과거 구문의 (as) if가 쓰였다.

22. '이제, 우리가 호랑이를 보호해야만 한다는 것은 명백하다.'라는 주어진 문장 뒤에 불을 끄는 것이 어떻게 호랑이 보호에 도움이 될지 궁금할 것이라는 (C), 전기를 만드는 과정에서 배출된 이산화탄소가 기후 변화의 원인이 되어 해수면 상승 등의 부정적 영향을 미친다는 (B), 해수면 상승으로 인해 호랑이 서식지가 줄어들 것이라는 (A)의 흐름이 가장 적절하다.

23. '심각하게 멸종의 위험에 빠진; 거의 멸종된'이라는 뜻의 단어는 endangered(멸종 위기에 처한)이다.

24. ② 빈칸에 A가 '그는 아직도 너에게 화가 난 것 같아.'라고 한 뒤 B가 지금은 괜찮다고 대답하는 것은 어색하다.

① 나도 역시 그렇게 느꼈을 거 같아.

③ 그는 늘 그런 식으로 말해.

④ 내 생각엔 그냥 그의 성격인 것 같아.

⑤ 난 그가 나쁜 의도로 그런 거라고 생각하지 않아.

25. ④ 도표에 따르면 기타 연료들은 4.2%를 차지하지만 가장 적은 비율을 이루는 것은 아니다. 가장 적은 비율을 이루는 것은 2.1%를 차지하는 바이오 연료와 폐기물(biofuels and waste)이다.

Build a Better World

어휘 만점 | Vocabulary Check-Up p. 151

01. 설립하다 **02.** 극히 중요한 **03.** 무슨 수를 써서라도 **04.** 방어하다 **05.** 인근의, 주위의 **06.** ~을 내주다 **07.** 독자성 **08.** 둘러싸다, 두르다 **09.** 기록부, 명부 **10.** 기본 원칙 **11.** 점령 **12.** 금(지)하다 **13.** (너무 아름답거나 놀라워서) 숨이 막히는[멎는 듯한] **14.** 지키다, 보호하다 **15.** 색조 **16.** 무늬를 새긴 **17.** (국가·사회의) 유산 **18.** 자기 **19.** 청자(색) **20.** (위험에서) 구하다 **21.** 불쏘시개 **22.** 유혹[매력]적인 **23.** conviction **24.** scholar **25.** intend **26.** get rid of **27.** independence **28.** commitment **29.** designate **30.** origin **31.** defeat **32.** insight **33.** keen **34.** colonial **35.** occupy **36.** in search of **37.** cannot help but **38.** inherit **39.** appreciate **40.** exhibition **41.** purchase **42.** scenery **43.** represent **44.** devote

문법 만점 | Point Check-Up pp. 152~153

1. (1) hit (2) selling (3) written **2.** (1) wouldn't be (2) wouldn't have been (3) would have been

문법 만점 | 확인 문제 pp. 154~155

01. (1) designed (2) wanting (3) wounded **02.** (1) had not been for (2) couldn't have traveled (3) were not for **03.** (1) some people interested in (2) a famous actor loved by (3) a book translated into twelve languages **04.** (1) could have become (2) would be (3) it had not been for **05.** (1) produced (2) inspired (3) directed **06.** (1) I would not have started volunteering (2) our community could not have become **07.** ④

01. (1) 분사와 수식을 받는 명사구(a new alert system)가 수동 관계이므로, 과거분사 designed를 써야 한다.
(2) 분사와 수식을 받는 명사구(lots of people)가 능동 관계이므로, 현재분사 wanting을 써야 한다.
(3) 분사와 수식을 받는 명사(soldiers)가 수동 관계이므로, 과거분사 wounded를 써야 한다.

02. (1) 과거(yesterday) 사실의 반대 상황을 가정하는 가정법 과거완료이므로, were not for를 had not been for로 고쳐야 한다.
(2) 과거(last year) 사실의 반대 상황을 가정하는 가정법 과거완료

이므로, couldn't travel을 couldn't have traveled로 고쳐야 한다.
(3) 현재 사실의 반대 상황을 가정하는 가정법 과거이므로, had not been for를 were not for로 고쳐야 한다.

04. (1) 과거 사실의 반대 상황을 가정하는 가정법 과거완료이므로, 주어 뒤에 「조동사의 과거형+have v-ed」의 형태가 적절하다.
(2) 현재 사실의 반대 상황을 가정하는 가정법 과거이므로, 주어 뒤에 「조동사의 과거형+동사원형」의 형태가 적절하다.
(3) '~이 없었다면'을 나타내는 가정법 과거완료이므로, if 뒤에 「it had not been for」가 적절하다.

05. (1) 새 영화가 '제작된' 것이므로 수동을 나타내는 과거분사 produced를 써야 한다.
(2) 영화가 실화에서 '영감을 받은' 것이므로 수동을 나타내는 과거분사 inspired를 써야 한다.
(3) 세 번째 영화가 '연출된' 것이므로 수동을 나타내는 과거분사 directed를 써야 한다.

오답

instruct: 지시하다

06. 과거 사실의 반대 상황을 가정하는 가정법 과거완료이므로, 「주어+조동사의 과거형+have v-ed」의 형태로 쓴다.

07. ⓑ 명사(the criminals)와 분사가 수동 관계이므로 현재분사 arresting을 과거분사 arrested로 고쳐야 한다.
ⓔ 과거(last week) 사실의 반대 상황을 가정하는 가정법 과거완료이므로, couldn't buy를 couldn't have bought로 고쳐야 한다.

본문 만점 | 빈칸 채우기 pp. 162~165

(1) her experience to share **(2)** selected from **(3)** man who gathered **(4)** is, known by **(5)** lived through **(6)** inherited a massive fortune **(7)** decided to use **(8)** was, influenced by his mentor **(9)** devoted most of his fortune to acquiring **(10)** He considered these items **(11)** would have been destroyed **(12)** could not help but admire **(13)** album called **(14)** depict the beautiful scenery **(15)** makes them look very inviting **(16)** I was shocked when **(17)** it was rescued **(18)** made me feel very sad **(19)** so that **(20)** The next item that impressed me was **(21)** encircling the entire vase **(22)** in search of freedom **(23)** could have bought **(24)** double the price **(25)** refused to part with it **(26)** Seeing it in person **(27)** that I will never forget **(28)** behind the creation **(29)** occupied by Japan **(30)** to get rid of **(31)** were forbidden to teach **(32)** couldn't stop thinking **(33)** at all costs **(34)** the owner was asking **(35)** was able to

정답 및 해설 **25**

share **(36)** most precious treasure **(37)** would have been lost **(38)** has, been designated **(39)** to preserving Korean history **(40)** surrounded by Korean art **(41)** for his personal enjoyment **(42)** to protect **(43)** he stopped collecting art **(44)** was able to defend **(45)** Thanks to him **(46)** Founded in 1938 **(47)** he named it **(48)** he had collected **(49)** was renamed **(50)** holds about 5,000 items

본문 만점 | **옳은 어법·어휘 고르기** | pp. 166~167

01. displayed **02.** inherited **03.** thinking **04.** who **05.** convictions **06.** represented **07.** As soon as **08.** look **09.** Knowing **10.** stretching **11.** it **12.** was **13.** arrested **14.** had **15.** fundamentals **16.** Standing **17.** to protect **18.** independence **19.** defend **20.** Founded

본문 만점 | **틀린 문장 고치기** | pp. 168~170

01. O **02.** X, select → selected **03.** X, whom → who **04.** O **05.** O **06.** O **07.** X, protecting → protect **08.** O **09.** O **10.** O **11.** X, taking → taken **12.** O **13.** O **14.** O **15.** X, to look → look **16.** X, shocking → shocked **17.** O **18.** X, was → were **19.** X, which → that **20.** X, calling → called **21.** X, encircled → encircling **22.** O **23.** O **24.** O **25.** X, parting → to part **26.** O **27.** O **28.** X, is → was **29.** X, occupying → occupied **30.** O **31.** X, was → were **32.** O **33.** O **34.** O **35.** X, defeat → defeated **36.** O **37.** O **38.** X, designating → designated **39.** X, Looked → Looking **40.** X, think → thinking **41.** X, does → did **42.** O **43.** X, While → During **44.** O **45.** O **46.** X, was named → named **47.** O **48.** O **49.** O

1회 | **내신 기출 문제** | pp. 171~173

1. ⑤ **2.** ③ **3.** ⑤ **4.** (i)nsight **5.** ③ **6.** so that future generations can also appreciate them **7.** 간송은 그것이 그런 종류의 화병 중에서 가장 아름다운 화병이라는 것을 알았기 때문에 **8.** ⓐ encircling ⓑ listed **9.** He knew he had to protect it at all costs. **10.** ⑤ **11.** ③ **12.** ④ **13.** ③ **14.** ①

1. 뒤에서 소녀가 소년이 할 수 있는 봉사활동을 추천해주고 있으므로, 빈칸에는 ⑤ '나도 그런 일을 할 수 있으면 좋겠다.'가 오는 것

이 적절하다.

오답
① 나는 독서에 집중할 수 없어.
② 학생들을 만나는 것은 항상 즐거워.
③ 내 목소리를 관리하는 법을 알려줘.
④ 소리 내어 읽는 것은 효과적인 공부 방법이야.

2. ③ 막대한 재산을 물려받은 것은 전형필이다.

3. ⑤ 그것들(old books ... works of art)이 '파괴되는' 것이므로 destroyed로 고쳐야 한다.

오답
② 선행사가 사람일 때 관계대명사는 who 또는 that 둘 다 쓸 수 있다.

4. '어떤 것을 잘 이해하거나 새롭고 독특한 아이디어를 생각해내는 능력'이라는 의미의 단어는 insight(통찰력)이다.

5. (A) 보기 중 문맥상 As soon as가 빈칸에 들어가서 화자가 들어가자마자 수묵화에 감탄했다고 하는 것이 적절하다.
(B) 화첩이 태워질 뻔했으나 구해졌다는 내용이므로, 빈칸에는 Fortunately(다행히도)가 들어가는 것이 적절하다.

오답
although: ~에도 불구하고 because: ~ 때문에
unfortunately: 유감스럽게도 sadly: 슬프게도

6. 「so that+주어+동사」: ~하기 위해서, ~하도록

7. 'because he knew that it was the most magnificent vase of its kind'에 그 이유가 제시되어 있다.

8. ⓐ 아름다운 무늬가 꽃병을 '둘러싸는' 능동의 의미이므로, 「with +목적어+v-ing」 구문의 현재분사로 써야 한다.
ⓑ 그것(화병)이 국보로 '등록되는' 수동의 의미이므로, 과거분사로 써야 한다.

9. He knew 뒤에 접속사 that이 생략된 형태의 명사절이 와야 한다.
at all costs: 무슨 수를 써서라도

10. ⑤ 훈민정음 해례본이 한국의 국보로 지정되었다고 했다.

오답
① 그것이 발견된 후 간송은 수년간의 기다림 후에 그것을 얻었다.
② 간송은 그것을 소유자가 요구한 금액의 10배에 샀다.
③ 일본이 패망하자 간송은 그것을 한국 국민과 공유했다.
④ 그것 덕분에 한글의 기본 원칙이 전해졌다.

11. ③ 훈민정음 해례본이 없었다면, 한글의 기원과 기본 원칙이 전해지지 않았을 것이라고 했으므로 가장 소중한(precious) 보물이라고 하는 것이 적절하다.

오답
① 흔한 ② 인공적인 ④ 편리한 ⑤ 화려한

12. ④ 동시동작을 나타내는 분사구문으로, 생략된 주어 I가 한국 미술

품에 '둘러싸인' 것이므로 과거분사 surrounded가 와야 한다.

13. (A) 한국의 문화적 독자성을 보호하기(protect) 위해 일제 강점기 동안 미술품을 수집했다고 하는 것이 적절하다. conceal은 '숨기다'라는 의미이다.
(B) 일제 강점기 동안 미술품을 수집하던 그가 독립 후에는 미술품이 안전하게 한국에 남아 있으리라는 것을 알았다고 했으므로 미술품 수집을 그만두었다(stopped)고 하는 것이 적절하다. start는 '시작하다'라는 의미이다.
(C) 일제 강점기를 나타내므로 가장 안 좋은(worst) 시기라고 하는 것이 적절하다. best는 '최고의'라는 의미이다.

14. 간송 미술관의 과거와 현재에 대한 내용이므로 ① '한국에는 사립 미술관이 많이 있다.'는 흐름과 관계없다.

2회 내신 기출 문제 pp. 174~176

1. ② 2. ③ 3. it had not been for his actions 4. ⑤ 5. ③
6. ⑤ 7. (A) impressed (B) offered (C) magnificent 8. With the money he spent on it 9. 그 학들은 살아서 자유를 찾아 날개를 뻗고 있는 것처럼 보인다. 10. ② 11. 그는 무슨 수를 써서라도 그것을 지켜야만 한다는 것을 알았다. 12. ⑤ 13. ① 14. ②

1. ② 음식 교육 시행을 지지하는 탄원서에 서명할 것을 촉구하는 내용이다.

2. 윤주가 한국 미술 전시회에 간 내용을 공유하기 위해 보고서를 작성했다는 주어진 글 다음에 전시회를 소개하는 (B), 전시된 미술품을 모은 전형필을 소개하는 (C), 그가 스승으로부터 영향을 받아 미술품을 수집했다는 내용의 (A)로 이어지는 것이 자연스럽다.

3. 가정법 과거완료 구문에서 without이 이끄는 구는 「if it had not been for ~」로 바꿔 쓸 수 있다.

4. ⑤ 바로 앞 문장에 'This decision'이 의미하는 것이 제시되어 있다.

5. ③ '(목적어)가 ~하게 하다'라는 의미의 「make+목적어+동사원형」 구문이므로, looking을 look으로 고쳐야 한다.

6. ⑤ 화자는 겸재의 수묵화들이 여전히 주변에 존재한다고 했으므로, 현시대에도 감상할 수 있다.
 오답
 ① 정선과 겸재는 동일 인물이다.
 ② 겸재가 그린 수묵화가 해악전신첩이라는 화첩에 들어있다.
 ③ 수묵화가 묘사하는 것은 금강산과 주변 지역이다.
 ④ 간송은 해악전신첩이 태워질 뻔했던 일 이후에 그것을 매입했다.

7. (A) 문맥상 아주 멋진 자기 화병이 화자를 감명시켰다(impressed)고 하는 것이 적절하다. disappoint는 '실망시키다'라는 뜻이다.

(B) 다른 일본인 미술상이 간송이 화병에 지급했던 금액의 두 배를 제안했고(offered), 이를 간송이 거절했다고 하는 것이 자연스럽다. expect는 '기대하다'라는 뜻이다.
(C) 그것이 가장 아름다운(magnificent) 화병이라서 간송이 내주지 않았다고 하는 것이 적절하다. humble은 '초라한'이라는 뜻이다.

8. 선행사 the money를 수식하는 목적격 관계대명사절 he spent on it을 쓰며, 목적격 관계대명사는 생략된 형태이다.

9. 「seem to-v」는 '~인 것 같다'의 의미이다.

10. (A) 동사 heard의 목적어 역할을 하는 명사절을 이끄는 접속사 that이 와야 한다.
(B) 동사 purchased와 접속사 and로 병렬 연결되어 있으므로, 과거형 hid가 와야 한다.
(C) 전치사 to의 목적어 역할을 하는 동명사 preserving이 와야 한다.

11. at all costs: 무슨 수를 써서라도

12. 간송이 지켜낸 문화유산인 훈민정음 해례본에 관한 글이므로, ⑤ '한국은 유네스코 세계기록유산의 16개 항목을 가지고 있다.'는 흐름과 관계없다.

13. 간송 미술관의 과거와 현재를 설명하고 있으므로, 주제로는 ① '간송 미술관의 역사'가 가장 적절하다.
 오답
 ② 간송이 한국의 미술품을 어떻게 수집했나
 ③ 간송 미술관의 소장품
 ④ 간송은 왜 미술관을 설립했나
 ⑤ 한국의 문화적 물품들의 중요성

14. ② 'he named it Bohwagak'에서 알 수 있다.
 오답
 ① 한국 최초의 사립 미술관이다.
 ③ 간송이 수집한 모든 중요한 문화적 물품들을 보관했다.
 ④ 간송이 죽은 뒤에 간송 미술관으로 개명되었다.
 ⑤ 한국의 국보 12점을 포함해 약 5,000점의 물품을 소장하고 있다.

1회 실전 적중 문제 pp. 177~179

1. ③ 2. ④ 3. ④ 4. ⑤ 5. ⓐ admire ⓑ called ⓒ Knowing
6. ② 7. ⑤ 8. Schools were forbidden to teach lessons in Korean 9. ④ 10. would have been lost to history 11. 나는 간송에 대해 생각하는 것을 멈출 수가 없었다 12. ② 13. ③ 14. ④

1. 봉사활동을 하고 싶어 하는 소년에게 소녀가 '너는 아이들을 좋아하고 수학을 잘하잖아.'라고 말한 것으로 보아 바로 앞에 ③ '초등

학생들에게 수학을 가르치는 게 어때?'라고 말하는 것이 자연스럽다.

오답

① 자원봉사자가 많아서 나는 너와 갈 수 없어.

② 너는 지난주에 어디에서 자원봉사를 했니?

④ 자원봉사를 하는 것이 내게는 쉽지 않아.

⑤ 너는 왜 봉사활동을 하고 싶니?

2. (A) 미술품과 골동품이 '선별된' 것이므로 과거분사 selected가 적절하다.

(B) 미술품이 '전시된' 것이므로 과거분사 displayed가 적절하다.

(C) 필명인 '간송으로 알려진' 것이므로 by가 적절하다. be known to는 '～에게 알려지다'라는 의미이다.

3. ④ 'Kansong devoted ... works of art'에 제시되어 있다.

오답

① 간송은 전형필의 본명이 아니라 필명이다.

② 24세에 막대한 재산을 물려받았다.

③ 오세창은 간송의 스승이다.

⑤ 한국의 문화유산을 보호하는 데 돈을 썼다.

4. 주어진 문장 '다행히도, 그것은 마지막 순간에 구해졌고 후에 간송에 의해 매입되었다.'는 화첩이 불쏘시개로 태워질 뻔했다는 문장 뒤인 ⑤에 들어가는 것이 자연스럽다.

5. ⓐ 「cannot help but+동사원형」: ～하지 않을 수 없다

ⓑ 화첩이 해악전신첩으로 '불리는' 것이므로 과거분사 called가 적절하다.

ⓒ 문장의 주어 역할을 하는 동명사 Knowing이 적절하다.

6. 빈칸 뒤에서 간송이 그것이 가장 아름다운 화병이라는 것을 알고 있었다고 했으므로, 빈칸에는 ② '그것을 내주는 것을 거절했다'가 자연스럽다.

오답

① 그것을 몰래 팔아 치웠다

③ 그에게 할인을 해 주었다

④ 집을 구매했다

⑤ 일본인 수집가를 만났다

7. ⑤ 앞에서 화자가 화병의 아름다운 무늬를 묘사했고 간송도 이것을 가장 아름다운 화병으로 생각한 것으로 보아, 화병을 직접 본 것이 실망스러운(disappointing) 경험이었다고 하는 것은 어색하다. 따라서 disappointing을 breathtaking(숨이 막히는[멎는 듯한]) 등으로 고쳐야 한다.

8. 학교가 '금지당한' 것이므로 수동태로 써야 하며 주어가 복수명사 Schools이므로 be동사는 were로 쓴다.

9. 빈칸 앞에서 일본에 의해 점령된 상태에서 간송은 훈민정음 해례본을 지키기 위해 그것을 숨겼다고 했고 빈칸 뒤에서는 그것을 한국 국민과 공유할 수 있었다고 했으므로, 빈칸에는 ④ '일본이 마침내 패망했다'가 오는 것이 자연스럽다.

오답

① 그가 그것을 박물관에 보관했다

② 그가 일제에 의해 체포되었다

③ 그 책이 그에 의해 구입되었다

⑤ 그가 그것의 중요성을 이해했다

10. 가정법 과거완료 구문이므로, 주어 뒤에 「조동사의 과거형+have v-ed」로 배열한다.

11. 「stop v-ing」: ～하는 것을 멈추다

12. 간송이 일제 강점기 동안 한국의 문화적 독자성을 보호하기 위해 한국의 미술품을 수집했다는 내용이므로, 문맥상 빈칸에는 ② Thanks to(～ 덕분에)가 가장 적절하다.

오답

① ～에 관하여 ③ ～에도 불구하고

④ ～의 앞에 ⑤ ～에 의하면

13. ③ 관계부사 where 대신 all of the important cultural items를 선행사로 하는 목적격 관계대명사 that이 와야 한다. 선행사에 최상급, the only, all 등이 포함된 경우 관계대명사는 보통 that을 쓴다.

14. ④ 조선 후기의 학자인 정약용이 유배 생활 동안 살았던 다산 초당을 소개하는 글이다.

2회 실전 적중 문제 pp. 180~182

1. Why don't we wait? 2. (A) who (B) to use 3. heritage
4. Kansong devoted most of his fortune to acquiring 5.
(A) the mountains, rivers, and valleys (B) the album 또는
the Haeak jeonsincheop 6. ③ 7. ⑤ 8. ① 9. ② 10. ②
11. ④ 12. more precious 13. ② 14. ①

1. 「Why don't+주어+동사원형 ～?」: ～하는 게 어때?

2. (A) 선행사가 사람인 the man이므로 주격 관계대명사 who가 적절하다.

(B) decide는 목적어로 to부정사를 취하므로 to use가 적절하다.

3. '한 사회에서 역사적, 문화적으로 중요하다고 여기는 예술, 전통, 그리고 신념'이라는 의미의 단어는 heritage((국가·사회의) 유산)이다.

4. 「devote A to B」는 'A를 B에 바치다'라는 의미로, to가 전치사이므로 뒤에 동명사 acquiring을 써야 한다.

5. (A) 바로 앞에 제시된 the mountains ... valleys를 가리킨다.

(B) 앞 문장의 the album을 가리키며, the album의 명칭인 the Haeak jeonsincheop을 가리킨다고 볼 수도 있다.

6. ⓐ와 ③(멋진 전시회를 여러분의 친구들과 감상해 보세요.)의 appreciate는 '진가를 알아보다, 감상하다'의 의미이다.

① 도와주셔서 감사합니다. <u>고마워요.</u>

② 당신의 협조에 다시 한번 감사드립니다.

④ <u>참석해주시면 고맙겠습니다.</u>

⑤ 나는 그가 심각하게 아프다는 것을 충분히 <u>인식하지 못했다.</u>

7. (A) 아름다운 무늬가 꽃병을 '둘러싸고 있는' 것이므로 현재분사 encircling이 적절하다.

 (B) alive와 접속사 and로 병렬 연결되어 있어 be동사의 보어 역할을 하며, 학들이 날개를 '뻗고 있는' 것이므로 현재분사 stretching이 적절하다.

 (C) 문장의 주어 역할을 하는 동명사 Seeing이 적절하다.

8. ① 간송이 화병 구매에 쓴 '돈으로' 좋은 집 20채를 살 수도 있었다고 하는 것이 자연스러우므로, 전치사 With(~로)가 적절하다.

 ② ~ 덕분에 ③ ~에 관하여 ④ ~ 때문에 ⑤ ~ 때문에

9. ⓑ 그것(훈민정음 해례본)은 1940년에 '발견된' 것이므로 수동태인 was found로 써야 한다. founded는 found(설립하다)의 과거형이다.

10. 주어진 글은 간송이 훈민정음 해례본 발견 소식을 듣고 그것을 지켜야 한다는 것을 알았다는 내용으로, 뒤에 수년 후 그가 그 책을 얻어서 숨겼다는 (B), 일본 패망 후에 그가 책을 국민들과 공유할 수 있었다는 (A), 이후에 한국의 국보, 유네스코 세계기록유산으로 지정되었다는 (C) 순으로 오는 것이 자연스럽다.

11. ⓐ at all costs와 ④ by all means는 '무슨 수를 써서라도'라는 의미이다.

 ① 결국 ② 또한 ③ 내내 ⑤ 무상으로

12. 빈칸 뒤에 than이 있으므로 비교급 more precious로 최상급의 의미를 나타낸다.

13. 일제 강점기에 한국의 미술품을 보호하기 위해 노력한 간송에 대한 글이므로, ② '한국 미술품의 보호자'가 제목으로 가장 적절하다.

 ① 한국의 문화적 정체성

 ③ 한국 예술의 높은 수준

 ④ 한국의 일제 강점기

 ⑤ 한국과 일본의 관계

14. (A) 간송이 미술품을 수집한 이유는 한국의 문화적 독자성(identity)을 보호하기 위해서였다고 하는 것이 자연스럽다. identification은 '신원 확인, 식별'이라는 의미이다.

 (B) 한국의 독립 후 미술품 수집을 그만둔 것은 미술품이 한국에 안전하게(safely) 남아 있으리라는 것을 알았기 때문이라고 하는 것이 자연스럽다. rarely는 '좀처럼 ~하지 않는'이라는 의미이다.

 (C) 간송 덕분에 한국 문화의 중요한 부분을 여전히 경험할 수 있

다고 했으므로 그가 한국의 민족혼과 자부심을 지켜낼(defend) 수 있었다고 하는 것이 자연스럽다. offend는 '기분 상하게 하다'라는 의미이다.

3회 실전 적중 문제 pp. 183~185

1. ② 2. ④ 3. 일본으로부터 한국의 문화유산을 보호하는 데 그 돈(재산)을 쓰기로 한 것 4. But for 5. ② 6. ④
7. ⑤ 8. ⑤ 9. ④ 10. ⑤ 11. ⑤ 12. included 13. ⓐ
Standing ⓑ surrounded 14. ②

1. (A) 뒤에 송암에 대해 쓰기로 했다고 대답했으므로 빈칸에는 ⓐ '너 역사 보고서 주제 정했니?'가 들어가는 것이 자연스럽다.

 (B)에 대한 대답으로 그가 시각장애인들을 위한 한국어 점자 체계를 발명한 이유를 설명하고 있으므로 빈칸에는 ⓒ '무엇이 그가 그렇게 하도록 했니?'가 들어가는 것이 자연스럽다.

 ⓑ 너 송암에 관한 보고서 끝마쳤니?

 ⓓ 무엇이 그가 시각장애인이 되게 했니?

2. ④ 스승의 지도와 간송 자신의 무관심(indifference)으로 예술품을 사는 데 재산을 바쳤다고 하는 것은 어색하다. 따라서 indifference를 convictions((강한) 신념) 등으로 고쳐야 한다.

3. This decision이 의미하는 것은 바로 앞 문장에 제시되어 있다.

4. 가정법 과거완료 구문이므로, Without을 But for로 바꿔 쓸 수 있다.

5. (A) 그것들(그림들)이 금강산과 주변 경치를 '묘사하는' 것이므로 능동태인 depict가 적절하다.

 (B) look의 보어가 와야 하므로 형용사 inviting이 적절하다.

 (C) make는 목적어와 목적격 보어가 능동 관계일 때 목적격 보어로 동사원형을 취하므로 feel이 적절하다.

6. ④ 매입 과정은 언급되지 않았다.

 ① 정선(겸재) ② 금강산과 주변 지역의 경치

 ③ 간송 ⑤ 여전히 주변에 존재함

7. 주어진 문장은 '하지만, 간송은 그것이 그런 종류의 화병 중에서 가장 아름다운 화병이라는 것을 알고 있었기 때문에 그것을 내주는 것을 거절했다.'는 의미로, 일본인 수집가가 간송이 그 화병에 지불한 금액의 두 배를 제안한 내용 뒤인 ⑤에 오는 것이 자연스럽다.

8. ⑤ 훈민정음 해례본의 발견 당시 한국은 여전히 일본에 의해 점령된 상태였다.

9. 한국이 일제에 의해 점령된 상태에서 한국어로 수업하는 것이 금지되고 한국어를 연구하는 학자들이 체포되었다고 했으므로, 문맥상 일제가 한글을 없애려고 했다는 것이 자연스럽다. 따라서 ④

enhance(향상시키다)는 적절하지 않다.

오답

①, ②, ③ 없애다, 제거하다 ⑤ 폐지하다

10. ⑤ 훈민정음 해례본이 '발견된' 것이므로 수동태로 써야 하며 간송이 그 사실을 들은(heard) 것보다 먼저 일어난 일이므로 과거완료 시제 had been discovered가 적절하다.

11. 한국이 일본에 의해 점령된 상황에서 훈민정음 해례본을 지키려 한 간송의 노력에 대한 글이므로, ⑤가 주제로 가장 적절하다.

12. (has since been) designated와 접속사 and로 병렬 연결되어 있으므로 included가 적절하다.

13. ⓐ 동시동작을 나타내는 분사구문으로, 생략된 주어 I가 '서 있는' 것이므로, 현재분사 Standing으로 써야 한다.
ⓑ 동시동작을 나타내는 분사구문으로, 생략된 주어 I가 한국 미술품에 의해 '둘러싸인' 것이므로 과거분사 surrounded로 써야 한다.

14. I는 간송이 놀라운 사람이라고 하며 간송 덕분에 한국의 가장 힘든 시기에 민족혼과 자부심을 지켜낼 수 있었다고 하는 것으로 보아, 심경으로는 ② '자랑스러운'이 가장 적절하다.

오답

① 부러워하는 ③ 황홀해하는 ④ 후회하는 ⑤ 기진맥진한

4회 실전 적중 문제
pp. 186~188

1. ⑤ 2. ① 3. devote 4. ⑤ 5. ①, ② 6. ⓐ shocked ⓑ was rescued 7. ⑤ 8. ③ 9. Kansong could have bought 20 nice houses 10. ② 11. ④ 12. Kansong's strong commitment to preserving Korean history 13. 그것(미술품)이 안전하게 한국에 남아 있으리라는 것을 알고 있었기 때문에 14. I would not[wouldn't] have started volunteering

1. B가 봉사활동에 대한 제안을 구하고 있으므로, ⑤ '어떻게 내가 (너의 재능을) 사용할 수 있을까?'는 흐름상 적절하지 않다.

오답

상대방에게 '~하는 게 어때?'라고 제안하는 표현으로는 Why don't you+동사원형 ~?, How[What] about+v-ing ~?, Why not+동사원형 ~? 등이 있다.

2. (A)에는 선행사 the man을 수식하는 주격 관계대명사 who나 that이 올 수 있으며, (B)에는 선행사 Oh Sechang을 부연 설명하는 계속적 용법의 주격 관계대명사 who가 와야 한다. 따라서 공통으로 들어갈 말은 ① who이다.

3. '일이나 목표를 위해 시간이나 에너지 같은 어떤 모든 것을 투입하다'라는 의미의 단어는 devote((~에) 바치다, 쏟다)이다.

4. ⑤ 'Kansong devoted ... works of art'에 his actions가 의미

하는 것이 제시되어 있다.

5. 「cannot help v-ing」, 「cannot (help) but+동사원형」은 '~하지 않을 수 없다'라는 의미이며, ①과 ②는 빈칸에 들어가기에 적절하지 않다.

6. ⓐ 내가 충격을 받은 주체이므로 과거분사 shocked가 적절하다.
ⓑ 그것(해악전신첩)이 '구해진' 것이므로 수동태 was rescued가 적절하다.

7. 훼손될 뻔한 상황에서 구해진 그림들을 미래 세대도 감상할 수 있을 것이라는 내용이므로 빈칸에는 ⑤ '감사한'이 들어가는 것이 자연스럽다.

오답

① 부끄러운 ② 우울한 ③ 궁금한 ④ 무지한

8. (A) 선행사 The next item을 수식하는 주격 관계대명사 that이 적절하다. what은 선행사를 포함하는 관계대명사이다.
(B) '~인 것처럼 보이다'라는 의미의 「seem to-v」가 쓰인 것이며 alive가 형용사이므로 to be alive 형태가 적절하다.
(C) 간송이 내주기를 거절한 것은 앞 문장의 the vase(화병)이므로, 목적어로는 대명사 it이 적절하다.

9. 「could have v-ed」는 '~했을 수도 있다'는 의미로, 과거의 일에 대한 추측을 나타낸다.

10. ⓑ는 한글을 가리키는 반면, 나머지는 모두 훈민정음 해례본을 가리킨다.

11. 빈칸 뒤에 학교들은 한국어로 수업하는 것을 금지당했고 한국어를 연구하는 학자들은 체포되었다는 내용이 이어지므로, 빈칸에는 ④ '한국어를 없애다'가 오는 것이 적절하다.

오답

① 한국의 고대 물품들을 보호하다
② 한국인들의 재산을 빼앗다
③ 한글의 원리를 알다
⑤ 한국인들을 감옥에 넣다

12. '~에의 전념, 헌신'을 나타내는 「commitment to v-ing」 구문에서 to는 전치사이므로 뒤에 동명사가 와야 한다. 따라서 preserve를 preserving으로 쓰는 것이 적절하다.

13. 'as he knew ... remain in Korea'에 그 이유가 제시되어 있다.

14. 과거 사실에 대한 가정이므로 「주어+조동사의 과거형+have v-ed」 형태의 가정법 과거완료로 써야 한다.

1. ② 2. ④ 3. occupation 4. ⑤ 5. (A) who (B) they 6. ④
7. so that future generations can also appreciate them
8. ③ 9. seems that the cranes are alive 10. at ten(10)
times the price 11. ④ 12. ⓐ Founded ⓑ holds 13. 그가
수년 동안 수집한 모든 중요한 문화적 물품들을 보관하는 장소
로 사용했다. 14. ②

1. (A) 빈칸 뒤에서 2분 안에 버스가 도착한다고 했으므로, 빈칸에는
 ⓐ '우리 기다리는 게 어때?'가 들어가는 것이 자연스럽다.
 (B) 본인의 재능으로 일상생활을 개선한 고등학생에 대해 들은 상
 황이므로, 빈칸에는 ⓒ '정말 멋진 사람이다!'가 들어가는 것이 자
 연스럽다.
 [오답]
 ⓑ 나는 그 이유를 모르겠어.
 ⓓ 어떻게 우리가 버스를 탈 수 있을까?

2. ④ 뒤에 간송이 한국의 미술품을 획득하는 데 재산을 썼다는 내용
 이 이어지므로 문화유산을 제공하는(provide) 데 돈을 썼다고 하
 는 것은 어색하다. 따라서 provide를 protect(보호하다) 등으로
 고쳐야 한다.

3. '군이 다른 나라를 장악하고 그곳을 지배하기 위해 머무는 상황'
 이라는 의미의 단어는 occupation(점령)이다.

4. ⑤ 뒤에서 오세창의 지도와 자신의 강한 신념으로 간송이 그의 재
 산을 한국의 문화 유산을 획득하는 데 바쳤다고 했으므로, 스승
 '오세창'에 의해 크게 영향을 받았다'고 하는 것이 자연스럽다.
 [오답]
 ① ~에 의해 공표되었다 ② ~에 큰 영향을 주었다
 ③ ~에 의해 갑자기 만들어졌다 ④ ~에게 나쁜 것이었다

5. (A) 선행사 Oh Sechang을 부연 설명하는 계속적 용법의 주격
 관계대명사 who가 적절하다.
 (B) 앞 문장의 these items를 가리키는 대명사 they가 적절하다.

6. ⓓ는 같은 문장에 나온 the mountains, rivers, and valleys를
 가리키는 반면, 나머지는 모두 정선이 그린 수묵화들을 가리킨다.

7. 「so that+주어+동사」: ~하기 위하여, ~하도록

8. ③ 간송은 그것을 보호하기 위해 20채의 집을 샀다. (간송이 화병
 을 구입한 돈으로 당시에 좋은 집 20채를 살 수 있었다고 했음)
 [오답]
 ① 그것은 학 무늬로 꾸며져 있다.
 ② 일본인 미술상이 1935년에 그것을 간송에게 팔았다.
 ④ 간송은 일본인 수집가에게 그것을 팔지 않았다.
 ⑤ 그것은 한국의 국보로 지정되어 있다.

9. '~인 것 같다'는 의미의 「seem+to-v」는 「It seems that+주

10. 어+동사」로 바꿔 쓸 수 있다.

10. 전치사 at을 쓰고, 정관사를 포함하는 표현 the price 앞에 배수
 사 ten times를 써야 한다.

11. 간송이 한국의 문화적 독자성을 보호하기 위해 미술품을 수집했
 다고 했으므로 빈칸에는 ④ '한국 역사를 보존하려는 강한 열망'이
 들어가는 것이 자연스럽다.
 [오답]
 ① 고대 물품들을 구입할 능력
 ② 역사에 기억되려는 노력
 ③ 한글 창제에 대한 호기심
 ⑤ 희귀 골동품에 대한 강한 애착

12. ⓐ 간송 미술관이 '설립된' 것이므로 과거분사 Founded가 적절
 하다.
 ⓑ 간송 미술관이 물품을 '소장하고 있는' 것이므로 능동태 holds
 가 적절하다.

13. 'He used the building ... over the years.'에 보화각을 사용한
 목적이 제시되어 있다.

14. ② 다산 초당은 정약용이 유배 생활하는 10년 동안 살았던 곳이
 다.

1. Without my mother's committed effort, I would not
have been able to 2. After carefully thinking about what
he could do for his country 3. 미래 세대 또한 이 그림들
을 감상할 수 있게 그것들이 여전히 주변에 존재해서 4. (1) ⓐ
admire, but admire 또는 admiring (2) ⓓ feeling, feel 5.
The cranes seem to be alive 6. (1) ⓐ called, a gorgeous
porcelain vase가 the Celadon 이하로 '불리는' 것이므로 과
거분사 called로 써야 한다. (2) ⓒ to part, refuse는 목적어로
to부정사를 취하는 동사이다. 7. He did it to protect Korea's
cultural identity 8. It explains the ideas and principles
behind the creation of Hangeul(, the writing system
of the Korean language). 9. (1) forbid (2) obtain (3)
designate (4) treasure (5) principle (6) commitment

1. if절 대신 without구가 쓰인 가정법 과거완료 구문이므로,
 「without+명사구」 뒤에 「주어+조동사의 과거형+have v-ed」 형
 태로 써야 한다.

2. thinking about의 목적어 역할을 하는 간접의문문은 「의문사+주
 어+동사」 어순으로 쓴다.

3. 'these paintings ... appreciate them.'에 그 이유가 제시되어
 있다.

4. ⓐ '~하지 않을 수 없다'는 「cannot help but+동사원형」 또는 「cannot help v-ing」 구문으로 나타낸다.
ⓓ 「make+목적어+동사원형」: (목적어)가 ~하게 하다

5. '~인 것처럼 보이다'라는 의미의 「It seems that+주어+동사」는 「주어+seem to-v」로 바꿔 쓸 수 있다.

6. ⓐ 분사가 명사구 a gorgeous porcelain vase를 뒤에서 수식하는 형태로, 아주 멋진 자기 화병이 청자 상감운학문 매병으로 '불리는' 것이므로 과거분사 called가 되어야 한다.
ⓒ refuse는 목적어로 to부정사를 취하는 동사이므로 to part로 써야 한다.

7. 목적을 나타내는 부사적 용법의 to부정사 to protect를 써서 문장을 완성한다.

8. Q: 훈민정음 해례본은 무엇을 설명하는가?
'This ancient book ... Korean language.'에 훈민정음 해례본이 설명하는 것이 제시되어 있다.

9. (1) 어떤 것이 허락되지 않는다고 말하다; 금지하다: forbid(금지하다)
(2) 대개 어떤 것을 요구하거나 찾은 결과로 얻다; 취득하다: obtain(얻다)
(3) 특정 목적을 위해 무언가나 누군가를 선정하다: designate(지정하다)
(4) 귀중한 것들의 모음: treasure(보물)
(5) 기반으로 사용될 수 있는 규칙이나 기준: principle(원리)
(6) 어떤 것에 헌신하는 특성이나 상황: commitment(전념, 헌신)

Lesson 05 Look, Think, and Create!

어휘 만점 **Vocabulary Check-Up** p.197

01. 로봇공학 **02.** 나누어 퍼뜨리다 **03.** 끊임없는 **04.** (도움·조언 등을 위해) ~에 의지하다, ~로 눈을 돌리다 **05.** 비교적 **06.** 발생시키다 **07.** 전형적인 **08.** (개선 방안을 찾기 위해) ~을 고려해 보다, ~로 눈을 돌리다 **09.** 흙더미, 언덕 **10.** 우월성 **11.** 이용하다 **12.** ~을 이어받다 **13.** 비추다 **14.** 놀라운 **15.** 포함하다 **16.** ~을 찾아내다 **17.** 나선형의 **18.** 유명한 **19.** 첨탑 **20.** ~에서 파생되다 **21.** 측면 **22.** 건축학의, 건축술의 **23.** construction **24.** innovative **25.** imitation **26.** evenly **27.** term **28.** escape **29.** agriculture **30.** pollution **31.** supply ~ with ... **32.** automatic **33.** column **34.** absorb **35.** alternative **36.** prefer ~ to ... **37.** split off **38.** install **39.** inspiration **40.** functional **41.** recognize **42.** architect **43.** sphere **44.** artificial

문법 만점 **Point Check-Up** pp.198~199

1. (1) O (2) O (3) X **2.** (1) which (2) which I thought (3) but it

문법 만점 **확인 문제** pp. 200~201

01. (1) which (2) Having been given (3) Having been surrounded **02.** (1) (Having been) Cooked too quickly (2) (Being) Written in large letters (3) (Being) Looked at through a magnifying glass **03.** (1) which was really annoying (2) which are still loved by many children (3) which some celebrities have visited **04.** (1) Being asked to leave (2) which caused him (3) which made me **05.** ① **06.** (1) which made her cheeks turn red (2) which made her husband smile **07.** ③

01. (1) 관계대명사 that은 계속적 용법으로 쓸 수 없으므로 which가 적절하다.
(2) 분사구문이 쓰인 문장으로, 주절의 주어인 he가 숙제를 '받은' 것이므로 수동의 의미를 나타내는 Having been given이 적절하다.
(3) 분사구문이 쓰인 문장으로, 주절의 주어인 we가 적들에 의해 '둘러싸인' 것이므로, 수동의 의미를 나타내는 Having been

surrounded가 적절하다.

02. (1) 수동형인 부사절의 시제가 주절의 시제보다 앞서므로 Having been cooked too quickly가 적절하며, Having been은 생략할 수 있다.

(2) 수동형인 부사절의 시제가 주절의 시제와 같으므로 Being written in large letters가 적절하며, Being은 생략할 수 있다.

(3) 수동형인 부사절의 시제가 주절의 시제와 같으므로 Being looked at through a magnifying glass가 적절하며, Being은 생략할 수 있다.

03. (1) 앞 절 전체를 선행사로 하는 주격 관계대명사 which의 계속적 용법으로 쓴다.

(2) a lot of picture books를 선행사로 하는 주격 관계대명사 which의 계속적 용법으로 쓴다.

(3) the luxurious hotel을 선행사로 하는 목적격 관계대명사 which의 계속적 용법으로 쓴다.

04. (1) 주절의 주어인 she가 '요구를 받은' 것이므로, 수동의 의미를 나타내는 분사구문 Being asked to leave가 적절하다.

(2),(3) 주격 관계대명사 which의 계속적 용법이 적절하다.

05. (A) 주절의 주어인 a thirsty crow가 피곤함을 느낀 주체이므로 (Being) Tired로 나타낼 수 있다.

(B) 주절의 주어인 it(the crow)이 좌절감을 느낀 주체이므로 (Being) Frustrated로 나타낼 수 있다.

06. (1), (2) 모두 앞 절에 대한 부가 설명이므로 콤마(,) 뒤에 계속적 용법의 주격 관계대명사 which를 써야 한다. 뒤에는 '~을 …하게 하다'의 의미로 「make+목적어+동사원형」의 순서로 쓴다.

07. ⓑ 계속적 용법의 관계대명사 which가 주어 역할을 하므로 it을 생략해야 한다. 또는, which it을 「접속사+대명사」인 and it으로 고쳐야 한다.

ⓒ 주절의 주어인 he가 '선택 받은' 것이므로, Chose가 아닌 수동의 의미를 나타내는 분사구문 (Being) Chosen을 써야 한다.

본문 만점 빈칸 채우기 pp. 208~211

(1) we need to survive (2) inspiration to create (3) based on nature (4) derived from (5) already come up with answers (6) to learn how they work (7) been able to find (8) one of the most prominent buildings (9) took over responsibility (10) under construction (11) everyone is fascinated by (12) should look to nature (13) to the straight lines (14) can be seen (15) incorporate images and forms (16) spheres that resemble fruits (17) turtles carved (18) the most impressive feature (19) who look

up can feel (20) The light that comes through (21) Inspired by trees (22) by distributing its weight (23) both beautiful and functional (24) an office building (25) as visually impressive as (26) excellent example (27) to install, run, and maintain (28) To solve this problem (29) built by (30) stay cool due to (31) referred to (32) are close to the ground (33) The heat generated by (34) at a comfortable temperature (35) surrounding the mound (36) stays relatively cool (37) is finally released (38) inspired Pearce to design (39) was constructed without (40) that can store (41) absorb heat during the day (42) to store heat (43) keep the building cool (44) comes into the building (45) through the building by (46) generated by human activity (47) but also fresh air (48) less energy than other buildings (49) Without the inspiration Pearce received (50) Using biomimicry in architecture (51) used to solve problems (52) makes us feel closer to nature (53) destroying the environment

본문 만점 옳은 어법 · 어휘 고르기 pp. 212~213

01. impresses **02.** with **03.** successful **04.** Designed **05.** inspiration **06.** to **07.** incorporate **08.** that **09.** as if **10.** resembles **11.** to support **12.** Due to **13.** escaping **14.** is released **15.** but also **16.** far **17.** have been **18.** being **19.** Imitating **20.** to stop

본문 만점 틀린 문장 고치기 pp. 214~216

01. ◯ **02.** ◯ **03.** X, base → based **04.** ◯ **05.** X, have → has **06.** X, do they → they **07.** ◯ **08.** ◯ **09.** X, building → buildings **10.** ◯ **11.** ◯ **12.** X, are → is **13.** ◯ **14.** ◯ **15.** X, saw → seen **16.** ◯ **17.** X, carving → carved **18.** ◯ **19.** X, are → were **20.** ◯ **21.** ◯ **22.** ◯ **23.** X, where → that **24.** ◯ **25.** X, visual → visually **26.** ◯ **27.** X, cost → costly **28.** ◯ **29.** X, build → built **30.** ◯ **31.** X, have → has **32.** ◯ **33.** ◯ **34.** ◯ **35.** X, absorb → absorbs **36.** X, coolly → cool **37.** ◯ **38.** X, designing → to design **39.** ◯ **40.** ◯ **41.** ◯ **42.** X, storing → store **43.** ◯ **44.** ◯ **45.** ◯ **46.** X, are → is **47.** ◯ **48.** X, save → saves **49.** X, receive → received **50.** ◯ **51.** ◯ **52.** X, to feel → feel **53.** ◯

1. ③ 2. ④ 3. ④ 4. ② 5. (r)emarkable 6. can feel as if they were standing in a great forest 7. ⓐ resembles ⓑ (Being) Inspired ⓒ to support 8. ② 9. ② 10. escaping through the top of the mound 11. ④ 12. the soil surrounding the mound absorbs heat in the hot daytime hours 13. ③ 14. ⓐ to solve ⓑ destroying

1. 일상 생활 속에서 영감을 얻을 수 있다는 내용이므로, 주제로는 ③이 적절하다.

2. (A) 문장의 주어가 It이고 동사 impresses와 병렬 연결되어 있으므로, supplies가 적절하다.
(B) 창조해 내는 행위가 자연 모방(biomimicry)으로 '불리는' 것이므로 과거분사 called가 적절하다.
(C) 뒤에 복수명사 aspects가 나오므로 other가 적절하다.

3. ⓓ는 바로 앞 문장의 biomimicry를 가리키는 반면, 나머지는 모두 Nature를 가리킨다.

4. 가우디가 자연의 특징을 건물 설계에 적용했다는 내용이므로 ② '많은 사람들은 가우디에 의해 설계된 수많은 건축물을 선호했다.'는 흐름과 관계없다.

5. '몹시 좋은 무언가로 인해 눈에 띄는'이라는 의미의 단어는 remarkable(놀라운)이다.

6. 주어진 주격 관계대명사절 뒤에 동사구 can feel이 오고, 주절과 같은 시점의 사실이 아닌 일을 가정하므로 「as if+주어+동사의 과거형」 형태의 가정법 과거 구문을 써야 한다.

7. ⓐ 주어가 The light이므로 단수형인 resembles가 적절하다.
ⓑ 분사구문에서 생략된 주어인 Gaudi가 나무에 의해 '영감을 받은' 것이므로 과거분사 Inspired가 적절하며, 앞에 Being이 생략되어 있다.
ⓒ 「allow+목적어+to-v」: ~가 …하게 하다

8. 빈칸 뒤에서 열이 흰개미집의 중앙 굴뚝과 꼭대기를 통해 나가고 시원한 공기가 작은 굴뚝을 통해 들어온다고 했으므로, 흰개미집이 시원하게 유지되는 것은 ② '끊임없는 공기의 흐름' 때문이라고 하는 것이 가장 적절하다.
오답
① 그것들의 큰 규모
③ 그것들을 짓는 데 사용된 재료
④ 상대적으로 뜨거운 온도
⑤ 흰개미에 의해 발생된 더 시원한 공기

9. ② 하라레에서 냉방 장치를 유지하는 것은 저렴하다. (매우 비쌀 수 있음)
오답

① Eastgate Centre는 시각적으로 인상적이지 않을 수 있다.
③ 집 중앙에 큰 굴뚝이 있다.
④ 흰개미의 일상 활동은 열을 발생시킨다.
⑤ 시원한 공기는 더 작은 굴뚝을 통해 집으로 들어온다.

10. 먼저 접속사 and와 주절의 주어와 동일한 주어 the heat을 생략한 후, 동사를 현재분사 escaping으로 바꿔 쓴다.

11. ④ help는 동사원형이나 to부정사를 목적어로 취하므로 keeping을 keep 또는 to keep으로 고쳐야 한다.

12. Q: 집 안의 온도는 왜 크게 올라가지 않나?
A: 그것은 뜨거운 낮 동안 집을 둘러싸고 있는 흙이 열을 흡수하기 때문이다.

13. (A) 에너지를 적게 쓰는 것에 대한 부연 설명이므로 돈을 절약해 준다(saves)고 하는 것이 적절하다. waste는 '낭비하다'라는 뜻이다.
(B) Pearce의 영감 없이는 앞에 제시된 건물의 장점을 갖는 것이 가능하지(possible) 않았을 것이라고 하는 것이 적절하다. impossible은 '불가능한'이라는 뜻이다.
(C) 자연 모방의 긍정적 효과를 언급하고 있으므로 인간이 무언가를 하는 방식을 향상시키는(improve) 데 자연의 가르침을 이용한다고 하는 것이 적절하다. ignore는 '무시하다'는 뜻이다.

14. ⓐ 목적을 나타내는 부사적 용법의 to부정사를 써야 한다.
ⓑ 「stop+v-ing」: ~하는 것을 멈추다

1. ④ 2. ③ 3. ② 4. ④ 5. ③ 6. He preferred the curves found in natural objects to the straight lines found 7. ③ 8. 가우디가 꼭대기 가까이에서 나뭇가지로 갈라지는 하나의 토대가 기둥에 있게 한 것 9. ③ 10. ⓐ rises ⓑ keeping 11. ③ 12. ③ 13. conventional 14. ③ 15. ②

1. ④ Hetrick이 자동차 사고에서 영감을 받아 에어백을 만들었다고 했으므로 나쁜 경험을 기회(opportunity)로 바꾸었다고 하는 것이 적절하다.
오답
① 역경 ② 영향 ③ 합의 ⑤ 보험

2. ③ 빈칸 앞에 자연 모방을 활용하는 건축가들이 자연을 세밀하게 연구한다는 내용이 오고 뒤에는 그들이 건축학적 문제에 대한 해결책을 찾을 수 있었다고 했으므로, 빈칸에는 As a result(결과적으로)가 적절하다.
오답
① 마찬가지로 ② 하지만 ④ 예를 들어 ⑤ 반면에

3. ② 주어가 The act이므로 단수형 is가 와야 한다.

4. 밑줄 친 (A) prominent는 '유명한'이라는 의미로, ④ famous(유

명한)와 바꿔 쓸 수 있다.

오답

① 막대한 ② 끈질긴 ③ 불가피한 ⑤ 현대의

5. ③ 선호가 '보여지는' 것이므로 see를 수동태 be seen으로 써야 한다.

6. 'B보다 A를 선호하다'를 나타내는 「prefer A to B」 구문으로 문장을 완성한다.

7. (A) 가우디가 디자인한 기둥들이 나무와 가지를 닮았다고 했으므로, 위를 올려다보는 방문객들이 마치 숲에 서 있는 것처럼(as if) 느낄 수 있다고 하는 것이 자연스럽다.
 (B) 가우디가 아름답고 기능적인 건물을 설계한 것은 그가 자연이 지닌 형태의 우월성을 인지했기 때문이라고(because) 하는 것이 자연스럽다.

오답

① ~ 전에, ~일지라도 ② ~ 후에, ~할 때
④ ~ 때문에, ~하는 동안 ⑤ ~일지라도, ~ 때문에

8. 바로 앞 문장의 'Gaudi gave ... near the top'에 제시되어 있다.

9. 흰개미집이 시원하게 유지되는 구조적인 이유에 관한 글이므로 ③ '게다가, 다른 실험에도 흰개미집이 사용되고 있다.'는 흐름과 관계없다.

10. ⓐ 문장의 주어가 The heat이므로 rise를 단수형인 rises로 써야 한다.
 ⓑ 문장에 동사(is pulled)가 이미 있으므로 keep을 현재분사 keeping으로 써서 앞 절의 내용을 부연 설명하는 분사구문이 되게 한다.

11. ③ 건물의 바닥 근처에 열린 공간을 통해 바깥 공기가 안으로 들어온다고 했다.

12. ③ 첫 번째 단락에서 흰개미집을 둘러싼 흙이 낮에 열을 흡수한다고 했고 해당 문장에서 건물의 바닥과 벽이 흰개미집의 흙과 같은 기능을 한다고 했으므로, 바닥과 벽이 낮 동안 열을 방출한다(emit)고 하는 것은 적절하지 않다. 따라서 emit를 absorb(흡수하다) 등으로 고쳐야 한다.

13. '일반적이거나 보통의 기준에 기반한; 전통적인'이라는 의미의 단어는 conventional(전형적인)이다.

14. (A) 돈을 아끼고 환경을 보호하는 데 도움을 준다고 하는 것으로 보아 에너지를 덜(less) 쓴다고 하는 것이 자연스럽다. more는 '더'라는 뜻이다.
 (B) 자연 모방에 대한 내용이므로, 흰개미로부터 받은(received) 영감이라고 하는 것이 자연스럽다. reject는 '거부[거절]하다'라는 뜻이다.
 (C) 자연이 주는 아이디어를 모방하는 것은 우리가 자연과 가깝게 느끼게 해주며, 그 결과 인간은 환경을 파괴하는 것(destroying)을 멈춘다고 하는 것이 자연스럽다. protect는 '보호하다'라는 뜻

이다.

15. ② 관계대명사 that은 계속적 용법으로 쓸 수 없으므로 which로 고쳐야 한다.

1회 실전 적중 문제 pp. 223~225

1. ③ 2. ④ 3. ② 4. ⑤ 5. ⑤ 6. ② 7. (f)unctional 8. ③ 9. ③ 10. ③ 11. ⑤ 12. the building has not only cool temperatures but also fresh air 13. ③ 14. Being frustrated, it was about to accept its fate

1. 창의적으로 생각하는 방법에 대한 대화이므로, 빈칸에는 ③ '좋은 아이디어를 생각해 내다'가 적절하다.

오답

① 많은 친구를 사귀다
② 더 나은 작가가 되다
④ 재미있는 책을 고르다
⑤ 소셜 미디어에서 인기 있다

2. 주어진 문장은 '이 용어는 '생명'을 뜻하는 그리스어인 bios와 '모방'을 뜻하는 그리스어인 mimesis에서 파생되었다.'라는 의미로, biomimicry라는 단어를 소개한 문장 뒤인 ④에 오는 것이 적절하다.

3. (A) 사람을 나타내는 선행사 Architects(건축가들)를 수식하는 주격 관계대명사 who 또는 that이 와야 한다.
 (B) 선행사 the problems를 수식하는 목적격 관계대명사 which 또는 that이 와야 한다.

4. ⑤ 'the building is still under construction'에서 공사가 아직도 진행 중임을 알 수 있다.

오답

① 바르셀로나에 있는 거대한 성당이다.
② 안토니 가우디가 설계했다.
③ 세계에서 가장 유명한 건물 중 하나이다.
④ 1882년에 건설이 시작됐다.

5. 가우디는 건축가들이 영감을 얻기 위해 자연으로 눈을 돌려야 한다고 믿었다는 내용의 주어진 문장 뒤에, 가우디가 자연물에서 발견되는 곡선을 선호했다는 (C), 이러한 선호를 Sagrada Familia를 포함한 가우디의 건물에서 볼 수 있으며, 그 성당의 많은 부분이 자연의 이미지와 형태를 포함한다는 (B), 이에 대한 예시인 (A) 순으로 오는 것이 적절하다.

6. ② 주절과 같은 때의 사실이 아닌 일을 가정하는 가정법 과거 「as if+주어+동사의 과거형」 구문이 쓰인 것이므로, are를 과거형 were로 고쳐야 한다.

7. '목적이나 쓰임새가 있는; 목적에 부합할 수 있는'이라는 의미의 단어는 functional(기능적인)이다.

8. 흰개미집에서 열을 빠져나가고 시원한 공기는 들어와서 집이 쾌적한 온도로 유지된다고 했으므로, 흰개미집이 ③ '시원하게 유지된다'고 하는 것이 적절하다.

오답

① 어둡다 ② 약하다 ④ 보호되다 ⑤ 무너지다

9. (A) 선행사 smaller outer chimneys를 수식하는 주격 관계대명사 that이 적절하다. what은 선행사를 포함하는 관계대명사이다.
(B) 연속동작을 나타내는 분사구문으로, 생략된 주어인 열(the heat)이 '빠져나가는' 것이므로 현재분사 escaping이 적절하다.
(C) 형용사 cool을 수식하므로 부사 relatively가 적절하다.

10. Eastgate Centre는 전형적인 냉방 시스템이 없다는 주어진 문장 뒤에, 그 대신 열기를 저장할 수 있는 건축 자재를 사용했다는 (B), 저장된 열의 방출에 관한 내용인 (C), 건물의 구조도 온도 유지에 도움을 준다는 추가적인 설명인 (A) 순으로 오는 것이 자연스럽다.

11. ⓐ와 ⑤(집에 도착했을 때쯤에는, 우리는 피곤하고 배가 고팠다.)의 by는 '~쯤에는'의 의미이다.

오답

① 그녀는 트럭에 의해 치였다.
② 식료품 가격이 10퍼센트 올랐다. (양 · 정도)
③ 너는 휴대폰으로 표를 예약할 수 있다.
④ 그는 아무 말 없이 바로 나를 지나서 걸어갔다.

12. not only A but also B: A뿐만 아니라 B도

13. 자연 모방(biomimicry)은 문제 해결을 돕고 사람들이 자연을 더 가깝게 느끼도록 해 준다고 했으므로, 주제로는 ③ '자연 모방의 긍정적 효과'가 적절하다.

오답

① 다양한 건축 기술 ② 로봇공학 연구의 중요성
④ 환경을 보호하는 방법 ⑤ 미래의 식량 부족 문제

14. Being frustrated로 문장을 시작하며, 주절에는 '막 ~하려고 하다'를 나타내는 「be about to-v」 구문을 쓴다.

2회 실전 적중 문제 pp. 226~228

1. ③ 2. The act of creating things based on nature 3. ④ 4. ⑤ 5. the church is one of the most prominent buildings in the world 6. (A) visitors (B) the roof 7. resemble 8. ③ 9. ③ 10. ⑤ 11. ③ 12. ① 13. She saw a cute boy in the photograph, which made her cheeks turn red.

1. (A) 빈칸 앞에는 영감이 일부 예술가들에게만 필요하다는 내용이고 뒤에는 모두에게 필요하다는 상반되는 내용이므로, 빈칸에는 However(그러나)가 적절하다.

(B) 앞에서 나열한 사례에 대해 빈칸 뒤에서 영감은 어디에나 있다고 요약하고 있으므로, 빈칸에는 In short(요약하면) 또는 Therefore(그러므로)가 적절하다.

오답

similarly: 유사하게도 moreover: 게다가
for example: 예를 들어

2. of가 전치사이므로, create를 전치사의 목적어 역할을 하는 동명사 creating으로 바꿔 쓴다.

3. ⓓ는 앞에 언급된 plants, animals, and other aspects of nature를 가리키는 반면, 나머지는 모두 Architects를 가리킨다.

4. (A) 가우디는 자연물에서 발견되는 곡선을 선호했으며 그의 건물에서 자연의 곡선, 이미지, 형태를 발견할 수 있다는 내용으로 보아, 건축가들이 영감(inspiration)을 얻기 위해 자연으로 눈을 돌려야 한다고 하는 것이 자연스럽다. depression은 '우울'이라는 의미이다.
(B) 앞에 가우디가 자연의 곡선을 더 선호한다는 내용이 나오므로, 뒤에서 이런 선호(preference)라고 하는 것이 적절하다. inference는 '추론'이라는 의미이다.
(C) 성당의 많은 부분은 자연에서 온 이미지와 형태를 포함한다(incorporate)고 하는 것이 적절하다. corporate는 '기업의'라는 의미이다.

5. 「one of the + 최상급 + 복수명사」: 가장 ~한 … 중 하나

6. (A)와 (B)는 각각 앞에서 언급된 visitors(관람객들)와 the roof(지붕)를 가리킨다.

7. '누군가 또는 어떤 것처럼 보이거나 비슷하다'라는 의미의 단어는 resemble(닮다)이다.

8. 주어진 문장은 '하라레의 뜨거운 기후 때문에, 냉방 장치를 설치하고, 작동하고, 유지하는 것이 매우 비쌀 수 있다.'라는 의미로, 이 문제를 해결하기 위한 Pearce의 대안을 소개하는 문장 앞인 ③에 오는 것이 적절하다.

9. (A) 끊임없는 공기의 흐름으로 인해 흰개미집이 시원한 것이므로, 빈칸에는 이유를 나타내는 due to(~ 때문에)가 오는 것이 자연스럽다.
(B) 흰개미집을 둘러싼 흙이 열을 흡수해서 온도가 서늘하게 유지되는 것이므로, 빈칸에는 결과를 나타내는 Therefore(그래서)가 오는 것이 자연스럽다.

오답

but for: ~이 없다면 however: 그러나
similarly: 비슷하게 despite: ~에도 불구하고

10. ⑤ 공기가 '방출되는' 것이므로 수동태 is released로 써야 한다.

11. 자연의 가르침을 이용하는 자연 모방 (기술)에 관한 내용이므로, 빈칸에는 ③ '자연이 주는 아이디어를 모방하는 것'이 적절하다.

오답

① 식물을 키우는 것 ② 공기를 정화하는 것
④ 다른 사람들로부터 도움 받는 것 ⑤ 나무 같은 천연 재료

12. ① very는 비교급을 수식하지 않으므로, 부사 far, much, even, a lot 등이 되어야 한다.

13. 두 번째 문장이 앞 문장에 대한 부가 설명이므로, 앞 문장 전체를 지칭하는 This 대신 관계대명사의 계속적 용법인 「콤마(,)＋which」로 문장을 연결한다.

3회 실전 적중 문제 pp. 229~231

1. (B) → (A) → (C) 2. ⑤ 3. ① 4. ⑤ 5. ② 6. ⓐ resembles ⓑ distributing 7. 하라레의 뜨거운 기후 때문에 냉방 장치를 설치하고, 작동하고, 유지하는 것이 매우 비쌀 수 있는 것 8. ② 9. (A) comfortable (B) increase 10. ⑤ 11. ④ 12. (A) Imitating the ideas of nature (B) the environment 13. ④

1. 글쓰기 대회가 있을 거라는 말 뒤에 시를 써서 대회에 제출할 거라고 대답하는 (B), 시를 위한 아이디어가 있는지 묻는 (A)가 온 후 노력 중이라고 하며 상대방에게 조언을 구하는 (C) 순으로 오는 것이 적절하다.

2. 자연 모방 기술과 이 기술을 활용하는 건축가들에 대한 내용이므로 요지로는 ⑤가 적절하다.

3. ① 누가 Sagrada Familia를 짓기 시작했는가? (알 수 없음)

오답

② 언제 가우디가 성당의 설계에 대한 책임을 이어받았는가? (1883년)

③ 무엇이 사람들이 Sagrada Familia에 매력을 느끼게 하는가? (독특한 디자인)

④ 가우디는 곡선과 직선 중 무엇을 선호했는가? (곡선)

⑤ 자연에서 온 이미지와 형태를 포함한 가우디의 예시들은 무엇인가? (성당의 첨탑들, 기둥의 초석들, 나선형 계단들)

4. ⑤ 거북이가 기둥 초석에 '조각된' 것이므로 과거분사 carved를 써야 한다.

5. 기둥이 단순히 장식용이 아니라 무게를 잘 지탱하는 기능도 있다고 했으므로, 빈칸에는 ② '아름다우면서도 기능적인'이 적절하다.

오답

① 지역 사회에 개방된 ③ 편하지 않지만 비용 효율적인
④ 자연재해를 견딜 만큼 강한 ⑤ 주위 환경과 조화를 이루는

6. ⓐ 주어가 The light이므로 동사는 단수형이 와야 하며 resemble은 전치사와 함께 쓰지 않는 동사이므로 resembles가 되어야 한다.

ⓑ 「by v-ing」: ~함으로써

7. 'Due to the hot climate ... to install, run, and maintain.'에 그 내용이 제시되어 있다.

8. 흰개미집이 공기의 흐름으로 인해 온도를 시원하게 유지한다는 내용의 글이므로, ② '흰개미집은 모양과 색이 다양하다.'는 글의 흐름과 관계없다.

9. (A) 더 시원한 공기가 들어온다고 했으므로 흰개미집을 쾌적한 (comfortable) 온도로 유지한다고 하는 것이 자연스럽다. convenient는 '편리한'이라는 의미이다.

(B) 흰개미집 안의 온도가 비교적 서늘하게 유지된다고 했으므로 온도가 크게 오르지(increase) 않는다고 하는 것이 자연스럽다. decrease는 '감소하다'라는 의미이다.

10. 주어진 문장 '이 공기는 자동 팬 장치에 의해 건물을 통과하여 이동한다.'는 바깥 공기가 건물로 들어온다는 문장 뒤, 이 공기가 굴뚝으로 방출된다는 문장 앞인 ⑤에 오는 것이 적절하다.

11. ④ 선행사인 앞 절 전체를 부연 설명하므로, 콤마(,) 뒤에 계속적 용법의 관계대명사 which가 와야 한다. 관계대명사 that은 계속적 용법으로 쓰지 않는다.

12. (A)와 (B)는 각각 앞 절의 명사구 Imitating the ideas of nature와 명사 the environment를 가리킨다.

13. ④ 감독은 자신의 육아 경험에서 영감을 얻었다.

4회 실전 적중 문제 pp. 232~234

1. (B) → (A) → (C) 2. (A) ⓑ (B) ⓒ (C) ⓐ 3. ③ 4. ③ 5. (i)ncorporate 6. 그(Gaudi)가 인공물에서 발견되는 직선보다는 자연물에서 발견되는 곡선을 선호하는 것 7. ⑤ 8. ③ 9. ③ 10. ① 11. ① 12. helps (to) keep the building cool 13. ⑤

1. 에어백의 발명에 대해 설명해달라는 질문에 대한 답으로 에어백을 발명한 사람과 발명의 계기가 된 사고에 대한 (B)가 오고, 그 사고의 결과에 대해서 묻는 (A), 이에 대한 설명인 (C) 순으로 오는 것이 자연스럽다.

2. (A) 뒤에 영화의 내용 설명이 이어지므로 ⓑ(영화가 무엇에 관한 것인지 말씀해 주세요.)가 적절하다.

(B) 뒤에 어디에서 영감을 얻었는지 대답하고 있으므로 ⓒ(정말 독특한 발상이네요! 그 장면들을 어떻게 만드셨나요?)가 적절하다.

(C) 뒤에 고맙다는 답변이 이어지므로 ⓐ(알겠습니다. 관객들은 이것이 역대 가장 놀라운 영화 중 하나라고 말하고 있습니다. 이 영화가 흥행하기를 바랍니다.)가 적절하다.

3. 자연이 주는 이점과 자연 모방 기술에 관한 내용이므로 ③ '창의력을 향상시키기 위해, 사람들은 새로운 것을 배울 필요가 있다.'는 글의 흐름과 관계없다.

4. ③ 자연 모방을 활용하는 건축가들이 자연을 연구해서 결과적으로 해결책을 찾을 수 있었다고 했으므로, 문제의 해답을 이미 '찾아낸' 성공적인 기술자로 자연을 본다는 것이 적절하다.

<div style="display:flex">

<div>

오답

① ~와 어울리다　② ~을 다 써버리다; ~을 바닥내다
④ ~에 싫증 나다　⑤ ~을 참다

5. '더 큰 무언가의 일부로 어떤 것을 포함시키다'라는 의미의 단어는 incorporate(포함하다)이다.

6. 밑줄 친 This preference(이런 선호)의 의미는 바로 앞 문장에 제시되어 있다.

7. 주어진 문장 '이것은 지붕의 무게가 균등하게 나누어지도록 해서 그것들이 지붕을 더 잘 지탱할 수 있게 해 준다.'는 기둥의 역할에 대한 설명으로, 나뭇가지로 갈라지는 기둥의 토대에 대해 언급한 문장 뒤인 ⑤에 오는 것이 적절하다. 주어진 문장에서 This는 앞 문장을, them은 the columns, its는 the roof를 가리킨다.

8. ③ 천장에 있는 작은 구멍들 사이로 빛이 들어온다.

9. ③ 흰개미들은 어떻게 그들의 집을 짓는가? (알 수 없음)
오답
① Eastgate Centre는 어디에 위치해있는가? (짐바브웨의 하라레)
② 왜 하라레에서 냉방 장치를 작동하는 것이 비쌀 수 있는가? (하라레의 뜨거운 기후 때문에)
④ 무엇이 뜨거운 낮 동안 열을 흡수하는가? (흰개미집을 둘러싸고 있는 흙)
⑤ 언제 뜨거운 낮 동안 흡수된 열이 방출되는가? (밤)

10. ① 분사구문이 쓰인 문장으로, 생략된 주어 It(The Eastgate Centre)이 '지어진' 것이므로 과거분사 Built를 써야 하며, 앞에 Being이 생략되어 있다.

11. ① Pearce가 냉방 시스템이 없는 대신 사용한 방법으로 Eastgate Centre의 바닥과 벽이 낮 동안 열을 흡수한다고 했으므로, 열을 생산하는(produce) 건축 자재라고 하는 것은 적절하지 않다. 따라서 produce를 absorb(흡수하다) 등으로 고쳐야 한다.

12. 「help + 동사원형[to부정사]」: ~하는 것을 돕다
「keep + 목적어 + 형용사」: ~을 …한 상태로 유지하다

13. ⑤ 자연 모방을 통해 인간이 환경을 파괴하는 것을 멈출 가능성이 커진다.

5회　실전 적중 문제　pp. 235~237

1. ④　2. (A) with (B) with (C) from　3. ④　4. ⑤　5. that　6. This allows them to support the roof　7. ③　8. install　9. ④　10. cool　11. ①　12. none of this would have been possible　13. ③　14. She answered that it was her first love, which made her husband smile.

</div>

<div>

1. 스위스의 한 기술자가 씨앗에서 영감을 얻어 벨크로를 발명했다는 내용이므로, 빈칸에는 ④ '사람들이 자연에서 유용한 아이디어를 발견할 수 있다는 것'이 적절하다.
오답
① 그가 그것을 벨크로라고 이름 지은 이유
② 애완동물이 사람들을 많이 도울 수 있다는 것
③ 사람들이 자연을 파괴해온 것
⑤ 씨앗이 그의 옷과 강아지 털에 매달린 이유

2. (A) supply A with B: A에게 B를 제공하다
(B) provide A with B: A에게 B를 제공하다
(C) be derived from: ~에서 파생되다

3. ⓐ와 ⓓ는 부사적 용법의 to부정사, ⓑ는 형용사적 용법의 to부정사를 이끌고, ⓒ와 ⓔ는 전치사이다.

4. ⑤ 바다 생물의 껍데기를 닮은 나선형 계단이 있다.

5. 빈칸에는 모두 앞의 명사(구)를 선행사로 하는 주격 관계대명사가 와야 하며, ⓐ의 선행사는 사람이므로 who나 that이, ⓑ~ⓓ의 선행사는 사물이므로 which나 that이 와야 한다. 따라서 공통으로 들어갈 수 있는 관계대명사는 that이다.

6. 「allow + 목적어 + to-v」: ~가 …하게 하다

7. Eastgate Centre를 소개하는 주어진 문장 뒤에, 그 건물의 외관이 인상적이지 않을 수 있다는 (B), 하지만 이 건물이 자연 모방의 훌륭한 예이며 기후로 인한 문제점이 있다고 언급한 (C), 이 문제점을 해결하기 위해 건축가는 흰개미집으로 눈을 돌렸다는 (A)로 이어지는 것이 적절하다.

8. '어떤 것을 어떤 장소에 두고 사용할 준비를 하다'라는 의미의 단어는 install(설치하다)이다.

9. 흰개미집의 굴뚝들을 통해 공기가 순환함으로써 온도가 시원하게 유지된다는 내용이므로, 주제로는 ④ '흰개미집이 그것의 온도를 조절하는 방법'이 적절하다.
오답
① 흰개미가 몸의 열을 유지하는 방법
② 뜨거운 공기가 차가운 공기보다 더 가벼운 이유
③ 사람들이 흰개미를 보호해야 하는 이유
⑤ 과학자들이 흰개미집을 시원하게 만들기 위해 한 것

10. **요약문**
전형적인 냉방 시스템 없이, Eastgate Centre는 내부 공기를 시원하게 유지하도록 설계되었다.

11. ① 바로 앞 절에 있는 openings (near the base of the building)를 가리킨다.

12. 가정법 과거완료 구문으로, without구 뒤에 「주어+조동사의 과거형+have v-ed」가 와야 한다.

13. 자연 모방 기술이 여러 분야의 문제 해결과 환경 파괴를 막는 것

</div>

</div>

에 도움을 준다는 내용이므로, 일반적인 문제 해결 과정을 설명하는 ③ '문제를 해결하는 첫 번째 단계는 그것을 정확하게 확인하는 것이다.'는 관계없다.

14. 두 번째 문장이 앞 문장에 대한 부가 설명이므로, 앞 문장 전체를 지칭하는 This 대신 관계대명사의 계속적 용법인 「콤마(,)+ which」로 문장을 연결한다.

통해 유추할 수 있다.

(2) '사람들의 활동으로 인해 생기는 열기는 아래로 내려가서 결국 열린 공간을 통해 빠져 나간다.'는 거짓이며 'Eventually, the air, along with heat ... on the roof.'에서 그 근거를 찾을 수 있다.

10. 'Imitating ... closer to nature.'에서 자연 모방을 통해 얻는 효과를 언급하며 Biomimicry를 Imitating the ideas of nature라고 표현하고 있다.

서술형으로 내신 만점 pp. 238~240

1. (A) Architects (who use biomimicry) (B) plants, animals, and other aspects of nature **2.** (1) ⓐ building, buildings (2) ⓒ finding, found **3.** by distributing its weight **4.** 마치 그들이 울창한 숲속에 서 있는 것처럼 느끼게 됨 **5.** 열이 흰개미집 꼭대기를 통해 빠져나감 **6.** (1) ⓒ that 또는 which, 명사구 smaller outer chimneys를 선행사로 하는 주격 관계대명사를 써야 함 (2) ⓔ to design, inspire는 목적격 보어로 to부정사를 취함 **7.** (a)utomatic **8.** More importantly, the Eastgate Centre uses far less energy than other buildings, which saves money and helps protect the environment from pollution. **9.** (1) True (2) False, 사람들의 활동으로 생기는 열기는 건물 내부의 열린 공간을 통해 위로 올라가서 지붕에 있는 굴뚝을 통해 빠져나간다고 했다. **10.** Imitating the ideas of nature

1. (A)는 앞 문장에, (B)는 앞 절에 제시되어 있다.

2. ⓐ 「one of the + 최상급 + 복수명사」: 가장 ~한 … 중 하나
ⓒ 곡선이 '발견되는' 것이므로 명사 the curves를 수식하는 과거분사 found가 되어야 한다.

3. 「by v-ing」: ~함으로써

4. 'so visitors who look up ... in a great forest'에 제시되어 있다.

5. 'eventually escaping through the top of the mound'에 제시되어 있다.

6. ⓒ 이어지는 절에 주어가 없고 smaller outer chimneys가 선행사이므로 관계부사 where을 주격 관계대명사 that 또는 which로 고쳐야 한다.
ⓔ 「inspire+목적어+to-v」: (목적어)가 ~하도록 영감을 주다

7. '명령이나 사람의 도움 없이 발생하거나 기능하는'이라는 의미의 단어는 automatic(자동의)이다.

8. 두 번째 문장이 앞 문장에 대한 부가 설명이므로, 앞 문장 전체를 지칭하는 This 대신 관계대명사의 계속적 용법인 「콤마(,)+ which」로 문장을 연결한다.

9. (1) '낮 동안 흰개미집의 흙은 열을 흡수한다.'는 참이며 'The floors and walls ... just like the soil of a termite mound.'를

Coach Carter

어휘 만점 **Vocabulary Check-Up**　　p. 243

01. (시합 등에) 참가하다 **02.** 실행하다, 준수하다 **03.** 의장, 회장 **04.** 학교운영위원회 **05.** (돌보지 않고) 방치하다 **06.** 대회, 경기 **07.** (스포츠에서) 무패의 **08.** 결국 ~한 처지가 되다 **09.** 승리를 거두다, 이기다 **10.** (트랙의) 한 바퀴 **11.** 다시 합류하다 **12.** 평균 평점 **13.** 중퇴하다 **14.** 명시하다 **15.** (약속 등을) 지키다, 이행하다 **16.** (가볍게) 던지다 **17.** ~이 없다, 부족하다 **18.** 깨닫다 **19.** 용어; (지급 · 계약 등의) 조건, 조항 **20.** 유지하다 **21.** 대하다, 다루다 **22.** 고투하다, 힘겹게 나아가다 **23.** resign **24.** vote **25.** discipline **26.** contract **27.** athlete **28.** impress **29.** progress **30.** adjust to **31.** academic **32.** cancel **33.** blame ~ for … **34.** skip **35.** quit **36.** graduate from **37.** confront **38.** abuse **39.** ignore **40.** bounce **41.** satisfy **42.** discover **43.** attend **44.** respect

본문 만점 **빈칸 채우기**　　pp. 250~253

(1) takes over (2) is located (3) end up living (4) keep blaming each other (5) but that they lack (6) comes up with (7) ignore him (8) should speak louder (9) One of the players (10) a term of respect (11) All of you will have my respect (12) gives out (13) If you sign and honor (14) It states that (15) why are you wearing (16) when we treat ourselves (17) starts bouncing (18) leave the gym (19) who doesn't want to sign (20) the others stay (21) to stay focused (22) how much basketball means (23) while Cruz watches (24) decides to come back (25) How can I get back (26) If you want to rejoin (27) continues coaching (28) It's time to give up (29) let's help him out (30) Carter seems impressed (31) With Cruz back (32) skipping classes (33) decides to do something (34) is waiting (35) where the library is (36) you signed (37) from your teachers (38) until we all satisfy (39) want us to win (40) What's more important than winning (41) adjust to the real world (42) for you to take responsibility (43) I want you to go home (44) I will do everything (45) to go to college (46) to graduate from high school (47) stop neglecting (48) they're good at (49) the best part of their lives (50) Don't you think (51) to keep winning (52) confronts Carter (53) be allowed to take (54) consider the message that (55) trying to teach them discipline (56) it won't be long before (57) Despite Carter's speech (58) is about to resign (59) he sees something shocking (60) can't make us play (61) what's important in life (62) one way to say this (63) enough to fulfill (64) competes in (65) as well as hope

본문 만점 **옳은 어법 · 어휘 고르기**　　pp. 254~255

01. had **02.** respect **03.** ignoring **04.** attend **05.** who **06.** play **07.** inspiring **08.** to go **09.** impressed **10.** canceled **11.** contracts **12.** adjust **13.** honoring **14.** neglecting **15.** confronts **16.** breaking **17.** Despite **18.** shocking **19.** enough **20.** to win

본문 만점 **틀린 문장 고치기**　　pp. 256~258

01. O **02.** X, locate → located **03.** O **04.** X, blame → blaming **05.** X, what → that **06.** O **07.** O **08.** X, toss → tosses **09.** O **10.** O **11.** X, maintains → maintain **12.** O **13.** O **14.** O **15.** X, which → who **16.** X, stay → to stay **17.** O **18.** O **19.** X, coming → to come **20.** O **21.** O **22.** X, giving → give **23.** O **24.** X, impressing → impressed **25.** O **26.** X, skipped → skipping **27.** O **28.** X, is the library → the library is **29.** O **30.** X, lock → locked **31.** X, win → to win **32.** X, take → taking **33.** X, are → is **34.** X, go → to go **35.** O **36.** X, going → to go **37.** X, graduating → to graduate **38.** O **39.** O **40.** O **41.** X, which → who **42.** X, is(2행) → be **43.** O **44.** O **45.** O **46.** X, shocking something → something shocking **47.** X, playing → play **48.** X, because → because of **49.** O **50.** O **51.** O **52.** X, very → far

내신 기출 문제　　pp. 259~261

1. ④ 2. not how they play basketball 3. ② 4. ⑤ 5. respect 6. ② 7. ③ 8. ⑤ 9. ⑤ 10. basketball 11. (A) confronts (B) breaking 12. ⑤

1. (A) 학교가 '위치되어 있는' 것이므로 과거분사 located를 써서 수동태로 나타낸다.
 (B) 「end up v-ing」: 결국 ~한 처지가 되다

(C) 「keep v-ing」: 계속해서 ~하다

2. not 뒤에 방법을 나타내는 관계부사 how가 이끄는 명사절이 와야 한다.

3. 앞에서 선수들이 Carter를 무시하고 잡담을 나눴다고 했으므로, 이유로는 ② '선수들이 그에게 주목하는 것 같지 않아서'가 적절하다.

 오답

 ① 농구장이 너무 시끄러워서

 ③ 선수 중 한 명이 다른 선수에게 공을 던져서

 ④ 선수들이 그가 말한 것을 이해하지 못해서

 ⑤ 그가 선수들의 이름을 알지 못해서

4. ⑤ Cruz 이외에도 두 명의 학생이 추가로 체육관을 떠났다.

5. 'sir(자네)'이 이것의 용어라고 하며 학생들이 악용하기 전까지 이것을 받게 될 것이라고 했으므로, 빈칸에는 respect(존중)가 들어가는 것이 적절하다.

6. ② Cruz가 농구가 그에게 어떤 의미인지 깨닫고 돌아가기로 한 것으로 보아 경기장 밖의 삶이 얼마나 편한지(comfortable) 깨달았다고 하는 것은 적절하지 않다. 따라서 comfortable을 tough(힘든) 등으로 바꿔야 한다.

7. ⓒ는 Coach(Carter)를 가리키는 반면, 나머지는 모두 Cruz를 가리킨다.

8. 빈칸 앞은 팀이 대회에서 우승하는 내용이고 뒤에는 Carter가 학생들의 학교 생활 문제를 알게 되는 내용이므로, 빈칸에는 ⑤ However(하지만)가 적절하다.

 오답

 ① 그러므로 ② 마침내 ③ 게다가 ④ 다행히도

9. ⑤ 규칙이나 계약을 지키는 것의 중요성을 말하고 있으므로 (A)는 '행동에 책임(responsibility)을 지는 것', (B)는 '자신의 인생에서 책임(responsibility)을 지는 첫 단계'라고 하는 것이 적절하다.

 오답

 ① take a risk: 위험을 무릅쓰다

 ② take revenge: 복수하다

 ③ take action: 조치를 취하다

 ④ take control: 통제하다, 제어하다

10. 교장은 체육관 문을 잠근 것이 소년들이 잘하는 것을 빼앗은 것이고, 이번 농구 시즌이 그들 인생의 정점이 될 것이라고 했으므로 the one thing은 basketball(농구)을 의미한다.

11. (A) Carter의 행동이 학부모들을 화나게 했고 학부모들은 그가 아이들에게서 농구를 빼앗게 둘 수 없다고 했으므로, 학교운영위원회가 Carter에게 대립한다(confront)고 하는 것이 적절하다. agree with는 '~에 동의하다'라는 뜻이다.

 (B) 아이들이 간단한 계약도 지키지 않는다면, 결국 법을 어길(breaking) 것이라고 하는 것이 적절하다. follow는 '따르다'라는

뜻이다.

12. ⑤ 비교급을 강조하는 부사로 far가 쓰인 것은 적절하다.

 오답

 ① 뒤에 절이 아닌 명사구가 이어지므로, 접속사 Although가 아닌 전치사 Despite 등이 되어야 한다.

 ② 사역동사 make의 목적어와 목적격 보어가 능동 관계이므로 목적격 보어로는 동사원형 play가 와야 한다.

 ③ one way를 수식하는 형용사적 용법의 to부정사 to say가 되어야 한다.

 ④ fail은 목적어로 to부정사를 취하므로 to win이 되어야 한다.

1. ④ 2. ④ 3. how tough life is, how much basketball means 4. ③ 5. ⑤ 6. ⑤ 7. ② 8. (A) make (B) that (C) breaking 9. ① 10. ④ 11. ③ 12. enough to fulfill the contract

1. ④ 왜 Carter는 양복을 입고 넥타이를 매는가? (알 수 없음)

 오답

 ① Carter는 농구팀의 문제를 아는가? (그들 자신에 대한 존중이 부족하다는 것)

 ② 'sir'이라는 용어는 무엇을 나타내는가? (존중)

 ③ 계약에 무엇이 쓰여 있나? (모든 수업에 출석하고 평균 2.3학점을 유지할 것)

 ⑤ 얼마나 많은 학생들이 체육관을 떠났는가? (Cruz와 두 명의 학생 즉, 총 3명)

2. ④ '누군가가 하고 있던 것을 멈추거나 중단하다'라는 뜻의 단어는 quit(그만두다)이다.

 오답

 take over: ~을 이어받다 term: 용어 honor: 이행하다 contract: 계약(서)

3. 동사 realizes의 목적어 역할을 하는 간접의문문으로 「의문사+주어+동사」의 어순으로 쓴다.

4. Cruz가 팀에 다시 합류하기 위해 해야 할 운동을 다른 팀원들이 나눠서 도와주려는 내용이므로, 빈칸에는 ③ impressed(감명받은, 감동받은)가 가장 적절하다.

 오답

 ① 긴급한 ② 침울한 ④ 실망한 ⑤ 열광적인

5. (A) 큰 대회에서도 우승한다는 내용이 이어지고 있으므로, undefeated(무패의)가 오는 것이 적절하다. undervalued는 '저평가된'이라는 의미이다.

 (B) 이어지는 대사에서 Carter는 행동에 책임을 지는 것을 강조하고 있으므로 계약 조건들(terms)을 충족시킬 때까지 체육관은 잠겨 있을 것이라고 하는 것이 자연스럽다. form은 '서식, 형식'이라

는 의미이다.

(C) 문맥상 규칙을 존중하고 행동에 책임을 지는 것이 중요하다는 것을 깨닫지 못하면 성공하지 못하며 현실 사회에 적응할(adjust) 수 없다고 하는 것이 자연스럽다. adopt는 '입양하다, 채택하다'의 의미이다.

6. 주어진 문장은 '만약 그 대답이 '그렇다'라면, 그럼 내가 여러분에게 약속하건대, 나는 여러분이 더 나은 삶을 살 수 있도록 내 힘이 닿는 한 모든 것을 할 것이다.'라는 의미로, 스스로에게 질문하라는 문장 뒤인 ⑤에 들어가는 것이 자연스럽다.

7. 체육관을 잠근 것에 대해 교장과 Carter가 대립하고 있으므로, 빈칸에는 ② '분노하며'가 오는 것이 적절하다.
오답
① 머뭇거리며 ③ 다정하게
④ 즐겁게 속삭이며 ⑤ 사랑스러운 목소리로

8. (A) to stop과 병렬 연결되어 있으므로 make가 적절하다. 병렬 구조이므로 make 앞에 need to나 to가 생략된 형태이다.
(B) 선행사 the one thing을 수식하는 목적격 관계대명사 that이 적절하다.
(C) 동시동작을 나타내는 분사구문으로 그들이 법을 '어기는' 것이므로 현재분사 breaking이 적절하다.

9. 빈칸 뒤에 아이들이 간단한 계약조차 지키지 못한다면, 나중에 사회에서도 법을 어기게 될 것이라고 한 것으로 보아 ① discipline (규율)이 가장 적절하다.
오답
② 공감 ③ 자존감 ④ 용기 ⑤ 능력

10. ④ 부모들은 아이들에게 패배에 대한 책임을 지라고 가르친다. (알 수 없음)
오답
① 교장은 Carter와 다른 의견을 가지고 있다.
② 아무도 농구팀 선수들이 대학에 갈 거라고 기대하지 않는다.
③ 부모들은 코치의 행동에 대해 화를 낸다.
⑤ 코치는 농구팀 선수들이 계약을 이행하기를 원한다.

11. ③ 모든 선수들이 체육관에서 함께 공부하고 있었다.

12. 「enough to-v」: ~할 만큼 (충분히)

2회 실전 적중 문제 pp. 265~267

1. ⑤ 2. ④ 3. ③, ④ 4. abuse 5. ④ inspired → inspiring
6. ② 7. ③ 8. stay locked, satisfy the terms 9. ② 10. ③
11. 만약 이 아이들이 간단한 계약을 지키지 못한다면, 머지않아 그들은 바깥세상 속에서 법을 어기게 될 것이다.

1. ⑤ 마지막 문장에서 Carter는 선수들의 문제가 그들 스스로에 대한 존중 부족이라는 것을 알게 되었고 그가 아이디어를 생각해 낸

다고 했으므로, 뒤에는 이 문제를 해결하기 위한 Carter의 방안이 제시되는 것이 가장 적절하다.

2. (A) take over: ~을 이어받다
(B) drop out: 중퇴하다
(C) blame ~ for ...: …에 대해 ~을 탓하다

3. ③ Carter는 선수들에게 공을 던진다. (선수들 중 한 명이 다른 선수에게 공을 던짐)
④ 계약의 조건들은 Cruz에게 이행하기에 쉽다. (Cruz는 계약 내용이 말도 안 된다고 함)
오답
① Carter는 선수들에게 자신을 소개한다.
② 선수들은 Carter가 말하는 것을 무시하는 것처럼 보인다.
⑤ Cruz와 두 명의 학생이 체육관을 떠난다.

4. '사용되도록 의도되지 않았던 방식으로 무언가를 사용하다'라는 의미의 단어는 abuse(남용하다)이다.

5. ④ 승리가 감동을 '유발하는' 것으로, 수식을 받는 명사와 분사가 능동 관계이므로 과거분사를 현재분사 inspiring으로 고쳐야 한다.

6. Carter가 Cruz에게 팀에 합류하기 위한 조건을 설명하지만 팀원들이 그것은 불가능하다고 말하는 주어진 글 뒤에 (A) 금요일이 되었지만 Cruz가 조건을 충족시키지 못했고, (C) Lyle이 Cruz를 돕고자 동참하겠다고 한 후, (B) Kenyon 또한 동참하겠다고 말하는 내용 순으로 오는 것이 자연스럽다.

7. ③ 'What's more important ... for your behavior.'에 Carter의 의견이 제시되어 있다.

8. 체육관이 '잠겨진' 상태로 유지되는 것이므로 동사 stay 뒤에 과거분사 locked를 쓴다.

9. ⓐ expect는 목적격 보어로 to부정사를 취하므로 going을 to go로 고쳐야 한다.
ⓒ 앞에 선행사(the one thing)가 있으므로 선행사를 포함하는 관계대명사 what을 목적격 관계대명사 that으로 고쳐야 한다.

10. (A) 코치는 아이들이 계약을 지키게 하려고 하고 있으므로 규율 (discipline)을 가르친다고 하는 것이 적절하다. dissatisfaction은 '불만족'이라는 의미이다.
(B) Carter가 자신의 생각을 말했지만 받아들여지지 않았으므로 문맥상 사직한다(resign)고 하는 것이 적절하다. assign은 '맡기다, 배정하다'라는 의미이다.
(C) Cruz가 인생에서 중요한 것이 무엇인지 깨달았다고 하며 감사 인사를 하고 있으므로, 그들이 계약을 이행한다(fulfill)고 하는 것이 적절하다. cancel은 '취소하다'라는 의미이다.

11. it won't be long before+주어+동사: 머지않아 ~할 것이다

1. ④ 2. ④ 3. ②, ③, ⑤ 4. ②, ⑤ 5. ⑤ 6. need to stop neglecting them, that they can do more 7. ④ 8. ③ 9. allowed to 10. ②, ⑤ 11. ④

1. ④ what 뒤의 절이 완전하므로 관계대명사 what이 아닌 명사절을 이끄는 접속사 that이 와야 한다.

2. 요약문
자신을 새로운 농구 코치라고 소개하며, Carter는 선수들을 <u>존중</u><u>하려고</u> 노력하는 반면 그들 중 일부는 고의로 그를 <u>무시하고</u> 체육관을 떠난다.
오답
① 존경하다 – 존경하다 ② 억압하다 – 방치하다
③ 존경하다 – 속이다 ⑤ 무시하다 – 존경하다

3. ② Cruz가 돌아오고, 팀은 감동적인 승리를 하기 시작한다. (Cruz는 관중들 사이에서 팀의 감동적인 승리를 지켜봄)
③ 일부 팀원들에게 1,000개의 팔굽혀펴기와 체육관 1,000바퀴 돌기가 요구된다. (Cruz에게 요구됨)
⑤ Carter는 다른 선수들이 Cruz를 돕도록 허락하지 않는다. (다른 선수들이 Cruz를 함께 도우며 Carter는 감명 받은 듯 보임)
오답
① Cruz는 경기장 밖의 삶이 쉽지 않다고 생각한다.
④ Lyle은 Cruz를 위해 팔굽혀펴기를 할 것이라고 말한다.

4. ② '수업에 빠지는 몇몇 선수들의 이름'과 ⑤ '도서관의 위치'는 알수 없다.
오답
① 큰 대회의 결과 (우승함)
③ 대화가 이루어지고 있는 장소 (체육관 문 앞)
④ 쪽지의 상세 내용 (연습이 취소되었고 코치가 학교 도서관에서 기다리고 있다는 것)

5. (A) 문맥상 계약서 조건을 충족시킬(meet) 때까지 체육관이 잠겨 있을 것이라고 하는 것이 적절하다. meet은 '만나다'라는 뜻외에도 '(필요·요구 등을) 충족시키다, 지키다'의 뜻을 지닌다. dissatisfy는 '불만을 느끼게 하다'라는 뜻이다.
(B) 선수들이 이기는 것보다 규칙을 존중하고(respecting) 행동에 책임지는 것이 중요하다고 하는 것이 적절하다. break는 '어기다'라는 뜻이다.
(C) 문맥상 계약을 준수하는 것(honoring)이 인생에서 책임을 지는 첫 단계라고 하는 것이 적절하다. refuse는 '거절하다'라는 뜻이다.

6. 「need to+동사원형」: ~할 필요가 있다
「stop v-ing」: ~하는 것을 멈추다[그만두다]
realize의 목적어 역할을 하는 명사절을 쓴다.

7. 교장은 몇몇 아이들에게는 이번 농구 시즌이 그들 인생의 정점이 될 것이라고 말하고 있으므로, 그들이 잘하는 한 가지(the one thing)는 ④ basketball(농구)을 의미한다.
오답
① 체육관 ② 대학 ③ 고등학교 ⑤ 문제

8. 빈칸 앞에서 Carter의 행동으로 학부모들이 화가 났고 뒤에서 학교운영위원회가 그와 대립하게 되었다고 했으므로, 빈칸에는 ③ Eventually(결국)가 오는 것이 적절하다.
오답
① 대신 ② 그럼에도 불구하고 ④ 그러나 ⑤ 대조적으로

9. '~하는 것이 허용되다, ~해도 되다'라는 의미의 수동태 구문 「be allowed to-v」가 쓰인 것이다.

10. ② 「make+목적어+동사원형」: (목적어)가 ~하게 하다
⑤ -thing으로 끝나는 말은 형용사가 뒤에서 수식하므로, something far more important가 되어야 한다.

11. 요약문
Cruz가 Carter에게 그의 <u>감사함</u>을 표현했을 때, Carter는 그가 가르쳤던 것이 <u>보람 있다</u>고 생각했을지도 모른다.
오답
① 감상 – 부끄러운 ② 불안감 – 유익한
③ 분노 – 믿을 수 있는 ⑤ 우울 – 유감스러워하는

서술형으로 내신 만점 pp. 271~272

1. (A) ⓒ (B) ⓐ (C) ⓑ 2. ⓐ to stay ⓑ coaching 또는 to coach ⓒ to go ⓓ impressed 3. is the first step for you to take responsibility 4. (1) True, The gym will stay locked until we all satisfy the terms of this contract. (2) False, What's more important than winning is respecting the rules and taking responsibility for your behavior. 5. belief in themselves, as well as hope for a brighter future

1. (A) 이름을 묻는 말에 대한 대답으로는 ⓒ 'Jason Lyle이요. 하지만 저는 자네가 아닌데요.'가 적절하다.
(B) 앞 문장에서 계약서에 대해 언급했으므로 계약의 구체적인 내용인 ⓐ '여기에는 여러분이 모든 수업에 출석할 것과 평균 2.3학점을 유지할 것이 명시되어 있다.'가 이어지는 것이 적절하다.
(C) 빈칸 앞에서 Cruz가 Carter의 말을 듣지 않았고 빈칸 뒤에 Cruz가 체육관을 나간 내용이 이어지므로 빈칸에는 ⓑ '그래, Cruz군, 지금 당장 체육관에서 나가 주게.'가 적절하다.

2. ⓐ 「teach+목적어+to-v」: (목적어)에게 ~하는 것을 가르치다
ⓑ continue는 동명사와 to부정사 둘 다를 목적어로 취할 수 있으므로, coach는 coaching 또는 to coach가 되어야 한다.

ⓒ 명사구 100 push-ups and 100 laps를 수식하는 형용사적 용법의 to부정사로 나타낸다.

ⓓ 「seem+형용사」는 '~인 것처럼 보이다'의 의미로 Carter가 학생들로 인해 '감명을 받은' 주체이므로 과거분사 impressed가 적절하다.

3. 명사구 the first step을 수식하는 형용사적 용법의 to부정사구를 써야 하며, to부정사구의 의미상 주어는 「for+목적격」으로 나타낸다.

4. (1) '체육관은 선수들이 계약을 이행하지 않는다면 열리지 않을 것이다.'는 참이며, 그 근거가 되는 문장은 '체육관은 우리 모두가 이 계약서의 조건을 충족시킬 때까지 잠겨 있을 것이다.'이다.

(2) 'Carter는 경기에서 이기는 것이 학생들의 삶을 개선하는 가장 좋은 방법이라고 생각한다.'는 거짓이며, 그 근거가 되는 문장은 '이기는 것보다 더 중요한 것은 규칙을 존중하고 여러분의 행동에 책임을 지는 것이다.'이다.

5. A as well as B: B뿐만 아니라 A도

1. ⑤ 2. they would have been destroyed or taken overseas 3. ④ 4. ④ 5. ⑤ 6. (B)→(C)→(A) 7. ④ 8. ⑤ 9. was written 10. collected art 11. ② 12. ② 13. ③ 14. ③ 15. ④ 16. ④ 17. alternative 18. ② 19. ⓐ (s)urrounding ⓑ (c)onventional ⓒ (i)nternal 20. ① 21. which 22. ④ 23. ③ 24. ④ 25. ⑤

1. ⑤ 누가 간송을 돕기 위해 돈을 기부했나? (알 수 없음)

 오답

 ① '나'는 지난주 어떤 종류의 전시회에 갔나? (미술품과 골동품 전시회)

 ② 간송의 실제 이름은 무엇이었나? (전형필)

 ③ 돈을 쓰기로 한 간송의 결정에 누가 영향을 주었나? (스승 오세창)

 ④ 간송은 그의 돈으로 무엇을 했나? (오래된 책, 그림, 미술품을 획득함)

2. 주절에 「주어+조동사의 과거형+have v-ed」가 쓰인 가정법 과거완료 구문이다.

3. ④ insight는 '통찰력'이며 '다른 사람이 어떻게 느끼는지 상상할 수 있는 능력'을 나타내는 단어는 empathy(공감)이다.

 오답

 ① 전시회: 대중에게 보여지기 위해 전시된 수집품목들

 ② 재산: 많은 양의 돈

 ③ 독립: 외부의 지배로부터의 자유

 ⑤ (강한) 신념: 깊고 강한 믿음

4. ④ 그것(그 화첩)이 '구해진' 것이므로 수동태 was rescued로 써야 한다.

5. 주어진 문장은 '하지만, 간송은 그것이 그런 종류의 화병 중에서 가장 아름다운 화병이라는 것을 알고 있었기 때문에 그것을 내주는 것을 거절했다.'는 내용으로, 문맥상 화병을 구매하려는 사람이 있었다는 내용 뒤인 ⑤에 오는 것이 적절하다.

6. 첫 문단에서 언급된 훈민정음 해례본에 대한 설명과 당시 1940년의 일제 강점기 상황에 대한 (B)가 오고, 간송이 훈민정음 해례본을 지키기 위해 집에 숨겼다는 내용의 (C)에 이어, 일본이 패망한 뒤 훈민정음 해례본을 국민과 공유했다는 (A)가 오는 것이 적절하다.

7. ④ 간송의 스승이 그에게 훈민정음 해례본의 가치를 일깨워주었다. (알 수 없음)

 오답

 ① '나'는 훈민정음 해례본을 절대 잊을 수 없을 것이다. (화자는 절대 잊을 수 없을 것이라고 함)

 ② 일본이 패망한 후 그는 자신이 소유했던 것을 대중에 보여주었

다. (일본이 패망하자, 그는 훈민정음 해례본을 한국 국민과 공유함)

③ 1940년, 학교에서 한국어로 수업하는 것은 허용되지 않았다. (한국어로 수업하는 것을 금지 당함)

⑤ 간송이 소유주가 요구하는 것보다 더 많은 돈을 책에 썼다. (소유주가 요구한 가격의 10배에 샀음)

8. ⑤ 일제 강점기의 상황에서도 우리나라의 문화유산을 지키는 간송에 대한 내용이므로, 간송이 한국 역사를 왜곡하려는 (distorting) 의지가 있다고 하는 것은 적절하지 않다. 따라서 distorting을 preserving(보호하려는) 등으로 바꿔야 한다.

9. 책이 '쓰여진' 것이므로 수동태 was written으로 써야 한다.

10. (A)는 문맥상 바로 앞 문장의 collect art를 의미하며, 과거형인 collected art로 써야 한다.

11. ⓑ it은 앞에 나온 art를 가리킨다.

12. 자연이 건축가에게 많은 영감을 준다는 내용이므로, 제목으로 ② '건축가들의 영감으로의 자연'이 가장 적절하다.

오답
① 성공한 기술자들의 비결
③ 자연 모방: 인간의 건강에 좋은가 혹은 나쁜가?
④ 자연과 인간의 극심한 갈등
⑤ 전 세계의 건축학적 도전

13. 요약문
가우디는 자연에서의 곡선의 아름다움을 선호해서, 아름다울 뿐만 아니라 실용적인 건물들을 설계했다.

오답
straight: 직선 fabulous: 굉장한 functional: 기능적인, 실용적인 ordinary: 일상적인 uniform: 획일적인

14. ③ Sagrada Familia의 천장 빛은 잎으로 다시 반사된다. (알 수 없음)

오답
① Sagrada Familia는 자연에서 발견되는 몇몇 특징을 닮았다.
② Sagrada Familia에는 바다 생물들의 껍데기를 닮은 나선형 계단이 있다.
④ 가우디는 성당 기둥을 설계할 때 나무에서 영감을 받았다.
⑤ 가우디가 설계한 기둥은 단지 건물을 아름답게 하기 위함은 아니다.

15. ④ '마치 ~인 것처럼'의 의미로 주절과 같은 시점인 현재의 일을 가정하는 「as if+주어+동사의 과거형」 형태의 가정법 과거 구문을 쓴다.

16. (A) 형용사 impressive를 수식하는 부사 visually(시각적으로)가 적절하다.
(B) 뒤에 절이 이어지므로 접속사 Because(~ 때문에)가 적절하다. 전치사 due to 뒤에는 명사(구)가 온다.

(C) 문장의 주어가 The heat이므로 동사는 단수형인 rises가 적절하다.

17. '일반적인 선택 대신에 사용될 수 있는 어떤 것'은 alternative(대안)이다.

18. ② 온도가 크게 올라가지 않는 흰개미집의 특성이 Pearce에게 영감을 주었다는 내용이므로, 흰개미집 안의 온도가 비교적 뜨겁게 (hot) 유지되었다고 하는 것은 적절하지 않다. 따라서 hot은 cool(서늘한) 등이 되어야 한다.

19. ⓐ 명사 the soil을 수식하며 능동을 나타내는 현재분사 surrounding을 써야 한다.
ⓑ conventional: 전형적인
ⓒ internal: 내부의

20. 자연 모방의 긍정적 효과에 대한 내용이므로, 문맥상 ① '자연의 아이디어를 모방하는 것'이 들어가는 것이 적절하다.

오답
② 건축 원리의 이해
③ 획기적인 냉방 시스템의 도입
④ 인간의 문화로부터의 영감을 적용하는 것
⑤ 오염으로부터 환경을 보호하는 것

21. 콤마(,) 뒤에 선행사에 대한 부가적인 설명을 하는 계속적 용법의 주격 관계대명사 which가 와야 한다.

22. (A) (Cruz는 체육관 밖으로 걸어 나갔다.)는 Cruz가 코치의 이야기를 더는 들을 필요가 없다고 하며 그만두겠다고 하는 대사 뒤인 ⑤에 오는 것이 적절하다.
(B) (Carter는 종이 몇 장을 나눠 준다.)는 Carter가 농구팀 선수들에게 계약서를 설명하는 장면인 ②에 들어가야 한다.
(C) (Cruz는 듣지 않고 공을 튕기기 시작한다.)는 Carter가 Cruz에게 체육관을 나가라고 하는 대사 앞인 ④에 들어가야 한다.

23. ③ 몇몇 선수들은 Cruz가 팀에 복귀하게 하는 것을 거부했다. (알 수 없음)

오답
① Cruz는 경기장 밖에서 힘든 시간을 보냈다. (Cruz는 경기장 밖의 삶이 얼마나 힘든지 깨달음)
② Cruz는 다시 농구팀에 합류하기 원했다. (Cruz는 팀으로 돌아가기로 마음먹음)
④ Cruz는 금요일까지 미션을 끝마치지 못했다. (Carter가 Cruz에게 아직 팔굽혀펴기 100개와 100바퀴 뛰는 것이 남았다고 함)
⑤ Carter는 Cruz를 돕는 다른 선수들의 노력에 감명 받았다. (Carter는 감명 받은 듯 보였음)

24. ④ Carter는 아이들에게 법 위에 있다는 메시지를 보내는 것과 아이들이 계약을 지키지 않게 되는 것을 우려하고 있으므로 Carter가 아이들에게 규율(discipline)을 가르치고자 한다는 것이 문맥상 자연스럽다.

오답

① 겸손 ② 감정 ③ 스포츠 ⑤ 만족

25. ⑤ 비교급 more를 강조하는 부사로 적절한 것은 far, still, even, a lot, much 등이다. a lot of(많은)는 형용사이다.

Memo

Memo

Got A Book For Vocabulary?

" The Original and The Best "

Here is the **No.1 vocabulary book** in Korea, recognized by more teachers and used by more students than any other vocabulary book ever made. **Get yours today!** You won't regret it!

어원학습분야 **1위**